PLANNING THE DOCUMENTATION OF MUSEUM COLLECTIONS

D. Andrew Roberts

Duxford, Cambridge
The Museum Documentation Association

October 1985

i

PLANNING THE DOCUMENTATION OF MUSEUM COLLECTIONS

Published by The Museum Documentation Association, Duxford, Cambridgeshire CB2 4QR, United Kingdom (0223) 833288.

First published October 1985.

This work was funded by a research grant from the Office of Arts and Libraries to investigate documentation procedures in museums.

ISBN 0 905963 53 9

Printed and bound by The Burlington Press (Cambridge) Ltd,
Foxton, Cambridge CB2 6SW

PREFACE AND ACKNOWLEDGEMENTS

This report describes the results of a project undertaken from September 1981 to March 1983 to investigate the state and future development of documentation procedures in museums. The project was funded by a research grant from the Office of Arts and Libraries and carried out by an investigator seconded from the Museum Documentation Association. The terms of reference of the project were to help museums plan the future development of their documentation policy, by providing detailed guidance on documentation objectives and practice (with particular attention to the role of inventory control procedures), the impact of new technology and the resource implications of documentation.

During the eighteen-month project, the investigator reviewed the available literature concerning documentation procedures, visited over 50 museums and related institutions in the United Kingdom, Canada and the United States, and attended meetings of the Documentation Committee of the International Council of Museums.

The resulting report is divided into ten main sections (of general interest to senior staff), four detailed appendices (of particular concern to officers with primary responsibility for documentation) and details of additional sources and references. A first draft was prepared in May 1983 and subsequently revised in February 1984. References have since been updated to include publications available in early 1985.

The preparation of the report would have been impossible without the cooperation of over 100 individuals in museums and other organisations. The investigator would like to express his thanks to all these advisers. Particular acknowledgement should be made of the help of Llywela Hopkins, Richard Light, Anna Mackay-Smith and Jennifer Stewart (Museum Documentation Association), Brenda Capstick (Museums Association), Gill Dishart (Office of Arts and Libraries), David Vance (Museum Computer Network), Gary Gautier and Philip Leslie (Smithsonian Institution), Peter Homulos, Barbara Rottenberg and Jane Sledge (Canadian Heritage Information Network), Joan Thornley (Museum of Fine Arts, Montreal) and Sonja Tanner-Kaplash (Royal Ontario Museum).

The report represents the personal views of the investigator. Neither the Office of Arts and Libraries nor the Museum Documentation Association are responsible for these views.

CONTENTS

ILLUSTRATIONS

TABLES

FIGURES

ABBREVIATIONS

AMC	Area Museum Council
C & AG	Comptroller and Auditor General
CCTA	Central Computer and Telecommunications Agency
CHIN	Canadian Heritage Information Network
CIDOC	Documentation Committee of the International Council of Museums
COM	computer output microform
DES	Department of Education and Science
E & AD	Exchequer and Audit Department
IRGMA	Information Retrieval Group of the Museums Association
ISO	International Organization for Standardization
MCN	Museum Computer Network
MDA	Museum Documentation Association
MSC	Manpower Services Commission
OAL	Office of Arts and Libraries
PAC	Public Accounts Committee
VDU	visual display unit

1:
Introduction

1.1 documentation in museums

Writing over a decade ago, the Committee drafting the Wright Report on non-national museums was concerned to stress the key role of documentation (GB. DES, 1973a):

"9.7 In order to be able to interpret and communicate knowledge effectively, a museum must first have detailed and accurate information about the objects in its collection. Museums can provide an efficient service only if their information resources are readily available and if their records are revised as a continuing process. Accurate and well documented information also has a vital part to play as a means of collection control: in addition to making it easier to determine collecting patterns and supervise conservation treatment, it simplifies the mundane tasks of stock-taking and audit."

In the intervening years, many museums have made impressive efforts to improve the standard of documentation of their collections and to introduce revised manual or automated systems. This investment has drawn attention to the magnitude of the documentation problem facing museums and to the need for careful long-term planning if this problem is to be made manageable. This report has been designed to help museum staff with this complex task. Its advice and recommendations are based upon evidence gathered during a research project funded by the Office of Arts and Libraries.

1.2 structure of report

The following three sections provide a general background to museum documentation. General influences which affect the state and development of documentation are introduced in Section 2. This concentrates on the situation in the United Kingdom, although reference is made to relevant experience in North American museums (an approach which is also followed at other points in the report). Section 3 and Appendix A establish features of the design of a museum documentation system and Section 4 examines the effect on the system of the complexity of records and operational requirements.

Four major sections then concentrate on the application of these general principles within an individual museum. Section 5 considers practical aspects of documentation procedures. The development of documentation for collections control and curation purposes is stressed in Section 6.

1

Methods for improving the documentation of existing collections are considered in Section 7. Section 8 evaluates the role of documentation in the audit strategy of the museum.

Section 9 and Appendices B and C consider methods of assessing a museum's current documentation practice and future requirements and the potential role of automated systems.

Section 10 incorporates advice on the adoption of a revised documentation system and the impact this may have on the resources for documentation. It concludes with an examination of areas of documentation that might need to be investigated on a cooperative basis in future years.

Practice in over fifty museums in the United Kingdom, Canada and the United States is reviewed in Appendix D.

Finally, details are given of additional sources of information and references about museum documentation and automation.

2:

Influences on the development of documentation

The museum community

Accountability for collections

Collections and documentation

Automated systems

Allocation of resources

Some of the influences on the development of documentation in museums are reviewed in Section 2. The implications of these influences need to be taken into account when formulating any new documentation policy. The experience of a number of museums in dealing with these influences is considered in some of the surveys of current practice in Appendix D.

The museum community

2.1 organisation of museums

While estimates of the number of museums in the United Kingdom do vary, one frequently quoted source (Museums Association, 1982) includes 1325 distinct entries. An interpretation of this figure suggests that there are approximately 750 institutions responsible for the management of these museums. The difference between the figures of museums and institutions is largely the result of the reorganisation of groups of local museums as single institutions and the fragmentation of individual institutions into separate branches.

Administrative changes such as local government reorganisation in 1974 led to the drawing together of many previously independent museums into county- or district-based institutions, with a single management structure. At the time of reorganisation, comments in the Wright Report on local museums (GB. DES, 1973a) and a government circular advising on the role of museums (GB. DES, 1973b) drew the attention of the new institutions to the importance of documentation and the potential use of computers. A number of these institutions have since shown an active concern for the development of a common documentation system within the museums in their county, such as the introduction of uniform procedures and the preparation of a county-wide catalogue.

There has also been a tendency towards the fragmentation of many institutions into physically separate branches, with the result that the typical national or local authority institution is now responsible for a number of museums. For example, of the 1325 museums noted in the *Museums Yearbook*, over half are in the charge of less than 300 local authority institutions. This fragmentation has been paralleled by the rearrangement of many institutions into specialised, professionally-staffed curatorial and support sections, with the result that a number of the larger institutions include ten or more sections responsible for curation, conservation, education, etc.

Fragmentation and rearrangement has frequently resulted in a new complexity when considering documentation procedures. For example, the maintenance of a single central acquisition and numbering procedure becomes increasingly difficult; central mechanisms for monitoring and coordinating items coming into the institution (enquiries, loans-in, potential acquisitions, etc.) can become unwieldy; and procedures for controlling the movement of items between sections (such as a curatorial department and a conservation unit) become more important. If they are to be successfully managed, many of these procedures require coordination between individual sections.

In North America, the comparable rearrangement of museum structures has often included the development of registration and technical support departments with some of these coordinating functions (the former with responsibility for acquisition and collections control aspects of documen-

tation and the latter for the support of computing systems appropriate for administrative and documentation uses) (Anon., 1984; Hoachlander, 1979; Porter, 1984).

In the United Kingdom, documentation responsibilities have rarely been concentrated within a single unit and few museums have internal technical support facilities, with the result that the development of documentation has sometimes been handicapped.

2.2 parent organisations

The parent organisations of these institutions have often been in a position to make an important contribution to the development of the museum's documentation system.

For example, a number of local authority museums have received extensive advice from management and systems experts and practical assistance from their centrally-supported computing service during the evaluation of their existing systems and the automation of their records. Similarly, some university museums have been able to utilise centrally-supported computing systems and related advisory facilities.

The national museums have been less able to benefit from this kind of practical computing assistance, although some have been in a position to turn to bodies such as the Management Services division of the Department of Education and Science (DES), Scottish Office Computer Services and the Central Computer and Telecommunications Agency (CCTA) for assistance. While one or two of the Trustee national museums have also received advice from the CCTA, this has tended to be of a limited nature, which has declined rather than grown in recent years. The greater degree of independence of the national museums has been one of the factors influencing an investment in internal documentation expertise and inhouse computing facilities.

2.3 museum support groups

In the United Kingdom, contributions towards the development of documentation within museums have also come from support organisations such as the Area Museum Councils (AMCs) and the Museum Documentation Association (MDA).

The provision of advice and funds by the AMCs has had a marked effect on the state of documentation in a number of non-national museums. For example, in Scotland, university and local authority museums have received help with the purchase of equipment and consumables. In North West England, support has been given to cataloguing within individual museums, the development of a central file on natural science collections and the cooperative examination of computer-based procedures. A number of newly-formed museums in Yorkshire and Humberside have been encouraged to adopt uniform documentation procedures. In South East England, funds have been provided to support major investigations into the

documentation requirements of individual museums and a county-wide group of museums.

The MDA directs much of its assistance to non-national museums through the AMCs, while also working to help individual national institutions. Since its formation in 1977, the Association has been involved in the provision of advice and guidance to museums, the development and maintenance of documentation standards, research into the principles of museum documentation and the design of both manual and automated documentation systems (MDA, 1981a; MDA. Development Committee, 1982; Roberts, Light and Stewart, 1980; Stewart, 1983). The cooperative development of general systems by support groups such as the MDA has had a positive effect on the standard of ducumentation within many museums. For example, over 300 institutions now use the MDA systems as the basis for various aspects of their documentation procedures.

In Canada, a number of Provincial advisers have been able to offer basic guidance on documentation to individual museums. However, the dominant support for documentation has come from the National Museums of Canada, through its National Programs Branch. This includes Museum Assistance Programmes, which provide financial assistance to non-national museums for work such as cataloguing and computerisation, and the Canadian Heritage Information Network (CHIN), which supports a central computing system and advisory services for use by both non-national and national museums (Anon., 1982a; 1982b).

Documentation advisory and support groups in the United States have received little support from either the national authorities or the museums themselves. The one enduring specialist body has been the Museum Computer Network (MCN), formed in the late 1960s to promote the development of cooperative automation schemes.

Bodies such as the MDA, CHIN and the MCN contribute to the work of the Documentation Committee of the International Council of Museums (CIDOC), which acts as a forum for the development of documentation on an international scale. As a result of such cooperation, there is now a greater awareness of the documentation approach in different countries and a constructive interchange of ideas and practical systems.

2.4 professional groups

Professional groups in the three countries have also been influencial in encouraging the development of documentation.

As early as 1888, the founders of the Museums Association were calling for its aims to include the development of an index of all provincial collections (Platnauer and Howarth, 1890). A series of meetings in the mid-1960s led to the formation of the Information Retrieval Group of the Museums Association (IRGMA), concerned with the establishment of documentation standards and systems. The work of IRGMA has subsequently been con-

tinued by the MDA (Museums Association. Information Retrieval Group, Standards Subcommittee, 1977; Roberts, 1975).

A series of professional groups were set up during the 1970s so that curators working in specific disciplines could meet to discuss common problems. Among other achievements these groups have initiated a scheme for geological site documentation (Cooper et al, 1980); developed natural science collection research units (Pettitt and Hancock, 1981); and prepared a cooperative classification scheme for use by social history museums (Group for Regional Studies in Museums, 1983).

In the United States and Canada, the comparable development of professional groups has included the formation of registrar committees within the respective museum associations, both of which have played an important role in encouraging discussion between registrars. Regional groups and discipline-based organisations such as the Mid-Atlantic Association of Museums and the Art Museum Association have also included documentation procedures within their conference plans and system development proposals.

2.5 professional standards

One of the aims of these groups has been to establish professional standards concerning the work of museums and their staff: standards which place increasing emphasis on the importance of documentation procedures and collections management. The development of these standards has been in response to growing pressure from staff within the museum community for more formal statements of policy and to pressure from outside authorities for a greater demonstration of accountability.

The Museums Association code of practice for museum authorities and the American Association of Museums statement on ethics both include a discussion of the constraints on the acquisition and disposal of collections (American Association of Museums, 1978; Boylan, 1977; Museums Association, 1982; Reger, 1982). The 1982 Museums Association Conference concentrated on the role of professional standards, including a debate on a draft code of conduct for curators, which incorporates detailed advice on the management and care of collections and records (Museums Association. Working Party on Ethics, 1983).

One of the management controls stressed in these statements is the need for the development of written acquisition and collections management policies, papers about which have been prepared by a number of museums in the United States and Canada and by a few non-national museums in the United Kingdom (such as Boylan, 1976a; 1976b; 1982; Canada. National Museums of Canada, 1981; Force, 1983; Museum of the American Indian, 1978; Royal Ontario Museum, 1982; Smithsonian Institution, 1977). An important statement outlining the role and scope of these policies in American museums suggested that they should include a detailed description of acquisition and disposal methods, loan policies, documentation

7

procedures and policies, inventory control and stocktaking arrangements (Malaro, 1979).

The 1982 Museums Association Conference also examined the progress of museum accreditation schemes in the United Kingdom and United States (Loughbrough, 1982; Morris, 1982; Reger, 1982; Thompson, 1982). In a personal communication, the Assistant Director of the American Association of Museums noted that the United States programme, established in 1970, "has been an important catalyst in the development of standards in collections management, including record keeping, policy making and care. The Accreditation Commission does not itself set standards for museums, but reflects, at any given time, the standards as they evolve in the field. Ten years ago, the Commission asked for collections policies, but did not require them; more recently, the Commission has required written collections policies." The Director of the Association, commenting on the reasons for a museum failing to be accredited, noted the most prevalent problems included poor or non-existent records, incomplete cataloguing of the collection, inadequate storage, security and environmental control (Reger, 1982).

Part of the United States accreditation procedure is an on-site evaluation, which employs a collections checklist incorporating a series of questions concerning the adequacy of the documentation system and the standard of records (Swinney, 1978). The accreditation questionnaire and checklists used by the Museums Association in the United Kingdom includes similar questions.

Accountability for collections

2.6 pressures for accountability

Museums have come under growing pressure to demonstrate accountability for their collections to an outside auditor or funding agency. These outside authorities consider a primary response to the requirement to show effective care and control of collections to be a regular stocktaking programme, which itself depends on the availability of a comprehensive inventory (often made up of lists of items in numerical and location order).

In the United Kingdom, the main source of pressure on national museums since as early as 1912 has been from the Exchequer and Audit Department (E & AD) and the Public Accounts Committee (PAC). Whether considering attitudes in other museums in this country or overseas, there appears to be no precedent for the awareness of the importance of accountability and the willingness to work towards achieving control over collections that has been shown by the United Kingdom national museums during the last 70 years. Comparable pressure on United Kingdom local authority museums has come from their parent bodies and District Audit organisations during the last decade.

In Canada, the main pressure has been felt since the late 1970s from the Auditor General and the Standing Committee on Public Accounts; in the United States, in the last decade, from Congress and individual State authorities. This growing outside pressure for accountability has been paralleled by the increasing awareness by the museum profession itself of the importance of professional standards for the care of collections.

The resulting response by many museums has been a pronounced change of emphasis toward devoting resources to improving the quality and relevance of control documentation. For example, in the United Kingdom, a number of museums have been involved in work such as projects to check and enhance the comprehensiveness of their records; the introduction of a stockchecking procedure based on the categorisation of the collection into different levels of risk; the initiation of the comprehensive recataloguing of collections; and the introduction of extensive checking and monitoring mechanisms into a new automated system. In Canada, CHIN has assisted individual museums to automate their inventory records. In the United States, a wide range of museums have introduced major new documentation programmes to provide a basic inventory of their collections. (Details of a number of these schemes are described in Appendix D.)

2.7 accountability of United Kingdom national museums

In the case of United Kingdom national museums, the manual for government accounting details some of the control requirements to be satisfied as part of the general framework of Parliamentary accountability (GB. Treasury, 1981a). The manual notes that departments holding items such as exhibits should record the acquisition, holding and disposal of such assets in the form of inventories. These inventories should be kept in the custody of a responsible officer. They should record serially against each item its description, date and source of acquisition, and references to any supporting files.

The holdings should be checked not less than yearly, when the inventory should be annotated and any discrepancies brought to the attention of a higher authority. The normal checking, or stocktaking, programme may in certain circumstances be extended beyond a year and may be undertaken using statistical sampling on a random basis. It should be carried out by two officers, one of whom should not be immediately concerned with the stock itself. In addition, there should be an irregular check on a test basis by officers from an independent section.

The Comptroller and Auditor General (the C & AG) is empowered to assess the effectiveness of both the inventory itself and the stocktaking procedure. In undertaking such audits, the C & AG is supported by a staff of about 600, forming the Exchequer and Audit Department (E & AD), established in 1866 (GB. Treasury, 1980 and 1981a). On the basis of the audit, a report is prepared which is presented to Parliament and published with the account to which it relates. These reports are considered by the

Public Accounts Committee (the PAC), established by Parliament in 1861 as one of the means of controlling the expenditure of public funds. The PAC reports include recommendations and expressions of opinion by the Committee to Parliament (GB. Treasury, 1981a).

The C & AG and PAC have undertaken a series of important investigations of national museum inventory control and stocktaking procedures. The reports on these investigations demonstrate the concern shown by the bodies that the national museums should have effective systems to ensure accountability, discourage theft and promptly identify losses, while acknowledging the magnitude of the control problems faced by museums. The investigations can be grouped into four phases, reaching back nearly 100 years: pre-1915 (reports issued in 1912–1915); 1915–1954 (reports issued in 1953–1954); 1954–1974 (reports issued in 1974); and post-1974 (reports issued in 1981).

Accountability investigations: pre-1915

As early as 1886 and 1894, Treasury Minutes had been issued concerning the need for stocktaking ('store audit') based on inventories of acquisitions. However, when the C & AG examined the position in several national museums and galleries it appeared that, while attempts had been made to keep inventories, in no case was there a survey of stock and no procedure existed for reporting to the Treasury and Parliament any losses that may occur.

The PAC was concerned by this situation, particularly in view of a theft from one national museum by a member of staff that was only detected when a pawnbroker was offered the articles. The Committee considered that items in national museums should be properly recorded and additions carefully noted, that records should be checked by independent officers and that rules should be laid down concerning additions and writing off deficiencies. They considered it essential that the results of stocktaking should be subject to review by the C & AG (GB. Parliament. HC. CPA, 1912; GB. E & AD, 1912).

The then Board of Education appointed an internal committee to investigate the issues. This proposed a new system of inventory records and stocktaking for use by museums under the control of the Board, and potential application in other national museums. By 1915, progress was being made with the implementation of these proposals and the Treasury was considering arrangements for compiling and checking a more complete catalogue of the Nation's possessions (GB. Parliament. HC. CPA, 1914 and 1915).

Accountability investigations: 1915-1954

No further progress was made during the first world war, after which the matter was not reconsidered until 1952, when it was again raised with the Treasury by the C & AG. During the 1954 investigations of the PAC, its

Chairman noted that the procedure seemed to have been rather leisurely (GB. Parliament. HC. CPA, 1954; GB. E & AD, 1953).

The C & AG was particularly concerned with procedures in the Trustee museums. It was agreed that losses within these museums would be reported to the Treasury and noted on the Appropriation Accounts. However, it was not clear whether the C & AG was to be allowed access to these museums to assess the state of their inventory records and stocktaking programme. The Committee felt it was essential that full rights of access be available.

In evidence to the PAC, the Treasury outlined the position concerning inventories and stocktaking in a number of the national museums. The Treasury official stressed the problems faced by the museums, including the scale of their collections, and suggested that it might be some years before comprehensive inventories were available in certain areas. In particular departments of museums, such as some at the British Museum and the Natural History Museum, it might be impracticable to ever produce full records. It was felt that the inventories had to be produced before stock-taking arrangements could be implemented. The Committee appreciated many of these difficulties and accepted that some selectivity might have to be introduced in the objects to be brought under control.

Accountability investigations: 1954–1974

The C & AG next reopened the investigations in 1968, when it enquired about the adequacy of arrangements, particularly in the Victoria and Albert Museum and the British Museum. As a result, a DES management services team reviewed the position in these museums and the Tate Gallery, National Gallery and National Portrait Gallery, reporting in 1971 (GB. DES, 1971).

The team proposed that objects be grouped into three sets, according to value and importance: category A ('first line' objects or 'the nation's treasures') to be subject to an annual stockcheck; category B (items of lesser importance) to be subject to a quinquennial stockcheck; category C (comparatively low value items) to a small but regular dipcheck. Heads of departments were to be responsible for assigning items to each category.

Departmental inventories were felt to be an inadequate source for stocktaking purposes, due to their lack of independence. It was therefore recommended that each museum have a central inventory for category A and B items, to be held in location order. This central inventory was to be prepared by independent stockcheckers, who would also be responsible for its subsequent regular use. It would include the minimum of details about each item (number, description, etc.), upon which the non-expert staff would rely when making their independent checks. The assessment of category C items would continue to be a departmental responsibility, based on local inventories.

Brief reference was made to the possible future use of computers, following the development of the work of IRGMA. It was felt, however, that a semi-mechanised system should be introduced for the proposed inventory.

The C & AG noted that the report had been under consideration by the DES and the museums during a period when general security considerations had become important. It was agreed that complete inventories were a fundamental part of any security system. However, the DES was concerned that the report proposed complete inventories of existing items before stocktaking could take place, and by its financial and staffing implications. The DES also noted that it could do no more than advise the Trustee museums, who had internal responsibility in such matters (GB. E & AD, 1974).

In its subsequent review, the PAC was advised by the DES that the proposals in the earlier report had not met with widespread acceptance. The approach of requiring a complete inventory was now felt to be questionable, due to factors such as the size and range of collections, the difficulty of marking certain objects and the impracticality of using non-expert staff. It had been concluded, however, that it was unrealistic to use expert staff for the maintenance and use of inventories on the scale anticipated in the report. It had been decided to depart from a simple approach common to all museums, and to instead establish a series of more flexible management objectives (GB. Parliament. HC. CPA, 1974):

routines for the registration and location of every significant item in the hands of the institution;
the adoption of a practicable routine for checking the presence of items in their appointed places, so as to prevent or detect losses, and to check their condition to forestall deterioration;
a long-term programme for the scholarly description and cataloguing of the collection as a background to its study and display;
periodic reviews to ensure that the collection was effectively organised for the purposes determined by the Trustees.

Accountability investigations: post-1974

In 1981, the C & AG reviewed progress towards achieving these management objectives in the British Museum, Science Museum and Victoria and Albert Museum, and the responsibilities of the Office of Arts and Libraries (OAL) for the general oversight of this field. It was confirmed that both the British Museum and the OAL doubted whether the development of a complete inventory was the correct method. The management objectives outlined during the previous investigation was the approach adopted by the OAL (GB. E & AD, 1981).

In the case of the British Museum, a review of inventory arrangements had been initiated in 1971. This showed that existing records varied in style and reliability and were incomplete, and that there was no regular departmental stocktaking. It was decided to introduce a records completion programme and to undertake a feasibility study of the possibility of computerising all the Museum's inventory and stock control records. Progress

with this programme was reviewed by the C & AG, as was the Museum's response to the management objectives. The availability of central inventories at the Science Museum and Victoria and Albert Museum was noted. Both museums reviewed their stocktaking programme and their progress towards the management objectives.

The OAL itself referred to its monitoring of the achievement of the management objectives during manpower reviews and of the work of the National Museums Security Adviser. The C & AG emphasised the importance of physical security arrangements, supported by frequent independent stocktaking. It was felt that the role of the security adviser might be strengthened and that the OAL should provide more central advice and guidance on matters such as the development of computerised inventory control systems.

The PAC considered this report in 1981. It reiterated the importance of the first management objective concerning inventories, noting that the availability of a complete inventory seemed a necessary prerequisite to moves to safeguard a collection or undertake any cataloguing or research (GB. Parliament. HC. CPA, 1981). The magnitude of the problems facing museums such as the British Museum, Science Museum and Victoria and Albert Museum was acknowledged by the Committee. It noted the difficulties of identification and description and of the potential for computerisation using systems such as those developed by the MDA.

However, it remained concerned about the length of time before all inventory records will be in a satisfactory state, and considered that the completion of this work should be given a proper measure of priority in the allocation of resources. It recommended that each national museum establish the work still to be done to bring its inventory records into a satisfactory state, including their computerisation where this would be worthwhile, and draw up a programme for its completion within a reasonable period. It accepted that for some low-value items it would be impracticable for the inventory to include full details.

As the three museums felt it would be difficult to institute systematic stocktaking before their inventory records were complete (including location details), the Committee considered the interim measures that might be adopted. The museums noted the problems of categorising items by value and the need for experts to undertake any checking. The Committee felt, however, that consideration should be given to the use of less expert, but independent, staff in certain circumstances and that they should draw up programmes of checks, the results of which should be adequately recorded. The museums should determine what types of checks were practicable and cost-effective for different types of objects and in relation to the potential risks of loss.

In a subsequent response to the report, the Treasury referred to support having been given to a research project to investigate the future development of documentation methods (of which this report is one result). It was con-

firmed that the recommendation to protect from erosion the resources allocated to the inventory projects had been brought to the notice of the museums and that stocktaking procedures were to be reviewed (GB. Treasury, 1981b).

The Rayner Scrutiny of the Victoria and Albert Museum and Science Museum noted these recent reports of the PAC when discussing inventory control and stocktaking procedures in the two museums (Burrett, 1982). It recommended that these museums should retain their existing manual control system rather than change to an automated approach and that their quinquennial stocktaking programme should be abandoned in favour of annual checks on the most valuable and attractive objects in each collection and those that had been moved during the preceding year.

2.8 accountability of United Kingdom non-national museums

Although the comparable accountability procedures of United Kingdom non-national museums are less well defined and monitored, they do exert a considerable influence on the institutions concerned. Auditing and control over local authority museums is exercised by both an internal audit (within the relevant parent organisation) and an independent external audit. The latter is supervised by the Audit Commission (which may appoint either a District Auditor and staff or a firm of private accountants to carry out the authority's audit).

Both internal and external audit undertake occasional checking of documentation and collections in many local authority museums. A number of cases can be cited in which a constructive report from the external auditor has been a decisive factor in persuading a museum committee to improve the documentation control system.

In the case of university museums, control and checking of the collections is often at the discretion of the internal museum staff, with no formal external auditing of collections by either the university authorities or an outside body.

2.9 accountability of Canadian museums

A position analogous to that of the United Kingdom national museums now exists in the case of the National Museums of Canada, which are subject to examination by the Auditor General of Canada and the House of Commons Standing Committee on Public Accounts.

A recent report by the Auditor General included a number of recommendations concerning documentation (Canada. Auditor General, 1981). It noted that a comprehensive collecting policy had recently been approved but that this did not require basic documentation to be prepared before a decision was made to acquire an item (Canada. National Museums of Canada, 1981). It was critical of the state of inventory records and the lack of annual or cyclic stockchecks. In the absence of sufficient documentation,

the National Museums were not fully aware of the size, value and condition of their collections, and were unable to rationalise the future development of these collections. The report concluded that the Museums should improve the acquisition process, specify the collecting priorities, complete the inventory and conduct regular inspections of the collections. It has since been decided that the Auditor General will take a more active role by conducting an annual dipcheck.

A number of the national museums are using the computing systems supported by CHIN to build up basic control files to aid their internal response to these requirements. CHIN is the successor to the National Inventory Programme, established in 1972 to develop a complete inventory of works of art and cultural objects in Canadian museums. Although the original stress of the programme was on documentation for research purposes, there is now a growing emphasis on the use of the computing systems for the planning and control of acquisitions (Canada. Department of Communication, 1982). Non-national museums also make extensive use of the CHIN systems as part of their control programmes, often with the encouragement of external auditors.

2.10 accountability of United States museums

In the last decade, it has been impressed upon United States museums that they are holding collections in trust for the nation. The abuse of this trust, particularly by a few museums in New York State, drew the attention of legal authorities within individual States and Congress itself to the policies and procedures of museums (Weil, 1983). The focus of these investigations was on the need for a museum to maintain proper records of the acquisition and disposal of collections and to have an active inventory control and checking programme (Malaro, 1979).

The resulting change of approach is illustrated by the Smithsonian Institution, which had no formal stocktaking policy and no general inventorying programme prior to 1977. With financial support from Congress, it initiated a five year project to undertake comprehensive retrospective inventorying of the collections and the production of new inventory records. With this project coming to a successful completion in 1983, the Institution has now established an internal audit team, whose functions include monitoring the maintenance of the inventories, and hopes to continue the inventorying programme on a permanent basis. In a number of the Institution's museums the resulting inventory records have been incorporated within a new computer-based documentation system.

Other museums in the United States have adopted a similar approach, seeing the need to establish an accurate automated inventory as an essential prelude to the future management of collections. This need for an inventory has often been accentuated by plans to move collections into new buildings or reorganise storage areas (Sarasan and Neuner, 1983).

Collections and documentation

2.11 scale of collections

The scale of inherited collections has been one of the major problems affecting the ability of museums to respond to external demands for accountability and to maintain comprehensive documentation for internal curatorial and control purposes.

In United Kingdom museums, the overall picture is of large inherited collections with a steady influx of new acquisitions. The total number of individual items in the object collections is estimated to be at least 100 million, of which the great majority are held by the national, local authority and university museums and a large proportion is natural science material. In addition, there are millions of items in bibliographic, archive and audio-visual collections.

It is thought that the annual growth rate of a large number of these collections has either been constant or declined in recent years. A typical rate for the object collections in many museums appears to range between 0.1 and 2.0% per annum, the major exceptions being local authority museums developing local natural science collections or receiving material from local archaeological rescue excavations, and university museums receiving natural science and archaeological material as a result of research programmes. The overall net increase may be over one million objects per annum. In the contrasting case of non-object collections, the growth rate of archives and photographic items frequently exceeds 10% per annum, producing a considerable documentation work-load.

By comparison, the total number of objects in Canadian collections has been estimated at 34 million, including 1.5 million in the National Museums (Canada. Department of Communication, 1982). In the United States in the early 1970s, the natural science collections in museums were estimated to exceed 200 million specimens, increasing by 1–2% per annum (Bryant, 1983; Irwin *et al*, 1973). More recently, it has been estimated that natural science collections are now close to 600 million specimens, taking into account both museums and universities, while the overall figure of museum objects has been put at more than 1000 million (American Association of Museums, 1984). As a result of a recently completed inventory, the Smithsonian Institution has revised its view of the scale of its own collections from around 80 million objects to over 100 million objects.

2.12 scale and complexity of records

Museums have become more aware of the scale and complexity of the records which describe these collections.

One documentation emphasis is now placed on the concept of an individual record (termed an 'item record' or a 'catalogue record') acting as the primary source of information about each item. (The main exception to this is in areas such as natural history or excavation archaeology where one

record may refer to a group of similar items.) The size of such a record typically ranges from 20 to 2000 data characters (letters, numbers and symbols), depending on factors such as the type and importance of the item (the lower range being more common for general natural science material; the upper range more common for social history, decorative art and fine art material).

A small local museum or single department in a large museum, with an object collection of 100 000 items, each supported by a record of around 1000 characters, may therefore be responsible for 100 million characters of primary information.

The scale of the records that might potentially be created for the objects in United Kingdom museums might be of the order of 50 000 million characters of primary information, taking into account the different types of collections held by museums.

These records are complex organisations of information that is gradually accumulated from the time the museum first becomes aware of the item. Some of the information in a record has a 'passive' nature (such as details of the description and history of the item) while other information is 'active' (such as the location details). The museum must be able to maintain both the passive and active aspects of its records and add additional details at any time in the future.

2.13 documentation systems

Although crucial to the effectiveness of documentation within the museum, these records form just one part of the overall documentation system. In recent years, attention has been directed towards the broader aspects of documentation. A number of museums have begun to adopt a more rigorous approach to the documentation of material when it first comes into the institution, the subsequent processing and formal transfer of ownership of any acquired material, the monitoring of temporary and permanent movements of that material both within the museum and when on loan to other institutions, and the exploitation of its catalogue records by means of indexes and information retrieval facilities.

One of the factors influencing this new emphasis on the adoption and maintenance of procedures has been concern over the standard of documentation of inherited collections. While most museums now take care to note basic information about new acquisitions, they tend to have significant gaps in their records from earlier decades. Those records that are available are usually less detailed, less reliable and less well maintained than the museum would wish. For many collections, there may be only one set of fading manuscript records, the security control over which may be superficial. Any indexes which have been prepared from these records may be incomplete, badly maintained and little used. The records may not have been annotated in the event of a loss, disposal or transfer of an item from the permanent collection. Location details may be cursory or out-of-date.

In view of these concerns, some museums have begun to parallel their more rigorous care of new acquisitions with programmes to reprocess the documentation of existing collections. As noted above, the emphasis in some museums has been on retrospective inventorying programmes to check the accuracy of existing inventory and location details as a basis for future collections control and accountability. Other museums have been concentrating on major recataloguing programmes to improve the standard of their basic item records as a source for general curatorial catalogues and indexes.

In the United Kingdom, this approach has been particularly prevalent in non-national museums, notably in the Midlands, North of England and Scotland. Many schemes have depended on allocations of resources from the Manpower Services Commission (MSC) which have resulted in a major influx of temporary cataloguing staff. In some cases, this has led to the reprocessing of a significant proportion of the original records of the museum.

Automated systems

2.14 documentation uses of automated systems

The use of automated systems such as computers and word processors has begun to have a profound effect on the development of documentation. Potential uses within museums can be grouped into five categories (Light and Roberts, 1984) (Table 1):

information management uses include the storage and processing of collection information as a basis for catalogues, information retrieval and collections control;

management control uses include controlling financial, staff, visitor and shop stock information;

word processing uses include the production of reports and manuals;

analytical research uses include the analysis of statistical results of an excavation or a technical examination;

education uses include interactive displays within public galleries.

In the case of object, archive and audio-visual collections, automated information management facilities can be used to aid the long-term development and maintenance of records as a basis for output such as catalogues, indexes, information retrieval and labels and for entry, acquisition, inventory, location and movement control of material, while in the museum or on loan to an outside organisation (Art Museum Association, 1982; Chenhall, 1975; 1978b; Cook, 1980; 1983; Gartenberg, 1982; Gautier, 1978a; Hickerson, 1981; Humphrey and Clausen, 1977; Kesner, 1982; Light and Roberts, 1984; Light, Roberts and Stewart, 1985; Megna, 1983; Orna and Pettitt, 1980; Sarasan and Neuner, 1983).

Table 1. Museum uses of automated systems

Information management uses	Management control uses
Objects:	enquiry monitoring
potential acquisition record	financial control/planning
entry control	project planning
acquisition control	staff management
item documentation	stock control
catalogues	equipment monitoring
indexes	environmental control
retrospective cataloguing	admissions analysis
information retrieval	public relations
co-operative catalogues	security control
inventory control	fire control
retrospective inventorying	valuation, inventory and loan control
location control	interrelation with other files
movement control	statistics
interrelation with other files	
labels	Word processing uses
collections and documentation audit	
secure record	mailing lists
terminology control	publications
vocabulary control	report generation
Library:	displays/labelling
ordering documentation	correspondence
acquisition documentation	procedural manuals
cataloguing	diaries
catalogues/bibliographies	
indexes	Analytical research uses
information retrieval	
co-operative cataloguing	mapping
external searches	graph plotting
circulation control	data analysis
stocktaking	graphic analysis
secure record	interrelation with other files
serials control	identification keys
interrelation with other files	
Archives and audio-visual collections:	Educational uses
entry documentation	
acquisition documentation	gallery displays
catalogues	recreation/games
indexes	computer literacy
information retrieval	
location control	
collections and documentation audit	
secure record	
interrelation with other files	
Support documentation:	
conservation records	
conservation indexes	
record photograph indexes	
field locality records	
field locality indexes	
excavation records	
structure plans	
planning control	
interrelation with other files	

In museum libraries, comparable uses include cataloguing as a basis for catalogues and information retrieval and ordering, acquisition, circulation and serial control. Many libraries outside the museum community now make extensive use of automated systems (Boss, 1983; Grosch, 1982; Library Association, 1982; Lundeen and Davis, 1982; Tedd, 1984; Woods, 1982; Woods and Pope, 1983). These capabilities are also relevant when dealing with other types of documentation within the museum, such as conservation, record photograph and locality details.

Management control and analytical research facilities can also contribute to documentation operations (for example, by monitoring work patterns and collection growth); conversely, documentation can be used as one of the sources for the provision of management and research information (Clarke, 1978; Cutbill, 1971; Doran and Hodson, 1975; National Assembly of State Arts Agencies, 1981; Orton, 1980; Williams, 1982).

Word processing facilities relevant to documentation include aids to document preparation (for procedural manuals, report generation, publications, etc.) and list maintenance (mailing lists, reference lists, accession lists, etc.) (Meadows, 1980; National Assembly of State Arts Agencies, 1981; Oakeshott and Meadows, 1981; Williams, 1982).

2.15 automation influences

In the case of museum documentation, factors influencing the introduction of automated systems have included the declining cost and increasing power of computer hardware, the growing availability of relevant software and the increasing expertise in their use. In view of their ability to store and manipulate large quantities of information, these systems have been recognised as offering the museum the means to:

prepare a wider range of products and services such as catalogues and retrieval facilities;
introduce a higher standard of collections management;
contribute more easily to cooperative schemes, such as the production of union catalogues;
deal with new pressures, such as a greater work-load due to the growth of collections or changing user expectations, staff shortages due to financial limitations or changes of personnel, greater demands for accountability and the rearrangement of collections;
maintain and update individual records;
link information from disparate sources and in a variety of permutations;
reduce the clerical effort and error rate involved in using manual procedures;
improve the standard of records by means of verification procedures;
improve the security of records by aiding the preparation and preservation of duplicate copies and restricting unauthorised access and amendment.

Against these important abilities must be balanced factors such as the staff expertise required to develop new procedures and manage their introduction and long-term application. Few museums have had staff with the skills to ensure the successful adoption of an automated system or expertise to evaluate the suitability of processing hardware and software. The possibility of introducing a new automated system can sometimes meet with resistance from individuals or trade unions.

Although the price of these systems has fallen in recent years, the introduction of inhouse facilities or the purchase of external computing resources can still represent a major capital and recurrent financial investment, with long-term implications such as the need for expenditure on regular maintenance, subsequent enhancement and the eventual replacement of the system with new facilities.

There can be problems with the hardware of the system itself, such as the lack of standardisation between components, poor reliability and robustness and the limited capabilities of small machines. There is also a limited availability of software suitable for the straightforward processing of museum records. While some systems are now adequate for museum use (unlike in the early 1970s when they placed severe limitations on developments), there are still few institutions which can be cited to demonstrate major successful applications.

In practice, the magnitude and nature of museum collections has often acted as a deterrant to their automation. As noted above, museums are characterised by having large numbers of detailed records to which reference is made infrequently: a very different position from that of the libraries and business organisations that have made more use of automated systems. Unlike libraries, museums have been unable to develop cooperative cataloguing schemes due to the unique nature of their objects. Their relatively low acquisition and object movement rate has not encouraged a major investment in automated entry, acquisition and circulation control systems.

There is also a serious danger that a new automated system is viewed by the museum as the cure for all the ills of the existing documentation procedures. In practice, the unconsidered introduction of such a system will tend to compound existing problems. It is essential that careful planning takes place before any change is implemented.

2.16 development of documentation applications

The development of documentation applications by museums in the United Kingdom and overseas has been examined in a number of reviews of documentation systems (Anon., 1978; Art Museum Association, 1982; Leviton *et al*, 1982; Light, Roberts and Stewart, 1985; Roberts, 1984; Roberts and Light, 1980; Sarasan and Neuner, 1983).

Early considerations tended to view a primary role of automated systems as being a means of preparing national union catalogues, to which museums

21

could contribute and have access. In France, Italy and Canada, this approach was nurtured by the national museum organisations, often without reference to the documentation requirements of the individual museums. The early emphasis in the United States was similar, but its development was handicapped by the absence of a national museum framework. In practice, individual museums began to examine the independent use of internally-developed or commercially-produced computing systems. In the United Kingdom, the initial emphasis was placed on the cooperative development of computing systems suitable for independent use by individual museums on local mainframe or minicomputers. In the United States and the United Kingdom, it was curatorial staff who usually prompted the investigation of computer use, with the result that work centred on the automation of the main item records as a basis for the production of internal catalogues and indexes.

The major early research in the United Kingdom was undertaken from 1967 to 1976, when a series of projects investigated the design and application of prototype computing systems suitable for processing museum records. This research has since been continued by the MDA.

Approximately 60 of the museum institutions in the United Kingdom were using automated systems for documentation purposes by the end of 1984. The computing systems developed by the MDA (including an information management package called Gos) have been adopted by a number of national, local authority and university museums, either independently or through a central bureau service. Other museums have adopted comparable computer packages for local use on computers in their parent body or within the museum itself. The approach of acquiring equipment for inhouse use is now becoming a significant factor, with the declining cost and greater availability of automated systems.

In Canada, the early pressure for a national catalogue has now been balanced by an interest in improving the documentation of individual museums for collections management purposes. CHIN supports a central computing system, with extensive online interactive facilities, on behalf of individual museums throughout the country, of whom approximately 150 are now active users.

In contrast, independence has been almost universal in the United States, where over 200 museums have contemplated the automation of their documentation. Most developments have concentrated on the local application of commercial systems or the design of a new inhouse processing package. However, there is a growing interest in cooperative projects. Both the Art Museum Association and the Getty Trust are proposing the development of major systems suitable for widespread distribution and use by individual museums (Englander, 1983). The Smithsonian Institution is also undertaking the development of a major Collection Information System, the results of which may be of relevance to other museums (Smithsonian Institution, 1984).

Allocation of resources

2.17 resources for documentation

The preceding paragraphs have referred to a number of the sources of funds for documentation purposes. In the case of United Kingdom museums, these have included the MSC which has supported recataloguing work; the CCTA and parent organisations who have supported system development or provided access to computers; and the OAL and the British Library who have sponsored research work by IRMGA and the MDA. Within the museum community itself, the AMCs have contributed funds to individual museums for specific documentation schemes and to the MDA for the maintenance of its advisory function. The primary research, development and advisory work of the MDA is now supported by the Museums and Galleries Commission, Welsh Office, Scottish Education Department and a number of individual national museums, with a total contribution of £67 000 in 1982-83 (MDA. Development Committee, 1982).

In Canada, the main support for documentation has come from within the museum community, with the substantial funding of the Museum Assistance Programmes and CHIN by the National Museums of Canada. For example, in mid-1982 the Museum Assistance Programmes awarded 17 grants totalling nearly $1 million to assist institutions with registration projects (Anon., 1982b). The direct resources devoted to CHIN for operational purposes are approximately $1.5 million per annum (Appendix Diii).

In the United States, agencies such as the National Endowment for the Humanities have supported projects within individual museums, such as the development of new computer systems or the implementation of retrospective inventorying programmes and Congress has made a major financial contribution to the retrospective inventorying work of the Smithsonian Institution (Appendix Diii). A number of museums have also received help from private benefactors. In some of the cases considered in Appendix Diii, this help has been directed towards the use of an inhouse computer system.

The acquisition of computers or the purchase of computing resources from an outside agency has been one of the major financial investments made by museums since the mid-1970s. In the decade up to 1984, the total investment in computing systems for use by United Kingdom museums was probably around £500 000. This figure may have been matched by the value of the resources contributed without charge by the parent organisations of some of the major computer users.

However, this direct expenditure has been far outweighed by the investment of staff time in documentation. While noting the wide variations both within and between museums, the investigator has estimated that an average of 20% of the effort of curatorial and support staff may be devoted to documentation work in United Kingdom museums, at a cost which is probably in excess of £10 million per annum. In many cases, the staff resources for documentation are concentrated in curatorial grades, with the result that

highly-qualified officers are often responsible for basic clerical work, such as the maintenance of location lists or the production of index entries.

3:
Documentation system framework

The principles underlying the design of a museum documentation system are considered in this section, as a basis for the subsequent discussion of specific aspects of documentation procedures.

3.1 the museum documentation system

The museum documentation system incorporates the procedures used to manage information concerning a museum's collections or of relevance to a museum's curatorial functions. The primary aim of this system is to aid the control and use of collections and to ensure the preservation of information about the cultural and environmental heritage. Its scope therefore includes all aspects of collections-orientated documentation, including collections control, cataloguing, indexing and information retrieval. These documentation procedures are supported by staff who design, develop, implement and maintain the system and by either manual or automated physical systems.

Key uses of the system include (Table 2):

aiding the care and control of collections by providing mechanisms and sources to help locate items, manage internal movements and external loans, apply insurance or indemnification procedures, undertake stock-checks and respond to collections audit requests, improve security and help reduce the risk of loss and maintain details of conservation;

aiding the use of collections by helping with the preparation of publications and lectures, providing sources for research and assisting in the development of displays and exhibitions;

aiding the preservation of information, whether about items in the collec-

tion or of interest to the museum, by providing facilities for its long-term storage and access.

In fulfilling these roles, the documentation sources are complemented by the knowledge of the museum staff, the direct use of the collections themselves (particularly if they are arranged in a classified or systematic order) and any publications concerning the collection.

The system can be used by a range of people from both the museum and the outside community, including:

the *staff* responsible for managing, utilising and enhancing the collections;

auditors requiring information about museum procedures and collections;

donors interested in adding to the collections;

enquirers requiring details of items in the collection and other information of interest;

researchers using the collections;

students and teachers interested in the collections;

visitors learning about the collections, the environment or history.

Table 2. Key uses of the museum documentation system

accountability	movement control
answering enquiries	numbering and marking
collections auditing	ownership negotiations
condition monitoring	photography
conservation control	preparation
co-operative catalogue development	preserving information
developing acquisition policies	publications
developing collections	research
developing collections management	responding to enquiries
policies	risk response
disposal management	security of collections
documentation auditing	security of documentation
education	stocktaking
entry control	storage allocation
environmental planning	storage assessment
exchange arrangements	structure plans
exhibition planning	transfer arrangements
identifying objects	valuation control
insurance negotiations	
inventory control	
labelling of objects	
lecturing	
loans-in management	
loans-out management	
location control	
loss detection	

3.2 museum documentation procedures

The implementation of the documentation system is supported by four groups of procedures (information management, management control, word processing and analytical processing) and links between these procedures.

Information management includes the storage and processing of collection information; management control includes the maintenance of financial controls; word processing includes the preparation and maintenance of reports, manuals and word lists; and analytical processing includes the manipulation of statistical details.

In terms of the overall museum procedures, information management is mainly concerned with supporting documentation activities, while management control, word processing and analytical processing are mainly concerned with supporting activities such as management, administration and research.

The primary documentation aspects of the curation and control of object and non-object collections can be illustrated by a framework showing the main information management procedures, the links between these procedures and the links from these procedures to other museum procedures (Figure 1). Group curation procedures are used to manage curatorial information about convenient groupings of items (such as a multi-item acquisition); item curation procedures to manage and utilise curatorial information about the individual items themselves (such as a single object); and control procedures to manage control information about groups and individual items for collections management purposes (such as the control of groups coming into the museum and during their formal acquisition, and of the individual items in these groups both within and outside the museum).

These curation and control procedures may be further broken down into seven stages:

the *pre-entry stage* is concerned with the curation and control of items prior to their entry into the museum, during the course of field work or when considering a potential acquisition;

the *entry stage* is concerned with the curation and control of items when they first enter the museum, whether as a potential acquisition, loan-in or enquiry, aiding the museum with the management of such groups prior to their incorporation into the collection or retrieval by their depositor;

the *acquisition stage* is concerned with the curation and control of items during their formal incorporation into the collection, as either a permanent acquisition or long-term loan;

the *post-acquisition stage* is concerned with the curation and control of groups of items after their acquisition and prior to their individual item documentation;

the *item stage* is concerned with the curation and control of the individual items within the collection or of interest to the museum, aiding the museum with the long-term management of acquired material;

the *output stage* uses information accumulated during preceding stages to produce catalogues and indexes and to respond to information retrieval requests;

the *exit stage* is concerned with the control of groups leaving the museum or department, on a semi-permanent or permanent basis.

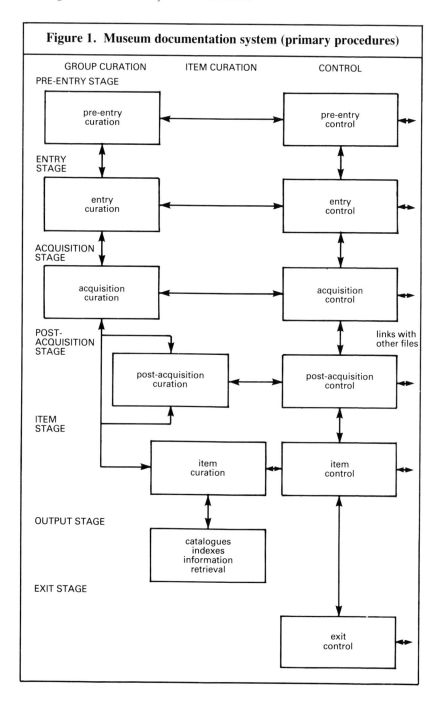

Figure 1. Museum documentation system (primary procedures)

GROUP CURATION ITEM CURATION CONTROL

PRE-ENTRY STAGE

pre-entry curation ⟷ pre-entry control

ENTRY STAGE

entry curation ⟷ entry control

ACQUISITION STAGE

acquisition curation ⟷ acquisition control

POST-ACQUISITION STAGE

post-acquisition curation ⟷ post-acquisition control

links with other files

ITEM STAGE

item curation ⟷ item control

OUTPUT STAGE

catalogues indexes information retrieval

EXIT STAGE

exit control

Details of the practical application of information management procedures during each of these stages are given later (Section 5.1–5.8).

3.3 documentation types

The documentation procedures can be applied to the documentation of various types of material, which can be grouped into physical collections and information assets which complement these collections: the former are managed by collections documentation facilities and the latter by support documentation facilities (Table 3).

Table 3. Documentation types

collections documentation
 object documentation
 non-object documentation
 (bibiographic material
 archive material
 audio-visual material)

support documentation
 conservation documentation
 record photographs documentation
 collection-group documentation
 biographic documentation
 corporate body documentation
 locality documentation
 event documentation
 activity documentation
 information documentation

The physical collections may include object, bibliographic, archive and audio-visual material. Comparable procedures can be adopted for the object and non-object types of item, although the relative importance and practical application of these procedures may show certain differences (such as location control of object collections being comparable to circulation control of bibliographic collections).

The information assets may include details of conservation and record photographs related to the physical collections; groups of items within the museum (such as a collection of similar social history objects or of natural history specimens from one collector, outlined within a collection research scheme); people and institutions (such as the museums in a county or area); places, events and activities; and general information (such as an object name authority list or a technical processes thesaurus). In the case of the information assets, the documentation procedures are often limited to the item and output stages, concerned with preparing, maintaining and utilising records about conservation, events, etc.

When documenting an object, the information may include intrinsic details (such as a physical description) and non-intrinsic details (such as its history prior to its acquisition by the museum, details of its subsequent incorporation into the collections, its use for display or as a loan and its movement while in the institution). For a place, the information may include

details of its location and history, objects found there (some of which may now be in the museum), its environmental significance and management status. Similarly, for an event, the information may consist of notes of what occurred, references to publications containing additional sources and details of objects in the collection associated with the event.

3.4 museum activities and documentation sources

Documentation procedures are associated with many of the activities undertaken by the museum (Table 4). Each documentation stage may involve one or more of these activities (Figure 2):

Table 4. Museum activities (defined in Appendix Ai)

accessioning	lecturing
acquiring	loaning-in
administering	loaning-out
auditing	locality recording
bibliographic recording	locating
biographic recording	location controlling
cataloguing	maintenance
circulation controlling	managing
collecting	marking
collections management	measuring
conservation recording	movement controlling
conserving	moving
curating	numbering
deaccessioning	object recording
depositing	ordering consumables
describing	organising
designing	photograph recording
displaying	photographing
disposing of items	planning
documenting	potential acquisition recording
donating	preserving
educating	process controlling
enquiring	progress controlling
entering	promoting
entry recording	publishing
estimating	purchasing
event recording	recording
examining	referring
exhibiting	registering
exit recording	researching
field recording	retrospective inventorying
financial management	security
group recording	selecting
identifying	selling
indexing	staffing
information retrieval	storing
insuring	transferring of title
interpreting	utilising
inventory controlling	valuing
inventorying	visiting
item recording	
labelling	

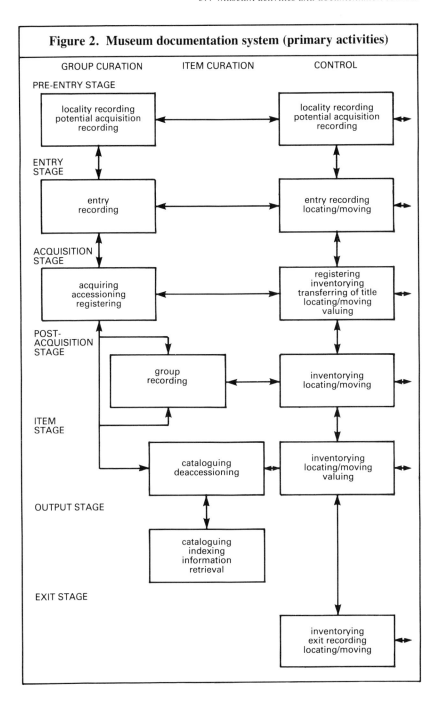

Figure 2. Museum documentation system (primary activities)

the *pre-entry stage* may involve locality recording and potential acquisition recording;

the *entry stage*, entry recording and locating items within the museum after their entry;

the *acquisition stage*, accessioning, registering and inventorying a group of items, the transferring of title in the group to the museum and the subsequent locating of the group;

the *post-acquisition stage*, recording further details of the group;

the *item stage*, cataloguing, inventorying and locating the individual items;

the *output stage*, indexing and information retrieval;

the *exit stage*, exit recording and locating.

Some of these activities (such as accessioning and transferring of title) tend to occur once only for each group or individual item; others (such as exit recording) may occur a number of times; a third set (such as cataloguing and inventorying) are continuous, with an initial implementation phase and subsequent maintenance responsibility.

Depending on the arrangement of the museum itself, these activities may be undertaken by staff working on a central or departmental basis, involving both curatorial departments and support sections (such as a conservation section, a photographic unit, documentation unit, registration department, inventory or registry).

The information resulting from these activities is held in various physical documentation sources, each of which may include separate entries about some or all of the items in the collection. Many of the documentation activities are directly paralleled by a source (such as inventorying resulting in entries in an inventory file; cataloguing resulting in records in an item file, used as a basis for catalogues and indexes). As with the activities, these sources may be developed and held centrally or distributed locally within relevant parts of the museum.

A source may be made up of various manual or automated files, such as a file of records and a file of correspondence conforming to a single activity (Figure 3):

the *pre-entry activities* may be supported by a locality file or a potential acquisition file;

entry activities by an entry file, a correspondence file and a location file;

acquisition activities by an acquisition file, an acquisition register, an inventory, a location file and a transfer of title file;

post-acquisition activities by a supplementary acquisition file;

item activities by an item file, an inventory and location file;

output activities in a catalogue file and index files;

exit activities by an exit file and an exit register.

The system maintains two types of file: main files and index files. A primary main file includes a series of entries corresponding to the items being docu-

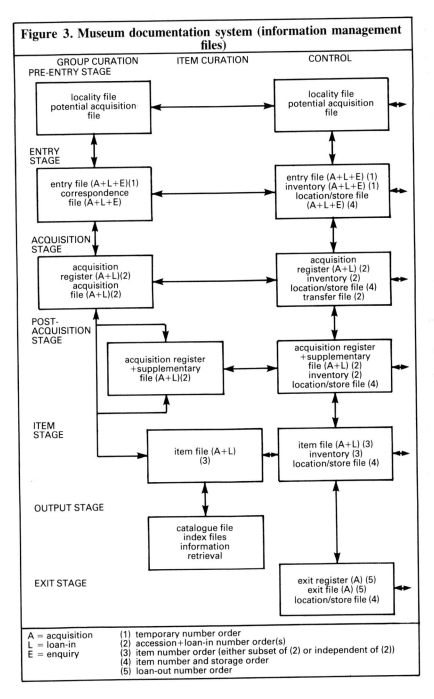

Figure 3. Museum documentation system (information management files)

mented (for example, the entry record files, acquisition register, item record file and exit record file). A secondary index file includes a series of entries derived from a main file (for example, indexes derived from an item record file).

The fundamental components of the main files are records, acting as a summary of the relevant information about an item of interest (for example, an entry record, acquisition record, item record or exit record). A record is itself made up of a series of data categories (such as object name, acquisition date, storage location), each of which includes a data content (composed of data characters) and a category name. The overall set of data categories used for a particular application may be summarised in a data standard, listing the allowed categories and defining the relationship between these categories. The form of the information within a category may be described by terminology standards, indicating the appropriate vocabulary, the syntactical rules governing the arrangement of this vocabulary and the allowed characters making up the vocabulary.

Appendix Ai incorporates a discussion of the museum activities, including a definition of each term and an examination of the requirements which it places on the documentation system. Appendix Aii includes a description of the documentation sources, with a definition of each term, the standard physical form in which it is normally found, its relationship to other sources and its role within the overall framework.

3.5 processing operations

The implementation of these documentation procedures depends upon various processing operations (Figure 4), which are supported by manual and automated equipment within the museum or at an outside parent organisation or service agency. (Some of the major operations applied when dealing with a new batch of item records are illustrated in Figure 5.)

Initial processing operations include:

recording information when creating a new record or supplementing an existing record (as at the entry, acquisition, item and exit stages);
entering information into a computer-based system;
editing information to correct errors introduced during recording and data entry;
validating information by comparison with standard terminology lists, etc.

Subsequent processing operations include:

manipulating input information into a standard format;
merging new records with existing records to produce an updated main file;
modifying the records in this file by the alteration or replacement of existing categories and the addition of new categories, using the editing facilities;

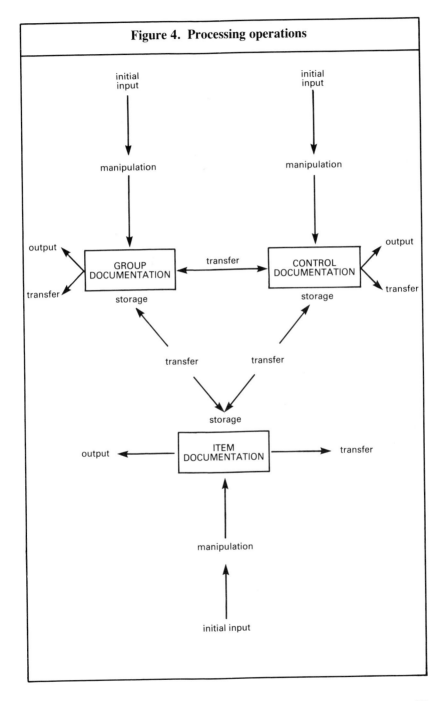

Figure 4. Processing operations

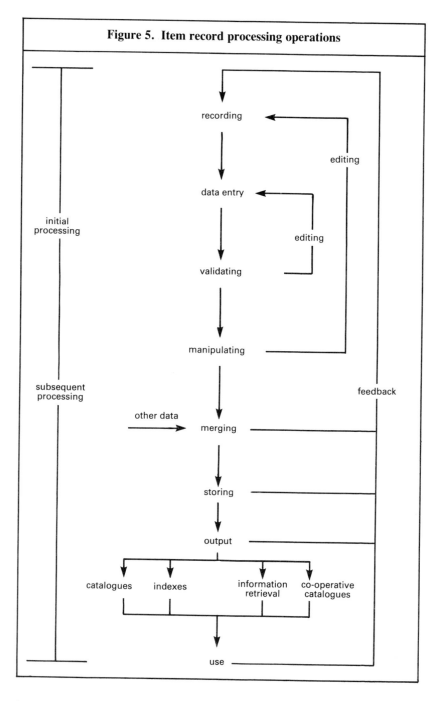

Figure 5. Item record processing operations

inverting new records in this file to produce entries suitable for incorporation in index files or printed indexes;
retrieving information from the main file or index files;
sorting primary records, index entries and retrieved information into standard sequences;
displaying sorted records, index entries or retrieved information on record or index cards, computer terminals, microfiche, etc.;
maintaining and storing secure copies of the main and index files for long-term preservation;
transferring information from the main files to other parts of the system (such as from one stage to another) or to other systems (such as to another museum for incorporation in a cooperative catalogue).

3.6 staff

Staff functions to support these documentation procedures include management, development and operation. In a small institution all three functions may be the concern of a single member of staff; larger institutions may be able to adopt varying degrees of specialisation. While it may be possible to receive help from the parent organisation or a service agency with some aspects of these functions (such as training, standardisation, forms design and software design aspects of systems development and certain data input aspects of system operation), most responsibility must lie within the museum.

One function that cannot be delegated to another organisation is that of system management. Some museums now have a management group with overall long-term responsibility for the system, including a full-time or part-time system manager concerned with the implementation of policy decisions and the coordination of system development.

This development function includes the preparation of specific applications of facilities (such as computer software) that have either been produced by the development staff or acquired from another organisation; the maintenance of these applications; the support of standards; the training of operations staff and users; and the production and promotion of procedural manuals. Since the system is never static, this work is a permanent responsibility: the existing system requires frequent maintenance and eventual amendment if it is to continue to be an effective response to changing circumstances, such as collections growth, staff turnover and technological developments.

System operation functions include work to develop and maintain individual records and files, such as the recording and data entry of new records, correcting and editing records after their initial preparation, maintaining and reprocessing these records and using them as a basis for catalogues, indexes, etc., and in response to user enquiries.

Primary responsibility for the development and operation of the system should be held by the departmental curatorial and support staff who are

most concerned with its use. The system manager and any central documentation staff may provide overall coordination.

One essential factor is the initial training of new staff and the continued in-service training of all staff involved with the documentation system, to encourage familiarity with the system and the adoption of uniform procedures. The system itself should be thoroughly documented in procedural manuals, outlining the form of the system, the role of individual staff and the standards that have been adopted.

3.7 scale of operation

The required scale of operation of the system will affect the optimum level of equipment and staff that must be concentrated on documentation, and the type of manual or automated system needed to cope with the pressures.

The manual or automated system hardware (such as record cards and computer files) must be sufficient to allow the storage of present and future main and index files. The actual storage requirements will depend upon the system being used, but a source record may typically result in a requirement of three to five times its basic size when the main file entry and index entries have been taken into account.

The system hardware, software and staff must also be able to support the level of data throughput created by the addition of new records and the dynamic nature of existing records (being able to cope with the maximum normal pressure of activities such as new entries, new acquisitions, cataloguing, movements and loans); and the level of use created by demands on the system from the museum and outside enquirers.

3.8 security and confidentiality

The system design should include provision for the security and confidentiality of both the system itself and the information which it is managing (MDA, 1981b; Museums Association, 1981).

General system security measures include:

the provision of backup staff and equipment as a contingency in case of the absence of a key person or the failure of an essential item of equipment;

documentation of all aspects of the system;

training of staff in the use of the system.

Physical security measures include:

ensuring that copies of primary files (such as an acquisition register) are held in a fire-proof safe;

major equipment (such as a computer) is located in a secure part of the museum;

access to both files and equipment is restricted to authorised staff and approved visitors.

Data security provisions include:

ensuring that the museum holds duplicate copies of all primary files;
the updating of records is controlled;
procedures for the maintenance of records to a consistent standard are adopted;
links between files and from files to physical collections are maintained;
removal of records from files is controlled and documented;
information is legible;
records are stored in an environment that deters physical decay;
record photographs are held of important items in the collection.

One of the concerns of these security measures should be to control access to confidential information, such as management details (object valuation, storage location, etc.), locality information (details of important field localities that might be threatened by uncontrolled collection) and biographical information (details of donors, etc.). The museum may need to adopt a vetting procedure before allowing access to files or maintain separate logical or physical non-confidential versions of records for public use.

4:
System standards and operation

The effect on the system of the complexity of records and the operational requirements for the input, storage and processing of information are considered in Section 4.

4.1 record characteristics

Museum records are complex arrangements of data, subject to frequent change after their initial production. The documentation system must be able to support this complex and dynamic nature by providing effective input, storage and processing facilities.

Figures 6 and 7 illustrate some of the problems which have to be managed by the system. Figure 6 is a sample item record suitable for incorporation within a main file, made up of approximately 30 categories with names such as 'ID' (acting as an abbreviation for 'record number') and data such as '1983.1'. This abstract record is comparable to the manual record in Figure 15 and its automated equivalent in Figure 18 (Section 5.6 and 5.7); its component categories are comparable to the individual headings or concepts on a manual recording form or the fields forming a record within an automated system. Figure 7 illustrates a number of index file entries derived from this main record, showing various approaches to index construction. The characteristics of this record and the effect this has on the system are summarised in Table 5.

Figure 6. Sample item record

record		category description
ID	1983.1	record number
OBNAME	axe, hand	object name
PERIOD	Palaeolithic	object period
COLL	Major T. Hopkins	collector/excavator
CPLACE	Brighton (west)	collection place
CDATE	2 January 1871	collection date
OWNER	W. Powell	previous owner
ODATE	1937	ownership date
OWNER	Evans, C.	previous owner
ODATE	1960	ownership date
OWNER	Williams, P.	previous owner
ODATE	1970	ownership date
OWNER	Smith, F.	previous owner
ODATE	1980.10.16	ownership date
ACQ	Roberts, E.	acquired from
ACQ	Jones, A. B.	acquired from
ACQDATE	1983.01.02	acquisition date
CONS	Price Williams, E.	conservator
CONSDATE	1983.01.20	conservation date
REFA	Smith, F.	reference author
REFD	1981	reference date
REFT	Some of the major nineteenth century Palaeolithic hand-axe finds from the south of England	reference title
REFJ	Arch Cambs, 999 (1), 29–34	reference journal
REFK	England, Southern	reference keyword
REFK	Palaeolithic	reference keyword
REFA	W. Powell	reference author
REFD	January 1939	reference date
.
STORE	Room 5	store location
SDATE	1982.11.11	store date
STORE	Bay C, Rack 19	store location
SDATE	1983.01.02	store date

Figure 7. Sample entries in index files

(a) single-category index
 1. OWNER (previous owner)
| | |
|---|---|
| Evans, C. | 1983.1 |
| Smith, F. | 1983.1 |
| W. Powell | 1983.1 |
| Williams, P. | 1983.1 |

 2. ODATE (ownership date)
| | |
|---|---|
| 1937 | 1983.1 |
| 1960 | 1983.1 |
| 1970 | 1983.1 |
| 1980.10.16 | 1983.1 |

Figure 7 continued

(b) dual-category index
 OWNER+ACQ (previous owner+acquired from)

Evans, C. (OWNER)	1983.1
Jones, A. B. (ACQ)	1983.1
Roberts, E. (ACQ)	1983.1
Smith, F. (OWNER)	1983.1
W. Powell (OWNER)	1983.1
Williams, P. (OWNER)	1983.1

(c) multicategory index (full text less stop-words)

Arch Cambs, 999(1), 29–34 (REF J)	1983.1
axe, hand (OBNAME)	1983.1
Bay C, Rack 19 (STORE)	1983.1
Brighton (west) (CPLACE)	1983.1
century (REFT)	1983.1
England (REFT)	1983.1
England, Southern (REFK)	1983.1
Evans, C. (OWNER)	1983.1
finds (REFT)	1983.1
hand-axe (REFT)	1983.1
January 1939 (REFD)	1983.1
Jones, A. B. (ACQ)	1983.1
major (REFT)	1983.1
Major T. Hopkins (COLL)	1983.1
nineteenth (REFT)	1983.1
Palaeolithic (PERIOD)	1983.1
Palaeolithic (REFT)	1983.1
Palaeolithic (REFK)	1983.1
Price Williams, E. (CONS)	1983.1
Roberts, E. (ACQ)	1983.1
Room 5 (STORE)	1983.1
Smith, F. (OWNER)	1983.1
Smith, F. (REFA)	1983.1
south (REFT)	1983.1
W. Powell (OWNER)	1983.1
W. Powell (REFA)	1983.1
Williams, P. (OWNER)	1983.1
1937 (ODATE)	1983.1
1960 (ODATE)	1983.1
1970 (ODATE)	1983.1
1980.10.16 (ODATE)	1983.1
1981 (REFD)	1983.1
1982.11.11 (SDATE)	1983.1
1983.01.02 (ACQDATE)	1983.1
1983.01.02 (SDATE)	1983.1
1983.01.20 (CONSDATE)	1983.1
2 January 1871 (CDATE)	1983.1

(d) associated categories index
 OWNERS+ODATE (previous owners+ownership date)

Evans, C.	1960	1983.1
Smith, F.	1980.10.16	1983.1
W. Powell	1937	1983.1
Williams, P.	1970	1983.1

Table 5. Characteristics of museum information
multiple occurrences of data categories logical relationship between data categories unlimited data category data length unlimited number of data categories in a record unlimited number of data categories in the system long-term growth of records unlimited record size dynamic nature of records ability to revise list of data categories indexing constraints cataloguing constraints vocabulary constraints character set constraints sorting flexibility different category types

4.2 data standards

The system may include one or more data standards defining the data categories allowed within a record and the relationship between these categories (Chenhall and Homulos, 1978; Light and Roberts, 1981; North American Planning Conference, 1980). These internal data standards can be based upon existing published documents, such as the MDA standard for object documentation (MDA, 1980) and the MARC standard for bibliographic documentation (British Library, 1980).

One approach is to adopt a single standard for each common type of documentation of interest to the museum (such as object documentation, bibliographic documentation and locality documentation) (Table 2); another is to adopt separate standards for convenient groupings of information (such as individual object disciplines or departmental interests). The former philosophy has the important long-term advantage of facilitating the interchange of data between different departments, but it does require a greater degree of central coordination.

The categories listed in the data standard should be influenced by input and output requirements and the need to conform to general curatorial practice. If the museum requires access to a specific item of information (such as 'acquisition date') this must be recorded in a discrete form, and not as part of a broader concept; if the museum hopes to be able to interchange records with other institutions, its information must be compatible with the records of those other institutions. As it is not always possible to anticipate these requirements, the system must allow for the extension or revision of the data standard to incorporate new or changed categories (for example, by refining an existing category such as STORE into three discrete categories such as ROOM, BAY and RACK).

A typical record (such as Figure 6) may include multiple occurrences of certain categories (such as ACQ, OWNER and STORE). Some of these

occurrences may be logically related to specific other occurrences (such as the two ACQ and the ACQDATE categories forming a group of information about the acquisition; the REFA, REFD, REFT, REFJ and REFK categories form a group of information about one reference; each pair of STORE and SDATE categories forming a group about a current storage location). When dealing with primary museum records, the ability to have multiple occurrences and to preserve relationships are important reflections of the intention of the recorder: without them, the record may be incomplete and the information about one concept (such as the acquisition, a reference or a location) might become mixed with similar information about another concept, resulting in confused catalogues and 'false drops' during retrieval.

While a number of the categories in Figure 6 contain only four data characters (for example ACQDATE), one contains nearly 100 data characters (REFT): the system should allow each category to be any reasonable variable length. Although the figure shows just a few categories, museum records can be far more diverse, with a full data standard potentially including hundreds of categories: the system should not impose a restrictive limit on the number of different categories allowed within a record. It should also allow the addition of categories after the initial preparation of the record (for example, a changed storage location; new loan details; an additional reference; further information about a previous owner): there should be no restrictive limitation on the total number of categories within a record.

One implication of these requirements is that there should be no restrictive limitation on the size of a record. Catalogue records can typically range in size from 20 to 2000 data characters, with exceptional examples of over 10 000 data characters: the system must be able to support individual records with these variations during both input and processing.

Existing manual records may include these categories in different orders (such as identification – description – production in a decorative art record and identification – field collection – production – description in an archaeology record): if these are to be automated, the automated system should either allow different sequences of groups of categories or include facilities to re-order groups of categories into a uniform sequence.

4.3 data types

The system should also be able to support three types of category, corresponding to the different nature and role of data. Categories containing a string of alphabetical or numerical data characters which are to be treated as text are termed 'string categories'; those containing numerical data characters which are to be treated as a whole number are termed 'integer categories'; those containing numerical data characters which are to be treated as real numbers are termed 'real number categories'.

String categories include those concerning descriptive concepts (such as an object name); personal and corporate body names (such as the collector,

owner, depositor and borrowing institution); place names (such as the collection place and production place); complex record numbers (such as object number and conservation number); and complex dates (such as collection date and production date). Integer categories include the basic components of a date (such as a year). Real number categories include dimensions (such as weight, height and width).

The system must be able to sort the data in a string category into alphabetical order; analyse the information in an integer category as if it were a whole number (for example, to be able to search for a range of dates); analyse the information in a real category as if it were a real number (for example, to be able to undertake mathematical operations on weights).

4.4 terminology standards

Various terminology standards governing vocabulary, syntax control and character sets may need to be applied to the data in each of these types of category. As with data standards, these internal terminology rules may be based on published documents such as recording manuals and classification schemes (see British Library, 1980; Chenhall, 1978a; Gorman and Winkler, 1978; Group for Regional Studies in Museums, 1983; MDA, 1980; 1981a; Orna, 1983).

In some cases (such as a painting title, reference title and an inscription), it may be decided to treat the full category as one unit, allowing its vocabularly to be influenced by the form of the original source. In other cases (such as descriptive concepts, personal names, place names and dates), it may be decided to control either just the syntax or both the syntax and vocabulary according to some agreed standards. For example:

the syntax of a descriptive concept might be defined as 'major component, minor component' (such as 'axe, hand') and the vocabulary might conform to a classification scheme;

the syntax of a personal name construction might be defined as 'surname, forenames (honorific)' (such as 'Hopkins, T. (Major)') and the vocabulary might conform to an established personal name authority list;

the syntax of a place name might be defined as 'primary name (detail)' (such as 'Brighton (west)') and the vocabulary might conform to a gazetteer;

the syntax of a date might be defined as 'year.month.day' (such as '1982.11.11').

In practice, existing manual and automated records frequently conflict with a newly introduced standard: when new records are being entered into the system, either the recorder or the system will have to standardise their form; when existing automated records are being reassessed, the automated system must include adequate facilities to enable the standardisation operation to be carried out effectively. If this standardisation fails, anomalous data may be held in the record and any index files (such as 'Major T.

Hopkins', 'W. Powell', '2 January 1871' and 'January 1939' in Figures 6 and 7).

The required standard form will be partly conditioned by indexing requirements, bring the most significant part of a concept to the front of an index term so that it sorts into a usable alphabetical order: until they are edited, 'Major T. Hopkins', 'W. Powell', '2 January 1871' and 'January 1939' will be out of order in the record and effectively lost from the indexes (they would only be found by a sequential search for 'Hopkins', 'Powell', '1871' or '1939'). This standard form may be excellent for retrieval purposes but inappropriate as part of a published catalogue, in which a more readable construction may be required (such as 'honorific forename surname' and 'day month year'): the need for the system to be able to redisplay information on output is therefore complementary to the need to standardise it on input.

If the data includes unusual characters (such as accented letters or non-Roman script), the system should be able to take this into account. Unusual characters can complicate procedures when sorting data into alphabetical order: in some systems, even a basic capability to sort upper and lower case letters into an acceptable sequence may be limited.

4.5 interchange standards

When designing the documentation system, a number of the decisions made by the museum concerning data and terminology standards (such as the appropriate data categories, the way these categories are represented in a record and the characters used to convey information) can be specific to its internal requirements. However, if the museum wishes to exchange records with other institutions it becomes necessary to adopt agreed common standards for the purpose of interchange.

This interchange might be from the museum to the parent body or a service agency which is responsible for external processing, file security or manipulating records to produce publications on behalf of the museum; from an outside agency back to the museum for local use after external processing; or from the museum to another institution for incorporation within a cooperative catalogue or indexes. This transfer of information might be an operation between a number of museums in the same county concerned to establish a county-wide catalogue; or between a number of museums throughout one country or in different countries interested in establishing cooperative sources (such as a national index of natural science type specimens or an international catalogue of the works of a particular school of painters).

If only two or three institutions are concerned, the interchange standards might be agreed on an *ad hoc* basis in response to a specific problem. If more institutions are involved, it becomes necessary to adopt commonly accepted interchange standards. Each donor institution is then responsible for transforming its records into the agreed form; each recipient institution

for being able to receive records in the interchange form and either process them according to the interchange standards or transform them into its own local standards.

In recent years, the Documentation Committee of the International Council of Museums (CIDOC) has been examining the requirements for internationally acceptable museum interchange standards. As a number of standards have already been developed for the library community, CIDOC has been examining the relevance of existing bibliographic standards from the museum viewpoint. Organisations such as the International Standards Organisation (ISO) and Unisist (the Unesco group concerned with information technology applications) have played a leading role in producing these bibliographic standards. Relevant documents include ISO 2709 concerning the logical structuring of a record (ISO, 1981); ISO 646 and ISO 2022 concerning the appropriate character set to use within an automated file (ISO, 1973a and 1973b); and ISO 1001 and ISO 3788 concerning the arrangement of records on a magnetic tape for interchange purposes (ISO, 1979 and 1976).

The bibliographic application of these standards is illustrated in documents such as a Unisist reference manual (Dierickx and Hopkinson, 1981) and the various national MARC (machine readable catalogue) systems (for example, British Library, 1980) (Hagler and Simmons, 1982). These include definitions of data categories for bibliographic use. Comparable definitions for museum interchange purposes are being considered by CIDOC, on the basis of a number of the systems currently used by museums in various countries (Light and Roberts, 1981).

4.6 initial processing

Reference was made earlier (Section 3.5) to the initial processing operations of recording, data entry, editing and validation, used during the incorporation of new records and the modification of existing records (by altering or replacing current categories and adding new categories). The quality of the input operations has a fundamental effect on the standard of the resulting records.

The staff responsible for input can be aided by procedural guidelines within the system documentation and by manual or automated facilities such as well-designed record cards or forms and computer software. The documentation and facilities must be commensurate with the complexity of the information being input and the required standard of the records.

When using a manual system, recording and data entry are a single-step operation leading to the production of a draft record; when using an automated system, recording and data entry can either be undertaken simultaneously (as a single-step operation) or consecutively (as a double-step operation). Single-step input involves a recorder creating the record while at the keyboard, thus circumventing a separate manual recording stage; double-step input involves the recorder preparing an initial manual

record in a format suitable for transcription or interpretation into a machine-readable style by a data entry operator.

The single-step method might be appropriate when a curator is recataloguing an existing collection or dealing with the management of new acquisitions; the double-step method when adequate manual records have already been prepared and the curator, an assistant or an outside agency is able to undertake data entry. In the double-step approach, the existing manual records might typically be specimen labels, accession registers, record cards or published catalogues.

If the organisation of the record conforms to the standards being adopted within the automated system, it may be possible for an operator to transcribe the information directly into machine-readable form with the minimum of amendment; if the organisation differs from the new standard, either the operator or a curator may have to interpret the information prior to entry or the system will have to be used to carry out a standardisation process during initial processing.

These operations of interpretation and standardisation of an original record are analogous to the work involved in reprocessing existing manual records into a new manual format. If manual reprocessing is being undertaken, it is essential that the resulting record is suitable for straightforward transcription into machine-readable form at a later date, without the need for yet another reprocessing cycle.

When using a manual system, the standard of completion of a record depends upon the expertise of the recorder and the availability of written guidelines. With an automated system, recorder expertise and written guidelines are still essential, but can be supplemented by automated entry, validation and editing facilities.

4.7 automated input

Automated input operations involve the inputting of the source data characters themselves and the category names corresponding to the structuring of the record (Figure 6), using various kinds of input device. Either the operator or the initial processing software will have to assign these category names to each significant item of data.

In a highly structured record with a number of discrete categories these names may represent a significant typing overhead (typically ranging from 10% to 40% of the number of data characters, with the result that a 1000-character source record may potentially involve the typing of between 1100 and 1400 keystrokes). The number of keystrokes required to create or amend a record may, however, be reduced by adopting certain data entry strategies which need to be supported by the input processing software. These strategies serve three functions: helping the operator; aiding the standardisation of the records; and speeding up the input operation. Methods include:

abbreviating words or phrases (with the software then interpreting the abbreviation to its full form);

using pseudo-category names or codes (with the software interpreting these names or codes into the full category structure);

carrying data over from one record to the next (with the software holding the current record as the basis for the next record);

declaring one or more categories to be constant in a series of records and typing these categories once only at the beginning of the series (with the software then inserting the category into the relevant records);

automatically inserting category names (with the software prompting the operator for the data conforming to a category).

The software may also be able to support various validation strategies to help the recorder or operator, including:

checking the presence within a record of mandatory categories (such as record number and recorder name);

checking that the data content of a category is alphabetic or numeric or falls within a defined range (such as not allowing a date '2083'));

checking the syntax of the data content (such as not allowing 'Mr' to occur at the beginning of a personal name);

checking the vocabulary used within a category against an established term list and rejecting non-approved terms.

It should be noted that excessive use of some of these entry and validation facilities can have the effect of slowing down the overall operating speed (such as heavy use of abbreviations and constants confusing the operator; wordy or slowly-produced prompts delaying typing; and excessive validation slowing down the system response). The net result, however, is usually to speed up and standardise data entry.

The number of original keystrokes produced by an operator may typically vary from 2000 to 12 000 per hour, depending on factors such as the use of these strategies; the degree of interpretation and structuring; the readability of the source; the expertise of the operator; and the hardware and software being used. An average rate for straightforward new records is around 6000 keystrokes per hour.

Despite these facilities, both newly created records and existing records will need to be edited to conform to the overall standards and reflect changing information. Automated editing facilities might need to be applied in various ways, such as:

changing an individual category in a record (for example, change 'Major T. Hopkins' to Hopkins, T. (Major)');

changing a series of categories in a record (for example, changing all occurrences of 'W. Powell' to 'Powell, W.');

changing one or more categories in a series of records (for example, changing every occurrence in a file of '2 January xxxx' to 'xxxx.01.02');

adding additional categories to a record or series of records (such as a new identification).

4.8 forms design

Both manual and automated recording operations can be assisted by well-designed input forms conforming to the system data standards and terminology rules. Similar principles can be applied to the design of physical forms on card or paper and logical forms displayed on a computer input device such as a visual display unit (VDU) (Lee, 1979). Physical forms may be intended for long-term use as part of a manual system or as the initial recording step in an automated system. (Typical examples are illustrated in Figures 9, 12, 15 and 22, and in publications such as Chenhall, 1975; Dudley and Wilkinson, 1979; MDA, 1981a; 1981b; Perry, 1980). Logical forms displayed on the VDU screen are one of the methods by which the input operator can be prompted to record relevant data categories and the category name can be automatically inserted in the automated record.

Whether the design is concerned with a physical form for use in a manual system or as an input document, or with a logical form for use in an automated system, it must reflect the standards adopted by the museum. It should include relevant groups of data categories in an order which conforms with the way in which the recorder builds up the record; provide for repetitions of categories relating to commonly recurring information (such as references in an object item record); have sufficient space to allow for the inclusion within a category of typical information, without having to resort to a continuation form; and be clear and unambiguous.

The design should also be influenced by the requirements and capabilities of the processing software that is to be used when the record is automated. If the museum has already selected a processing system and is designing a physical form as a temporary record prior to data entry, it will be possible to match the detailed design to the processing system's capabilities. If, however, the museum intends to use a physical form as a manual record for the foreseeable future, it will be more constrained in its design and its future processing system options.

4.9 subsequent processing

Reference has also been made to the subsequent processing operations concerned with the manipulation, storage, output and transfer of information (Section 3.5). In both manual and automated systems, the validated input record acts as the basis for an entry in a primary main file and one or more derived secondary index files.

In a manual system, a main file is usually made up of records stored on cards or sheets. In the case of the main item records concerning the collections (objects, bibliographic material, etc.), this file is often considered to be an internal catalogue. In an automated system, the main file may either be a direct access or sequential access set of records, stored on magnetic disc or

magnetic tape, available for interactive or batch use (concepts discussed in Appendix C). The machine-readable main file may be complemented by a printed equivalent, analogous to the physical records in a manual system.

Whether using a manual or automated system, the logical records in the main file are usually held in a standard sequence (typically in record number order). If a user is interested in information about a specific item whose number is known, it is possible to promptly locate the relevant record within the file by either moving direct to that part of the file (as in a manual system or a direct access automated system) or by moving through the file until the record is located (as in a sequential access automated system) (Appendix C). If the user is interested in an item because of some other criterion (such as a donor name), it would be necessary to search through all or part of the file, checking the donor entry in each record, before a relevant record will be found. As more than one item may have been acquired from the donor, the user would have to search the complete file before being satisfied with the response to the request.

Indexes act as subordinate directories to the main file, designed to aid this retrieval process. The indexing operation is known as inversion, whereby information is extracted from a main file record and re-ordered from the main file sequence into new alphabetical or numerical sequences. If a donor index file were available, the request for information about the donor could be answered by turning to this file and locating the relevant donor entries. These would provide details of the record numbers of entries in the main file, to which reference could then be made for information about the relevant items.

A single record in a main file may be complemented by entries in one or more index files (Figures 6 and 7). Each of the index files may include entries derived from one or more categories from the main file records: typical approaches are to base the index on one category from each main record (Figure 7a); two or more categories (Figure 7b); all categories from the full text, less predefined 'stop words' such as conjunctions and prepositions (Figure 7c); two or more categories used together in a precoordinated form (Figure 7d) (MDA, 1981b). If the index incorporates terms extracted from more than one category, this category may be noted as a qualification to the term itself (for example, in Figure 7b and 7c).

In a manual system, the production and maintenance of each index is a demanding and time consuming exercise, as a result of which only one or two indexes may be held, and those that are available are often inaccurate and incomplete. The index entries are usually stored on cards.

One of the advantages of automated systems is their ability to produce and maintain a series of indexes, giving a broader range of 'access points' to the information in the main file. These systems tend to adopt two types of approach: the first concentrating on selective information retrieval from an online direct access index file; the second on the production of printed

catalogues and indexes (analogous to manual indexes) corresponding to the machine-readable file, which the user then consults for relevant information.

Unfortunately, many of the automated systems specialise in one or other of these retrieval and production facilities, whereas both are frequently required in the museum context (the former being particularly important when maintaining records and answering complex enquiries and the latter when producing publications). Museum requirements include the ability to:

select or reject records on the basis of any combination of data categories from a record (for example, to select only those records including conservation categories);

select or reject records on the basis of the data content within individual categories (for example, to select only those records in which the acquisition method is 'purchase');

sort all records from a file into a new order (as when producing an artist catalogue);

manipulate the data content of a category into a new format (for example, to change the syntax of a personal name or date);

display a record on a page in an acceptable format (for example, arranging the record in a way which takes account of new pages and including page headings conforming to the content of the page).

The extensive features of some of the online retrieval systems include the ability to switch from one file to another and to save a search for later reuse (Henry *et al*, 1980).

The application of automated systems depends upon system dialogue methods which enable the user to communicate with the system at the time of output and input, using some form of query or command language (Lee, 1979; Samet, 1981). The forms technique described in Section 4.8 is one example of the approach which is commonly used during input. In this case, data is inserted into the categories within a form which is presented to the user on a VDU screen. Other methods include 'question and answer' prompting techniques and selection from a 'menu' which lists possible options.

The method offered by the system should be commensurate with the skills of its users, offering different degrees of assistance to 'active' (frequent) and 'passive' (infrequent) users. In practice, the facilities offered to an active user (such as a cataloguer) may be far more extensive than those offered to a passive user (such as other curatorial staff or museum visitors). Complex searches may need to be carried out by an active user acting as an 'intermediary' on behalf of a number of passive users, as happens in many public and academic libraries.

4.10 *file maintenance*

The standard of maintenance of the records in the main file and the entries

in the index file is another critical factor governing the effectiveness of the system.

In the case of the main file, it will be necessary to add new records corresponding to additions to the collection; to delete or annotate records in the event of any removals from the collection; and to amend existing records by editing the content of categories and adding new categories. While files held primarily for curation purposes (such as item record files concerning the physical collection) may need to be amended less often than those held primarily for control purposes (such as inventory files), both types are subject to change.

With both manual and automated systems, the basic physical maintenance of the records should be a straightforward matter. However, in practice the operation can be complicated by a number of factors, such as the revisions being typed by separate staff; the revisions having to be cumulated for a period of days or weeks before a series of changes to a file are carried out; and duplicate copies held for management or security purposes also having to be revised or recreated from the master copies (Section 6.21).

In the case of index files, any changes to the main record should be reflected by a corresponding change in the index entries (such as the deletion, amendment or addition of a category in the record being paralleled by the deletion, amendment or addition of relevant terms in the index files). These changes may either be carried out at the time of altering the main record or later, as a cumulative exercise. If they are not implemented at some point, the index soon becomes unreliable and will eventually have to be recreated from the main file. As well as being a waste of resources, the degradation of an index is a misleading situation, since it may not be clear to the user that the index is inaccurate and unreliable.

The most important factor in maintaining both main and index files is not the sophistication of the operations that are being used, but the consistency with which these operations are applied by the museum staff. The scale of the maintenance problem has only been commonly appreciated in recent years, when it has become apparent that a number of the first generation of automated systems are inefficient in dealing with dynamic records, having been designed on the false assumption that museum records are rarely revised once created.

4.11 logical and physical organisation

A distinction can be made between the logical and physical organisation of main files and records (Figure 8). Any logical main file may be made up of a series of separate physical files. For example, the main item record file may be arranged on an annual basis or dispersed within individual departments on a discipline basis. Furthermore, the physical records within each of these files may be considered to be part of a broader logical record, such as a record about an individual object or bibliographic item. For example, infor-

Figure 8. Organisation of files and records

Entry file	Acquisition file	Item files
ENTRY1	ACQ1	Archaeology ARCH1 Botany BOT1 Geology GEOL1 GEOL2 GEOL3

Exit file	Inventory file	Conservation file
LOAN1 (ARCH1) LOAN2 (GEOL1) LOAN3 (GEOL1) LOAN4 (GEOL3) LOAN5 (GEOL1)	INV1 (ARCH1) INV2 (BOT1) INV3 (GEOL1) INV4 (GEOL2) INV5 (GEOL3)	CONS1 (ARCH1) CONS2 (ARCH1) CONS3 (BOT1) CONS4 (GEOL1)

Purchase file	Locality file	Bibliographic file
PUR1 (ACQ1)	LOC1 (ARCH1) LOC2 (BOT1, GEOL1, GEOL3) LOC3 (GEOL2)	REF1 (BOT1, GEOL1, GEOL3, LOC2) REF2 (CONS4)

mation about one object may be included as part of a record within the entry file, acquisition file and purchase file, and as a complete record within the item file, inventory file, conservation file and exit file.

In Figure 8, one archaeology, one botany and three geology objects (ARCH1, BOT1 and GEOL1–3) have been acquired as a group (ACQ1), following their earlier deposit in the museum (ENTRY1). Details of the financial transaction are held in a separate management control file (PUR1); their current location in five records in an inventory file (INV1–5); separate conservation work in four records in a conservation file (CONS1–4), two of which concern independent examinations of the same object; loans to other institutions in five records in an exit file (LOAN1–5), three of which concern independent loans of the same object. The full information about one object (GEOL1) is dispersed as part of ENTRY1, ACQ1 and PUR1, and all of GEOL1, INV3, LOAN2, 3 and 5, and CONS4.

In this illustration, additional details about the localities from which the objects were collected are given in an independent locality file, which incorporates records with full details about localities, including a note of objects collected from that place (for example, three of the objects were found at LOC2); similarly, details of references referring to these objects are held in a separate bibliographic file, one record within which describes three of the objects and one of the localities.

Alternative permutations of the physical arrangement may be adopted in other circumstances. For example, the museum may not hold separate exit, locality or bibliographic files, but may incorporate relevant details within the item records, in which case each item record would have to include full details of loans, the locality and references. Access to loan, locality and reference information could then be obtained by preparing subordinate loan, place name and author indexes, derived from the main file records. The approach adopted should be the most effective compromise between recording efficiency and convenience of use.

4.12 linking files and records

As it is inevitable that there will be some fragmentation of information into separate physical files and records, there must be a means of linking related records. These links are necessary:

between records produced at separate information management stages (such as entry ⟷ acquisition ⟷ item ⟷ exit); between curation and control records at each stage (such as acquisition register ⟷ inventory file ⟷ transfer of title file; item file ⟷ inventory file ⟷ valuation file); between different documentation types (such as object record ⟷ bibliographic record ⟷ conservation record ⟷ record photograph ⟷ biographic record ⟷ locality record); between the primary information management procedures and other museum procedures (such as acquisition control ⟷ financial control).

The links may be explicit or implicit. An explicit link is a number incorporated within both related records (such as an entry number being noted in the acquisition record); an implicit link is some other information which allows the user to connect one record to another specific record (such as the donor name in an acquisition record acting as a link to a donor file; the author and date forming a brief reference in an object item record acting as a link to the full reference in a bibliographic file). The linkage operation may be one-step (as in the example above) or via an intermediary connection (such as the link between an entry record and an item record being via the acquisition record).

The explicit numerical link is usually considered as the record number or identity number of that particular target record. It also acts as the primary link between the documentation system and the physical collection itself, with the relevant number being marked or tagged on the group or individual item to which it refers. The most sophisticated documentation system will be of limited value in the curation and control of collections if this link is broken.

5:
Documentation procedures

Detailed practical aspects of documentation procedures are examined in this section. It concentrates on the information management procedures, using the documentation framework introduced in Section 3.

5.1 information management procedures

The primary information management procedures concerned with the curation and control of collections were outlined in Section 3 (Figure 3).

Group curation procedures are particularly concerned with the preservation of information accumulated before and during the entry of material into the museum and during the processing of acquired material. The files relating to these procedures are often dynamic, subject to frequent change due to the addition, deletion and amendment of records. The quality of the acquisition details will be directly affected by the quality of the preceding entry details, and will itself be one of the major influences on the quality of subsequent item records, catalogues and indexes.

Item curation procedures are concerned with the preservation of information accumulated after the acquisition of material into the museum and the utilisation of that information to produce catalogues and indexes and for

information retrieval. Files concerned exclusively with item curation may be less dynamic than group curation or control files, being subject to gradual long-term addition of information rather than very frequent active change. The large numbers of records within the files may be detailed and complex, reflecting the scale of the collections and the data standard complications discussed earlier.

Control procedures are concerned with the application of information to aid the management of the collections from the time the museum first becomes aware of a potential acquisition. They may be specific to a single stage of the overall framework (such as entry control) or more broad ranging (such as inventory and location control of material from the time it first comes into the museum). Files concerned with control are often highly dynamic, subject to frequent change due to the revision of existing details. The number of control records may be comparable to those held for item curation purposes, but each may be less detailed and far simpler in structure.

In practice, the current approach adopted by many museums is to make little distinction between curation and control procedures, despite their different nature and function. A single file may be used for both purposes (such as a register being used for both initial curation details and subsequent inventory control or an item record file including location details).

Similar procedures can be applied during the information management of all four types of physical collection (objects, bibliographic items, archives and audio-visual material) (Section 5.2–5.8). Comparable operations are also applied when developing support documentation (about conservation, record photographs, localities, etc.) (Section 5.9–5.14). The resulting sources form a network of interrelated main files and subordinate indexes.

The museum should consider undertaking an assessment of the overall effectiveness of its documentation procedures, based on the guidelines in Section 9 and Appendix B. In undertaking this assessment, it should consider whether the procedures achieve the standard of documentation recommended in the following paragraphs.

Details of the general procedures are given in standard museum, library and archive publications (such as British Library, 1980; Cook, 1980; Cooper *et al*, 1980; Dudley and Wilkinson, 1979; Fédération Internationale des Archives du Film, 1979a; 1979b; Gorman and Winkler, 1978; Hickerson, 1981; Lewis, 1976; Matthews, 1980; MDA, 1981b; Porta, Montserrat and Morral, 1982).

5.2 pre-entry stage

The pre-entry stage involves the procedures used when recording information about items that may subsequently come into the museum (such as potential acquisitions and material found during field work and excavation programmes). Practical procedures may include opening a specific potential acquisition record or adding details to a general correspondence file,

the preparation of field notes or the use of a parallel comprehensive excavation recording system.

The procedures are primarily concerned with accumulating curatorial information that might be suitable for absorption within a subsequent acquisition or item record and with keeping track of basic control details about the material (such as field record numbers). Information that is to be incorporated within subsequent stages should be recorded in a compatible format, using comparable data categories, syntax and vocabulary. The pre-entry record should be linked to any subsequent entry or acquisition record.

5.3 entry stage

The entry stage concentrates on procedures applied when material first enters the museum, as an anticipated acquisition, on loan or as an enquiry. Inadequate recording at this stage may jeopardise the effective control of material and may have a permanent impact on the quality of the documentation about acquired items and be a serious detriment to their value as part of the collections.

Practical procedures applied in advance of the entry itself may include collecting and transport arrangements and the notification of the anticipated arrival to the person responsible for entry management and documentation. Procedures applied at the time of entry may include the completion of a daybook or some style of manual multi-part entry or enquiry form (such as the example in Figure 9), or an automated equivalent, the use of which may extend to the documentation of all groups coming into the museum or may be restricted to items left as retained enquiries. Subsequent procedures prior to the return of the group to its depositor or its acquisition into the collections may include maintaining the details in this entry record as a basis for the control of the material.

Formal entry procedures should be applied for all material entering the institution and retained for any period (the exception being items brought in as an enquiry that are dealt with immediately). Although the detailed procedures may be specific to different categories of entry (such as acquisitions and long-term loans-in being treated differently from short-term loans-in) they should be applied universally.

A documentation unit (made up of one or more members of staff working either part-time or full-time on documentation duties) should be responsible for the overall management of the entry procedures in each department or the museum as a whole. This unit should be advised at the earliest possible opportunity of any anticipated entries (such as known acquisitions or loans) and have authority to influence the time scale of the subsequent procedures to ensure the availability and effective use of staff. The initial entry record itself may be completed by support or warding staff at an entrance, reception or enquiry desk. These staff should be trained and supervised by the person responsible for entry management, who should be able to emphasise the importance of consistent initial recording. The procedures should be

Figure 9. Entry form (A4) (obverse and reverse)

Sheet of	LEEDS CITY ART GALLERIES Lotherton Hall Aberford Leeds LS25 3EB (0532) 813259	Institution: group number LEEAG:	№ 028

OWNERSHIP

depositor: AMAGS YH (for Yorkshire Museum, York) 0532 638909 (0904 29745) phone number

address: Farnley Hall LS12 5HA (York Yo1 2DR)

owner: LEEDM & exechtors of the late Dr Tom Marmion phone number

address: Civic Buildings & as file: TN (0532) 462632 & as file: TN

copyright holder: as above phone number

address

GROUP

summary description, identification and history of group

The Burmantofts Pottery Exhibition (Bradford/Leeds) after all loans (other than Marmion) have been returned. 20 packing cases containing 128 items as listed by Yorkshire Museum and information panel. Yorkshire Museum list relates to Burmantofts Pottery, Leeds and Bradford, 1983 ISBN 0946657 02 5

ENTRY

method or reason	price	insurance valuation	return required?	agreed return date
exhibition		as file: TN	yes	to be negotiated

note: LEEDM items to be returned to Museum Store (contact: Alan Garlick: 755821). Marmion items to be negotiated with exechtors by P. Walton. Some Marmion items on loan to LEEAG to be retained

depositor: I agree that the information given on this form is correct and accept the conditions overleaf signed date 25 6 85

museum recipient: I acknowledge receipt of the group described above, on behalf of the museum: signed date 25/6/85

ACTION

group passed to:	curator	temporary store	signed	date
	P Walton	LH Drawing Room		3. 7. 1985

note: Lotherton showing 6. 7. 1985 to 9. 2. 1986

retained group: cat nos	initial/accession number	store	signed	date
115, 116, 117		exhibition		3. 7. 1985

returned group: I acknowledge the return of the group described above, in satisfactory condition: signed date

ENTRY

© Museum Documentation Association 1981 September 1981 MDA 017
Published by the MDA, Duxford Airfield, Duxford, Cambridgeshire, U.K.

Leeds City Art Galleries

ENTRY FORM

For any group of items entering the museum, other than that previously temporarily removed from the permanent collection.

CONDITIONS OF ACCEPTANCE

General

Except in the case of negligence on the part of itself or its officers, the museum does not accept liability for loss of, or damage to, or deterioration in, the item(s) described overleaf. The same care and precautions will be taken for the safe custody of this deposit as for the safe custody of items within the museum's permanent collection.

It is the depositor's responsibility to collect the item(s) described overleaf by the agreed return date. In the event of the item(s) not being collected by the depositor, the museum reserves the right to dispose of the item(s) after they have been in its possession for not less than three months.

The top part of this form will be given to the depositor as a receipt for the item(s). This part must be presented to the museum when the collector comes to retrieve the item(s). Both this part and a museum part of the form will then be signed by the collector in recognition of their having received the item(s) back in satisfactory condition. The collector and the museum will then retain the respective parts of the form.

Enquiries

Neither the museum nor its officers can accept any responsibility for an opinion that may be expressed on items submitted for examination. Opinions may be given only to the owner of an item or to the representative of the owner.

An officer of the museum is not authorised to give valuations, to assist in the disposal of private property or to express opinions regarding the merits of business firms.

Acquisitions

In the case of an acquisition by the museum, the owner (or a depositor acting on behalf of the owner) transfers absolute ownership of the group specified overleaf to the museum, without conditions.

Loans

In the case of loans to the museum, it may be agreed that the museum will undertake to return the object by the return date. In this circumstance, a museum part of the form will be sent with the object. Both parts should be signed by the depositor: the first part to be retained by the depositor and the second part to be returned to the museum.

Special conditions

MDA 017

thoroughly documented in procedural manuals, concerned with both the practical entry operation and the overall management of the procedures.

The material itself should be retained in a holding area prior to full examination. It should be labelled with brief details, including a unique temporary entry number. This number should be used as a link between different stages and files, by being noted in a preceding pre-entry record, a following acquisition record, any documents used during the entry stage itself, such as the entry record and supporting correspondence or management files (for example, insurance, valuation or financial details concerning the movement of the material into the museum and its initial care by the institution) and any associated conservation records or record photographs.

A main file of entry records should be retained in entry number order and used as a basic source in the subsequent control of the material. In a manual system, this may incorporate one part of the multi-part entry form, another being given to the depositor of the material as a receipt. Although in an automated system the museum part of the form may be replaced or superceded by an automated record, it is still necessary to provide the depositor with a receipt. This receipt should include conditions outlining the museum's responsibility for the deposited material. It should be signed by an authorised museum official and the depositor and produced as evidence when the depositor comes to retrieve the group. Countersigned copies of the form should be retained by both the museum and the depositor after the retrieval of the group. The museum copy should be held indefinitely, for audit and control purposes.

The record itself should incorporate control categories concerned with aspects such as details of the deposit (name of the depositor, date of deposit, reason for the deposit); the initial and subsequent location of the group; and details of subsequent action (including information about the eventual fate of the group, such as its return to the depositor or incorporation within the collection). These details should be kept up-to-date during the progress of the material and regularly monitored by the person responsible for entry management.

If the department or museum accepts relatively few entries, it may be possible to restrict the primary documentation to the entry record itself. In cases where larger numbers of groups are being dealt with, it may be necessary to prepare manual or automated indexes or separate main files to aid the control of the items (such as location, depositor or loans-in indexes). (Advice on location control procedures is given in Section 6.1–6.17.)

The record should also incorporate curatorial categories such as details of the owner of the group and information about the material itself (for example, a brief description and outline history). While the depth and value of this information will clearly depend on whether the group is to be acquired and the expertise of the person completing the record, it should be compatible with the subsequent acquisition and item standards. The record

form or its supporting procedural manual should include guidance on the syntax and vocabulary of the information to be recorded.

5.4 acquisition stage

The acquisition stage is concerned with the curation and control of groups of items during their formal incorporation or accessioning into the collection as either a permanent acquisition or long-term loan. Effective recording at this stage is essential if the museum is to maintain proper control over its collections and demonstrate full accountability to outside authorities.

Practical procedures applied by a museum may include the completion of a provisional manual acquisition record or a comparable automated record, with a working description of the acquired group; a formal acquisition record derived from the manual or automated entry record or provisional acquisition record, which may remain largely unchanged after its initial preparation, acting as a passive historical summary of basic knowledge about the acquisition at the time of its acceptance; an inventory record comparable with the formal acquisition entry; and formal transfer of title documentation defining the museum's legal title to permanently acquired groups.

If used, the provisional acquisition record (such as the form illustrated in Figure 10) tends to be completed locally (within a section or department), possibly before the formal acceptance of the group, then submitted to a central office as the basis for a decision concerning acceptance and as the formal acquisition register entry. It may then be returned to the section or department, having been annotated with a centrally assigned acquisition number, for use as a local copy of the register entry.

The formal acquisition record is typically a register entry prepared after the formal acceptance of the group. Details may be noted in a bound register volume or on loose-leaf sheets, with pre-printed column headings (Figure 11), or produced as output from an automated file. Many museums make no distinction between permanent acquisitions and long-term loans, describing both in a single register; others have separate registers for the two types of acquisition. The main function of the register is to act as a long-term summary record of the material coming into the care of the museum. It can be considered as an inventory at the group level. It tends to be a closed record, only being annotated in the event of a major change of circumstances affecting the group, such as the loss, disposal or permanent transfer between departments or to another museum of any of its component items.

Depending on the discipline being documented, the nature of the acquisition and the policy of the museum, the register entry may be concerned with an individual item (as when processing objects such as paintings or sculpture) or an overall acquired group (as when processing many kinds of natural science specimens). In the former case, the register entry is directly comparable to the subsequent catalogue record. In the latter case the entry

Figure 10. Acquisition form (A4) (obverse and reverse)

SMUZA1	OBJECT DATA FORM	ZOOLOGY-A

Nov Acc'n / Nov Tag N Y Z 8 1 8 . 1 9 8 4 . OOO PART

01E PREVIOUS Acc'n No	13A No PARTS	01A DAYBOOK No	01D INWARD LOAN No	02A SIZE of collection

05A SCIENTIFIC NAME and authority
Alcedo atthis (L.)

05B Classification : system : identifier : date
#5662 : : Hider m : 31.07.1984

05F STATUS : Checklist No 52C VALUE : valuer : date

50A ACQUISITION - purchase price : method : source role
: gift : donor

50D Source name and address : date
Parker LS mr & 57 Beech Road & Leicester : 31.07.1984

50F Previous identification No : conditions : finance source

50I Format on receipt : condition on receipt
in the flesh : good 20D FORMAT - current
 cabinet skin
78B DISPOSAL reason : authority : disposer name : date

76C STORE location : recorder : date OOD DOCUMENT recorder : date
NWM B15 : Hider m : 14.08.1984 Hider m : 31.07.1984

index section

04C COMMON NAME
Kingfisher

06A SYNONYM scientific name and authority

06B Classification : system : identifier : date

06A

06B

05A PREVIOUS IDENTIFICATION

05B Classification : system : identifier : date

05A

05B

22A DIMENSIONS - part : aspect : value 22A tail : : 39mm
wing : : 80mm
22A tarsus : : 11mm 22A bill : : 44mm
22 Weight : value 45B Sex : value 45B Stage : value
weight : 40.5g sex : male stage : adult

10A CONDITION - part : aspect : value : recorder : date

12A COMPLETENESS - part : aspect : value : recorder : date

85B COLLECTION method : identity No : collector : date
(N1) : : Parker LS : 30.07.1984
82A Habitat

80D Locality type 80B classification : system : ident 80E identity No/ Tetrad No 80A Locality full name
 River Soar
81A Place - house/street : town : parish : district : county/region : country : continent 81I O.S.Grid ref
EMGAS, Aylestone Road : Leicester : : : Leics SK 578 026
95B Acknowledgement : recorder : date 95B Labelled : recorder : date
ackn : : Hider m : 31.07.1984 label : : Hider m : 31.07.1984
95B Preparation method : preparer name : date
taxidermy & cabinet skin : : Lomas AD : 00.08.1984
75A DOCUMENTATION - link : class : cross reference/history file ref 75I Illustration/photo No
 H : correspondence : NB/Coll/Spec
75F Title of book

75D Author : date 75G Publisher/journal : volume/page

Leicestershire Museums, Art Galleries and Records Service

TAG NUMBER	OCCUR' No	other data
9 9 A	0 1	(N¹) Flew into window of Gas Board offices. This is the third Kingfisher this summer to kill itself this way at these premises.

Amendments - by year

DATA INPUT BY: M. Hider 15/8/84

Figure 11. Facing pages from an acquisition register

29

MUSEUM

Date	Accn. No.	OBJECT	Acquisition	Classi-fication
1	2	3	4	5
	8501-12	Lambskin, officers, sealed pattern 1904	G	267
	-13	Leopard skin, officers, sealed pattern 1904	,,	,,
	8501-14	Lanyard, officers, 4th Kings African Rifles c 1950	G	1012
	8501-15	Italian flag from Gondar citadel	G	1012
	8501-16	Flag, 93 motor Co. Kings African Rifles c 1962	G	1012
	~~8501-17~~	~~100 items, badges, shako plates, and moulded drops c 1855 - 1870~~	~~P~~	~~1012~~
	8501-18	Other ranks shoulder belt plate, 1st Herefordshire Local Militia c 1808	P	1012
	8501-19	Pair of silver maple leaves, 1944	G	1012
17 JAN	8501-20	2 colours: Regimental colour, 60th Royal American Regt c 1776; colour 2nd South Carolina Regt c 1776.	L	
	8501-21	Inns of Court OTC c 1910: officer's cap badge, pair of collar badges, 2½ pairs of shoulder titles, with 2 officers buttons, Yorkshire Hussars c 1900	G	1012

National Army Museum

29

ACCESSION BOOK

REGIMENT

Value	SOURCE (Donor or Lender and Address)	Location	REMARKS
6	7	8	
	War Office	uniform	
	,,	,,	
	Major C Sr J Wallis	,,	
	Major S. D Whetham	,,	
	Major J. O Spurway	,,	
£3333	~~Prescott Holdings Ltd~~	,,	Remitted as 8501-41 to 4 D.K. Smith
£170	Mrs B Pickup	,,	
	Mr. J. C Reid	,,	
£7000	Mr. J. R. Wood	,,	
	Mr. C. G. Williamson	,,	

may refer to tens, hundreds or thousands of specimens, as a result of which it may either include only a brief outline of the individual specimens or be restricted even further to a general description of the overall group (as with some entomological collections).

In the case of permanent acquisitions, the actual transfer of title of ownership may be formalised in various ways, such as correspondence between the museum and a donor (for example, a letter of acknowledgement) or a financial order from the museum to a seller. Either way may be complemented by a specific transfer form used for documentation purposes (such as the example in Figure 12).

The museum should ensure that formal acquisition procedures are used, and that these procedures are applied to all permanent acquisitions and long-term loans. The decision whether to combine or isolate the documentation for the two categories of acquisition will depend on factors such as historical precedent and the respective growth rates of the two categories.

As with the entry procedures, a documentation unit should be responsible for the overall management of the acquisition procedures, coordinating the work of the curatorial and support staff concerned with the development of the primary acquisition record, completion of transfer formalities and subsequent maintenance of files and monitoring the allocation of acquisition numbers.

The acquisition number should be noted within the preceding entry record and subsequent item records, on all acquisition files, associated management files (such as insurance, valuation and purchase files and on any committee minutes authorising the acquisition) and any conservation records or photographs of the group.

If the primary acquisition registers are manual documents, they should be kept in a secure fire-proof location under controlled access, with a duplicate copy (such as a microfiche) being stored outside the museum. If the main register details are automated, care should be taken to protect the master copy from corruption and unauthorised use, and duplicate copies should again be held outside the museum (at another installation with suitable facilities to be able to read the information in the event of the destruction of the master copy). The system procedural manuals should include guidelines concerning the staff approved to complete and amend the acquisition records. Major amendments (such as details of a transfer) should always be signed and dated, and accompanied by a reference to a committee minute.

The preliminary acquisition records, if used, should be developed for both curation and control purposes, being held in acquisition number order as a working outline of recent acquisitions. As the file might act as a suitable basis for subsequent post-acquisition and item records, it should conform to the overall data standards adopted by the museum. It may include far more curatorial information than is required within the formal acquisition records.

These manual or automated formal records have a more specific control-orientated function as the basic inventory statement of the scope of the collection. The entries within the register should be arranged in acquisition number order and limited to essential details about the acquisition, the depositor and the group. These details should be sufficient to demonstrate the acceptance of the group and any subsequent major changes, to act as an indication of the general location of the material and as a formal link between the entry, acquisition and item record numbers. Specific reference should be made to each important component item within the group, including a note of its item number (Section 5.6) and a brief description. The records should be supported by adequate title to the group, provided by details in its correspondence file and a transfer of title document, with appropriate statements of any conditions affecting the acquisition.

Information about the progress of the acquisitioning procedure should be noted within the entry record or, from preference, the preliminary acquisition record.

As at the entry stage, if large numbers of groups are being acquired it may be necessary to prepare manual or automated indexes or separate files to aid control. This is particularly important in the case of location details, which may need to be recorded in a separate location file during the period between the entry of the group and the cataloguing of its components (Section 6.1–6.17). The location information should be adequate to ensure the prompt tracing of the group and any of its component items during day-to-day collections management or periodic stockchecking (Section 8).

5.5 post-acquisition stage

The post-acquisition stage is concerned with the curation and control of groups after their formal acquisition and prior to the cataloguing of their components. The approach consists of initially developing the existing acquisition record (typically the full preliminary record with both curatorial and control information) by the addition of subordinate supplementary sub-records about the individual items within the group (Figure 13). The overall group record is, therefore, initially retained as the primary source of information about the material: it is only later that independent individual records are prepared for each discrete item in the group.

Although currently adopted by few museums, this approach can be an effective method of developing the basic acquisition details during the interregnum before detailed cataloguing. It can be particularly efficient within an automated system where there can be a direct continuum between the preliminary acquisition record, the post-acquisition record and the individual item records.

It may be worth-while considering the adoption of a post-acquisition approach, particularly if a preliminary acquisition record is being prepared or if there is a serious delay between the acquisition and individual cataloguing.

Figure 12. Transfer of title form (A4) (obverse and reverse)

Sheet 1 **of** 1	

DERBYSHIRE MUSEUM SERVICE
JOHN TURNER HOUSE
THE PARKWAY, DARLEY DALE
MATLOCK
DERBYSHIRE DE4 2FW

Institution transfer of title number
DERSR **Nº 0062**

DERBYSHIRE MUSEUM SERVICE

ACQUISITION

The museum gratefully acknowledges the acquisition into the collection of the items described below, from:

Mrs. M. Fox,
34 The Fleet,
Belper,
DERBY.

GROUP

These items have been acquired by: Derbyshire Museum Service Headquarters date 14th December 198

group number	initial/accession number	
0185	DERSR	

identity number	brief description	
1	Shawl with Florence Nightingale associations	
.2	Collection of related documents and press cuttings	
	to celebrate 150th Anniversary of Florence Nightingale's	
	birth.	
.3	Postal Cover - to celebrate 150th Anniversary of	
	Florence Nightingale's birth	

TRANSFER

In order to complete the transfer of title from you to the museum, we would be grateful if you could read the relevant notes overleaf and then sign this form. Please retain the first part of the form for your files and return the second part to the museum.

Museum officer: _Nimball_ date: 15 Dec 1984

Depositor: _M Fox_ date: 28.12 1984.

We recommend that you keep the first part of this form in a secure place. It would help the museum if it could be produced in the event of any query concerning the acquisition or the items.

TRANSFER OF TITLE
© Museum Documentation Association 1981 September 1981 MDA 019
Published by the MDA, Duxford Airfield, Duxford, Cambridgeshire, U.K.

Derbyshire Museum Service

TRANSFER OF TITLE

For items being acquired by the museum.

NOTES

The owner (or a depositor acting on behalf of the owner) transfers ownership of the item(s) specified overleaf to the museum, without conditions.

If the item(s) have been *donated*, the depositor confirms that they are given to the museum as an absolute and perpetual gift.

If the item(s) have been *purchased*, the depositor confirms that he or she was the absolute owner of the item(s) or had full power to sell the item(s), prior to the purchase.

If the item(s) are a *bequest*, the depositor confirms that their acquisition by the museum was at the wish of the deceased, and encloses a copy or extract of the relevant will and probate act.

MDA 019

Figure 13. Acquisition/post-acquisition form (A4) (obverse and reverse)

MUSEUM OF LONDON

A. ACCESSION RECORD

No. 84.250	/ 1-16

Recorder Anne Jones	Dept. Tudor & Stuart	Date March 1984

OBJECT Antiquities found between Southwark Bridge and Bull Wharf.	Period/date 16th/17th cent./18th century

DESCRIPTION class: material: form: decoration

.

.

.

.

.

.

.

dimensions: .

PRODUCTION method: maker: date: place

HISTORY use/collection/excavation

X-ref.: | Index |

REF.

ACQUISITION from: Peter Woon

gift ☑ bequest ☐
loan ☐ purchase ☐

price:

date:

Location	Neg.	Conservation	Notes
Register: object:	source:	locality:	association:

Museum of London

MUSEUM OF LONDON

ACCESSION RECORD (Group) No. 84.200 / 1-5

Recorder	Dept.	Date
Anne Jones	Tudor & Stuart	March 1984

Index

/no.	OBJECT: Period/date	DESCRIPTION PRODUCTION HISTORY
1.	Clock Face. 18th century.	Joy watch in hollow-cast pewter, badly squashed with a hole through centre, but it appears that the detail, such as it is, is on one side only. Apparant traces of Roman numerals around circumference of circle. Diam: 47mm x 52mm.
2.	Book Mount. Early 17th century.	Decorative brass hinged clasp for a book, with convoluted shape decorated with an etched design, and with the four rivet holes with grooved concentric circles. Dimensions: max: 42mm x 34mm.
3.	Boss. 17th century.	Decorative boss made from thin brass plate, circular with scalloped edge through which are punched 3 equally spaced holes; the centre rises into a flattened dome. Diam: 39mm. Diam. of centre: 18mm.
4.	Boss. 17th century.	Almost identical to /3, but dome not quite so flattened and less dented. Diam: 38mm. Diam of centre: 18mm.
5.	Boss. Early 16th century.	Bronze boss of thin metal with hole through centre which is very shallowly domed. Around edge is a worn decorative bond depicting human heads in profile within a circle, with flower and leaf design. Diam: 46mm. Very similar to 83.609, but less good condition.

73

5.6 item stage

The item stage is concerned with the detailed curation and continuing control of the individual components of the acquired groups in the collection. The curatorial operations involved in item documentation are often thought of as cataloguing. (The use of the item records to produce physical catalogues and indexes is considered as part of the subsequent output stage, described in Section 5.7). The individual item records may be partly derived from precursor acquisition or post-acquisition records, upon which they may depend for basic information such as previous ownership, object history and field collection details. Unlike the formal acquisition records which remain basically unchanged after their initial preparation, these item records are subject to long-term development to reflect the growing knowledge about the collection. This feature of the records must be supported by the manual and automated systems used to maintain the files.

Practical procedures may include the completion of master records concerning the items in permanent acquisitions or long-term loans (the records acting as an item inventory of the collection). Depending on the type of material being documented, these records may refer to individual items, or may be restricted to a selection of important items (as with type specimens in entomological collections) or to groups of items (as with bulk archaeological or natural science material).

Two approaches tend to be adopted when developing item documentation. The first (often referred to as registration) is to work on a subject or material basis, by allowing a number of similar objects to accumulate and then documenting them at the same time (such as a number of natural history specimens with closely-related taxonomy). The alternative approach is to deal with items on a chronological basis, according to their order of acquisition. In the former approach, items are often allocated registration numbers, which are independent of their earlier acquisition numbers; in the chronological approach, the item numbers are usually a direct subdivision of the earlier acquisition numbers. If independent registration numbers have been allocated, each item record must include a note of the earlier acquisition number, and the acquisition record must include details of all subordinate registration numbers.

In a manual system, the item record is usually noted in a bound register (Figure 14), on a record card or sheet (such as the example in Figure 15) or attached to the object itself (as with the labels or notes attached to herbarium and entomological specimens). This manual record may be used as a source for data entry into an automated system, or a direct data entry approach may be adopted, circumventing the manual recording stage by creating the record while at a computer input terminal. The resulting manual or automated records are usually held in item number order within a main file. They are typically prepared by permanent curatorial staff or temporary staff (such as a job creation team) working in individual departments or

Figure 14. Facing pages from an item register (Bristol Museums and Art Gallery)

Figure 15. Item record card (A5) (obverse and reverse)
Sheffield City Museum

Card 1	File		Institution : identity number	part of record
of 1			SHEFM: 1984.151	

IDENTIFICA-TION	simple name	full name or classified identification	XXXX	number of items
	teapot	ceramics & porcelain & Rockingham & teapot		

brief description

C Rockingham porcelain teapot, circular with low wide body flaring out to a wide shoulder, a figure seven handle, a curved spout and a domed lid, the whole having a white ground painted with pink, blue and gilt roses. **D** 1

DESCRIPTION part : aspect : description

whole: **material: porcelain**

body: **shape: circular & low & wide & flaring & (wide) shoulder**

handle: **shape : (figure) seven**

spout: **shape: curved**

whole: **colour: white & blue & pink & gilt**

whole: **surface treatment: painted**

decoration: **subject: roses & bands**

dimensions
height (with lid): 14.5cms diameter (at shoulder) : 16.5cms

C	completeness	part : condition	D
	complete	whole : good	

PRODUCTION	person's role : name		place	date 2
	manufacturer: Rockingham Works		Swinton & Rotherham	1826 (circa)

DESCRIPTION inscription type : method : position : description : transcription D

C

DECORATIVE ARTS B

© Museums Association 1979
Published by the MDAU, Duxford Airfield, Duxford, Cambridgeshire, U.K.

April 1979 MDA 011

PROCESS	type	method : operator : date : note	cross-reference D
C			

PROVENANCE	date : person's role : name : place : note		D
C	Apr 1984 : vendor : Bowden, B. Mr (Bryan): Carr House Rd 199 & Doncaster: Apr 1984 : purchaser : Sheffield Decorative and Fine Art Society : Carr House Rd 199 & Doncaster : £600 paid		

ACQUISITION	method	from	(branch of N.A.D.F.A.S.)	date D
	gift	Sheffield Decorative and Fine Art Society		18 Apr. 1984

VALUATION	grant-aided : note	price	conditions D	valuation : date	D	previous id. number D
	yes/no		yes/no	£600: Apr. 1984		

LOANS AND EXHIBITIONS	date : purpose : to : title : note	D
C		

ASSOCIATION	nature of association	concept	person	
C	date	place names	event	D

DOCUMEN-TATION	L	class	author : date : title : journal or publisher : volume : note	reference number
	1		Cox A. & Cox A : 1983: Rockingham Pottery and Porcelain 1745=1842: Faber and Faber: : fig 85 shows teapot of same shape.	
C	2.		Cox A. & Cox A : 1983 : Rockingham Pottery and Porcelain 1745=1842 : Faber and Faber : P224 fig. 51	

NOTES	notes
C	This teapot comes from the same service as 1984.150, a trio marked with an early version of the red griffin mark, which was probably discontinued soon after 1826.

LOCATION	storage location : date	recorder : date
		AB ; 5 Jun 1984

MDA 011

sections. The resulting records are usually stored within the department or section and are available for day-to-day use.

Individual item records should be developed and maintained for each significant item in the collection. All material not documented within an individual item record should be included within a convenient group record, so that there is a comprehensive coverage to some level of the whole collection. These records should be held in item number order and this number should be used to link related records in separate files (such as associated object, bibliographic, locality and conservation records). The records may initially be skeletal in form, including essential information to control the collection and preserve curatorial details which might otherwise be lost; the skeletal record can then be built up to a more acceptable comprehensive level as fuller curatorial details are accumulated. The record must conform to the overall museum data standards from the outset and the system must be able to support the required complexity of these standards.

The standards should be coordinated by a documentation unit in each department or, from preference, the museum as a whole. This unit should be able to train individual staff on the appropriate terminology control principles to follow when preparing a record, and support this training by reference to procedural manuals with full details of the required standards. Particular care must be taken to supervise the work of temporary staff. A primary responsibility of the coordinating unit should be to monitor the maintenance of the records after their intial preparation, by, firstly, encouraging staff to keep them up-to-date and, secondly, undertaking random checks of the content of key control categories, such as location.

A secure copy of the records should be held outside the department, preferably on microfiche or as a machine-readable file. Access to the records should be restricted to authorised persons unless confidential information is omitted and held in separate files.

One of the most important aspects of the item stage is the need for effective location control documentation (Section 6.13–6.17). Three types of approach to location control have tended to be adopted by museums. The first consists of noting location details within the main item record (as in Figure 15). The second method depends upon data in one or more categories in the main record acting as an indirect pointer to the location of the item within a systematically arranged store (such as a natural science collection being arranged taxonomically or geographically). The third method consists of maintaining a separate file with location details (Figure 16). This file can be held within the documentation area of the stores themselves.

If being used within a manual system, each of these methods has the limitation that the records are held in numerical order rather than location order: ideal when trying to locate a known item but inappropriate when checking the contents of a particular storage area. To circumvent this problem, some museums prepare store records, arranged in storage location

Figure 16. Location list (St. Albans Museums Service)

```
*id SABMS : 81.2557
*ident *sname unguent bottle
*store Ver & J2 : 10.4.1981
£
```

```
*id SABMS : 81.2568
*ident *sname bowl
*store Ver & R2 : 17.4.1981
£
```

```
*id SABMS : 81.2558
*ident *sname unguent bottle
*store Ver & J2 : 10.4.1981
£
```

```
*id SABMS : 81.2569
*ident *sname bowl
*store Ver & R2 : 17.4.1981
£
```

```
*id SABMS : 81.2559
*ident *sname dish
*store Ver & NN : 7.4.1981
£
```

```
*id SABMS : 81.2570
*ident *sname lid
*store Ver & S2 : 17.4.1981
£
```

```
*id SABMS : 81.2560
*ident *sname brooch
*store Ver & B1 : 9.4.1981
£
```

```
*id SABMS : 81.2571
*ident *sname jar
*store Ver & O1 : 17.4.1981
£
```

```
*id SABMS : 81.2561
*ident *sname jar
*store Ver & O1 : 16.4.1981
£
```

```
*id SABMS : 81.2572
*ident *sname jar
*store Ver & E : 17.4.1981
£
```

```
*id SABMS : 81.2562
*ident *sname beaker
*store Ver & P1 : 16.4.1981
£
```

```
*id SABMS : 81.2573
*ident *sname mortarium
*store Ver & S1 : 17.4.1981
£
```

```
*id SABMS : 81.2563
*ident *sname beaker
*store Ver & P1 : 16.4.1981
£
```

```
*id SABMS : 81.2574
*ident *sname mortarium
*store Ver & S1 : 17.4.1981
£
```

```
*id SABMS : 81.2564
*ident *sname beaker
*store Ver & P1 : 16.4.1981
£
```

```
*id SABMS : 81.2575
*ident *sname mortarium
*store Ver & S1 : 17.4.1981
£
```

```
*id SABMS : 81.2565
*ident *sname flagon
*store Ver & Q2 : 17.4.1981
£
```

```
*id SABMS : 81.2576
*ident *sname beaker
*store Ver & Y : 17.4.1981
£
```

```
*id SABMS : 81.2566
*ident *sname flagon
*store Ver & Q2 : 17.4.1981
£
```

```
*id SABMS : 81.2577
*ident *sname beaker
*store Ver & E : 17.4.1981
£
```

```
*id SABMS : 81.2567
*ident *sname beaker
*store Ver & A : 17.4.1981
£
```

```
*id SABMS : 81.2578
*ident *sname beaker
*store Ver & P1 : 17.4.1981
£
```

order, in addition to the numerical sequence (Figure 17). These are typically held within the store itself.

Maintenance is a crucial factor affecting the long-term value of a location control mechanism. While major changes of location may be noted in the records, minor or short-term changes within a department are often controlled by movement control mechanisms such as by placing a store tag in the temporarily vacated position of the item.

Figure 17. Store list (Wiltshire Library and Museum Service)

```
STORE LIST

        STOCK CHECK: name: date: notes and action
                  MN : 2.7.1985 : Re-packed

MEREM      box 7
           1977.7          TRADE - glovemaker          skiving knife
           1977.8          TRADE - glovemaker          glove knife
           1977.9          TRADE - glovemaker          glove knife
           1977.10         TRADE - glovemaker          fourchette cutter
           1977.11         TRADE - glovemaker          shears
           1977.12         TRADE - glovemaker          measure stick
```

5.7 output stage

The output stage is concerned with the utilisation of the curatorial aspects of entry, acquisition and item documentation to produce products such as catalogues and indexes and to answer specific information retrieval requests. If the entry, acquisition and item records are in numerical order, it is the output products that act as directories to these records, helping the user to gain access to the information which they contain. The need for these outputs is often cited as one of the main reasons for a change of documentation procedures, such as the improvement of the quality of item records or the automation of item information.

They can be produced using both manual and automated techniques. In either case, the preparation of each new output (such as another index) is an additional exercise which involves the rearrangement and reproduction of the item records. Within a manual system, this task falls on the staff who are responsible for time-consuming work such as the reproduction and re-ordering of entries and proofreading their contents; within an automated system, it should be the system itself that does the rearranging and reproduction, with the minimum of staff intervention, other than the issuing of instructions. In view of these advantages of automation, a number of museums are now developing automated files as a basis for future output.

The distinction between the terms catalogue and index is primarily one of convenience and convention. A collection catalogue is usually a self-contained and comprehensive arrangement of the item records, typically including one entry for each record, in numerical, subject or artist order. An index tends to be a directory with briefer entries, typically including more

than one for each record, guiding the user to the relevant details in a catalogue.

One approach to the preparation of a collection catalogue is for the item records themselves or a copy of them to act in this capacity (see Figures 15 and 18). Another approach is for the item records to form the nucleus of a collection catalogue, within which they become subsumed, with the addition of extra interpretative and illustrative information. Alternatively, the museum may maintain concise catalogues, more analogous to an index, with basic information about the items in the collections (Figure 19). Any of these catalogues may be either comprehensive or selective in their coverage. Comprehensive catalogues of a whole collection are now rare; selective catalogues (such as those on a subject, material, permanent display, special exhibition or significant items basis) continue to be an aim of many curators.

Selective indexes are also more common than comprehensive versions, relating to a particular collection or department. The particular indexes developed by a department will depend upon its subject coverage and user requirements. They may be simple re-orderings of the information from one category in the main records (Figure 20) or more complex statements based on the permutation of the information in a number of different categories (Figure 21) (MDA, 1981b). One of the features of an automated system with good catalogue and index production facilities is its ability to display information in a variety of ways for different purposes and users. Facilities range from the inclusion or omission of any data category, the re-ordering of categories, to the manipulation of the data content of individual categories. These results can be displayed on index cards for incorporation within a manual file, on paper, on computer output microfiche (COM) or as computer typeset documents. They can also be held in machine-readable form, suitable for incorporation with other sequences to produce combined catalogues and indexes either within the museum or on a broader co-operative basis.

One role of manually-produced or computer-produced printed indexes is as a basis for information retrieval. When asking a specific question, the user is able to scan through the entries to identify items of interest. If the information is held in machine-readable form, an automated system can carry out the same procedure during either a sequential or interactive search (Appendix C). The sequential search approach involves scanning through a file of main records or index entries. The interactive search approach uses direct access inverted index files to permit rapid retrieval, with the aid of one of the output dialogue methods discussed earlier (Section 4.9).

With either a manual or automated system, the main files can also be used as the basis for a range of other specialised outputs, such as acquisition lists (for distribution to users or for incorporation in reports) and object labels to be used within the stores or on display.

Effort should be concentrated on the development of the main files in a form suitable as a basis for the straightforward production of the required

Figure 18. Full entries in a collection catalogue
Tyne and Wear County Council Museums

TYNE AND WEAR COUNTY MUSEUMS SERVICE GEOLOGICAL COLLECTIONS
 Catalogue Listing Page 141

TWCMS: C1862

identification: fossil, ammonite, Mollusca Ammonoidea <u>Aegasteroceras</u>
<u>sagittarium</u>, current, Old, J.M. Dr, February 1953.

Field collection: Robin Hood's Bay, North Yorkshire, NGR, NZ 953056, zone:
Obtusum Zone; complex: Lias (Lower), Sinemurian; age: Jurassic (Lower),
(between Mill Beck and Stoupe Beck).
Old, J.M. Dr, February 1953.

acquisition: bequest (previously on loan from November 1962), Old, J.M. Dr
(7 Silksworth Lane, Sunderland), November 1984.

previous id. number: Sunderland Museum 103' 1962.

description: 1, hand specimen, fair, incomplete.

recorder: Brooks, G.L., 24 January 1978.

notes: Dr Old No. 53.2.24.
 --**--

TWCMS: C1863

identification: fossil, ammonite, Mollusca Ammonoidea <u>Leptechioceras</u> sp.,
current, Old, J.M. Dr, February 1953.

field collection: Robin Hood's Bay, North Yorkshire, NGR, NZ 953056, zone:
Raricostatum Zone, Macdonnelli Subzone; complex: Lias (Lower), Sinemurian;
age: Jurassic (Lower).
Old, J.M. Dr, February 1953.

acquisition: bequest (previously on loan from November 1962), Old, J.M. Dr
(7 Silkworth Lane, Sunderland), November 1984.

previous id. number: Sunderland Musleum 103' 1962.

description: 3, hand specimen, fair, incomplete.

recorder: Brooks, G.L., 24 January 1978.

notes: Dr Old No. 53.2.25/26/27.
 --**--

TWCMS: C1864.

identification: fossil, ammonite, Mollusca Ammonoidea ?<u>Arnioceras</u> sp.,
current, Brooks, G.L., 16 January 1978,
see ref: 1.

field collection: Redcar, Cleveland, NGR, NZ 610250, complex: Lias (Lower),
Sinemurian; age: Jurassic (Lower).
loose, Old, J.M. Dr, February 1953.

Figure 19. Limited entries in a concise catalogue
National Galleries of Scotland

2281 **Toledo**
pencil, chalk, ink on paper, 36 x 46.5
inscr
bought, 1980

2510 **Castle of the Scaligeri (d1931)**
pencil on paper, 25.3 x 33
sig inscr
bought, 1982

2511 **Road with Farm**
pencil on paper, 21 x 25.5
bought, 1982

2512 **Farm near Edinburgh (Study for GMA 2252)**
pencil on paper, 17.2 x 22.4
bought, 1982

2513 **The Road to Gubbio**
pencil on paper, 36 x 50.2
inscr
bought, 1982

2514 **Provins**
pencil on paper, 15.7 x 19.2
inscr
bought, 1982

2515 **French (?) Hill Town**
pencil on paper, 14.2 x 18.8
bought, 1982

2516 **Granada**
ink, pencil on paper, 16.8 x 53
inscr
bought, 1982

2526 **Dedicatory Window for Unidentified Church**
ink, watercolour, gouache on card, 45 x 23.5
inscr
bought, 1982

2527 **Window for Brechin Cathedral (Abraham, Adam and Isaac)**
pencil, watercolour, ink, gouache, crayon on paper, 30 x 17.8
bought, 1982

2528 **Window for St. Salvator's St Andrews**
pencil, watercolour, ink, gouache, crayon on paper, 54 x 30.7
bought, 1982

2529 **War Memorial Window for St. Mary's, Biggar**
pencil, watercolour, ink, gouache on paper, 16.5 x 8.5
bought, 1982

2530 **Memorial Window to Christina Steele Mack, Fairmilehead Parish Church**
pencil, watercolour, ink, gouache on paper, 33.5 x 8.8
inscr
bought, 1982

2531 **Baptistry Window for Roman Catholic Church, Bathgate**
pencil, watercolour, ink, gouache, crayon on paper, 53.6 x 6.3
inscr
bought, 1982

2532 **Three Pairs of Lights for Unidentified Church**
pencil, watercolour, ink, gouache on paper, each 13.5 x 15.1
inscr
bought, 1982

2533 **Window for St. Andrews Church, Tain**
pencil, watercolour, ink, gouache on paper, 36.5 x 35.5
inscr
bought, 1982

2534 **Two Lights, David of Scotland and Margaret, for Unidentified Church**
pencil, watercolour, ink, gouache on paper, each 12.7 x 5.1
inscr
bought, 1982

2535 **Three Double Lights for the Convent Chapel of Marie Reparatrice, Elie**
pencil, watercolour, ink, gouache on paper, each 9 x 10
bought, 1982

2536 **Nec Tamen Consumebatur (design with burning bush and fishermen for unidentified window)**
gouache, watercolour, ink on paper, 77.7 x 7.2
bought, 1982

2537 **St Mungo, Single Light for Brechin Cathedral**
chalk, gouache, watercolour, ink on paper, 90 x 53
sig
bought, 1982

2538 **Stained Glass Design for an Unidentified Music Room**
pencil, chalk, ink, watercolour, gouache on paper, 82 x 57.5
sig
bought, 1982

2774 **San Simone, Venice**
watercolour, ink, crayon on paper, 50.2 x 65
sig
bequeathed by Alan F. Stark, 1983

WITORSKI, Janusz, 1939-, Polish

2239 **Atelier 72 (1972)**
paper collage, ink on paper, 70 x 49.7
sig
bought, 1980

WOOD, Christopher, 1901-1930, British (English)

1637 **Cumberland Landscape**
pencil on paper, 25.5 x 35.5
inscr
given by H.S. Ede, 1977

1638 **Portrait of Mille, Bourgoint**
pencil on paper, 53 x 42
given by H.S. Ede, 1977

1639 **Study of Male Nude From Behind**
pencil on paper, 42 x 29
given by H.S. Ede, 1977

1640 **Studies of Female Nude**
pencil on paper, 42 x 29
given by H.S. Ede, 1977

1712 **Boy in a Bedroom (1930)**
oil on canvas, 54.5 x 65
bought, 1978

Figure 20. Checking index: classified identification
Tyne and Wear County Council Museums

TYNE AND WEAR COUNTY MUSEUMS SERVICE GEOLOGICAL COLLECTIONS
Classified Identification Index 1 Page 2

Brachiopoda Articulata Tetrarhynchia sp.
 TWCMS: C4054
 Staithes, North Yorkshire, NGR, NZ 782185, zone:
 Spinatum Zone; complex: Lias (Middle), Pliensbachian
 (Upper); age: Jurassic (Lower).
 TWCMS: C4055
 Saltburn, Cleveland, NGR, NZ 667216, zone: Spinatum
 Zone; complex: Lias (Middle), Pliensbachian (Upper);
 age: Jurassic (Lower).
 TWCMS: C4056
 Saltburn, Cleveland, NGR, NZ 667216, zone:
 Margaritatus Zone; complex: Lias (Middle),
 Pliensbachian (Upper); age: Jurassic (Lower).

Brachiopoda Articulata Tetrarhynchia tetrahedra
 TWCMS: C4052
 Saltburn, Cleveland, NGR, NZ 667216, zone: Spinatum
 Zone; complex: Lias (Middle), Pliensbachian (Upper);
 age: Jurassic (Lower).
 TWCMS: C4053
 Straithes, North Yorkshire, NGR, NZ 782185, zone:
 ?Spinatum Zone; complex: Lias (Middle), Pliensbachian
 (Upper); age: Jurassic (Lower).
 TWCMS: C4057
 Slapewatt, Guisborough, Cleveland, NGR, NZ 638159,
 zone: Spinatum Zone; complex: Lias (Middle),
 Pliensbachian (Upper); age: Jurassic (Lower).

Coelenterata Scleractinia Oppelismilia mucronata
 TWCMS: C3993
 Redcar, Cleveland, NGR, NZ 610250, complex: Lias
 (Lower); age: Jurassic (Lower).

Echinodermata Crinoidea Pentacrinites sp.
 TWCMS: C2575
 Redcar, Cleveland, NGR, NZ 610250, complex: Lias
 (Lower); age: Jurassic (Lower).
 TWCMS: C4074
 East Scar (east of), Redcar, Cleveland, NGR, NZ
 610250, complex: Lias (Lower); age: Jurassic (Lower).

Mollusca Ammonoidea Aegasteroceras sagittarium
 TWCMS: B11653
 Robin Hood's Bay, North Yorkshire, NGR, NZ 953056,
 zone: Obtusum Zone; complex: Lias (Lower),
 Sinemurian; age: Jurassic (Lower).
 TWCMS: B11960
 Robin Hood's Bay, North Yorkshire, NGR, NZ 953056,
 zone; Obtusum Zone; complex: Lias (Lower)
 Sinemurian; age: Jurassic (Lower).

Figure 21. Complex production index: stratigraphy
Tyne and Wear County Council Museums

TYNE AND WEAR COUNTY MUSEUMS SERVICE GEOLOGICAL COLLECTIONS
 Stratigraphical index (hierarchical) 4 Page 8

(Jurassic (Lower))
 (Lias (Lower))
 (Pliensbachian (Lower))
 (Davoei Zone)
 Mollusca Ammonoidea <u>Lytoceras</u> sp.
 TWCMS: B11687
 Mollusca Ammonoidea <u>Oistoceras figulinum</u>
 TWCMS: B9203; B9229; B9250; B11660; B11662; B11665;
 B11667; B11669
 Mollusca Ammonoidea <u>Oistoceras</u> sp.
 TWCMS: B9206; B11661; B11674
 Mollusca Bivalvia <u>Bakevellia</u> sp.
 TWCMS: C3799
 Figulinum Subzone
 Brachiopods Articulata <u>Tetrarhynchia</u>
 <u>dunrobinensis</u>
 TWCMS: C4051
 Brachiopoda Articulata <u>Tetrarhynchia</u> sp.
 TWCMS: C3998
 Mollusca Ammonoidea <u>Oistoceras figulinum</u>
 TWCMS: B11666; B11668
 Mollusca Ammonoidea <u>Oistoceras</u> sp.
 TWCMS: B6603; B11961; B11976; B11996; C1345; C1973
 Mollusca Bivalvia <u>Entolium</u> sp.
 TWCMS: C3970
 Mollusca Bivalvia <u>Placonopsis numismalis</u>
 TWCMS: C3953
 Mollusca Bivalvia <u>Pleuromya</u> sp.
 TWCMS: C3800
 Maculatum Subzone
 Mollusca Ammonoidea <u>Androgynoceras</u> sp.
 TWCMS: B6615; C1959; C1972; C2508
 Mollusca Ammonoidea <u>Liparaceras</u> sp.
 TWCMS: C2522
 ?Ibex Zone
 Mollusca Ammonoidea <u>Lytoceras</u> sp.
 TWCMS: B6616
 Jamesoni Zone
 Brachiopoda Articulata <u>Tetrarhynchia</u> cf.
 <u>dunrobinensis</u>
 TWCMS: C3996 to 3997
 Mollusca Ammonoidea <u>Lytoceras</u> sp.
 TWCMS: B11993
 Mollusca Ammonoidea ?<u>Metoxynoticeras</u> sp.
 TWCMS: C2520
 Mollusca Ammonoidea <u>Microderoceras</u> sp.
 TWCMS: B9201
 Mollusca Ammonoidea <u>Parinodiceras</u> sp.
 TWCMS: C2523
 Mollusca Ammonoidea <u>Platypleuroceras</u> sp.
 TWCMS: B11659: C2489; C2501

outputs. The documentation unit should be responsible for the standard of these records and the support of the systems used to produce the outputs. The records themselves should be arranged and maintained so that they are an appropriate source for catalogues and indexes. The system must include facilities commensurate with the output requirements, such as adequate catalogue and index production or information retrieval capabilities.

5.8 exit stage

The exit stage is concerned with the control of material leaving the museum or an individual department, on a temporary or permanent basis (such as during the movement of an item to a conservation department, a loan of an object to another museum or a bibliographic item to an individual, a permanent transfer between departments or to another museum, or the loss or disposal of an item).

Practical procedures adopted by many museums include using a movement control procedure to monitor temporary inter-departmental moves; controlling external loans by means of a separate loans or circulation control procedure; and formalising inter-departmental or inter-museum transfers and any losses or disposals by annotating the relevant acquisition and item records. These procedures are usually strictly supervised, in contrast to the less formal short-term movements of material within an individual department.

Formal movement control procedures should be introduced, in addition to procedures adopted for the short-term movement of items within a department (Section 5.6). These should include the use of a movement form. The documentation unit should be responsible for monitoring these movements and ensuring the return of items to their host department.

Loans of objects out of the collection are often preceded by a clarification of the acceptability of the recipient, the suitability of the item as a loan and appropriate insurance or indemnification arrangements. If approved, the loan itself may be noted in a register and accompanied by a multi-part exit or loan form (such as the example in Figure 22), with details of the items themselves, of the loan and borrower and of subsequent action to be taken to monitor the loan. This can act as a formal statement of the loan for both the museum and the recipient, as an approval for the departure of the item and as a mechanism for controlling the loan and ensuring its eventual renewal or return.

The loan and its documentation should be assigned an exit number; one set of the completed loan forms should be kept in numerical order indefinitely, as a formal log of the operations. Details of the loan should be incorporated within the item record, either by adding the exit number or by a fuller reference to the loan itself (as in the case of temporary exhibitions). This number can also be used as a means of linking the loan details to any related management files, such as information about security or insurance

Figure 22. Exit form (A4) (obverse and reverse)

Area Museums Service for South Eastern England

EXIT FORM

For items being removed from the museum's permanent collection.

CONDITIONS

General

Except in the case of disposal, the recipient of the item(s) described overleaf undertakes to take the same care and precautions for the safe custody of these item(s) as would be applied if they remained within the museum's permanent collection.

Except in the case of disposal or where noted overleaf, it is the recipient's responsibility to return the item(s) described overleaf by the agreed return date.

Two parts of this form will be given to the remover together with the item(s). Both parts should be signed by the recipient as an acknowledgement of receipt. The second should then be returned to the museum.

If the item(s) are returned by the recipient, they should be accompanied by the top part of the form. Both this part and the second (museum) part will then be signed by a museum officer in recognition of having received the item(s) back in satisfactory condition (subject to later detailed examination).

If it has been agreed and noted overleaf that the item(s) are to be retrieved by the museum, the collector will be accompanied by the second (museum) part of the form. Again, both parts will be signed by the museum officer, in recognition of having received the item(s) back in satisfactory condition (subject to detailed examination on returning to the museum).

In both circumstances, the original recipient and the museum will retain their respective parts of the form for future reference.

Special conditions

MDA 018

arrangements. The documentation unit should be responsible for coordinating these aspects.

Circulation control procedures for bibliographic items should include appropriate charging, discharging and overdue control mechanisms.

Permanent transfer arrangements between departments or to another museum usually include the authorisation of the transfer by the director or trustees. This must be confirmed in the central and departmental acquisition and item records and any separate inventory control files by an annotation including a note of the relevant formal papers or committee minutes and details of the recipient department or museum. The annotated original acquisition records must be retained indefinitely by the donor department.

If the change is an internal transfer, the recipient department should ensure that it can trace the item back to the original acquisition and inventory records, should include details of the item within its own acquisition records, take responsibility for the item records and include a reference to the item within its own inventory and location control system.

In the case of a loss or disposal, the relevant authorisation procedure should be implemented, after which the central and departmental acquisition and item records should be annotated and then retained indefinitely.

In either a transfer or a loss or disposal case, care must be taken to ensure that any retained catalogue or index entries are either annotated or removed. The acquisition and item numbers assigned to the material should not be reused by the 'donor' department.

5.9 conservation documentation

Conservation details about technical examination and conservation of the physical collections may be held as a separate specialised main file, supplementary to the primary record sequence (Figure 23). They may be concerned with acquisitions (both object and non-object) or with items held by outside institutions but submitted to the museum for processing.

If redesigning the system, it is recommended that these records are held in a separate conservation number sequence, linked to the main files by means of the main record numbers (for example, an examination carried out prior to the acquisition of an item should refer to the entry and acquisition records for that item and vice versa). The records should conform to the overall collection data standards, which should be extended to include specific conservation details. These records should serve both control and curation functions: for control by including details of the progress of the conservation work (such as dates and financial information); for curation, by including additional details about the item itself (such as structural and descriptive information). They should be linked to any separate photograph records and to management files such as files concerning charging for work done for outside institutions).

Items should be traced during movements to and from the conservation

Figure 23. Conservation record card (A5) (obverse and reverse)
Ashmolean Museum, Oxford

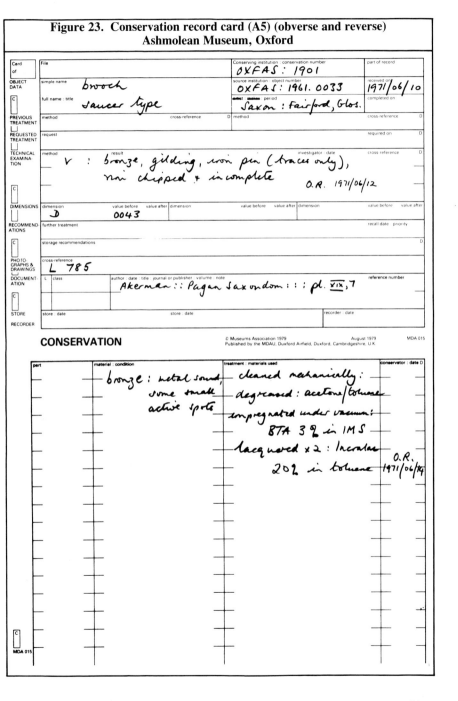

Card of	File		Conserving institution : conservation number OXFAS : 1901		part of record	
OBJECT DATA	simple name *brooch*		source institution : object number OXFAS : 1961. 0033		received on 1971/06/10	
C	full name : title *saucer type*		artist : maker : period *Saxon : Fairford, Glos.*		completed on	
PREVIOUS TREATMENT	method	cross-reference	D	method	cross-reference D	
REQUESTED TREATMENT	request				required on D	
TECHNICAL EXAMINA-TION	method *V : bronze, gilding, iron pin (traces only), rim chipped + incomplete*	result		investigator : date *O.R. 1971/06/12*	cross-reference D	
C						
DIMENSIONS	dimension *D*	value before value after *0043*	dimension	value before value after	dimension	value before value after
RECOMMEND-ATIONS	further treatment				recall date : priority	
C	storage recommendations				D	
PHOTO-GRAPHS & DRAWINGS	cross-reference *L 785*					
DOCUMENT-ATION	L class *Akerman : : Pagan Saxondom : : : pl. xix, 7*		author : date : title : journal or publisher : volume : note		reference number	
C						
STORE	store : date		store : date		recorder : date	
RECORDER						

CONSERVATION

© Museums Association 1979 August 1979 MDA 015
Published by the MDAU, Duxford Airfield, Duxford, Cambridgeshire, U.K.

part	material : condition	treatment : materials used	conservator : date D
	bronze : metal sound, some small active spots	*cleaned mechanically : degreased : acetone/toluene impregnated under vacuum : BTA 3% in IMS lacquered x2 : Incralac 20% in toluene*	*O.R. 1971/06/14*

C
MDA 015

department and while in the conservation department itself by the application of the movement control systems.

One person within the conservation department should be responsible for maintaining the information management procedures and liaising with the documentation coordinators within collection-holding departments.

5.10 record photograph documentation

Record photographs of items in the collection may be held for a variety of purposes including security, insurance, stocktaking, to complement the written descriptions of items and their conservation and for sale to the public. They may be arranged in item number order or in a specific photograph sequence. In the latter case, it is essential that there is a link between these photographs and the main records. It may be necessary to build up separate records about the photographs, referring to their production details. If used for security, insurance or stocktaking purposes, the image should incorporate details of the item's record number and the date of photography.

5.11 collection-group documentation

Records may also be held about convenient groupings of items (such as particular collections) which may be distinct from the acquisition group records. For example, the Federation for Natural Sciences Collection Research has been promoting the development of regional catalogues of natural science collections in museums (Figure 24) (Hancock and Pettitt, 1981; Pettitt and Hancock, 1981; Pettitt, 1985) and individual museums have been carrying out general surveys of the material which they hold.

The latter exercise can be particularly useful in a museum with large natural science collections involved in a rapid collections inventory for basic audit and control purposes, where the speedy development of individual item records would be impractical (Section 6.21).

If considering such an approach, the individual collections should be stored in one area; be of manageable size; be meaningful to the user of the museum; and be uniform in terms of internal characteristics and storage, security, conservation and curation requirements. The records should be compatible with the data and terminology standards adopted for the primary item files.

5.12 locality documentation

Locality details about places of interest to the museum may be based upon the collection localities of items within the institution or upon separate field work (Association of County Archaeological Officers, 1978; Cooper *et al*, 1980; Flood and Perring, 1978; MDA, 1981b; Stanley, 1984; Stansfield, 1984; Stewart, 1980a; 1980b). Typical procedures include the development of a primary locality record (Figure 25), a supplementary file (with

**Figure 24. Natural science collection research form (A4)
(obverse only) Sheffield City Museum**

COLLECTION RESEARCH – DATA CODING FORM (C)　　　UPDATE ENTRY

IMPORTANT: Please consult notes on the reverse
before completing this form　　　LIT REF ONLY

1	4	6

1	COLL	Salt, Jonathan (1759-1815) (of Sheffield)
2	SUBJ	Lichens (herbarium sheets; some in folders)
3	GEOG	British Isles (mainly Derbyshire and Yorkshire); Europe (a few specimens only)
4	PERI	1795-1807
5	NUMB	86
6	ASSN	Dr. Younge (reference in Desmond, R. 1977)
7	LOCN	
8	ACQN	donated 1877 (by Sheffield Literary and Philosophical Society)
9	MSSM	
10	LREF	Hawksworth, D. L. 1967. Lichens collected by Jonathan Salt between 1795 and 1807 now in the herbarium of Sheffield Museum. *The Naturalist*, no. 901, 47-50
11	BIOG	
12	MUSE	SHEFM
13	NMCO	T.H. Riley　　date 20 Oct. 1981
14	ADDN	Specimens re-determined by Hawksworth et al. (ca. 1966). Includes several species now extinct in Derbyshire and several species new to the Derbyshire and Yorkshire lists of Watson, (1946; 1953)
15	CLAS	B2, t, B7
16	OCOD	CBIB, t, XNDER, t, XNYOR, t, BEUX
17	IDEN	8141 /H

Figure 25. Geology locality record sheet (A4) (obverse and reverse)

Sheet of	File		Institution DBYMU
	Filing number		Locality number 42701

IDENTI-FICATION

Locality name **Duckmanton Railway Cutting**		

Parish Calow * Sutton cum Duckmanton	district North East Derbyshire	county Derbyshire

Other geopolitical division Chesterfield Rural District (pre 1974)	region

NGR SK 42387039	accuracy centred	Status : date (Grade 1) SSSI * CTR

Field recorder : date Stanley, M.F., Mr : 19.6.1977	field recorder : date

C

Museum recorder : date Stanley, M.F., Mr : 1.12.1977	Record type : method primary : fieldwork secondary : Literature search

DESCRIP-TION

Type of locality railway cutting * disused	main extraction product

Condition of locality : date
overgrown (4 exposures at present but 5 sections will be cleared) : 19.6.1977

length 500m	width 40m=60m	height 9m=12m	depth 15m	area −

Non-geological interests
botanical (survey to be carried out in 1978)

General description of locality	Type locality Stratotype * International boundary * Westphalian B

A disused, deep railway cutting with measures exposed over some 500m including the Clay Cross Marine Band and 5 coal seams separated by shales, ironstones, mudstones, siltstones and sandstones. The base of Westphalian B (Clay Cross M.B.=Anthracoceratites vanderbeckei M.B.) and 75 metres of Westphalian A are exposed west of the bridge. 50m of Westphalian B are exposed east of the bridge. Dip is 20deg E.N.E.

C

Stratigraphy
Carboniferous, Upper * Westphalian A * Coal Measures, Lower;
Carboniferous, Upper * Westphalian B * Coal Measures, Middle * Clay Cross M.B.

Petrology
Deep Hard Coal * Sitwell Coal * Chavery Coal * Clay Cross M.B. (all west of bridge) * 2nd Ell Coal * 1st Ell Coal (east of bridge)

Mineralogy

Palaeontology Foraminifera * ostracods * brachiopods * bivalves (forams, ostracods and bivalves all from Clay Cross M.B.) * Anthracosia regularis (in roof of Chavery Coal) * A.ovum * A.phrygiana (both of 1st Ell Coal)

Structure
cone-in-cone above Chavery coal

Relationships

Geomorphology

C

Palaeoenvironment non-marine and marine faunas

HISTORY

General history of locality

C

GEOLOGY LOCALITY
A4 SUMMARY RECORD

© GCG & Museums Association, 1977 First edition, June 1977
Published by the MDAU, Duxford Airfield, Duxford, Cambridgeshire U.K.

Derby Museums and Art Gallery

MANAGEMENT

Planning authority | Planning status

Conservation status : date : note
(Grade 1) SSSI

Management body
Derbyshire Naturalist's Trust (Estate Office, Twyford, Barrow-on-Trent, Derbys. DE7 H1J)

Owner
Derbyshire Naturalists Trust (DNT)

Tenant/occupier

Development rights owner

ACCESS [C]

Restrictions
by permit only from Conservation Officer (DNT)

Category: private

approach route: entrance on south side of cutting on Deepsick Lane (off A632), over stile and down steps

USE [C]

Facilities: car parking on both sides (wide grass verge) of road by the bridge

Present use: geological nature reserve : opened 19.6.1977

Potential use (general)

Potential use (educational)

grade

Threats to locality

next appraisal date

VISITS [C]

Reason : opening of reserve visitors : date members of Derbyshire Naturalists Trust : 10.6.1977

INTERESTED PEOPLE [C]

Role: researcher person's name : date Calver, M.A. (I.G.S., Ring Road, Halton, Leeds) : 1971 onwards

DOCUMENTS & COLLECTIONS

Maps — date : publisher : sheet : scale : notes
: IGS : SK47 SW : 1 in 10560

Transparency numbers | Negative and print numbers

Plans/diagrams — date : publisher : notes
June 1977 : Owen, B. (IGS Leeds) : logged section of west side of bridge in locality file

Microforms

References [C]

Class | Author : date : title : journal or publisher : volume : notes | Collections
described | Rhys, G.H. et al : 1967 : Geology of country around Chesterfield : H.M.S.O. : : p155 and 160 |
described | Anon : 1978 : The W.H. Wilcockson Nature Reserve Duckmanton Railway Cutting Geological Trail : Derbyshire Naturalists Trust : 16pp |

correspondence, field notes, etc.) and plotting of localities on maps. The work may be coordinated by staff working in an environmental record centre based within the museum or at an outside agency (such as a county planning department).

If locality records are held within the museum, the system should include full provision for their development and maintenance, security and use, ensuring that there is a link between these records and the item files. The locality details should be held in locality number order. If held outside the museum, the item records should include pointers to these external files. In either case, the standards adopted should be compatible with those of the main item records.

5.13 information documentation

The museum may also hold a range of other types of files concerned with information supporting the main collections.

For example, information about people and organisations ('corporate bodies') of curatorial interest to the museum may be preserved within separate record sequences (Gorman and Winkler, 1978). Biographical files may be concerned with people associated with the collections themselves (previous owners, donors, collectors, artists, etc.) or of more general historical interest to the museum (local dignitaries, etc.). Corporate body files may be concerned with museums or craft centres within a county or region, or with organisations of general historical interest (local firms, etc.) (Norgate, 1982). If developing such files, the museum should be aware of the impact of data protection legislation and take steps to preserve the confidentiality of the information. Care should be taken to ensure there is no confusion between the curatorial role of these records and the distinct management role of internal personnel records.

Separate records may also be held of events or activities of interest to the museum (such as military campaigns and agricultural, industrial or social activities). In each case, these records should be linked to item records to which they are related and should conform to any relevant data and terminology standards.

Similarly, authority or thesaurus control records may be maintained as a means of checking the information being incorporated in main files (such as an object name thesaurus) (Orna, 1983). Reference should be made to these control records and the other information records when preparing the main item files.

5.14 related procedures

A number of references have been made to the need for the information management procedures to be integrated with management control, word processing and analytical research procedures. While it might be inappropriate for any of these procedures to be developed exclusively

because of documentation requirements, the need for their effective support must be taken into account when redesigning the overall documentation system. This is particularly important if the museum is considering automating any of its activities.

Management control facilities of relevance to documentation include the maintenance of committee minutes (with references to acquisition, transfer and disposal decisions); the organisation of general museum files (such as correspondence files); financial control (such as details of the purchase of items for incorporation within the collection and expenditure on documentation consumables and equipment); insurance or indemnity arrangements (affected by the valuation of items in the collection); and progress control (such as prompting the retrieval from the museum of an enquiry, monitoring the progress of the documentation of an item after its initial acquisition and bringing forward to the attention of staff the need to request the return of an overdue loan) (National Assembly of State Arts Agencies, 1981; Williams, 1982).

Word processing facilities include mechanisms for the input of text into an automated system and its subsequent output in various formats including reports, procedural manuals, publications, mailing lists, record cards, record forms and letters (Meadows, 1980; National Assembly of State Arts Agencies, 1981; Oakeshott and Meadows, 1981; Williams, 1982).

Analytical research facilities include mechanisms for the manipulation of data held within the information management system (such as statistical analysis of archaeological finds or natural science specimens and of record or data category sizes) and the provision of data from the management control system relevant to the development of documentation (such as statistical analyses of collection growth) (Clarke, 1978; Cutbill, 1971; Doran and Hodson, 1975; Orton, 1980).

6:
Control and curation documentation

The importance of the development of documentation for collections control and item curation purposes is reviewed in Section 6.

Inventory and location control documentation

6.1 inventory and location control

The discussion of information management procedures referred to the importance of inventory and location control documentation (Figure 26).

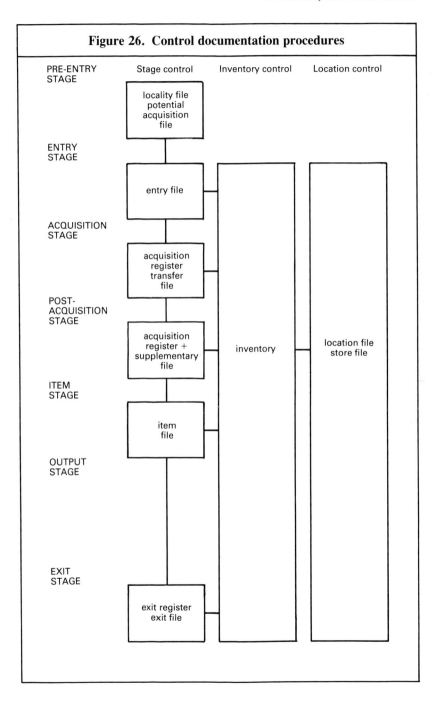

Figure 26. Control documentation procedures

Inventory control is concerned with the development and maintenance of a comprehensive numerically ordered inventory of the collections in the care of the museum, as an essential basis for their management, use and detailed cataloguing.

Location control is concerned with the maintenance of methods for tracking the location and movements of these collections while they are within the museum and during temporary absences at other institutions, providing a link between the inventory and the collections themselves.

Inventorying is the process of developing inventory and location records at the time of acceptance of a collection or when reprocessing an inadequately documented collection. (The retrospective inventorying procedures that can be adopted in the latter case are considered in Section 7.)

The internal documentation and collections audit programmes discussed later (Section 8) are a means of verifying the maintenance of inventory and location control and item curation procedures, checking the existence of items within the museum (using the control records as a guide) and demonstrating accountability to outside authorities. These operations are often termed 'stocktaking' or, confusingly, 'inventorying' or a 'collections inventory'.

A number of museums in both the United Kingdom and North America have introduced new control procedures or been involved in major retrospective inventorying projects during the last decade (Beelitz, 1979; Burrett, 1982; Evelyn, 1981; GB. E & AD, 1981; GB. Parliament. HC. CPA, 1981; Light, Roberts and Stewart, 1985; Neufeld, 1983; Pole, 1983; Sarasan, 1979; Sarasan and Neuner, 1983; Smith, 1983; Stuckert, 1982; Sunderland and Geyer, 1982; Thornton, 1983; Wilcox, 1980). Further details of some of these schemes are discussed in Appendix D.

6.2 control documentation programme

If the museum has any doubts concerning the effectiveness of its approach to inventory and location control, it is recommended that detailed consideration be given to the adoption of formal control procedures, a retrospective inventory programme and regular internal documentation and collections audits.

During the assessment of documentation procedures, the museum should evaluate whether its approach to collections control is appropriate to its current requirements (Section 9). An emphasis should be placed on a critical examination of present control documentation procedures and the standard of the inventory and location records. If there is concern regarding the implementation of procedures for the control of incoming material and the movement of items, steps should be taken to immediately adopt and maintain a more rigorous approach. If there is concern about the standard of control documentation for established collections, consideration should be given to concentrating museum resources on rectifying the problems within a realistic timescale, by undertaking the necessary retrospective

inventorying and extending the control procedures to include the inventoried material.

Unless rigorous care is then taken to maintain the standard and comprehensiveness of the inventory and location control records, their value will gradually decrease. If new acquisitions are not incorporated within the system or permanent movements are not logged, the records will come to be viewed with increasing wariness by both staff and external auditors and it will eventually be necessary to implement another major retrospective inventorying project.

Once new procedures have been introduced, arrangements should be made to ensure that they are being consistently implemented, by having documentation and collections audit programmes to monitor the standard of records and verify the location of the collections (including a formal stocktaking programme) (Section 8).

It is recommended that the museum adopts a written policy on the role of control documentation, approved by the museum authorities and the external auditors. This should define any new inventory and location control procedures and internal audit programmes that are to be introduced as a result of the assessment of documentation. Those museums that already have inventory and location control procedures should use these as a basis for the policy.

6.3 collections control

One danger when considering control procedures is to regard the four aspects of inventory control, location control, retrospective inventorying and stockchecking as being isolated from each other or from other museum activities. As noted above, there is little point in undertaking an expensive retrospective inventorying exercise without also adopting methods for logging the subsequent movement of items, ensuring the incorporation into the control system of details about new acquisitions and regularly checking the standard of the procedures. Similarly, the value of new control documentation procedures will be undermined if there are problems with the standard of the overall collections management procedures, the implementation of restrictions on access to the collections, the physical security systems and suitable storage arrangements for environmental control and preservation.

If an overall collections management programme is drawn up, it may be possible to combine work on control documentation with that of other activities. For example, if it is necessary to undertake the retrospective inventorying of a collection, it might be be efficient to combine the physical inventorying with checks on the durability of markings, an evaluation of the conservation requirements of the items, a consideration of the future storage requirements and the optimum shelf arrangement of the collection, a cleaning programme, an assessment of the standard of preservation and paper conservation requirements of the records and the development of new basic

automated records. While this report concentrates on the documentation aspects of collections control, the other aspects must clearly be taken into account.

6.4 *inventory control principles*

In examining the requirements for inventory control, the general accountability principles considered earlier (Section 2.7) provide a basis for a discussion of the appropriate methods for museums. There are, however, a number of particular characteristics of museums and their collections that must be taken into account before finalising the museum approach (Section 6.6–6.17).

Government accounting practice in the United Kingdom requires a responsible officer to maintain a record of the acquisition, holding and disposal of items such as exhibits, including details of the description of each item, its date of receipt, the source from which it was acquired and references to appropriate files, with these records being arranged serially within the inventory (GB. Treasury, 1981a). The Accounting Officer (the Director in the case of most national museums) is responsible for deciding on the measures to adopt to ensure adequate collections control and accounting procedures. Although the general principle is that a separate record should be prepared for each attractive or valuable item, the manual notes that there may be circumstances in which the Accounting Officer decides to introduce simpler and less expensive recording arrangements for particular types of material. When accepting incoming items, it is considered to be essential that a record is prepared immediately, preferably at the point of receipt, as a preliminary to formal store accounting. When dealing with outgoing items, it is essential that proper authority be given for the removal.

6.5 *location control principles*

The basic principle underlying the design of the location control procedures is the need to locate any group or individual item listed in an inventory, without excessive delay or expenditure of effort, using either direct or indirect methods. The logical separation of inventory and location control procedures provides the opportunity to delegate location management to a local level within the museum without endangering the integrity of the inventory records.

A general distinction can be made between four location control functions:

linking details of an item from its inventory record to its permanent location;
tracking the movements of an item to and from its permanent location;
maintaining details of the content of a particular storage location;
maintaining location details of a particular class of item (such as loans-in, loans-out or high value items).

The practical procedures used to support these functions depend upon various features of the museum, including the size and growth rate of the acquired collections, the number of non-acquired items, the mobility of the collections, storage arrangements, physical dimensions and characteristics of items, value of items, standard of security arrangements, auditing practice, standard of inventory and other records, standard of maintenance of documentation procedures, equipment and staff available for documentation.

6.6 integration of curatorial and control documentation

In addition to inventory and location control details, museums are concerned to preserve other control and curatorial information about the collections in their care. One way of reducing the work required and the risk of error when maintaining documentation procedures is to have as few duplications of information as possible. In many circumstances, documentation files held for general purposes can fulfil the requirements of an inventory (such as an entry file acting as a secondary inventory of incoming material and an acquisition register and item file together acting as a primary inventory of acquired material). Difficulties arise when there are no existing files or those which do exist are inaccurate or incomplete, in which case it may be necessary to undertake retrospective inventorying, as a result of which a new inventory can be produced which may subsequently be maintained as the primary control file of the collection.

6.7 departmental control documentation

In many museums, responsibility for both the collections and their documentation is on a departmental basis during some stages of the processing of material. In the largest institutions, all documentation procedures, including those concerning acquisition, may be departmental; in others, acquisition documentation may be central, but individual item documentation may be departmental. In these circumstances it may be appropriate for inventory control documentation to be delegated to a departmental level, as long as there were strict central management control procedures governing the formal acquisition, transfer and disposal of collections and regular monitoring to ensure the consistent implementation of local inventory procedures. Particular care has to be taken during the permanent transfer of material between departments (Section 6.17).

6.8 group records

It is sometimes impractical to prepare an individual description for every item in a collection, due to the volume and nature of the material and the limited number of staff available for its management. This is frequently the case during the acquisition of a group (when a large number of items may have been received simultaneously from a single source, and their sub-

sequent assessment and processing may be a protracted operation) and during the post-acquisition processing of collections such as certain bulk archaeological, natural science and social history material (when the nature of the items – their small size, low monetary value or role as a coherent statistical group – may preclude the need for individual documentation).

In such circumstances, it may be necessary to prepare a group record about the overall collection of items, either as an interim measure before the individual documentation of the items or as a long-term measure reflecting the nature of the material. It is therefore necessary that the inventory procedures be able to incorporate both these group and individual records. The museum should define the circumstances under which material can be grouped together and the procedures to follow if it is necessary to adopt individual control over any of the component items of the group (Section 6.12).

6.9 acquired and non-acquired material

The items for which the museum is responsible at any one time may include formally acquired material (such as permanent acquisitions within the museum itself or on loan to another institution and long-term loans to the museum from another institution or individual) and non-acquired material (such as secondary collections held for potential exchange or scientific analysis, enquiries, short-term loans and potential acquisitions). Items within the latter group may be held temporarily, after which they may be returned to their depositor, or may be retained indefinitely before being acquired as part of the collections or disposed of informally. Although the detailed procedures that are adopted for the care of acquired and non-acquired material will differ, both types of item need to be brought within the scope of the inventory and location control procedures.

To fulfil the inventory control requirement, the museum might consider that it has a secondary and a primary inventory: all incoming material could be described in the secondary inventory; details of material which is subsequently formally acquired could be transferred to and preserved in the primary inventory. The museum should define the types of material to be included in the latter (in particular, whether it considers long-term loans as part of its acquisitions).

6.10 control of non-acquired material

Inventory and location control over non-acquired material should be imposed from the time a group first comes into the museum, using the basic entry procedures (general aspects of which were discussed in Section 5.3). The inventory control procedures which should be implemented include the preparation and maintenance of an entry record about each distinct group of material retained in the museum. The initial entry record should incorporate basic inventory and location information, including a temporary

entry number, brief description of the group, date of entry, temporary location, details of the source, reference to any supporting documentation and the name of the person responsible for its compilation. The record should be maintained until a decision is made on the fate of the group (such as its return to the depositor, retention as part of a secondary non-acquired collection or incorporation into the primary acquired collection). When this decision has been taken, the record should be annotated with a signed and dated note of these details.

In the case of returned material, the record should be held indefinitely as a passive reference to the end of the museum's responsibility for the material.

In the case of retained non-acquired material, the record should be held as the active reference about the group, to which further information can be added until the material is exchanged or discarded, at which point the record should be further annotated and then held indefinitely as a passive reference. Location details of the group may either be held within this record, or incorporated within a separate location record with minimum details such as temporary number, brief description, location and date of recording.

In the case of retained acquired material, the record should be annotated with the permanent record number of the corresponding acquisition record and then held indefinitely as a passive reference to the group after the formal acquisition.

Since the acceptance and return of an entry such as an enquiry is dependent upon the unpredictable involvement of an outside depositor, it may be necessary for a number of staff in each department or the museum as a whole to be authorised to open and close an entry record. In these circumstances, particular care needs to be taken to supervise the assignment of entry numbers and the maintenance of the records, to ensure that all material retained by the museum is documented and that all decisions concerning its fate are noted. However, the documentation unit should be responsible for the management of these records, including ensuring that a complete serially arranged inventory sequence is available at all times, and that appropriate access control and security measures are adopted.

6.11 initial control of acquired material

Control over acquired material should be imposed from the time of acquisition of each group into the collection. (General aspects of the relevant acquisition, item and exit documentation procedures were discussed in Section 5.4, 5.5 and 5.8). The inventory control procedures include the preparation and maintenance of an acquisition record for each acquired group and an item record for each significant individual item within the group. The primary acquisition record should be drafted during the consideration of the acquisition, formally adopted at the time of authorisation of the acquisition and then maintained indefinitely as the primary inventory document about the acquisition, thus superseding the entry record as the inventory reference.

For inventory control purposes, the record should incorporate a note of the entry number, a unique acquisition number, a description of the material, the date of acquisition, details of the source, references to supporting documentation (including a note of the authorisation of the acquisition, such as approval in a file or in committee minutes) and the name of the person responsible for its compilation. In a museum arranged on a departmental basis, the department with responsibility for the acquisition should also be indicated within the record. (This may either be by means of an explicit note or it may be implicit in the departmental arrangement of the records.)

For location control purposes, either the acquisition record or a separate location record about the acquisition should include details of the holding area where the group is stored until the processing of any significant component items. If, at that time, all or part of the group is held as a unit without detailed item records (such as some bulk collections), these acquisition location details will need to be maintained indefinitely. If the group is completely dispersed as one or more significant items, the responsibility for location control should be assumed by the procedures followed for these items.

As with the arrangements for non-acquired material, the documentation unit should be responsible for the management of these acquisition records and acquisition number allocation and for the implementation of access and security arrangements. It is essential that at least one copy of the records is held outside the department or the museum.

6.12 groups and significant items

In many circumstances, it is possible for the acquisition record to refer to a single item, in which case there will be a direct relationship between the acquisition record and a subsequent item record, and the acquisition record should fulfil the necessary inventory control functions. Alternatively, the acquisition record may be concerned with a group of items, in which case it should include a description of the overall group and a specific note of each significant item within the group, including the addition of the unique record numbers of those items. In those museums where cataloguing is delayed until some time after the formal acquisition, it may be necessary to add these item numbers to the acquisition record at a later date (although the description of these items should be included at the outset). Until that time, the group should be held together as a single unit.

The museum should define its approach towards acquired groups and individual significant items. An acquired group may be considered as a number of related items received from one source at one time. A significant item may be considered as one that might require separate conservation and storage, be suitable for display or loan, be supported by a separate item record and be viewed by an outside curatorial expert as a coherent independent entity. This item may be more than one physical object, such as an album of photographs, a triptych, a clutch of eggs and nest or a tube con-

taining diatoms, in which case the description incorporated within the acquisition record should indicate the approximate number of component parts.

6.13 item records

Every significant item should be supported by an individual item record, opened as soon as possible after the acquisition of the group and the assessment of its component items, and then maintained indefinitely as an essential curatorial document (Section 5.6).

For inventory control purposes, the item record should be considered as being supplementary to the primary acquisition record. It should include a permanent item number, a formal description of the individual item and references to supporting documentation. If the item number is a subdivision of the acquisition number, it acts as a direct link between the item and acquisition records; if it is part of an independent registration number sequence, the acquisition number must be noted within the new item record or the control link will be broken. In most circumstances, the item records are then held in item number order. If they are not (due to having been subsumed within a catalogue entry, as discussed in Section 5.7), then the information used as the basis for ordering the record (such as an artist name) must be incorporated within the acquisition record to preserve the control link.

For location control purposes, the item record may also include an explicit or implicit link to the permanent location of the item: an explicit link involves noting the location within the record; an implicit link involves using some other data category within the record as a pointer to the location (such as the artist name or object classification, conforming to the general systematic arrangement of the stores).

If using a manual system, these location methods might be appropriate when dealing with a relatively passive collection whose item records are accessible from the stores themselves, readily available for consultation and amendment. Two disadvantages are the difficulty of preparing up-to-date duplicate copies of the records for security purposes and the risk to the security of the records themselves. These drawbacks are less significant if these location methods are adopted when using an automated system. However, in this case, either the machine-readable record or a printed manual equivalent of the record must be available for amendment: with the former technique, the record has to be accessible for reference and amendment using either an inhouse or external computer system to which the user is linked by a terminal; with the latter technique, the printed record can be consulted and annotated, and any amendments to the computer file can be carried out later as a separate operation.

With both manual and automated systems, it is possible to maintain an 'audit trail' of previous locations (including the location itself and the date the item was transferred to that location). This can be a valuable aid in the

event of conservation problems or when trying to track a misplaced item. In these circumstances, if using manual record cards, the sequence of permanent locations can either be noted on the master card or on an attached card; if using automated records, the system must be capable of supporting the addition of an indefinite number of location entries and of preserving the logical link between the particular pairs of location and date categories. (In practice, many automated systems are restricted to preserving only the current location or the current location and one or two former locations.)

The alternative implicit link method can be effective when the records are in the same order as that of the main part of the collections (such as some painting, print and photograph collections which may be in artist or numerical order) or when simple but effective control has to be exercised over a large number of systematically arranged specimens (such as some natural science collections). However, it does have serious limitations, such as maintaining effective control when the items are divided into arrangements which conflict with the systematic sequence (as when a proportion of the collection is out of sequence on display or in a separate area due to its size, value or specialised storage requirements). These limitations can be overcome by making an explicit reference to the location of any item not in the standard sequence and relying on the implicit reference as a default.

6.14 location records

As noted in Section 5.6, another location control method consists of preparing and maintaining a separate file of location records, comparable with the main item file but incorporating only minimum details such as item number, object name or classification, location and date. These finding records may be comprehensive or selective in their coverage: the latter option may be effective in cases such as needing a secure list of the location of valuable items or loans into the collection or when needing to complement a general implicit location approach with an explicit mechanism for a part of the collection. They may be held in a manual system (on cards, strips, log books, etc.) or automated system (when the records themselves or a printed equivalent may again be available). They may either be in numerical order or another order (such as artist, subject or classification) to which direct reference can be made from the main acquisition or item sequence.

Although this approach has the disadvantage of involving the preparation and maintenance of a separate file of records, it does have a number of important advantages. For example:

when using a manual system the format of separate location records is more suitable for duplication, so that copies can be held at different places or for security purposes;
the omission of confidential location details from the main records may allow these main records to be more freely available to outside users;
less pressure is placed upon the main records due to regular use by staff;

it is easier to retain details of previous locations and to incorporate additional information, such as a note of periodic stocktaking.

In both manual and automated systems, physically separate location records may be more manageable in terms of storage and filing requirements. In an automated approach, this may mean that the location details for a department or of high value items or loans into the collection are sufficiently compact to be able to be processed and sorted on a local microcomputer.

6.15 store records

In some circumstances, it may also be important to have access to information according to the storage order itself (as when undertaking comprehensive stocktaking, when moving large parts of the collection or when undertaking regular security checks of high value material). The records may be held within, or be accessible from, the documentation area or individual stores. In the latter situation, they can serve as a visual checklist of the content of a particular location.

When using a manual system, their preparation involves duplicating and re-ordering the location details from the item or location record and producing an independent record in storage order. If the requirement for details in storage order is very infrequent, it may be more effective to undertake this operation afresh each time the store sequence is required, rather than have to maintain two parallel sequences; if frequent, separate sequences will have to be prepared and both will have to be amended in the event of any change of location.

When using an automated system, it may be possible either to retrieve details of the current contents of a store direct from the machine-readable records using an online search or to prepare printed lists of the contents in anticipation of use. In the former case, amendments can be carried out interactively; in the latter case, amendments can be marked on the store list for later implementation.

6.16 movement control

Temporary and long-term movements of items may be logged by three methods:

amending the permanent location details on the item record or the separate location record and any store record;
maintaining a separate movements or loan record;
leaving an indication of the movement at the permanent storage location (such as a receipt, movement card or movement tag).

The consistency with which the approach is applied is the most important factor influencing the standard of the overall location control procedures.

In the case of temporary internal movements (within an individual department in a departmental museum), the simplest and most effective approach is often the last method of leaving an indicator in place of the item. In exceptional circumstances, when dealing with high-value items such as paintings or coins, this indicator may need to be supported by a separate movement record. In the case of temporary and long-term movements between departments or to an outside institution, the use of an indicator and the completion of a movement record or loan form may be supported by the amendment of the location details themselves (Section 5.8).

If the move is a permanent internal change, care must be taken to ensure that all references to the original location are either amended or superseded by a new dated indication of the current location. In some circumstances (such as when a collection is being reorganised or moved to a new building), the permanent change may involve a number of isolated movements, each of which needs to be noted within the location control procedure. A number of the museums reviewed in Appendix D have found the use of an automated tracking procedure to be very helpful in such circumstances.

6.17 deacquisition control

If, at any time after the acquisition, there is a major permanent change affecting the material (such as the permanent transfer, disposal or loss of the group or any of its component significant items), this should be noted within both the acquisition and item records by including a signed and dated reference to the formal papers or committee minutes which authorised the change, and brief details of the change itself. The annotated original acquisition record should be retained indefinitely; the annotated item record and any separate location records may either be retained or removed from the sequence.

In the case of a transfer, the annotation should refer to the recipient department or museum. If the transfer is internal and control documentation is arranged on a departmental basis, the recipient department should enter the item within its own inventory and location records (from preference, using the acquisition number of the donor department), indicating the source of acquisition as the donor department. In this way, the recipient department retains basic control over each acquisition coming into its care. If the transfer is external, the recipient should treat the item as an independent acquisition and assign an acquisition number according to its own procedures, making a separate reference within its files and records to the different acquisition number of the donor museum.

In the event of a disposal or loss, the annotation should indicate the fate of the item. Procedures should be drawn up concerning the steps to be implemented in the case of an item being thought to be missing, and the time delay and checks that should be introduced before documenting its loss within the primary records. One approach is to delay for three years before considering a missing item as being irretrievably lost.

Item curation documentation

6.18 curatorial documentation

The discussion of information management procedures (Section 5) referred to the role of item documentation for curatorial purposes. This is concerned with the development of a master item or catalogue record about each significant acquired item within the collection, and the use of these records as a basis for catalogues, indexes, information retrieval and other output products. For curatorial purposes, the item record incorporates intrinsic information deduced by an examination of the item itself (description, condition, etc.) and non-intrinsic information that must be derived by investigation and research (history of the item, etc.). It therefore acts as an important adjunct to the item; without the record, the value of the item may be severely diminished.

Aspects of the construction and use of these records were examined earlier, when considering standards and operation (Section 4.1–4.12). The appreciation of the complexity of these records and the recent emphasis on recataloguing programmes to improve their standard and comprehensiveness has been noted as being a major influence on the development of documentation (Section 2.12–2.13). The following paragraphs add further details about cataloguing constraints, while Section 7 notes features of recataloguing and retrospective indexing programmes and Section 8 describes methods of monitoring the effectiveness of the procedures.

Guidance on the approaches that have been adopted by museums is given in various recent publications (such as Burnett and Wright, 1982; Chenhall, 1975; Light, Roberts and Stewart, 1985; MDA, 1981a; 1981b; Neufeld, 1981; Orna and Pettitt, 1980; Pole, 1983; Sarasan and Neuner, 1983; Seaborne and Neufeld, 1982; Smith, 1983; Thornton, 1983). Examples of practice in some museums are considered in Appendix D.

This is an area in which libraries have valuable experiences from which museums may benefit. Libraries have cooperated to develop standards and conventions for cataloguing, including the MARC recording format and the Anglo American Cataloguing Rules (British Library, 1980; Gorman and Winkler, 1978). They have also been actively investigating the function, performance and economics of records and catalogues, working in research groups such as the Centre for Catalogue Research, funded by the British Library Research and Development Department (Bryant, 1980; 1982; Seal, Bryant and Hall, 1982), and the Graphic Information Research Unit of the Royal College of Art (Reynolds, 1979).

6.19 curatorial documentation programme

If the museum is concerned about the quality or comprehensiveness of its item records for curatorial purposes, it should consider whether resources should be devoted to rectifying the position. Steps should be taken to ensure

that adequate records are prepared for newly acquired material, that these records are further developed after their initial preparation by the maintenance of the existing details and the addition of new details, and that recataloguing and retrospective indexing programmes are introduced to improve the standard of inadequate records and indexes providing access to these records (Section 7).

It may be possible to integrate the initial stages of this work with the development of control documentation. However, unlike control records, curatorial records have the feature of long-term growth to take account of new information about the item, such as an additional indentification or the discovery of further details about its earlier history, as a result of which resources must be allocated to both maintain and enhance the records and the documentation system must be able to support these changes.

Although the preparation, maintenance, enhancement and use of curatorial records is one of the most expensive aspects of the management of museum collections, few institutions have attempted to monitor the work in any detail, and little research has been carried out into the practical procedures. If the museum is to be in a position to assess the resources and time required to develop and maintain its curatorial records, it must be able to define the desired standard of both the records and the outputs, on the basis of the needs of its own staff and outside users. It should critically consider the content and arrangement of the information in the records themselves and the most effective methods of producing and maintaining the records and using the information to produce catalogues, indexes, etc. This evaluation is an urgent requirement in many museums.

6.20 *development of curatorial records*

The importance of developing an item record for curatorial and control purposes was noted earlier (Section 5.6 and 6.13). In the case of curatorial purposes, the item record should be considered as the primary source about a significant item, incorporating full details of that item, or indicators to such details (for example, in general history or artist files). The form and extent of these 'full' details should depend upon the nature and scale of the collections, the availability and expertise of staff, the recording strategy and procedures that are being adopted, and the needs of users.

The museum should identify the required recording approach for each collection within its care. This exercise should consider the data categories that might be incorporated within a typical record, noting the categories that are essential to form a minimum acceptable record, the categories that are desirable as a preferred standard record and the additional categories that might be included in exceptional circumstances. In each case, an assessment should be made of the syntax of the information to be recorded within the category. A distinction should be made between data which is likely to be needed as the basis for an index entry (which should be recorded in a controlled form, as described in Section 4.4) and data which is of value within

the record or catalogue entry based on the record, but of little potential interest as an indexing concept. The former information may include concepts such as personal and place names, which must be carefully standardised by reference to authority lists; the latter may include a general physical description and detailed historical notes, over which less control need be exercised, other than to strongly discourage a discursive approach.

The documentation unit should be responsible for coordinating these investigations and the subsequent implementation of the recording procedures, including the maintenance of standards and the preparation of procedural manuals (Section 5.6). It is important that the effectiveness of the procedures is regularly monitored by means of documentation audit programmes (Section 8.4–8.6).

6.21 recording strategy

Careful consideration should be given to the most efficient means of preparing records, using manual or automated techniques (Section 4.6–4.8). General aspects include the availability of adequate work space, access to appropriate reference books, the organisation of the items into the optimum order for recording and the arrangement of staff on an individual or team basis.

The production of the master record may include various stages of recording and data entry (such as drawing up a rough record, formalising this record as a manuscript draft, typing this record into permanent manual form, entering this information into permanent machine-readable form and then editing and validating the permanent record), involving one or more staff with different skills. These steps should be limited to the minimum number commensurate with staff aptitude and the availability of equipment, to reduce the duplication of effort and the introduction of errors due to transcription problems.

With the growing availability of automated systems, serious thought should be given to the automation of the records at an early stage in their production. One approach is to replace manual typing with a comparable automated operation, using the manuscript record as a basis. Another is for the recorder to have access to a computer terminal and create the record while at the keyboard. The latter strategy will be particularly powerful when systems with facilities to aid the recorder (by standardising and speeding up the input operation) become generally available. In the interim, it is possible to introduce techniques to speed up recording within a manual system, such as declaring an abbreviation for commonly occurring information and establishing one record as being a standard reference for a class of items and referring to this record as an authority when completing the individual details of the components of the class.

Although the museum may require a number of copies of these records (for security and reference purposes), one set must be considered as the primary file sequence and care taken to ensure that its entries are well

maintained (Section 4.10). If using a manual system, it will be necessary to decide whether to also maintain the other sets to prevent them from becoming outdated as new information is accumulated. As such an approach is both expensive and prone to error, it may be felt that an alternative strategy of recreating the additional sets after an agreed period (such as every five or ten years) is a more effective approach. (In these circumstances, care must still be taken to ensure that new records of recent acquisitions are incorporated in the additional sets.) The preferred approach will depend on factors such as the degree of change of the records, the extent of any recataloguing programmes, the extent of use of the duplicate sets, the importance of the collection and the resources that can be devoted to this work.

If the availability of a number of duplicate sets of records is an important consideration for the museum (perhaps due to the dispersed arrangement of its buildings), this may be a crucial influence towards automating the records. If using an automated system, it should be possible for it to incorporate procedures for the maintenance of records and the regular production of a comprehensive set of records for security purposes and the updating or replacement of any printed copies held for local reference.

6.22 output considerations

These master records form the basis for catalogues, indexes and other outputs (Section 4.9 and 5.7), the production of which is both time consuming and expensive, irrespective of whether the museum is using a manual or automated system. In considering the form of these outputs, the museum has to accept a compromise between the investment it is willing to make in their preparation and the requirements of its users (both staff and outside researchers, etc.).

The costs included in the preparation of the outputs are affected by the form and scale of the master records and the outputs themselves and by the processing system being used. In many systems, costs will increase according to the number of different outputs (such as a catalogue and three indexes compared with a catalogue and ten indexes or a full online retrieval capability), the number of entries in each output and the scale of these entries (for example, whether an index includes basic information or full details about each item). Although it may be anticipated that users require full and immediate access to all information known about the items in the collection, the cost of supporting such a standard of access would be a considerable burden on the museum, which may not be justified by the scale of utilisation of the resulting facilities.

Factors to consider when evaluating the real needs of different groups of user include:

the categories of information to which those user require access;
the form of the packaging of this information (whether on index cards, COM, computer printout or an online facility);

the standard of presentation of the information (whether a 'pretty' display is necessary for public acceptability);

the need for the public to have direct access to information or whether museum staff should act as intermediaries;

the importance of comprehensiveness and currency (whether the outputs need to be complete and regularly updated);

the need for multiple copies of outputs;

the size of outputs.

A number of these factors are concerned with the usability of the outputs, the effectiveness of which will influence the frequency with which they are consulted.

When designing the outputs, consideration should also be given to the education of users by means of written guides and instruction programmes. These may include descriptions of aspects such as the layout of the information, the ordering of entries (filing rules), classification systems used within the entries, the meaning of cryptic information such as location details and control numbers and the use of any equipment such as microfiche readers or computer terminals. While an education programme will be necessary for internal staff users, it will be particularly important if the public have access to the outputs.

Few museums have, as yet, given any detailed consideration to these usage problems, the resolution of which is fundamental to the successful exploitation of the curatorial information locked within item records. Before embarking on any major change of curatorial documentation procedures, it is recommended that the museum undertakes an investigation of the actual output requirements of its users and adopts the conclusions of this investigation as a basis for the planning of its real curatorial output needs. This should, in turn, influence its attitude towards recording practice and system facilities.

7:
Retrospective documentation

Section 7 concentrates on methods for introducing an improved standard of documentation to an existing collection, by means of retrospective inventorying, recataloguing and indexing programmes.

7.1 retrospective documentation programmes

The preceding sections have described the development, maintenance and use of control and curatorial documentation for incoming material. With these principles in mind, the museum should incorporate an evaluation of the standard of documentation of its existing collections in the documentation assessment (Section 9).

If the standard of inherited documentation is found to be inadequate, it may be necessary to adopt a programme for the retrospective inventorying or recataloguing of all or part of the collections. The former may be considered as an urgent project to establish comprehensive control over a collection; the latter as a long-term project to enhance the standard of selected item records. While a practical project may involve a graduation between these two extremes. it is important to distinguish their different emphasis, priorities and timescales.

In many cases, the implementation of a comprehensive retrospective inventorying programme with specific aims and a restricted timescale should be seen as an essential prelude to any longer-term and selective recataloguing work. The importance of an effective inventory was stressed in the

recent investigations of museum accountability by the C & AG and the PAC (Section 2.7). In the last decade, a number of museums have invested considerable resources in improving a proportion of their item records, while failing to gain basic control over the collection itself. It is recommended that museums give detailed consideration to the importance of collections control before entering into any major recataloguing commitment, and that the latter is only approved if the museum is satisfied with the standard of its control procedures.

If the standard of access to the information in inherited records is found to be inadequate, it may also be necessary to implement a separate retrospective indexing programme. This may be considered as an urgent project to exploit the information within control and curatorial records, by the preparation of comprehensive basic indexes derived from the information in those records. The advantages of such a programme should also be examined by the museum before it commits itself to a major recataloguing project.

Details of these approaches within museums are noted in various recent papers (such as Burnett and Wright, 1982; Evelyn, 1981; Light, Roberts and Stewart, 1985; Neufeld, 1983; Pettitt, 1981; Pole, 1983; Sarasan, 1979; Sarasan and Neuner, 1983; Shimmin, 1984; Smith, 1983; Stuckert, 1982; Sunderland and Geyer, 1982; Thompson, 1984; Thornton, 1983; Vanns, 1984; Wilcox, 1980) and examined in the reports in Appendix D.

7.2 retrospective inventorying

Retrospective inventorying is concerned with improving the standard of control over an existing collection for which inventory and location records have never been developed or where there are doubts concerning the comprehensiveness or reliability of those records which do exist. It may involve a check and reconciliation of the collections and the existing records or the establishment of new records. The objectives might be to determine or confirm the current contents and location of the items in the collections, establish whether any items are missing that were known to have been acquired, identify those items that have not previously been included within an existing inventory and establish a new basis for the future control of the collections. The impetus for the retrospective inventorying of an individual collection, a department or the overall museum, may be growing internal concern of collections control, external pressure on the museum to demonstrate accountability (perhaps following a serious loss or an adverse audit report) or a decision to reorganise or move the collections.

In those museums where inventory records have normally been established at the time of acceptance of an acquisition, subsequent events such as transfers between departments or disposals of items may not always have been carefully recorded. In the case of a long-established museum, there may have been periods during which inventory records were not pre-

pared (perhaps due to staff shortages). Records originating from the last century or during periods of stress may have been misplaced in later years.

Similarly in a museum which does have location records, movements of items, changes of responsibility, and additions to or removals from the collection may not always have been recorded, with the inevitable result that the location files will include inaccuracies. If location records have not been prepared, staff may be having serious problems in finding specific items and maintaining overall control of the collections.

7.3 retrospective inventorying planning

The success or failure of an inventorying project will be determined by the care which goes into its planning and implementation (Section 6.2). As an inventorying project must be part of a wider scheme to improve the standard of control, may affect many non-documentation activities and may require a major investment of staff time and equipment resources, it is essential that it has the full and active involvement of senior officers and departmental curatorial and support staff.

Following the detailed assessment of the state of documentation in the museum and the potential role of automation (Section 9), a proposal should be drawn up for any necessary inventorying on a departmental or museum-wide basis. This may include a preliminary statement of the inventorying approach that might be adopted, an outline of the development plan and timetable, an estimate of the required staffing and equipment and an examination of the relationship of the inventorying work to the broader development of control and non-documentation procedures. The importance of this work was stressed by the PAC in 1981 (Section 2.7).

Before reaching a final conclusion on the form of the project, a pilot scheme should be undertaken to check the feasibility of the proposed plan and to confirm the estimates of time and resource requirements. The pilot scheme and the main project should be closely monitored to ensure that they are progressing as intended and that standards are being consistently maintained. Experience in a number of museums indicates that a major project dealing with an important and poorly controlled collection may take up to five years, and may require the involvement of both permanent museum staff and additional temporary assistants. A project on this scale may demand both a redirection of internal museum resources and an input from an external funding agency (Section 10.9).

7.4 retrospective inventorying methodology

The inventorying methodology to be adopted will depend upon factors which can be considered during the documentation assessment, such as the aims and urgency of the project, the resources available, the arrangement of the collections, the security and physical safety of the collections and the standard of existing documentation. The essential principle is one of

matching collection-derived records against documentation-derived records, as a result of which a new or verified file can be produced as a basis for subsequent control purposes.

Three approaches have been used successfully by a number of museums:

working first from the collection itself and then reconciling the accumulated information with the available records;

working with the available records and then comparing these with the collection;

working independently with both the collection and the records and then matching the two files of information.

The first approach may be appropriate if the existing inventory records are unreliable. It is carried out by working through the stores, preparing a summary record for each item or group of items which is found, including information such as item number (or numbers), location, brief description, condition and storage requirements. These records can be sorted into numerical order to form a new baseline inventory for the current collections. If there are existing inventory records, the new details can be matched with these records and any discrepancies reconciled by a process of elimination; if there are no existing records, the new details have to act as an unreconciled statement of the surviving collections.

The second approach has been the method adopted in the more common circumstance of having a file of existing inventory records that are felt to be reasonably reliable, but need to be verified against the collection. Either the records themselves, or entries in a new file based on details extracted from the records, are used as a source when working through the stores, when annotations can be added with details of current location, condition, etc., after which a reconciliation can be carried out.

The third approach may be considered if the inventory records are reliable but limited in detail or if an emphasis is being placed on condition, conservation and storage assessments. It combines the first stages of each of the other approaches, where files of records are prepared from the existing documentation and the stores. These records can then be compared with each other and matches combined as the basis for a new source.

7.5 *data capture during inventorying*

Each inventorying approach depends upon the accumulation of information from a variety of sources, including the collection itself and internal and external documentation (registers, indexes, correspondence files, committee minutes, etc.), and the permutation of this information into different sequences (including the final inventory and location records and intermediary lists such as an index of object names used as a guide during the location and reconciling operations). Internally designed preformatted record cards or sheets can be a useful guide to the required information during these recording stages.

When working in the stores, it is important to note a precise definition of the location (according to a predetermined system) and the date the item was seen at that location. If the inventorying is in anticipation of a major collection move, it may be useful to assign both storage unit codes and location codes: the former referring to a movable unit (such as a box, drawer or cabinet) which may contain a number of individual objects and the latter to the current location of that unit within the store. It may also be important to estimate the storage requirements of the item, including noting its physical dimensions and required storage conditions, as the basis for an overall storage assessment. An estimate might be made of the condition of the item and its general conservation priority. The marked or tagged item number should also be captured as the basic link between the collection and existing records.

If the majority of items are clearly marked with their item number, the existing records are reasonable and the aim of the project is limited to achieving rapid control over the collection, it may be possible to restrict the data capture of other store-derived information to the minimum of identifying details. If, in contrast, there are serious problems with the numbers or the records, or the aim is broader than achieving rapid control (such as the production of new core control records as a basis for a long-term recataloguing programme), a more exhaustive capture of store-derived information may have to be planned, both as an aid during the reconciliation of store-derived and documentation-derived information and as the source for the new records. Some of the data categories that might be considered include any alternative numbers, department code, item name, classification, function, number of specimens, number of parts, material, artist, title, geographical details, cultural details, general description, and reference to the content of associated labels.

When working with the existing documentation, available numbering and identifying details may also be captured. Depending on the specific aim of the project, consideration should also be given to including acquisition details (such as the source, date and reference to files), insurance and valuation details, disposal history and notes of previous stocktaking, any of which may be useful during complicated reconciliation procedures and may form an important part of any new records.

Whether working from the stores or the documentation, there will inevitably be queries concerning particular records at both the time of their initial preparation and their subsequent matching and reconciliation. In anticipation of this, it may be useful to include an error code category, and draw up a list of appropriate codes to include the status of a record at different stages in its processing.

7.6 store control and access during inventorying

An item should be considered as being included within the location control

system from the moment its physical location is recorded. The storage area should be labelled in some way to indicate to all staff that the inventorying has been carried out and that any subsequent movements of material to or from that area need to be documented.

Although it may seem desirable to impose a ban on movements during the inventorying, this will be impractical during a protracted project dealing with a large or dispersed collection. If a subsequent movement of an inventoried item is to an area that has already been inventoried, the store-derived record for that item must be revised; if it is to an area that has not yet been inventoried, the record may need to be deleted from the file and the item reprocessed when the second area is examined.

In some cases, it may be feasible to work through the collection more than once: the first time to accumulate essential control details quickly; the second and later times to supplement these details with further information. However, if the items are held in inaccessible storage, have a high security risk, or are fragile, this approach may be inappropriate and it may be essential to reduce the number of examinations to the minimum and adopt a longer timescale for the retrospective inventorying.

7.7 *physical grouping while inventorying*

Reference was made earlier to the impracticality of preparing an individual inventory record for all incoming items. Similar constraints apply during retrospective inventorying. In the absence of documentation-derived records, it may be necessary to decide upon the most effective grouping of material while working on the physical inventorying in the stores.

In exceptional cases (such as inadequately documented archaeological, natural science or social history collections), it may be necessary to initially divide the overall collections into general collection-groups, made up of related items with similar characteristics. Each of these groups can be supported by a new inventory record (Section 5.11). In effect, these collection-group records then refer to an acquired group that has been identified in the museum during the course of inventorying, with any evidence of the original acquisition of its component items from one or more outside depositors being treated as secondary information.

If circumstances make it necessary to adopt this approach, it should not be considered as fulfilling the full inventorying requirements but only as a necessary interim stage in the process, to be followed by the more specific inventorying of important material. The more specific inventory requirements may be met by records about smaller groups or significant items (as discussed in Section 6.12).

When establishing new group records during inventorying, each should refer to a closely related batch of items and incorporate an estimated or exact count of the individual component items. Similarly, a new item record should refer to a discrete item and include an indication of its component parts.

7.8 numbering, marking and reconciliation

The standard of numbering and marking is a crucial factor determining the procedures to be introduced and the ability to unambiguously link a store-derived record to a documentation-derived record. If different numbering systems, an inconsistent implementation of numbering procedures or poor marking procedures have been employed in the past, it may be necessary to capture all available numbers (such as the acquisition numbers, a catalogue number and field number) and also to assign and tag a temporary number to those items which are in doubt.

Problems due to the original assignment of numbers and subsequent failures of marking are just two of the causes of discrepancy between the sources of information. Other problem areas are:

inventorying transcription errors arising when copying item numbers from either the existing records or the collection;
items that were never documented but are identified within the collection;
items that were documented superficially or with confusing terminology, so that it is difficult to unambiguously link the description to a specific physical object;
items that were documented but have since been misplaced or lost or have left the museum as an unrecorded loan.

In view of these complications, the final reconciliation of the collection and its records may be a protracted process, as a result of which the museum may eventually be able to identify one set of previously non-acquired items and another of missing items.

In the case of unattributed items found in the store, a formal decision will have to be taken on whether each should be acquired, retained indefinitely as non-acquired material (in the hope that further information may be discovered) or disposed of, as inappropriate to the museum. If the latter circumstance arises, it may be necessary to take legal advice before reaching an irrevocable decision. In the case of missing items, the formal procedures for notifying and recording a loss should be implemented including annotating the relevant acquisition register entry (Section 6.17).

7.9 automation of retrospective inventorying

A number of museums have now used computing systems as a major aid during an inventorying project. Aspects of automation which are of particular interest are the ability to gradually build up records and re-order information while carrying out the documentation and storage work, and the long-term utility of the resulting machine-readable file, incorporating accurate inventory and location details, suitable as a basis for an automated control system or as the nucleus of a more general machine-readable catalogue file. In view of the growing availability of small portable data entry machines suitable for use in a store and relatively inexpensive

microcomputers capable of holding basic inventory information, this option should be given serious consideration by any museum embarking on an inventorying programme. Possible applications when using the first or second inventorying approaches (Section 7.4) include:

automating the initial documentation-derived and store-derived records (either by direct data entry into machine-readable form or after the preliminary accumulation of information on a record sheet);
sorting the resulting records into alternative orders and using checklists or worksheets derived from these records as a guide when turning to the second stage of checking against the collections or the documentation;
noting additional details on these lists or sheets and then using these for further data entry to update the original file;
producing selective lists from this file showing reconciliation problems requiring additional checking;
further revising the file to the stage where it can act as a long-term source for control or cataloguing procedures.

If following the third approach of initially producing separate documentation-derived and store-derived files, it may be possible to prepare these files in machine-readable form and then automatically or visually match those records with a common characteristic, producing as a result one derived file of combined records and another of separate anomalous records requiring manual reconciliation.

In each case, the recording and data entry operations can be considerably aided by software designed to help the user with efficient input, using the facilities for validating, carrying forward and abbreviating information discussed earlier (Section 4.6–4.7).

7.10 recataloguing

Recataloguing is concerned with enhancing the standard of item records, either after or in parallel with the introduction of comprehensive collections control. These improved records can then form the basis for more effective catalogues and indexes, exploiting curatorial information about the collection.

A number of the retrospective inventorying principles discussed in the preceding paragraphs can be adopted during a recataloguing programme, such as the need for careful planning and the accumulation of collection-derived and documentation-derived information. A greater degree of curatorial expertise will be required by the staff involved in the implementation of the programme than was the case during retrospective inventorying. The staff will need access to appropriate reference facilities to aid them with identification, etc.

Serious consideration should be given to the automation of the new records, particularly if the control information for the collection is in

machine-readable form or if there is an urgent requirement for multiple copies of the records and a number of catalogues and indexes. If it is decided to introduce automated procedures, this should be approved at the beginning of the programme as an integral part of the overall planning, and thoroughly evaluated during a pilot project before the commencement of a major scheme.

7.11 retrospective indexing

Retrospective indexing is concerned with providing access to the information in control and curatorial records, complementing the basic numerical and location sequences. These indexes may be derived from the newly-produced records resulting from retrospective inventorying and recataloguing programmes or from existing records if these are sufficiently well organised into discrete data catagories. If the records are in machine-readable form, it should be possible for the automated system to be used to produce the indexes. If the records are manual, it should be possible for a person who is familiar with their construction to draw up a plan for the extraction of relevant data from the records. The guidelines provided by this plan may then be followed by junior staff who can produce the index entries. The latter approach may either continue to be based on manual methods, with the staff preparing manual index cards, or may involve the automation of this limited index information.

Particular care must be taken to assess the index requirements of users (Section 6.22).

8:
Documentation and collections audit

The role of documentation as part of an internal audit programme is stressed in Section 8. It examines the feasibility of stocktaking and other methods of demonstrating accountability within the context of museum collections.

8.1 audit considerations

The importance of documentation and collections audit programmes was noted when introducing the discussion of inventory and location control procedures (Section 6.1–6.2). They are a means of verifying the maintenance and effectiveness of control and curation procedures, checking the existence of items within the museum and demonstrating accountability to external authorities, such as auditors in the parent organisation or an outside agency.

In the case of United Kingdom museums, the original emphasis was on the importance of a regular comprehensive stocktaking programme as a method of assessing this effectiveness and demonstrating the museums' accountability over collections (Section 2.6–2.10). The initial response by some national museums was the adoption of a comprehensive quinquennial stocktaking programme. More recently, it was agreed that a more flexible series of management objectives should be established, including 'the introduction of routines for the registration and location of every significant item' and 'the adoption of a practicable routine for checking the presence of items' (GB. Parliament. HC. CPA, 1974).

Although this is an area that is rarely referred to within museum publications, reference can be made to a few relevant reports (Burrett, 1982; GB. E & AD, 1981; GB. Parliament. HC. CPA, 1981; Light, Roberts and

Stewart, 1985). Details of current practice in a number of museums is discussed in Appendix D.

8.2 stocktaking principles

The general principles which have been promulgated for stocktaking provide a basis for the consideration of the appropriate checking methods for museums. However, as when examining inventory control principles (Section 6.4), there are particular characteristics of museums and their collections which need to be considered before finalising a specific checking policy.

The manual of government accounting describes the role of stocktaking as being a periodic check of store account balances (GB. Treasury, 1981a). The decision concerning the extent of these verification checks is vested in the Accounting Officer, who has to weigh the cost of the investigation of discrepancies against the benefits that might be gained.

The manual distinguishes between normal and independent stocktaking. The normal programme should be carried out by two officers of the department concerned, one of whom should not usually be involved with store management. Although the manual recommends that a normal stocktaking programme should be carried out at least once a year, it accepts that it may be necessary to spread the work over a longer period (when steps should be taken to ensure that the whole collection is covered within the prescribed period) or to concentrate on random sampling (so as to reduce the workload by directing effort to the part of the collection where it is likely to be most worthwhile). The inventory record for a verified item should be annotated with a reference to the date of the check. Any discrepancies should be notified to the relevant authority for further investigation, as a result of which the inventory record may be further annotated.

If adopting a periodic checking arrangement, the proposed dates for the checking of a particular group of items within the cycle should not be known by the staff responsible for the stores and only the minimum necessary notice should be given of a particular check. If implementing a random sampling approach, an acceptable figure of discrepancies should be established in advance of the selective check (based on knowledge from previous checks). If the error rate is greater than this acceptable figure, a full check becomes necessary.

The independent programme should be carried out by officers separate from the department responsible for the stores and accounting procedures. It should incorporate test counts made at irregular intervals. The overall results of both types of programme should be retained for internal reference and for subsequent inspection by external auditors.

The general responsibilities of the external auditors are outlined in guidelines for stocktaking prepared by a committee representing the major accountancy bodies (Auditing Practices Committee, 1983; Consultative Committee of Accountancy Bodies, 1969; Consultative Committee of

Accounting Bodies, 1975). Although dealing primarily with the role of an external auditor, these statements provide further advice on the possible form of the internal checking arrangements. They emphasise the importance of the auditor observing the process of stocktaking to evaluate its practical effectiveness. The extent to which the auditor's attendance at stocktaking is necessary should be judged by a preliminary review of the inventory records and control system.

Before the stocktaking, the auditor should become familiar with the type, scale and location of the collections and the current control procedures and should review the proposed organisation of the stocktaking itself, including the form of the instructions issued to the staff concerned with the check. These instructions should state the need for the stocktaking to be supervised by senior staff, that one of the officers concerned should not normally be involved with stock management, the check should be conducted by at least two people and the results of the check should be reconciled with the stock control records and discrepancies investigated.

During the stocktaking, the auditor is responsible for verifying that the instructions and procedures form an effective basis for an accurate check and that they are implemented correctly. The auditor should carry out additional test checks, particularly of high value items. As a result of this monitoring, the auditor should be able to report on these observations and tests and conclude whether the scheme is satisfactory.

In the particular case of the external audit of national museum collections, the role of the Exchequer and Audit Department was considered during the most recent investigation by the Public Accounts Committee (GB. Parliament. HC. CPA, 1981). In evidence to the Committee, the Comptroller and Auditor General noted that the Department was not itself responsible for undertaking a stocktake but was concerned to assess and report to Parliament on the internal procedures which were being implemented in the light of the special difficulties faced by museums. It was emphasised that the normal commercial approaches to stocktaking methods did not apply because of the identification problems of the large numbers of objects in museums.

8.3 role of comprehensive stocktaking

While recognising that they hold collections in trust for the nation, and that they must demonstrate proper care for these collections, museums have come to question whether a comprehensive stocktaking programme is an effective approach. If it were feasible, comprehensive stocktaking would have various roles:

it would act as a formal statement of accountability by the museum;
help identify – but not, in itself, prevent – losses from the collection (as a result of which it might be possible to make an insurance claim, trace the missing item or introduce security measures which might reduce further losses of a similar kind);

help identify the misplacement of items;
help monitor the standard of implementation of procedures;
impress upon staff the importance of careful control over the collections;
deter misappropriation by staff who will be aware that any unauthorised
and undocumented removal will eventually be detected.

However, the nature of museums and their collections poses questions on
the feasibility of the principles outlined above.

A major problem is the scale of the collections that would have to be
checked. It has already been suggested that some inventory records may
need to be concerned with groups rather than individual items. Even so, the
magnitude of many collections is such that a full stocktaking programme
would need to be spread over five or more years. In these circumstances,
there may be a long period between the actual removal of an item and the
detection of its loss. In the case of a significant item, it is likely that its
removal will be identified far sooner by other means, such as the regular use
of the collection by departmental staff or an outside party becoming
suspicious of an item offered for sale and notifying the police. If the item is
exceptionally valuable, its removal may be prevented more effectively by
physical security measures.

The cost of staff time to undertake a regular comprehensive check of a
large collection is likely to be out of all proportion to the benefit to be gained
by detecting loss and lowering the risk of misappropriation. It has been
suggested that a regular stocktaking programme and the maintenance of
inventory and location records could be supported by a special stocktaking
team employed on a central basis to examine individual departments.
Although this approach may appear to be less expensive than the use of
expert departmental staff, it would still represent a significant cost. Unless
additional resources were made available for this work, it would be to the
detriment of funding for other activities within the museum. In those
museums where retrospective inventorying or regular stocktaking has been
carried out, the detected level of loss or misappropriation appears to be
minor. The implementation of a regular check on such a scale would be
likely to cause severe disruption to the running of the museum, including
diverting curatorial, support and security staff from their duties of develop-
ing and protecting the collection, leaving it more susceptible to risk of theft
from an outside person. In circumstances where stocktaking is being carried
out, it may be necessary to close the department to the public. Physical
handling of a collection during an operation on the scale of a comprehensive
check may result in damage to some items: a risk which may not be justified
by the value of the programme. The risk of damage is likely to be greater if
independent staff are involved, who are not familiar with the characteristics
of the material. In these circumstances, the departmental staff with
responsibility for an important collection might find it necessary to closely
supervise any independent exercise.

A comprehensive stocktaking programme would introduce new pressures on the documentation facilities within the museum. The emphasis during the discussion of control documentation has been on the importance of inventory records, the maintenance of sufficient information to enable the user to locate an individual item and on the control of that item when it is moved from its permanent location, all of which are essential features of the day-to-day work of the museum. However, the maintenance of store records arranged in location order providing details of the content of each store is of far less importance for normal curatorial and control purposes, but essential for the efficient implementation of a comprehensive stocktaking programme for a large collection. Those museums developing automated records are in the position of being able to contemplate producing and maintaining store lists, should the need arise; those with manual records would find the exercise very expensive for large collections.

Any programme using non-departmental staff would be dependent upon the availability of descriptions or photographs suitable for use when identifying an item on a scale greater than that required by departmental checks by expert staff, as a result of which the inventory record may need to be more detailed and expensive to maintain than would otherwise have been the case. If these records are being held by the separate team, there will be an inevitable requirement for a duplication of details between the central and departmental records and serious problems in maintaining the location details within the central records. Even with the availability of descriptive central records, it is unlikely that a special stocktaking team would be able to detect examples of the careful substitution of items perpetrated by the expert officers responsible for the collection or by outside experts who have used the collection.

Comprehensive stocktaking depends upon comprehensive inventory records: in those museums with incomplete records where a retrospective inventorying programme is necessary, it may be many years before this stage can be achieved. (It is important to note that the retrospective inventorying itself acts as a full single stocktake.) Any attempt at comprehensive stocktaking in the intervening period would inevitably be suspect to criticism because of its potential inaccuracy, the difficulty of undertaking the work efficiently and the danger that it may detract from the emphasis on the preparation of long-term records.

8.4 *documentation and collections audit programmes*

In view of these problems, it might be concluded that a universal programme of regular comprehensive stocktaking, whether by departmental staff or a special team, is inappropriate within the museum context. It is, however, clear that some scheme of checking is essential if the museum is to be able to monitor the implementation of its overall collections management policy and demonstrate accountability to outside bodies.

It is recommended that museums should introduce internal documentation and collections audit programmes as a means of verifying the standard of maintenance of control and curation procedures and the care of the collections. The documentation audit programme might include a regular evaluation of the effectiveness of the entry, acquisition, inventory, location and exit control and item curation procedures, to ensure that they are being applied consistently and that staff are familiar with the control and documentation priorities. The collections audit programme might include a monitoring of the location and physical condition of individual items within the collection to ensure that movement and conservation problems are being identified, that losses are being detected and to discourage misappropriations.

Three verification methods may be used as the nucleus for the audit programmes:

a review of practical control documentation *procedures* to verify that the procedures are being correctly implemented;

a check on the control and curation *records* to verify that they are being correctly maintained;

a *physical check* or stocktake of the collection to verify that items in the collections have not been misplaced or misappropriated and that accurate documentation has been prepared concerning their acquisition and location.

The retrospective inventorying process discussed earlier acts as a full verification of the accuracy of the control records and a basic check on the curation records and on the content and location of the collections, equivalent to a full documentation and collections audit. While a major project of these dimensions should only need to be carried out once, the systematic audit checks should be applied with a selectivity and frequency that is determined by the characteristics of the museum and its individual collections. The practicable level of checks should be assessed by the museum in consultation with its external auditors, the active involvement of whom should be encouraged.

8.5 collection categorisation

A number of characteristics need to be taken into account when considering the required scale and frequency of the audit programmes. One factor is the general standard of security, including the range of physical security measures, the control of access to the collections, the degree of supervision exercised over visitors, the degree of vetting of staff prior to appointment, the policy of the museum concerning personal collecting by staff, the monitoring of staff movement within storage areas and the degree of separation between curatorial and store management functions. Another factor is the standard of the storage and conservation arrangements, including the ease of access to individual items, the degree of logical organisation within

the stores, the standard of environmental control and the availability of conservation facilities.

Consideration should also be given to the present and future staffing resources that might be devoted to an audit programme, and the skills of these staff in identifying items in the collection.

Relevant features of the collection itself include its size and growth rate, the scale of movement of individual items, the frequency of use of items, the type of material within the collection (its portability, marketability and monetary value), the importance which the museum attaches to individual items (their cultural, social or scientific significance on a national or local basis) and any particular responsibility for certain items (such as material on loan to the museum or loaned out from the museum).

Finally, account must also be taken of the standard and comprehensiveness of inventory and location records, of control documentation procedures, of any retrospective inventorying programme currently in progress or recently completed and of the standard and comprehensiveness of curation records.

As a result of these considerations, it may be decided that certain items in the collection fall into one or more checking categories (for example, high value items or loans into the museum may be considered to warrant a higher frequency of checking than lower value items). In these circumstances, details of the category should either be noted within the inventory records or held in separate confidential lists. The collection can thus be divided into segments, each of which can be subject to a distinct audit programme on a judgemental basis. This approach is likely to be more satisfactory and effective than a more general random selection technique, where the whole collection is equally liable to be checked.

It is suggested that one officer in each museum should be responsible for coordinating and maintaining the assessment of these characteristics, with the advice of senior management and departmental staff and external auditors. In larger museums this assessment may have to be made on a department-by-department or collection-by-collection basis. It should be updated at regular intervals, depending on changing circumstances such as the development of storage, security or documentation facilities. As a number of the characteristics are also relevant during the proposed assessment of documentation in the museum (Section 9), it may be possible for the officer conducting a documentation review to accumulate some of the evidence on which the decisions concerning the audit programmes can be based.

8.6 audit policy

Following the assessment of these characteristics, a formal audit policy should be drawn up for the overall museum and each department or collection. This should take into account relevant aspects of the stocktaking principles discussed earlier (Section 8.2).

One officer (such as the Director, Secretary, Administrative Officer or Documentation Officer) should be responsible for coordinating the implementation of the policy, including taking an active part in monitoring the practical checking by departmental staff and undertaking independent test checks ('spot' or 'dip' checks). The checking itself should be carried out by the coordinator and two other staff, one of whom should not have direct responsibility for record or store management. These staff should be given written instructions on the procedure to follow but only minimum advance notice of the items or records that are to be checked. The coordinator should prepare a written report on the results of the check for the attention of the Director, Museum Committee and external auditors. Relevant procedures should be implemented for investigating and writing off or adding on any discrepancies. The records consulted as part of the check should be annotated with the date and a reference to the written report. These records play an important role in aiding the audit programmes.

As noted above, any comprehensive checks need to be supported by control records in location order (Section 6.15). These may be held on record cards or as stock lists in a form suitable for use in the stores (store lists). The typical approach is for one person to read an item number from the object itself, and for another person to annotate the relevant entry to confirm the presence of the item. Any discrepancies can then be placed to one side or noted as needing further checking, following the procedures described earlier (Section 7.8).

When the reconciliation has been completed, the inventory records for that collection can also be annotated, as the formal confirmation of the checking procedure. If using manual records, these annotations can be added by means of a stamp. If using automated records, a decision has to be taken whether to hold the stocktaking details in a manual form (written on the computer-produced lists) or enter the information into the automated record. One approach would be to annotate the computer-produced store list and preserve this for audit reference purposes, while only inputting into the automated file details of any unreconciled discrepancies. In these circumstances, it may be possible to update the master records from the store list, without having to first transfer details onto an inventory list.

Similar recording principles can be adopted when implementing selective checks on a judgemental basis. In this case, either the inventory or location records can be taken to the stores, the relevant items identified, and the inventory records then annotated. One approach that has recently been adopted by a number of museums is to introduce a monthly checking programme for 10 or 20 items and records from each department. If using an automated system, it is possible for a computer program to be used to select the items to be checked, on the basis of the criteria identified by the museum. If dealing with a large collection, any comprehensive checks will have to concentrate on the verification of control records, placing only limited emphasis on curatorial details. In contrast, a regular programme of

selective checks can incorporate a detailed verification and enhancement of curatorial information. Examples of this approach and other checking practices are considered in Appendix D.

9:
Documentation and automation assessment

Documentation assessment methodology

Automated systems

Section 9 includes guidance on methods to adopt when preparing and undertaking an assessment of the standard of documentation within the museum and advice on the potential role of automated systems for documentation purposes.

Documentation assessment methodology

9.1 role of documentation assessment

The role of a documemtation assessment is to provide a detailed analysis of the existing documentation system, to identify its features and key problem areas and provide evidence before deciding whether the museum needs to invest in a major system development. Any such development must take as

its starting point the existing procedures and capitalise upon these, wherever possible.

The assessment itself should be preceded by the establishment of a set of terms of reference. Its remit may range from an examination of a specific aspect of the procedures in one department to all features of the documentation procedures of the museum. If it is to be effective, the assessment may need to examine aspects of both the museum itself and the strengths and weaknesses of the documentation system. While it is assumed that it will be primarily directed to the development of the documentation system, it may form part of a broader reconsideration of a range of activities within the museum.

If a major assessment is felt to be necessary, a pilot assessment may need to be undertaken first, in order that the resources for the full exercise may be identified and the timescale of the operation may be estimated. This preliminary study may highlight the problem areas that are of particular concern. It may also establish whether a comparable emphasis has to be placed on the examination of each department or whether some have a sufficient similarity to be considered as a group.

Aspects of the system that might deserve particular attention include (Section 5–8):

the standard of maintenance and the comprehensiveness of existing procedures;

the effectiveness of item records, catalogues and indexes for curatorial purposes;

the effectiveness of acquisition, inventory and location records for control purposes;

the scale of any backlogs of unprocessed material;

the work needed to eliminate these backlogs and bring records, catalogues and indexes to a satisfactory state for control and curation purposes;

the pressure of incoming or outgoing material;

the standard of existing collections audit procedures and the documentation that might be required to support future procedures;

the cost and effectiveness of the staff time and equipment resources currently devoted to documentation;

the standard of existing planning and coordination.

A report should be prepared after the assessment itself to act as a basis for subsequent action by the museum. This should summarise the findings of the assessment concerning the current approach to documentation and any problem areas. It might also consider the impact upon the system of any future internal museum developments or outside influences such as the potential impact of new technology and pressures for a greater degree of accountability. The report should conclude by noting areas of potential

development of the management of documentation and the allocation of resources.

It may be possible to implement minor changes, such as reducing an unnecessary duplication of effort, with the minimum of further investigation; the implementation of major changes will, however, require more extensive consideration (Section 10).

9.2 responsibility for the assessment

The primary responsibility for implementing the assessment programme should be held by permanent museum staff. It is the museum staff who are most familiar with the procedures, problems and priorities of their own institution and it is museum staff who have to use the resulting systems and be confident of their day-to-day operation. The number of staff involved in the assessment will clearly depend on the scale of the proposed development and the expertise available in the museum. However, experience in both museums and libraries suggests that two factors are often crucial to a successful project: first, one person must have primary responsibility for its management; second, this person must have the full support and involvement of staff at all levels in the museum.

In the case of a minor evaluation of procedures, the approach adopted might be to delegate a curator to act as a part-time investigator, supported by an informal working party. In a more significant exercise, it may be necessary to second or appoint a full-time officer with support staff and the substantial involvement of a committee representing different functions in the museum. (This role is one of the responsibilities exercised by two or three of the documentation officers now working in museums.)

In either circumstance, this investigator would be the appropriate person to act as the link between the museum and any outside consultants, such as experts in the parent organisation. In the case of a major study, outside experts can play a crucial role in complementing the internal expertise of museum staff with a detailed knowledge of systems analysis, design and implementation techniques. This can be particularly important if the museum decides to consider adopting automated systems on the basis of the evidence accumulated during the assessment. The investigator should also be able to liaise with colleagues in other museums to benefit from relevant experiences. This aspect can play an important role in placing the problems of an individual museum in context and identifying solutions to comparable problems that have already been examined elsewhere. A number of organisations (such as the support groups considered in Section 2.3) arrange regular meetings to consider documentation procedures, further details of which are noted in **Sources**.

9.3 assessment methods

Various methods can be used in combination to gather information when investigating the system (Lee, 1978; Levitan, 1982; Martyn and Lancaster,

1981; Matthews, 1980; Orna, 1982; Orna and Pettitt, 1980; Sarasan, 1985; Sarasan and Neuner, 1983).

Interviews with individual staff and group discussions are often the most effective ways for the investigator to build up a knowledge of procedures.

Observation of staff while they are involved in documentation activities can complement the interview, showing procedural and environmental problems.

Questionnaires can be used as a basic guide to direct and record a discussion with staff or can be circulated as part of the information-gathering process. (It should be noted, however, that there are major drawbacks in the use of the circulated questionnaire, including the time and skill required to produce an effective and unambiguous set of questions, the antagonism which such an approach may generate, the likelihood of a poor response rate and the difficulty in interpreting the resulting information.)

Sample documents can be collected by the investigator as another guide. These may include formal memoranda concerning the documentation system (such as acquisition and loan policies), documentation manuals (such as procedural notes, data standards, vocabulary control lists and automated system operation manuals) and typical illustrations of entries from physical sources (such as register entries, record cards, index cards and computer listings).

One use of these documents is as a basis for separate one-page summaries of the main features of each documentation source (files, etc.) and data category. A source summary can include details of the form and function of the source; a data category summary can include details of the use of that category. Aspects that should be considered when constructing these summaries are noted in Table 6.

Flow charts can be drawn up which help the analysis of the sequence of activities, sources, staff and timescale involved in responding to typical documentation problems, such as the processing of a new acquisition, the management of loans-out and answering an enquiry.

The use of the system can be monitored by recording details in the source summaries of the number of times and reasons why staff refer to a source.

Demands on the system can be considered following a period of monitoring and evaluating external enquiries and internal staff expectations.

9.4 outline of a full assessment programme

Appendix B incorporates a detailed checklist of the questions that might be considered during the documentation assessment. This includes a review of the organisation of the museum, its resources, priorities and collections, as a basis for an overall impression of the general framework within which the documentation system operates and of which it is an integral part. It concentrates on the documentation system itself, the practical aspects of the procedures used when documenting collections and a review of support documentation procedures.

Table 6. Outline of source and data category summaries

Source summary:
 source definition
 physical form of source and entries
 relationship to other sources
 frequency of use
 primary uses
 number of copies and location of each
 staff with direct access
 staff responsible for maintenance
 standard of maintenance
 number of entries
 growth rate of entries
 ordering of entries
 allowed data categories
 average number of data characters per category and per entry

Data category summary:
 data category definition
 primary uses
 components of this category
 related categories
 group category of which this is a part
 sources within which data category is noted
 consistency of use
 vocabulary control
 syntax control
 average number of data characters

A draft of this checklist was used during a series of visits to United Kingdom museums, the results of which are described in Appendix D.

Automated systems

9.5 information management applications of automated systems

The development of the use of automated systems for documentation purposes was examined earlier, when considering major influences on museums (Section 2.18–2.20). Reference was made to information management, management control, word processing, analytical research and educational uses, key aspects of which were summarised in Table 1. The following paragraphs concentrate on an assessment of the information management role of automated systems, comments about which were included in the detailed discussion of the principles of the documentation system.

The working group and investigator who were responsible for the documentation assessment (Section 9.2) might also be in a position to review the potential role of automated systems, following the background guidelines provided in this section. The museum should also consider consulting its parent organisation and support groups (such as the MDA) for specific assistance. Courses, workshops and conferences are arranged by a number of organisations, including Aslib and its various groups, the CCTA, Cimtech, the Library Association and the MDA (see **Sources**).

Descriptions of the applications and experiences of museums, archives and libraries are given in various recent papers (such as Abell Seddon, 1982; Armstrong, 1981; Armstrong, Guy and Painter, 1981; Ashford, 1980; Ashford and Matkin, 1982; Bartle and Cook, 1983; Boss, 1983; Boss and McQueen, 1982; Brunton, 1979; 1980; Chen and Bressler, 1982; Davis and Hebron, 1982; Etchells-Butler, 1982; Fraser, 1982; Hamilton *et al*, 1985; Henry *et al*, 1980; Lee, 1979; Light, 1979; 1982; 1983; Light and Roberts, 1984; Light, Roberts and Stewart, 1985; MDA, 1981b; Megna, 1983; Mollo, 1982; Neufeld, 1981; 1983; Orna and Pettitt, 1980; Painter, 1982; 1983; Perry, 1980; Pettitt, 1979; 1981; Porter, 1983; Porter, Light and Roberts, 1976; Prowse, 1983; Roberts, 1982; 1984; Rowat, 1982; Sarasan, 1981; Sarasan and Neuner, 1983; Seaborne and Neufeld, 1982; Spirer, 1981; Stewart, 1980c; Stuckert, 1982; Sunderland, 1983; Sunderland and Geyer, 1982; Tedd, 1983; 1984; Tenorio *et al*, 1983; Turner and Robson, 1979; Watson, 1983; Whitehead, 1980a; 1980b; 1981; 1983; Will, 1982; Williams, 1981; Williams, D. W., 1983; Williams, H. L., 1983; Williams and Goldsmith, 1981). Further information about a number of projects within museums is also included in Appendix D.

9.6 general automated system features

The basic components of an automated system are hardware, software, data and staff (Bradbeer, de Bono and Laurie, 1982; Evans, 1981). The hardware is the physical features of the system, including input and output devices (terminals, printers, etc.), a central processing unit and storage facilities. Software is the programs used to manage the system itself and to process information. Data is the museum information that is input into, processed by, and output from the system. Staff include systems and applications designers who develop and maintain the system, operators who manage the flow of information and the end user.

Technical aspects of these systems are reviewed in more detail in Appendix C.

The hardware and software components may be categorised into four types of system called mainframe computers, minicomputers, microcomputers and word processors:

a mainframe computer is a large machine with facilities to support a wide variety of applications for many different users;

a minicomputer is a smaller machine that, unlike a mainframe, does not require a carefully controlled environment, but may still be used for a variety of applications;

a microcomputer is at the lower end of the price range, with a microprocessor as its central processing unit;

a word processor is a minicomputer or microcomputer with facilities that are primarily concerned with word processing.

The features and capacity of the larger minicomputers have become indistinguishable from those of small mainframe systems, the terminology used being a matter of convenience and manufacturers' decision. Similar considerations apply to the distinction between smaller minicomputers and some microcomputers. The general image of microcomputers is misleading, since they range from major business systems to what are basically only sophisticated data entry terminals. The present discussion will distinguish between upper and lower range machines (termed 'significant microcomputers' and 'limited microcomputers' respectively). It is also increasingly difficult to be dogmatic about the differences between small minicomputers, microcomputers and word processors, the latter being best considered as a specialised application of the overall technology.

It is important to note that the overall system used by the museum may be a combination of one or more of each of these types of machine, situated both within the museum ('inhouse') and at an outside installation such as the parent organisation or a service agency. In the case of an outside installation, the museum may either make independent use of the facilities, treating the system very much as if it were an inhouse facility (frequently called 'timesharing'), or rely upon the supporting organisation to undertake work on its behalf (using it as a 'bureau'). The bureau services may be limited to one aspect of the overall work (such as processing information after it has been prepared in machine-readable form by the museum) or provide total support, according to the requirements of the museum.

9.7 mainframe computer systems

Mainframe computers used by museums are typically located in the parent organisation or at a remote government installation or support bureau to which the museum has access. Larger museums may also require inhouse systems on this scale if they are involved in substantial widespread computing work. In the case of an external system, the museum access may be either direct (via terminals within the museum) or indirect (through a service agency). The initial purchase cost of these systems can be from £100 000 to well over £1 million, depending on their size and associated facilities.

The sponsoring organisation may have a charging mechanism which involves a payment being made for each 'unit' of computing power used by the museum. This charge may be notional in a case such as a university or local authority museum using the central computer of its parent organisa-

tion. However, if it is imposed, the resulting financial outlay can be a major expense (including the cost of the initial processing of a new record and its subsequent regular maintenance). These systems require specially designed rooms, with appropriate power supply, ducting and environmental conditions (including air-conditioning). They usually offer extensive facilities, including substantial data storage capabilities, high-speed processing power, a number of data-entry terminals and a range of output devices, including high-speed printers, graph plotters and COM equipment. A number of different software packages may be available, one or more of which might be appropriate for museum use.

The service usually has a range of support staff to manage and operate the system and liaise with users, as a result of which the museum may be relieved of many of the technical aspects of system maintenance that are necessary when using smaller inhouse machines. The system might have hundreds of different users, a significant proportion of whom may be able to utilise the machine simultaneously. However, the pressure on the machine by these users can often begin to overstretch key resources, with the result that the response offered to an individual user may be less effective than expected. If using the machine of a parent organisation, the museum may find that the effectiveness of the system is further influenced by being treated as a low-priority user, to whom both advice and resources are less freely available than may be desirable.

9.8 *minicomputer systems*

Minicomputers are typically located in the parent organisation or at a central location within the museum itself. The initial purchase cost of such systems ranges from £20 000 to £150 000, depending on the form of the central machine and the number of associated printers, terminals, software packages, etc. The typical cost of an annual maintenance contract for the equipment is 10–15% of the purchase price.

Although minicomputers do not require a major reconstruction of existing rooms, it is most important that they are located in a separate machine area, away from the staff who might be disturbed by the noise of printers, etc. They do need an adequate electrical supply, which is carefully regulated to suppress voltage fluctuations, and basic environmental control facilities to dissipate heat. They can include a wide range of facilities such as terminals, printers and a number of software packages, although such additions do increase the overall cost of the system. The number of users able to simultaneously utilise the system is usually up to twenty. The effective data capacity and speed of such machines can, however, be commensurate with that of a multipurpose mainframe.

One approach when building up an inhouse minicomputer-based system is to acquire the machine itself direct from its manufacturer. Other facilities, such as software packages for specific purposes, can then be added to the basic configuration according to the requirements of the museum. In these

circumstances, the museum will require considerable internal expertise to evaluate, implement, program and maintain the appropriate system requirements. The alternative approach is to acquire a complete 'turnkey' system (including hardware and software) from a single distributor. This distributor is then responsible for acting as an agent for the museum by designing an overall system incorporating those hardware and software features necessary to support a specific application (such as an information management system) (Appendix C). While the result of this latter approach may be that the system will have a more limited function, it will remove from the museum some of the requirements for expertise in programming, analysis and support.

However, in both cases it is the museum staff responsible for the system that are the first contact of a user in the event of any difficulties in applying the software or any technical problems caused by machine malfunction. If the museum has an inhouse minicomputer, it will need at least one person with full-time responsibility for the management of the system. In view of the need to ensure the adequate support of critical functions the museum may, in fact, decide that it is essential that it has two officers with familiarity with the system. If the facilities are being heavily used by staff, it may also be necessary to have one or more operators to coordinate practical aspects such as the use of printers.

9.9 microcomputer systems

Since the late 1970s, museums have also begun to acquire microcomputer-based systems for installation at a central point or distributed around the institution. These systems can either be used for data entry and independent processing or restricted to data entry and basic processing (editing, etc.) prior to passing information to another machine for more extensive manipulation. The overall systems (including peripherals) typically cost up to £20 000, with the option – not always exercised – of a maintenance contract at 10–15% of the capital cost.

The more significant systems can have a number of attached input and output devices, but the limited machines may be restricted to a single terminal and printer. The environmental requirements of the significant systems are comparable to those for minicomputers; in contrast, the more limited systems may be compact enough to be accommodated on a table or wall unit within a normal office. Software appropriate for information processing use may be limited, although both word processing and management control packages should be available. Staffing considerations for the significant systems are also comparable to those for minicomputers, with the current emphasis being on the museum needing considerable skills to make effective use of many of the raw systems. The larger systems are able to cope with three or four simultaneous users, but most are restricted to one person dealing with a single problem at any one time. The storage capacity

and speed of operation may also be restricted, to an inconvenient extent on many of the more limited machines.

Some of the limited microcomputers may be considered as basic data entry machines suitable for data capture and editing. The data may then be passed to a local or remote processor for more significant manipulation. This type of machine has the advantage of relatively low cost (up to £2500), ease of use, versatility and portability, comparable to a standard typewriter. A number of museums use such machines as independent data entry devices, the information from which is then passed to a larger inhouse processor or a computing system in a service agency.

The wide range of microcomputer systems is reviewed in more detail in a recent report on their potential role in museums (Light and Roberts, 1984). In discussing the introduction of microcomputers into the museum, this report stresses the importance of concentrating first on a particular application, then the software that might be used to support this application, and only then the hardware to run this software. The museum may, however, find that its choice of system is also strongly influenced by the policy of its parent organisation or a related advisory group. For example, the CCTA has drawn up a preferred list of microcomputers for use by national government bodies (Anon., 1983).

The various types of machine are usually obtained from a distributor rather than their original manufacturer. The choice of distributor can be important, since the museum may need to call for frequent help if the machine proves unreliable or if the documentation proves inadequate. Many distributors are newly-established small companies with limited experience of dealing with professional users and no guarantee of long-term survival. Rather than choose an unknown local company, it may be advisable to depend upon a more distant company with whom another museum or the parent organisation has already had successful contacts. (Most hardware components and software can be posted to and from their distributor without too much risk of loss or damage.)

Machine and software malfunctions can be a serious problem, particularly with newly released equipment that has not been adequately tested: a machine or software that has been available for purchase for more than six months may be a more satisfactory solution than a competitor with more sophisticated facilities which is supposed to become available in one month's time. The quality of the suppliers' documentation of the hardware and software should be examined prior to a purchase as inadequate descriptions of the components and their uses can lead to considerable frustration and time wasting by the museum.

9.10 word processing systems

Word processing systems are comparable to small minicomputers and microcomputers in terms of cost, maintenance, environmental conditions

and range of attachments. They differ, however, in their more restricted capabilities, which tend to be predominantly concerned with office and financial management and publication programmes. Some of the systems now also offer information storage and retrieval facilities. Against the restriction should be balanced the ease with which they can be used by untrained non-specialists. Their manufacturers have, in effect, produced a highly packaged small computer dedicated to specific tasks, incorporating both hardware and software features.

9.11 external and inhouse systems

If considering using an automated system, the museum should review the facilities to which it has access at an outside organisation (on either a timesharing or bureau basis) and the available systems that it could acquire for inhouse use. These facilities should be assessed in the context of the proposed application, the available expertise within the museum and the scale of the financial investment which the museum is able to commit to the work (Section 9.12). Care should be taken to ensure that the proposed system will be able to organise data in a form which corresponds to the complexity of the museum requirements, store and maintain data for long-term use, provide adequate processing capabilities, offer easy-to-use outputs and retrieval capabilities, protect data by preserving duplicate copies of files and controlling unauthorised amendment or use of records.

If considering using an external system, the museum should examine:

the total cost of this use (including aspects such as processing and telecommunication charges);

the level of museum expertise required to support either timesharing or bureau use;

the standard of support guaranteed to the museum;

the timescale of any services offered to the museum;

the experience of the outside organisation in dealing with problems similar to those of the museum;

the commitment of the organisation to the needs of the museum and the long-term development of its facilities;

the compatibility of the outside system with any inhouse developments that might be considered by the museum (such as the acquisition of a local data entry capability to be used in association with external processing).

The museum should be aware of its long-term commitment to finance the support of the records held at the outside organisation. These will need regular maintenance and processing, the cost of which may grow each year, in parallel with the increasing number of records.

If considering using an internal system, the museum should also investigate aspects such as:

the cost of the initial acquisition and long-term maintenance, replacement
and enhancement costs;

the degree of staff expertise that would be required to implement and
support the system;

the relationship of this system to any outside facilities;

the quality of the proposed hardware and software (in terms of reliability
and ease of maintenance);

the reputation of the supplier and manufacturer in working with other
museums and providing support and advice;

the ability of the system to be expanded and upgraded by the addition of
new hardware and software to take account of growth, changing museum
requirements and new technological developments;

the environmental requirements of the system (including power and
temperature control, space requirements, noise levels, etc.).

Particular care should be taken to investigate all aspects of the staffing and
financial implications of the inhouse approach. The scale of the require-
ments for staff with both technical and managerial aptitude to implement
and maintain a system has sometimes been misjudged by museums when
acquiring inhouse facilities. Similarly, the scale of the total financial invest-
ment can be far greater than might be expected from a brief examination of
basic system costs. Additional unanticipated purchases (such as essential
processing or storage facilities to cope with a rapid growth of work) can be a
major drain on resources. The need to replace items of hardware and
software (due to machine obsolescence or changing requirements) after
perhaps five years of use can also be a serious problem if not anticipated
from the outset (Section 10.1–10.6).

If the museum does not have experience in using an automated system, it
may be advisable to first gain familiarity with the techniques by using an
outside bureau for initial experiments and then acquiring one or more small
inhouse microcomputers suitable for data entry, with which to gain further
experience while continuing to use the bureau or a timesharing system for
processing. The decision whether to adopt major inhouse facilities will be
influenced by factors such as growing internal staff expertise, the suitability
and cost of external processing compared with the potential convenience
and cost of independent systems and the availability of user-friendly systems
suitable for museum applications. In the longer-term, the overall system
configuration used by the museum can be made up of a variety of inhouse
and external facilities, with the former arranged on a centralised or
distributed basis. The most suitable approach will depend upon the require-
ments of the individual museum.

9.12 application principles

The assessment of documentation should enable the museum to identify
those aspects of its procedures that are most in need of revision and most

frequently used. The decision whether to automate one or more of these aspects will be influenced by factors such as the suitability of existing automated systems, the availability of museum expertise and the required financial investment. In general terms, computer hardware appropriate to many museum requirements is now widely available at a cost which, although substantial, is not prohibitive when compared with the cost of staff time to undertake comparable manual procedures. There are, however, problems in the adoption of the hardware due to aspects such as lack of standardisation between components, reliability and maintenance difficulties (particularly with smaller machines) and a lack of expertise in evaluating and using such facilities. In contrast, the choice of software appropriate to some of the demanding information management requirements of museums is currently limited. Some of the software packages that are available are costly and few museums have staff with the expertise to develop inhouse approaches.

It is therefore most important to balance the positive features of automation with an examination of the capability of the museum to apply these features. If it is decided to automate aspects of the documentation system, these developments should be carefully planned and integrated into the overall revision of the documentation procedures.

Particular attention should be given to a balance between human and machine aspects of the total documentation system. Even if it were technically feasible, it would be undesirable to plan to automate all the challenging parts of the procedures, leaving staff with routine work such as strictly-controlled data entry and tedious proof-reading. The museum should use the machine to aid staff with tasks such as the maintenance and re-ordering of information, rather than attempt to automate features which are more suitable for human involvement.

Similar consideration should be given to the balance between manual and machine-readable information. There are a number of gradations between completely manual records and completely automated records, with the most efficient position probably lying somewhere between the two extremes. It may, for example, be impractical to consider automating information such as inscriptions and illustrations, due to technical limitations of present systems. Similarly, while detailed information such as descriptive and historical notes could easily be incorporated in a machine-readable file, the cost of input, storage and maintenance may be an unnecessary burden when compared with the frequency with which the information would then be used.

9.13 control documentation applications

The general area of control documentation, including inventory and location control (Section 6.1–6.17), retrospective inventorying (Section 7) and collections and documentation audit (Section 8), is one in which automated

systems are likely to play an expanding role in the future. The methods can be applied to object and non-object collections.

If the museum is planning a major retrospective inventorying programme, consideration should be given to the automation of the store-derived and documentation-derived information accumulated during the work. The ability to maintain and sort this information, to compare the two sets of records and then to use the file as an aid when reconciling discrepancies can be an important feature. As the inventorying approach is based upon the capture of the minimum of information about each item, the cost of data entry is relatively low and the size of the resulting records and files is relatively small, when compared with the automation of fuller curatorial records.

The resulting file has a long-term role as a basis for primary inventory and location control, as a source for index entries and as a potential building-block for more substantial curatorial records. Details of new acquisitions can be incorporated into the file and existing records can be annotated in the event of a loss, transfer or disposal. The location details can be updated following any permanent movements. If necessary, steps can also be taken to incorporate details of short-term movements. If a comprehensive collections audit is to be carried out, this file can be used to produce store lists; for selective documentation and collections audit programmes it can incorporate details of the categorisation of the collection into different risk groups, which can be used as a basis when deciding the items that should be checked during each audit period. The information in the control records (such as object name, method of acquisition, date of acquisition and donor) can be used to produce useful indexes to the collection on either a departmental or museum-wide basis.

Another aspect of control documentation that might be appropriate for automation in certain museums is the management of the secondary inventory and location details of incoming material, at the entry stage, prior to an acquisition decision. Particular attention might also be made to loans-in or loans-out and to the maintenance of valuation details (including their regular revision).

9.14 *curatorial documentation applications*

A second area of application is curatorial documentation, including aspects of the development of item records and the use of these records as a basis for catalogues and indexes (Section 6.18–6.22). These methods are also appropriate to both object and non-object collections.

As in the case of retrospective inventorying, if the museum is planning a major recataloguing programme it should consider automating the new records at an early stage of their preparation (Section 7). The machine-readable file can then be processed to produce multiple copies of records for reference and security purposes, and as a source for other outputs. A similar

approach can be adopted with new records of recently approved acquisitions.

The cost of both these exercises may be appreciable if the museum is dealing with large-size records. However, it should be an acceptable investment if the preparation of the machine-readable record is instead of comparable manual procedures, such as the typing of a manual record card. The cost may be reduced if the core of the record has already been automated during a retrospective inventorying programme.

In practice, only a small proportion of the total collection may be recatalogued or newly acquired during the next five- or ten-year period. The cost of automating the existing curatorial records of the remainder of the collections may be an appreciable investment which is of questionable value in many circumstances.

One approach is to consider automating only those data categories that are known to be useful for indexing and retrieval purposes, as a retrospective indexing exercise (Section 6.22 and 7.11). The resulting automated file can complement the control records and indexes and the existing manual records by acting as a valuable directory to the full curatorial details. This approach can be particularly useful if the museum has a large number of records that have been produced on computer-compatible record cards as part of recent recataloguing programmes and for which it has been unable to prepare manual indexes. Fuller details can be added to the file over a longer period or when particular records are required for a specific purpose, such as an exhibition catalogue.

An alternative approach is to gradually automate the full details from existing records, incorporating a proportion of the outstanding manual file each year. Except when dealing with a small collection, this has a major disadvantage that the indexes will only be complete at the very end of the project, which may take many years. A number of the large museums that have adopted this approach have eventually come to question whether it is an effective use of resources.

9.15 support documentation applications

A third application is the maintenance and use of support documentation, such as conservation, record photographs, localities and other information sources (Section 5.9–5.13). If preparing new records, it may be possible for these to be automated; if records are already available, it may be possible to index them using a similar approach to the retrospective indexing of the physical collections. It may be particularly useful to interrelate this information with the files about the physical collections.

10:
The development of documentation

System change

Future investment of resources

Cooperative developments

Section 10 includes advice on the future development of documentation within the museum, reviewing the methods to adopt when considering changing the existing documentation system and procedures; and some of the aspects of documentation that could be investigated on a cooperative basis.

System change

10.1 revising the documentation system

The review of the principles of the documentation system and its local application within the museum (Section 3–8) and the assessment of museum procedures and the role of automation (Section 9) can be considered as the preliminary stages in a general system development programme. These stages should result in a clearer understanding by the museum of its docu-

mentation practice and problems and give an indication of the potential methods for resolving these problems. As suggested earlier (Section 9.1), a report prepared as part of the assessment exercise can act as a starting point for subsequent decisions about the need to revise the documentation system. This paper has placed an emphasis on the value of this preliminary work, as a means of establishing an informed basis for future developments.

The assessment may have clarified one or more areas where the museum feels effort should be concentrated on improving the current standard of documentation. This is the point at which the conventional approach to system development can be introduced into the museum. If the museum is part of a parent organisation with an established system development procedure, the detailed aspects of the approach may be predetermined. As a general guide, the stages in the development procedure may include:

an analysis and definition of the problem;

an examination of the alternative solutions that may be adopted to overcome the problem and the recommendation of a preferred solution;

the detailed investigation of this solution and the development of an inhouse system or the selection of an external system;

the implementation, operation and subsequent maintenance of this system.

Problems which become apparent with the new system during its operation and maintenance may result in the need for a further review and the initiation of a new development, hence the concept of a system development cycle.

If the assessment has identified more than one problem area, an overall long-term documentation development programme should be drawn up. This should illustrate the inter-relationship of the individual problems and include an assessment of priorities. Individual development projects can then be considered as being subordinate to this overall programme. Each stage in the implementation of a project should conclude with a progress report, to be used by the museum management as evidence when deciding whether to allocate further resources to the project.

Further advice on these aspects is included in a number of publications concerning system design and analysis which, although usually concentrating on the role of automation, include comments of relevance in all development circumstances (such as Boss and McQueen, 1982; GB. CCTA, 1982a; Grosch, 1982; Lee, 1978; 1979; Light and Roberts, 1984; Matthews, 1980; Orna, 1982; Orna and Pettitt, 1980; Rush and Chenhall, 1979; Sarasan and Neuner, 1983).

Any museum contemplating a major development is advised to consult experts in its parent organisation and pertinent outside bodies at an early stage. Some of the organisations that might be able to provide general help are noted in **Sources**: these may be able to offer technical advice or may arrange seminars concerning system development.

10.2 responsibility for the development programme

It was suggested earlier (Section 9.2) that the primary responsibility for the assessment should be held by a museum officer and a coordinating working party or committee, with help from outside experts. This approach may provide an effective basis for a subsequent development programme. While it is again important that the development officer has the full support and involvement of staff throughout the museum, a major development programme will demand a more concentrated effort by a few individuals. Each specific problem may be the responsibility of a small project team which reports to the coordinating committee and receives advice and practical support from the development officer or an assistant.

When estimating the work required to successfully implement a project, particular care should be taken to allow sufficient staff time for all stages of the development. Inadequate planning at this point can have serious consequences during the years when the system is operational.

As few museums have staff with detailed expertise in system analysis, system design and automated systems, it may be necessary to support a major development programme with additional inhouse staff, to draw upon experts in the parent organisation or a support group or to employ outside consultants. The expertise required will gradually change during the course of a project, with an initial emphasis on an ability to design a revised system, implement and test the practical applications of this revised system and then, in the long-term, to maintain, manage and apply the resulting facilities. The problems of requiring appropriate skills are most marked if introducing an automated system, where specialised design and programming ability may be needed, unless the museum adopts the facilities of an outside agency or implements a turnkey system (Appendix C).

10.3 problem definition

The purpose of the problem definition stage is to identify and analyse the documentation problem and draw up a precise definition of the objectives of the development project. The assessment report acts as the starting point for this work. Its findings can be complemented by a more detailed analysis of the identified problem as the basis for a specification of the requirements to be satisfied by the revised system.

Some problems can be resolved without a major redesign of the existing system, such as a failure to implement established procedures (for example, terminology conventions, the control of incoming material, the maintenance of location lists or the production of indexes) or the inadequacy of staff training and supervision. While the resolution of problems of this kind may not require a large investment in a new system, it may well involve a re-evaluation of working practice and the need to coordinate and manage the implementation of documentation procedures, with a widespread impact upon the role of curatorial and support staff.

Other problems may require a substantial revision or extension to the documentation system itself, such as:

the need to introduce inventory and location control procedures;
the need for a retrospective inventorying or indexing programme;
a long-term requirement for a new recording strategy to improve the standard of item records and the production of catalogues and indexes;
the need to replace existing outdated facilities (for example, an early automated system which has come to the end of its operational life or whose software is no longer adequate for the changing requirements of the museum).

In cases such as these, the report on the problem should describe the present system and outline the future requirements. It should:

note the essential and desirable features;
assess the benefit to the museum of the proposed development;
assess the impact of the development on other aspects of the documentation development programme and other museum activities;
estimate the resources and time required for an examination of alternative solutions.

If it is agreed to proceed with the project, this report forms an important basis for the subsequent examination of alternative solutions and during the development of the revised system or negotiations with the potential vendors of externally-developed systems.

10.4 solutions to the problem

In the case of problems which require a revised system, the next stage in the development process is to identify and investigate the practical alternative solutions to the problem, assess whether one of these solutions should be pursued and, if so, put forward proposals for a detailed study of the implementation of this solution. The previous work on the assessment of documentation, the potential role of automation and the problem definition report should have provided the development staff with substantial evidence on the different options that might be considered and the viability of these options in the particular circumstances of the museum.

The effort that needs to be devoted to this stage of the development programme will clearly depend upon the significance of the project. Although it may be a time-consuming and protracted process, it should form an important basis for subsequent work.

The conclusion will inevitably be a compromise between the level of resources required to implement and maintain a revised system (both financial and staff resources) and the benefit to be gained from the change. When considering this balance between cost and benefit, a distinction should be made between essential and desirable features of the system. The constraints to take into account include:

the type of problem that is being considered;
the existing system design and standard of records;
the range, scale and growth rate of any collections to be incorporated within the system;
the cost of converting existing files;
the organisational implications of any change;
the availability of temporary staff or financial assistance from an outside source;
the ability of existing staff to undertake any additional work required by an extended system;
the expertise of existing staff to support a new system;
the impact of a change upon different grades of staff;
the cost of training;
the cost of developing an inhouse system;
the availability and cost of acquiring an external system;
the availability and cost of using the facilities of an outside bureau or the parent organisation;
the cost of applying and maintaining the system;
the impact of the change on the museum environment, including space and environmental control requirements;
the availability of outside advice;
the urgency of the change and the timescale for its introduction;
the benefit to be gained from a revised system;
the importance of facilities to amend information and the need for access to information;
the user-friendliness of the revised system;
the required level of security of information and the system itself;
the desirable level of reliability of the system;
the required range of facilities;
the required growth potential;
the disruption caused by the adoption of a major change;
the risk involved in the change and the potential need to withdraw from an unsuccessful development;
the impact of future developments within the parent organisation or on a cooperative basis.

A major influence on the form of the new system will be the anticipated future scale of operation. It is important that the facilities of the revised system are commensurate with this scale of operation. Factors to take into account include:

the present number of main files;
the number of records in each main file;
the size of the records (including data characters and structural overheads);
the number of index files;

the number of entries in each index file;

the size of the index entries (including data characters and structure);

the number and nature of the links between files and records;

the frequency and scale of change to each record and index entry (such as additions of references, changes of location due to internal or external movements and revision of valuations);

the number of new records and index entries resulting from new work (such as the entry of material into the museum, the processing of new acquisitions and their cataloguing and indexing, the preparation of new loans and new conservation details);

the number of new records and index entries resulting from reprocessing work (such as recataloguing or the preparation of a new inventory or index);

the future level of information management desired by the museum (such as comprehensive collections control and monitoring, full catalogue records, extensive indexes and retrieval capabilities and effective terminology control);

the time scale of operations (such as the maximum delay between the acceptance of an acquisition and its cataloguing or between the movement of an item and its logging in the inventory);

the time scale of changes (such as the target date for the completion of a new inventory, catalogue or index or the introduction of revised procedures).

The primary aim of the investigation of alternative solutions is to establish the general approach for the subsequent development. It should not be concerned with detailed aspects such as specific types of hardware or software. Areas that should be resolved include:

whether to concentrate on a manual or automated system and the required scale of the preferred approach;

whether to consider devoting resources to the inhouse design of new facilities, the acquisition of the major components of the system from an external agency or the parent organisation, or the use of the bureau service or timesharing facilities of an external agency or the parent organisation;

the likely impact of the new system upon the work of different grades of staff and the potential need for additional expertise or the redirection of existing expertise;

the probable scale of investment needed to develop, acquire and maintain the system.

In order to gain a clearer idea of the assistance that might be received from external bodies it may be necessary to contact a number of potential suppliers, consult the parent organisation and support groups such as the CCTA and the MDA and examine in detail the experience of other museums. It may also be important to consider whether the museum or its

parent organisation has established any new technology agreements with trade unions concerning the introduction of automated systems (for example, National Association of Local Government Officers, 1980).

Before committing itself to an automated approach, the museum should be conscious of the scale of the resources and expertise needed to develop and maintain a satisfactory computer-based system (see Section 9 and Appendix C).

The resulting report should outline and compare the alternative solutions and justify the case for the preferred approach. It should incorporate a proposal for the detailed study stage, including an estimate of the likely cost, staff requirements and timescale of the study. On the basis of this report the museum can decide whether to proceed with the plan, to delay its implementation but reconsider the position at a later date or to reject the proposal.

10.5 detailed study, design and selection

If it is agreed to proceed, the development officer should be responsible for coordinating a detailed study of the preferred solution, the translation of this study into a practical design and the selection of appropriate hardware and software. (Reference should be made to earlier sections for advice on these aspects, such as the discussion of system standards and operation (Section 4) and automation (Section 9.5–9.15 and Appendix C).)

The study should include the preparation of a precise written specification of all manual and automated features of the system, including:

operational procedures;
data input, processing and output procedures;
the structure of input forms and any other physical records;
information flow;
definition of files, records, data categories and terminology conventions;
software requirements;
hardware configuration;
staff requirements and functions;
environmental requirements;
the drafting of manuals describing the form and use of the system.

It should also incorporate a detailed plan and schedule for the subsequent work to design or acquire and then implement and test the system, the training requirements to familiarise staff with the use of the system and the conversion procedures to be followed when transferring from the old system. The conclusions of the study should be carefully evaluated to ensure that all relevant problems have been taken into account. Staff who are to be involved in the development and use of the system should be consulted to see whether they agree with the detailed interpretation of their requirements.

If the museum has decided that major aspects of the system (such as data standards or computer software) should be developed inhouse, or has

agreed that the development work should be done by its parent organisation or an outside body, this is the point at which the detailed drafting can begin, using the system specification as a basis. Similarly, if major aspects are to be acquired from an outside body or if use is to be made of the facilities of an outside bureau, this is the point at which the museum will need to enter into formal negotiations for the selection and procurement of the appropriate systems. The development officer and the departmental staff who will adopt the new system should continue to take an active part in the subsequent development or selection procedure. They should be in a position to recommend positive changes to the agreed system specification in the light of practical experience.

If the museum is considering acquiring computer hardware and software or using an external agency as a bureau or timesharing service, it is important that it consults its legal advisers concerning these negotiations. Care must be taken to ensure that any contract includes adequate protection for the museum in the event of a shortcoming such as the failure of the hardware to support the expected workload or the inability of the software to perform as required. The provision of computing systems is a rapidly changing and highly competitive area, in which it is possible for a supplier to propose the acquisition of a system which has not been fully evaluated or whose design work has not been completed. It is essential to distinguish between the current capabilities of a system and the claims of future enhancements.

The negotiation and selection procedure should be influenced by the established approach of the museum or its parent organisation (such as a local authority or the CCTA). The detailed study undertaken by the museum is a basic part of the procedure since it acts as the formal functional specification of the desired system. One approach is to draw up a 'request for proposals' document which incorporates a description of the required system and the contractual terms under which the museum will negotiate. This is then submitted to a number of potential vendors to enable them to determine whether to enter into negotiations with the museum. The aim of this method includes helping the vendors to assess the full requirements of the museum and helping the museum negotiate an acceptable price and undertake a detailed evaluation of the proposals (Matthews, 1980). Aspects to incorporate in the document include the contractual terms, the functional specification, essential requirements, desirable features, the support needed from the supplier, the expected price and the procurement timetable (Anon., 1982c; GB. CCTA, 1982a; Institute of Purchasing and Supply, 1979; Sambridge, 1979).

The evaluation of any submitted proposals should ensure they fulfil the essential requirements and then balance the relative merits and disadvantages. Factors to take into account include (Boss and McQueen, 1982; Matthews, 1980):

the total cost of the system over five years (such as the cost of processing

units, terminals, telecommunication equipment, storage systems, software, site preparation, consumables, enhancements, staff time, staff training and retrospective conversion);
the delivery schedule;
the performance of the vendor at other museums or libraries;
the availability of alternative hardware and software maintenance arrangements in the event of difficulties with the original vendor.

A report should be drawn up which demonstrates the procedure by which one of the alternative proposals was selected and details the cost and implications to the museum of that conclusion. A final decision can then be taken on whether to accept the proposal and award a contract.

10.6 implementation and review

Implementation may involve the installation of a system acquired from an outside agency, the development of links with external bureaux, the finalisation of inhouse developments, the completion of the reorganisation of internal procedures, the supervision of the changeover to the new system and its evaluation and acceptance. Progress with the implementation and the adherence to the agreed schedule should be carefully monitored and steps taken to respond to any problems, such as a delay in the delivery of hardware. Again, both the development officer and departmental staff should be closely involved at each stage.

If new equipment is being installed within the museum it may be necessary to reorganise work areas prior to its arrival. It is essential that adequate space is available for hardware and storage and for the efficient use of the new system. As noted earlier (Section 9.6–9.10), it may be necessary to arrange for some environmental changes if computer equipment is being installed, including adequate power and ventilation facilities. It may also be necessary to arrange for ducting or wiring to be distributed in the museum. If a system is being acquired from an outside source, the supplier should specify any necessary environmental conditions during the negotiation procedure. Care should also be taken to ensure that adequate security provisions are made, including controlling access to equipment areas and incorporating the new system within any emergency planning arrangements.

As the system becomes available, staff should be trained in its use. If it is being acquired from an outside source, this supplier should provide training manuals and practical advice to staff. The museum should ensure that adequate help is received at the early stages of implementation as it is possible that the supplier would either charge for any assistance or be unwilling to provide help at a later date. Appropriate training should be arranged for the documentation coordinator, any departmental supervisors and the individual staff concerned with the application of the system. Areas to incorporate within the training programme include an awareness of all new

procedures and standards, familiarity with equipment and knowledge and practice in emergency arrangements. If the public are to have direct use of the system or its outputs, thought should be given to instructing them in the use of equipment such as microfiche readers and computer terminals, any new organisation of information, etc. Both staff and users must have access to manuals giving advice on all these aspects. Arrangements should also be made to extend existing training programmes to reflect the new system, with particular emphasis on the instruction of staff appointed after the conversion to the new system.

The second major pre-conversion exercise is the testing of the system to ensure that it is working correctly. An outside supplier will again accept some responsibility for 'bedding-in' a system, but faults may not become apparent until after this stage. This is when expertise within the museum and a good working relationship with the supplier become particularly important. There may be a protracted period during which a complex new system fails to achieve the standard of reliability and performance that the museum had been led to expect. One of the complicating factors is the degree to which the new system has been tailored to match the exact practical requirements of the museum. If the museum has accepted responsibility for developing its own applications of a general system, there may be a further development period after the initial acquisition of the basic system (Appendix C). During this period, the ability of the museum to test and evaluate all the features of the new system may be limited.

During the conversion of procedures and information to the new system it will probably be necessary to also maintain some of the old procedures. This transitional period is a demanding time for museum staff, since they may be under pressure to maintain an old approach and learn the skills required by the new one. The introduction of the new techniques should be carefully planned to reduce these problems. A gradual phased introduction, concentrating first on a series of pilot projects, may be necessary.

If the system requires the retrospective conversion of existing manual records into a new manual or new machine-readable form, or of existing automated records from one machine-readable form into another, this should be planned long before the installation of the equipment. It may be convenient for a bureau to undertake this conversion on behalf of the museum as a means of further reducing the transitional pressures on internal staff.

The museum should carefully evaluate the new system before finally accepting it from the supplier. In addition, it should arrange for an internal post-implementation review a year or more after the acceptance, when the use of the system has stabilised. This should be used to assess the effectiveness of the change and identify any modifications to the physical system or the documentation procedures that may have been shown to be necessary. The subsequent operation of the system should also be monitored and steps taken to ensure its long-term maintenance and periodic review. In

the case of an automated system, there will almost certainly be a need to begin to plan its eventual replacement within a few years of its first introduction. This continued committment to system revision should be appreciated from the outset.

Future investment of resources

10.7 staff

Previous paragraphs have included a number of comments concerning the staffing requirements for the coordination and maintenance of documentation procedures, further details of which are given in various articles (such as Anon., 1984; Burnett and Wright, 1982; Dudley and Wilkinson, 1979; Hoachlander, 1979; Orna and Pettitt, 1980; Pettitt, 1981; Porter, 1984; Sarasan and Neuner, 1983).

One emphasis has been placed on the importance of the coordination of documentation work through an overall management group and a documentation unit (with a full-time or part-time manager). This group may be responsible for considering policy for general documentation procedures, standards and training, assessment programmes and development projects. In a large museum, overall coordination may depend upon departmental liaison, with each department possibly having a local part-time manager responsible for advising individual staff on procedures and standards (as part of the broader museum-wide planning framework) and the central manager being supported by one or more assistants to undertake work such as system analysis and design. The detailed form of the coordination and its staffing requirements will depend upon the individual circumstances of the museum and features such as its relationship to its parent organisation.

Whatever the approach that is adopted, most of the staff investment in documentation will inevitably be the local responsibility of individual curatorial and support staff working in the museum departments. Priority areas when reviewing and changing the system should be to concentrate on capitalising upon staff skills and to maintain a balance between staff concerned to implement control procedures and those interested in developing curatorial records. In many cases, it should be possible for support staff to be responsible for the essential routine aspects of documentation, such as monitoring the entry and subsequent movement of items, updating location details and lists and preparing manual index entries, while curatorial staff concentrate on the formal aspects of acquiring items and the preparation of detailed records.

If considering changing the system, and particularly if introducing automated procedures, care should be taken to ensure that the museum has access to staff with appropriate expertise to maintain the new approach. These requirements will extend beyond the period when the system is being actively changed. The new system may require an additional permanent

staff investment to ensure its adequate maintenance, enhancement and operation, to support the application and use of agreed standards, to prepare procedural manuals and to train staff in the new facilities. It is important to make a realistic estimate of the scale of this investment.

It may be necessary to complement the long-term permanent staff investment with a short-term influx of temporary assistants, particularly if undertaking a major retrospective documentation programme (Section 7). Temporary staff with limited experience and qualifications can play an important role in work such as the extraction of inventory information from existing records; the checking of less fragile and less valuable items in store; the data entry into machine-readable form of manual records; and the preparation of manual index entries in the absence of automated facilities. Those with relevant academic qualifications may also be able to play a greater role in the interpretation of existing records and help prepare drafts of fuller item records.

The decision to implement a retrospective documentation project will inevitably place an additional strain on museum resources. Either the museum or an external agency will have to provide funds to support the temporary staff and any new systems (see Section 10.9) and the permanent staff will have to redirect their work to take an active part in the project. The degree of supervision required to ensure the smooth running of a project of this kind has sometimes been misjudged by museums.

10.8 systems and environment

Comparable references have also been made to the cost of a system and its environmental requirements. When acquiring a new system, care must be taken to establish realistic figures for the required financial investment and staffing implications. Cost factors include the initial acquisition of any hardware and software, its subsequent enhancement and maintenance, long-term replacement and the purchase of consumables.

Allowance must also be made for the provision of adequate space for the physical system itself and for work areas and the storage of both consumables and output. In the case of an automated system, it is important that noisy heat-generating equipment is accommodated in a separate area.

Cooperative developments

10.9 cooperative funding

While the long-term funding of documentation work must clearly be an internal museum responsibility, there is also a strong case for an urgent injection of additional funds to provide museums with assistance to implement retrospective documentation projects (Section 7). The availability of such assistance would be a major contribution to the control and exploita-

tion of collections in museums. In the case of national museums, it would also aid the implementation of the recommendation by the PAC that inventory records are brought to a satisfactory state (Section 2.7).

It is recommended that the Museums and Galleries Commission and the relevant government funding agencies consider establishing a separate Retrospective Documentation Scheme to provide substantial short-term assistance with retrospective documentation to both national and non-national museums. When considering this recommendation, these bodies might examine aspects such as:

the need for the provision of support for both temporary staff and new documentation systems (such as an inhouse computer system with data entry and basic processing facilities, suitable for use during an inventorying project);

the need for support to be provided to a museum over an extended period (up to five years in the case of a major scheme);

the importance of retrospective inventorying as a basis for future collections control and accountability;

the importance of retrospective indexing as a means of exploiting the information inherent in museum records.

In view of the magnitude of the retrospective documentation work that needs to be undertaken by museums, this scheme will have to be funded on a substantial scale if it is to have a significant impact on the standard of control over collections. As an illustration, a grant of £100 000 per annum could be used to maintain one large or two small projects within a single museum. Each of these projects might need to last up to five years, during which a concerted attempt could be made to improve the standard of documentation of existing collections. The grant would need to support both a project team and relevant documentation systems (see Section 10.11). The museum would need to delegate one or more of its permanent staff to manage and liaise with the project team (Section 10.7).

This approach would be analogous to the important retrospective documentation projects undertaken in recent years in a number of museums (details of some of which are given in Appendix D). However, only a few museums have been in a position to fund major projects with internal resources. National museums have been unable to turn to other substantial sources of project funds. While many non-national museums have been assisted by the Manpower Services Commission (in one case, for example, to a total of over £450 000 during the last six years), there are serious doubts about the future scale and appropriateness of this external investment.

It is suggested that the provision of adequate funds to support this work should be recognised as being primarily a responsibility of the museum community. It is recommended that the Museums and Galleries Commission be strengthened to enable it to coordinate the implementation of a Retrospec-

tive Documentation Scheme for museums, with technical advice from bodies such as the MDA. In the case of non-national museums, it might be appropriate for the new support to be channelled through the AMCs, with their knowledge of local museum problems and conditions. The close cooperation and active financial involvement of the Manpower Services Commission should be sought.

10.10 advisory function

Many of the problems considered in this report are common to museums throughout the country. There are a number of areas in which cooperation between museums themselves and support groups (such as the MDA and the AMCs) may result in the development of expertise.

It is recommended that the advisory work of the MDA be extended to include further guidance to both national and non-national museums on the key aspects of documentation covered in this report, such as data standards, terminology control, the security and preservation of documents, control documentation, retrospective documentation, documentation assessment programmes and automation assessment. The Association will require additional staff and support facilities if it is to carry out this broadened role.

The provision of advice about standards is an essential aspect of this work. The introduction of a centrally-supported documentation system (including record cards, manuals, computer storage formats, etc.) has had a marked impact upon the uniformity of records prepared in recent years. With the growing availability of small microcomputers, a number of museums are now beginning to develop local systems for the data entry and initial processing of information. It is important that the MDA is in a position to advise these museums on the appropriate recording strategy, to ensure that data is compatible with the established standards and that it can be interchanged with other institutions (Section 10.12).

In the case of automation, there is an urgent need for the provision of advice to museums about appropriate systems (particularly micro-computers, information management packages and data interchange problems). The MDA should monitor the future development of systems in the United Kingdom and North America, with particular attention to new bibliographic and museum software (such as that proposed by the Getty Trust and the Art Museum Association) and new facilities (such as data entry systems and optical videodiscs). It should continue to build up a computing bureau to help museums involved in automation projects.

While the primary concern of the MDA should be to concentrate on the documentation aspects of automation, there is a need for the broader provision of guidance to museums about automation techniques such as word processing and management control. It is recommended that the Museums and Galleries Commission, the AMCs and government funding agencies consider the effectiveness of the present advisory arrangements for national

and non-national museums and the possibility of providing more extensive automation advice, in cooperation with bodies such as the Arts Council, CCTA, the Local Authorities Management Services and Computer Committee, the MDA and the Museums Association.

The provision of general background advice is no substitute for detailed assistance to help a museum with a specific task (such as an internal assessment and change of documentation procedures). The availability of an expert consultant with specialised museum documentation knowledge might be of considerable benefit to a museum that is in the early stages of building up internal staff expertise. It is recommended that the AMCs establish local registers of consultants to whom museums can be referred. In addition, the MDA should consider employing a senior officer who could be seconded to fulfil a consultancy role within museums.

Finally, reference was made earlier to the need for museums to have legal assistance when designing parts of the documentation system, such as the forms and registers used to record details of incoming material and the transfer of ownership and formal acquisition of items (Section 5.3–5.4 and Appendix B). It is recommended that the Museums and Galleries Commission considers examining these aspects in more detail and issues guidelines to museums on the necessary procedures.

10.11 system development

The basic building blocks for a manual or automated documentation system are now available. However, there are still serious shortcomings in the suitability of these building blocks for straightforward use within those museums that do not have expert documentation or computer officers on their staff. This is particularly relevant in the case of automated systems, where appropriate hardware is now becoming widely available but there is little low-cost user-friendly software tailored to museum applications.

It is recommended that the MDA monitors the production of new software (Section 10.10) and is itself involved in developing specific systems to fulfil some of the major needs that are not met by other sources. Areas of concern include:

the provision of data entry software suitable for inputting basic control and complex curatorial records, using local data entry microcomputers during both current and retrospective documentation work;
software to help the checking and editing of records;
software to support the indexing and retrieval of information from control and curatorial records;
interchange procedures to enable museums to transfer data from local inhouse systems to other installations for more substantial processing and combination with the records of other institutions.

These facilities might be used as the basis for a range of systems to support current and retrospective documentation procedures, including entry,

inventory and location control, documentation and collections audit and retrospective inventorying, recataloguing and retrospective indexing.

10.12 cooperative catalogues and indexes

The goal of cooperative or union catalogues and indexes was one of the spurs behind the interest shown in documentation during the 1960s (Section 2.16). There has been relatively little progress towards these aims within the United Kingdom, apart from projects such as the preparation of county-wide catalogues and the work of the Federation for Natural Sciences Collection Research to produce catalogues of collections and develop a type specimens list (Section 5.11). There has also been a preliminary proposal for a national inventory of Scottish archaeological collections (GB. SED, 1981).

As more museums automate their records, it is essential that compatible standards are adopted and data interchange facilities are prepared so that machine-readable data can be pooled to produce any required cooperative files. If the systems, advisory and computing resources are available it may then be possible to produce important new combinations of information for the museum community.

The MDA can play an important role in this work by acting as an advisor and link between individual museums. To carry out this role effectively and at reasonable cost, the Association will need to complement its existing resources with additional staff and computer systems. It is recommended that the Museums and Galleries Commission considers strengthening the funding basis of the MDA to enable it to develop its function as a coordinating computer unit for museums.

Appendix A:
Museum activities and documentation sources

Ai **Museum activities**
Aii **Documentation sources**

Appendix A includes a number of application of thesaurus concepts. The standard relationships used in these examples are:

BT	broader (or more general) term
NT	narrower (or more specific) term
RT	related term
SEE	refer to the alternative term for information
USE	use the alternative term noted
UF	use this term instead of the term noted

Appendix Ai:
Museum activities

The following concepts illustrate some of the varied activities which a museum supports with its available sources (see Section 3.4). The entry for each activity includes a note of any associated terms, a definition of the meaning of this term and a reference to any museum documentation system requirements that need to be fulfilled if the museum is to function effectively.

accessioning
 RT transferring of title & registering & acquiring
 definition: processing an acquisition into the museum collection
 mds requirements: access to information about the group being acquired
 and the reason it entered the museum; details of decisions concerning
 its acquisition

acquiring
 RT collecting & donating & purchasing & accessioning & transferring of
 title

definition: receiving a group of items (an acquisition) such that it is amenable to accessioning

mds requirements: the museum must be able to maintain a track of the location of the group while it is being processed and must ensure that a formal transfer of ownership title takes place and is fully documented

administering

RT organising & managing

definition: general procedures ensuring the efficient running of the museum

mds requirements: access to information concerning aspects of the collection such as location, valuation and donor

auditing

definition: assessment and evaluation of procedures for the management of the museum and its collections

mds requirements: access to descriptions of management and documentation procedures; access to documentation sources, including catalogues and inventories; access to the collections themselves; reference to details of stocktaking

bibliographic recording

SEE cataloguing

biographic recording

SEE cataloguing

cataloguing

RT describing & identifying & documenting

definition: preparing and maintaining detailed records of items in the collection or of interest to the museum

mds requirements: access to the details about an individual item and to all other items that might be relevant for comparative purposes (both within this collection and other collections); systems to process individual records into the form of an organised catalogue giving full details about all of, or a selected part of, the items in the collection

circulation controlling

RT inventorying & locating & moving & location controlling & movement controlling

definition: management of the circulation of items (particularly bibliographic material on loan to users)

mds requirements: maintenance of location control procedures and interface with library systems

collecting

RT selecting & acquiring & potential acquisition recording

definition: extending the current collection to include new items

164

mds requirements: detailed acquisition policy guiding the extension of the collection; appropriate methods for documenting items while they are being collected and for passing this information into the museum at the time of entry

collections management
BT management
RT curating
definition: the overall process of maintaining the collection
mds requirements: access to detailed information about the collection in a number of permutations; means of amending and preserving information

conservation recording
SEE cataloguing

conserving
RT preserving & examining
definition: procedures for the physical examination and treatment of the collection
mds requirements: access to detailed documentation about the object itself and any previous conservation; access to details of different conservation techniques and their effect on items in the collection; methods for aiding the assessment of documentation priorities; details of the environment of the building

curating
RT collections management
definition: general management of the collection
mds requirements: access to detailed records and means of preserving information within records

deaccessioning
RT disposing of items & exit recording
definition: the process of permanently removing an item from the collection
mds requirements: methods of extending records to indicate the final history within the collection of an item

depositing
RT entering
definition: leaving an item at the museum for identification, donation, etc.
mds requirements: mechanisms to control the entry of an item and note subsequent information accumulate during the presence of the item

describing
RT identifying & cataloguing & measuring
definition: the process of assigning a physical description to an item
mds requirements: access to details of comparable items

designing
 definition: preparing the brief for a new display, exhibition, etc.
 mds requirements: access to a description of exhibits

displaying
 RT exhibiting
 definition: procedures for the semi-permanent presentation of items from
 the collection to the public
 mds requirements: methods for assessing the range of the collection when
 deciding on items to display; maintenance of location control when the
 item is moved to and from display

disposing of items
 RT deaccessioning & exit recording
 definition: deaccessioning items from the collection
 mds requirements: ability to extend records to indicate final history of an
 item within the collection; details of the range of items in the collection
 as a guide when assessing potential for disposal

documenting
 UF recording
 definition: the overall process of documenting a collection
 mds requirements: availability of system overview and procedural
 manual; access to details of all items in the collection and relevant
 items elsewhere, to all historical and curatorial files and to relevant
 references

donating
 RT acquiring
 definition: passing a group of items to the museum for acquisition as a gift
 mds requirements: mechanisms for accumulating basic information about
 the group and its acquisition

educating
 definition: assisting visitors with learning about the collection
 mds requirements: access to full documentation about the collection and
 to the collection itself

enquiring
 RT referring
 definition: placing questions concerning the collection or other items of
 interest to the enquirer
 mds requirements: details of current collection for reference and
 comparison purposes

entering
 RT depositing & loaning-in & entry recording
 definition: passing a group of items into the museum

mds requirements: mechanisms for accumulating basic information about the group and controlling its entry

entry recording
RT depositing & entering & loaning-in & movement controlling & location controlling
definition: processing a group or an individual item into the museum
mds requirements: mechanisms for accumulating basic information concerning the group and its component items and the reason why it has entered the museum; procedures for maintaining a track of its movement immediately after entry

estimating
RT financial management
definition: assessing the potential cost of proposals

event recording
SEE cataloguing

examining
RT conserving
definition: assessing the physical state of an item
mds requirements: methods for recording information about the state

exhibiting
RT displaying
definition: procedures for the temporary displaying of items
mds requirements: methods for assessing the range of the collection when deciding on items to display; maintenance of location control for both acquired items and loans

exit recording
RT deaccessioning & disposing of items & loaning-out & movement controlling & location controlling
definition: processing an item out of the museum on a temporary or permanent basis
mds requirements: mechanism for maintaining location details and exit procedures

field recording
definition: documenting items or localities outside the museum
mds requirements: methods for recording information and passing this information to the museum (for both acquired and non-acquired material)

financial management
BT managing
RT estimating
definition: the overall process of managing the finances of the museum

group recording
SEE cataloguing

identifying
RT describing & cataloguing
definition: process of naming and describing items
mds requirements: access to details of comparable items within both this and other collections; access to references describing comparable items

indexing
definition: preparing and maintaining directories acting as guides to the information about the collection
mds requirements: access to catalogue details; systems to manipulate catalogue entries into different orders and forms

information retrieval
UF selective retrieval
definition: retrieval of selective details about items from the available documentation
mds requirements: access to details of items in different permutations

insuring
definition: financial protection against loss of the collection or its environment
mds requirements: access to detailed records of insured items subsequent to loss; methods for valuation control and stocktaking; mechanisms for protecting the documentation itself such that it is available after damage to the building

interpreting
definition: exploitation of the collection
mds requirements: access to detailed records (via indexes) and to current location

inventory controlling
RT inventorying & location controlling
definition: management of essential control details about the ownership and location of items in the collection
mds requirements: maintenance of inventory details

inventorying
RT inventory controlling & retrospective inventorying & circulation controlling & locating & moving
definition: preparing and maintaining an active guide to the collection and its location
mds requirements: access to basic details of acquisitions and maintenance of subsequent changes to these details (such as storage location)

item recording
 SEE cataloguing

labelling
 definition: associating a label with an item
 mds requirements: ability to produce a label as an abstract of the available documentation

lecturing
 definition: presentation of information
 mds requirements: knowledge of, and access to, the collection

loaning-in
 RT entry recording
 definition: process of managing items entering the museum on loan from another institution
 mds requirements: maintenance of standard acquisition procedures and special loan procedures governing loan-period, security, etc.

loaning-out
 RT exit recording
 definition: process of managing items leaving the museum on loan
 mds requirements: maintenance of location lists; management of loan procedures governing loan-period, etc.

locality recording
 SEE cataloguing

locating
 RT inventorying & location controlling
 definition: procedures for finding items in the collection
 mds requirements: access to location lists detailing storage location of collection and stock lists of collection

location controlling
 RT locating & inventory controlling & movement controlling & entry recording & exit recording
 definition: management of details about the location of items in the collection
 mds requirements: maintenance of location details

maintenance
 definition: general support of museum facilities

managing
 NT collections management & financial management
 RT administering & planning & organising
 definition: general procedures concerning the direction of the museum
 mds requirements: access to accurate and comprehensive information concerning all aspects of the museum and its collections

marking
> RT numbering
> definition: affixing a number on an item
> mds requirements: maintenance of accurate numbering procedures

measuring
> RT describing
> definition: describing the dimensions of an item
> mds requirements: facilities for recording details of the measurement

movement controlling
> RT moving & circulation controlling & location controlling & entry recording & exit recording
> definition: management of the movement of items within the museum and to outside agencies
> mds requirements: maintenance of current location details

moving
> RT movement controlling & circulation controlling & inventorying & locating & storing
> definition: transferring an item from one location to another within the museum or to another institution
> mds requirements: effective inventory and location control

numbering
> RT marking
> definition: assigning a number to an item
> mds requirements: maintenance and security of accurate numbering procedures

object recording
> SEE cataloguing

ordering consumables
> definition: general stock support

organising
> RT administering & managing
> definition: general procedures concerning interrelationship of structures within the museum

photograph recording
> SEE cataloguing

photographing
> definition: procedures for the photographic reproduction of aspects of the collection or the building
> mds requirements: maintenance of photographic records and annotation of object records with details of photographs

planning
RT managing
definition: developing proposals for the future of the museum
mds requirements: access to details about the collection

potential acquisition recording
RT collecting
definition: a provisional form of documentation for an item that might be appropriate for acquisition (prior to a decision concerning acquisition)
mds requirements: methods for recording and passing information to the museum

preserving
RT conserving
definition: procedures for the physical preservation of the collection
mds requirements: access to documentation about the object and any previous preservation, and about preservation techniques

process controlling
definition: management of processes within the museum

progress controlling
definition: management of the progress of projects, such as the documentation of collections
mds requirements: maintenance of progress information within the documentation system

promoting
definition: exploitation of the museum and its collection
mds requirements: access to documentation

publishing
definition: dissemination of information concerning the collection via publications
mds requirements: access to detailed documentation of collections within the museum and elsewhere; methods for extracting information from the documentation in a form suitable for publication

purchasing
RT acquiring
definition: passing a group of items to the museum for acquisition as a purchase
mds requirements: mechanisms for accumulating basic information about the group and its acquisition

recording
USE documenting

referring
RT enquiring

definition: making reference to the collection

mds requirements: availability of detailed catalogues and indexes concerning the collection

registering

RT accessioning & inventorying

definition: processing an item into the museum's documentation (often regarded as synonymous with accessioning, but can be considered as a distinct documentation activity)

mds requirements: access to information accumulated when the item entered the museum and any subsequent additional details

researching

definition: extending and consolidating knowledge of the collection and related items

mds requirements: access to full documentation of the collection and of collections elsewhere

retrospective inventorying

RT inventorying

definition: reprocessing a collection as the basis for a new inventory

mds requirements: access to existing documentation and location details

security

definition: protection of the building and its collection

mds requirements: availability of stocktaking records, valuation details, etc.; mechanisms for protecting the documentation from threat; methods for securing the documentation from unauthorised access and use

selecting

RT collecting

definition: assessing items for suitability for inclusion in the collection

mds requirements: availability of acquisition policy and access to details of current collection strengths and weaknesses

selective retrieval

SEE information retrieval

selling

definition: commercial activities of museum

staffing

definition: the curatorial, assistant and warding staff concerned with the work of the museum

stocktaking

definition: the process of checking the location of the museum collections to ensure their continuing security and preservation

mds requirements: availability of details of stocktaking procedures; access to the collections themselves and a comprehensive inventory arranged in location order

storing
RT moving & displaying
definition: procedures for the physical arrangement of the collection
mds requirements: maintenance and availability of location lists and details of specific requirements for individual items

transferring of title
RT accessioning & acquiring
definition: arranging and implementing the transfer of ownership of a new acquisition to that of the museum
mds requirements: means of preserving transfer details

utilising
definition: making use of an item or its documentation
mds requirements: access to effective indexes to the collection

valuation controlling
RT valuing
definition: management of details about the value of items
mds requirements: maintenance of valuation information

valuing
RT valuation controlling
definition: procedures for the valuation of items in the collection
mds requirements: access to previous valuations; methods for preserving details of new valuations; mechanisms for the automatic revision of valuations

visiting
definition: procedures for members of the public, researchers, etc., to view the collection or consult the staff of the museum
mds requirements: ability to respond to queries concerning the collection

Appendix Aii:
Documentation sources

The following entries illustrate the range of documentation sources for different types of material (see Section 3.4). They include a definition of the use of each term, the standard form in which the source is normally found, its relationship to other sources and its primary function within the overall system.

acquisition source
> UF register
> definition: details accumulated during the processing of a group of items into the collection, including transfer of title, acquisition and entry details
> typical physical form: envelopes in accession number order (one envelope for each acquired group) and bound register with brief manuscript entries (one entry for each acquired group)
> preceded by entry source
> related to transfer of title source & inventory & location source & store source
> followed by item source
> used as primary source about acquired groups

bibliographic source
> UF information source
> SEE item source

biographic source
> UF information source
> SEE item source

catalogue
> definition: the core information known about all of, or a selection of, the items in the collection, arranged in a convenient standard order
> typical physical form: record cards, printed entries or computer file arranged in classified order; one entry for each item
> preceded by item source
> related to indexes
> used as primary source about the collection and its constitutent items during all activities

conservation source
> SEE item source

entry source
> UF loans-in source

definition: details accumulated during the entry of a group of items into the museum

typical physical form: envelopes and entry record sheets in entry number order; one envelope and one sheet for each discrete entry

preceded by locality source or potential acquisition source

related to inventory & location source & store source

followed by acquisition source

used as primary source about group

event source
UF information source
SEE item source

exit source
UF loans-out source

definition: details of items from the permanent collection that are currently absent from the institution

typical physical form: envelopes and exit record sheets in exit number order; one envelope and one sheet for each exit

related to inventory & location source & store source

used as primary source for controlling items leaving the museum

field record source
USE locality source

indexes
definition: sources acting as a directory to one or more aspects of information for all of, or a selection of, the items in the collection, arranged in alpha-numeric order

typical physical form: simple index cards, printed entries or computer file, in alpha-numeric order; may include zero, one, or more than one entry for each original item

preceded by item source

related to catalogue

used as primary sources about the collection and its constituent items during all activities

information source
USE bibliographic source & biographic source & event source

inventory
UF register

definition: source of basic current details about each item within the museum (both acquisitions and long-term loans-in) or owned by the museum (loans-out, etc)

typical physical form: as part of a register or as simple index cards or computer file in item number order; one entry for each item

related to location source & store source & entry source & acquisition source & item source & exit source

used as primary source for location control and stocktaking

item source

NT object source & locality source & photograph source & event source & bibliographic source & biographic source & conservation source

definition: all known information, or pointers to the information, concerning items in the collection or of interest to the museum

typical physical form: individual summary record (on record cards or sheets, printed entries or computer file) and supplementary information source (in envelopes), in item number order; one record and one envelope for each item

preceded by acquisition source

related to inventory & location source & item source

followed by catalogue and indexes

used as source for development of catalogue and indexes

note: general term for various types of item source, including those for objects, localities, photographs, conservation, and information about events, bibliographic items and people

loans-in source

USE entry source

loans-out source

USE exit source

locality source

UF field record source

SEE item source

location source

definition: source of basic location details about each item within the museum or owned by the museum

typical physical form: index cards or computer file, in item number order; one entry for each item

related to inventory & entry source & acquisition source & item source & exit source & store source

used as primary source for location control

object source

SEE item source

photograph source

SEE item source

potential acquisition source

definition: details of groups that might be acquired

typical physical form: envelopes in subject order; one for each potential acquisition
followed by entry source (in the case of acquired groups)
used as primary source about groups

record
 SEE item source

register
 USE acquisition source or inventory

store source
 definition: comprehensive or selective source of basic details about the items stored in each part of the museum
 typical physical form: index cards or computer file, in location order; one entry for each item
 related to inventory & entry source & acquisition source & item source & exit source & location source
 used as primary source for stocktaking

supplementary information source
 SEE item source

transfer of title source
 definition: details concerning the transfer of ownership to the museum of an acquired item
 typical physical form: envelopes and transfer of title record sheet in transfer number order; one envelope for each acquisition
 related to acquisition source
 used as evidence concerning ownership

Appendix B:
Documentation assessment

B1 Introduction

This self-contained appendix may be used as a guide when undertaking an internal reassessment of current documentation procedures. It includes sections considering the general and specific form and use of the documentation system for various types of material of interest to the museum. Advice on the assessment methodology is given in Section 9.

The checklist is paralleled by Appendix Di and ii, which use a similar sequence as a basis for a review of current practice in a number of United Kingdom museums.

B2 Museum framework

B2.1 Management

(a) museum organisation

(See B3.1 for documentation organisation.)

Review the internal organisation of the institution, such as its arrangement into separate departments or buildings, to identify influences on the arrangement of the documentation procedures. For example, in a centralised museum it may be possible to concentrate documentation sources in one place, to have a unit with primary responsibility for the management of the system, to have uniform procedures and standards of vocabulary for all collections and to have an agreed balance of resources corresponding to the relative importance to the museum of the different stages of documentation. In a fragmented museum it may be necessary to delegate some or all of the aspects of documentation to a departmental level (such as arrangements for the entry of material into the care of the museum, acquisition and numbering procedures, cataloguing, indexing, responding to enquiries and maintaining location details).

In either case, consider whether an effective balance has been achieved between procedural convenience and overall management requirements. If acquisition procedures and numbering are carried out centrally does this cause delays and complicate the procedures. Conversely, if entry arrangements, acquisition procedures and numbering are carried out locally, are there controls to ensure the proper authorisation of new acquisitions, the preparation of formal acquisition records and the production of security copies, and are steps taken to prevent conflicts in the assignment of numbers in different departments? If there is no central register, does this hinder management in its accountability for the collections and the implementation of auditing procedures?

Are central staff sufficiently aware of local requirements to maintain effective acquisition registers and inventories, or do these become outdated by departmental changes. Are departmental staff sufficiently skilled for the documentation work they are expected to undertake, are these skills being fully used or under-exploited and would some central expertise be a more efficient approach? Is the training of departmental staff in the procedures needed to maintain and develop the system undertaken on a museum-wide basis or duplicated within individual departments?

Are there marked differences in the level of resources allocated to documentation by the various departments, after taking into account factors such as the size, growth rate, importance and standard of curation of their collections? Have the procedures in individual departments always been distinctive, gradually evolved from a common basis to now be distinctive or retained an original close similarity of approach? If distinctive, are the differences genuine reflections of local requirements, such as curatorial

practice in the natural sciences compared with that in fine art? If two or more departments do have a common origin, has this had a lasting effect on their documentation system, such as a close similarity of approach or a heritage of combined acquisition registers? Does any one department have adequate access to relevant information elsewhere, such as a curatorial department referring to other curatorial files, to conservation, photograph, bibliographic and archive records, or a conservation department referring to curatorial and bibliographic records? Are any of these organisational problems accentuated by a dispersal of the institution into separate buildings? Has geographical isolation placed additional demands on the system (such as the need for parallel acquisition arrangements and duplicate sets of catalogues and indexes), requiring a greater degree of both independence and coordination than in the case of a single building? Overall, is the benefit derived from the independence of a procedure greater than or less than the resources invested in the mechanisms required to ensure its adequate coordination?

(b) organisational change

Examine the potential impact on the present documentation system of any plans to change the organisation of the museum, such as by opening a new building, setting up a new department, moving and rearranging an existing department, closing down an existing building or consolidating the present departmental arrangement. Will a plan to open a new building or develop a new department result in:

> additional documentation staff and training requirements;
> the need to support, monitor and integrate into the overall system a new accessioning and numbering centre;
> the need to prepare an extra set of catalogues and indexes for use by isolated staff;
> the need to undertake a physical inventory of an existing collection before dispersing it to two departments, so that the staff of each can accept responsibility for their inheritance with an assurance that it has been itemised;
> the need to monitor the movement of items during their relocation;
> the need to prepare new location indexes to reflect the reorganised collections.

Similarly, a plan to close an existing branch or department may result in:

> the need for an inventory of its collections before they are consolidated into other departments;
> the need to extend the catalogues, indexes and location details held by these other departments and the long-term need to provide additional staff to support the greater collections in the recipient departments.

Have documentation implications such as these been taken into account

when planning a change? If not, should the existing planning process be extended to include such aspects?

(c) parent organisation

Consider whether the position of the museum within its broader organisational framework has any implications for the development of documentation. Is the museum able to turn to staff in its parent organisation for advice about this system assessment and any subsequent system design, for guidance on the impact of new technology or for legal assistance with aspects such as the wording and use of formal transfer of ownership documents and rules governing the disposal of objects left as enquiries that have not been collected by their owner? Similarly, does the organisation have any major equipment that could be used by the museum, such as a computing system.

(d) museum environment

Consider the environment of the museum to assess whether the documentation system is making optimum use of the available space and layout. If documentation sources are held at a central location, is this readily accessible to all authorised staff, with space for research and appropriate equipment (photocopiers, microfiche readers, computer terminals, etc.)? Similarly, within individual departments is there adequate space and facilities in appropriate areas (stores, work rooms, enquiry office, etc.) to allow the most effective use of resources? Are physical parts of the system, such as the current registers and blank record cards, readily available for use? Are the resulting records stored in an area with suitable environmental conditions, protected from decay, with appropriate security provisions, such as a fire-proof safe for registers, and with control over access by unauthorised persons? If an inhouse computer system is being used, has adequate allowance been made for its environmental impact, by isolating heat-generating processors and noisy printers from staff work-areas and by providing temperature-controlled dust-free storage areas for magnetic tapes, magnetic discs, etc.

(e) environmental change

Have the present and future environmental requirements of the documentation system been taken into account when designing any new buildings or planning a substantial reconstruction of part of the existing museum? In the case of present needs, has suitable space been allowed for document preparation, storage of sources, etc.? When planning for future needs, has allowance been made for the use of automated systems within individual offices and work areas, such as the provision of ducts suitable for carrying cabling and the designation of areas suitable for eventual use as computer rooms?

(f) museum priorities

Consider the main priorities of the museum and whether the documentation facilities are appropriate to these priorities. For example:

if an emphasis is on research, are there methods for adding newly-discovered information to existing catalogue records and are those records readily available for consultation, with appropriate indexes and retrieval methods;

if an emphasis is on preparing circulating exhibitions, are there procedures for managing and monitoring the loan of material into and out of the museum;

if dealing with the identification of objects for members of the public is an important feature, are there adequate procedures for logging-in deposited material in the absence of the relevant curator?

Are there any plans to redirect the priorities which might affect the future development of documentation, such as partial withdrawal of an identification service, the expansion of a loan scheme or the introduction of a new conservation facility?

(g) enquiries

Is answering enquiries from the public, researchers, etc., considered to be a relatively minor or an important part of the work of the museum? Is the existing documentation system able to give effective help when the museum is preparing a response, such as by providing indexes or information retrieval sources?

Has any attempt been made to monitor the enquiries and assess their number, frequency, origin, range, the type of response required, the staff time and level of expertise and the type of sources needed to accomplish this response? If not, would it be feasible to mount such an evaluation?

Are enquiries coordinated by a central unit which needs access to sources about all the collections and information in the museum, or are they dealt with by individual departments using the internal departmental sources? Do all identifications require direct staff assistance or are there publically-available sources to deal with some of the problems? If sources were more readily available, without confidential information and in an appropriate form, would the public be able to answer a greater proportion of questions without the assistance of staff? Are most questions straightforward and easily answered from available sources or are they complex and time-consuming? Is it possible to answer typical questions by referring to the object documentation of one department or do sources from different departments have to be consulted, in which case would combined indexes or retrieval facilities be useful? Are questions frequently more broad ranging (needing a response based on the details of objects, people, places, etc., available within the museum's various files), requiring a documentation

approach which concentrates not only on the objects in the collection but also on more general information analysis?

B2.2 Resources

(a) museum staff

(see B3.2 for documentation staffing)

Summarise evidence and impressions about the permanent staff of the museum that might be helpful when deciding how to proceed with the development of documentation, such as information about the number and general functions of staff in each department and details of individuals with potentially useful experience who have indicated that they might be able to contribute to developments (experience may include knowledge of documentation systems in other museums, libraries or archives in which they have worked, familiarity with the documentation approach of different departments in this museum, or an interest in the use of computer systems). Does the sophistication of the documentation system match the abilities of museum staff? For example, if the present system is complex, is it being well maintained by staff with extensive relevant experience and training (and could it be further developed?) or is it in danger of collapsing due to inappropriate staff skills (in which case, should it be simplified?). In consideration how to plan for the future, is the museum able to draw upon staff with aptitudes that might be appropriate to a more demanding system, such as an inhouse computer cataloguing system with limited 'user-friendly' features, or is one of the strengths of the museum its support staff who might be able to play a more active role in maintaining basic sources, such as location indexes?

Investigate how much help has been received from staff within the museum's parent organisation. Does that organisation have expertise in areas such as system analysis, system design and computing systems? To what extent would the museum be able to benefit from any expertise, both during this assessment (such as by calling in advisers to help with the process) and in the longer term (such as by receiving help with computer programming)? Similarly, consider whether help might be available from an outside agency, such as an AMC, the MDA or a commercial organisation, which may have developed expertise or services in relevant fields. Has the museum received any other major temporary help in recent years, such as school-leavers or graduates on Manpower Services Commission (MSC) schemes and, if yes, with what type of work have they been involved? If there are any documentation projects for which a temporary scheme might be appropriate, investigate the attitude of relevant trade unions and the local MSC office, and consider experience gained during any earlier projects.

In the case of the museum staff, consider whether there are future staff trends which may have an impact on the documentation system and which should be taken into account when planning its development, such as:

financial pressures resulting in fewer staff and a decline in job mobility;
gradual increases in seniority of existing staff resulting in a disinclination
to undertake routine clerical tasks like the manual preparation of index
entries;
greater relevant experience and qualifications of incoming staff due to a
growing familiarity with system and automation concepts in museums;
higher expectations of incoming staff due to a greater degree of pre-
service training.

Similarly, in the case of the parent organisation, outside agencies and other
museums, investigate whether there are likely to be major changes of policy
that would affect the provisions of assistance to the museum.

(b) equipment

(See B3.2 for documentation equipment.)

Consider the museum investment in equipment and the effect of this
approach on the resources available as part of the documentation system.
Have equipment purchases been restricted to occasional minor acquisitions
or is there a history of a gradual build-up of facilities? Are activities such as
documentation supported by adequate filing and storage systems and access
to duplicating facilities? Have any inhouse automated systems been
introduced or been proposed as a future investment, to aid research, for con-
servation analysis, environmental and security monitoring, administration,
financial control, stock control, publication, word processing, object control,
cataloguing and indexing, bibliographic circulation control, archaeology
excavation analysis, natural history site assessment, etc.? Has the intro-
duction of any one automated system been done in isolation from other
interests, such as a word processing system being acquired only to help in
the preparation of educational material, rather than as part of an overall
plan? Are any of the non-documentation systems of relevance to the devel-
opment of documentation itself, such as a research-orientated computer
having the potential to act as a cataloguing aid? Conversely, could an auto-
mated documentation system also be of use for publication and word
processing purposes?

Is the primary responsibility for automated systems at a departmental
level or does one person have overall authority to advise on and coordinate
technological assessments? If at a departmental level, is there anyone in the
museum with expertise in evaluating automated systems that might be of use
to documentation, such as a publication manager who has recently assessed
the use of microcomputers for the data entry of text? Conversely, can
expertise gained while considering documentation systems be of value to
staff concerned with other activities, such as advising an administrative
officer on the word processing capabilities of microcomputers?

Can staff in the parent organisation or an outside agency such as the
MDA or CCTA make a contribution to these evaluations by providing

expert technological advice? Does the parent organisation maintain or plan to acquire any systems that might be of use to the museum, such as a major online computer processing facility or a distributed word processing network, that might remove some of the need for the museum to invest in inhouse equipment and expertise? Does the AMC have equipment such as a data entry microcomputer that might be of help? Would the data entry and processing facilities provided by the MDA or some commercial bureaux be useful in the early stages of investing in automated equipment, or as a long-term backup to reduce the need for specific equipment, such as a magnetic tape unit or the ability to sort large files?

(c) funding

Before coming to any conclusions about the development of the documentation system, take into account the financial position of the museum to judge the scale of funding that might be available in the future. Have plans already been put forward for other schemes which would affect the availability of funds for any new documentation system? Would the museum be more able to consider funding a computer system on the basis of a regular capital outlay rather than a larger single investment? Consider sources of funds other than the museum's regular financing bodies. For example:

MSC schemes include the provision of consumables and a basic equipment contribution which might be used to build up elements of a system such as a data entry microcomputer;
the AMCs can assist their members with the purchase of consumables and certain items of equipment;
exceptional developments might be appropriate for research funding;
a new system might be suitable for business sponsorship, such as the acquisition of a microcomputer produced by a local firm.

B2.3 *Collections and information*

(a) object and non-object collections

Review the staffing, current size, average growth rate, acquisition policy and any specialised curatorial approaches for each object collection in the museum. (Distinguish between object, bibliographic, archive and audio-visual collections (excluding both non-historical museum files and record photographs).)

Consider whether the documentation procedures used to support each collection are appropriate to its particular needs. Are the collections sufficiently similar to allow a common documentation approach to be adopted or are there marked differences resulting in specialised documentation approaches? For example:

a well-staffed department with a small paintings collection and few new acquisitions may have been able to concentrate on detailed cataloguing,

using relatively basic acquisition procedures, preparing only basic indexes since staff are thoroughly familiar with all aspects of the collection, but needing specific location control systems due to the high security risk and comprehensive loan management procedures due to the frequent demands for material to be sent to other institutions;

an archaeology or natural history department with a high acquisition rate may have had to implement simple acquisition and cataloguing procedures, dealing with the bulk of material on a general basis, preparing group records with common information about the type and location of the items, concentrating effort on the development of basic indexes and location procedures; another archaeology department with a low acquisition rate may be able to divert more effort to backlog recataloguing until the time when the rate increases;

a collection whose primary interest is to reflect the local heritage may need to be supported by comprehensive personal and place name indexes, another, whose value is its broad-ranging cover, may be served by a well organised object name index while a third, whose role is as a specialised research tool, may require detailed classified taxonomic name and collection place name indexes.

Have exceptional documentation procedures been introduced for any limited parts of a collection, such as the high-value portion of a paintings collection requiring more comprehensive location control procedures than the less valuable material, or the type specimens within a large natural science collection requiring more detailed cataloguing and loan procedures than the majority of specimens?

Are there any long-term developments which are likely to affect the documentation requirements of each collection, such as:

a plan to build up a major social history collection from the present small nucleus in response to new research priorities or a display programme, resulting in considerable additional accessioning, cataloguing, indexing and location control pressures;

the indefinite freezing of a staff post following a retirement, resulting in a need to concentrate the remaining staff effort on new accessions and basic control procedures;

a decline in the acquisition of prints and drawings due to limited purchase funds and increased prices, or a decline in the acquisition of natural history specimens due to environmental protection laws, resulting in the opportunity to change emphasis from accessioning to indexing;

an increased requirement for indexes due to greater demands for use of a geology collection following the publication of its first catalogue?

Undertake a comparable review of any non-object collections in the museum (bibliographic material, archives and audio-visual material), considering how the documentation requirements compare with or differ from those for objects. Are the collections managed by specialist staff with

expertise in these areas or are they in the care of curatorial staff with object-orientated training? Are there any exceptional features creating documentation problems, such as the size and rapid growth rate of a photograph collection resulting in cataloguing and indexing pressures on the staff available for its management?

(b) collection growth

For all types of collection, the growth rate can be a crucial factor when deciding on any documentation developments, particularly as any change may need to be introduced over a long period. What will be the size of each collection in 10 and 20 years, if anticipated trends prove correct? (A growth rate of 2% per annum will result in a doubling of the collection size in less than 35 years.) Consider the impact on the documentation system of the expected long-term growth rate, in terms of accessioning, cataloguing, indexing and control pressures, manual and computer storage requirements, staff requirements, etc. If the growth rate is negligible, will it be possible to concentrate on areas such as backlog recataloguing rather than accessioning and cataloguing new items? If substantial, will all available effort have to be devoted to basic accessioning for the foreseeable future? In such a circumstance would it be possible to sustain any new commitments, such as additional indexes, or would they have to be abandoned in the face of the pressure from collection growth? While improving the quality of documentation or introducing more efficient procedures for new acquisitions may have a negligible effect on the overall standard and efficiency of the system if the growth rate is 0.2% per annum, it would make a major impression if the growth rate is 20% per annum.

(c) display and storage

What proportion of the collections is on display to the public? Are the items in 'permanent' displays fairly static or frequently changed? Are the documentation requirements of the material on display different from that in store? For example, if the displays are only a small proportion of the total collection, there may be a requirement for additional catalogues and indexes of the stored material to help make it accessible to the public.

Is material in store held in one building or in the museum and various outstations? Is it held as one unit or as separate sets for each collection? Is store management the responsibility of a single section such as conservation, technical services or registration or of individual departments? Are items moved within and between stores by departmental staff or a specialist working party?

How are the collections themselves organised in the stores? Consider the effect that these storage arrangements have on documentation requirements. For example, stores dispersed in outstations or in the care of a special unit may need more formal movement control arrangements than those under

departmental care. A classified storage organisation may reduced the pressure for one type of index but increase the need for others, such as in the case of a palaeontology collection arranged in geographical and strati-graphical sequence requiring a taxonomic index while another arranged in taxonomic sequence depends on a geographical index; or an archaeology collection arranged by type of material may need a place name index while another arranged by site may need a material index.

(d) conservation documentation

If the museum has a conservation department, consider the implications which this has for the documentation system. If the department keeps separate records about the collection, what is their relationship to the curatorial records? Does the department have copies of, or easy access to, the curatorial records? How many items does the department process in a year? Is the future growth pattern likely to place new pressures on docu-mentation procedures? Does movement of material to and from conserva-tion place extra demands on movement control procedures? If the depart-ment does work for outside museums (for example, as an agency for an AMC), does this place new requirements on the entry procedures used by the museum? Conversely, if this museum uses an outside agency for its conservation, does it need additional procedures for noting details of the external processing and managing the movement of items to and from that agency.

(e) record photograph documentation

Are record photographs of the collection held within individual departments or on a central basis? How many are available and what is their growth rate? How are they arranged? Are they held for security and insurance reasons (as evidence after a loss from the collection) or for sale to the public? Does the approach adopted affect documentation procedures, such as by resulting in the need to record a link between individual items and their photographs?

(f) information documentation

If the museum has separate information assets not directly concerned with the physical object and non-object collections, such as biographical, event and locality information, review the range, scale, growth pattern, resources and organisation of the material, and consider its implications for the docu-mentation system. Is it held within the individual departments or on a central basis? How important is its role in helping the museum to answer enquiries? Are members of the public able to use it independently or only through an intermediary? Does the system provide links between this infor-mation and the physical collections themselves?

B3 Documentation framework

B3.1 Documentation management

(a) coordination of documentation

Note whether a committee or an individual has a formal responsibility to coordinate aspects of documentation. If there is a committee, does it include representatives of all departments, staff functions and interests concerned with documentation? Does it include any outside representatives or advisers, such as a systems expert from the parent organisation? Does one or more of its members act in an executive capacity, able to devote time to investigations on its behalf? What is its position within the organisational structure of the museum, who was responsible for initiating its formation, who has established its terms of reference and to whom does it report? Are its terms of reference concerned with a specific short-term function or a long-term role, and what was its date of formation and expected life-span? What is its role: does it include undertaking this assessment, planning a particular system change, considering the introduction of automation, reviewing documentation policy, coordinating the resources devoted to documentation or directing the emphasis of procedures? How effective has it been in concentrating attention on documentation problems, introducing any changes and improving procedures?

If, instead of a committee, an individual is responsible for the coordination, note the person's role and effectiveness. What is the person's permanent function within the museum? Is this coordination a major or minor part of the permanent work-load? Who has initiated the coordination, what authority does the individual have to undertake the coordination and to whom does the person report any outcome? What is the relationship of the assessment to the coordinating work?

If neither a committee nor an individual is responsible for the active coordination of documentation, is there a need for such management and by what authority is this assessment being undertaken? In the absence of any coordination, how is a change of procedures implemented, how are standards maintained and how is effective use made of resources?

(b) documentation policy and priorities

What is the present documentation policy and priorities of the museum? For example, there may be a policy to upgrade all records to a new standard as a basis for publications about the collections, to introduce new procedures to aid the security of the collections or to adopt a more positive approach towards coordination and planning. There may be an emphasis on one or more aspects of documentation, such as basic accessioning of current acquisitions, cataloguing new acquisitions, recataloguing material acquired in the past, the preparation of indexes, improving location control or loan management or the introduction of a revised system. Are there any existing

plans to redirect the current policies or priorities? If there are, review the basis for these plans during the course of the assessment.

(c) implementation of documentation procedures

Is the practical implementation of each documentation activity (such as entry control, inventory control, cataloguing, indexing, location control and loan management) carried out on a central basis or within individual units (departments, sections, etc.)? If there is any diversification into individual units, at which points in the documentation procedure does this occur? For example, there may be a central approach to all activities except cataloguing and location control, there may be a single central entry procedure and loan mechanism with local processing of acquisitions or all activities may be implemented at a departmental or sectional level.

Of the individual units within the museum, review the degree of involvement of all those that make a direct contribution to the development of documentation, such as collection-holding departments and their components, any conservation unit, photograph unit, documentation or registration unit, enquiry or information unit, administration and technical support services. For each unit, summarise the impact on documentation of its internal organisation and environment, such as the availability of staff and adequate space for the preparation and filing of sources, note the sources (registers, catalogues, etc.) for which it is responsible and outline the role it plays in each major documentation activity.

In the case of collection-holding departments, note whether they undertake all relevant activities on a departmental basis or whether certain work is concentrated within individual sections. For example, acquisition procedures may be carried out at a departmental level while cataloguing and location control is a sectional responsibility.

In the case of a registry within administration, note whether it takes an active or a passive part in documentation work. For example, an active registry may monitor progress and bring forward to the attention of the relevant officer the need for the completion of a particular task, such as the return of a loan or the finalisation of acquisition formalities, while a passive registry may be restricted to acting as an archive for deposited papers. Similarly, if there is a separate inventory unit, note whether it is active or passive. An active inventory may keep track of the movement of items between departments or on long-term loan to other institutions, while a passive inventory may just note initial details of new acquisitions.

If there is a documentation or registration unit, outline its function as part of the overall documentation framework. What is its role in areas such as the practical implementation of general procedures (for example, object accessioning and location control), the documentation of specific physical collections or sets of information (for example, an audio-visual collection and biographical or event records), the provision of background advice and training within other units, system planning, design and support, the

maintenance of standards and undertaking procedural and technology assessments? For example:

such a unit may concentrate on advisory work, system development, standarisation and assessment roles and not be responsible for carrying out any recording itself;

it may complement the advisory role by having specialist cataloguers who can be seconded to individual departments to provide short-term assistance with particular projects;

it may also be in charge of the day-to-day development of a particular collection or set of information;

it may have a registrarial role, concerned with formal aspects of the accessioning of all acquired objects and the maintenance of location details, complementing or replacing the role of a separate inventory unit.

B3.2 Documentation resources

(a) permanent staff concerned with documentation

Review the permanent staff resources devoted to documentation in each of the units within the museum that are concerned with documentation developments. This review should establish the basis for an assessment of the overall scale and effectiveness of the current permanent staff investment in documentation. For each person, consider aspects such as:

the approximate proportion of their time spent on documentation work (including preparation, background research, filing, system analysis, design and maintenance, training, etc.);

their relative contribution to clerical and intellectual tasks (for example, routine location control or filing as compared with research or system design);

their grades and expertise;

relevant experience and training before joining the museum (for example, familiarity with automated systems);

their degree of specialisation (for example, as cataloguers and system designers).

Have there been any problems in finding and retaining suitably qualified staff for documentation work (perhaps due to a shortage of candidates with appropriate cataloguing or computing skills, salary levels lower than those of comparable positions in industry and other types of museum, or the lack of attraction of a particular job)? If there have been problems, have they had a serious effect on progress in developing documentation, have they resulted in any change of procedure or priorities and have they now been overcome?

Is the current staffing adequate to manage the workload or are there serious shortages? Are there any particular problem areas or imbalances,

such as insufficient cataloguers leading to a growing backlog of new acquisitions to process, or too few support staff to maintain indexes and location lists.

Is the most effective use being made of the available expertise? For example, are junior support staff being expected to undertake work for which they are untrained and ill-prepared, with the result that it is carried out inefficiently and inaccurately; conversely, are senior curatorial staff having to undertake basic index preparation, location control and routine filing, with consequent pressures on more demanding activities and a growing feeling of disenchantment? Does each person with a critical function have a backup with sufficient relevant expertise to be able to ensure continued basic support of the system in the event of holidays, illness, resignation, etc.? For example, is more than one person allowed to assign accession numbers, complete acquisition formalities, change location details or authorise the departure of a loan from the museum and is more than one person familiar with the procedures for maintaining each automated aspect of the system (in association with any outside experts who should be available to provide more detailed technical assistance)? If there is no immediate backup to support critical functions, has the museum identified the acceptable period during which the function can be sidestepped or delayed (such as two weeks before the assignment of a new accession number) or has it established alternative procedures as a fallback mechanism (such as a parallel manual system to duplicate automated retrieval procedures)? Consider the effect on future plans of the available staff expertise and future staff trends.

(b) temporary staff concerned with documentation

Consider the role of any temporary staff that have been concerned with documentation developments in recent years. Has the museum had any relevant staff on a volunteer basis, on secondment or placement (such as from the University of Leicester Department of Museum Studies), on short-term contracts or on job creation schemes (such as MSC projects)? In each case, review the scale of the investment by both the museum and any outside funding agency:

> how many staff have been involved;
> what was the duration of the project;
> what proportion of the time was concerned with documentation;
> what skills have the staff contributed to the museum;
> with what type of work have they been concerned?

If the staff were on a job creation programme, have they themselves benefited in terms of the development of expertise and interests and any subsequent employment? For example, a person concerned with a temporary documentation project may have subsequently worked in permanent posts in museums, to which they have been able to contribute the expertise gained

during the project. To what extent have permanent staff been involved in the supervision of the projects and what effect has this had on their own attitudes and work pattern? For example, a curator may have become involved virtually full-time in the supervision of a large short-term project or job creation team concerned with backlog recataloguing, to the detriment of responsibility towards current acquisitions and system development.

If a programme has now finished, has it accomplished what it set out to achieve, or have parts of the work still to be completed; what is the standard of the results; has the project created any short-term or long-term problems for the museum; has it been to the overall benefit of the museum? For example:

> such a project may have resulted in a dramatic improvement in the coverage and standard of some areas of documentation, such as catalogue records;
> it may have enabled the museum to automate a large proportion of its records, to its permanent benefit;
> it may have revitalised the attitude towards documentation of the permanent staff, leading to a long-term change of emphasis and priorities;
> it may, however, have left an inheritance of inadequate, incomplete and unindexed records that will either have to be discarded or recatalogued;
> it may have resulted in a backlog of work of badly processed recent acquisitions and disenchanted permanent staff.

What is the time scale of any current project? Are continuation or new projects being planned? If these projects are to be funded by an outside agency (such as the MSC), what would be the effect on the museum's plans of any change of policy by the agency? Should the approach adopted by any current or future projects be reconsidered as a result of this assessment?

Also note the assistance which the museum has received, or may hope to receive in the future, from staff in its parent organisation or an outside agency, such as system design and implementation, advice, backup support and the provision of services. How effective has this help been in the past?

(c) staff training and procedural manuals

Is any training in documentation skills given to permanent or temporary staff, either at the beginning of their contract or subsequently while in-service? If training is given, outline the approach adopted and the standard of instruction. For example, does it include:

> guidance on the practical implementation of procedures;
> general awareness of the principles of the system;
> the introduction of new developments;
> reviews of technological influences;
> the discussion of future options?

Is it aimed at junior departmental staff or senior managers? Is it undertaken

on a local basis within individual units or on a broader scale? Is it carried out by staff of the unit concerned or by an officer from administration or a documentation unit or someone from an outside advisory body? Do staff attend outside meetings, seminars, lectures or courses concerned with documentation, such as MDA or AMC seminars or CCTA systems and automation training courses? How effective is the training approach adopted by the museum:

is it helping to develop expertise in individual staff;
is it spreading skills between staff;
is it improving the standard of documentation?

Are there any manuals concerning the use of the system (procedural manuals, memoranda, etc.)? If there are manuals, what is their scope (for example, a detailed description of procedures, staff functions and responsibilities, data standards, terminology lists, system descriptions and technical documentation, acquisition policy statements, loan policies)? Are they maintained within individual units or centrally (for example, by administration or a documentation unit on behalf of the collection-holding department)? How widely available are these manuals? Who is responsible for their maintenance and upkeep and the distribution of additions or amendments? How much have the documents changed in recent years, in response to new system developments? What methods are used to evaluate whether the guidelines are being followed? How effective are these methods and the guidelines themselves in dealing with the practical problems faced by staff when implementing the system? What other guidelines, if any, are required?

If no training is being undertaken or if no manuals are available, how do staff become familiar with procedures, how are new procedures introduced and how does the museum ensure that documentation standards are maintained?

Whether or not training and manuals are available, will the current approach have to be reconsidered or developed if the museum is to introduce any changes as a result of this assessment or if there should be a change in the expertise of incoming staff?

(d) documentation equipment

Review the equipment available for documentation. (As noted in B2.2, this may be equipment primarily acquired for other purposes but now used as part of the documentation system, such as a research computer, or equipment maintained by the parent organisation or an outside agency.) Note the role, location and environmental impact of all relevant manual and automated equipment used for document preparation, filing, storage, retrieval, etc. Have long-term financial arrangements been made to enable existing equipment to be maintained and replaced on a regular basis? In the case of the more essential items of equipment (such as a card duplicator,

mechanised storage unit, data entry terminal or computer processor), note when each was acquired, its estimated life-span, maintenance arrangements and the availability of a backup.

Is the equipment available within the museum itself or in an outside organisation adequate for the documentation approach that has been adopted and commensurate with the scale of the collections? For example, if extensive manual indexes are being prepared, have appropriate card duplicating facilities been acquired and have adequate funds and space been allowed for the number of filing cabinets that will eventually be required; if procedures are being automated, have sufficient terminals, processing units and storage facilities been planned and is the operating system and computer software appropriate to the museum's requirements?

In the case of automated system hardware and software, does the museum have adequate expertise and backup to ensure its long-term use? Is there effective local maintenance support? Are there other museums with similar systems that may be able to offer advice in the event of any problems or with which the museum may be able to cooperate in system development? Has a satisfactory balance been reached between internal and external resources? For example, the museum may be finding some aspects of the service offered by a bureau inadequate, slow or costly, and may be able to overcome these problems by a relatively minor investment (such as the acquisition of a data entry machine); conversely, the museum may be being unnecessarily independent in its approach, using inappropriate equipment when superior facilities are readily available in its parent organisation (such as specialised printers or graph plotters). Similarly, has an effective balance been reached in the distribution of equipment around the museum? Is this compatible with the general approach to documentation and the staffing arrangements within the museum? Has it resulted in any unnecessary duplication or under-utilisation of equipment? For example, pooling all automated equipment within a central unit may have resulted in its extensive use, but may also have led to staff resistance and inefficiency due to its remoteness from the work areas, in which case the distribution of terminals to local units may have been more effective; conversely, having independent groups of equipment within each unit may have resulted in a lack of use and unnecessary duplication of some items such as processing units, in which case combining some of the processing power into a central unit may have been more advantageous.

With these aspects in mind, review any existing plans for the acquisition of a major new item of equipment, considering its role, location, relation to other equipment and expected life-span.

(e) cost of documentation

Having reviewed staff and equipment resources, summarise the cost to the museum of the various aspects of the development of documentation, as a basic guide for future planning purposes. Take into account the full range of

documentation work, including research, recording and processing. Consider the typical recent annual investment in permanent staff, temporary staff, training, equipment, system maintenance, system development and support, consumables, direct overheads; external expenditure by the museum on advice and services, and the contribution of the parent organisation or any outside agencies. Also note any exceptional capital investments within the last five years in major new systems. Are any current plans or outside pressures likely to affect this cost picture, such as the intention to invest in a new system, a change in the charging policy of a service bureau, or the withdrawal of support by an external funding agency?

B3.3 Documentation system

(a) design of the documentation system

Does the design of the documentation system reflect an overall plan or a piecemeal approach? For example, is a single design being implemented for the whole museum or are local decisions taken within individual departments; is a single design being considered for all procedures from the point of entry of an item into the museum, including accessioning, cataloguing and location control, or are individual aspects of the procedures being examined in isolation? Who is responsible for system design? What is the scale of the internal investment in the current design? Has the museum received external advice or assistance with the implementation of the design? If the museum has an automated system, what is its current scope (for example, it may be restricted to catalogue and index operations or may be a more general part of the overall procedures)? Has the museum designed its own software and applications or has it used packages produced by an outside agency? In the latter case, have the packages and the support offered by the agency been to the standard required by the museum? Has the museum used manual components (such as registers or record cards) of an externally produced system? If so, what is their role and have both they and their support been appropriate to the museum's needs? How effective is the current design in fulfilling the requirements of the museum? Are there any existing plans to change the design?

(b) documentation sources

Summarise the individual documentation sources that are held within the museum, such as registers, catalogues, indexes, location lists and correspondence files. Include details of sources about both physical collections and support documentation. Note where each source is located. Who is responsible for the preparation of new entries? Are these checked by their originator or proof-read by a second person? Are they stored in manuscript, typescript or machine-readable form? What steps are taken to standardise the entries? Are there agreed lists of data categories governing the overall

content of each type of record? Are there terminology rules concerning recording methodology, such as syntax definitions and vocabulary controls. For example, there may be rules governing the arrangement of personal names and the appropriate terms to use when naming objects. Are staff trained in the use of these rules and able to refer to procedural manuals outlining their scope? If an automated system is being used, are new entries automatically validated against these rules at the time of input into the system? Have these rules been drawn up internally by museum staff or are they based on, or part of, a wider cooperative scheme? Who is responsible for the subsequent maintenance of the entries to take account of amendments, changes of vocabulary, etc.? How effective is this maintenance in ensuring the long-term accuracy of the entries in the sources? Are any steps taken to monitor the maintenance, such as checking that alterations have been undertaken correctly?

Are there unambiguous links between related entries in different sources? For example:

is an individual item or catalogue record linked to the corresponding acquisition record and, through this, to an earlier entry record, by means of the various numbers assigned during the history of the item (item number, accession number or temporary entry number);
conversely, is an acquisition record linked to each of the item records for the component items of the accession;
is a conservation record linked to the relevant object record;
is a locality record linked to details of any photographs taken at that site?

Are there comparable links from documentation sources to related management files? For example:

does the record of an object that was purchased by the museum have a direct link to the relevant record of the financial transaction, and *vice versa*;
does an insurance manifest have a direct link to the relevant location list entry and to the item record;
if an item has been transferred to another museum, does its register entry and item record refer to the relevant committee minutes as authorisation?

(c) scale of documentation workload

Estimate the scale of the primary documentation tasks facing the museum. In the case of the permanent object and non-object collections how many new acquisitions and individual items are received each year? What is the time delay between the approval of an acquisition, its accessioning and its individual item documentation? What proportion of new acquisitions are supported by basic accession records and individual item records and are assigned accession numbers and item numbers? How many of the individual items have been marked or tagged with the relevant number? If the propor-

tion is less than 100%, are steps being taken to improve the basic coverage, or does the nature of the collection remove the need for a complete cover (as in the case of certain natural science material)?

Similarly, for older acquisitions, what is the cumulative size of the collections in terms of acquisitions and individual items, what proportion is supported by basic acquisition records and item records and how many items have been numbered? If the proportion is less than 100%, is the backlog being eroded each year (and, if so, how long will it be before it is removed) or is it growing due to the volume of recent acquisitions? Are the records themselves adequate for present purposes or in need of substantial development? What proportion of the collections need to be recatalogued? Has this proportion been eroded in recent years by any major recataloguing programmes? How many of these records have been automated, and what is the current automation strategy? For example, is selective or comprehensive information being automated from all records, or from a particular subset of records, such as those of the most important collection? Overall, what are the estimated figures for:

the present number of individual item records;
the potential number of records to achieve a satisfactory coverage of the existing collections;
the potential number of records for acquisitions that might be received in the next 10 years;
the average size of the records;
the potential average size if all of these records were to be of the present higher standards?

For example, there may now be 100 000 records of around 500 characters each, compared with a requirement for 200 000 records of 1000 characters each. Is, therefore, the main requirement for more or better records?

Prepare comparable figures for the case of information sequences (about localities, etc.). How many records are held, how many are needed to complete the coverage of the existing sequences, what is their growth rate and what is the current average size and the desirable average size of the records?

What proportion of these collection and information records is supported by publicly-available catalogues? Is a greater coverage of catalogues required? How many indexes or retrieval facilities are there for these records? How comprehensive and well maintained are these indexes? Are others required? How comprehensive and well maintained are any location lists of the collections? Is a greater coverage required? How many movements of items are there into the museum, out of the museum and internally within and between departments? Are there adquate methods to control these movements?

(d) use of documentation sources

Outline the main uses made of the documentation system by internal staff and external auditors, outside researchers, members of the public, etc. Is the main emphasis on uses for collections management and control, research or enquiry purposes? How effective is the documentation system in helping support these uses? Could any serious deficiencies (such as the absence of certain indexes handicapping work of researchers, or an inability to provide information as a basis for stocktaking) be overcome by the development of new procedures? Would the benefit derived from such a change be greater than or less than the cost of the change itself? For example, would the preparation of additional indexes be far more expensive than the savings of time made by the users of the indexes?

(e) security and confidentiality of documentation procedures and sources

Review the methods used to aid the security of documentation procedures and sources. Is the operation of critical procedures (such as the updating of a location list, the amendment of an acquisition register entry or the reconstruction of a computer file) restricted to a small number of authorised staff? Are there backup personnel able to ensure the continuation of critical operations in the event of illness? Are the main procedures thoroughly documented? Are key items of equipment supported by an appropriate backup or effective maintenance arrangements? Is there control over access to areas such as a computer room and a registry?

Is there a unique numerical link between the documentation and the physical items (by tagging or marking the items with a relevant number), between separate documentation sources and from the documentation system to other museum activities? Is this link effective from the moment an item is left in the museum (as a potential acquisition, loan, enquiry, etc.) and during all subsequent operations?

Are record photographs available for important items in the collection, with appropriate links between the photographs and the items themselves, for use as an identification aid after a theft, for insurance purposes, during stocktaking and auditing, etc.?

Consider whether each primary source is protected from threat of fire, flood, theft, tampering or careless use. Are sources such as registers kept in a fire-proof safe? Are record cards and correspondence kept in locked filing units in areas of the museum with controlled access? Do staff have to sign out any primary documentation source which they take into their care, and restrict the use of the source to within the museum itself? Is there strict control over confidential information such as acquisition, location and valuation details?

Are duplicate copies of all primary sources held at an outside location, available for use after any major incident? For example:

the museum registers may have been microfilmed and a copy deposited in the parent organisation or at a record office;

important photographs may have been copied for storage at an outside archive;

computer files may have been duplicated, and a copy held at an outside agency which has facilities to enable it to read the information in the event of a mishap within the museum.

In such circumstances, are there procedures to ensure that subsequent amendments and additions to the sources are also copied on a regular basis?

Consider whether the sources themselves are sufficiently protected from decay, due to factors such as inadequate environmental conditions (excessive light, heat, humidity, infestation or smoke), wear and tear caused by overuse, lack of care (using acidic paper, paper clips, staples, etc.) or ageing. Has the state of preservation of the sources made it necessary to introduce any procedures such as restrictions on access (for example, to reduce the level of use), changes to storage arrangements (for example, to remove the sources from excessive heat), the transfer of originals to an archive or the start of a paper conservation programme? Are the old sources legible or have they faded to an unrecognisable state? Are the current sources going to survive for the next hundred years, or are they of an inadequate standard that will compound the problems in the future?

What would be the effect on documentation procedures of a decision that particular sources or parts of sources should be treated as confidential? Have any such decisions been taken? Have public versions of catalogues or indexes been prepared which omit confidential details? Have any vetting arrangements been introduced to ensure the authenticity of requests from members of the public for access to certain details? For example, the museum may feel that valuation, location or some acquisition details should normally be restricted to internal use. Information about places may need to be treated as confidential from a collector who might otherwise interfere with a site of archaeological or environmental importance. Biographic information may need to be restricted from the public to protect the interests of donors or land owners on whose property important finds were made. Will new data protection laws affect these decisions when they concern computer files?

B3.4 *Documentation and collections audit*

Are the object, bibliographic and archive documentation and collections subject to any stocktaking or auditing procedures? If no stocktaking or audit programme is being implemented, are you confident of the security of the documentation and collection, and that losses are being promptly identified? If either comprehensive stocktaking or selective stockchecking is carried out by the museum, describe the programme. Is it implemented by staff from the department concerned or from another department or section in the museum, without direct responsibility for the physical custody of the items? If undertaken by staff from another department, are they competent

to detect unauthorised substitutions? What is the scope of the museum stocktaking (such as a regular comprehensive stocktake or an irregular dipcheck)? Does it cover object, bibliographic and archive collections? If selective, how is it decided which material to check (for example, by type, value, etc.)? How frequently is the museum stocktaking (annual, biennial, quinquennial)? How many items are checked each year, and what proportion is this of the total collections? How does the available documentation assist while preparing for, and during, the stocktaking? Would additional documentation sources help the museum stocktaking programme?

Have the internal or external auditors considered the integrity of the collection itself? Have they commented on, or recommended, any collection control and check methods to the museum? Do they examine museum stocktaking procedures or undertake stockchecks themselves? If they do undertake stockchecks, describe the programme that is implemented. What is the purpose, frequence and scope of the audit stocktaking (a regular comprehensive check or an irregular dipcheck)? How does the available documentation assist while preparing for, and during, the stockchecking? Would additional documentation sources help the audit stockchecking programme?

During subsequent stages in the assessment, consider how the collections might be categorised as a basis for future audit programmes and the work needed to bring the records to a satisfactory state for audit and accountability purposes.

B3.5 Deacquisition, insurance and indemnification

What would be the effect on the documentation of an item on the discovery of its loss, its disposal (due to decay, etc.) or its transfer to another museum? Would the register entry be annotated? If so, by whom would this be done and what authorisation would be necessary? Would the item record and any index entries be annotated and retained or removed from the relevant sources?

Note whether separate documentation is held for insurance or indemnification purposes (such as a valuation or location list) and, if so, whether it is selective or comprehensive, how it is arranged and by whom it is maintained. How does it interrelate with the primary item records? Are valuation details included within these primary records? How often are the valuations reassessed and on what basis is this reassessment carried out? Does it take account of inflation on a regular basis? Are there any exclusions in the insurance policy or indemnification arrangements, such as an invalidation clause coming into effect if a loss is not identified and reported within a certain period?

B4 Collections documentation

The following four subsections consider aspects of the practical procedures concerning the physical collections of the museum. If object, bibliographic, archive or audio-visual collections are held by the museum, refer to the relevant subsection below.

In the case of any of the non-object collections, if they are a major interest of this assessment or if distinctive procedures are used which show a marked difference from those for objects, complete with full subsection; if, in contrast, they are not a primary interest of this assessment or the procedures are comparable with those for objects, complete only the introductory outline, noting any key features.

B4.1 *Object collections documentation*

(a) Outline of object documentation procedures

While undertaking this assessment, draw up a brief overall outline of the documentation procedures used for the main object collections in the museum. (Typical features include procedures for group documentation (entry and acquisition recording), item documentation (individual item recording or registration, cataloguing and indexing) and control documentation (location management, etc.).)

Figure B1 illustrates a typical general outline (based on the description in the main text).

Use Figure B2 to draw up a comparative outline of your own procedures. Note whether there is a well established sequence of activities, the range of sources and the order of entries within the sources, links between the sources and to other parts of the museum, and the departmental responsibility for each stage. Prepare separate flow charts for each of the main activities of interest to the museum (accessioning, loans-out, etc.).

Consider aspects such as the range of sources and the order of entries within these sources (register in numerical sequence, catalogue in artist sequence, etc.), responsibility for each source (departmental, registry, documentation unit, etc.) and cross-reference links between the sources themselves and the rest of the museum (from an acquisition record to the financial transaction which authorised the purchase, from an acquisition record to the item records of its component objects, from an item record to a conservation record, etc.). In addition to a general outline based on the overall sources, prepare individual flow charts of any operations that are of particular importance, such as the activities involved in processing a new acquisition or a loan-out. Examine the relative role of each stage and source to identify omissions in the procedure (such as inadequate control of incoming material) or unnecessary duplication of effort (such as the completion of a detailed acquisition register entry and a comparable item record card, where a more basic register entry may have been adequate for its management and control function).

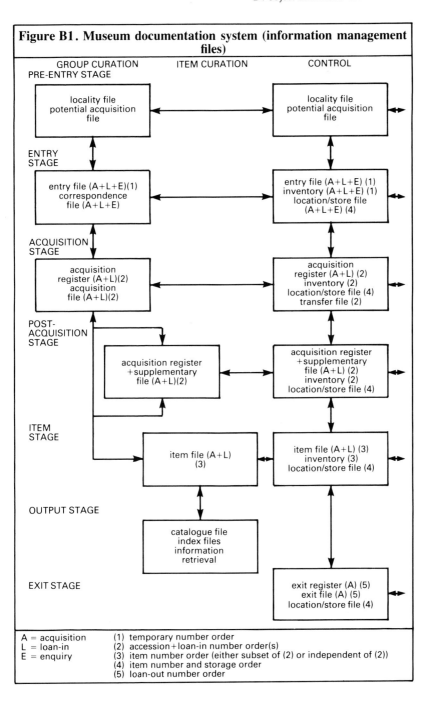

Figure B1. Museum documentation system (information management files)

| GROUP CURATION | ITEM CURATION | CONTROL |

PRE-ENTRY STAGE

locality file
potential acquisition
file

locality file
potential acquisition
file

ENTRY STAGE

entry file (A+L+E)(1)
correspondence
file (A+L+E)

entry file (A+L+E) (1)
inventory (A+L+E) (1)
location/store file
(A+L+E) (4)

ACQUISITION STAGE

acquisition
register (A+L)(2)
acquisition
file (A+L)(2)

acquisition
register (A+L) (2)
inventory (2)
location/store file (4)
transfer file (2)

POST-ACQUISITION STAGE

acquisition register
+supplementary
file (A+L)(2)

acquisition register
+supplementary
file (A+L) (2)
inventory (2)
location/store file (4)

ITEM STAGE

item file (A+L)
(3)

item file (A+L) (3)
inventory (3)
location/store file (4)

OUTPUT STAGE

catalogue file
index files
information
retrieval

EXIT STAGE

exit register (A) (5)
exit file (A) (5)
location/store file (4)

A = acquisition
L = loan-in
E = enquiry

(1) temporary number order
(2) accession+loan-in number order(s)
(3) item number order (either subset of (2) or independent of (2))
(4) item number and storage order
(5) loan-out number order

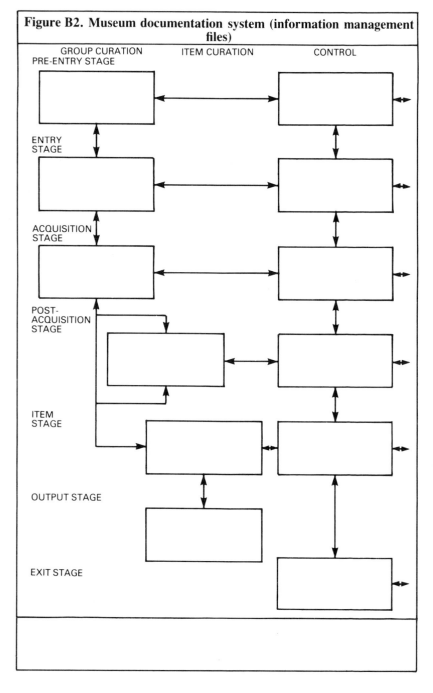

Figure B2. Museum documentation system (information management files)

(b) Pre-entry stage

What documentation is prepared when a member of staff becomes aware of a potential acquisition (eg is a record compiled or a file opened for the item concerned)?

What proportion of potential acquisitions do you acquire or borrow, and what proportion do you decline?

Is any documentation kept of the declined proportion?

What importance do you place on information about such material?

Do you link this information with subsequent acquisition records?

Review the pre-entry procedures used by the museum to ensure that preliminary information about objects that may subsequently enter the museum (as potential acquisitions, field discoveries, excavated material, etc.) is recorded in a suitable form (Section 5.2). Consider whether these initial procedures are effective in aiding the smooth implementation of acquisition procedures. Note whether pre-entry details are held in an organised and readily accessible manner. For objects that are subsequently acquired, are these details linked to the acquisition record so that they can be consulted at a later date? In the case of objects found during field work, note whether a field record includes a reference to the subsequent accession number for that object and, conversely, whether the acquisition record refers to the earlier field number. Is the field information recorded in a form that is compatible with the museum standards for data categories, syntax and vocabulary? Similarly, if the museum receives material from archaeological excavations, consider whether the excavation recording system is compatible and integrated with the museum accessioning system, or whether finds have to be reprocessed when they are acquired.

(c) Entry stage

1 general procedure when material enters the museum

When a group enters the museum, does the procedure vary from different types of entry (eg acquisitions, long-term loans, short-term loans, enquiries, etc.)?

Is each group documented in some way immediately it enters the building?

If no, what types are omitted from the entry documentation, and how are they controlled?

If yes, how are they documented and by whom, and is the work done on a central, departmental or sectional basis?

What information is noted?

Is the group assigned a temporary number?

What is the form of the number?

By whom is it assigned?

Is the number physically attached to the group in some way?

Is this number noted on the acquisition record (see (d)), forming a direct link between the two documents?

To whom is the group passed after entering and immediate processing?

Do you have a designated area to which the group is moved for initial control purposes (such as assessing whether it is a threat to the permanent collection and should be fumigated or removed)?

Is a record photograph and initial condition description prepared at this stage?

Are all groups coming into the museum covered by your insurance policy or by an indemnity arrangement?

If additional cover is needed for certain items, is there a procedure whereby this cover is obtained?

Is a file opened, with details of correspondence, etc?

Where are the resulting sources (files, etc.) kept?

Is the appropriate procedure detailed in a written documentation manual?

Are there any checks on the entry procedure?

2 enquiries and identifications

Of the enquiries brought to the museum, how many are retained for further examination, as a potential acquisition, for detailed identification, etc?

Do you include short-term loans-in within this category?

In the cases of material retained in the museum, who is responsible for its management and documentation, and is this done on a central, departmental or sectional basis?

How do they process the item, and respond to the enquiry?

Does the documentation system help the museum respond to the enquiry and keep track of the item while it is in the institution's care?

Does it help ensure the item's return to the enquirer?

If the item is not retrieved, what is the appropriate documentation procedure and what happens to the item itself?

Does the museum keep any details of the enquiry after the item has been returned?

Do you monitor the type and frequency of retained and general enquiries?

If yes, is the documentation procedure reassessed in view of the results of such monitoring (eg by the preparation of new indexes)?

Where are the resulting records and files kept?

Are the appropriate entry procedures detailed in a written documentation manual?

Are there any checks on the procedures?

3 other entries

Do objects enter the museum for reasons other than acquisition, loan and enquiry?

If yes, for what reasons?
Who deals with these items and what procedures are adopted, in comparison with those for enquiries?

Consider the entry procedures implemented when objects first come into the museum (as anticipated acquisitions, loans, enquiries, etc.) (Section 5.3). Are the procedures comparable or distinct for the different types of entry? Is some form of entry procedure adopted for every object that comes into the museum, irrespective of its origin, or are there exceptions, such as informal enquiries, major acquisitions or items collected or brought in by staff? If there are exceptions, do these result in problems later (for example, gaps in the coverage causing difficulties when the museum comes to dispose of uncollected enquiries, to complete delayed acquisition formalities or to pinpoint the exact find spot of a field collection)?

Outline the procedures that are implemented, noting aspects such as:

who is responsible for the overall management;
what notification is received of incoming material;
how material is grouped (for example, acquisitions and long-term loans-in may be treated differently from enquiries and short-term loans-in);
the number of entries received in a year;
where and by whom the initial processing is undertaken;
how long material remains at the entry stage before subsequent action;
the sources that are used when recording details of the entries (record forms, correspondence files, etc.).

Are the procedures effective for both the control of the entry and the provision of information as the basis for subsequent operations? For example, does the design of the entry record include specific printed conditions delimiting the responsibility of the museum and the depositor towards the care and subsequent retrieval of the material, does it require signing by both the depositor and a museum official and does it provide help with controlling the progress of the entry, by indicating further action? Is the design compatible with the main acquisition and item recording standards, so that information can be transferred from one stage to the next? Are the staff who accept entries and deal with their immediate management sufficiently experienced and trained in the work to ensure the effective capture of essential details? Are there unambiguous links between the entry record and any preceding pre-entry record, superseding acquisition record or contemporary correspondence and financial files, such as by means of a temporary entry number being assigned to the entry record and noted on the various related documents? Is a temporary number allocated to each group of material, noted on the record and tagged securely to the group itself? If not, is there a danger of confusion between different entry groups?

Note the procedures used after the initial entry and processing of a group. Does the documentation system help monitor the progress of these procedures (for example, by bringing to the attention of staff an uncollected

enquiry)? Does responsibility for the care of the item pass to another person (for example, an enquiry being referred to the relevant curator)? Is material held in a separate control area, isolated from the main collection and readily accessible during subsequent considerations? Is the location of the material noted on its entry record or within a separate location control procedure and amended in the event of a move (for example, a temporary transfer to a photographic or conservation department)? In the case of an item left as an enquiry (for identification or potential acquisition), are there formal guidelines concerning the action to take in the event of it not being retrieved? For example, are steps taken to return the object to its owner and, if these are unsuccessful, is it eventually disposed of or incorporated into the collection? In the case of field collections, is the mechanism used to document material while it is undergoing initial physical processing, preservation and conservation compatible with subsequent documentation procedures? In the example of natural science and archaeological material held in storage pending examination and an acquisition, exchange or disposal decision, are details such as locality and collector information noted in a way that aids their incorporation into subsequent records?

More generally, what insurance or indemnification arrangements are made for material entering the museum, prior to its formal acquisition or return to the owner? Are these and other problems fully considered in procedural manuals and training programmes? Note whether legal advice has been taken on the implementation of these procedures and the design of record forms, etc., to ensure that they are unambiguous and authoritative.

(d) Acquisition stage

1 general procedure for acquired material

Does the museum make any distinction between the processing of permanent acquisitions, long-term loans-in and short-term loans-in?
(If yes, answer 2 and 3 independently; if no, answer 2 and ignore 3.)

2 permanent acquisitions

How many acquisitions are received in a typical year?
Is the decision whether to acquire a group taken on a central, departmental or sectional basis?
Who is then responsible for the development of its documentation and is this done on a central, departmental or sectional basis?
Does an anticipated acquisition go through the standard entry procedure outlined in (c)?
Are steps taken to ensure that the item can be acquired without contravening legal considerations?
If the group is a donation, is a letter of acknowledgement sent and is a

formal transfer of ownership title document prepared and signed by both parties?

If a bequest, is a copy of the will filed by the museum and is a transfer document prepared?

If a purchase, are details of the financial transaction kept with other correspondence about the acquisition, or in the financial files, and is a non-financial transfer document prepared?

Do you take steps to acquire the copyright of relevant acquisitions?

Are all acquisitions covered by your insurance policy or by an indemnity arrangement?

If additional permanent cover is needed, is there a procedure whereby cover is obtained, and for arranging that the group is added to any insurance manifest?

Do you complete an acquisition form (distinct from a register)?

If yes, is it competed on a central, departmental, sectional or documentation section basis, and by whom is the work done?

What information does it contain?

Is an entry prepared in a register?

If yes, is it completed on a central, departmental, sectional or documentation section basis, and by whom is the work done?

Does it include entries about the whole collection or that of a department, section or particular subject?

Where is it held?

What details are noted in the register, and how do these compare with those on the acquisition form, if used?

Is it completed in permanent ink or typescript?

Is there a procedure for correcting errors in the original entry in the register?

Is the register subsequently amended for any reason (eg due to a transfer between departments or a re-identification) or does it remain as an historical record of the group at the time of formal registration?

When and how is the group assigned a permanent accession number?

What relation does this number have to any earlier temporary number?

Is the earlier number noted on the acquisition record or register entry?

How is this number affixed to the group?

What relation does it have to the subsequent item numbers?

Are these item numbers noted on the acquisition record or register entry?

Is a file opened and kept, with details of any acquisition correspondence?

If yes, where is the file held, who is responsible for its maintenance and who has right of access?

Does it include confidential information?

Does the documentation system provide mechanisms to help you know where the group is during these procedures?

Is there any control over movement of the object during the period between its acquisition and item documentation?

Are the appropriate acquisition procedures detailed in a written documentation manual?

Are there any checks on the procedures?

3 loans-in

Do you make any distinction between long-term and short-term loans-in to the museum?

If yes, are both considered in this subsection, or have short-term loans-in already been dealt with under enquiries (see (c))?

How many loans are received in a typical year?

What is the cumulative total of loans currently in the museum?

Is the decision concerning whether an object should be borrowed by the museum a central or department responsibility?

Who is then responsible for the development of its documentation?

Who is responsible for acknowledging the loan's receipt and for ensuring its eventual return or renewal?

Does the loan go through the standard entry procedure as detailed in (c)?

Is a formal loan document prepared and signed by both parties?

Are all loans covered by your insurance policy or by an indemnity arrangement?

If additional permanent cover is needed, is there a procedure whereby this cover is obtained, and for arranging that the object is added to any insurance manifest?

Is an entry about the loan prepared in a register?

If yes, is this the same as the register of permanent acquisitions?

Is it completed on a central, departmental or sectional basis?

Does it include all loans, or those for a department or section?

By whom is it prepared and maintained?

Where is it held?

What details are noted in the register?

What is the physical form of the register (eg is it a bound book with stiff board covers and archival quality paper)?

Is it always completed in permanent ink?

Is it annotated when the loan is returned?

Is the object assigned a permanent accession number or a separate loan number?

What relation does this number have to any earlier temporary number?

How is this number affixed to the object?

Is a file opened and kept, with details of loan correspondence?

If yes, is it held with the permanent acquisition files?

Does the documentation system provide mechanisms to help you know where the object is during these procedures?

Are the appropriate loan procedures detailed in a written documentation manual?

Are there any checks on the procedures?

Review the procedures used in the acquisition stage, during which formal steps are taken to incorporate material into the collection (Section 5.4). These steps may include the preparation of an entry in an acquisition register, based on preliminary details noted on an acquisition form, and supported by transfer of title arrangements. Is there a time delay between the entry of material into the museum and the completion of these acquisition formalities, during which the entry documentation is the primary evidence about the material and its origin, current location, etc.? Note whether material is acquired as individual items or as a coherent group (such as related objects from a single donor or all finds from an excavation). If the procedure allows the grouping of material, does this result in any problems (such as when processing groups that are of interest to more than one department or numbering complications and difficulties in linking the group details to information about the component items)?

Note whether similar or independent procedures are applied to permanent acquisitions (permanent additions to the collection) and long-term loans-in (additions of a defined duration or a duration that can be terminated by agreement with the depositor). Review the approach adopted for both types of material, considering the number of annual acquisitions; the mechanism for authorising their acceptance; the practical procedures and the physical sources used during their subsequent processing. If the authorisation arrangements differ for certain categories of acquisition (such as all purchases being considered by the director or high-value material being referred to the committee or trustees), does this affect the documentation procedures?

Is the processing before and after the formal acceptance done on a central or departmental basis? For example, the processing may include the local completion of some type of acquisition form as a preliminary record about the acquisition, which can then be forwarded for authorisation, or used as a loose-leaf register entry. If this is the approach, is it used for both permanent acquisitions and long-term loans; is the design and standard of completion of the form compatible with previous and subsequent stages in the processing; is it used as a means of advising a central unit (such as a registry or documentation unit) of the details of the acquisition; do these details include a locally-assigned accession number, or is the number allocated centrally and added to the form, which is then returned to the curator as a notification of the number? Does the form have a long-term role (for example, as a working version of a corresponding register entry or in place of a more formal register)? Is it amended in the event of a major change of information such as a transfer of responsibility to another department? Would it be a suitable basis for a summary list of the collection?

Whether or not an acquisition form is used, the overall procedure may include the local or central completion of a formal acquisition register entry after the approval of the acquisition. If a register is used, what is its role (for example, as the formal statement of the material being accepted as an addi-

tion to the collection; for reference during collections management and auditing)? Does it include both permanent acquisitions and long-term loans-in, in either combined or separate sequences? Is it prepared and arranged in a central or departmental basis; by whom is it prepared; where is it held? If it is arranged on a departmental basis has this resulted in any complications due to the fragmentation of departments and transfers of material, such as entries for some of the items held by one department being in the registers of other departments and, conversely, some of the items noted in the register of one department having been passed to other departments in whose registers they do not appear? What is the physical format of the register (for example, is it a bound volume with column headings and sequentially pre-numbered pages)? From what source is the register entry prepared (for example, from the earlier entry record or from the acquisition form referred to above)? What information does each register entry include (for example, details of the depositor and the material itself)? What is the depth of each entry (for example, is it restricted to a brief description of the overall acquisition, or does it consider the particular features of each component item to the extent that they could be uniquely identified from the entry)? In view of the entries about the acquisition in other sources (particularly the individual item records) and the specific management and control role of the register, is this entry too shallow, too extensive or well balanced? Are there any procedures for verifying the entry and correcting errors or omissions? Under what circumstances is the entry amended (for example, following a permanent transfer, disposal or loan)? What authorisation is required for an amendment (for example, minuted committee approval, to which reference can be made as part of the amendment)? What has been the standard of entry, verification and maintenance in the past? Can the register be referred to with confidence that it represents a correct picture of each collection, or is it likely to include serious inaccuracies and omissions? If it includes location information, is this at a general or specific level (for example, a general reference to a department of a specific reference to a particular storage unit) and has this been maintained since the initial acceptance of the group? Could the register be used as a basis for an accurate summary or physical inventory of the collection? How effective are the security provisions concerning the register? For example, is a duplicate copy held at an outside location; is the master copy kept in a fire-proof safe, under restricted access; does its physical form discourage tampering (such as the removal or substitution of pages)? If there is no register, what alternative arrangements have been made for the maintenance of a secure record of additions to the collection? If, in either case, the source does not include specific location information, what procedures are used to maintain an up-to-date track of the location of the addition prior to its detailed item documentation (such as the maintenance of the entry record or a separate location control procedure)?

Are the transfer formalities for a permanent acquisition sufficient to

ensure that the museum has an adequate title to the material? If the museum
sometimes has difficulty in proving its right to title of old acquisitions, have
steps been taken to ensure that similar problems do not occur in the future,
when queries arise concerning today's acquisitions? For example, is
approval for each acquisition noted in appropriate commmittee minutes, to
which reference can be made in the documentation files? Is a formal multi-
part transfer of title form completed for each acquisition, noting details of
the material (including its museum accession number) and the depositor,
and, if so, are parts of the form signed and filed by both the museum and the
person concerned? In the case of a donation, is the acquisition supported by
an acknowledgement letter, a copy of which can also be filed by the
museum. In the case of a bequest, does the museum receive and file a copy
of the will? If the acquisition is a purchase, is it always supported by a
financial order, to which reference can be made in the documentation files
and, conversely, which can itself include reference to the documentation
files?

What approach is adopted concerning the copyright of modern works?
Does the museum aim to acquire the copyright of items by a living artist or
does it remain vested in the artist? Is the position clearly noted in both the
object and photograph documentation?

When considering the accession numbering approach, note whether any
distinction is made between permanent acquisitions or loans and whether
the numbers are allocated on a central or departmental basis. Review the
form of the numbers used during the history of the museum, examining any
complications caused by changes in approach or the method of construction
of the numbers. Note how these numbers are marked or tagged on the group
in the period prior to individual item documentation. Is the number used as
a means of linking the acquisition record to a correspondence file and to
other records, such as by being noted on the entry record, on individual item
records and within financial, valuation, insurance and location files?

Is each acquisition supported by a file for correspondence, master
transfer documents, etc., or is an alternative filing arrangement adopted,
such as a file for each artist or collector? Is responsibility for these files a
function of a registry or documentation unit or a curatorial concern?

As at the entry stage, review the insurance or indemnification arrange-
ments for new acquisitions. Are all new permanent acquisitions and loans
added to an insurance manifest? Are the insurers informed in the event of a
significant increase or decrease in the total liability? Also review the
availability of procedural manuals and staff training and whether reference
has been made to legal advice concerning the procedures.

(e) Post-acquisition stage

Do you use the group acquisition record as the basis for a more detailed
record, including references to the individual items in the group but

retaining the general framework of a group record (eg on supplementary sheets)?

If yes, describe the process, and note its relation to the subsequent development of individual records about each item in the group.

Does the museum also have a post-acquisition stage, in which the acquisition records are used as the nucleus for subsequent detailed group documentation (Section 5.5)? If it does, review the role of the post-acquisition records with respect to earlier acquisition and subsequent individual item records. Does the post-acquisition record include information about each item in the group, such as location, identification and description details? What is the physical form of the record (for example, the earlier acquisition form may be complemented by supplementary sheets for each item)? Why was this approach chosen?

(f) Item stage

1 item record

(the preparation of a record about each item in the collection, as distinct from a catalogue (see (g)).

After processing an acquisition, how long is it before each individual object within it is documented?

How many new item records of recent acquisitions are prepared in a typical year?

Who is responsible for the recording?

How is the information noted (eg on a record card, record sheet, etc.)?

What details are noted?

Do the details include the storage location?

If yes, is this always amended if the object is moved, or only amended if the object is moved for a significant period, or never amended?

If no, do you maintain separate location lists (see 2) or have alternative means of finding a specific item (eg by storage arrangement)?

Are details of any conservation of the item included in the record, or are these held separately (see B5)?

If held separately, does the item record include a numerical or other type of cross-reference to the conservation details?

Does the item record include a numerical or other type of cross-reference to any separate record photographs of the item (see B5)?

Does the item record include full details of bibliographic references about the item or used while documenting the item, or a more basic cross-reference to separate bibliographic records?

Are there written procedures for preparing the record?

Is any control applied to the vocabulary used in the record or the syntax of the information being noted?

Is a duplicate copy of the record kept in a secure place?

In the case of current acquisitions, is the information noted at this stage

considered to form the full record (subject to later addition of minor details) or a preliminary record (subject to substantial expansion and reworking)?

What proportion of the collection do you consider to be inadequately recorded as far as item documentation is concerned?

In the case of old acquisitions, have any significant parts of the collection been reprocessed during the last ten years?

Do any need reprocessing in the near future?

If any have been reprocessed, what is the typical annual figure for revised records?

If any of the collection is inadequately documentaed, how do you make use of it and ensure its effective management?

Is an individual item number assigned and marked on each object?

If yes, when and by whom?

What relation does this number have to the earlier accession number?

Is the earlier number noted on the item record?

In what order is the primary copy of the record kept (eg numerical order)?

Does it include tracings, showing any index entries that have been prepared from the main record (see (g))?

In what order is the collection itself arranged?

If an object is disposed of, is its record removed from the file or annotated and retained?

Is the set of records ever checked in any way?

Is a supplementary file opened and kept for each object or certain notable objects (including correspondence, etc.) or do you continue to concentrate on any acquisition files?

If an item file is prepared, is it (and any included papers) annotated with the object number?

How are these files ordered, where are they kept and are they secure from fire, etc?

Is a duplicate set available?

Are the appropriate item procedures detailed in a written documentation manual?

Are there any checks on the item documentation procedures?

2 item control

Is a separate location list maintained, noting details of the current location of each object?

If there is a location list, what information does it include about each object and what is its coverage (eg acquisitions, enquiries, loans-in, loans-out, etc.)?

Does the information include a photograph of the individual item or of a display/storage area?

In what order is it maintained (eg by item, display or specific location)?

What is its physical form?

Is it maintained centrally or on a departmental basis?

Is there any provision for ensuring that it is only amended by authorised staff?

What are its main uses?

Is it safe from threat by fire, etc?

Is a duplicate copy kept in a secure place?

Where are the resulting sources kept?

Are the appropriate item control procedures detailed in a written documentation manual?

Are there any checks on the procedures?

If yes, by whom are these carried out?

Is this done in association with a stocktaking or collections audit (see B3.4)?

3 internal movements

Who is authorised to decide to move an item *within* the department (see (h) for inter-departmental moves), and how is this decision implemented?

If an item is moved within the department, what effect does the movement have on the item record and location documentation?

Review the item documentation procedures used when preparing and maintaining details of the individual objects in the collections (Section 5.6). These may include the development of a primary item record for each object, to which can be added all relevant information about that object and which can itself be used as the basis for entries in catalogues and indexes. In contrast to the closed formal acquisition record, the item record may be a document which is extended to include new information about the object, such as a re-identification or conservation. However, in certain cases the nature of a collection may preclude the need for an individual record (as with some bulk natural science and archaeology material). If this is applicable, note the arrangements that have been made to preserve any information about particular individual items. If this is not the position, is it intended that a separate item record should be prepared for each object, or is the earlier acquisition or post-acquisition record considered to fulfil this role? Does the scope of the item records include both permanent acquisitions and long-term loans-in? Note whether there is a time delay between the completion of acquisition formalities and the preparation of item documentation. If there is a significant delay, does this have an adverse effect on the preparation of the item documentation and the overall standard of the record? Is it due to the pressure of new acquisitions or to the particular documentation approach that has been adopted? (The basic alternatives are a registration or subject sequence separate from the earlier acquisition ordering or a chronological sequence parallel with the earlier acquisition ordering.)

Which approach has the museum adopted, and what effect has the decision had on the documentation procedures? For example, the registration

approach can place additional demands on the acquisition record, due to the time delay when the former record is the primary evidence about the item, the need to make a specific note of the numerical links between the acquisition record and the latter item records and the isolation from each other of the individual item records concerned with the single acquisition. With the chronological approach, the time delay should be less significant, the link between the acquisition record and the individual item records should be unambiguous and the individual records should be closely associated. However, the preparation of the subject-orientated sections of each record can be more demanding, due to the isolation of similar objects.

Review the existing set of records, noting their arrangement into numerical or other order; how many there are; their average size; the quality and depth of recording; their state of preservation and legibility; their adequacy for future use. If there is a backlog of items to process or reprocess, note the scale of this backlog in terms of the number of new records and their required additional detail. In the case of current acquisitions, how many new records are prepared in a year; by whom are they prepared; how much time does this preparation take (including background research and the completion of the record itself); where are the resulting sources held?

Does the recording procedure involve the use of a register (analogous to the earlier acquisition register, but on a subject basis), record cards or sheets or direct entry of information into an automated system (via a computer terminal)? If a register is used, does this have a constraining effect by limiting the amount of new information that can be added to the entry in the future? (Has it had to be paralleled by the additional use of a record card or sheet because of this limitation?) If a record card or sheet is used instead of a register, is it part of, or compatible with, the series designed by the MDA? In both cases, is an original manuscript draft used as the basis for a typescript version (which may itself be used later as a basis for data entry into an automated system)? Is the typed version produced by a clerical member of staff, rather than the curatorial originator of the manuscript precursor? Is each version proofread and corrected to ensure that it conforms to its precursor? Is each retained by the museum and used as part of different sources about the collection (for example, the manuscript in subject order and the typescript in numerical order) or is the earlier draft discarded? If the earlier version is retained, is it maintained in parallel with the typescript in the event of changes of information, or does it gradually become out-of-date? Does the approach involve any unnecessary duplication of effort or inefficient use of staff time which could be reduced by using alternative methods? For example, it might be possible to undertake data entry from the manuscript version into an automated system, thereby replacing the existing typing operation by the production of a machine-readable equivalent which has a wider potential utility. If the museum is already using a direct data entry procedure working from the object itself, describe the procedure and examine its effectiveness. Does the data entry

system help the user by providing prompts or validation mechanisms for information, or is the input totally under the control of the recorder? Does the system enable common information to be carried forward from one record to the next, or does each have to be entered independently? Can the data entry terminal be taken to the object or does the object have to be moved to a static terminal? Does the recorder work from preliminary informal notes or create the record while at the terminal?

As an alternative to the preparation of a separate record in a register, on a record card or in an automated system, the documentation procedure may concentrate on the attachment of information to the object itself (such as a herbarium or entomological specimen with an added note or label). If this is the case, note any particular problems which it creates, such as linking an acquisition to its components; wear of the specimen and information; security arrangements for the information.

In all circumstances, examine the standard of the records themselves, noting the allowed data categories, syntax and vocabulary control arrangements. Do the records incorporate illustrations or photographs to complement the textual description when identifying an object? Are the records gradually built up after their initial preparation, to include new information about the item? How effective are the arrangements for these additions and the overall maintenance of the records? Can those records that have been newly prepared or reworked during the last ten years be consulted with confidence that they are an accurate reflection of the history of the object to which they refer, or would they need major reassessment before being used as the basis for future operations (such as data entry into an automated system or as the origin for a printed catalogue, new index or location control procedure)? If any major reprocessing has been carried out in the last decade, note the approach that has been adopted, whether permanent or temporary staff have been used for the work, the scale of the operation, the quality of the resulting records and the scale of any remaining work to complete a current programme.

Summarise the approach adopted to the location control of objects and the use of this approach during general collections management, stocktaking and audit). If information about current location is included within the item record, is it at a general or specific level (for example, referring to a general storage area or a specific drawer within that area)? Is there a separate location control source, with details about the location? If there is, note whether it is comprehensive (for example, referring to all permanent acquisitions and long-term loans) or selective. What is its physical form? Is it held in both item number and location order? In either case, has the location information been effectively maintained so that it can be used with confidence as an accurate guide to the collection? If there are no location sources or they are not comprehensive, what methods are used to find and control individual items (such as a classified arrangement of the items in storage)? Are the documentation procedures adequate to control the local movements of

material within a department? For example, is the location information amended in the event of a temporary move or are alternative steps taken to indicate the change (such as a store tag or label being left in place of the object)?

Also review the numbering arrangements for the objects, noting any problems or complications caused by changes of practice since the establishment of the museum. For example, there may be numbering overlaps between departments, due to a lack of central monitoring, with the result that two items now have the same number; there may be confusions caused by the fragmentation into departments, where the current collection of a modern department has come from more than one old department with different numbering procedures; there may be problems in linking an item to its documentation, due to attempts at renumbering by earlier curators. If there are serious problems, consider how they might be rectified or circumvented without having to resort to a renumbering programme. Another cause of difficulties in linking an object to its documentation can be inadequate marking procedures. Examine the proportion of the collection that is marked with one recognisable number per item, more than one recognisable number per item or no recognisable number. If this is a serious problem, what steps have been taken or could be taken to rectify the position? In the case of new acquisitions, is the item number used as a link from the item documentation to other sources and museum activities, such as the earlier acquisition record and contemporary location, valuation, purchase, conservation, photograph, loan-out and exhibition records?

Finally, review the security arrangements concerning access and backup copies of these item and location records and the availability of procedural manuals and staff training.

(g) Output stage

1 catalogues

Do you have separate published or internal catalogues, or consider the item records to be the catalogue of the collection?

If separate, what physical form do the catalogues take?

In what order are they held?

Are they concise (abstracts of the full information) or full?

How often are they revised?

Are they publically available?

Does the 'full' catalogue include *all* the information about the object, or only a selection of the information (for example, excluding valuations)?

If a record is amended, is the corresponding catalogue entry also amended?

If an object is disposed of, is its catalogue entry removed or annotated and retained?

Where is the internal catalogue kept?

Is it safe from fire, etc?
Is a duplicate copy available?
Is the internal catalogue accessible to only authorised staff, to all staff, or to all staff and the public?
Who is responsible for its production and maintenance?
Are the appropriate procedures detailed in a written documentation manual?

2 indexes

Are any indexes prepared to act as directories to the collection?
If yes, what is their physical form?
Note the different indexes that are produced and the content and comprehensiveness or each.
If a record is amended, are the indexes also revised?
If an object is disposed of, are relevant index entries annotated or removed?
How much are the indexes used and by whom?
Are others needed and justified on a cost basis?
Are the indexes accessible to both staff and the public?
Where are the resulting sources kept?
Who is responsible for index production and maintenance?
Are the appropriate procedures detailed in a written documentation manual?
Are there any checks on the indexing procedures?

3 information retrieval

If your records are being automated, do you offer an information retrieval or online interrogation service? If yes, describe, and note its cost to the user?

4 labels

Do you prepare a label to attach to – or store with – the object?
If yes, by whom is this done?
What information does the label contain?
Are there established procedures for its preparation?

5 other permutations of information

Do you produce information sheets, etc., about the items in the collection?
Do you have any other permutations of information from the records?

Outline the ways in which these item records are used to produce output such as collection catalogues and indexes, information retrieval and labels (Section 5.7). These outputs can be considered as secondary sources derived from the primary files. Has the need for better or more extensive outputs been an influence behind a change of documentation procedures, or an

incentive to a future change, such as the adoption of automated cataloguing procedures?

If any catalogues are maintained by the museum, review the approach to catalogue production, noting details of their original preparation, the arrangements that have been made for their subsequent maintenance, the scope, ordering and content of each, whether they are internal files (with either restricted or public access) or published documents, whether they are held as manual sources or in machine-readable form and their physical format (such as on cards, slips, computer-typeset documents, computer output microform, online files, etc.).

Also review the comparable approach to index production, noting the indexes that are available on a central or departmental basis, whether they are comprehensive or selective, the staff who have been responsible for their preparation (whether clerical or curatorial), the standard of original preparation and subsequent maintenance, whether the method of reproduction is manual or automated and their physical format (such as on cards or computer printout). Are the available indexes an effective response to user requirements (for example, one may be superfluous and rarely used while another may be essential for research purposes)? Have they been well designed or do they include unnecessary details (such as extensive descriptive information which could be found from the item record)? Are their entries arranged in the most effective order (for example, a place name index being arranged by country, county, place, rather than alphabetically by place)? Has it been possible to produce the indexes from the item records with the minimum of curatorial intervention, or are the item records inadequate as a straightforward source of index information (for example, by not being sufficiently analysed into discrete concepts)? Are there a large number of item records that require indexing for which there is insufficient resources (for example, due to the termination of a job creation project)?

If using a manual system, consider whether the indexes are suitable for use for information retrieval purposes. Similarly, if using an automated system, consider whether its information retrieval capabilities are appropriate to the requirements of the museum. Is there an extensive demand or need for selective retrieval facilities?

Also note the approach adopted for the manual or automated production of object labels to attach or store with an object. If it is museum practice to prepare a label, when and by whom is this done and what information does the label contain? Is its preparation based on the details in the item record or undertaken as a separate exercise? Does the design of the label present any particular problems, such as the need for a small print size or waterproof paper? If the item records are in machine-readable form, but label production is a manual process, would it be constructive to investigate a change of procedure to include their automation, despite these problems?

Finally, note whether the museum has contributed records to any external cooperative cataloguing or indexing schemes and whether this has placed

new demands on the documentation system. If the museum records have been automated, has it been possible to interchange information in machine-readable form as part of these cooperative projects?

(h) Exit stage

1 inter-departmental movements

Who is authorised to decide to move an item to another department (see (f) for intra-departmental moves), and how is this decision implemented?
If an item is moved, is the effect on the documentation different from that of an intra-departmental move?
If yes, what is the effect on the item and location documentation?
If the movement is a permanent transfer, is the item renumbered in the new department?
Is the original register entry for the item amended or (if renumbered) a new entry prepared in the recipient department?
Is the documentation maintained on a central or departmental basis?

2 loans-out

Who is authorised to decide to loan an item from the collection and how is this decision implemented?
Is any separate loan documentation prepared?
If yes, what does this consist of, and who is responsible for its maintenance?
Is a condition report prepared before the item leaves the museum and checked when it is returned?
What effect does the loan have on the item and location documentation for the item itself?
Are steps taken to ensure that the recipient has adequate security, insurance, packing and transport arrangements?
Does the documentation assist the person who is responsible for ensuring the return of a loaned item (eg by indicating when this return is due)?
How is the item reabsorbed, as far as the documentation system is concerned?

Review the control procedures used to manage any movements of objects out of the department or the museum (such as movements or transfers to other departments and external loans) (Section 5.8). In the case of inter-departmental moves, note any procedures used in addition to the standard intra-departmental controls. If the move is a permanent transfer to another department, what steps are taken to formalise the transfer? In the case of a loan to another museum, note the authorisation and control procedures that are adopted before confirming the loan, at the time of dispatch of the object and during the loan period. Who is responsible for this operation and for ensuring the return of the loan?

B4.2 Bibliographic collections documentation

If you have already noted the procedures used to document bibliographic material in B4.1, limit these investigation to the outline (a).

(a) Outline

In those museums with significant bibliographic collections or professionally-qualified library staff, it may be necessary to treat an assessment of the bibliographic documentation procedures as a separate exercise, undertaken with the assistance of an adviser with expertise in bibliographic systems. This is particularly important in view of the growing availability of specialised automated library systems. Advice on bibliographic assessment is given in a number of library publications, particularly those concerning automation (such as Matthews, 1980). Review the systems and staff used during bibliographic procedures (such as ordering, acquisition, cataloguing, catalogue production and information retrieval, circulation control and serials control) and the relationship of these procedures to management control procedures (such as financial control of purchases). Note whether any distinction is made between items held in special collections with an intrinsic museum interest (such as a book with fine binding) and those with a standard library interest (such as a loan copy of a current text). Consider the relationship between the bibliographic records and procedures and the object records and procedures.

(b) Pre-entry stage

What is the documentation procedure for ordering items?
Do you have any standing order arrangements?
Do you use a subscription agency?

(c) Entry stage

What procedures are followed when bibliographic items are received? Do you make any distinction in the documentation procedure for bibliographic items with an intrinsic museum interest (eg a book with a fine binding or an important manuscript) and those with standard library interest (eg a loan copy of a current text)?

(d) Acquisition stage

How many bibliographic acquisitions are received in a typical year?
Is the decision whether to acquire a bibliographic item taken on a central, departmental or sectional basis?
Who is then responsible for the development of its documentation and is this done on a central, departmental or sectional basis?
If the item is a donation, is a letter of acknowledgement sent and is a

formal transfer of ownership title document prepared and signed by both parties?

If a bequest, is a copy of the will filed by the museum and is a transfer document prepared?

If a purchase, are details of the financial transaction kept with other correspondence about the acquisition, or in the financial files, and is a non-financial transfer document prepared?

Are all acquisitions covered by your insurance policy or by an indemnity arrangement?

Do you complete an acquisition form (distinct from a register)?

If yes, is it completed on a central, departmental, sectional or documentation section basis, and by whom is the work done?

What information does it contain?

Is an entry prepared in a register?

If yes, is it completed on a central, departmental, sectional or documentation section basis, and by whom is the work done?

Does it include entries about the whole collection or that of a department, section or particular subject?

Where is it held?

What details are noted in the register, and how do these compare with those on the acquisition form, if used?

What is the physical form of the register (eg is it a bound book with stiff board covers and archival quality paper), and what do you call the register?

When and how is the group assigned a permanent accession number?

How is this number affixed to the group?

Is a file opened and kept, with details of any acquisition correspondence?

If yes, where is this file held, who is responsible for its maintenance and who has right of access?

Does the documentation system provide mechanisms to help you know where the group is during these procedures?

Are the appropriate acquisition procedures detailed in a written documentation manual?

Describe the procedures used to log issues of periodicals received in the library?

How many interlibrary loans are received in a typical year?

Who is responsible for the development of the documentation about these loans?

What is the form of this documentation?

Who is responsible for ensuring a loan's eventual return or renewal?

(e) Post-acquisition stage

—

(f) Item stage

After the initial processing of an acquisition, how long is it before a full bibliographic catalogue record is prepared?

How many new bibliographic records of recent acquisitions are prepared in a typical year?

Does the record conform to an established bibliographic standard?

Who is responsible for the recording?

How is the information noted (eg on a record card, record sheet, etc.)?

What details are noted?

Do you include book plates in any items?

Are the bibliographic files restricted to records about bibliographic items held by the library, or do they include records of other references of interest (such as articles cited while preparing object records)?

If restricted to the former, are the latter records the responsibility of individual members of staff, or treated as information records?

Is the library a member of a cooperative cataloguing group, or user of any externally produced bibliographic records?

Are details of any conservation of the bibliographic item included in the record, or are these held separately?

If held separately, does the bibliographic record include a numerical or other type of cross-reference to the conservation details?

Are there written procedures for preparing the record?

Is any control applied to the terminology used in the record or the syntax of the information being noted?

Is a duplicate copy of the record kept in a secure place?

What proportion of the bibliographic collection do you consider to be inadequately recorded as far as individual bibliographic documentation is concerned?

In the case of old acquisitions, have any significant parts of the collection been reprocessed during the last ten years?

Do any need reprocessing in the near future?

If any have been reprocessed, what is the typical annual figure for revised records?

Is an individual number assigned and marked on each item, distinct from any earlier accession number?

If yes, when and by whom?

What does the number indicate?

What relation does this number have to the earlier accession number?

In what order is the primary copy of the record kept (eg numerical or by author)?

Does it include tracings to entries about the item in other sequences, such as subject cataloguing?

In what order is the collection itself arranged?

If an item (such as a superseded edition of a book) is disposed of, is its record removed from the file or annotated and retained?

Is the set of records ever checked in any way?

Is a separate location list maintained, noting details of the current location of each item?

If there is a location list, what information does it include about each item (eg books, manuscripts, etc.)?

In what order is it maintained (eg by item, display or specific location)?

What is its physical form?

Is it maintained centrally or on a departmental basis?

If centrally, does it include details of material in departmental libraries?

Is there any provision for ensuring that it is only amended by authorised staff?

What are its main uses?

(g) Output stage

Do you have separate published or internal catalogues, or consider the bibliographic records to be the catalogue of the collection?

If separate, what physical form do the catalogues take?

In what order are they held?

Are they concise (abstracts of the full information) or full?

How often are they revised?

Are they publically available?

If a record is amended, is the corresponding catalogue entry also amended?

If an item is disposed of, is its catalogue entry removed or annotated and retained?

Where is the internal catalogue kept?

Is it safe from fire, etc?

Is a duplicate copy available?

Is the internal catalogue accessible to only authorised staff, to all staff, or to all staff and the public?

Who is responsible for its production and maintenance?

If your records are being automated, do you offer an information retrieval or online interrogation service based on these records?

If yes, describe, and note its cost to the user?

Do you keep details of enquiries received from museum staff or outside users?

Do you offer a general information retrieval service, searching manual or computer files on behalf of users?

(h) Exit stage

Who is authorised to decide to loan an item from the bibliographic collection and how is this decision implemented?

Is any separate circulation control documentation prepared?

If yes, what does this consist of, and who is responsible for its maintenance?

What records are kept of periodicals that have been sent for binding?

B4.3 Archive collections documentation

If you have already noted the procedures used to document archive material in B4.1, limit this investigation to the outline (a).

(a) Outline

Similar considerations apply in the assessment of archive documentation, general guidance on which is given in various publications (such as Hickerson, 1981). Review the procedures applied when documenting any archive collections, noting the links between the archive records and object or bibliographic records.

(b) Pre-entry stage

What documentation is prepared when a member of staff becomes aware of a potential acquisition (eg is a record completed or a file opened for the item concerned)?
What proportion of potential acquisitions do you acquire or borrow, and what proportion do you decline?
Is any documentation kept of the declined proportion?
What importance do you place on information about such material?

(c) Entry stage

What documentation procedures are applied when archive items are received?

(d) Acquisition stage

How many acquisitions are received in a typical year?
Is the decision whether to acquire a group taken on a central, departmental or sectional basis?
Who is then responsible for the development of its documentation and is this done on a central, departmental or sectional basis?
If the group is a donation, is a letter of acknowledgement sent and is a formal transfer of ownership title document prepared and signed by both parties?
If a bequest, is a copy of the will filed by the museum and is a transfer document prepared?
If a purchase, are details of the financial transaction kept with other correspondence about the acquisition, or in the financial files, and is a non-financial transfer document prepared?
Are all acquisitions covered by your insurance policy or by an indemnity arrangement?
Do you complete an acquisition form (distinct from a register)?
If yes, is it completed on a central, departmental, sectional or documentation section basis, and by whom is the work done?

What information does it contain?

Is an entry prepared in a register?

If yes, is it completed on a central, departmental, sectional or documentation section basis, and by whom is the work done?

Does it include entries about the whole collection or that of a department, section or particular subject?

Where is it held?

What details are noted in the register, and how do these compare with those on the acquisition form, if used?

What is the physical form of the register (eg is it a bound book with stiff board covers and archival quality paper), and what do you call the register?

Is it completed in permanent ink?

Is there a procedure for correcting errors in the original entry in the register?

Is the register subsequently amended for any reason (eg due to changes of storage location or a re-identification) or does it remain as an historical record of the group at the time of formal registration?

When and how is the group assigned a permanent accession number?

How is this number affixed to the group?

What relation does it have to any subsequent item numbers?

Are these item numbers noted on the acquisition record or register entry?

Is a file opened and kept, with details of any acquisition correspondence?

If yes, where is this file held, who is responsible for its maintenance and who has right of access?

Does it include confidential information?

Does the documentation system provide mechanisms to help you know where the group is during these procedures?

Is there any control over movement of the item during the period between its acquisition and item documentation?

Are the appropriate acquisition procedures detailed in a written documentation manual?

(e) Post-acquisition stage

——

(f) Item stage

After processing an acquisition, how long is it before each individual item within it is documented?

How many new item records of recent acquisitions are prepared in a typical year?

Who is responsible for the recording?

How is the information noted (eg on a record card, record sheet, etc.)?

What details are noted?

Do the details include the storage location?

If yes, is this always amended if the item is moved, or only amended if the item is moved for a significant period, or never amended?

If no, do you maintain separate location lists (see below) or have alternative means of finding a specific item (eg by storage arrangement)?

Are details of any conservation of the item included in the record, or are these held separately?

If held separately, does the item record include a numerical or other type of cross-reference to the conservation details?

Does the item record include a numerical or other type of cross-reference to any separate record photographs of the item?

Are there written procedures for preparing the record?

Is any control applied to the terminology used in the record or the syntax of the information being noted?

Is a duplicate copy of the record kept in a secure place?

In the case of current acquisitions, is the information noted at this stage considered to form the full record (subject to later addition of minor details) or a preliminary record (subject to substantial expansion and reworking)?

What proportion of the collection do you consider to be inadequately recorded as far as item documentation is concerned?

In the case of old acquisitions, have any significant parts of the collection been reprocessed during the last ten years?

Do any need reprocessing in the near future?

If any have been reprocessed, what is the typical annual figure for revised records?

If any of the collection is inadequately documented, how do you make use of it and ensure its effective management?

Is an individual item number assigned and marked on each item?

If yes, when and by whom?

What relation does this number have to the earlier accession number?

Is the earlier number noted on the item record?

In what order is the primary copy of the record kept (eg numerical)?

In what order is the collection itself arranged?

If an item is disposed of, is its record removed from the file or annotated and retained?

Is the set of records ever checked in any way?

Is a separate location list maintained, noting details of the current location of each item?

If there is a location list, what information does it include about each item?

In what order is it maintained (eg by item, display or specific location)?

What is its physical form?

Is it maintained centrally or on a departmental basis?

Is there any provision for ensuring that it is only amended by authorised staff?

What are its main uses?

(g) Output stage

Do you have separate published or internal catalogues or indexes, or consider the item records to be the catalogue of the collection?
If separate, what physical form do the catalogues or indexes take?
In what order are they held?
Are they concise (abstracts of the full information) or full?
How often are they revised?
Are they publically available?
If a record is amended, is the corresponding catalogue entry also amended?
If an item is disposed of, is its catalogue entry removed or annotated and retained?
Where is the internal catalogue kept?
Is it safe from fire, etc?
Is a duplicate copy available?
Is the internal catalogue accessible to only authorised staff, to all staff, or to all staff and the public?
Who is responsible for its production and maintenance?
If your records are being automated, do you offer an information retrieval or online interrogation service?
If yes, describe the service, and note its cost to the user.

B4.4 *Audio-visual collections documentation*

If you have already noted the procedures used to document audio-visual material in B4.1, limit this investigation to the outline (a).

(a) Outline

Also note any specialised aspects of the comparable approach adopted with audio-visual collections such as film and photographs (excluding record photographs of the object collections).

(b) Pre-entry stage

What is the scale and scope of your audio-visual collections?
What documentation is prepared when a member of staff becomes aware of a potential acquisition (eg is a record compiled or a file opened for the item concerned)?
What proportion of potential acquisitions do you acquire or borrow, and what proportion do you decline?
Is any documentation kept of the declined proportion?
What importance do you place on information about each material?

(c) Entry stage

What documentation procedures are applied when audio-visual items are received?

(d) Acquisition stage

How many acquisitions are received in a typical year?
Is the decision whether to acquire a group taken on a central, departmental or sectional basis?
Who is then responsible for the development of its documentation and is this done on a central, departmental or section basis?
If the group is a donation, is a letter of acknowledgement sent and is a formal transfer of ownership title document prepared and signed by both parties?
If a bequest, is a copy of the will filed by the museum and is a transfer document prepared?
If a purchase, are details of the financial transaction kept with other correspondence about the acquisition, or in the financial files, and is a non-financial transfer document prepared?
Do you take steps to acquire the copyright of relevant acquisitions?
Are all acquisitions covered by your insurance policy or by an indemnity arrangement?
Do you complete an acquisition form (distinct from a register)?
If yes, is it completed on a central, departmental, sectional or documentation section basis, and by whom is the work done?
What information does it contain?
Is an entry prepared in a register?
If yes, is it completed on a central, departmental, sectional or documentation section basis, and by whom is the work done?
Does it include entries about the whole collection or that of a department, section or particular subject?
Where is it held?
What details are noted in the register, and how do these compare with those on the acquisition form, if used?
What is the physical form of the register (eg is it a bound book with stiff board covers and archival quality paper), and what do you call the register?
Is it completed in permanent ink?
Is there a procedure for correcting errors in the original entry in the register?
Is the register subsequently amended for any reason (eg due to changes of storage location or a re-identification) or does it remain as an historical record of the group at the time of formal registration?
When and how is the group assigned a permanent accession number?
How is this number affixed to the group?

What relation does it have to any subsequent item numbers?

Are these item numbers noted on the acquisition record or register entry?

Is a file opened and kept, with details of any acquisition correspondence?

If yes, where is this file held, who is responsible for its maintenance and who has right of access?

Does it include confidential information?

Does the documentation system provide mechanisms to help you know where the group is during these procedures?

Is there any control over movement of the item during the period between its acquisition and item documentation?

Are the appropriate acquisition procedures detailed in a written documentation manual?

How many loans are received in a typical year?

What is the cumulative total of loans currently in the museum?

Is the decision concerning whether an item should be borrowed by the museum a central or departmental responsibility?

Who is then responsible for the development of its documentation?

Who is responsible for acknowledging the loan's receipt and for ensuring its eventual return or renewal?

Is a formal loan document prepared and signed by both parties?

Are all loans covered by your insurance policy or by an indemnity arrangement?

Is an entry about the loan prepared in a register?

If yes, is this the same as the register of permanent acquisitions?

By whom is it prepared and maintained?

Where is it held?

What details are noted in the register?

What is the physical form of the register (eg is it a bound book with stiff board covers and archival quality paper)?

Is it annotated when the loan is returned?

Is the item assigned a permanent accession number or a separate loan number?

(e) Post-acquisition stage

——

(f) Item stage

After processing an acquisition, how long is it before each individual item within it is documented?

How many new item records of recent acquisitions are prepared in a typical year?

Who is responsible for the recording?

How is the information noted (eg on a record card, rcord sheet, etc.)?

What details are noted?

Do the details include the storage location?

If yes, is this always amended if the item is moved, or only amended if the item is moved for a significant period, or never amended?

If no, do you maintain separate location lists (see below) or have alternative means of finding a specific item (eg by storage arrangement)?

Are details of any conservation of the item included in the record, or are these held separately?

If held separately, does the item record include a numerical or other type of cross-reference to the conservation details?

Does the item record include a numerical or other type of cross-reference to any separate record photographs of the item?

Are there written procedures for preparing the record?

Is any control applied to the terminology used in the record or the syntax of the information being noted?

Is a duplicate copy of the record kept in a secure place?

In the case of current acquisitions, is the information noted at this stage considered to form the full record (subject to later addition of minor details) or a preliminary record (subject to substantial expansion and reworking)?

What proportion of the collection do you consider to be inadequately recorded as far as item documentation is concerned?

In the case of old acquisitions, have any significant parts of the collection been reprocessed during the last ten years?

Do any need reprocessing in the near future?

If any have been reprocessed, what is the typical annual figure for revised records?

If any of the collection is inadequately documented, how do you make use of it and ensure its effective management?

Is an individual item number assigned and marked on each item?

If yes, when and by whom?

What relation does this number have to the earlier accession number?

Is the earlier number noted on the item record?

In what order is the primary copy of the record kept (eg numerical)?

In what order is the collection itself arranged?

If an item is disposed of, is its record removed from the file or annotated and retained?

Is the set of records ever checked in any way?

Is a separate location list maintained, noting details of the current location of each item?

If there is a location list, what information does it include about item?

In what order is it maintained (eg by item, display or specific location)?

What is its physical form?

Is it maintained centrally or on a departmental basis?

Is there any provision for ensuring that it is only amended by authorised staff?

What are its main uses?

(g) Output stage

> Do you have separate published or internal catalogues or indexes, or con-
> sider the item records to be the catalogue of the collection?
> If separate, what physical form do the catalogues or indexes take?
> In what order are they held?
> Are they concise (abstracts of the full information) or full?
> How often are they revised?
> Are they publically available?
> If a record is amended, is the corresponding catalogue entry also
> amended?
> If an item is disposed of, is its catalogue entry removed or annotated and
> retained?
> Where is the internal catalogue kept?
> Is it safe from fire, etc?
> Is a duplicate copy available?
> Is the internal catalogue accessible to only authorised staff, to all staff, or
> to all staff and the public?
> Who is responsible for its production and maintenance?
> If your records are being automated, do you offer an information
> retrieval or online interrogation service?
> If yes, describe, and note its cost to the user?

(h) Exit stage

> Who is authorised to decide to loan an item from the collection and how
> is this decision implemented?
> Is any separate loan documentation prepared?
> If yes, what does this consist of, and who is responsible for its
> maintenance?
> Is a condition report prepared before the item leaves the museum and
> checked when it is returned?
> What effect does the loan have on the item and location documentation
> for the item itself?
> Does the documentation assist the person who is responsible for ensuring
> the return of a loaned item (eg by indicating when this return is due)?
> How is the item reabsorbed, as far as the documentation system is
> concerned?

B5 Support documentation

B5.1 Conservation documentation

Note whether the museum maintains separate internal conservation records
(Section 5.9). If it does not, are conservation details included in the item
records? If the museum does keep separate records, are they held on a

central or departmental basis, how many records are held, what is their growth rate, how detailed are they, by whom are they maintained, in what sequence are they filed and do they conform to the item data standards? Is a separate record held for each conservation of an item, or are all the details of different conservations affecting an item over a period of years accumulated into one record?

Review the effectiveness of the links between these records and the main files, any separate record photograph and management control details. If the conservation records include curatorial details of the items (such as an extensive description based on a technical examination) are these duplicated within the item records or do the item records include a clear pointer to these additional details? Does the item record include an explicit cross-reference to the conservation record? Are photographs taken during an examination or conservation held within the conservation files or separately?

If the museum does conservation work for outside institutions, does it send them copies of the records and relevant photographs? If not, does it provide details of the conservation number which the museum can add to its own item record? If conservation work is done for the museum by outside agencies, do the agencies provide detailed records about this work and, if so, how are these details absorbed within the documentation system?

B5.2 Record photographs documentation

Are record photographs taken of all items, or only those of a significant value? Where are the record photographs held? Are they kept separate from historical photographs in the museum collection? Do they include a clear indication of the item's identity number and the date of photography? Are these photographs arranged in item number order or according to a specific photograph sequence (Section 5.10)?

B5.3 Information documentation

If the museum maintains any separate collection records, note their coverage and function (Section 5.11). Who is responsible for their maintenance? Are copies contributed to an outside organisation for incorporation within a cooperative scheme? How do these records relate to the individual item records and what data and terminology standards are used to guide their preparation?

If locality records are held by the museum, review the procedures used to maintain the details and the relationship of these locality records to the main item records (Section 5.12). How many records are available; what is their growth rate; by whom are they maintained? What geographical area comes within the scope of these records? Have complementary recording arrangements been made with museums in adjacent areas?

Do you have detailed records of archaeological excavations

(archaeological archive)? If so, how are they arranged and related to any finds now in the museum collections?

Finally, review the availability of biographical, corporate body, event and activity records, noting whether these are held by individual researchers or as a common source (Section 5.13). Examine the scope and potential for these records. Also review the availability and use of any authority control procedures. Are the various information records available for direct public use or only accessible via a member of curatorial staff?

Appendix C: Technical aspects
of automated systems

C1 **Sources of information**

C2 **Hardware and software**

C2.1 central processing unit and main memory
C2.2 secondary and external store
C2.3 specialised storage systems
C2.4 file organisation methods
C2.5 input peripherals
C2.6 output peripherals
C2.7 system communications
C2.8 software and programming
C2.9 information management packages
C2.10 support programs
C2.11 videotex systems

Whether negotiating with an outside organisation for access to computing facilities or planning the acquisition of equipment for inhouse use, it is important that the museum is aware of some of the technical aspects of the systems it may be examining. Appendix C reviews features of the hardware and software that might be used by museums.

C1 Sources of information

Details of general developments tend to appear first in manufacturer and trade literature and the proliferating computer journals (*Byte, Computing*, etc.). They are also consolidated into annual or occasional directories, most of which concentrate on the smaller-scale inhouse machines (such as Flewitt, 1980; Knight, 1982; Olney, 1982).

More general advice on how to evaluate and purchase basic equipment is given in a number of publications (such as Bennett, 1981; National Computing Centre, 1981), from consultants, parent organisations and advisory groups (for example, the CCTA; Cimtech; Information

Technology Centre; MDA; National Computing Centre; Online Information Centre).

Information about specific developments in museums and libraries, such as the release of new software appropriate for information management purposes, often appears first in professional journals (*Library Technology Reports*; *MDA Information: Program*; *Vine*; etc.) or occasional reports (such as Hamilton *et al*, 1985 and Light and Roberts, 1984).

Addresses of some of these sources are given later.

C2 Hardware and software

C2.1 *central processing unit and main memory*

The heart of each of these systems is its central processing unit (or 'CPU') and its main memory (or store). The CPU incorporates a control unit and an arithmetic/logic unit. The latter manipulates data which it takes from and returns to the memory, under the supervision of programs that are also held in memory, on the direction of the control unit. As the main memory is limited in capacity, data and most programs are held in a secondary store and only copied into the main memory when needed, after which the processed data is passed back to the secondary store (input and output or 'I/O' operations). The data and programs that are copied into memory are temporarily held in an area called 'random access memory' (RAM). Programs which are permanently held in memory ('core resident' programs) may be fixed in an area called 'read-only memory' (ROM), in which case they cannot be altered by the user.

The data being processed by the CPU is made up of individual characters, corresponding to the original source data. The machine stores and recognises characters as a series of binary digits (or 'bits'). Rules such as the American Standard Code for Information Interchange (ASCII) and the Extended Binary Coded Decimal Interchange Code (EBCDIC) define the appropriate combination of bits to represent each allowed character. This combination of bits corresponding to a character is termed a byte (typically made up of 8 bits).

The capacity of the main memory is measured in bytes. In practice, the standard capacity units are approximately 1000 bytes (a kilobyte, 'Kb' or 'K') or 1 million bytes (a megabyte, 'Mb' or 'mb'). A mainframe or minicomputer may have a main memory capacity of from 64K to well over 1mb; a microcomputer, typically from 16K to 512K. Another measure of capacity is the number of bits that can be extracted from or passed to the main memory simultaneously. This capacity is called a 'word', the size of which is related to the machine's operating speed. A mainframe computer may have the ability to access up to 64 bits at one time and a minicomputer may typically access 16 or 32 bits; a microcomputer 8, 16 or 32 bits.

In the case of a microcomputer, the control and arithmetic/logic CPU functions are incorporated in a microprocessor (or 'chip'). In a small microcomputer this will typically be an 8-bit device (such as the Zilog Z80 microprocessor); in a more significant microcomputer it may be a 16-bit device (such as the Intel 8086 or Motorola MC68000 microprocessor). While 8-bit microcomputers have a restricted capacity and speed, they are widely available at a low price and have an extensive range of commercially-prepared software. In contrast, 16-bit microcomputers have a greater capacity and speed but have only recently become available and, at present, are more expensive and have a restricted range of software. Because of this, some of the significant microcomputers incorporate both an 8-bit and a 16-bit device (a 'dual-processing unit' or 'DPU'), in an attempt to provide a wide range of capabilities.

The operating speed of mainframe computers and minicomputers may be measured in nanoseconds (billionths of a second) down to microseconds (millionths of a second); and of microcomputers, in milliseconds (thousandths of a second). The ability of a system to process records is a key feature to be considered when examining different options and applications. As records of control information and index data categories are relatively small, it may be possible to process them with a minicomputer or significant microcomputer. In contrast, full curatorial records may be too large to be processed by most microcomputers. The speed of processing on small machines may also be a prohibitive factor when dealing with large numbers of records.

C2.2 secondary and external store

Various types of secondary store (or mass store) may be used to hold information in machine-readable form ready for processing. Storage methods commonly used in museum applications include hard discs, floppy discs, magnetic tapes and, potentially, optical videodiscs. As with main memory, the storage capacity of each disc or tape can be measured in megabytes (mb) (approximately one million characters of information). A 1mb unit is therefore theoretically capable of holding 1000 typical museum records of 1000 characters each. (In practice, the capacity is less than this due to the way the information is arranged within the unit.)

Hard discs are used for storing large amounts of information ready for immediate access by the CPU. The unit has the appearance of a drum within which is a series of discs (a 'disc pack'), each of which is analogous to a gramophone record that can be used for information storage. The disc pack may either have its discs fixed within the unit or allow one or more to be removed and act as an external interchangeable store for security, exchange and transfer purposes. The capacity of a disc unit may be between 5 and 300mb, of which from 5 to 15mb might be removable. A typical mainframe computer installation may have a series of such disc units providing 1000s of mb of capacity; a minicomputer installation may have

three or four units with 100s of mb of capacity; a significant microcomputer installation may include one or two units with up to 200mb capacity. At present, the smaller units cost from £2000 for 10mb capacity to around £10 000 for 200mb (prices which are tending to fall as more systems become available). Information is read to and from the spinning disc by one or more moveable heads which can usually locate the relevant data on the disc almost instantaneously and then transfer it at high speed (depending on the machine architecture), giving a 'direct-access' capability.

Floppy discs are analogous to a single and insecure gramophone record. A unit (or 'disc drive') may hold one or two interchangeable discs, each with a capacity of from 0.2 to 1mb. They are typically found as an integral part of a microcomputer or word processing system, for holding information during data entry or while undertaking basic processing. The drive itself may cost up to £1000 and each disc from £2 to £10. The disc may be 8" or 5" in diameter: although there are some agreed standards for storing information on 8" discs, there is no agreement concerning 5" discs. It may therefore be impossible to read data from a disc created within one type of computer onto a different microcomputer.

Magnetic tape is far more flexible as an exchange medium since there are agreed international standards concerning its use. A magnetic tape unit (a 'tape deck') is analogous to a cassette recorder, physically holding and reading information to and from an interchangeable tape. The tape itself may be used in support of or in place of a hard disc to store large quantities of information for security, processing or exchange purposes. However, unlike a hard disc, the data on a tape cannot be read by direct access. The tape has to be read serially by the unit's read/write head until the relevant section of information is found. The data transfer to or from the tape is itself slower than to or from a disc, due to the physical limitations of the read/write system. While the packing of data on the tape (the 'density') and the length of the tape itself can vary, a typical reel may hold around 40mb of information. A basic tape drive costs from £5000 and the individual tapes from £5 to £10. A single user may have hundreds of tapes within an external store as a long-term working archive. A mainframe installation may have five to ten tape decks; a minicomputer installation one or two; a significant microcomputer installation just one.

Overall, standard mainframe or minicomputer systems tend to have both hard disc and magnetic tape facilities; a significant microcomputer system may have the capacity for a hard disc, magnetic tape and floppy disc facilities (although the tape unit is rarely available as part of a standard business system); limited microcomputer and word processor systems may be restricted to a small hard disc and floppy disc facilities.

The availability of adequate and appropriate storage facilities is a crucial aspect of the system being used by the museum. In addition to the source records created during data entry, the system may have to support a normalised version of these records, one or more index files, control files (such

as vocabulary lists), work space for use when altering records, the processing software and the operating system. Particular care should be taken when estimating the anticipated size of the files to be processed by the system, including a realistic assessment of the number of records and the average number of characters in each.

C2.3 specialised storage systems

Two types of specialised storage system are of particular interest in connection with the storage, retrieval and publication of visual images. These videodisc and micrographic systems may be used independently or in association with a computer system.

Of the four videodisc systems that have been developed, the optical videodisc approach has most relevance to museums (Barrett, 1981a; 1981b; Graddon and Cannon, 1982; Greenhalgh, 1982; Horder, 1981a; Library Association, 1983; Nyerges, 1982; Sorkow, 1983; Sustik, 1981). It is particularly suited to a 'still-picture' use, whereby the same image on a disc can be scanned repeatedly, thus giving the appearance of a still image on the monitor screen. Each disc may hold thousands of these images (typically 50 000 on each side). The optical videodisc systems have a very high information storage capacity, low information storage cost and give rapid random access to the information. They can act as a high-quality non-erasable archive of information.

At present, the production of a master disc is an expensive manufacturing process. However, further research should result in cheaper and improved methods of recording, suitable for local use within a single institution. The reproduction of these discs is already relatively inexpensive.

In the future, one could envisage optical videodiscs being used in association with a microcomputer for the mass storage of images from a museum's print collection or for copies of photographs of the object collection. Given appropriate software and indexing techniques, images and text conforming to a retrieval request could then be displayed on a monitor. A number of institutions have already examined the potential, notably in France (Inventaire Général des monuments et des richesses artistiques de la France), Canada (Public Archives of Canada) and the United States (Nyerges, 1982; Sustik, 1981) (see Appendix D).

Comparable systems using micrographic facilities as part of an automated information storage and retrieval system are also available (Horder, 1980; 1981b; 1981c). In these systems, the image (whether text or graphic) is held on microform. The input into the system is either direct from a standard computer file or via a camera capable of producing microforms. The microforms are maintained in a central store, to which access is provided by retrieval software. The retrieved image can then be displayed on a monitor or presented as a hard copy. These systems are most appropriate in institutions requiring rapid access to large amounts of mixed text and graphic information. Although the established remote-access systems are

expensive, there is some interest in recent smaller-scale developments using microcomputer-based retrieval facilities (for example, Warren, 1983).

C2.4 *file organisation methods*

Records stored within a system tend to be organised in three different ways, according to various requirements such as ease of file maintenance and speed of retrieval (Lee, 1979). The alternatives with a serial storage device (such as a magnetic tape) are serial or sequential organisation; with a direct access storage device (such as a magnetic disc) the options are serial, sequential or random organisation.

A serial organisation file is one in which each record is placed in turn in the next available storage space. Records within the file can only be accessed in the order in which they occur in the storage medium. A sequential organisation file is one in which records are held and accessed according to a predetermined sequence (such as numerical order). Records within the file can be accessed serially (if on magnetic tape or magnetic disc). Both serially and sequentially organised files on serial access storage devices are typically accessed by reading each record in the file until the required one is found. Systems using these approaches tend to be described as off-line batch-processing systems.

In contrast, a random organisation file contains records stored without regard to a particular sequence. Both sequentially and randomly organised files on direct access devices can be read by additional access methods (such as indexing techniques), the principle of which is to provide high-speed methods of locating relevant information. Systems incorporating these approaches are thought of as online or interactive systems.

When museums concentrated on using mainframe computers with limited direct access magnetic disc storage capacity for any one user, batch-processing systems played a dominant role. Recently, additional storage capacity and inhouse mini- and microcomputers have become important factors, as a result of which online systems have become more of a viable alternative. Details of the various types of information management systems based on these approaches and currently used by museums are given later.

C2.5 *input peripherals*

Input peripherals act as a link between the outside world and the processing system, providing a means of translating data into machine-readable form and then transferring this data to the secondary store for subsequent use (Section 4.6–4.7). If the peripheral is directly linked to the system it may also be used as a terminal, acting as a contact with and a means of interrogating the system.

The less common approach is to use a machine to automatically read an existing record (for example, optical character recognition (OCR) devices can read a limited number of typefaces; computer input microform (CIM)

devices can read information on microforms; certain specialised machines can interpret typed or written characters). Unfortunately, a number of these devices are either at an experimental stage or limited to simple and well-presented information.

The more common approach is to type the information into machine-readable form using some style of keyboard or keypad. When using this method, the machine can either be linked directly to the computer or 'stand-alone' as a separate 'work-station' with an attached temporary storage mechanism. In either case, the input device itself may be 'dumb' or 'intelligent'. A dumb linked terminal can transmit characters corresponding to keystrokes to the computer where they can be held in secondary storage ready for processing. If the terminal incorporates some basic intelligence or processing capabilities it will be able to aid the recorder during data entry, prior to the transmission of data to the computer; if it has some basic storage facilities it will also be able to accumulate data independent of the computer.

A typical dumb linked terminal is a visual display unit (VDU), consisting of a keyboard and monitor screen. A typical dumb stand-alone terminal is a simple microcomputer with a storage capability. An intelligent linked terminal typically consists of a VDU and a separate microprocessor with data entry software. An intelligent stand-alone data entry system is a microcomputer or word processor with processing, storage and transfer capabilities.

Some of these stand-alone systems are sufficiently robust and portable to be used in the field or within a museum storage or work area. The data processing facilities on intelligent machines include features to help the user during data entry, such as by providing prompts or a screen-format and by validating the record as it is constructed: facilities which can alternatively be provided by the central processing system when using a linked terminal (Section 4.7). The machine-readable data store on a stand-alone machine may either be an integral part of the machine (analogous to main memory) or a removable device such as a floppy disc or cassette (analogous to secondary store). In the former case, the storage capacity may be limited (typically to a few thousand characters: the product of approximately an hour of continuous typing); in the latter case, multiple secondary storage units can be used in association with a single machine, giving a far greater effective storage capacity (typically 100 000s of characters).

The preferred approach will depend on factors such as cost (the integral machines tend to be cheaper), the method of transfer of data to another device (whether direct or via a secondary storage unit) and anticipated use (such as recording specimen label data or location details while in a storage area or recording full catalogue details while in a work area).

In the case of a stand-alone terminal, the data transfer onto the central system is a separate activity. This can be an advantage in reducing the number of permanent links into the computing system (for example, twenty

stand-alone terminals could use one link at different times during a day or week). The transfer may be done in various ways, such as taking the terminal itself to the main system and linking the two together; extracting machine-readable data (for example, on a paper tape or floppy disc) from the terminal, sending or taking this to the main system then reading it onto the main system using an appropriate reader; and connecting the terminal to the main system with a temporary remote contact (analogous to the permanent contact of a linked machine). The typical remote contact mechanism for linked machines is some type of telecommunications link. Irrespective of the method employed, data transfer is dependent upon standardisation and compatibility of both machines and recording procedures.

General ergonomic features to consider include (GB. CCTA, 1980; 1982b; GB. Health and Safety Executive, 1983):

the speed of operation (speeds of less than 15 characters per second can be distracting to the typist);

the quality of keyboard or keypad (this can have a marked effect on the ease and speed of use of a machine);

the quality of the image on the screen or hard-copy printout (poor quality VDU monitors can be very tiring);

the size of the screen on a monitor (a depth of 24 lines and width of 80 characters is the minimum acceptable for serious data entry work);

the safety of the device (there are doubts concerning the dangers of long-term exposure to radiation from VDU's);

the ease of use of any paper-feed mechanism on an associated printer.

As with microcomputers, the machine must be robust, reliable, easy to maintain and produced and distributed by a reputable organisation.

Typical costs of machines range from dumb linked terminals at £400–£1000, intelligent linked terminals at £500–£3000 and dumb stand-alone terminals at £1200–£3000.

C2.6 output peripherals

Output peripherals are another means by which the system communicates with the outside world, providing facilities for translating data from machine–readable form into a style that can be read by a user, such as a presentation on a linked terminal monitor screen, paper or on microfiche (Section 4.9).

Monitor screens are typically an integral part of a VDU, costing from £500–£1000 and are able to display around 24 lines of information, each of up to 80 characters, at any one time.

In the case of paper output, major computer installations have machines costing over £10 000 which use printer-chains (line-printers) or laser devices to produce the image at high-speed (typically around 1000 lines per minute).

At the other financial extreme, matrix printers costing around £500–£1000 can work at up to a few hundred characters per second to produce a reasonable quality image suitable for proof-reading and other internal uses; daisy wheel printers costing around £1500–£2000 can produce a higher quality image (letter or report standard) at a speed of around 10–50 characters per second. Although usually set up to accept continuous line-printer stationery, in some cases these machines can also have individual page-feed mechanisms. Both types of mechanisms can often be used for various kinds of stock, including paper, card and self-adhesive labels.

Consumables are a major cost factor to take into account when considering output devices. For example, a single sheet of line-printer paper typically costs around 0.5p: a box containing 2000 sheets can be used alarmingly quickly within an active museum environment.

A typical mainframe installation may have hundreds of linked VDU's, a series of high-speed line-printers and daisy wheel printers; a minicomputer installation may have up to 20 VDU's and two or three matrix and daisy wheel printers; a microcomputer installation may have one VDU and a single matrix printer.

Many installations also develop contacts with outside bureaux able to accept machine-readable data for specialised work such as computer typesetting or microfiche production. Computer typesetting software and machinery uses the machine-readable source to produce high-quality camera ready copy as a basis for printing lithographic plates, ideal for book or catalogue publication. The typical cost of processing one page of information (around 500 words) to produce a camera master is around £5: £1000 to typeset a 200-page book. As an alternative to printed output, the installation may also have access to a bureau able to produce COM direct from the machine-readable source. COM is a compact output format which can be easily reproduced and distributed, of great value when dealing with large quantities of information such as museum catalogues and indexes. A typical cost is around £20 to produce a master mocrofiche, equivalent to around 200 pages of printed output. Each copy of this master costs around 15p.

C2.7 system communications

Reference was made earlier to the input/output (I/O) operations involved in communicating data both to and from main memory and input and output peripherals. These operations depend upon a series of connections called a 'bus', which is used to link internal and external parts of a system. If a computer has a non-standard bus, the range of equipment with which it can be linked may be limited (for example, to devices produced by a single manufacturer). Standard buses (such as the S-100) have the potential capability of allowing the linkage of a wider range of equipment (for example, a processor, VDU, data entry machine and printer could each be from a different manufacturer, giving the museum more freedom in identify-

ing the optimum facilities). These links to the outside world are called 'ports'.

While larger machines may allow a modular approach of adding on a number of additional peripherals, in the case of smaller microcomputers and word processors with fewer ports, this adding-on capability can be severely limited. The minimum acceptable situation should be established before the museum commits itself to an item of equipment. For example, in the case of a small stand-alone data entry machine or a general microcomputer or word processor, there must be communications facilities for transferring information to another machine, for either regular data transfer or occasional security and backup purposes.

The two basic methods noted earlier were to use a telecommunications link or physically transfer the data to a recipient machine. The telecommunications link may be the telephone system, connected to both items of hardware by devices such as modems or acoustic couplers. The data may be transmitted over either the standard voice circuits or within a higher-speed and higher-quality packet-switching system. While this approach is adequate when interrogating a distant computer (for example, when undertaking a retrieval search on an international bibliographic system), it has limitations if used for the transfer of original data either within the museum or to an outside installation. The transfer is at slow speed (typically 30 or 120 characters per second) and subject to the occasional corruption of data due to 'noise' on the line. The alternative is to use fixed dedicated lines with appropriate control units which can pass data from one machine to another and potentially act as the basis for a network of independent machines.

C2.8 *software and programming*

The software or programs used to instruct the processor can be grouped into system software and applications software: the former includes the facilities used to control the basic operation of the system; the latter includes program packages used to aid the particular requirements of the user, such as cataloguing, location control and word processing.

Programs or program packages can either be acquired from an outside source (such as the system manufacturer or a software house) or developed by the museum using either its own staff or an outside consultancy. They are usually designed on paper and then transferred into machine-readable form for testing and 'debugging' until they are felt to meet the original design brief, after which they have to be maintained and, if necessary, extended or enhanced. While the development of a major package (such as a comprehensive information management system) may take ten or more person-years of work, it is possible for someone with the minimum of experience to build up a simple program capable of carrying out limited but useful tasks in a relatively brief time.

An application program is usually held in secondary store until required, when it is loaded into the main memory. The more frequently used system

programs may be permanently located in main store, possibly in a section known as a read-only memory (ROM).

Programs are usually written in a high-level language which acts as a notation corresponding to groups of binary codes: this notation is interpreted by the machine into a machine-level version of the program which is then used to execute the required operation. There is a wide range of different languages, many of which are not standardised between different machines, such as FORTRAN, COBOL, PL/1, PASCAL and BASIC.

A compiler or interpreter acts as the interface between the high-level source program and its machine-level equivalent. If the user wishes to undertake original programming, a suitable compiler for the language being used must be available on the machine; if the user prefers to avoid programming and is able to acquire externally-developed software it may be possible to receive this in a compiled form. If a compiler exists for the language and machine of interest to the user it will typically cost up to £500; if not, it will have to be developed by a programmer, an exercise which might typically take one month of work. In either circumstance, the compiler will need to be maintained after its initial incorporation into the system so it should be acquired from a well-established organisation. The computer installation will need to have a member of staff with appropriate expertise to maintain the compiler.

The operating system is concerned with the overall management and execution of individual application programs, controlling features such as job scheduling and queuing, store utilisation, file security and terminal sessions. It can incorporate the basic commands ('command language'), which a user adopts when communicating with the system. The operating system has an important role in helping the user with many of the operational aspects of the system.

On larger machines, the operating system may provide extensive facilities; it may allow a number of users (multiuser facility) to apply a number of programs (multiprogramming) to the execution of two or more tasks (multitasking) at the same time. For example, at any one time, three users may each be applying one program to sort and print a catalogue and produce a series of indexes and another program to help with a word processing job. However, the operating systems on smaller machines may be more restrictive. For example, the CP/M-type operating systems used on many 8-bit microcomputers are restricted to single-user single-task operation: the three users referred to above would either have to wait for access to the machine while it dealt with each operation in turn or set up an automatic queue to run jobs later or use separate machines. (The UNIX-type operating systems used on a number of 16-bit microcomputers go some way to overcoming these problems by offering multiuser and multitasking capabilities.)

In the case of mainframe computers and minicomputers, the operating system will usually be provided by the manufacturer as an integral part of the purchase and support arrangement; with microcomputers there is a

greater degree of choice, with the available systems typically costing up to £300.

Utility programs are used to support routine tasks such as archiving files from secondary disc storage to magnetic tape. One important development of utility systems in the last decade has been in the area of data management software, which treats the data itself as an integrated whole, protected and organised separately from the rest of the processing system (Elbra, 1982; Lee, 1979). Centralised data management software is usually called a data base management system (dbms), which may include components such as a file handler, information retrieval system, report generator and control facilities. A number of these dbms's have been used as a source for museum applications, including major mainframe-based systems such as SPIRES and microcomputer-based systems such as DMS.

The way these systems organise data is aimed at achieving three major objectives: data integration, where information from several physically-separated files can be coordinated, accessed and operated upon as though it were in a single logical file; data integrity, where an item of information is stored in one place only, from which it can be accessed for different purposes; data independence, where there is insulation between the programs themselves and the physical organisation of data. Overall, dbms's concentrate on accessing information through the structure of the records rather than their content. Techniques known as partitioning, chaining and inversion are used to organise data so that different logical record sequences can be created from a single physical sequence. The systems may be categorised as relational, hierarchical or network according to the conceptual approach which they adopt to the data. Prices of systems for mini- and microcomputers typically range from £300–£5000.

The automated system used by the museum may also incorporate one or more program packages, according to the requirements of its users. These packages may include data entry and processing procedures suitable for information management, word processing, management control and analytical processing (Section 2). From a documentation viewpoint, a distinction may be made between major information management packages (which may include both input and processing capabilities or be restricted to processing procedures) and support program packages.

These packages may range in scale from a general purpose product made up of 10 000s of lines of source coding and requiring over 100K of memory to a simple program able to undertake a basic isolated task. Its suitability for implementation on different machines may be limited in various ways. For example, it may have been designed for use on a mainframe or, alternatively, on a microcomputer; it may incorporate machine-dependent features limiting its use to a particular type of hardware or, alternatively, it may be portable and suitable for transfer to a wide range of manufacturer's machines.

Irrespective of its scale, portability and complexity, if the package is to be

of long-term use to the museum it must be thoroughly documented, effectively supported (including the provision of training), well maintained and, ideally, suitable as a basis for further development. The initial preparation of a major package may take at least ten person-years of work, cost more than £100 000 and require a permanent investment of resources to ensure its subsequent maintenance. Although the preparation of a smaller program package may be far less time consuming and expensive, the need to ensure its subsequent maintenance must be taken into account if it is to be used by the museum. Furthermore, program packages are rarely static objects which comprehensively fulfil the changing requirements of the user: they need to be developed or be adaptable in response to new circumstances and hardware improvements, a procedure which typically continues for five to ten years, after which the user has to seriously consider whether their further enhancement is the most appropriate solution or whether a fresh start should be made, based on the accumulated experience.

Despite these problems, one software development approach is for the museum to prepare its own programs. Alternatively, the museum may commission an outside body (such as its parent organisation, a service agency or a consultancy) to undertake the writing and maintenance of software on its behalf. The third approach is for a group of museums to cooperate in the production of new software for their general benefit. The fourth approach is to gain access to existing software by either using an outside machine on which the software is already available or acquiring it from another agency. This software may have been developed by a variety of sources, such as a hardware manufacturer, a commercial or cooperative software agency or another user who is now willing to make their work available and provide the necessary maintenance cover. The package may be acquired free of charge, by a single lump-sum payment, by an initial lump-sum plus maintenance charge or by an annual lease (including maintenance).

In the case of major packages for mainframe and minicomputer use, typical initial payment costs may be up to £100 000, plus 10% per annum for maintenance, support and training; typical leasing costs for a comparable cover may be up to £25 000 per annum. Software for microcomputers can be far cheaper, due to more limited capabilities or support, the strength of the competition and the potential scale of the market. It is typically purchased by a single lump-sum payment ranging up to £1000. A number of organisations are now developing microcomputer versions of existing mainframe or minicomputer packages which, while having some limitations and being less well supported, may offer adequate facilities at a fraction of the price of their precursor.

The design of a program package may adopt either a specific or general approach: the former concentrates on developing a package suitable for a specific anticipated function; the latter concentrates on developing a package able to be used as a building-block for a number of different functions. General purpose programs tend to be more appropriate for major

processing work in museums since they have the potential of being used in a wide variety of compatible ways to satisfy particular requirements (for example, the same package may be used to aid different operations in each department). However, they have the disadvantage of requiring tailoring before they fulfil these specific requirements.

Although not strictly 'programming', this tailoring is skilled and time-consuming work, involving aspects such as the design of input and output styles and index specifications, using the basic facilities provided by the package. This work can consume a year or more of effort in these case of a major project. As with program maintenance and enhancement, this is a continuing responsibility. Possible approaches include the museum doing this work itself once it has acquired the package, for the software distributor to do the work on behalf of the museum or for the museum to adopt the existing tailored application used by another museum or available from a distributor.

Systems provided by a distributor are often described as 'turnkey'. These typically include a predetermined combination of either a raw applications package or a tailored applications package, together with the necessary hardware configuration (including processor and input and output peripherals) to satisfy the museum's anticipated requirements. The systems may be available for either purchase or lease. While it can be an expensive way of acquiring a system, this approach does have the advantage of removing much of the system planning, installation and implementation responsibility from the museum to a single outside agency. This method has been most effective within the library community, particularly with circulation control and information retrieval systems where the scale of the potential market (in terms of number of users and the magnitude of the requirements of each) has resulted in a series of non-commercial and commercial developments (Boss and McQueen, 1982; Matthews, 1980). (It is also the approach adopted by distributors of word processing systems, which consist of a tailored application package incorporated as part of a minicomputer or microcomputer configuration.)

Before committing itself to any decision concerning gaining access to a package or acquiring a package for inhouse use, the museum should carefully investigate the suitability of the proposed approach. Factors to consider include:

is the software adequate for the required function (for example, does it have any limitations such as restricted record or file sizes);
is it user-friendly, with effective input and output procedures;
has it been used by another museum or library and, if so, what experience they have had in its use;
how much will it cost to access or acquire;
what effort and staff will be involved in its maintenance and tailoring;
how does it fit into any existing system framework (for example, is a compiler for its language already available or easily obtainable and

supportable, or can it be acquired in a compiled-version, will its use require additional main or secondary storage, is the existing operating system suitable and will it require other software to make it usable, such as data entry facilities);
has it been written by a reputable organisation with a policy of developing enhancements;
will it be supplied by a competent distributor;
is its documentation comprehensive and easy to use;
is support and training offered by the designer, distributor or external host;
is there a user group which arranges courses, seminars and conferences, distributes newsletter and user-developed applications?

C2.9 *information management packages*

The program packages that have been developed for general information management purposes (such as cataloguing, information retrieval and collections control) can be considered in three groups. (Further details of these packages are available from the MDA.)

The first group uses data management software as the basis for an information storage and retrieval package. The package may either be constructed around an independent dbms or be self-contained (the latter sometimes being called 'free-text' or 'FTX' systems). Applications of dbms's include systems such as PARIS (using the BASIS dbms), MINISIS (using the MPE dbms), DARIS/DAMIS (using the DMSII dbms), SPIRES, INQUIRE, ADABAS and FOCUS. All these have been used by museums, based on either a mainframe or a large minicomputer. If available for purchase, these systems are typically priced at from £20 000–£100 000; if leased, this may be up to £25 000 per annum. The self-contained type of system for use on mainframes or minicomputers includes packages such as ADLIB, STAIRS, CAIRS, ASSASSIN and STATUS, a number of which have been applied by museums. These are typically priced at up to £25 000; or are available for lease at up to £10 000 per annum. Recent developments have included the announcement of microcomputer-based packages, using 8-bit or 16-bit machines. These are either based on minicomputer precursors (such as HOMER, based on ASSASSIN and FIRS, based on STATUS); or are original designs (such as STAR). They are typically priced at up to £12 000.

This group of systems usually maintains two types of direct access file (a main file of source records and separate index files) which may have a sequential or random organisation depending on the system design. The 'indexed sequential' approach incorporates a sequential main file and inverted random index files. There may be one or more index files, each including information extracted from one or more categories in the source records (Section 4.9). Access to information in these index files may be by structure and then content or by content alone, depending on their arrange-

ment: with the first approach, a separate index file may be held for each type
of indexed category of information (such as author or descriptive concepts);
with the second approach, a single general index file may be held for all the
indexed categories of information. If the index files are limited in scope (for
example, to four or five primary categories), it may be necessary to comple-
ment their use by sequential searches through the main file.

Information within each category in a record may either have a free form
('natural language'), in which case every significant word is added to the
index file, or be controlled by some type of vocabulary control procedure.
File updating and index maintenance is either undertaken interactively at the
time of record input or as a batch process at convenient intervals (such as
overnight or weekly).

The strengths of this first group of systems lies in their potential ability to
maintain and update large numbers of records; high-speed of operation
during retrieval; the degree of support with forms design, validation, etc.,
offered during input; the ability to relate together information in different
ways for individual users; and potential flexibility in dealing with distinct
problems such as cataloguing, information retrieval and collections control.
Problems include the high price and complexity of major systems and
their lack of portability between different types of machine; their heavy
secondary storage requirements; and limitations in analysis, structuring and
associating the categories within complex curatorial item records to fulfil the
demanding criteria outlined earlier (Section 4).

The second group of packages concentrates on self-contained catalogue
systems designed for archival, bibliographic or museum information storage
purposes. Systems such as GOS and SELGEM have been used by museums,
the former in mainframe, minicomputer and microcomputer implementa-
tions. They range in price up to £5000, or £1000 per annum. While access
to information within these systems is usually by structure, using a sequen-
tial search through a serially or sequentially organised full file, they may
also complement this full file with a random access index file. Their primary
role is to produce printed catalogues and indexes (analogous to the auto-
mated main and index files). These can be prepared in anticipation of user
needs and widely distributed within the museum and to outside institutions.
As the entries within these printed indexes cannot be combined
automatically by the user, they often have a 'pre-coordinated' form, with
information from two or more data categories being associated together
during their production. File updating and index maintenance is carried out
as a batch operation at intervals (such as weekly, monthly or quarterly),
between which additional supplementary files might be prepared for any
new records.

The strengths of the second group lie in their ability to maintain and sort
large numbers of complex catalogue records in a form suitable for
occasional publication and indexing; flexible input and output capabilities;
emphasis on batch working, resulting in low secondary store requirements;

general portability; and low cost of acquisition, support and hardware requirements. Against this must be balanced limited facilities for updating records; an inability to provide general rapid information retrieval capabilities; and restricted overall retrieval capabilities when compared with many of the first group of packages.

The third group concentrates on self-contained text file-handling and indexing packages, designed for archive and bibliographic indexing purposes. They include systems such as library keyword indexing packages, a number of which are now orientated towards microcomputer use. Examples used for archive and museum applications include PROSPEC and FAMULUS. They are often free of charge or of low cost. As with the catalogue packages, access to information is usually by structure, using a sequential search through a serially or sequentially organised file. Their strengths include their wide availability; low cost; and relative ease of use. Problems include restricted input, storage and output capabilities and the present absence of minicomputer and microcomputer implementations.

Individual systems within each of the groups differ considerably in major features, such as:

their cost;

whether or not they are available as turnkey systems;

the degree of initial tailoring to match a particular application which is provided by the distributor before they are acquired;

the ease with which further tailoring can be carried out by the purchaser or the distributor;

their suitability for cataloguing, information retrieval and control type applications;

the portability of the package between different types of hardware;

the required hardware configuration (memory size, magnetic disc capacity, etc.);

maximum record size, record numbers and file size before efficient use is degraded;

the comprehensiveness of the facilities (for example, whether they include an operating system and command language and input, vocabulary control and data interchange features);

the quality of subsequent support, maintenance and enhancement by the distributor;

the degree of subsequent support that has to be provided by the user;

the degree to which they can structure records and files and cope with the complexities of museum data;

the ease with which they are applied by users;

the maximum number of users which they can support simultaneously without serious degradation of response time.

C2.10 support programs

The use of a major information management package may be comple-

mented by other programs with a general or specific function. Relevant programs include general dbms's (such as dBase II, DMS and BDMS), data entry and word processing packages (such as Wordstar), statistical packages (such as SPSS) and financial packages (such as Visicalc) (see Light and Roberts, 1984). If using an external system, the museum will be able to adopt those programs supported by that installation; if using an inhouse machine, it will be able to purchase programs from manufacturers or distributors. As with information management packages, it is essential that these programs are fully supported; they might also require tailoring before they fulfil the requirements of the museum.

C2.11 Videotex systems

Another type of application system which has been examined by museums is videotex (Library Association, 1983). Videotex systems are primarily concerned with enabling the user to gain access to remote stores of information, using a simple terminal or television set. The 'videotex' term is used to encompass teletext services (passive teletext) and viewdata services (interactive teletext). A museum or individual curator may wish to be an information provider or an information user. As a provider, the museum may allow the public access to details of forthcoming exhibitions, opening hours, etc. and, conceivably, catalogue information. As a user, it might wish to gain access to public service information or bibliographic and museum catalogues, either held on the videotex system itself or accessed through the system which is used as an intermediary or 'gateway'.

Teletext is the service supported by the television companies (Ceefax and Oracle), aimed at providing a general audience with access to a limited number of pages of information, using a television set. Use of the system is free, provided one has a suitable television. It is a one-way passive system, enabling the user to receive predetermined pages of information, conveyed as part of the standard television signal. The user is unable to interact with the accumulated information, being restricted to the selection of pages of information from a bank of around 200 offered on each channel.

Viewdata is a more specialised system, aimed at specific audiences (such as certain business communities). It enables information to be passed to and from a central computer using a telephone line and terminal. Unlike teletext, viewdata is an interactive system. To be able to benefit from it, the user needs a suitably modified telephone and a television or monitor. Charges are then levied for the use of the telephone, the system itself (per minute) and any information that is examined (per page). In the United Kingdom, the publically available viewdata system is Prestel, supported by British Telecom. The British Library has been investigating the library implications of Prestel, from both the information provision and information access viewpoints. For example, it has been considering the provision of selective reading lists and use by local public libraries. The information community itself has also been interested in using Prestel to interrogate databases. These

might be within the system or on a more conventional bibliographic system.

In either case, the interrogation capabilities of viewdata are very different from those of the normal bibliographic services. While these more restricted capabilities may prove a hindrance to experienced users, they may be very suitable for general public users (Meadows, 1980).

There are already over 200 000 pages of information within the Prestel system. These pages may be joined by many more, including extensive bibliographic files from both the national cataloguing agencies and the commercial online systems. Museums, either individually or in cooperation, may wish to consider whether they have a parallel role within such a framework.

It is also possible to have private viewdata systems, accessible only to their sponsor, the use of which is being considered by the CCTA (Anon., 1981). Various commercial organisations provide the appropriate hardware and software to support these private systems on behalf of the individual sponsors. As an example, the Arts Council has introduced procedures for touring exhibition ordering and control, via a private viewdata system. Its development should prove an interesting test bed for museums and Area Museum Councils.

Appendix D: Examples of documentation practice

Di Documentation system applications
 (United Kingdom museums)

Dii Surveys of documentation practice
 (United Kingdom museums)

Diii Surveys of automation, collections control and procedural
 developments (North American museums)

The three parts of Appendix D include details of current documentation practice in a sample of over 50 museums. During the project, the investigator visited 36 United Kingdom museums to review their current documentation applications. Appendix Di summarises the overall impression gained during these visits. Appendix Dii complements this summary with a description of the work in each individual museum. 16 museums in Canada and the United States were also visited and Appendix Diii considers documentation developments in these museums.

Appendix Di:
Documentation system applications
(United Kingdom museums)

Di1 Introduction

Di2 Museum framework
 Management/resources
 Collections

Di1 Introduction

Appendix Di is a description of documentation practice in a number of United Kingdom museums (Table D1), based on visits made by the investigator during 1982. The aim is to provide further background information about documentation procedures to which an individual museum can refer for analogies when considering its own approach. The selection of museums to visit was based on two distinct criteria: first, that the visits should include one or more example of each of the major types of museum (based on administrative body, museum organisation, museum size, collection size and collection diversity); and second, that they should include a selection of the museums that were actively changing their procedures. As a result of this selection policy, the sample museums probably demonstrate a higher degree of support for documentation than is usual. In the limited time available, a number of important examples had to be omitted from the review and it was only possible to concentrate on object documentation procedures. However, it is hoped that its scope is still sufficiently comprehensive to be of relevance to most curators.

Before a visit, the museum was sent documents outlining the form of a typical museum documentation system and providing a checklist of the questions to be asked by the investigator. Extensively revised versions of these documents are given in Appendices A and B. The investigator is very grateful for the effort devoted to the visits by the staff of the museums concerned. In a number of cases, the preparation for the visit and the meeting itself took two or three days on the part of the museum officers. The drafting of this appendix would have been impossible without this level of support. Of the museums approached, only one declined to cooperate with the visit.

Table D1. Museum applications surveyed

Institution	Abbreviation	Governing body	Museums	Collecting departments	Date of foundation
National museums					
British Museum	BM	Trustees	2	9	1753
British Museum (Natural History)	BMNH	Trustees	2	6	1881
Imperial War Museum	IWM	Trustees	3	7	1917
Museum of London	MoL	Board of Governors	1	9	1975
National Army Museum	NAM	Trustees	2	4	1960
National Gallery	NG	Trustees	1	central	1824
National Maritime Museum	NMM	Trustees	1	6	1934
National Portrait Gallery	NPG	Trustees	1	central	1856
Science Museum	ScM	Office of Arts and Libraries (1)	2	8	1857
Tate Gallery	TG	Trustees	1	4	1897
Victoria and Albert Museum	VAM	Office of Arts and Libraries (1)	6	11	1852
National Museum of Wales	NMW	Council	7	5	1907
Welsh Folk Museum	WFM	Council	1	6	1948
National Galleries of Scotland	NGS	Trustees	5	4	1850
National Museum of Antiquities of Scotland	NMAS	Trustees	1	4	1780
Local authority museums					
Bath Museums Service	BATLT	District Council	4	4	1979
Brighton: Royal Pavilion, Art Gallery and Museums	BTNRP	Borough Council	5	5	1850
Bristol: City Museums and Art Gallery	BRSMG	City/District Council	7	8	1823
Derbyshire County Museum Service	DERSR	County Council	4	4	1976
Glasgow Museums and Art Galleries	GLAMG	District Council	8	6	1854
Leeds City Museums	LEEDM	City Council	3	7	1821
Leicestershire Museums, Art Galleries and Records Service	LEICS	County Council	13	4	1974
Liverpool: Merseyside County Museum	LIVCM	County Council	3	14	1851
Newport Museum and Art Gallery	NPTMG	Borough Council	2	central	1888
North Hertfordshire Museum Service	NHERT	District Council	2	central	1974
St. Albans Museum Service	SABMS	City/District Council	2	central	1938
Saffron Walden Museum	SAFWM	District Council	1	central	1832
Sheffield City Museum	SHEFM	District Council	5	5	1875
Stevenage Museum	STEVM	Borough Council	1	central	1954
Stoke-on-Trent City Museum and Art Gallery	STKMG	District Council	3	6	1826
Tyne and Wear County Museum Service	TWCMS	County Council	11	3	1974
Wiltshire County Museum Service	WILTM	(County Council)	(1+13)	(central)	1965
York: Castle Museum	YORCM	District Council	1	4	1938
University museums					
Glasgow: Hunterian Museum and Art Gallery	GLAHM	University	2	4	1807
Manchester Museum	MANCH	University	1	8	1821
Newcastle: Hancock Museum	NEWHM	University	1	central	1829

(1) Trustees status after the passage of the National Heritage 1982 Bill

Although staff of the museums concerned have seen copies of this appendix, it must be stressed that all comments and interpretations are the responsibility of the investigator, and may not be agreed with by the museums themselves.

Where relevant, reference will be made to the experience of individual museums, using the abbreviations for their names given in Table D1. Unless otherwise stated, these references refer to practice at the time of the visit (either spring or autumn 1982). In a number of cases, certain details of the procedure are known to have changed in the intervening period prior to the publication of the report. The following sections therefore summarise the procedures in the museums concerned as they were in 1982. They are supported by individual surveys of each of the museums (Appendix Dii). Except for a concentration on object collections documentation, both the review and the surveys follow the approach adopted in the assessment checklist (Appendix B).

Di2 Museum framework

Management/resources

The 36 institutions visited comprised 15 national museums, 18 local authority museums and 3 university museums (Table D1). They are together responsible for over 120 separate museums, including the main museums and 80 branches or assisted museums. LEICS and TWCMS, for example, are each responsible for ten or more branches, while WILTM is coordinating aspects of the development of 13 independent institutions. Seven are arranged as a single central organisation. The majority of these are either art museums with relatively small collections, or the smaller local authority museums. The other 29 are arranged on a departmental or museum basis, with a number of collecting departments. In the case of the larger national museums (notably the BMNH), departments may be further subdivided into sections.

A number of the museums surveyed considered documentation to be one of their highest priorities. In museums such as BRSMG and YORCM, the current stress on documentation is partly due to the neglect suffered by this aspect of their work in previous decades. In national collections such as the BM, NMM and ScM there is a concern to improve the comprehensiveness and quality of documentation.

Collections

The museums concerned are estimated to be responsible for over 90 million objects (60 million in the BMNH alone), representing a significant proportion of the total object collections in United Kingdom museums (Table D2). In the specialised art museums and a few of the small local authority

Table D2. Museum collections

Museum	Object collections	Library	Archive	Photographs	Film	Sound recordings	Biographic records	Archaeological archive	Locality records	Charts and plans	General records
						Significant other material					
BM	5 300 000	*	*	*							
BMNH	60 000 000	*									
IWM	300 000	*	*	*	*	*					
MoL		*						*			
NAM	30 000	*	*	*							
NG	2 000	*									
NMM	100 000	*	*	*						*	*
NPG	8 000	*	*								
ScM	400 000	*	*	*							
TG	10 000	*	*								
VAM	4 000 000	*		*							
NMW											
WFM	700 000	*	*						*		
NGS											
NMAS	1 060 000	*									
BATLT	44 000		*								
BTNRP	1 090 000	*									
BRSMG	2 640 000		*				*		*		
DERSR	50 000	*	*	*							
GLAMG		*		*							
LEEDM	750 000	*		*							
LEICS	1 600 000	*	*						*		
LIVCM	1 300 000		*	*					*		
NPTMG	100 000										
NHERT	500 000		*						*		
SABMS	120 000		*	*							
SAFWM	130 000		*	*							
SHEFM	120 000	*	*	*					*		
STEVM	12 000		*	*							
STKMG									*		
TWCMS	250 000		*	*					*		
WILTM	15 000			*					*		*
YORCM	100 000										
GLAHM	900 000										
MANCH	9 000 000										
NEWHM	300 000		*	*					*		

museums, each curator may be in a charge of a few hundred or a few thousand objects. At the other extreme, a natural scientist (particularly in the university museums) may be expected to manage 100 000s of objects.

Problems in caring for natural science and archaeological collections are often exacerbated by their growth rate, which may be far higher than that of other types of material. For example, the rate in the Botany section at LEICS is 2–3% per annum. While the rate in the Zoology Department of BMNH is only 0.5% per annum, it amounts to 50 000 additional specimens that have to be processed. While a growth in excess of 10% per annum can also be identified occasionally in other disciplines, the general trend is towards relatively low figures, resulting in a fairly stable collection.

In many of the museums, the non-object collections (including photographs, archival and bibliographic items) are also of great importance. In institutions such as the IWM (with 5 million photographs and 50 000 cans of film), the NMM (440 000 ship plans, 10 600 feet of archival items) and LEICS (10 million archival items), the material represents a vast resource, often growing at a rapid rate. In documentation terms, these non-object collections can represent an even greater problem than the object collections due to their scale, a history of neglect and the lack of expertise in dealing with such problems.

A number of the museums have formal internal or published acquisition policies (eg LEICS AND NPTMG), defining their primary interests in developing the collections. In both these and a number of other cases, a key factor in assessing new acquisitions is curatorial knowledge of the existing collections, supplemented by reference to the available documentation.

Di3 Documentation framework

Documentation management

In a number of cases, the overall development of documentation policy and procedures is being coordinated by a Working Party or Committee, usually responsible to the Director or Trustees (eg NMM, ScM and BTNRP) (Table D3). Although usually established with a specific remit to investigate a revision of the existing procedures, such committees may have a longer-term responsibility to coordinate the subsequent development, as at the NMM.

Of the various stages of documentation, most museums consider the initial entry and acquisition work to be of primary importance, as an essential prelude to subsequent processing and a key factor in ensuring the value of the collection.

The museums concerned adopt various approaches to the implementation of documentation procedures, using staff at a central, departmental or sectional level, sometimes in association with a documentation unit (Table D3). Eleven of the national, three of the local authority and one of the

Museum	Practical implementation				Documentation/ information unit	Policy co-ordination
	Central	Departmental	Sectional	Documentation/ information unit		
BM		*	*	*	(Dept Scientific Research)	Director
BMNH		*	*	*	Biometrics and Computing Section	
IWM		*		*	Dept Information Retrieval	
MoL		*		*	Library and Documentation	
NAM	*	*		*	Dept Documentation	Deputy Director
NG	*			*	Registrar	
NMM	*	*		*	Information Retrieval Section	Deputy Director/ Co-ordinating Committee
NPG	*			*	Registrar	
ScM	*	*		*	Library	Documentation Working Party
TG	*	*		*	Technical Services	
VAM	*	*			–	
NMW		*			–	
WFM		*			Research assistant	
NGS	*					Documentation Working Group
NMAS	*					
BATLT	*	*				
BTNRP		*		*	Documentation Supervisor (Assistant Keeper)	Documentation Committee
BRSMG	*	*			(Deputy Museums Officer)	Management Team
DERSR	*	*				Deputy Museums Officer
GLAMG	*	*				
LEEDM	*	*				Director
LEICS	*	*		*	Documentation and Information Retrieval	Director
LIVCM	*	*				Director
NPTMG	*	*				Assistant Director
NHERT		*				Curator
SABMS	*	*			(Documentation Officer)	Director/Documentation Officer
SAFWM	*					Curator
SHEFM	*	*				Director
STEVM	*					Curator
STKMG	*	*				Director/Section heads
TWCMS	*	*			(Senior Museums Officer)	Director
WILTM	*	*		*	(Museums Officer)	Museums Officer
YORCM	*	*				Curator
GLAHM	*	*				Director
MANCH	*	*		*	Computer Cataloguing Unit	Steering Committee
NEWHM	*					Curator

Table D3. Documentation responsibility

university museums have staff whose primary function is to act as a documentation adviser or officer. Most of the others have a member of staff who acts in this capacity at an informal level. In a number of cases, the officer concerned works within a documentation department or section (eg Biometrics and Computing Section at the BMNH; Information Section at the NMM; Information Retrieval Department at IWM; Library and Documentation at MoL; Documentation Section at LEICS). Elsewhere, the officer is based in a related department, which has relevant facilities (particularly computing resources), such as the Department of Scientific Research at the BM. It should be noted, however, that no two museums have documentation sections with identical functions. Each institution has evolved an approach which is appropriate to its particular circumstances and should be viewed within the overall context of the museum organisation.

A number of the museums also have a Registry, responsible for the maintenance of files concerning all or part of acquisition documentation (eg ScM, VAM, NMM, TG, BRSMG and LEICS). In some of these cases, the responsibility of Registry extends to the control of the primary copy of the museum register (eg ScM and VAM). Although two of the museums have a Central Inventory within their Registry, neither of the registers in these sections includes location details of individual objects.

Documentation resources

In many of the museums, the majority of the curatorial staff are involved in documentation duties to some degree (Table D4). For individual officers, this input can range up to 100% in the case of those whose duties are primarily concerned with documentation services. For the museums as a whole, documentation duties typically absorb around 20% of the time of the curatorial and assistant staff. They are, therefore, one of the most time-consuming activities of the museums.

Over half the museums have benefited from temporary assistance, through job creation schemes, temporary projects or volunteers. The major example of such a project in the national museums is at the BM, with its record completion and Ethnography schemes. However, the most dramatic beneficiaries have been the non-national museums that have had MSC assistance. In cases such as TWCMS, GLAHM, MANCH and NEWHM, the period from the mid 1970s to 1982 was marked by the presence of temporary documentation staff comparable in number or considerably greater than the permanent establishment of the museum. Significant proportions of the existing collections were reprocessed during this period. The withdrawal of this outside support is causing deep concern in museums such as TWCMS and NEWHM.

Most of the museums that have recently introduced new procedures have also begun to prepare documentation about the system itself. There are, however, many cases in which scarcely any written guidance is available for

Museum	Permanent staff involved in documentation		Temporary staff (1982–83)	
	Number	Overall proportion of time for documentation	Yes/No	Number
BM	up to 150		yes	
BMNH			no	
IWM	over 25	(18fte)	no	
MoL	31		yes	
NAM	15	40%	no	1
NG				
NMM	120	20%	no	
NPG			no	
ScM	40		yes	
TG	10		no	
VAM	150			
NMW				
WFM			yes	
NGS				
NMAS	9	40%	yes	
BATLT	6	10%	yes	2
BTNRP	9	under 20%	no	
BRSMG	30	50%	yes	9
DERSR	8	10%	yes	10
GLAMG	30		yes	
LEEDM	4	60%	yes	
LEICS	45	40%	yes	15
LIVCM	28	7.5%	yes	
NPTMG	8		no	
NHERT		30%	no	
SABMS	4	30%	yes	1
SAFWM	3	20%	yes	1
SHEFM	20	5%	no	
STEVM	2	20%	yes	2
STKMG	12		no	
TWCMS	27	25%	yes	23
WILTM	6	25%	yes	
YORCM	6	20%	yes	
GLAHM	9	10%	yes	15
MANCH	13	over 20%	yes	21
NEWHM	2	30%	yes	8

Table D4. Staff

staff. The problems which this creates for new inexperienced staff are accentuated by the lack of formal training programmes, particularly in the national museums. One or two of the documentation services do, however, have a responsibility for aspects of staff training (notably at the NMM and WFM). Museums using parts of the MDA systems sometimes take part in the Association's training seminars and courses.

Apart from the standard investment in filing systems, etc., the major equipment available for documentation purposes is microform facilities (eg at the BM and IWM) and inhouse computer facilities (eg at the BM, BMNH, IWM, MoL, NAM, NMM, ScM, BRSMG, LEICS, GLAHM, MANCH and NEWHM). A major investment in computer equipment has been avoided in a number of cases by either using a local computing centre within the parent organisation (eg BTNRP, DERSR, LEICS, MANCH and NEWHM) or using the MDA computing bureau (eg IWM, NAM, NGS, SABMS, TWCMS, WILTM and GLAHM) (Table D5). In some of these examples, terminals or microcomputers are used to enter and retrieve data from the external processing system (eg IWM, NAM, DERSR, LEICS, TWCMS, GLAHM, MANCH and NEWHM) while in others the museum relies upon the outside processing centre to enter, edit and output data on its behalf (eg NGS, SABMS and WILTM).

The object documentation uses of the computer systems include building up control records for collections management purposes (eg BM, BTNRP, MANCH and NEWHM) and full item records as a basis for both collections management and the production of catalogues, indexes and information retrieval sources (eg BMNH, IWM, NAM, ScM, BRSMG, DERSR, LEICS, SABMS, TWCMS, WILTM, GLAHM and MANCH). Most of the museums have limited their initial computerisation programme to the processing of existing sources, without fundamentally changing their documentation procedures. In contrast, a few (notably the ScM and LEICS) have adopted the approach of reassessing their documentation system and then beginning to automate the underlying procedures. This is an approach which has been followed by other museums in the period since 1982.

Museums making independent use of a major inhouse system or a machine in their parent authority either have one or more full-time members of staff to manage the configuration and advise other staff on its use (eg BM, BMNH, MoL, NMM, ScM and LEICS) or have designated an existing member of staff to act in this capacity on a part-time basis (eg BTNRP, MANCH and NEWHM). Similarly, those museums that have begun to use less substantial inhouse microcomputer systems usually have one person responsible for their investigation and management (eg IWM, NAM, TG, NMAS, BRSMG, LIVCM and GLAHM). The inhouse microcomputers are increasingly being used for other documentation purposes (such as map plotting) and for word processing, financial planning, etc.

In those museums where it has been possible to estimate the proportion of museum expenditure devoted to documentation, the figure is usually

Table D5. Automation of object documentation: museum systems

Museum	System
BM	inhouse mini with departmental terminals
BMNH	inhouse mini with departmental terminals
IWM	inhouse data entry micros to MDA bureau
MoL	inhouse mini with terminals and micros
NAM	inhouse data entry micros to MDA bureau
NG	–
NMM	inhouse processing micros (formerly University of Cambridge Computing Service) with departmental data entry micros
ScM	inhouse mini with departmental terminals
TG	inhouse micro
VAM	–
NMW	–
WFM	–
NGS	MDA bureau
NMAS	inhouse micro
BATLT	–
BTNRP	parent body mainframe
BRSMG	inhouse micros and MDA bureau
DERSR	parent body mainframe with inhouse terminals
GLAMG	–
LEEDM	–
LEICS	parent body mainframe with inhouse data entry micros and terminals
LIVCM	inhouse micros
NPTMG	–
NHERT	MDA bureau
SABMS	MDA bureau
SAFWM	–
SHEFM	–
STEVM	–
STKMG	–
TWCMS	MDA bureau with inhouse data entry machine
WILTM	MDA bureau and inhouse data entry micro
YORCM	parent body mainframe and inhouse terminal (1983)
GLAHM	MDA bureau and parent body mainframe, with inhouse data entry micros
MANCH	parent body mainframe with inhouse data entry micros and terminals
NEWHM	parent body mainframe with inhouse terminals and data entry micro

between 5% and 15%. The overwhelming factor is that of staff time devoted to the preparation and management of documentation.

Documentation system

In many of the museums, similar documentation procedures are adopted for object, bibliographic, archive and audio-visual material. Elsewhere, distinct procedures are adopted for the non-object collections. In general terms, the overall documentation system currently used by each of the museums surveyed conforms to the framework outlined in this report. The most significant differences are in the comprehensiveness of the procedures and the timescale of their implementation. The degree of similarity is sometimes disguised by the terms used by individual museums when describing their procedures.

Basic acquisition details are available for most groups of objects in the majority of the museums, the main exceptions usually being older material. Those museums that have historically not had an accessioning system have either recently introduced such procedures (eg DERSR) or initiated a major item documentation programme (eg BTNRP and SABMS).

The degree of item documentation is more variable, both between museums and between individual collections within a single museum. Furthermore, in many cases the exisiting records have been considered to be inadequate and major reprocessing schemes have been introduced in the last decade. (It is in this area that MSC aid has had most impact in non-national museums.)

The magnitude of the problem is illustrated by the IWM, where the majority of item records are considered to be of a basic standard, the NMM, with 30% of the material without item records, and LEICS where 70% of the material has still to be individually documented. The NMM is expecting that it will take another ten years to produce computer versions of the existing item records, as a basic source for future developments. At LEICS, the outstanding item documentation task is estimated to represent 300 person-years of work.

The national museums sometimes complement these item records by having separate location lists. This approach is rare in the non-national institutions, who tend to rely upon a location note within the primary item records.

Even in those collections where item records have been prepared, the degree of exploitation of the available information can be very low. Few museums (apart from the major art collections such as the NG, NPG, TG and NGS) have prepared or published catalogues for more than a fraction of their collections, and few museums have significant indexes, apart from disparate lists of dubious accuracy.

Notable uses of the documentation cited by museums included responding to enquiries, collections management, research, publications, stocktaking and auditing. A number of museums commented that the poor quality

and scope of the existing records placed severe limitations on their use (eg DERSR, GLAMG and TWCMS).

Most of the museums take care to ensure that their primary registers are kept in lockable cabinets, access to which is, however, usually uncontrolled. In a number of cases only one copy of these registers was available. Some museums (notably the BM, BMNH, NAM, SAFWM and SHEFM) have taken the precaution of microfilming their registers. Few of the museums have manually-prepared duplicate copies of their item records. One or two of the museums that had decided to computerise their records noted the ability to produce security copies of the resulting files as one of the factors that had influenced the decision (eg NMM and WILTM). Some of the museums have examined the stability of the records themselves, and the appropriateness of the environment in which they are maintained. While few of the museums had a comprehensive record photography coverage, many ensured that photographs were available of the more important items in their collections.

Many of the museums were conscious of problems created by the standard of their existing records and procedures, frequently due to historical neglect. However, they were often able to stress the considerable changes and improvements that had been initiated in the last decade and where to be pursued in the future. A number had either recently begun a major revision of their system or were giving detailed consideration to such a revision. The museums that were most critical of their current state were often those that had given the greatest thought and effort to changing that state.

Documentation and collections audit

Most of the museums had a limited collections audit programme in operation, or felt that their use of the collections fulfilled an audit function (Table D6). At an internal departmental level, the most common approach was to undertake a periodic dip check or an occasional selective check of high value items (eg BMNH, IWM, NMM, ScM, VAM, WFM, LEEDM and LIVCM). In a few cases, a comprehensive departmental or museum-wide stockcheck had recently been carried out, usually at the initiative of the staff concerned, and including more general aspects such as storage and conservation requirements (eg IWM, MoL, NG, NPG, NMW, BRSMG, LEEDM, SHEFM, YORCM AND GLAHM). The discontinued practice in the Departmental museums (eg ScM and VAM) of having a formal quinquennial programme was not matched elsewhere, although a few of the institutions did not intend to repeat recent comprehensive checks on a cyclic basis (eg NAM, TG and NGS). The checking programmes were usually implemented by departmental staff, sometimes with the involvement of another senior museum officer (eg BM, NMM, BRSMG and SHEFM). In the case of the BM, it was noted that its new internal audit staff would act in this capacity.

Table D6. Documentation and collections audit

Museum	Museum policy	Parent body and external audit policy
BM	full collections management check and selective checks	E & AD review and reference in reports
BMNH	selective checks	E & AD reference in reports
IWM	selective and full checks	E & AD dip checks
MoL	full collections management check	–
NAM	selective and full cyclic checks	E & AD advice
NG	full collections management check recently completed	E & AD reference in reports
NMM	selective checks	–
NPG	full collections management check recently completed	E & AD reference in reports
ScM	selective checks	E & AD dip checks, review and reference in reports
TG	full cyclic check to be introduced	E & AD reference in reports
VAM	selective checks, some cyclic	E & AD dip checks and reference in reports
NMW	full collections management check (Art) recently completed	Welsh Office report
WFM	selective collections management checks	–
NGS	full collections management check recently completed	–
NMAS	–	E & AD dip checks
BATLT	–	District Audit review
BTNRP	–	Internal Audit dip checks
BRSMG	full collections management check	Internal and District Audit dip checks and review
DERSR	–	–
GLAMG	–	Internal Audit dip checks
LEEDM	full collections management check	Internal Audit dip checks
LEICS	full collections management check	Internal and District Audit dip and selective checks and review
LIVCM	selective collections management checks	District Audit dip checks and review
NPTMG	–	–
NHERT	full collections management check	Internal Audit dip checks
SABMS	selective collections management check	Internal Audit dip checks and review
SAFWM	selective collections management check	Internal and District Audit dip checks
SHEFM	full collections management check	Internal Audit dip checks
STEVM	–	–
STKMG	–	Internal Audit dip checks and review
TWCMS	full collections management check	Internal Audit dip checks and review
WILTM	selective checks to be introduced	–
YORCM	full collections management check	Internal and District Audit review
GLAHM	selective cyclic checks	–
MANCH	–	–
NEWHM	–	–

Although some national museums had been examined by E & AD, Welsh Officer or Scottish Education Department staff (BM, IWM, NAM, ScM, VAM, NMW and NMAS), others appeared to have had no direct practical involvement with outside auditors as far as documentation and collections audit was concerned (MoL, NG, NMM, NPG, TG, WFM and NGS), although they were sometimes referred to in C & AG and PAC reports. Similarly, while a number of the local authority museums were aware of the interest in their procedures and collections of both the authority's own Internal Audit department and the District Audit (BATLT, BTNRP, BRSMG, GLAMG, LEEDM, LEICS, LIVCM, NHERT, SABMS, SAFWM, SHEFM, STKMG, TWCMS and YORCM), there were other comparable museums whose documentation had not been examined by any auditors (DERSR, NPTMG, STEVM and WILTM). More consistently, it did appear that the university museums were not examined by outside auditors.

In the cases where there was active audit monitoring, the auditors usually limited their practical involvement to annual or biennial dip checks (eg IWM, ScM, NMAS, BTNRP, BRSMG, GLAMG, LEEDM, LEICS, LIVCM, NHERT, SABMS, SAFWM, SHEFM, STKMG and TWCMS). More significantly, a number of the national and local authority museums had been encouraged to adopt revised documentation procedures (including major retrospective documentation programmes) following reports from the auditors (eg BM, ScM, VAM, NMW, BATLT, BRSMG, LEICS, NHERT, SABMS, STKMG, TWCMS and YORCM). The aim of these revisions was usually to enable the museum to manage its collections more effectively, rather than support any specific stocktaking function. These reports had sometimes been initiated by an approach to the auditors by the museum director or committee (eg YORCM). Some of the resulting reports had been influencial in supporting the museum in the appointment of a new member of staff or the introduction of a new computerised system (eg LEICS and YORCM).

A number of the museums noted that the aim of improving the overall standard of collections control by introducing new documentation procedures, improving the standard of records and beginning a major computerisation programme, had often been initiated by the museum concerned rather than by outside auditors. Nevertheless, the subsequent support of the auditors in pressing for a major new documentation investment was welcomed.

Deacquisition, insurance and indemnification

Most museums noted that the primary register would be annotated in the event of a loss from the collections. Similar consideration apply to any disposal or transfer to another institution or (in the larger museums) a different department.

A number of museums have separate lists of the collections for insurance

or indemnification purposes. With the exception of some art collections, most of these lists are restricted to items over a certain value.

Di4 Object collections documentation

Pre-entry stage

Most of the museums keep details of certain potential acquisitions in a general departmental correspondence file, often restricting the contents to those concerning significant material. In some cases, however, specific systems are maintained for all such material. For example, at the NPG all potential acquisitions, however tenuous, are noted in an offers log book and a permanent record card prepared for inclusion in an offers index. At the NGS, any item that is of interest as a potential acquisition is detailed in a permanent file. At IWM, NMM, ScM and VAM a potential acquisition file is opened at the request of the relevant department.

Except in the case of acquisitions resulting from an enquiry left in the museum, most museums decided whether or not to acquire material before it enters the institution. (In the case of some high-value collections, such as those at the TG and NGS, this decision may be supported by a detailed technical examination and assessment of the object during a preliminary entry into the museum.) This decision having been taken, the museum is able to pass the material direct to the acquisition stage (circumventing the entry stage) when it eventually comes into the institution for permanent incorporation into the collection.

This procedure, and the pre-entry stage itself, is particularly important in the case of natural science, archaeology and social history material first seen in the field. Some of the museums have major independent systems for the documentation of such material. In the natural sciences, well established field recording schemes have been prepared, with considerable emphasis being placed on the collector of a specimen and the field number assigned at the time of collection. In archaeology, major excavation and field units may be independent of the museum or an integral department (as at MoL and SABMS), in both cases providing pre-processed material and records for the museum to digest. In social history, some museums make a major attempt to document material prior to its receipt in the institution.

Entry stage

Most material entering the museums does so as either an anticipated acquisition or loan-in, or as an item retained for identification, potential acquisition, etc. The way in which this material is grouped and subsequently processed inevitably reflects the different pressures faced by the museums, such as the importance and scale of the various categories of entry (Table D7).

Table 7. Entry stage – grouping of material

Museum	Typical grouping at entry				
BM	A	/	L	/	E
BMNH	A	/	L	/	E
IWM	A	+	L(l-t)	+	E
MoL	A	+	L(l-t)/L(s-t)	/	E
NAM	A	/	L	/	E
NG	A	/	L	/	E
NMM	A	+	L	/	E
NPG	A	+	L(l-t)/L(s-t)	/	E
ScM	A	+	L(l-t)/L(s-t)	/	E
TG	A	+	L	/	E
VAM	A	+	L	+	E
NMW	A	/	L	/	E
WFM	A	+	L	/	E
NGS	A	+	L	/	E
NMAS	A	+	L	+	E
BATLT	A	+	L	+	E
BTNRP	A	+	L	/	E
BRSMG	A	+	L(l-t)/L(s-t)	/	E
DERSR	A	+	L	+	E
GLAMG	A	+	L(l-t)/L(s-t)	/	E
LEEDM	A	+	L(l-t)/L(s-t)	+	E
LEICS	A	/	L	/	E
LIVCM	A	+	L(l-t)/L(s-t)	/	E
NPTMG	A	/	L	/	E
NHERT	A	+	L	/	E
SABMS	A	/	L	/	E
SAFWM	A	/	L(l-t)/L(s-t)	/	E
SHEFM	A	/	L	/	E
STEVM	A	+	L	+	E
STKMG	A	/	L	/	E
TWCMS	A	/	L	/	E
WILTM	A	+	L	+	E
YORCM	A	/	L	/	E
GLAHM	A	/	L	/	E
MANCH	A	/	L	/	E
NEWHM	A	+	L	/	E

A = acquisitions (groups or individual items)
L = loans-in (l-t) (long-term)
 (s-t) (short-term)
E = retained enquiries and potential acquisitions
+ = combined procedures
/ = distinct procedures

Many of the museums tend to adopt distinct initial procedures for acquisitions/loans-in and retained enquiries, the former being relatively superficial and the latter relatively comprehensive. While the superficiality of the entry mechanism for acquisitions/loans-in is usually promptly rectified at the subsequent acquisition stage, enquiries rarely receive any additional documentation, unless they are later accepted as acquisitions and reprocessed according to different criteria. In a number of cases (such as the BM), an unexpected object left in the museum as a potential acquisition is initially included within the enquiry mechanism prior to a formal decision concerning its acceptability. The enquiry procedure may therefore be considered as the default action to be implemented if a prior decision has not already been taken about the object.

The majority of museums make no major distinction between the procedures adopted for anticipated acquisitions and long-term loans-in (eg IWM, MoL, NMM, LIVCM and SHEFM). Others undertake comparable but distinct procedures (eg BM, BMNH, NAM and LEICS). In some cases, short-term loans are treated in the same way as enquiries (eg LEEDM); in others, according to a separate system, which may be informal (eg MoL, NPG, ScM, BRSMG, GLAMG and LIVCM). Elsewhere, no distinction is made between long-term and short-term loans-in (eg NAM, NG, NMM, LEICS and SABMS).

The procedures adopted for anticipated acquisitions can be relatively informal, particularly in the case of material collected in the field by staff (eg LEICS). Natural science field collections can present particular preservation problems, which may require their initial processing in a special temporary system analogous to that for potential acquisitions (eg STKMG and NEWHM). By its nature, certain natural science material is also suitable for subsequent exchange with other institutions. In anticipation of this eventual disposal, it may be held in a separate duplicate collection while in the museum (eg at BMNH), the documentation of which may be less comprehensive than that for the permanent collection.

Acquisition stage

It is convenient to consider together the procedures used by museums when processing permanent acquisitions (permanent additions to the collection) and long-term loans-in (additions of either a defined duration or a duration that can be terminated by agreement with the depositor) (Table D8).

One group of museums (including the IWM, NMM, ScM, WFM, BRSMG, LIVCM and NEWHM) makes no significant distinction between the two types of material, both of which are 'acquired'. Details of each acquired group are entered in a register. A single sequence of numbers is assigned, irrespective of whether the material is a permanent or temporary addition to the collection, the only distinction being the possible addition of a suffix or prefix to indicate a loan. At the other extreme, some museums (such as BTNRP) do not have a separate acquisition process, but rely upon

Table D8. Acquisition stage

Museum	Permanent acquisition		Long-term loans-in		Donation formalities	File location
	Register	Number sequences	Register	Number sequences		
BM	A	A	L	L	letter	department
BMNH	A	A	–	–		department
IWM	A+L	A+L	A+L	A+L		department
MoL	A	A	L	L	form	Library
NAM	A+L	A+L	A+L	A+L	letter	Records
NG	A	A	–	–		Research Assistant
NMM	A+L	A+L	A+L	A+L	letter	Registry
NPG	A	A+L	L	A+L	letter	Registry
ScM	A+L	A+L	A+L	A+L	form	Registry
TG	A	A	–	L	letter	central
VAM	A	A	L	L	letter	Registry
NMW	A+L	A+L	A+L	A+L		department
WFM	A+L	A+L	A+L	A+L	letter	Documentation
NGS	A	A	–	–		central
NMAS	A	A	L	L	letter	department
BATLT	A	A	L	L	letter	department
BTNRP	–	–	–	–	letter	department
BRSMG	A+L	A+L	A+L	A+L	form	archive
DERSR	A	A	L	L	letter	department
GLAMG	A+L	A	A+L	L	letter	department
LEEDM	A+L	A+L	A+L	A+L	letter	department
LEICS	A	A	L	L	certificate	dept/central
LIVCM	A+L	A+L	A+L	A+L	form	dept/central
NPTMG	A	A	L	L		central
NHERT	A	A	–	–	letter	department
SABMS	A	A	–	–	letter	central
SAFWM	A	A	L	L	letter	central
SHEFM	A+L	A	A+L	L	form	department
STEVM	A+L	A+L	A+L	A+L		central
STKMG	A	A	L	L	form	department
TWCMS	A+L	A+L	A+L	A+L	form	department
WILTM	A	A	–	–	form	dept/central
YORCM	A	A	L	L	letter	central
GLAHM	A	A	–	–	certificate	department
MANCH	A	A	–	–		department
NEWHM	A+L	A+L	A+L	A+L		central

A = permanent acquisition
L = long-term loan-in

subsequent item documentation to provide information about their collections. In between these two groups come a number of museums that make some significant distinction between permanent acquisitions and long-term loans-in. For example, the NPG has two sets of registers but only one numbering sequence. GLAMG and SHEFM in contrast, have one set of registers but two numbering sequences. Many museums (eg BM, MoL, VAM, LEICS, STKMG and YORCM) make a total distinction between the two classes of material, having separate registers and numbering sequences. The TG does not have a loan register but does maintain a separate loan numbering sequence. Others, however, have no formal loan-in acquisition stage at all (eg BMNH, NG, NGS, NHERT, GLAHM and MANCH). In many of the large institutions, the approach adopted is based on well-established historical precedent, reflecting the early nature of the institution. In both the NMM and the ScM, for example, a significant proportion of the early collections was received on loan.

Most museums, therefore, have a document or series of documents which they consider to be an acquisition register (variously called an accession book, accession register, loan register, inventory, etc.) (Table D9). In each case, the register fulfills the purpose of acting as the primary historical document about the acquisition, used by both the museum itself and its external auditors for collections management and control. It tends to be annotated in the case of any major change affecting the acquisition, such as its transfer, disposal, loss or return to the owner. It is maintained with care and attention by many officers. However, few registers include detailed current location information about the individual components of the acquisition. Furthermore, there is often only one copy of the register available, access to which may be unrestricted and the physical security of which may be poor. The register itself may be a hard-bound tome (as at the BM, BMNH, NAM, NG, NPG, ScM, TG, BRSMG, YORCM, GLAHM, etc.), loose-leaf sheets which are subsequently bound (eg VAM and LEICS), loose-leaf sheets or forms held in binders (eg IWM, MoL, WFM, BATLT and GLAMG) or in the acquisition file (NMM), a soft-bound book with tear-out sheets (DERSR) or standard record cards (SABMS).

In a number of museums, the entry in the register is based on information noted on an acquisition form, which is itself returned to the department for local use after the completion of the register abstract (eg NAM, ScM, BRSMG and LIVCM). In those museums where the allocation of accession numbers is on a central basis, this form may be the mechanism by which the curator is advised of the assigned number. The accession numbers may either be allocated on a departmental basis (eg BM, IWM, NMM, VAM, GLAMG, LEICS and STKMG), occasionally by reference to a single list (eg MoL and SHEFM), or on a central basis (eg NG, NPG, TG, NMAS, BRSMG, LIVCM, SAFWM and STEVM).

In those cases where the registers are held on a departmental basis (eg BM and VAM) the permanent transfer of material between departments

Table D9. Acquisition register and number

| Museum | Register | | | | Number allocation |
	organi-sation	description	style	location	
BM	S	accession book	bound register	D+microfilm	D
BMNH	S	accession register	bound register	D	D or S
IWM	D	accession register	loose-leaf form	D	D
MoL	C	register	loose-leaf form	I+D (form)	I/D (3)
NAM	D	register	bound register	I+D (form)+ microfilm	I
NG	C	inventory	bound register	C	C
NMM	D	acquisition record	loose-leaf sheet	C+D (form)	D
NPG	C	register	bound register	I+I	I
ScM	D	inventory	bound register	C+D (form)	C
TG	C	inventory	bound register	C	C
VAM	D	inventory	loose-leaf sheet (1)	C+C+D	D
NMW	S	accession register	bound register	D	D
WFM	C	register	loose-leaf sheet	I	I
NGS	D	accession register	bound register	D	D
NMAS	C	Scroll Catalogue	loose-leaf sheet	C+C	C
BATLT	D	accession form	loose-leaf form	D+C	D
BTNRP	—	—	—	—	—
BRSMG	C	accession register	bound register	C+D (form)	C
DERSR	D	accession book	soft-bound book	D+C	C/D (3)
GLAMG	D	accession register	loose-leaf form	C+C+D+S	D
LEEDM	D	accession register	bound register	C	D
LEICS	D	ledger	loose-leaf form (1)	C+D+I	D
LIVCM	C	accession register	loose-leaf sheet (2)	C+D (form)	C
NPTMG	C	accession register	loose-leaf form	C	C
NHERT	D	register	bound register	D	D
SABMS	C	record	record card	C+D	C
SAFWM	C	accession register	bound register	C+microfilm	C
SHEFM	D	accession book	bound register	D	C/D (3)
STEVM	C	register	bound book	C	C
STKMG	D	accession register	bound register	D+external (form)	D
TWCMS	D	inventory	bound register	D+external (form)	C/D (3)
WILTM	D	deposit record	loose-leaf form	D	D
YORCM	D	ledger	bound register	C	D
GLAHM	D	accession register	bound register	D	D
MANCH	D	accession register	bound register	D+D	D
NEWHM	D	accession register	bound register	C	C

C = central
D = departmental
S = sectional
I = documentation/information section

(1) subsequently bound
(2) under revision
(3) assigned by departmental staff on the basis of a master list held centrally

has to be carefully regulated. The gradual evolution of departments at the BM, with fragmentation continuing until the late 1960s, has been a particular problem. Details of the holdings of one department may be noted both in its own registers and in those of one or more related departments (of which it may have a copy). Furthermore, its own register may include material which has since been transferred to another department.

Many museums are now conscious of the difficulty in demonstrating whether they originally acquired or borrowed an item. Most take care to ensure that a new donation is acknowledged by letter, certificate or transfer form, detailing the method and conditions (if any) of the transfer. Similarly, a bequest may be supported by correspondence and an extract from the will, and a purchase by documents relating to the financial transaction.

In a number of museums, such correspondence is maintained in files which are the responsibility of a general central archive or registry (eg NMM, ScM, VAM and BRSMG). In others, it is managed by the documentation section as part of an independent filing sequence (eg MoL, NAM, NG, NPG and WFM). However, in the majority of museums, file management is one of the general curatorial responsibilities, exercised on a central (eg TG, NGS, NPTMG, SAFWM, YORCM and NEWHM) or departmental (eg BM, BMNH, IWM, NMW, BATLT, DERSR, SHEFM and STKMG) basis.

Post-acquisition stage

Most museums pass direct from the acquisition stage, in which incoming material is often treated as a group, to the item stage, where each component of the group is independently documented. In some cases, however, there is an intermediary stage in which the acquisition records are used as the nucleus for subsequent group documentation. The approach (practiced by the IWM, MoL, GLAMG, LEICS and NPTMG) consists of using the acquisition records themselves as the basis of the more detailed post-acquisition record, while retaining the integrity of the group. The additional details about the component items within the group may, as is the case at the MoL, be noted on supplementary sheets appended to the core acquisition record.

Item stage

At some time after the acquisition of a group, nearly all the museums prepare an individual item record for each of its component objects. The majority of museums now deal with current acquisitions promptly, although the actual delay may vary from a few weeks (as at SABMS) to a few years (as at NMAS). The resulting record is usually considered to be the full details about the item, subject to minor amendment, but unlikely to be substantially reworked.

Most museums deal with material according to its order of acquisition into the collection. The individual numbers assigned to each item are

usually based on the earlier accession number, with the addition of a suffix should this be necessary (Table D10). The resulting records may be filed in numerical order (BM, MoL, NAM, NMM, WFM, LEICS, SABMS, SAFWM, GLAHM, etc.) or on a subject (BATLT, LIVCM, etc.) or artist (NPG, TG and NGS) basis. If in numerical order, these records are directly parallel with the earlier acquisition register entries; if in subject or artist order, they are distinct from the earlier acquisition entries, to which reference then has to be made for information about the group.

In a few cases, completely independent item number sequences are established on a departmental or sectional basis, forming a series of 'registration numbers' distinct from the earlier accession numbers. This is sometimes the approach in a museum with a central assignment of accession numbers, followed by the local development of item records within independent departments or sections (eg BMNH, NMW, NMAS, BRSMG and NEWHM). These museums often consider this stage of the process as registration. The corresponding order of the item records usually reflects the new subject-based registration sequence. When using this approach, there is a tendency to delay documenting an individual item until a group of related items can be dealt with simultaneously (on a taxonomic or material basis). This can result in a serious time delay before the processing is complete. The approach also has the effect of dispersing information about the original acquisition.

The preceding discussions have touched upon the core numbers assigned to items during their history: a field number prior to the entry of the acquisition into the museum, a temporary number during the entry logging procedures, an initial group accession number and a subsequent individual item number. In addition, there may be separate conservation or photograph numbers, loan-out numbers and various file numbers. The form and interrelation of the primary numbers is shown in Table D11. This table confirms that the majority of the museums have a straightforward approach to numbering, with responsibility remaining at either a central or departmental level, and the minimum of complications. In most of the cases there is a direct numerical link between a group acquisition and individual item record. The complications arise in those museums with separate registration sequences, where there may be no direct link between the group record and the item records or from one item record to another about an object from the same acquisition.

The records themselves may be noted in a bound or loose-leaf item register (as at the BM, VAM and BRSMG) on record cards or sheets (as at the NAM, NMM, WFM, LEICS, SAFWM, MANCH, etc.) or by direct input into a computer file (in some sections at the BM and NMM). Some curators using registers also construct parallel detailed record sheets, in an attempt to move away from the constraining influence of the bound volume (eg BRSMG). A number of museums are giving detailed consideration to the use of data entry microcomputers for the direct automation of informa-

Table D10. Item stage

Museum	Item record order	Form of item number	File arrangement
BM	acquisition/item	accession number/suffix	acquisition
BMNH	variable	registration number	
IWM	acquisition/item	accession number/suffix	acquisition
MoL	acquisition/item	accession number/suffix	acquisition
NAM	acquisition/item	accession number/suffix	acquisition
NG			
NMM	acquisition/item	accession number/suffix	acquisition & item
NPG	sitter & artist	accession number	acquisition & artist
ScM		accession number/suffix	acquisition & subject
TG	artist/item	accession number	artist/item
VAM	subject or artist	accession number	acquisition
NMW	subject/item	registration number	
WFM	acquisition/item	accession number/suffix	acquisition
NGS	artist	accession number	
NMAS	material/site/item	material/item number	
BATLT	subject	accession number/suffix	
BTNRP		item number	
BRSMG	subject/item	registration number	acquisition & subject
DERSR		accession number/suffix	subject
GLAMG		(accession number)	subject
LEEDM	subject/item	accession number/suffix	acquisition
LEICS	acquisition/item	accession number/suffix	
LIVCM	subject/item	accession number/suffix	
NPTMG	acquisition	accession number/suffix	acquisition (general)
NHERT	acquisition/item	accession number	acquisition (general)
SABMS	acquisition/item & subject	accession number	acquisition
SAFWM	acquisition/item	accession number	acquisition (general)
SHEFM	acquisition/item & subject	accession number/suffix	
STEVM	acquisition/item	accession number/element	
STKMG	acquisition/item	accession number/suffix	acquisition
TWCMS	acquisition/item & subject	accession number/suffix	
WILTM	item	item number	item
YORCM	subject	accession number	acquisition (general)
GLAHM	acquisition-item & subject	accession number/suffix	collector
MANCH	acquisition/item	accession number/suffix	acquisition
NEWHM	registration	registration number	acquisition (general)

Table D11. Numbering sequences and interrelation

Museum	Entry stage		Acquisition stage		Item stage	
BM	T	——	A (D)	→←	A+ (D or S)	
BMNH		——	A (D or S)	——	R (D or S)	
IWM		——	A (D)	→←	A+ (D)	
MoL	T	——	A (I)	→←	A+ (D)	
NAM		——	A (I)	→←	A+ (D)	
NG		——	(C)	——	(D)	
NMM	T	——	A (D)	→←	A+ (D)	
NPG	T	——	A (I)	→←	A (I)	
ScM		——	A (C)	→←	A+ (D)	
TG	T	——	A (C)	→←	A (C)	
VAM	T	——	A (D)	→←	A (D)	
NMW		——	A (D)	→←	R (S)	
WFM		——	A (I)	→←	A+ (I)	
NGS		——	A (D)	→←	A (D)	
NMAS	T	——	A (C)	—←	R (D)	
BATLT		——	A (D)	→←	A+ (D)	
BTNRP	−	——	−	——	I (I)	
BRSMG		——	A (C)	——	R (D or S)	
DERSR	T	——	A (C/D)	→←	A+ (D)	
GLAMG		——	A (D)		—	
LEEDM	T	——	A (D)	→←	A+ (D)	
LEICS		——	A (D)	→←	A+ (D)	
LIVCM	T	——	A (C)	——	A+ (D)	
NPTMG		——	A (C)	→←	A+ (D)	
NHERT	T	——	A (D)	→←	A (D)	
SABMS	T	——	A (C)	→←	A (C)	
SAFWM		——	A (C)	→←	A (C)	
SHEFM	T	——	A (C/D)	→←	A+ (D)	
STEVM	T	——	A (C)	→←	A+ (C)	
STKMG	T	——	A (D)	→←	A+ (D)	
TWCMS	T	—	—	A (C/D)	→←	A+ (D)
WILTM	T	→←	T (D)	→←	I (D)	
YORCM		——	A (D)	→←	A (D)	
GLAHM		——	A (D)	→←	A+ (D)	
MANCH		——	A (D)	→←	A+ (D)	
NEWHM		——	A (C)	——	R (D)	

T = temporary number
A = accession number
A+ = accession number + item suffix
R = registration number, independent of accession sequence
I = new item number, with no precursor
→← = link from this record to the next record (→) or vice versa (←)
—|| = no direct link from (—|) or to (|—) a record
(C) = central allocation of number
(C/D) = departmental allocation from central list
(D) = departmental allocation
(S) = sectional allocation
(I) = documentation/information section allocation

tion, circumventing the manual recording stage (eg NAM, NMM and WILTM).

Museums completing item record cards or sheets often use the standard MDA designs (eg sections within IWM, MoL, NAM, WFM, BATLT, DERSR, GLAMG, LEEDM, LIVCM, NHERT, SABMS, SAFWM, SHEFM, STEVM, STKMG, TWCMS, WILTM and GLAHM) or internal designs based on the same principles (eg sections in ScM, BRSMG, LEICS and WILTM). The availability of these recording media has had the effect of establishing a standard for the various categories of information included within an item record. It has been one of the factors behind the more detailed and uniform level of item recording of new acquisitions now seen in many museums.

Some of the museums using these media, and a few others, now have formal documentation manuals, outlining the procedures, syntax and vocabulary to use when preparing the item records. These instructions may be a straightforward application of the basic MDA publications (eg IWM, NAM, BATLT, DERSR, GLAMG and STEVM), a specific version tailored to the requirements of the local situation (eg TWCMS and WILTM), or extensive notes prepared by the museum's documentation section (eg NMM). They are often the only procedural manual for documentation available in the museum.

In most of those museums that have begun to automate their documentation, it is the item records which have been used as the basic source for data input. In a number of cases, this automation has been in parallel with major schemes to re-document the original collections. The reprocessing of old collections has been a feature of the documentation work of many museums in the last decade, accentuated by a realisation of the inadequacy of the original records and (in the case of local authority museums) by rationalisation within the new museum authorities created after reorganisation in 1974. In some museums the work has been based on the development of existing records (eg BM and NMM); elsewhere, it has been the first burst of serious object documentation which the museum has experienced in recent decades (eg BTNRP, SABMS and WILTM). The scale of the operation is rarely appreciated outside the museums concerned; the scale of the remaining work is only too obvious when one considers the quality of records that are still used in many institutions. At the IWM, for example, 95% of the existing records are considered inadequate; at the NMM, 80% of records are felt to be unsuitable for use as a basis for publications; at SABMS the majority of the collection is not supported by item records; at STKMG, large parts of the collection are without item records; at YORCM, the complete collection is to be reprocessed to a higher standard.

In terms of achievements, the BM has been engaged during the last decade in a major records completion project to bring its basic records to an acceptable state. Substantial parts of the collection have been reprocessed in many museums (eg MoL, NAM, NMM, BTNRP, BRSMG, LEEDM,

LIVCM, NHERT, SABMS, SAFWM, STEVM, TWCMS, WILTM, GLAHM, MANCH and NEWHM): significant proportions in the case of the NMM, LIVCM, STEVM, TWCMS, WILTM, GLAHM, MANCH and NEWHM. As noted earlier, in a number of the non-national museums this work has been dependent upon help from MSC teams. Local authority and university museums (such as GLAHM, MANCH and NEWHM) will find great difficulty in maintaining their impetus and drive towards complete reprocessing if the funding for these teams is withdrawn. They will also be severely handicapped in any attempt to exploit the information in the newly created records which are, as yet, largely unindexed.

In these museums, the help has often extended beyond the preparation of master item records, to their conventional typing and duplication (eg at TWCMS and GLAHM) and their transcription for automation (notably at MANCH and NEWHM, as well as TWCMS and GLAHM). In many other museums, these clerical duties often have to be omitted due to lack of resources or be carried out by the curatorial staff. The staff responsible for the production of the records themselves can range from the most highly qualified subject specialist to untrained and inexperienced school-leavers.

One of the driving forces behind the new emphasis on documentation in a number of museums has been the need to develop effective records for collections control purposes (Table D12). In many cases, the only documentation concerning the location of an object is a note on its item record (the coverage of which may, as already indicated, be far from complete) (eg BATLT, BTNRP, DERSR, LEEDM, NHERT, SHEFM, STKMG, TWCMS, YORCM, GLAHM, MANCH and NEWHM). Elsewhere, there may be partial (eg NMM, LEICS, LIVCM, SABMS and SAFWM) or complete (eg MoL, NAM, NG, NPG, TG, VAM, WFM, NGS and NMAS) location lists (in numerical order) or store lists (in store order) separate from the main record. While such lists may be unnecessary for basic location purposes in some well organised collections (for example, in the taxonomically arranged sections at BMNH), they can play an important role for more general collections management, stocktaking and auditing purposes. This role can be handicapped when only a numerically arranged sequence is available, or when the location details are not maintained.

In those museums with rigorous store management procedures (eg MoL and WFM) or an independent officer and Working Party responsible for movements (eg NG, NPG and TG) any change of location, however temporary, can be logged. In other cases, the available location lists may become out-of-date or only major long-term changes may be noted on the item record (BATLT, BTNRP, DERSR, LEEDM, LEICS, TWCMS, MANCH, etc.). In some museums, each store may have its associated contents list on which can be noted temporary movements (eg TG and SABMS). Another common practice is to leave a store tag in the place of a removed item (eg NMAS, LEEDM, STKMG, GLAHM and NEWHM).

Museum	Location control	Movement control within the institution
BM	item record & location list	variable
BMNH	taxonomy	variable
IWM	location list	variable
MoL	item record & location list	location list
NAM	item record & item list	variable
NG	location list	Working Party log
NMM	item record & location list	variable
NPG	location list	Working Party log & location list
ScM	item record & location list	location list
TG	artist list & location list	Working Party log & location list
VAM	item list & location list	location control form & location list
NMW		variable
WFM	subject list	movement log & subject list
NGS	item list	movement log & item list
NMAS	item list	store tag & item list
BATLT	item record	item record (long-term)
BTNRP	item record	item record (long-term)
BRSMG	none (except art)	none (except art)
DERSR	item record	item record (long-term) & memorandum (long-term)
GLAMG	subject list or location list	movement log
LEEDM	item record	store tag & item record (long-term)
LEICS	location list (high value) & item record	item record (long-term)
LIVCM	location list (high value)	movement control form (long-term)
NPTMG	none	none
NHERT	item record	none
SABMS	item record & location list	location list & item record (long-term)
SAFWM	location card	location card
SHEFM	item record	item record (long-term)
STEVM	none	none
STKMG	item record	store tag & item record (long-term)
TWCMS	item record	item record (long-term)
WILTM	item record & location list	item record (long-term) & location list
YORCM	item record	item record (long-term)
GLAHM	item record	store tag & item record (long-term)
MANCH	item record	item record (long-term)
NEWHM	item record	store tag & item record (long-term)

Table D12. Item location and movement control

One section in BMNH uses the specimen label to indicate the item's absence from the store.

Output stage

Another spur to improved documentation is the wish to have effective catalogues and indexes of the collection, for public and curatorial use (Table D13). These are frequently based directly on the item records, which may, in the case of important collections, be supplemented by other sources.

There are now very few institutions with comprehensive published catalogues. The notable exceptions are the key national art collections with their concise and full catalogues (NG, NPG, TG and NGS). In some cases, the complete or sectional catalogues of the past are still consulted by curatorial staff as an essential primary source to the collection (eg the 1892 catalogue of the NMAS, and pre-war catalogues from the ScM and VAM). The more recent emphasis has been on selective catalogues, such as those of a particular subject (eg from the WFM) or of a certain range of natural science type specimens (eg BRSMG and GLAHM). The long-expressed aim of cooperative national or subject catalogues also continues to be raised.

The aim of producing catalogues was one factor behind the revision of documentation practice cited by a number of museums (eg IWM, NMM, ScM, LIVCM, WILTM, YORCM and MANCH). In many cases, the item records in numerical or subject sequence are considered to act as the catalogue (eg MoL, VAM, BATLT, BTNRP, BRSMG, LEICS, SABMS, SAFWM and SHEFM). In other circumstances, such as at the BM, a catalogue produced from the item records and other sources is then considered as the primary document about the collection, superseding the item record itself.

The ability of an automated system to produce selective well-presented catalogues in a form suitable for immediate publication is seen as one of the major factors in favour of computerisation. The comparable procedure of producing specific indexes based on different permutations of information is also of key importance. Few museums have comprehensive indexes at present, the notable exceptions including some central donor (eg MoL, NMM, NPG, TG, WFM, BRSMG, GLAMG, LEEDM, NPTMG and YORCM) and subject (eg NAM, NG, NMM, WFM, BRSMG, NPTMG and YORCM) indexes. Others, however, have important departmental or specialised listings, such as the range derived from new computer files at the NMM, SABMS, MANCH and NEWHM. A number of the computer users are on the point of producing comprehensive indexes to those parts of their collections that have been processed.

Reference was made earlier to the impact of temporary employment schemes on the scope of item records. If the schemes are curtailed, the permanent staff in a number of those museums will become responsible for

Museum	Typical catalogues and indexes
	Table D13. Catalogues and indexes
BM	various departmental catalogues and indexes
BMNH	various departmental catalogues and indexes
IWM	various departmental catalogues and indexes
MoL	departmental subject catalogue (item records); central donor index
NAM	central subject index (photos); departmental index
NG	central concise and full catalogue: central subject index
NMM	departmental catalogue (item records) and index; central donor and subject index
NPG	central concise and full catalogue; offers, sitter and artist index
ScM	departmental subject catalogue
TG	central concise and full catalogue and donor index
VAM	departmental subject catalogue (item records); various departmental indexes
NMW	various departmental catalogues and indexes
WFM	departmental subject catalogue; central subject, donor and geog index
NGS	central concise and full catalogue
NMAS	central subject catalogue (item records)
BATLT	departmental subject catalogue (item records)
BTNRP	departmental catalogue (item records) and indexes
BRSMG	various departmental catalogues (item records);central subject and donor index
DERSR	limited indexes
GLAMG	various departmental catalogues; departmental subject catalogues; central donor index
LEEDM	central donor index
LEICS	central catalogue (item records)
LIVCM	various departmental catalogues
NPTMG	central donor and subject index
NHERT	various departmental indexes
SABMS	central catalogue (item records); various departmental indexes
SAFWM	central catalogue (item records); departmental index
SHEFM	departmental subject catalogue (item records); central accession number catalogue; department subject and donor index
STEVM	departmental name, subject and geog index (photos)
STKMG	various departmental catalogues; departmental donor index
TWCMS	various departmental catalogues and subject indexes
WILTM	central subject catalogue and central index
YORCM	central subject and donor index
GLAHM	various departmental catalogues and indexes
MANCH	various departmental catalogues and indexes
NEWHM	various central catalogues and indexes

285

the exploitation of the records by the preparation of indexes, a process which will inevitably be protracted, as a result of the lack of resources.

Exit stage

Reference was made above to the superficial control which is often adopted with moves of items within a department. More rigorous procedures tend to be used for moves between departments and to other institutions. A number of museums (eg BM, NG, NPG, TG and LIVCM) have introduced formal systems for controlling a long-term transfer to another department or the movement of an item to conservation. Problems introduced by undocumented transfers in the early history of the museum were particularly serious at the BM, with its departmental registers.

Museums also take great care to document and control loans to other institutions. Nearly all those consulted have a formal system to ensure the acceptability of the recipient and the suitability of the item which that recipient proposes to borrow. Most use one or more types of loan form or register, coordinating procedures on a departmental or central basis (Table D14). In a few cases, the documentation section (eg MoL, NG, NPG and LEICS) or a specific member of staff (eg NAM, TG, WFM and NMAS) is responsible for assisting the curatorial officers with the management of the loan. A number of museums (particularly the non-national institutions) annotate the item record while a loan is absent, showing its change of location. However, few museums make a more permanent note on the item record concerning the loan itself.

Di5 Other documentation

As already noted, there was little time during the survey to adequately review the documentation procedures adopted for non-object collections and other information sources. Aspects that were referred to by the museums included procedures to control record and sale photographs (eg BM, NMM, ScM, WFM, SAFWM and SHEFM) and the importance of separate conservation documentation (eg BM, MoL, NAM, TG, WFM, BRSMG, SABMS, SAFWM, TWCMS, WILTM and YORCM).

A number of the museums had primary collections of archival (eg IWM, MoL, NAM, NMM, TG, WFM, BRSMG, LEICS, LIVCM and WILTM), bibliographic (eg IWM, MoL, NAM, NMM, TG, VAM, WFM and BRSMG), historic photograph (eg IWM, MoL, NAM, NMM, WFM and WILTM) and audio-visual material (eg IWM), which was usually documented within the object system or by analogous procedures. One museum (the NMM) was particularly aware of the role of its information resources, such as ship histories, biographies and geographic records, which were valuable when responding to enquiries.

Table D14. Loan-out procedures

Museum	Responsibility for implementation of procedures	Documentation
BM	departmental	register
BMNH	departmental or sectional	forms
IWM	departmental	loan review card
MoL	departmental/documentation section	loan receipt form
NAM	departmental/central (Research Assistant)	register
NG	Registrar	
NMM	departmental/Registry	loan form
NPG	Registrar	loan form
ScM	departmental	loan form
TG	Loans Coordinator (Technical Services)	loan forms
VAM	departmental	
NMW	departmental	
WFM	central/documentation research assistant	loan forms
NGS	departmental	loan forms
NMAS	central (Administration Officer)	loan form
BATLT	departmental	loan form
BTNRP	departmental	loan form
BRSMG	departmental/central	loan form
DERSR	central	correspondence
GLAMG	departmental	loan forms
LEEDM	departmental	loan form
LEICS	central/documentation section	loan form
LIVCM	departmental/central	loan form
NPTMG	central	loan form
NHERT		loan form
SABMS	central/departmental	correspondence
SAFWM	central	loan form
SHEFM	departmental	loan form
STEVM	central	loan form
STKMG	departmental/central	loan form/loan register
TWCMS	departmental	loan form
WILTM	departmental	loan form
YORCM	central	loan form/loan register
GLAHM	departmental	loan form
MANCH	departmental	loan book/tear-out form
NEWHM	central	loan book

The use of biographic records was also recognised in museums with natural science material (such as BRSMG), a number of which were building up details of discrete collections from named collectors. Natural science and archaeology departments were also often responsible for documentation about sites of interest in their area, either as part of an environmental record centre function (eg BRSMG, GLAMG, LEICS, LIVCM, NPTMG, SAFWM, SHEFM, STKMG, TWCMS and WILTM) or because of a specific excavation programme (eg MoL and SABMS).

Appendix Dii:
Surveys of documentation practice
(United Kingdom museums)

Dii1 Introduction

Dii2 National museums

Dii3 Local authority museums

Dii1 Introduction

Appendix Dii incorporates separate reports on documentation practice in the United Kingdom museums visited by the investigator during the course of the project and already introduced in Appendix Di.

It must be stressed that the reports are based on individual visits of no more than a half-day or a day. These visits were preceded by the distribution of a questionnaire and followed by the submission of draft conclusions. In most cases, the review concentrated on the documentation procedures for the object collections; in some circumstances, it was further limited to individual departments or branches of a museum or museum service.

In the limited time available, it was only possible to undertake a brief factual review of the documentation framework and procedures of each museum. As it was impracticable to extend this review into a critical examination of the museum's documentation system, it would have been improper and unrealistic to have included any specific criticisms in the reports. The details of practice should not, therefore, be considered as model approaches to be followed by other museums.

Although the investigator is very grateful for the effort devoted to the visits by museum staff, it should be noted that the museums themselves do not necessarily agree with the interpretations in the reports. Each museum has, however, had an opportunity to review drafts of its report and has authorised the use of the published version.

It is also important to stress that there was a delay of three years between the visits and publication, during which a number of the museums have revised their documentation systems. While the delay in publication is

unfortunate, the basic procedural details are usually still essentially valid. The main change has been the gradual adoption of improved collections management procedures and new or revised computer systems in a proportion of the musems. In most of the cases where there have been significant changes, brief details are given at the end of the individual report.

As in Appendix Di, the reports follow the structure of the assessment checklist (Appendix B).

Dii2 National Museums

Dii2.1 The British Museum

Introduction

Report based on a discussion with Mr David McCutcheon (Computer Project Manager, Department of Scientific Research), 25 March 1982. The details of practical procedures concentrates on those in the Ethnography Department.

A brief reference to the current position is given at the end of the report.

Museum framework

Management/resources
The British Museum is arranged on a departmental basis, with nine collecting departments, administration and research services:

Coins and Medals
Egyptian Antiquities
Ethnography (Museum of Mankind)
Greek and Roman Antiquities
Medieval and Later Antiquities
Oriental Antiquities
Prehistoric and Romano-British Antiquities
Prints and Drawings
Western Asiatic Antiquities
Scientific Research
Conservation
Central Administration.

The Director and Deputy Director are assisted by departmental Keepers and Research grade staff.

Collections
The object collections exceed five million items:

Coins and Medals	500 000
Egyptian Antiquities	70 000
Ethnography	250 000

Greek and Roman Antiquities	200 000
Medieval and Later Antiquities	500 000
Oriental Antiquities	100 000
Prehistoric and Romano-British Antiquities	1 500 000
Prints and Drawings	2 000 000
Western Asiatic Antiquities	200 000

The departmental acquisition rate is normally less than 1000 items per year, apart from Coins and Medals (where it can vary from 2000 to 7000 per annum), Prehistoric and Romano–British Antiquities (where excavations account for a significant influx of material) and Western Asiatic Antiquities (in which large collections may occasionally be received).

Documentation framework

Documentation management
The Director is responsible for the development of documentation policy, the implementation of which is coordinated at a departmental level by individual Keepers. Certain aspects such as stocktaking, inventory control and auditing are also considered by senior Central Administration staff. The use of computer systems is being coordinated by the Department of Scientific Research. There is no central Registry.

The first concern is the development of primary item records of the collections. Other priorities are the maintenance of entry and acquisition documentation, the preparation of published catalogues and the use of records as a source for indexes.

Documentation resources
Most of the 150 Keepers, Assistant Keepers and Museum Assistant staff are involved in documentation to varying degrees. The museum has also been helped by temporary staff involved in a series of records completion projects (reconciliation of records with objects, preparation of indexes, etc.). A team of five assistants has been involved in a special scheme to collate and computerise records in Ethnography. Detailed manuals are available for the current project in Ethnography and Coins and Medals. Training tends to be undertaken in-service.

The Museum has been actively developing the use of computer systems, supported by the Department of Scientific Research. This involves the application of an inhouse minicomputer-based system using various programes, including the GOS package developed by the MDA, with applications and extensions undertaken by the museum. Major current projects are within the Departments of Ethnography, Coins and Medals and Egyptian Antiquities (Orna and Pettitt, 1980).

The major capital cost to date has been the investment in additional computing facilities to supplement those already available in the Department of Scientific Research. It was not possible to quantify the dominant recurrent cost of permanent departmental staff time.

Documentation system

All material deposited in the museum is logged in departmental receipt books (Figure D1). Acquired groups are noted in departmental acquisition registers and their individual components later detailed in specific item registers. Separate catalogues may be prepared, in which case their entries often become the primary source about the object. There are a variety of indexes to parts of the collections. The museum has been concentrating on the preparation of records about all items in its collections as a source for subsequent use and manipulation.

During the last decade, the museum has been engaged in a major Records Completion Project, to ensure that comprehensive records are available in all departments. This project has complemented the long-term investment in documentation, with the result that individual item records should be available for most of the collections within a few years.

Considerable attention has been paid to the security of the documentation. Microfilm copies of registers are available and access to the original sources is controlled. The collection is also being photographed. Conservation has assessed the stability of the records themselves.

Documentation and collections audit

Recent emphasis within departments has been on the accumulation of background information about the collections in a form suitable for subsequent use for stocktaking, etc. There has, therefore, been no significant departmental stocktaking in recent years, although large parts of the collections have been checked for broader purposes. The museum is concerned about the practicalities of stocktaking, noting the problems of identifying material and the threat of damage to material caused by the stocktaking itself. It is, however, exploring the use of computer-generated indexes as an aid to such exercises.

There is no comprehensive stocktaking programme using non-departmental staff. One recent exercise coordinated by the Museum Secretary did, however, assess the state of a representative part of the Coins and Medals collection. The museum is in the process of establishing a team of internal auditors, one of whose functions will be stockchecking. The E & AD and the PAC have also considered the museum's procedures, and have expressed support for the approach of upgrading the available records (see Section 2.7).

Deacquisition and indemnification

The relevant records are annotated after any loss. The collection is indemnified.

Object collections documentation

Pre-entry stage

In the event of a significant potential acquisition, the department will open a file to hold related correspondence, etc.

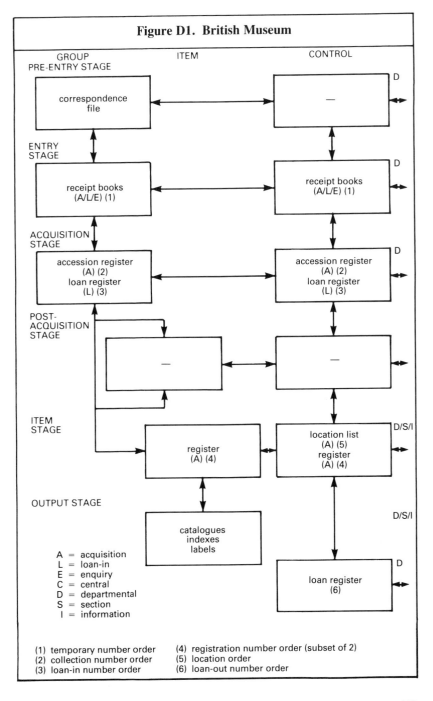

Figure D1. British Museum

GROUP ITEM CONTROL

PRE-ENTRY STAGE

correspondence file — D

ENTRY STAGE

receipt books (A/L/E) (1) — receipt books (A/L/E) (1) D

ACQUISITION STAGE

accession register (A) (2) loan register (L) (3) — accession register (A) (2) loan register (L) (3) D

POST-ACQUISITION STAGE

— —

ITEM STAGE

register (A) (4) — location list (A) (5) register (A) (4) D/S/I

OUTPUT STAGE

catalogues indexes labels

A = acquisition
L = loan-in
E = enquiry
C = central
D = departmental
S = section
I = information

D/S/I

loan register (6) D

(1) temporary number order
(2) collection number order
(3) loan-in number order
(4) registration number order (subset of 2)
(5) location order
(6) loan-out number order

Entry stage

Analogous but distinct procedures are adopted for acquisitions, deposits (offers), loans and enquiries, all of which are referred to the relevant department. For each type of material, a numbered entry is made in a three-part receipt book, one copy of which is passed to the depositor, another held with the group and the third retained in the book itself. A tag may also be attached to the group. It is then passed for processing by the relevant member of staff.

Acquisition stage

Approved acquisitions are acknowledged by letter. In the case of a purchase a receipt is also issued. Financial control of major purchases is a central responsibility, after which a confirmation note is sent to the Keeper for filing. More minor payments are processed within the department by its Executive Officer.

The group is detailed in a departmental acquisition register (donations/ purchases book) and a permanent label attached to each of its component items (noting accession number and item suffix, depositor and geographical area of origin). The group is then passed to the department store to await registration. The acquisition entry includes a note of progress in processing each component item, thus acting as a direct link with the item itself up to the point of registration. Additional information may be noted in the acquisition register. The details do not, however, always include locations. The group accession number (collection number) is usually assigned on a 'year + month + sequence' basis.

Each department is responsible for files concerning acquisitions. They may not be held in accession number order, depending on local circumstances and convenience. A single copy of these files is held in the department itself.

The museum has a policy of microfilming its acquisition registers, with new entries being included in the programme on a regular basis. The master register is then held under controlled access in the department, while additional copies are available for consultation.

A major problem with the documentation of the old collections is the gradual fragmentation of the original museum into departments, a process which continued into the 1960s. In some cases this has resulted in the primary registers and files for old material being in another department.

Relatively few items are received on loan, those that are received being processed within the department concerned. The original receipt will be supported by an entry in a loans register, distinct from the accession register. The loan is not assigned a permanent accession number. A loan file of supplementary correspondence is maintained.

Item stage

Each item within an acquisition is individually registered at some point after its acceptance (with varying time delays of up to several years, depending on

departmental circumstances). Such item registration is done in order of receipt rather than on a subject basis. This stage is the primary documentation process within the museum, usually undertaken by the Assistant Keepers. The item's registration number is based on the earlier accession number, with the addition of a suffix.

In those departments where computing projects are underway, it is the item records that are being processed.

The standard of item location documentation varies in different departments. In those departments where location lists are available they might be incorporated within the register (location details in the item records) or held as a separate index. The development of location lists is one of the primary concerns of the Records Completion Project, which is directed towards preparing a complete record coverage suitable for subsequent manipulation and use. In the current computerisation scheme in Coins and Medals, the development of location lists is seen as a priority. Basic information is being taken from the discs held, with each record then manipulated to form a location index. The project is expected to take five years.

Procedures for documenting movements vary between departments. Some departments leave an index card in place of the item. In the past, control over movements was poor, with permanent changes not being recorded. Permanent transfers between departments were one of the primary causes of long-term location problems. Such moves now require approval by the Director. Any movement to Conservation is fully logged on a transfer document.

Output stage
The museum has a policy of developing independent catalogues of the collection, using the item records as one source, but also drawing on other information. Where available, the catalogue entry usually becomes the definitive record about the object. These catalogues may be published or available internally in loose-leaf or bound volumes. Entries are usually accompanied by a new catalogue number, with reference being made back to the original registration number.

A wide range of indexes are held in different departments, ranging from comprehensive to incomplete and inadequate. A detailed review of their future development is underway. Most departments prepare labels at the early stages of documentation. Information sheets, etc., are available for parts of the collection.

Exit stage
There are well established procedures for loans from the collections, maintained at a departmental level, with the personal supervision of the Keeper. Loans-out registers are used to document the movement.

The British Museum is forbidden by Act of Parliament from disposing of anything but duplicates in Coins and Medals and Prints and Drawings. The

keeper annotates the register entries in the rare event of disposal of material of this kind.

Other documentation

There is a wide range of other types of material and records. Procedures in Conservation are well established, with detailed records being held of all material that the department examines and processes (Bradley, 1983). Record photographs are held on a departmental basis, with central copies for significant items.

Museum comments

The current registration procedures are felt to be effective and well maintained, with the exception of location details. The repercussions of inadequate procedures in the past – notably before 1903 – are, however, still being felt. Problems include the lack of indexes, badly organised existing indexes, lack of cross-referencing between records and objects, absence of location mechanisms and the indequacy of records for comprehensive stocktaking. The museum is actively reassessing its long-term procedures.

Update

As expected, the Museum has now outgrown its current computer system and is considering adopting a powerful online facility which will support a wider range of collections management functions. The Information Retrieval team has been strengthened to include eleven staff spread around the Departments, with continued support from the computer staff. Details of the ethnography project are given in a recent paper (McCutcheon, 1985). Other projects initiated since the report are in the Departments of Oriental Antiquities and Medieval and Later Antiquities.

Dii2.2 The British Museum (Natural History)

Introduction

Report based on a series of meetings with Dr Gordon Corbet (Head, Central Services); Dr K. W. Davey (Assistant to the Director); Dr Howard Brunton (Department of Palaeontology); Mr J. F. Peake (Deputy Keeper) and Mr Iain Bishop (Department of Zoology); Dr D. R. C. Kempe (Deputy Keeper), Dr Andrew L. Graham and Mr Peter Embrey (Department of Mineralogy); Mr Richard Pankhurst (Department of Botany), 9 March 1982. It was not possible to visit the Entomology Department.

Information about subsequent developments is given at the end of the report.

Museum framework

Management/ resources

The British Museum (Natural History) is a Trustee museum, arranged on a departmental basis, with five scientific departments (which are further subdivided into sections), four service departments and a central directorate:

> Botany Department
> Entomology Department
> Mineralogy Department
> Palaeontology Department
> Zoology Department
> Administrative Services
> Central Services
> Library Services
> Public Services

A key priority for the scientific departments is their research function. There is also an emphasis on curation and enquiries. Education and display work is concentrated within Public Services. It was stressed during the survey that a primary objective of the museum is to build up collections that are representative samples of natural science communities, taking into account geography, age, size, sex, etc. In order to be statistically representative of the vast populations of most species, these samples need to be on a large scale, and the individual items within the samples are correspondingly unimportant.

The Director is supported by departmental Keepers and Scientific Officer grade staff.

Collections

The collections total over 60 million specimens of unparalleled international taxonomic significance:

Zoology	
Mammals	400 000
Bird skins	2 250 000
Fish	2 500 000
Crustacea	3 500 000
Mollusca	7 500 000
Arachnida	9 500 000
Entomology	24 000 000
Palaeontology	8 000 000
Mineralogy	
Minerals	180 000
Rocks	97 000

297

Ocean-bottom deposits	30 000
Meteorites	1 350
Botany	4 500 000
Others	1 000 000

Acquisition rates vary between sections, with the annual additions ranging from about 250 000 in the Entomology Department, 50 000 in the Zoology Department (including 2000 mammals) to 400–700 minerals and 20–30 meteorites.

Documentation framework

Documentation management
Documentation is undertaken at either a departmental or sectional level. Central Services provides assistance with the computerisation of documentation (through a Biometric and Computing Section).

Documentation resources
The majority of the museum's 300 curatorial and research staff are involved in documentation, with a considerable overlap of staff functions.

The procedures for loans from the museum are described in the general staff manual. Any other guidelines are developed within the departments. For example, in Zoology there are sectional manuals describing standards for recording place names, and in Minerals there is a detailed procedural chart. Training is in-service. Staff turnover is very infrequent.

The museum first appointed staff to provide central assistance with the computerisation of documentation in the early 1970s (Orna and Pettitt, 1980). The Biometric and Computing Section has two central minicomputers, a small central data entry unit, departmental data entry terminals and scientific staff. (It provides a mathematical and statistical service to research staff in addition to documentation applications.) A number of computer-based internal and published catalogues and indexes have been produced, based on departmental item records (eg for mammals and ocean-bottom deposits). The emphasis is often on current acquisitions. There has, however, been little investigation as yet into the use of computers for broader collections management tasks (Brunton, 1979; 1980; Doughty, 1982)

Departments such as Botany and Palaeontology are now considering the acquisition of data entry machines for local use, followed by central processing. These developments might be reflected in a more diversified use of the processing power.

Documentation system
In the case of their permanent collections, most departments distinguish between initial accessioning and subsequent item registration and cataloguing, although the approaches adopted can be very different (Figure D2). In some cases all groups are accessioned and each item then registered. In

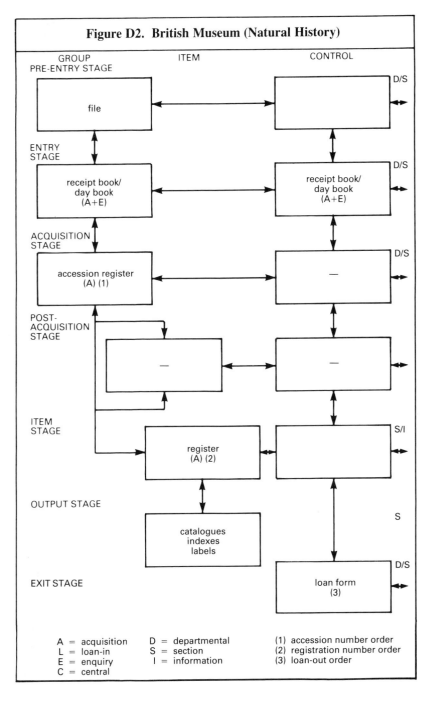

Figure D2. British Museum (Natural History)

other cases only key items may be registered. The approach is influenced by factors such as the volume of material being received, staff resources and the taxonomic arrangement of specimens.

Secure microfilm copies of registers are held.

Documentation and collections audit

The museum has vast collections of items of low monetary but high scientific value. In such circumstances, it has argued that comprehensive stocktaking is unrealistic, but that an emphasis should be placed on selective programmes and overall security provisions. Individual departments have identified grade A items that are most at risk, and adopted programmes to check these. For example, in Mineralogy the complete meteorite collection is checked (including weighing) every ten years and all gemstones are checked every five years. In Palaeontology and Zoology, the most important items are heavily used and therefore subject to informal checks.

The reviews of audit practice of the E & AD and PAC have sometimes referred to the specialised stocktaking problems of the museum (see Section 2.7).

Object collections documentation

Pre-entry stage

Departments hold details of material which they anticipate acquiring in the future. In Meteorites (Mineralogy Department), a record card is prepared about any potential acquisition, giving brief details of the material and referring to related correspondence.

Entry stage

Departments adopt distinct procedures for acquisitions, loans and enquiries, dealing with them on a central departmental or sectional basis. A distinction is also made concerning whether to include material in permanent or other collections. There may, for example, be a research or study collection, exhibition collection or (as in the case of Minerals) a duplicate collection. Only the permanent collection material will go through all documentation processes.

The processing of enquiries corresponds to the different administrative organisation of the departments, with Palaeontology and Mineralogy receiving material on a central basis and Zoology preferring to stress sectional responsibility because it is usually immediately obvious to which section the enquiry refers. In Palaeontology, an enquiry pad is held at the central Reception Desk. Any incoming material is logged in this book. One copy of the form is sent with the enquiry to the relevant section for examination. After processing, the form (with response) and group are passed back to the Desk, for eventual return to the enquirer. Some sections retain notes about the enquiries while others rely upon the central records.

Acquisition stage

Specimens are acquired by donation, purchase, exchange and direct field

collecting by staff. Exchange is a particularly important feature in a section such as Minerals, as shown by the emphasis placed on the management of the duplicate collection.

The approach to accessioning tends to reflect the extent to which incoming acquisitions are limited to the type of material curated by a single section. For example, in Palaeontology it is common to receive an acquisition including a diversified range of fossils, whereas in Zoology most acquisitions consist of shells, birds or fish, etc. Palaeontology deals with acquisitions on a departmental basis while Mineraology and Zoology work at a sectional level. In the Mineralogy Department, where relatively few specimens are acquired, individual entries are made for each item in sectional accession registers. In the Palaeontology Department, one officer is responsible for the maintenance of a central departmental accession register in which are noted details of a group, including an accession number and the type of material (thereby indicating the section to which the material is to be passed). In Zoology, different procedures are adopted in the sections: Mammals, for example, does not have an accessioning procedure; other sections do have a group accessioning mechanism, directed towards processing large-scale collections.

One feature of the Meteorite Section is that all newly acquired material has its weight recorded and noted on the report to the Trustees. This value is used as a key identifying factor during subsequent stocktaking.

Details of correspondence are held at a local level within the relevant department or section. Any archival material relevant to the day-to-day use of the collection is also kept locally.

Loans-in tend to be dealt with by the individual staff member to whom they are directed. They are not accessioned. In Palaeontology, a card file is maintained at sectional level, showing details of loans.

Item stage

The approach to item documentation is also varied. In Palaeontology and Mineralogy, all individual specimens are processed at sectional level while in Zoology some sections may have to adopt a selective approach.

Palaeontology's 15 sections have about 20 individual registers in which are noted details of particular ranges of specimens. The items are assigned new registration numbers at this stage. No reference is made to the earlier accession number (nor *vice versa*). No specific note is made of item locations. The registers are bound books, held in metal cabinets. They are annotated if significant new information is discovered about an item, but not in the case of changes of taxonomy. (The collection itself is arranged in taxonomic order. An expert should be able to go from a taxonomic name in the register to the current location in store, even if there have been subsequent changes of taxonomy.)

In the Mineral Section of Mineralogy, an individual catalogue slip is prepared for each new item based directly on the comparable accession register entry. The slip is subsequently filed in systematic order. The

location of the specimen (on display or in the systematically arranged reference collection) is noted on the slip. In the Ocean Bottom Deposits and Rocks Sections a catalogue slip is prepared and filed in geographic order, while the collections themselves are in accession number order. Meteorite specimens are detailed in the accession register and arranged in a chemical sequence. A separate record is also prepared for the meteorite itself (which may be represented by a number of specimens from different sources).

In Zoology, the Mammals Section prepares individual item entries for each new acquisition (about 2000 per annum), without an early acquisition record. The Mollusca Section, in contrast, places an emphasis on the registration of type and figured specimens.

Those sections that have been examining computerisation options have tended to concentrate on the processing of item information, by reference to the item record and the specimen itself. As noted above, the register entry may now be outdated by changes of taxonomy.

One complication concerns material originally considered to be outside the permanent collection, and held in a research or duplicate collection. It is sometimes decided to incorporate individual items from these collections into the main sequence, at which point an item record has to be prepared without the benefit of full acquisition details.

Output stage
In many sections, the systematically arranged and well-labelled collections act as their own catalogues. In a number of sections (particularly in Mineralogy), the individual item records are used to form a systematically or geographically arranged catalogue. For Meteorites, the preparation of a new world list of meteorites has a high priority. Elsewhere, specific topical catalogues might be prepared for restricted parts of the collections, such as type and figured specimens.

There are great variations in the scale and scope of indexes within individual sections. As an example, the Minerals and Rocks Sections prepare detailed species and topographical lists for the full collection.

A number of sections place a major emphasis on the preparation of typed, written or printed specimen labels. If a specimen from the Mineral Section is on display, its location is noted on its label and this label is then placed in the relevant systematic position for that specimen within the main reference sequence.

Exit stage
A uniform museum procedure is in operation to control loans-out. All loans must be authorized by the head or deputy head of a department. The individual section is then responsible for implementing the practical procedures. Standard forms are completed prior to the loan, the first concerning the suitability of the borrower and the second concerning the loan itself. The latter form is three-part, two copies being sent to the recipient (one to be returned to the museum) and the third retained in the loan pad. In

Palaeontology, loans are supervised by the Keeper's Secretary, who pursues any outstanding items. In Mineralogy, the work is supervised by the Meteorites Section, since most loans are of meteorites. In Zoology, it is undertaken at a sectional level, with a loan card being placed in the store to indicate the absence of the specimen.

Museum comments

The museum is conscious of the problems created by the poor quality of documentatioon of old acquisitions in many sections.

Update
Since 1982, the collections have grown to 65 million items, the Museum has taken over responsibility for the management of the Geological Museum from the Natural Environment Research Council, and the majority of the database processing is done on hard disc micros (Apricots) in the sections, using Museum developed software. One of the minicomputers has been retired, and Biometrics and Computing Section no longer offer a data input service. Computer typesetting is playing a larger part in database application, and a laser printer has been purchased.

Dii2.3 The Imperial War Museum

Introduction

Report based on a discussion with Mr Roger Smither (Keeper, Department of Information Retrieval) and written comments from Mr J. J. Chadwick (Museum Secretary), Mr J. F. Golding (Establishment and Finance Officer) and Mr D. J. Penn (Keeper, Department of Exhibits and Firearms), 17 February 1982. The report concentrates on the procedures in the Department of Exhibits and Firearms, with reference to any exceptional differences elsewhere.

A brief note of subsequent developments is given at the end of the report.

Museum framework

Management/resources
The Museum has Trustee status, with collections vested in a Board of Trustees by the Imperial War Museum Acts of 1920 and 1953. The Board has powers of disposal that are subject to constraints laid down in the 1920 Act. Based at the Imperial War Museum itself, HMS Belfast and Duxford Airfield, the museum has a departmental arrangement, with seven collecting departments, three service departments and a central staff:

Art
Documents (manuscripts)
Exhibits and Firearms
Film

Photographs
Printed books (library)
Sound records
Education and Publication
Information Retrieval
Permanent Exhibitions.

The Director is assisted by a Deputy Director, a Senior Keeper, central support staff including a Research and Information Officer and departmental Keepers, Assistant Keepers, Research Assistants, etc.

The museum's priorities include the care of the existing collections (including conservation and security) and their enhancement by new acquisitions, etc., the provision of exhibitions and public services and access to the collections.

Collections

Its major collections include 300 000 object, archive and bibliographic items (with a growth rate of 600 acquisitions per year), 5 million photographs (growth of 100 000 per year), 50 000 cans of film (increasing by 200 a year) and 6000 hours of sound recordings (growing by 1000 hours a year) (Smither, 1985). Conservation records are maintained separately within relevant departments.

There is no formal museum acquisition policy, although individual departments have internal guidelines for the development of their collections, based on the museum's terms of reference, with purchasing coordinated by the Deputy Director. The guidelines are partly based on the documentation, where this is available. Keepers have discretion over accepting items with certain conditions (such as ensuring availability to the public), but this does not include placing items on permanent display. Care is taken to ensure that the museum cooperates with other national bodies and regimental museums when considering the development of its collections.

Documentation framework

Documentation management
The collecting departments are responsible for proposing policy initiatives and implementing procedures, with coordination of certain aspects by the Department of Information Retrieval. The first priority is the processing of new acquisitions, followed by the development of item documentation and the introduction of more effective systems.

Documentation resources
Of the 135 curatorial staff, 25 are engaged in documentation duties for more than 30% of their time, of whom 5.5 are in Information Retrieval. Ten of these staff are engaged in documentation full-time, and the total investment is estimated at 18 full-time equivalent posts. In certain cases, documentation

duties are referred to in staff job descriptions. The help from temporary staff is relatively minor, being concentrated on students on placement.

Information Retrieval is currently developing a procedural manual to guide item documentation (including the use of MDA cards). Specific manuals are also available in some collecting departments covering their internal procedures, with that for Exhibits and Firearms including loans, accessioning and transfer mechanisms. Similar rules for film cataloguing have been published for international discussion (Smither with Penn, 1976). New staff are trained in-service by relevant departmental staff, with some help from Information Retrieval. Little use has yet been made of outside agencies and training courses, such as those arranged by Aslib and the MDA, although there is an interest in such schemes.

The museum played a leading part in investigating the use of computers, during the early 1970s, one result of which was its development of the Apparat program package (Roads, 1968; Orna and Pettitt, 1980; Smither, 1979; 1980). This was designed and developed for the museum by a commercial software house, with the resulting package being implemented on a DES computer at Darlington. Its use was concentrated on the processing of the museum's film records. Many of its features have since become available within standard MDA systems and its use is now being phased out.

The second major application of computers is through the MDA computing bureau, involving the data entry, processing and management of substantial item records prepared by various collecting departments and Information Retrieval itself. The museum now undertakes much of the data entry itself using small microcomputers, passing the accumulated information to the Association for processing.

During the last decade, the museum has invested £35 000 in the development of a computer software package, £9000 in inhouse computing equipment and £5000 in microform facilities. Its present recurrent expenditure on external computing system use is £10 000 per annum. Staff costs are difficult to quantify, but the investigator would estimate them at approximately £250 000 per annum (on the basis of 18 full-time equivalent staff).

Documentation system

Documentation procedures operate at a departmental level with distinctive local variants at each stage. Acquisitions and loans are processed in similar ways, being noted on an accession form which is incorporated within loose-leaf registers (Figure D3). The details on the form are sufficient to identify the individual items within the group. Individual item records and associated catalogues and indexes may be prepared at a later date, by the department with some assistance from Information Retrieval. Enquiries are also processed within each department using informal procedures.

Most groups have been accessioned (the exceptions being pre-war collections and certain art groups) and most departments have basic item

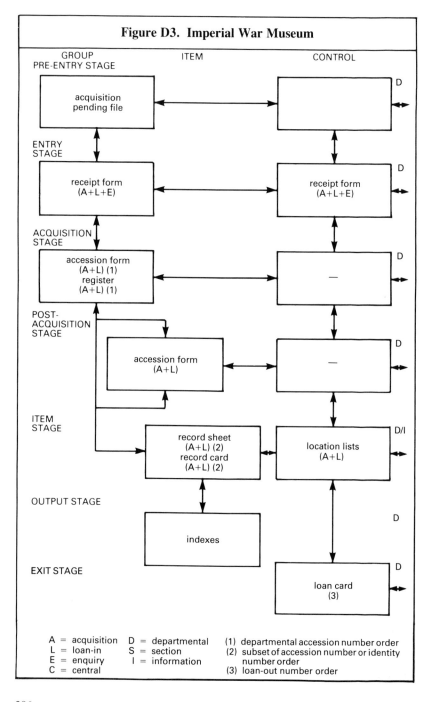

Figure D3. Imperial War Museum

GROUP	ITEM	CONTROL

PRE-ENTRY STAGE

acquisition pending file ⟷ [] D

ENTRY STAGE

receipt form (A+L+E) ⟷ receipt form (A+L+E) D

ACQUISITION STAGE

accession form (A+L) (1) register (A+L) (1) ⟷ — D

POST-ACQUISITION STAGE

accession form (A+L) ⟷ — D

ITEM STAGE

record sheet (A+L) (2) record card (A+L) (2) ⟷ location lists (A+L) D/I

OUTPUT STAGE

indexes — D

EXIT STAGE

loan card (3) D

A = acquisition D = departmental (1) departmental accession number order
L = loan-in S = section (2) subset of accession number or identity
E = enquiry I = information number order
C = central (3) loan-out number order

records for substantial parts of their collections. There are, however, few detailed item records and associated catalogues, although this is an area that has been developed recently (particularly in parallel to exhibition programmes).

Internal and external use of the documentation is significant, particularly for research purposes. Future emphasis is likely to be on the use of documentation as an aid when preparing exhibitions and as a guide to acquisition policies.

Consideration has been given to the security of the documentation, with records being held in non-public areas, but not themselves being secure. Photographs are being taken of certain collections.

Documentation and collections audit
Internal stocktaking consists of departmental procedures with central spot checks. The departmental work is variable, including, for example, a comprehensive annual stocktake by Printed Books. In other departments, it is limited to occasional dip checks. The central checks are rarely implemented.

E & AD undertake occasional checks, the last of which was in 1978, when Art, Exhibits and Firearms and the Library were examined. Staff in these departments were asked to describe their procedures and illustrate the use of the registers.

The museum is conscious of the need for more effective registration and location and movement control as an aid to stocktaking.

Deacquisition and indemnification
Any losses are referred to the Security Officer and Trustees, noted in the Appropriation Account and on the relevant records. Indemnity cover is available.

Object collections documentation

Pre-entry stage
Potential acquistions are referred to the relevant Keeper and an Acquisitions Pending file opened.

Entry stage
All material entering the museum is processed on a departmental basis (with the general information desk referring personal enquiries to the relevant department). The particular departmental procedures differ but acquisitions and loans tend to be treated more formally than enquiries.

In Exhibits and Firearms, the Deputy Keeper prepares a two-part receipt form, one copy of which is passed to the depositor and the other kept with the group. Although there is no temporary number, acquisitions and loans are assigned their permanent number within a week. Consideration is being given to also introducing the use of a special loan form. A tag is tied to the

group which is then passed to the appropriate member of staff. Some classes of object are segregated for more detailed attention.

Details of the group will be included in an acquisition file, if relevant and necessary.

The volume of enquiries is monitored. They are either dealt with immediately or accepted into the department to be answered by letter. In the latter case, they are dealt with fairly informally, being stored with similar items prior to examination. There are no established mechanisms for ensuring their eventual return and no procedure for the disposal of uncollected items. Correspondence, etc., is filed by the name of the enquirer. Material is not insured.

There are no manuals describing procedures, although one or two are in preparation within departments such as Exhibits and Firearms.

Acquisition stage

Similar approaches are adopted for acquisitions and long-term loans, both of which are considered by the Keeper, with reference to central staff in exceptional circumstances. In the case of loans, the Departments of Permanent Exhibitions and of Education and Publications are also involved, and may maintain independent records. The Keeper is normally responsible for subsequent action, with the cooperation of the Deputy Director in certain cases. Until recently there was also a Special Collections Officer who was particularly concerned with complex groups of interest to more than one department, whose processing as independent acquisitions needed central coordination.

In view of the nature of its collections, the Keeper of Exhibits and Firearms is particularly concerned to check the legal right of ownership of potential donors (especially with material such as war souvenirs). However, no formal transfer of ownership document is prepared, although this is currently being reviewed. Steps are taken to acquire the copyright of relevant material such as photographs, film and sound recordings.

In Exhibits and Firearms, an accession form is completed for the group by the Keeper. This sheet will include sufficient information to clearly identify each of its component items but makes no reference to their location. It is then used as part of a loose-leaf register of the collection. The details on the form are subject to later revision and correction. There is some concern that the form itself could be replaced by a substitute. The Art Department has recently reintroduced the use of a bound register. Most other departments have similar procedures, although in the case of audio-visual material (Film, Sound Records and Photographs) the processing of an acquisition is inextricably linked with technical records relating to the type of material, copies made, etc. An accession number is assigned to the group, on a departmental basis. It is attached to the group itself with a green tag.

An acquisition file is opened for the group and, as with the register, retained in the department. In Exhibits and Firearms, a microfilm copy is prepared of new register entries on an annual basis, as a security measure.

Steps are taken to provide specific indemnity cover for exhibition loans. They are processed through the standard acquisition procedure. The department is responsible for ensuring their eventual return. No specific loan form is completed or signed, although their introduction is being considered by Exhibits and Firearms.

Post-acquisition and item stages
The general item documentation procedure is to list individual items at a basic level within the acquisition record for the group. More detailed recording is dependent on local circumstances and resources.

The conventional approach within departments is to either add additional information to the accession sheet or to use individual record sheets, noting relevant details but omitting storage location. More recently, a number of projects, particularly those involving the Department of Information Retrieval, have used MDA record cards, on which the location is noted. The latter records are then computerised. The records are filed numerically, either according to the accessioning system or within a new sequence. In most cases, the record is considered to be a preliminary document, subject to later development.

Some material has been subject to reprocessing in recent years, but it is estimated that 95% of the collections of Exhibits and Firearms have inadequate item records.

Details of recording conventions and procedures for use with the MDA cards are given in the new Information Retrieval manual.

Information Retrieval is actively involved in those projects using MDA cards, with some of its own staff being engaged in the recording itself. It is also then responsible for supervising the subsequent computer processing of the records and the maintenance of catalogues and indexes.

Except in the case of the computerised files, duplicate copies of the records are not available.

Any correspondence, notes, etc., are included in the acquisition file rather than an individual item file.

A number of location lists are maintained for specific parts of the collections, for departmental use in locating material. Information Retrieval and the Department of Exhibits and Firearms maintain a gallery list for use during any evacuation or flooding of the museum. Both departmental and display staff move material within the museum, often making no amendment to relevant records.

Output stage
Few catalogues are available at present. The ability to produce new catalogues is, however, one of the aims of the computerisation exercises and more will be produced by this method in the future. The museum will probably produce two versions of the computer listings, one (with full confidential information) for staff use and the other for public access.

Selective manual indexes are available for parts of the collection, used by staff on behalf of enquirers. Others are being produced from the computer files. Labels are not prepared, although this is currently being reconsidered. A number of information sheets are available.

Exit stage

Loans out are considered by the Keeper, with reference to the Director in certain cases (such as any post-1940 item requested by an overseas institution). Rigorous steps are then taken to ensure that the recipient places adequate control over the loan. The condition of the object is noted on relevant loan documentation. A loan review card is prepared and incorporated in a file, subject to annual review. This is passed to a loans terminated file on the return of the object.

Disposal questions are referred to the Director (except in certain well established categories, such as exchange of duplicates), after which the record is annotated.

Other documentation

Comparable records are maintained for archival and bibliographic material, and photograph (Ritchie Calder, 1981) and film collections.

Museum comments

The museum is concerned that the system has obvious defects and anomalies, reflecting a long history of *ad hoc* growth. It is now concerned to enhance the system and upgrade the standard of records. There is particular interest in improving initial entry procedures, with subsequent effect on all later stages of documenation.

Update

Further details of the museum and its procedures are given in a recent paper (Smither, 1985). Although various details in the documentation procedures have been revised since the original visit, there have been no fundamental changes. The first of the published catalogues to be produced from the computerised files have appeared and been widely distributed (Imperial War Museum, 1984).

The Museum itself is now responsible for a fourth site, the Cabinet War Rooms in Whitehall. Its departmental structure has also be altered, with the principal changes being the amalgamation of the Departments of Education and Publications and of Permanent Exhibitions into a single Department of Museum Services, and the grouping of the three audiovisual departments (Film, Photographs and Sound Records) into a section under the Senior Keeper.

Dii2.4 The Museum of London

Introduction

Report based on a discussion with Miss Joanna Clark (Head, Library and Documentation), 24 February 1982.

A reference to the subsequent increased use of computer facilities is given at the end of the report.

Museum framework

Management/resources
The Museum of London is managed by a Board of Governors and funded by the Office of Arts and Libraries, Greater London Council and City of London. The Museum of London Act 1965 vests the collections in the governors of the museum. The museum is organised on a departmental basis, with central administration and service sections:

Modern
Tudor and Stuart
Medieval
Prehistoric and Roman
Greater London Archaeology
Costume and Textiles
Prints, Drawings and Paintings
Department of Urban Archaeology
Library and Documentation
Conservation.

The Director, Deputy Director and Assistant Director are aided by Curators, and Senior Keepers, Keepers, Senior Assistant Keepers and Assistant Keepers.

Collections
Although there is no written acquisition policy, a general description of the museum's emphasis is given in its annual report. Internal policies are based on departmental knowledge, with some reference to documentation.

Documentation framework

Documentation management
Since late 1978, the Head of Library and Documentation has been responsible for the overall development and coordination of documentation procedures. Departmental proposals are referred to the Head for comment and consideration. There is a considerable emphasis on entry and acquisition documentation.

Documentation resources
There is a core central documentation staff of two officers and one half-time

assistant in Library and Documentation, all of whom have documentation duties referred to in their job descriptions. Of approximately 30 other curatorial staff, all are involved in local documentation duties to varying degrees. These are specified in the job descriptions of newly appointed staff. The museum is occasionally aided by temporary staff, one of whom has recently been involved in examining the documentation procedures in one department.

The overall documentation procedures are outlined in a manual maintained by Library and Documentation, supplemented by some departmental manuals (such as a detailed guide for the Department of Urban Archaeology and new proposals in Modern). Training is in-service and at MDA seminars and courses.

The recent computing investment has been primarily for use by the Department of Urban Archaeology, with more general museum documentation requirements still to be assessed. The new systems include a minicomputer with two linked terminals and three small microcomputers. Their major application is with excavation processing. Work has also been undertaken with a portable microcomputer in the museum stores (Neufeld, 1983).

Documentation system
The new museum has had to contend with the inheritance of two collections with distinct documentation procedures, to accommodate these procedures, and weld them into a single scheme. Enquiries are processed within a temporary documentation system coordinated by the Information Office (Figure D4). Acquisitions and long-term loans are considered at departmental level, where a group record (including details of each component item) is produced. This is allocated an accession number from a central list, then passed to Library and Documentation for filing in numerical order. This record and any supplementary files are held centrally, but referred to and maintained by departmental staff. An abstract of the information is held within the department itself for use within a catalogue of its collection.

The majority of collections (apart from Modern) have comprehensive acquisition records but the degree of item documentation is more variable.

Both internal and external research (the latter of which is on an exceptional scale) place heavy dependence on the documentation.

The museum itself is notably secure. Primary records are kept in a safe and supplementary files are kept in cabinets. There is, however, no control over access to the documentation by staff. Photographs are taken of objects of high value.

Documentation and collections audit
The museum is still involved in a comprehensive check of the old collections from its original constituents, including a full stocktaking programme. Certain departments also have a short-term programme of stocktaking on a

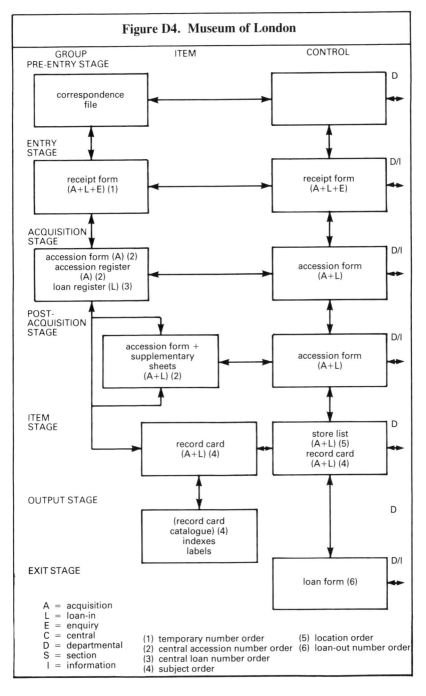

Figure D4. Museum of London

GROUP	ITEM	CONTROL

PRE-ENTRY STAGE

correspondence file ⟷ [] D

ENTRY STAGE

receipt form (A+L+E) (1) ⟷ receipt form (A+L+E) — D/I

ACQUISITION STAGE

accession form (A) (2)
accession register (A) (2)
loan register (L) (3) ⟷ accession form (A+L) — D/I

POST-ACQUISITION STAGE

accession form + supplementary sheets (A+L) (2) ⟷ accession form (A+L) — D/I

ITEM STAGE

record card (A+L) (4) ⟷ store list (A+L) (5) / record card (A+L) (4) — D

OUTPUT STAGE

(record card catalogue) (4) indexes labels — D

EXIT STAGE

loan form (6) — D/I

A = acquisition
L = loan-in
E = enquiry
C = central
D = departmental
S = section
I = information

(1) temporary number order
(2) central accession number order
(3) central loan number order
(4) subject order

(5) location order
(6) loan-out number order

313

subject basis. There is, however, no formal cyclic stocktaking programme in operation.

External auditors have limited any checks to those related to the financial control of recent purchases.

Deacquisition and indemnification
Losses are reported to the Governors, after which the record is annotated.

Object collections documentation

Pre-entry stage
Details of any potential acquisitions are retained on an *ad hoc* basis, in departmental correspondence files.

Entry stage
A uniform procedure is in operation for all material presented at the museum desk. There are, however, no equivalent stages for other groups, such as those brought in by staff or carriers or sent by post. The standard procedure is coordinated by the Information Office staff. A prenumbered two-part form is completed at the desk for any material requiring attention. One part is returned to the depositor as a receipt and the other passed with the group itself to the relevant curator. In the case of an enquiry, the response is noted on the form, one copy of which is then retained by the department and another passed back to the desk with the group for eventual return to the depositor.

A file is opened by the department, if required.

Acquisition stage
Acquisitions are considered and then processed by the departments, with assistance from Library and Documentation. At present, there are no formal procedures for documenting the transfer of ownership itself, but a new form for this stage is now being designed. In general, the copyright of acquired works is not also acquired, although this is sometimes done for commissioned works.

The appropriate accessioning procedures are outlined in a manual prepared by Library and Documentation. The department is responsible for initiating the procedure, which it does by completing an accession form and supplementary sheets for the group, with basic details of its overall interest and any particular component items, including initial storage location (see Figure 13). The responsible department may decide to treat a coherent group as a single acquisition, while miscellaneous material may be divided into convenient sets. The work is coordinated by the department that initiated the accessioning procedures, with additional details being added by other departments if the group crosses departmental boundaries.

The group's accession number is assigned by the department from a single list held by Library and Documentation ('year prefix + running number'). The curator logs the allocation of the number in an accession number book

in Library and Documentation (noting the number, brief object description, acquisition method, recorder and date). This acts as an informal register and note of curatorial responsibility.

The completed form is passed to Library and Documentation where it is filed in a loose-leaf sequence. A central correspondence file is also then opened and maintained by Library and Documentation. In theory, the details on the form (including storage location) are altered if new information is found. In practice, this usually only happens for major changes of detail.

The Department of Urban Archaeology uses separate procedures for processing excavated material, using site and context records. Significant items to be incorporated within the collections of other departments are assigned individual accession numbers and then treated as normal acquisitions.

Short-term loans for exhibitions are processed by the department concerned. Details of the items are included in a single exhibition file. Long-term loans (which are rare) follow procedures analogous to those for acquisitions. They are detailed on a copy of the standard form and then held in a separate loan sequence by Library and Documentation. They are numbered in a separate sequence from the permanent accessions ('L + running number'). In each case, the department and Library and Documentation consult the museum's legal advisors on the style of a formal deposit agreement and the appropriate insurance procedures.

Post-acquisition and item stages
Details of the component items in each acquisition are noted on the supplementary sheets which are appended to the initial group form. This is originated by the curatorial staff at the time of accessioning. Although the form is considered to be the primary record, each department also holds record cards with an abstract of the primary information. The details noted on both the form and card include the storage location, which should be amended in the case of long-term moves.

Substantial parts of the collections have been reprocessed in recent years, partly as a reflection of the merging of the original museums. This reprocessing often includes the allocation of a new identity number, based on a straightforward subdivision of the group accession number. Newly-developed procedures for the historic photograph collection have included the use of the MDA and SHIC systems (Neufeld, 1982; Seaborne, 1984; Seaborne and Neufeld, 1982).

The primary form is kept in Library and Documentation, as part of the file for the acquisition. Papers within the file serve to complement the record about the acquisition and its individual items.

There are no written procedures for the production of the detailed records, with varying standards being adopted by individual departments.

Both the records and the files are held in numerical order, the former in a

fireproof safe and the latter in cabinets. It is hoped to produce a microform copy of the records.

Store inventories are maintained for the reserve collections, in the form of typed lists or computer files (Neufeld, 1983) for each location giving basic details of content. These lists are annotated by the curatorial or reserve collection staff if an item is moved. A duplicate copy of the lists is to be kept in the museum safe. Curatorial staff may implement temporary moves but only the reserve collection staff may authorise a permanent change.

Output stage

The departmental record cards are considered to be the catalogues of the collection. They include a selection of non-confidential information, accessible to the public by prior arrangement. The aim is to eventually produce a central catalogue which would take the place of these departmental sequences.

Library and Documentation maintain a unified donor index with basic details of the name of the person and relevant accession numbers. Departments then have local indexes according to individual requirements. Brief labels are prepared.

Exit stage

Requests for a loan from the collection are referred to the Board of Governors and then implemented by the departmental and Library and Documentation staff. Prior to the meeting of the Board, a loan request form is prepared, the details on which are agreed to by the recipient. If approved, a loan receipt form is completed by Library and Documentation and sent to the department for additional information. The loan is assigned a permanent number and a copy of the form is filed centrally according to this number. A supplementary entry in a recipient index is also prepared. Responsibility for monitoring the loan is shared by the department and Library and Documentation. The latter will pursue any overdue loans and check-off the form when the object is returned.

Any disposal questions are referred to the Governors, after which the record is annotated.

Other documentation

Archives, historical bibliographic material and historical photographs are treated as objects for documentation purposes. Separate site records are maintained by the Department of Urban Archaeology. The Conservation Department also maintains separate records, a cross-reference to which is noted on the item record of the conserved object.

Museum comments

The system is felt to be effective in certain areas but clearly deficient in others, due to insufficient curatorial staff and resources. The first aim is to

complete the existing coverage and then to consider overall improvements. There is interest in the use of computer systems for the manipulation of basic information and in using temporary staff to develop stocklists, etc.

Update

The abolition of the Greater London Council (April 1986) will alter the constitution markedly. A bill amending the Museum of London Act, 1965, is to be presented to Parliament in autumn 1985. This will provide funding by the Office of Arts and Libraries and the City of London on an equal basis.

There has been increasing use of the computing facility in the documentation of the general collections, including the production of inventories and indexes to existing written records. A computer manager was appointed in December 1984. Proposed capital expenditure for 1985–86 includes approximately £20 000 for upgraded equipment in order to computerise accessioning procedures; it is hoped that this will be the first phase of a project towards the eventual production of a full computer catalogue.

A transfer of title form is now in use for all acquisitions.

Dii2.5 The National Army Museum

Introduction

Report based on a discussion with Mr Boris Mollo (Deputy Director and Keeper of Records), 19 February 1982.

Brief details of the current position are given at the end of the report.

Museum framework

Management/resources

The National Army Museum is a Trustee Museum (formerly Ministry of Defence), organised on a departmental basis, with 3 curatorial departments:

> Records (Fine Art, Photographs, Books and Archives)
> Weapons
> Uniforms

There are supporting education, conservation, design and administrative staff.

Collections

The object collections include about 30 000 acquisitions (both individual objects and groups) with a growth rate of 1000 per annum, and approximately 60 000 photographs. These are complemented by extensive bibliographic and archive collections and records of people, events and conservation.

The museum has a formal acquisition policy based strongly upon a knowledge of the collection derived from documentation.

Documentation framework

Documentation management
The Keeper of Records coordinates documentation developments and procedures. The first priority is acquisition documentation, followed by conservation, photography, etc., prior to the production of a full item record.

Documentation resources
All 15 curatorial staff are involved in documentation to an estimated 40% of their time (the high figure reflecting a current emphasis on documenting the backlog). These duties are referred to in job descriptions. Although the staff receive some outside voluntary assistance, there have been no significant temporary employment projects. A procedural manual, emphasising the use of the new system and equipment, is now being developed. Staff are trained in-service.

The museum is using the MDA computing burreau for the computer processing of certain item records. After an initial use of both the data entry and processing facilities, it is now concentrating on its own data entry, using an inhouse microcomputer, followed by processing by the Association (Light and Roberts, 1984; Mollo, 1982).

The investigator has estimated current staff costs at £60 000 per annum. Other capital and recurrent costs are not quantifiable.

Documentation system
With a relatively new collection, having both object and archive strengths, the museum has concentrated on building up its records to a uniform standard. New acquisitions and loans are processed first by the departments, where an accession form is completed for submission to Records (Figure D5). An abstract of the information is noted in a central register, accession numbers assigned and the form then returned to the department for subsequent item documentation and the preparation of indexes.

Most collections have been accessioned and have item records conforming to a superceded standard. These old records and collections are now being reprocessed.

Records are readily available to staff and enquirers through use of the museum reading room.

Microfilm copies have been prepared of the accession register and the master files of the photograph collection. Record photographs are available of all unique objects.

Documentation and collections audit
The museum has a well established internal procedure for stocktaking based on inventory lists. Two sets of inventory lists are maintained on a central

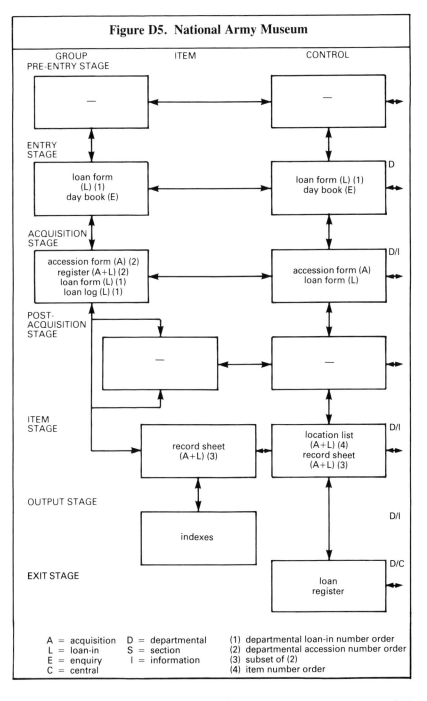

Figure D5. National Army Museum

basis for each part of the collection. One (the 'A' list) is of all valuable items, while the other (the 'B' list) is of all loans to the museum, with a subset ('B*') of valuable loans. These lists are on loose-leaf sheets held by the Keeper of Documentation, with a copy in the department concerned. A separate list is maintained for the print collection (in subject order, corresponding to the sequencing of the prints themselves). Both the archives and photographs are in numerical order and can therefore be controlled from their primary records.

The Deputy Director is responsible for independent checking of the A and B lists (valuable items and loans) and for dip checking of the overall collections. Valuable material (A and B*) is checked over a two-year cycle (one-eighth being examined every three months). Other loans (B other than B*) are checked over a five-year cycle (one-twentieth being examined every three months). The total number of items concerned is about 1000. The procedure adopted is for the department to be passed a copy of the relevant section of the inventory list which they then check prior to an independent double check by the Deputy Director.

Departments are responsible for checking all items not on the A or B lists, on a ten-year cycle. (These items are, in theory, noted on a 'C' list. In practice, only one C list exists – for photograph albums – while the other collections are checked against their primary documentation.) Each department submits a programme to the Director outlining how this work is to be undertaken and maintains a log of its progress. In addition, all items on display are inspected weekly by departmental staff. Borrowers of objects from the collection are asked to submit an annual note certifying their continued safety.

These procedures have been drawn up by the museum after discussion with E & AD. The auditors do not themselves carry out any checking.

Deacquisition and indemnification
Any losses are reported to the Council, after which the register in annotated. Government indemnity arrangements apply.

Object collections documentation

Pre-entry stage
Queries concerning acquisitions are considered by the head of a department, with reference to the Director. No formal documentation procedure is in operation (except for purchases).

Entry stage
Distinct procedures are adopted for acquisitions, loans and enquiries. In each case, initial processing is carried out in the department concerned, where the curators are responsible for maintaining basic documentation about the entry.

There are no formal entry stages for those acquisitions that are known about in advance of receipt. Loans are noted on an initial loan form.

Retained enquiries are also processed by the departments, being assigned a temporary number and logged in a day book. The enquiry procedures are not themselves documented nor monitored. Any resulting files are retained in the department. Items are also received for copying (in which case they are treated as enquiries) and on offer but subsequently rejected (processed informally).

Any correspondence concerning the group is kept in general departmental files.

Acquisition stage
All acquisitions are referred to the Director for approval, after which the head of the collecting department is responsible for coordinating the group's processing. A standard letter of acknowledgement is sent in response to a donation, but no formal transfer document. No steps are taken to acquire the copyright of relevant modern works.

Details of the group are noted on an accesssion form within the department. This information is at a level sufficient to identify each item in the group. It includes storage location. The form is sent to Records, where primary information is entered in a central bound register, maintained by the Keeper of Records (see Figure 11). Accession numbers are allocated at this point, at the discretion of the Keeper who may, for example, judge that a single form should be assigned a series of numbers corresponding to convenient subgroupings of the material that it describes. (A more complex group may have been split into its different departmental interests and noted on a series of forms, each of which will be processed independently by Records.) The register is one of a standard design prepared by the Army Museums Ogilby Trust and also widely used by regimental museums. Any subsequent amendments to the register entry (which are rare) will be initialled by the Director. It is kept in the Reading Room, and a microfilm duplicate held at an out-station, for security purposes. The form itself is returned to the department, with an annotation of the relevant accession numbers for the group. This then stays with the group until individual item records are prepared.

Loans are referred to the Director, and then processed by the relevant head of department together with a Research Assistant (attached to the Director's secretariat) who is responsible for the central coordination of loan procedures. In addition to the accession form, a loan form is completed by the department and an entry made in a loan log by the Research Assistant. The loan form is passed to the Keeper of Documentation for standard processing as if it were an acquisition. The Director's Research Assistant is responsible for files, etc., concerning the loan. These procedures are detailed in an internal manual.

Item stage
Individual item records are usually prepared within 3–6 months of accessioning. A draft is produced on an A4 sheet by the department concerned.

This is then passed to Records for typing, under the supervision of the Keeper of Records. Details include storage location, which is amended if the item is permanently moved. The individual item numbers are identical to, or a subdivision of, the group accession numbers.

Major parts of the collection have been reprocessed to the new standard (which is compatible with that of the MDA) in recent years.

There is no detailed manual for completing the records, although reference is made to general MDA guidelines. Detailed lists of standard military titles and terms are maintained.

The typing procedure has, until recently, consisted of using a paper-tape machine to produce multiple copies of index cards. This will be superceded by using a data entry microcomputer and subsequently producing printed and microfiche indexes. Under the conventional system, the master documents were passed back to the department for local use.

The only supplementary files for individual objects are those associated with the paintings collection.

Reference was made above to the various inventory control lists maintained by the museum. The museum stores are arranged on a departmental basis, with authority to move items being passed to staff by the head of the department. Documentation procedures are at the discretion of the department.

Output stage
No separate catalogue is maintained. Indexes are, however, produced for use within each department. In addition, the comprehensive record photograph collection acts as a central index to the objects.

Exit stage
Requests for loans-out are considered by the Director and then processed by the relevant head of department and the Research Assistant responsible for all loans. The department takes internal steps to log the movements while the Research Assistant maintains a register of loans. It is this person that is responsible for the subsequent management of the loans.

Disposals are referred to the Museum Council after which the relevant records are annotated, following written procedures.

Other documentation

Reference has already been made to the treatment of archives, bibliographic items and photographs as objects, and the separate conservation records.

Museum comments

The overall system is felt to be fairly effective, but subject to more rigorous enforcement. The gradual introduction of computing systems will make the approach more versatile and flexible. The museum is particularly interested

in developing methods for access to relevant information in other military collections.

Update

The Museum has continued as an active user of the MDA computing bureau, passing data to and from the MDA in machine-readable form, using a series of newly-acquired data entry microcomputers dispersed in the departments. Around 8000 records have been incorporated in the computer file, including all new acquisitions since 1984. Comprehensive and departmental catalogues and a complex general index are produced on both printout and microfiche; and accession sheets are produced on archival quality paper. A full time documentation officer is to be appointed to coordinate the practical aspects of the computer system and to cooperate with the MDA in a general reassessment of documentation procedures.

Dii2.6 The National Gallery

Introduction

Report based on a discussion with Ms Margaret Stewart (Registrar) and Mr Michael Helstan (Assistant Keeper), 15 March 1982. It should be stressed that the comments in the report represent the interpretations of the investigator and are not necessarily agreed with by the Gallery.

Museum framework

Management/resources
The Gallery is a Trustee museum, organised as a single unit (with schools of painting used as a subdivision for purposes of curatorial responsibility) together with Conservation, Scientific, Education and Publications Departments.

The Director is assisted by both Keeper and Scientific grade staff.

Collections
The primary object collection numbers approximately 2000 paintings, nearly all of which are on permanent display. The object records are paralleled by those concerning conservation. The photographic library includes around 100 000 illustrations (Hector, 1981).

Documentation framework

Documentation management
The responsibility for the documentation of the collection is shared between the Keepers, the Conservation Department and the Registrar. The Registrar coordinates movements of objects for loan and exhibition, the location index and the accession register. The Director maintains separate

files with acquisition details. A Research Assistant is responsible for object files (research dossiers) and the Chief Restorer for analogous conservation files.

Documentation system
With a small high-value collection, the emphasis within the gallery is on the development of definitive records about each acquisition and the total location control of the collection (Figure D6). Acquisitions are noted in a formal register, described in the biennial report and then documented in detail, with information being held in acquisition files. Illustrated and sectional text catalogues are prepared by curatorial staff.

Documentation and collections audit
A comprehensive stocktake has recently been undertaken, at the initiative of the Director. The card index was checked against the collection itself by the Working Party. The Registrar's effort was concentrated on checking items on loan from the gallery.

The gallery has been referred to in the reviews of audit practice undertaken by the E & AD and PAC (see Section 2.7).

Object collections documentation

Pre-entry stage
The Director is responsible for considering potential acquisitions. The Registrar is advised when an object is entering the collection.

Entry stage
Distinct procedures are adopted for acquisitions and loans (the concern of the Registrar) and enquiries (a curatorial responsibility). The former are received by the Gallery Working Party and their documentation prepared by the Registrar. The latter are accepted by prior arrangement for identification purposes. Any enquiries retained in the gallery are logged on a receipt and both the Registrar and Conservation informed.

Acquisition and item stages
Acquisitions are entered in an accession register (inventory) by the Registrar. The volume is held in a locked cabinet. Its details (which do not include location) are only amended in exceptional circumstances, such as the transfer of items to the Tate Gallery in 1950. Details of the acquisition itself are retained by the Director. Other correspondence, etc., is held in a numerically ordered supplementary dossier which is the responsibility of the Research Assistant. The relevant Assistant Keeper will pass accumulated information about the acquisition to the file for retention.

Formal loan documentation is prepared before the receipt of an item. Details of loans are then kept in a separate index. They are not included in the register or allocated a permanent number. A separate dossier is opened for loans.

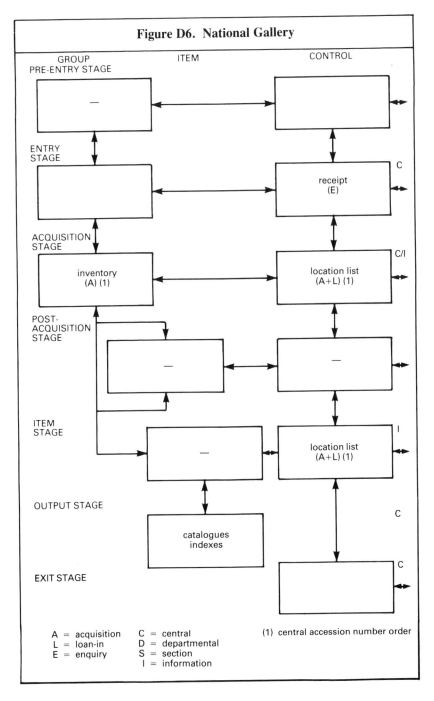

Figure D6. National Gallery

GROUP ITEM CONTROL

PRE-ENTRY STAGE

—

ENTRY STAGE

receipt (E) C

ACQUISITION STAGE

inventory (A) (1)

location list (A+L) (1) C/I

POST-ACQUISITION STAGE

— —

ITEM STAGE

— location list (A+L) (1) I

OUTPUT STAGE

catalogues indexes C

EXIT STAGE C

A = acquisition C = central (1) central accession number order
L = loan-in D = departmental
E = enquiry S = section
 I = information

The gallery maintains three copies of a location list which is amended in response to any movement. The change of location is reported by the head of the Working Party. The lists themselves are available to the Registrar, Chief Warder and Lower Gallery Warder. All movements are logged by the Working Party.

Output stage
Information about each item is included in an illustrated summary catalogue and definitive school-based text catalogues. The Research Assistant maintains a basic subject index, a more detailed equivalent of which is held by the Library.

All recent acquisitions are described in the gallery's Biennial Report, the entries being prepared by relevant members of the curatorial staff.

Exit stage
The Registrar is responsible for coordinating the documentation aspects of loans from the gallery. This is often in consultation with the Government Picture Collection.

Museum comments

A primary concern of the Registrar is the need for effectiveness of the procedures and complete security.

Dii2.7 The National Maritime Museum

Introduction

Report based on a discussion with Dr Jonathan Cutbill (Information Retrieval Officer), Dr Roger Knight (Custodian of Manuscripts) and Ms Phillipa Gamse (Research Assistant, Information Retrieval), 10 March 1982.

Information about subsequent organisational changes and developments is given at the end of the report.

Museum framework

Management/resources
The National Maritime Museum is a Trustee museum, organised on a departmental basis together with a central administrative staff:

Navigation and Astronomy
Pictures
Printed Books and Manuscripts
Ships
Weapons and Antiquities
Archaeological Research Centre

Conservation
Museum Services.

The Director is assisted by a central staff and departmental Heads, Curators and Research staff.

Collections
The collections are characterised by their variety, with the greater proportion being non-object material. The object collections themselves total around 100 000 items with a growth rate of around 1000 per year. The scale of the overall collections is illustrated by listing departmental holdings:

	current size	annual growth
Navigation and Astronomy		
objects	3 500	200
charts	48 000	450
information records	40 000	1 000
Pictures		
objects	70 000	150
photographs	300 000	10 000
information records	30 000	1 000
Printed Books and Manuscripts		
books, etc.	70 000	3 300
news cuttings	1 000 000	2 500
archival items	10 600 ft	350 ft
information records	30 000	?
Ships		
objects	2 500	40
ships plans	750 000	18 000
Weapons and Antiquities		
objects	10 000	370
information records	200 000	5 000
Archaeological Research Centre		
objects	730	?
information records	5 000	500

There are also independent files in Conservation and approximately 40 000

record negatives of the collections. The Registry holds official museum files, including those concerning the collections.

The overall acquisition policy is delimited in the Museum Act of 1934.

Documentation framework

Documentation management
Overall responsibility for curatorial matters is held by the Deputy Director, with working responsibility for individual collections at a departmental level. The current documentation policy was formulated in 1976 by a committee of senior staff and the Information Retrieval Officer. This drew up a long-term programme for the development of all aspects of documentation resources (the Petrel Project). Under this policy, the Information Retrieval Section became responsible for general advice on documentation: design, development and maintenance of central systems; estimating for, procuring and maintaining computing resources for the museum; and mantaining files derived from more than one department. It has a joint responsibility with the departments for the production of specific departmental programmes and the provision of procedural manuals. A Petrel Coordinating Committee has been formed, which is responsible for advising the Deputy Director on the priorities for the allocation to individual departments of the resources of the Information Retrieval Section and for drawing up uniform conventions and procedures.

Long-term priorities are the maintenance of acquisition documentation, the preparation of item records containing all available information in a manageable form, research to upgrade item records to a standard suitable as a source for publication and the publication of catalogues, lists, etc. (It is assumed that internal indexes are made available as a direct by-product of other processes.) The current emphasis is on the development of item records for all the collections. It is estimated that it will take another 10 years to produce computer versions of these records, using the existing sources of information. As a parallel stage, it is then intended to upgrade these records until they are of a standard adequate to support the production of publications about the collection. The actual preparation of these publications is seen as the third stage (and has already been achieved for some collections).

Documentation resources
The museum has a total complement of approximately 400 staff, including 148 on the warding staff. Of the curatorial staff, 122 are involved in both the production and use of documentation to an estimated 20% of their time. In the case of those concerned with record production, these duties are referred to in their job descriptions. There has been no outside help from temporary staff.

There are formal written instructions for acquisition and loan-in procedures. Additional manuals have also been drawn up for all projects that

have been included within the new computer-based procedures. These include general definitions of recording and terminology conventions and specific guidelines for individual projects. They are drawn up jointly by Information Retrieval and the relevant department, and updated as necessary. A major reappraisal of the existing documents is now underway. Few manuals exist for the old procedures that are still in use.

Information Retrieval staff give training and advice to departmental staff when a new project is initiated. Any new staff entrants are then trained in-service by their immediate colleagues and Information Retrieval staff. New Information Retrieval staff are themselves trained in-service and by the MDA.

As already noted, the museum is engaged in a major computerisation programme, the initial aim of which is to transfer all item records into a computer system (Bartle and Cook, 1983; Light and Roberts, 1984; Orna and Pettitt, 1980). This procedure is seen as an integral part of the work of the museum, coordinated by Information Retrieval, but with no additional staffing or temporary staffing. Records are prepared by curatorial staff using small data entry microcomputers installed in the local departments. The information is then passed to Cambridge for independent processing using the MDA's programs and a museum applications package on the university computer. After processing, etc., the department receives line-printer and microfiche copies of its catalogues and indexes. All routine use of the computer is undertaken by departmental staff with only general supervision and help from Information Retrieval.

The Information Retrieval Section is also developing a major inhouse microcomputer system, suitable for internal processing of its production work (Light and Roberts, 1984). But the end of 1982, this included two processing units, a disc pack, tape deck, printers, etc., built up over a two year period and amenable to further expansion. A third machine (of compatible design) is available in the Archaeological Research Centre. All use MDA programs for key processing tasks, with major internal developments and applications.

The major capital and consumable investments are now concerned with the computer system. These are at an estimated level of £15 000 per annum, including inhouse equipment purchases, and external data entry and processing costs. The dominant recurring cost is that of staff resources within the departments and Information Retrieval. The investigator estimates these at £250 000 per annum.

Documentation system
The museum is notable for its range of material, for which a variety of procedures have been developed, many of which are now being revised and computer-based. Acquisitions and loans are processed by individual departments in cooperation with the Registry which holds resulting files (Figure D7). Individual item records are also prepared locally, either on record

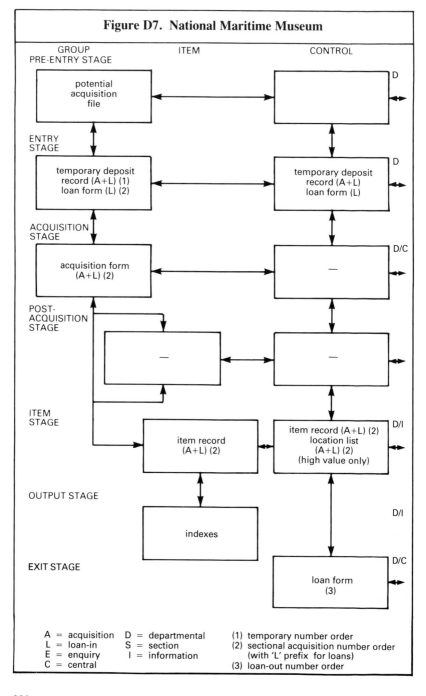

Figure D7. National Maritime Museum

GROUP ITEM CONTROL

PRE-ENTRY STAGE

potential acquisition file — D

ENTRY STAGE

temporary deposit record (A+L) (1) loan form (L) (2) — temporary deposit record (A+L) loan form (L) — D

ACQUISITION STAGE

acquisition form (A+L) (2) — — D/C

POST-ACQUISITION STAGE

— — —

ITEM STAGE

item record (A+L) (2) — item record (A+L) (2) location list (A+L) (2) (high value only) — D/I

OUTPUT STAGE

indexes — D/I

EXIT STAGE

loan form (3) — D/C

A = acquisition D = departmental (1) temporary number order
L = loan-in S = section (2) sectional acquisition number order
E = enquiry I = information (with 'L' prefix for loans)
C = central (3) loan-out number order

sheets or directly in machine-readable form using small microcomputers. These records are held on the computer where they can be processed to produce printed catalogues and indexes for internal and public use. Enquiries are dealt with informally, not being retained in the museum. There are also extensive information files, independent of the object records, which are heavily used when responding to questions from outside users.

It is estimated that all groups have been accessioned. Excluding the news cuttings collections, item records exist for 70% of material, indexes for 50% of material and published catalogues for about 10% of the object collection. The standard of all records is, however, subject to improvement.

The computerisation scheme and completion of item records are seen as major factors in enhancing the security of the collection itself and its documentation. Attention is being given to the security of the computing system and files and the protection of information from tampering. Parts of the collection have been photographed.

Documentation and collections audit
The museum has a limited programme of internal departmental stocktaking done on a periodic basis for valuable items. In the future, an independent appointee of the Museum Secretary is also to be present. The system is currently under review.

As computer-produced store lists become available, they are being used as a guide to a comprehensive stocktake of the relevant collections. Effective location lists with adequate object descriptions are seen as a key aid to future stocktaking.

Auditors have made no comments on the documentation procedures.

Deacquisition and indemnification
The records would be annotated after any loss. Loans in to the museum are indemnified. (Valuations are noted on the acquisition record but not on individual item records.)

Object collections documentation

Pre-entry stage
Any potential acquisitions are referred to the Head of Department, at the request of whom Registry will open a Potential Acquisition File, in which are placed subsequent correspondence, etc.

Entry stage
The museum has distinct procedures for acquisitions and loans (detailed in internal memoranda) and enquiries (dealt with informally by curatorial staff, and not retained in the museum).

In the former cases, material is referred to the department concerned or (at the weekend) accepted by the information desk, where a receipt is issued pending subsequent attention by the department. In the department a

temporary deposit record is completed, using a prenumbered slip. If the material is a loan, a loan-in form will also be completed. The material is usually held in a cupboard, with a copy of the slip.

Any correspondence is added to files maintained by the Registry. Ephemeral documents concerning a potential acquisition are retained for a year after the last addition to the file. If the acquisition is not forthcoming, the file will then be passed to the Head of Department who decides whether its information should be included within the Information Retrieval records, or retained for a further period, or discarded. It is then returned to Registry for action. If the acquisition is agreed, the papers are transferred to a permanent file after receipt of the material.

Objects brought to the museum as enquiries are dealt with informally by the relevant curatorial staff. Any information felt to be worth retaining is passed to Information Retrieval for inclusion within the record system.

Acquisition stage

The museum considers all accepted material as an acquisition, which it may either own or loan. Few significant distinctions are made between the two types of entry, both of which are processed promptly. Major parts of the old collections are loans to the museums.

Responsibility for processing the acquisition remains with the Head of Department, after referring it to the Director and Trustees in certain defined circumstances. Its receipt is acknowledged in a letter sent to the depositor. The department then completes a two-part acquisition form (Master Record of Acquisitions), which is inserted in the Potential Acquisition File and forwarded to the Registry. The department does not have a bound register. It is, however, subsequently returned one copy of the form as its record of the acquisition. This includes standard details about the group, excluding its location. The information tends to concentrate on the group as a unit, although reference may be made to any component items. Complex multimedia groups tend to be treated as one acquisition, processed by the accepting department, before being split and passed to other staff. The department is responsible for assigning an accession number to the group on the basis of 'section code + year + running number'.

Registry meanwhile assigns a file number to the Acquisition File, and completes previous owner and object index cards. It adds the file number to the acquisition form, retains one copy and returns the other to the department. In the case of a gift, the file itself is also passed temporarily to the Head of Department who is responsible for drafting a Trustees' letter of thanks, to be signed by the Director. (No other formal transfer document is exchanged with the depositor.) The acquisition form retained in the Registry is arranged in an annual sequence in departmental acquisition number order. All subsequent correspondence is passed to the permanent Acquisition File held by Registry.

The full procedure are detailed in a formal memorandum. If followed, they result in both the department and Registry having full acquisition

records, noting both acquisition and file numbers, and Registry also having previous owner and object name indexes.

Loans-in are processed with a comparable procedure that is detailed in a separate memorandum. The museum finds it convenient to distinguish long-term 'loans' and 'period loans' of a defined duration. In both cases, an initial loan form is drawn up prior to the acceptance of the item and the material indemnified. The item is assigned a standard acquisition number with the addition of an 'L' suffix. Registry is responsible for managing aspects of the loan such as bringing its imminent termination to the attention of the department.

Item stage
Individual departments are responsible for developing item records for each acquisition, a process which usually begins within a year of receipt, although it may be delayed for up to five years. In a number of cases current material may be added to the existing collections, to be processed later on a subject basis. Whenever done, the information is now noted on internally designed A4 sheets or direct onto the data entry microcomputer files. This information includes storage location, which will be amended if the item is subsequently moved. Individual item numbers are assigned to the material at this stage. These are based on a subdivision of the group acquisition number.

As noted above, it is intended to include each item record within the computing system. This is partly a reflection of the need to reassess the existing records, of which 80% are felt to be inadequate for publication use. Two approaches are being used: one, to computerise the existing records so that they are in a form suitable for subsequent revision and extension; the other, to revise the existing records prior to computerisation. Approximately 20% of the collection has been reassessed using these procedures during the last five years. Detailed procedural guidelines, including terminology and syntax control, are available for those collections that are being reprocessed. The computer records are held in numerical order, with multiple copies available. The master file is updated as necessary.

The individual departments will, if necessary, prepare separate supplementary files. In contrast to the group files, these are retained in the department, in item number order.

Master location lists are held for high-value items. In the future, shelf or store lists will be prepared from the computer files. Individual departments have movement control systems for their collections. The primary item record is revised in the case of permanent changes.

Output stage
The item records are intended to be used as the basis for entries in printed catalogues for public use. In addition to the manual indexes held by Registry and individual departments, new computer-based indexes are now being produced, on both printout and microfiche. The current versions are

primarily for internal use as development aids. Labels are not usually produced.

Exit stage

There is a formal loans-out procedure, operated by the individual departments with help from Registry. A loan form and conservation report are completed in advance of any loan, and the item record amended on the departure of the object.

The records are annotated after any disposal or transfer.

Other documentation

Reference has already been made to the key importance of non-object items and information within the museum. This point was emphasised during 1976, when a survey of enquiries demonstrated that 96% were not directly concerned with the objects in the collection. Most information files within the museum are not derived from the objects themselves. For example, individual departments have extensive files of internal information, often with usable manual indexes (which may be computerised in the future) and Information Retrieval has major communal sources. Initial computer processing is being concentrated on a series of files concerning ship histories, events, biographies and geographic information. There are also large photograph collections, with records held in photograph order. (The central information desk holds a Public Visual Index of primary record and historical photographs.)

The major library holdings are currently being reclassified and their catalogue computerised. In the Manuscripts Collection, procedures analogous to those for objects have been adopted (Bartle and Cook, 1983). An item list acts as the primary source of information about the collection. Selected areas (such as the Nelson letters) have been processed to produce catalogues and indexes. A location list is held of valuable items, for auditing purposes.

Update

In April 1984 the Information Retrieval Section was replaced by a larger museum-wide group, known as the Information Project Group. This was formed from the Information Retrieval Section with seconded curators from all departments, initially totalling eighteen staff. Comprehensive surveys of the collections, documentation procedures and postal enquiries were followed by a reassessment of policy.

The Group's general aims are to improve the quality of collection-related information and to improve access to and control over the information by means of effective computer technology, where appropriate. Its terms of reference are: the construction of minimum inventory records to a common standard through all departments; the revision of existing collection documentation procedures, and the implementation of new ones, to ensure that

the inventory records can be maintained and generated for all new acquisitions; and to establish control of data standards. A separate museum enquiry service is also to be set up.

The Group's computer resources are now two Cromemco super micro-computers with eleven terminals, with five Epson stand-alone micros.

Further details of practical developments up to 1984 are given in a separate paper (Cutbill, 1985).

Dii2.8 The National Portrait Gallery

Introduction

Report based on a discussion with Mr Kai Kin Yung (Registrar), 15 March 1982, which concentrated on the permanent gallery collection and the function of the Registrar.

Museum framework

Management/resources
The National Portrait Gallery is a Trustee museum, arranged as a single unit, but with distinctions between its museum and archive functions, reflecting its importance as an information centre covering all aspects of portraits.

The Director is assisted by Keeper and Assistant Keeper grade staff concerned with exhibition, display, registration, conservation and the archive. There are also important education and publication services.

Collections
The permanent collections include 6000 paintings, sculpture and photo-graphs (Hector, 1981), 2000 drawings and 300 miniatures and waxes, with an annual increase of about 100 items. (These are represented by approx-imately 5000 separate registrations.) There is also a Contemporary Portraits Collection. Conservation details are incorporated within the museum records. Archive and bibliographic material is, however, held separately (Vaughan, 1981).

Positive reference is made to the documentation and archive during consideration of an addition to the collection.

Documentation framework

Documentation management
The Registrar is responsible for the coordination and maintenance of documentation and conservation. The priorities are basic documentation, photography and system maintenance.

Documentation resources
The Registrar and assistant are concerned with intital documentation and

the maintenance of the concise catalogue while curatorial staff undertake the development of detailed item records. There has been some temporary help with specific projects, such as the compilation of the complete illustrated catalogue (Yung, 1981). A brief guide to procedures is available. No use has yet been made of computers.

Documentation system
The gallery takes care to preserve details of any prospective acquisition when an offer first comes to its attention (Figure D8). Acquired material is then noted in either a permanent collection or contemporary portraits collection register, a duplicate copy of which is held in a safe. Potential donor (Offerer), artist and sitter indexes are retained, and published catalogue entries prepared. These sources are currently being referred to during a comprehensive stocktake of the collection, initiated by the Registrar.

Apart from the need for further development of item records, the documentation is comprehensive.

A primary use of the documentation is in the preparation of the illustrated concise catalogue and catalogues raisonne.

Although there is little control over access to the documentation and concern over the contents of the files, there is a secure duplicate copy of the registers.

Documentation and collections audit
The gallery has just commenced a comprehensive stocktaking, repeating an exercise last undertaken in 1971. The collection is being checked on a location basis, a copy of the complete illustrated catalogue being annotated while in the store. The work is seen as a check of location itself, on the condition of items and on the accuracy of the concise catalogue details. It is being done by the Registrar staff, at the Registrar's initiative.

There has been no consideration of the documentation by E & AD, although reference has been made to the gallery in recent C & AG and PAC reports (see Section 2.7).

Deacquisition and indemnification
The register is annotated by the Director in the event of any loss. The collection is covered by a government indemnity.

Object collections documentation

Pre-entry stage
Any potential acquisition, however tenuous, is noted in an offers log book and on an offers record card. Details of those that are subsequently declined are passed to the archive.

Entry stage
Distinct procedures are adopted for different types of entry. Potential

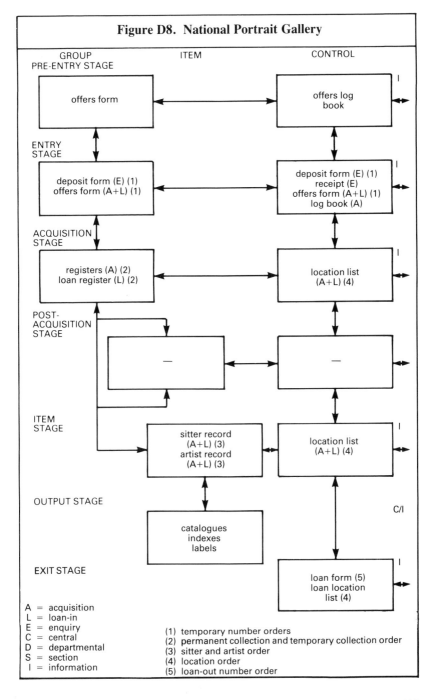

Figure D8. National Portrait Gallery

GROUP ITEM CONTROL

PRE-ENTRY STAGE

| offers form | ←→ | offers log book | I |

ENTRY STAGE

| deposit form (E) (1)
offers form (A+L) (1) | ←→ | deposit form (E) (1)
receipt (E)
offers form (A+L) (1)
log book (A) | I |

ACQUISITION STAGE

| registers (A) (2)
loan register (L) (2) | ←→ | location list
(A+L) (4) | I |

POST-ACQUISITION STAGE

| — | ←→ | — | |

ITEM STAGE

| sitter record
(A+L) (3)
artist record
(A+L) (3) | ←→ | location list
(A+L) (4) | I |

OUTPUT STAGE

| catalogues
indexes
labels | | | C/I |

EXIT STAGE

| | | loan form (5)
loan location
list (4) | I |

A = acquisition
L = loan-in
E = enquiry
C = central
D = departmental
S = section
I = information

(1) temporary number orders
(2) permanent collection and temporary collection order
(3) sitter and artist order
(4) location order
(5) loan-out number order

acquisitions and long-term loans are passed to the Registrar for processing. Short-term loans for exhibition are dealt with separately. Enquiries, if retained in the gallery, are logged in a deposit book, and a receipt issued. The work is supervised by the Registrar.

Offers are noted on a form and in the deposit book. They are assigned a temporary offer number. Details of their condition, history, etc., are preserved in a file, while the item is referred to a staff meeting and then to the Trustees.

Deposits are assigned a temporary number and have a label attached to them. The label is the stub from the deposit form and includes the temporary number, sitter, title, depositor and date of deposit. The group is the responsibility of the Registrar, held in an area separate from the main collection. A record photograph is prepared.

The gallery has enquiry days when members of the public may bring items for identification, etc., and also arrange to see items by previous appointment. One of the reasons for retaining such items in the gallery is for their recording. Details are noted in the deposit book and eventually held by the archives. Any correspondence, etc., is retained in a supplementary file.

Acquisition stage
Donations are acknowledged by correspondence with the depositor. Any purchase is noted on a form, one copy of which is passed to accounts for processing and the other held in the acquisition files. As copyright of photographs and prints would normally remain vested in the artist or a commissioner, the gallery tries to establish the copyright holder and to negotiate for its transfer. (This is often very difficult in the case of living photographers, in which case a separate agreement might have to be made for each use of the image.)

Details are entered in the permanent collection register, photograph register or the contemporary collection register, two copies of which are held (one in a safe). The offers book is also annotated. The note in the register does not include the location of the item. Subsequent changes of information are, however, noted in the book. The items are numbered according to three sequences, reflecting the different collections.

Details of correspondence, etc., are held in a permanent file, preserved in filing cabinets. This is the formal version of the earlier offers file.

Long-term loans are noted in a separate loans register and assigned a standard accession number. There are few items in this category. Short-term loans for exhibition are processed by a separate temporary procedures.

Item stage
Details of each object are noted on sitter and artist record cards.

Certain historical information may be held in the archive, separate from the records in the Registrar's Office.

Separate location lists are held in numerical order for each display area and for loans-out. Although major movements are undertaken by the

Working Party, curators are also at liberty to change locations. The notification to the Registrar and amendment of the location list are retrospective and may be delayed.

Output stage
The gallery prepares an annual report, with details of all new acquisitions, and an illustrated concise catalogue (Yung, 1981). Entries in both are drawn up by the Registrar. Detailed period catalogues are also prepared by the curatorial staff.

Reference has already been made to the offers index (prepared when the gallery first becomes aware of an item) and the sitter and artist sequences. New acquisitions are placed on display, accompanied by an exhibition label which is subsequently held in the supplementary file.

Exit stage
The Registrar is responsible for coordinating loans from the collection, with reference to the National Museums Security Adviser, etc. A loan form is completed and returned to the gallery in advance of the movement. The location list is annotated when the item leaves the gallery. A separate index of borrowers is also maintained. A record sheet showing brief details of loans to temporary exhibitions is also kept on file.

Museum comments

The system is felt to be adequate, although there are some areas of concern. There could be additional means of accesss to the collection such as a subject index. The state of the documents themselves is also being considered: there is a need for more care over the removal of papers from the files; a log of the contents of each file; and a need for subdivision into areas such as acquisition, conservation, etc.

Dii2.9 The Science Museum

Introduction

Report based on a discussion with Dr Leonard Will (Assistant Keeper, Science Museum Library) and Mr Peter Mann (Assistant Keeper, Department of Transport), 26 March 1982.

Details of the major developments since then are given at the end of the report.

Museum framework

Management/resources
The Science Museum (Burrett, 1982) is a Trustee museum (formerly Office of Arts and Libraries), with three centres:

Science Museum
National Railway Museum
National Museum of Photography

The museum is arranged on a departmental basis, with the following curatorial divisions:

Chemistry
Astronomy, Mathematics, Earth Sciences, Electrical Engineering and Communications
Mechanical and Civil Engineering
Physics
Transport
Wellcome Museum of the History of Medicine.

It includes the Science Museum Library (including the Pictorial and Archives Collections) and a central Inventory and Registry.

The museum is headed by a Director, supported by a Superintendent (whose responsibilities include the Inventory and Registry), and departmental teams including Keepers, Deputy and Assistant Keepers and Research Assistants.

Collections

The important object collections are estimated to include about 133 000 discrete acquisitions (53 000 for the main collection and 80 000 for the Wellcome Museum), representing perhaps 400 000 individual objects. The current overall annual acquisition rate is from 1000–2000 groups.

It is estimated that the Pictorial Collection (formed by merging visual image items from other parts of the collections) may include up to 500 000 items, with a relatively high growth rate. In addition to the Pictorial Collection itself, photograph collections are still held in the Physics Department. The library, of which the Pictorial Collection now forms a part, has a further 500 000 bibliographic items, archival material and an index of portraits.

There are also some records of conservation work undertaken by the museum, but these are not yet arranged in any single standard form.

The museum's acquisition policy is partly based on information derived from the object documentation.

Documentation framework

Documentation management

The development of documentation procedures is being examined by a Documentation Working Party, under the Chairmanship of a senior Keeper. One officer is responsible for introducing automated systems into the library and for advising on equivalent systems in the museum. Day-to-day responsibility for the documentation of collections is held by individual

curators, aided by Registry staff (particularly with acquisitions documenta-
tion). The first documentation priority is the maintenance of the basic
register (or inventory) entry of each group.

Documentation resources
The procedures involve three groups of staff: the Inventory Section (one
person), the Data Processing Section (one Assistant Keeper, one Senior
Data Processor and two Data Processors), and the curatorial staff them-
selves (an unquantifiable proportion of the time of over 40 Assistant
Keepers and Keepers, plus approximately 100 assistant staff). Specific
reference is made to the importance of documentation duties in the job
description of many staff. In addition to the permanent staff, there is a
major temporary team working on the documentation of the newly acquired
Wellcome Museum (Burnett and Wright, 1982; Orna and Pettitt, 1980).
There is no formal manual or training programme for the current system.
Training in the use of the new system is primarily in-service.

The museum has been involved in using semi-mechanised (Chaldecott,
1967) and mechanised documentation systems since the mid 1960s. It has
recently acquired a major new computer system, the use of which will be
developed in the next few years (Burnett and Wright, 1982; Will, 1982). The
aim is to provide an integrated computerised documentation system,
including the registration documentation (inventory records), and allowing
straighforward access to information. Initial effort is being concentrated on
the development of data structures able to accommodate full records, to
examine and then computerise the registration procedures and to incorpo-
rate location control facilities. The system is based on a Prime 150 Mark 2
minicomputer, using the Adlib information management package. It in-
cludes over 300 megabytes of disc space for online storage and 16 terminals
distributed around the museum.

The major capital investment is the recent acquisition of the computer
system, costing £115 000 at 1981–82 prices. Annual maintenance will
continue in the future at around £10 000 per annum. It was not possible to
quantify staff costs.

Documentation system
The present documentation system is based upon principles established in
1913, following recommendations by the PAC (see Section 2.7). While the
following description will concentrate on this system, the introduction of a
new computer system and the current reassessment of procedures will result
in significant changes to detailed aspects of the system. The procedure for
both acquistions and long-term loans is that a group is first passed to the
relevant curator who notes basic intitial details on a form, a copy of which is
passed to the Registry (Figure D9). Within the Registry, the Inventory
Section prepares an entry in a register (an inventory ledger), assigns an
inventory number, then returns the annotated record to the curator, after

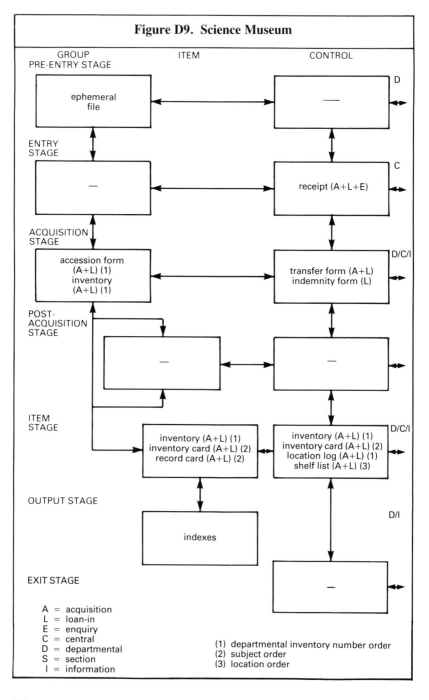

Figure D9. Science Museum

which he or she is responsible for the group, including its full documentation (details of which are kept in technical files).

All groups in the main collection are thought to have been accessioned by incorporation in the inventory. Although there are item records for most of the objects in the collection, these are often limited to a basic description and acquisition information. Work is in progress to bring the Wellcome material to a higher standard. In numerical terms the dominant problem, therefore, is the Pictorial Collection.

The museum is concerned that the existing system is less secure than might be desirable, with few back up files, etc. There is, however, a duplication of some information between Registry and the departments. Record photographs are in principle available of most objects in the main collections, but there is some backlog in the work of photography.

Documentation and collections audit
Museum staff are understood to be personally responsible for the collections in their care. An initial duty of a curator on joining the staff or taking responsibility for a new collection is to check the presence of all objects in their charge and to sign that they have been seen. (Ideally this is done during an overlap of old and new staff.) The primary aim of this exercise is to aid familiarity with the collection and to ensure a periodic stocktaking. The directive in force until the 1970s was that a quinquennial stocktaking programme should be operative (see Section 2.7). This has now been revised to the more flexible guideline that an active stocktaking programme must be in effect.

Independent stockchecking is undertaken by E & AD on an annual basis. This typically involves a random check of ten objects. The Department has examined the overall documentation procedures, but has not made any significant recommendations concerning their revision. Reference has been made to the museum's stocktaking procedures and problems in the reports of the C & AG and PAC and the recent Rayner review (see Section 2.7).

Deacquisition and indemnification
The record will be annotated in the case of a loss. Indemnity arrangements apply.

Object collections documentation

Pre-entry stage
Details of potential acquisitions are noted in *ephemeral files* (previously known as potential acquisition files) which are the responsibility of relevant curatorial staff. Such files may be disposed of by the Registry after one year.

Entry stage
At present, two basic procedures are adopted for items coming into the museum: that for acquisitions and long-term loans (between which no major distinction is made) and that for enquiries. Initial procedures include

passing unanticipated groups to the museum information office where a petty cash receipt is prepared, one copy of which is kept by the office. The curator concerned is then asked to collect the group from the office, together with an informal note giving details of the depositor, etc., based on the receipt. No temporary number is assigned to or attached to the group, nor is there any special procedure for its isolation from the main collection or record photography

Details of correspondence, etc., are kept in an ephemeral file. No record of an enquiry is kept after the disposal of the ephemeral file.

Acquisition stage
As noted above, the museum makes no major distinction between permanent acquisitions and long-term loans, which are considered as *acquisitions*. As with entry procedures, these mechanisms are now being reassessed. A potential acquisition is referred to the Keeper for approval. On receipt it is passed to the relevant curator who completes an acquisition form with basic details of the object (Form 361). The primary function of this form is to act as a notification to the Registry that the object has been received and should be registered. It usually refers to a single object. After completion it is passed to the Inventory section.

The individual objects in a complex group will tend to be accessioned separately, with a separate decision being taken about the suitability of each part. There would be no direct link in the inventory record between the different objects.

For gifts, the depositor is asked to sign a basic transfer of title form (Form 1) which, when returned to the museum, is also passed to the Registry. For loans, the same form and an indemnity form (Form 1a) are completed and passed for filing. Loans are a significant proportion of the total collection, particularly for older material. For purchases, it is assumed that the payment invoice is sufficient evidence of ownership.

The papers passed to the Registry are incorporated in a numbered file (Object File) and an entry is added to the bound register (inventory ledger), including an accession number (inventory number) assigned by the Registry staff. (The Registry does not maintain any collections management indexes such as one of donors. It concentrates on an accounting function.)

Under the old Registry filing system, papers dealing with the acquisition were on a file containing all correspondence with a particular company or individual (a Nominal File). Thus all acquisitions from a single source would be recorded on one file, regardless of subject or curator. The file number was the next sequential number if an acquisition was from a new source. Under the new Registry system, introduced in 1977, each new acquisition goes on a new Object File even if from an existing source (although, in practice, this is not always adhered to). The number of the Object File contains a component identifying the collection of which the object is a part and the numbers are then sequential for that collection.

A further form (Form 2) is completed by the Registry with basic details of the acquisition, including its newly assigned number. This is passed back to the curator who, by signing the form, indicates the acceptance of responsibility for this object. This signed receipt form is returned to the Inventory, where it is filed in a classified subject sequence according to the collection of which the object is now a part. This broad subject division reflects curatorial responsibilities within the museum. Forms relevant to a single subject are sorted together in a box file which reflects the responsibility of one curator. It should be noted that a curator may be responsible for more than one of these subject areas. Furthermore, a subject may be reassigned from one department to another, at which point responsibility for it might change. In such circumstances, the subject filing mechanism eases the transfer of responsibility.

The inventory section also prepares two copies of a basic 6″ × 4″ item record (Form 100) which is returned to the curator to be filed in numerical and subject order. In addition, the curators are responsible for technical files which include miscellaneous information about one acquisition. Correspondence about the object now tends to be added to these files rather than the Object Files held by the Registry.

In the past, the register entries tended to be amended if new information came to light about the object. Present practice concentrates on only amending the entry if the object has to be disposed of or returned to the original lender. The register itself is kept in the inventory room and the Object Files in the adjacent Registry. Neither are supported by duplicate copies nor kept in a fireproof environment.

The procedures are not detailed in a written manual.

The museum is conscious of the complexity of the system and of the duplication of effort involved in its implementation. Revised procedures are now being introduced which are centred on the use of a single three-part form acting as a combined entry and transfer of title document. As well as being more efficient, the revised procedure will be more effective as a documentation mechanism, easing the recording of key information in a form suitable for computerisation.

The procedure for short-term loans is quite distinct from that described above, with the objects being treated more informally. Curators receiving a short-term loan may optionally complete the basic transfer form, but keep both this and other correspondence in an ephemeral file. As noted earlier, this will then be subject to disposal after one year. No further details are preserved of short-term loans.

Item stage
The collecting departments tend to rely on the inventory cards (Form 100) for their primary object documentation. Details of new information is noted on these, including current storage location. As with so many aspects of the procedure this approach is currently being reassessed and a more detailed

record card may be introduced in the future. Changes have already been implemented in the Wellcome and Pictorial collections, both of which use A4 MDA-style record cards (Burnett and Wright, 1982; Sheridan, 1981a; 1981b).

The importance attached to accounting and management procedures is implicit in the description of acquisition practice. This emphasis is also reflected in the maintenance of inventory control procedures. Each collection is supported by a location log in the form of a location book or loose-leaf binder. This includes details of the inventory number, basic description, location and a stocktaking note of each item in the collection, in numerical order. Any change of location is noted in the list. In addition, some departments have shelf lists in location order. The inventory card described above also includes details of the current storage location.

Any significant movement is noted in the location log. There is, however, little control over access to stores or the implementation of a movement. It is hoped to introduce more effective controls in the future.

Output stage
The possibility of producing printed catalogues from the computer files is seen as one of the strong advantages of the new system. Within the conventional procedures, a number of departments have extensive subject catalogues, either in the form of published guides (usually pre-war) or as more informal handlists. There are also the numerical and subject cards produced by the Inventory and maintained by the curators.

The computer system will be able to provide direct access to a number of online index files and to produce printed listings. Leaflets and information sheets are produced by the education service.

Exit stage
A substantial part of the collection is on loan to other institutions. Responsibility for ensuring control of an outward loan resides on the curator concerned. There is no loan agreement form although one is now being prepared. On leaving the museum, a receipt is prepared. This is added to the object file when the item is returned to the museum. There is no effective review system to ensure the timely return of long-term loans. (In the past, the Inventory section was advised of loans-out and maintained a separate ledger in which they were logged.)

The documentation will be annotated if the museum disposes of an object.

Other documentation

Details of record photographs and lists of other photographs held for sale are available.

Museum comments

There is considerable dissatisfaction with the present system which is felt to

have serious omissions. However, the museum is currently undertaking a major review and revision of the procedures to enable it to manage and exploit the collection more effectively.

Update

The museum is now divided into four curatorial departments:

Physical sciences
Wellcome Museum of the History of Medicine
Engineering
Transport

Since the preceding description was written, a revised object documentation procedure has been implemented. This preserves some of the previous procedures, but eliminates most of the manual transcription of information from one form to another. A booklet specifying the new procedures for acquisitions, loans, disposals and other procedures has been prepared and distributed to curatorial staff.

For each object acquired by purchase, donation, or on long-term loan, a triplicate acquisition form is completed. The top copy of this is signed by the donor, vendor or lender (unless an invoice has been provided) and this forms the museum's primary evidence of ownership. This is filed in the central registry with any papers needed to support the museum's title to the object. The second copy of the acquisition form is retained by the donor, lender or vendor as a receipt, and the third copy is kept in a 'technical file' in the curatorial department, with any other papers about the object.

A basic computer record for each object is input direct from the triplicate acquisition form (or from a draft form, in which case the triplicate form is printed out by the computer). Inventory numbers, of the same form as used previously, are now automatically allocated by the computer. All other documentation required is printed out from this computer record: index cards for curators, file labels, acquisition lists, location lists, etc. When curators catalogue items more fully, or when an object is sent on loan to another museum, the extra information is added to the same computer record. Files relating to objects are now identified by the inventory number, not by a separate file number as previously.

Direct access indexes are provided for online retrieval by the most frequently needed characteristics, but records can be selected and sorted by any of the data they contain. Terminal connection points have been installed in all curatorial departments, but the programme of training curators in their use is still at an early stage.

The same computer system is being used to handle records of the museum's library stock in a MARC format; work has been done on extending this to cover the Pictorial and Archives Collections.

Dii2.10 The Tate Gallery

Introduction

Report based on a discussion with Mr Peter Wilson (Head of Technical Services and Senior Registrar) and Mrs Judith Jeffreys (Assistant Director), 25 February 1982. It concentrates on object documentation, with reference to analogous procedures in archives and the library.

Museum framework

Management/resources
The Tate Gallery (a Trustee museum) is organised primarily on a departmental basis, with collecting and service departments:

> British Collection
> Modern Collection
> Department of Museum Services (including Archives, Library and Education)
> Conservation Department
> Department of Exhibitions and Technical Services
> Information Department
> Tate Gallery Publications Ltd
> Administration and Accommodation

The Director and Assistant Director are supported by a number of Keeper, Assistant Keeper and Research Assistant Staff.

Collections
The gallery's object collection totals about 20 000 prints, paintings, sculpture, etc. (with a growth rate of approximately 600 per annum). This is paralleled by major archive and bibliographic collections, including exhibition catalogues (approximately 100 000, growing by 5000 per annum), books, periodicals (500–600 titles), sale catalogues, manuscripts, posters, photographs (Hector, 1981), private view cards and press cuttings.

The gallery has a well established acquisition policy based on curatorial knowledge of the collections, supplemented by reference to documentation where necessary.

Documentation framework

Documentation management
There are two areas of documentation within the gallery, for the gallery collections and the archive and library. The responsibility for coordination of the former is with Technical Services, which is itself concerned with registration and location control documentation and the management of the gallery operations technicians, while the curatorial staff develop item records and Conservation retains internal report files. Responsibility for the archive and library is vested in the specialist staff of that department.

All aspects of the documentation procedure are considered to be of equal importance. Practical deadlines are set by the requirement to produce an updated concise catalogue and a biennial report.

Documentation resources
It is estimated that 10 staff are involved in documentation, to varying degrees. These duties are referred to in the job descriptions of core staff. There has been no major temporary assistance. A unified procedural manual is being developed by Technical Services. Training is in-service at present, although an active programme is planned for junior staff entering Technical Services.

Detailed consideration is being given to the appropriate systems and software to use for collections management purposes, such as location control.

Documentation system
The gallery has comprehensive procedures for entry, acquisition, item and control documentation, placing considerable emphasis on internal collection management documentation and external publications (Figure D10). All acquisitions and loans are logged when they enter the gallery. Acquisitions are noted in a central accessions register and detailed in a concise catalogue entry and a location list maintained by Technical Services. Catalogue files are prepared by relevant curatorial staff, and used as the basis for an entry in the gallery's biennial report. Parallel conservation files are maintained with technical information. All movements are controlled and logged by Technical Services.

Comprehensive acquisition, item and control documentation is available, with the only serious deficiencies being that some item records are incomplete and some detailed location information is missing or inaccurate.

The primary accession register is kept in a safe, and other documentation is held in rooms with restricted access. There are, however, few duplicate copies of internal files (although there are, of course, extensive published catalogues). All items are photographed.

Documentation and collections audit
The gallery has recently decided to reintroduce a regular comprehensive stocktake, the last having been completed in the early 1970s. The new programme is to start in 1982 and be repeated on a two year cycle. It has been agreed at the initiative of staff, without influence from outside auditors. The plan is for curatorial staff to check the stores in which their collections are held. (The curators are not responsible for maintaining the stores, hence this approach gives a degree of internal independence to the check). The check will be undertaken with reference to the central location list.

Periodic checks are also undertaken by the store keepers themselves, referring to local store lists. Conservation has also undertaken a comprehensive check for condition control purposes.

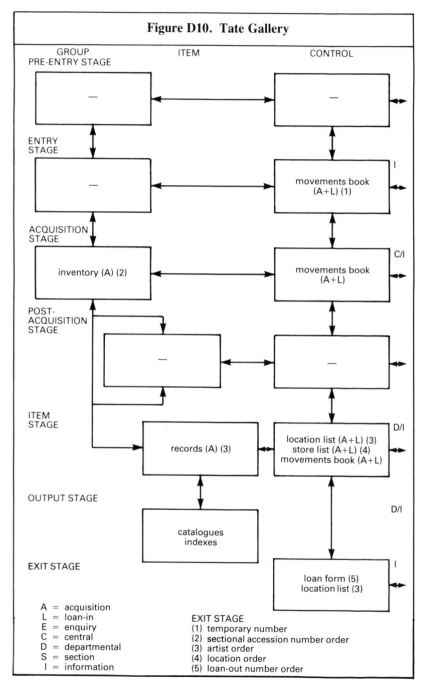

Figure D10. Tate Gallery

GROUP	ITEM	CONTROL

PRE-ENTRY STAGE

— | | —

ENTRY STAGE

— | | movements book (A+L) (1) | I

ACQUISITION STAGE

inventory (A) (2) | | movements book (A+L) | C/I

POST-ACQUISITION STAGE

— | | — |

ITEM STAGE

records (A) (3) | | location list (A+L) (3) store list (A+L) (4) movements book (A+L) | D/I

OUTPUT STAGE

catalogues indexes | | | D/I

EXIT STAGE

| | loan form (5) location list (3) | I

A = acquisition
L = loan-in
E = enquiry
C = central
D = departmental
S = section
I = information

EXIT STAGE
(1) temporary number
(2) sectional accession number order
(3) artist order
(4) location order
(5) loan-out number order

The auditors have not assessed the standard of documentation, although reference has been made to the Gallery in E & AD and PAC reports (see Section 2.7).

Object collections documentation

Pre-entry stage

Potential acquisitions are first discussed at regular departmental meetings of the relevant collections before being referred to the Director for consideration. A programme for submission to the Board of Trustees is agreed at 'Agenda Meetings', chaired by the Director, which are held in the week preceding the Board Meeting. Relevant items will be assessed by a Board meeting of the Trustees, for which they have to be deposited with the gallery. During this period they will be examined by Conservation, etc., to assess their suitability for the collection.

The present documentation strategy is being reconsidered. The resulting formal procedures will include a conservation report, a storage and display practicality report, accumulation of art information and assignment of a temporary number.

Entry stage

Formal entry procedures are adopted for acquisitions and loans-in. Enquiries are not retained in the gallery.

Acquisitions and loans are logged in a movement book and assigned a temporary number that is attached to the item itself by an adhesive label. The number will be either a strong room number, loan number or temporary exhibition catalogue number, depending upon the type of item. All material entering the gallery for consideration by the Trustees is held in the Strong Room. Both this and other material may be moved to and from conservation, photography, etc., with all movement being undertaken by the Operations Technicians responsible to Technical Services. Each item is dealt with independently, with no grouping.

Both Conservation and Technical Services may prepare files on the item, which will be managed by the central Registry.

The appropriate procedures are being detailed in a manual, now in preparation. They are supervised by Technical Services, with reference to standard checklists of activities.

Acquisition stage

The Trustees consider all acquisitions, except Print Collection items and other items up to a set price, which may by purchased by the Director. The Archive and Library may both purchase without the prior agreement of the Trustees. Their processing is then the responsibility of the relevant member of the curatorial staff, the Assistant Director and Technical Services, with assistance from Conservation Department (dimensions, medium, etc.). Formal aspects of acquisition are managed by the Assistant Director.

Although there is no separate transfer document, a donation will be acknowledged by a letter of thanks and a purchase will be supported by a payment advice. Steps are taken to acquire the copyright of paintings. For prints and photographs, the artist retains copyright, and the gallery asks for their permission prior to any reproduction of the work.

Following each Board, Technical Services prepares a list of new acquisitions for distribution to relevant members of staff. The details are incorporated into the computerised concise catalogue supplement by Technical Services. In the case of paintings and sculpture, the Assistant Director uses the list as the basis for a brief entry in a formal bound accession register (inventory). This is held separate from all other documentation in the care of the Assistant Director, who is responsible for any subsequent annotations. (Prints are noted in a separate register, held by the Print Collection.)

An accession number is assigned by Technical Services. The object is passed to Conservation, where the number is marked. It is photographed and an examination is carried out, details of which are placed in a conservation report file.

The various procedures are coordinated and checked by Technical Services, which is itself responsible for keeping track of the location of the object at all times. The appropriate action is being detailed in a manual now in preparation.

Loans-in are assessed by the Director and their subsequent management is then undertaken by the Assistant Director. Appropriate indemnity arrangements are made for the object prior to its receipt. The loan goes through the standard entry procedure, during which it is assigned a permanent loan number which it retains during its period in the gallery. Although not accessioned, its subsequent processing is analogous to that for acquisitions, although photography, conservation and storage arrangements are often restricted.

Item stage

The main catalogue record is maintained by the relevant member of the curatorial staff, incorporating all art historical information about the item. Its nucleus is usually established within a year of acquisition, but it continues to be developed on a long-term basis. The painting and sculpture records are held centrally within the curatorial area. The sequence is maintained in artist order, with each artist being represented by a general folder and then specific folders about each of their works in the collection. (Any confidential information is kept in a separate folder.) A separate but analogous sequence is maintained for the print collection. An abstract of the details about each item is noted in a record sheet. With the exception of a recent developments by the Modern Department, there is little control over the style of recording and no general guidance on the completion of the record.

An installation record for each item is being developed by Technical

Services. This includes details of the appropriate storage, display and handling procedures and requirements for the item. It will note, for example, the component parts of a complex mobile installation when on display.

Technical Services maintain a central file of locations, in artist order, and local lists within each store. The former list is on a Kardex system with a separate card for each item, showing details of moves on an historical basis. It is heavily used for collections management and curatorial purposes. Only authorised staff are allowed to amend the details, following guidelines in a written manual. The records are subject to checks by Technical Services staff.

Technical Services is responsible for all movements of items within the gallery. Any request for a movement is referred to it, after which an Action Sheet is prepared for the attention of the Operations Technicians. A log is made in a movement book and both the central location list and the local store lists are revised.

Output stage

The Gallery's concise catalogue is updated and reissued at regular intervals. It is divided into the British Collection and Modern Collection, with each arranged alphabetically by artist. The master copy of the concise catalogue is held in machine-readable form by the printers (Tate Gallery, 1980). The Publications Department also hold a version of the concise catalogue on an in-house microcomputer, which is used to print self-adhesive labels for photograph sales. This version can be sorted into acquisition number sequence, if required. There is also a separate list to the collections in accession number order, in Technical Services. This is limited to number and artist name.

The catalogue file is used as the basis for a full entry about each recent acquisition that appears in the biennial report. The full record is also used as one of the sources for the entry about a work in cumulative general catalogues about parts of the collection, such as the print collection in the Modern Collection.

These catalogues include various indexes to the collection; they are used extensively by staff and outside researchers. In addition the information desk has a subject index, based on the catalogue entries. Labels are not prepared, although they are being considered for sculpture. A number of information sheets are available.

Exit stage

Proposed loans are considered first by a loans committee including senior curatorial, conservation and collections management staff, and chaired by the Director, then referred to the Trustees. Subsequent action is supervised by a Loans Coordinator in Technical Services.

Prior to the meeting of the Loans Committee, the item is passed to Conservation for a comprehensive examination and condition report. The Loans Coordinator undertakes appropriate packing, transport and insur-

ance arrangements, and completes Progress and Departure forms. The movement is noted on the location list and in the conservation records. The eventual return of the item is again supervised by the Loans Coordinator and its condition reassessed by Conservation.

Items are sometimes transferred to other national collections. Copies of the catalogue and conservation files for that item are also transferred. Its entries in the concise catalogue and location list are retained, with appropriate annotations.

Other documentation

Detailed parallel records of technical examinations and processing of items in the collection are held by Conservation (Perry, 1983). These include copies of photographs taken for internal purposes. (Photographs suitable for public reference and purchase are held in Publications.) The primary conservation records are in numerical order, each in a wallet, and including a summary card of historical information and record sheets detailing technical examinations, etc.

The standard procedure for the major parts of the archive colleciton is to prepare an initial entry in an accession register, followed by the later compilation of a more detailed entry in one of a range of subject-based major registers. Accession numbers are allocated to group deposits at the time of completion of the accession register. The subsequent processing results in the development of lists about each accession, supported by appropriate entries in a number of card indexes. The manuscript collection (within Archives) includes historical gallery files concerning acquisitions and exhibitions and declined acquisitions.

The primary book collection in the Library is catalogued in a classified sequence supported by author and subject indexes. The major Exhibition Catalogues collection is catalogued in two sequences, representing one person exhibitions (arranged in artist order) and group exhibitions (arranged by place of exhibition).

Museum comments

Although recognised as comprehensive, the system is felt to lack a certain unified style and would benefit from more central management. Consideration is being given to the further development and coordination of procedures, and the extension of the item records. There is also interest in the introduction of an internal computing system for location control purposes.

Update

Since this report was written, the post of Assistant Director has been abolished. The Keeper of Museum Services now has managerial responsibility for Exhibitions and Technical Services. A registrar's office, managed by a Registrar, has been formed within Technical Services and the elements of

the accessions procedure and the loans-in procedures formerly handled by the Assistant Director are now dealt with by the Registrar and his staff. The loans-out procedure has been formalised and a start has been made on a similar procedure for accessions. Technical Services is currently commissioning the first stage of an online computer based collection management and cataloguing system for the gallery.

Dii2.11 The Victoria and Albert Museum

Introduction

Report based on discussions with Miss Susan Lambert (Deputy Keeper, Prints, Drawings, Photographs and Paintings Department) (12 March 1982) and Mr Charles Truman (Assistant Keeper, Ceramics Department), Dr J. Haldane (Deputy Keeper, Library), Mr Michael Wilson (Senior Research Assistant, Library), and Mr R. D'Souza (Central Inventory) (13 September 1982). The report concentrates on practice in the Prints, Drawings, Photographs and Paintings Department, the Ceramics Department, the Library and the Central Inventory, with reference to broader considerations.

A brief reference to subsequent developments is given at the end of the report.

Museum framework

Management/resources

The Victoria and Albert Museum (Burrett, 1982) is a Trustee museum (previously a Departmental museum), with a number of centres:

> Victoria and Albert Museum
> Bethnal Green Museum (Museum of Childhood)
> Ham House
> Osterley Park House
> Theatre Museum
> Wellington Museum (Apsley House).

The museum is arranged on a departmental basis, with collecting departments reflecting both subject and geographic bases:

> Ceramics Department
> Furniture and Woodwork Department (responsible for Ham House, Osterley Park House and Wellington Museum)
> Metalwork Department
> Indian Department
> Far Eastern Department
> Prints, Drawings, Photographs and Paintings Department
> Sculpture Department

Textiles and Dress Department
Museum of Childhood
Theatre Museum
Conservation
Library
Museum Services
Administration (including Registry and Central Inventory).

The Director is assisted by departmental Keeper and Research grade staff.

Collections
Estimates of the size of the object collections noted in the recent Rayner
Report range from 2.5 to 4 million items (Burrett, 1982). The overall annual
growth rate is approximately 5000 permanent acquisitions and 500 long-
term loans. As an illustration of one department, the Ceramics collection
includes approximately 70 000 items (some of which, such as a dinner
service, may be a group), with from 100–200 new acquisitions each year.
Bibliographic and archive material is held both in individual departments
and the central National Art Library (with a growth rate of 8000 individual
bibliographic items and 1500 periodical titles per annum). Photographs of
artistic values are held in one of the departments.

Departmental acquisition policy is based on curatorial knowledge, with
frequent reference to the available documentation.

Documentation framework

Documentation management
Although originating from a common background, documentation proce-
dures are now primarily a departmental responsibility, with a certain degree
of coordination in a Central Inventory (within Administration). Recently, a
documentation committee has been assessing documentation policy and
procedures, with initial reference to the potential use of computers and
microforms. A key priority is the maintenance of acquisition details.

Documentation resources
The total establishment of the museum is over 600 staff. Many of the 150
curatorial staff are involved in documentation. In the case of Prints,
Drawings, Photographs and Paintings this averages 30% of their time. (This
is thought to be 20% for grade A staff, 50% for grade C, D and E staff, 10%
for grade F and G staff.) The departmental Senior Museum Assistants play
a key role in many of the collections management aspects. Staff in the
Registry and Central Inventory are also concerned with aspects of docu-
mentation. Documentation duties are referred to in job descriptions. There
has been little assistance from temporary staff, the main exceptions being
students on secondment to the departments and advice from visiting
authorities.

There is a brief guide to the inventory procedures. Some departments

have detailed manuals concerning item documentation. Training is given in-service at a departmental level. This is frequently the responsibility of a Senior Research Assistant or Senior Museum Assistant within the department.

Apart from standard files, consumables, etc., there has been no significant investment in equipment for object documentation. The library has used a tape typewriter to aid the preparation of multiple index entries. With the exception of a few experiments, such as one with part of the Theatre Museum collection, no use has yet been made of computers.

The only significant cost is that of the recurrent investment in staff time. On the basis of a typical department, the investigator has estimated an annual cost of around £450 000.

Documentation system
Documentation effort is concentrated within individual departments, using similar procedures, but with little central coordination (Figure D11). Material entering a department may be logged in a day book or on a receipt. Acquired groups are then notified to Registry, using an Objects Submitted on Approval form, where a file is opened and an entry made in a central acquisition register (inventory). A copy of the accumulated inventory for the year is subsequently returned to the department; other copies are held centrally. The department prepares individual item records about each component of the group, which it arranges in museum number order to produce an item register. Supporting departmental indexes and finding lists are also prepared.

All groups are thought to have been accessioned (with an entry in a departmental register and the central inventory). However, the degree of item documentation is much more variable. In one department, for example, accessioning is almost comprehensive, but there is a five year backlog in the preparation of item records.

There is a duplication of the basic inventory details between the Central Inventory (copies in the Inventory itself and in the Board Room) and the department. However, only one of the central copies (that in the Central Inventory itself) is maintained, the others gradually becoming superseded. No microfilm copy is held. The documents are stored in a standard metal cabinet.

The earlier acquisition registers and subsequent more detailed item registers are only available in the departments. There may be only a single copy of the primary item register, which may be held on open access shelves within the General Office. A microfilm copy of the library subject catalogue is being prepared.

Documentation and collections audit
Historically, each department was expected to implement a quinquennial stocktaking programme to identify losses and report on the condition of the collections (see Section 2.7). Since the 1960s, however, it has been

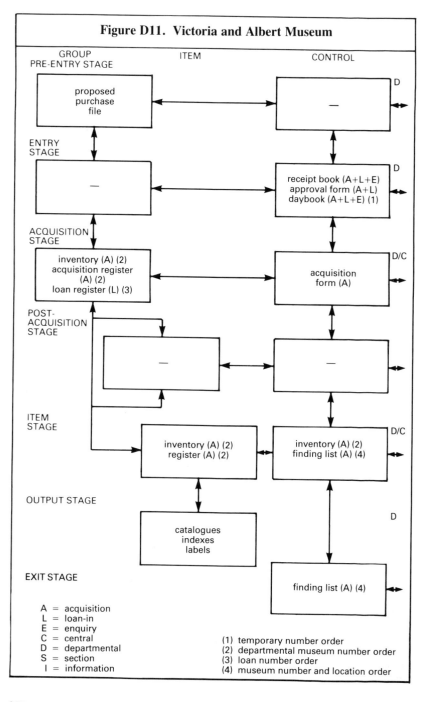

Figure D11. Victoria and Albert Museum

appreciated that such an ambitious aim may be impractical in some sections (a view that has been reinforced by comments in the Rayner Report) (Burrett, 1982). In practice, therefore, in certain departments, stocktaking is now done on a regular basis; in others, more irregularly. The typical procedure is to take the finding list to the store or display area. The cards are then checked against the collection, any anomalies being put to one side for further consideration. The checked cards are used as an authority for annotating the numerically arranged inventory. The work is coordinated by the Senior Museum Assistant, with help from Museum Assistants. It is often undertaken in parallel with a cleaning and condition checking programme. Any losses or gains are reported to the Finance Officer and, through him, to the Central Inventory. A comprehensive list of total losses, findings and values is then prepared for the whole museum. After approval, the appropriate inventory entries are then annotated on the Central Inventory copy.

In the Library, a member of staff has been responsible for a comprehensive check of certain collections during the last eighteen months. There is also an annual stockcheck of all rare books and manuscripts, during a week when the library is closed to readers. This is undertaken by comparing the shelf cards with the collections themselves.

E &AD has also undertaken random dip checks of departmental collections, and reference has been made to the Museum in recent C & AG and PAC reports (Section 2.7).

Deacquisition and indemnification
A Board of Survey is arranged if a department wishes to dispose of an acquisition. After the approval of the disposal, the relevant Registered Papers file is passed to the Central Inventory for checking against the primary inventory copy. After the disposal itself, the inventory entries are annotated with details of the action. (Only the primary copy of the inventory is altered, and those in the Board Room therefore become superseded.) The department is responsible for taking similar action to annotate both its copy of the inventory and its registers.

A department may maintain an indemnity list, giving details of the overall value of its collections.

Object collections documentation

Pre-entry stage
Departments are responsible for requesting Registry to open a file (such as a Proposed Purchase file) in the event of staff becoming aware of a potential acquisition.

Entry stage
All material entering the museum is managed at a departmental level, with similar procedures for acquisitions, loans and any enquiries retained by the department. In theory, incoming material passes through the central Transit

Room. In practice, most items are received by the department concerned, who then advise the Transit Room of their entry. The Transit Room acknowledges this entry by issuing a receipt for the item.

Either a receipt book or a form for Objects Submitted on Approval may be used as an initial log of acceptance of the group within the department. In some departments, primary details are then entered in a daybook. (This should log all groups entering the department, including those from other departments in the museum.) The information noted in this book includes a temporary number ('year + running number'), date, Registry File number, brief description, depositor's name and date of return. Another department, however, does not have a daybook, but issues a receipt for the item. The material itself is usually retained in a holding area within the department (for example, in the General Office). There tends to be no direct link between the group and any entry in a daybook. A copy of the receipt may, however, be kept with the material.

In certain cases (always with an acquisition), a file is opened and held by Registry, including any correspondence about the group.

If possible, an object brought to the department as an enquiry is dealt with immediately. If retained, it may be logged in and out of the department using the daybook. A receipt may also be prepared, to be handed back to the department when the object is retrieved. If the enquiry is a significant item, it may be photographed while in the museum, in which case the resulting photograph will be held in the archive.

Material is also sometimes accepted for conservation.

Acquisition stage

The decision to propose an item for acquisition is taken by the department. Registry is asked to open a file (to include Registered Papers), with the physical file then being forwarded to the department at an early stage in the deliberations. This file may include papers about a group of items to be acquired at the same time from a single source. The Registered Papers concerning an acquisition are considered by the Director. In the case of a donation, after its approval a letter of thanks and form are passed to the depositor, with the form being signed and returned to the museum. The subsequent documentation procedure places an emphasis on individual items, with diverse groups being divided into independent acquisitions. (The main exception to this is the file procedure.)

An entry concerning each donation, bequest or purchase is prepared in an acquisition register (which may be loose-leaf or bound), with basic details that may include the location. The details are entered promptly after the acceptance of the item, with the work being done by the Senior Museum Assistant. Each entry refers to a single item (except for material, such as a dinner service, which is acquired as a single unit). This register is considered to be a closed document, and is only annotated in exceptional circumstances.

Individual items are assigned a unique item number (Museum Number) at this stage (on a 'departmental prefix + running number + year' basis), with

no intervening group number. The number is issued by the department concerned, not the Central Inventory or Registry. It is affixed to the item itself at this stage.

The accumulated information about the group of items is passed to the Registry, who process the file and arrange for the preparation of a brief entry about each item in the central inventory. The maintenance of these entries for all acquisitions is one of the main functions of the Central Inventory section undertaken by its single member of staff. The Registered Papers file received by the Registry includes a copy of the Objects Submitted on Approval form, completed by the department. Two styles of form are used: a Gift form (for donations and bequests) and a Purchase form. These are passed to the Central Inventory, where the details are copied onto an Inventory Sheet. These sheets are arranged on a departmental basis, in consecutive museum number order, within the Central Inventory. They include columns for basic details about an item (museum number, brief description, date of acquisition, daybook number (eg Transit Room receipt number), Registered Paper file number, purchase details and remarks). During the year, only the single master copy of these sheets is available.

The department may request that the entry for a high-value item is annotated with a red star. These items may then be subject to more rigorous stocktaking and control procedures.

A few months after the end of the calendar year, the department is asked to complete its submission of entries for that year. Some time later, the sheets are arranged into a single set and passed for typing. The original copy is subsequently held within the Central Inventory, while the relevant section of the typescript copy is passed to the Senior Museum Assistant in the department for proofreading (and possible revision). The pages in this document are numbered. Unlike the original, entries in the typescript copy only include the museum number and the basic object description. The corrected document is used as the basis of the formal inventory for that year. Three copies are printed and returned to the Central Inventory: one is separated into departmental sets, and the loose-leaves passed to that department for retention; the other two are maintained as complete sets for that year (one being bound and held in the Board Room and the other bound and held in the Central Inventory itself). The earlier manuscript copy (with fuller details) is then also bound and held in the Board Room; the source typescript copy is discarded. The separate departmental copies are used locally as a formal record of the entry and as part of the location control mechanism. The Central Inventory copy is maintained as the primary authority for the subsequent fate of the item.

As noted, the current volumes are bound on a calendar year basis. From 1844 to 1908, however, the details were accumulated and bound according to departments, with a single volume covering the acquisitions of that department for one or more years.

Procedures similar to these are adopted for both long- and short-term

loans. A separate loan form (Objects Submitted on Approval for Loan) is used during the early stages of negotiations, including provision for assessing indemnity requirements.

The Central Inventory keeps details of short-term loans-in in a basic manuscript list. It notes long-term loans-in in two files: one in a single alphabetical sequence arranged by depositor, and the other in a departmental subdivision of this sequence. A copy of the latter is passed to the department to act as its loan register entry. Loan numbers are assigned on a central basis by the Inventory. They are allocated on a rotational sequence, according to the name of the depositor. Central Inventory keeps a running total of the indemnity value of loans into the museum. The Treasury is informed of changes to this total. The Registry is responsible for maintaining a file about the loan. Its duties include advising the department prior to the loan's termination date.

Item stage

In most departments, the Assistant Keepers, Research Assistants and Museum Assistants are responsible for preparing individual item entries, usually within a year of receipt of the group (although in one department there is currently a five year backlog). These entries may be noted on individual sheets, which are then held in museum number order, or on separate pages in a bound register. A single copy of the register is maintained in the department. Loose-leaf pages may be bound into convenient volumes. These registers are then kept on open shelves.

In Ceramics, a draft entry is prepared by an Assistant Keeper or Museum Assistant, for approval by the Deputy Keeper. When finalised, the entry is handwritten in the bound register, in museum number order. (Blank pages are left for details of any items that have not yet been entered in the sequence.) Each entry includes full details about the item (number, description, condition, price, source, date, remarks, etc.). It does not include the storage location (this being noted in inventory and location lists). The entry is only changed if significant new evidence, such as a reattribution, becomes apparent, or if there is a long-term transfer to another department or institution. Any correspndence about the item is included in the existing file, held by Registry.

As noted above, the Central Inventory passes one copy of the annual list of acquisitions to the Department, for use as an inventory. The current location of the item should be noted on this inventory by the Department's Senior Museum Assistant. Details of stocktaking will be marked on this list in later years. It should be amended or annotated if the item is moved within the department, sent on long-term loan, transferred or disposed. (In the latter cases, the item register entry should also be annotated and the Central Inventory advised of the charge.)

In practice, the process of finalising the annual list of acquisitions can be protracted, due to delays in notification of details and corrections, typing and

printing schedules, etc. It may, therefore, be some years after the acquisition of the item before the formal inventory list is available to be annotated.

Each department also has finding lists (location and store lists), maintained by its Senior Museum Assistant. These are often in two sequences: number and location, with the numerical list being treated as the primary document. Both sequences should be amended in the event of any major move of an item. In practice, however, the lists may become inaccurate due to failures to maintain them. In this case, their use for stocktaking and general location management may be more limited than might have been expected. Part of the stocktaking process is then the rectification of the lists (and the departmental copy of the inventory). In some departments, there may be little control over access to either the inventory or the location lists, both of which may be amended by any member of staff.

Any internal movement may be logged on a location control form or display card which is left at the original location. It should also be noted on the finding list. If long-term, the inventory should be annotated.

Output stage
Departments tend to consider their item records as forming the catalogue of the collection. They may also have separate, subject-based published catalogues, which may, however, be pre-war. Various indexes are also held in individual departments, usually on typed sheets or 5" × 3" cards. These may be maintained by the Senior Museum Assistant.

In Prints and Drawings, there is an artist index, with a full entry about each item in the collection. Similarly, in Furniture and Woodwork, there is a subject index with full details. In Ceramics, a maker and donor/provenance index and a subject index are prepared. The appropriate index terms are indicated on the master item record, and the index entries then extracted onto cards. These are kept in the department's general office.

Practice concerning the use of labels varies. One approach is to attach a photocopy of the full record to the object itself. Another is to base the label on the details in the item record. In Ceramics, the label is primarily for display purposes. It is kept in a file if the item is not on display.

Exit stage
Departmental Keepers are responsible for loans-out from the collection to other institutions. Each is detailed in relevant correspondence and noted on the finding lists. Long-term loans (of two or more years) are also noted by the Central Inventory. The primary inventory copy is annotated with brief details of the loan. The return of the item is also noted.

Details of transfers of items between departments are documented on Registered Papers, and subject to the approval of the Director. Central Inventory annotates the master copy of the inventory with details of the transfer (which may be a loan, subject to later cancellation, or a permanent change). The item is not renumbered and an entry is not prepared in the registers or inventory of the recipient department.

Other documentation
Many of the documentation procedures of the National Art Library are comparable with those for the object collections in the museum. This is particularly the case with any bibliographic material which has an interest as an object in its own right, such as a book with fine binding.

An acquired item is passed to the accessions section, where it is numbered and included in an independent accession register. Separate details are kept of manuscripts and valuable items. The new acquisition is then referred to the Senior Research Assistant, who is responsible for coordinating its cataloguing, with the help of a number of specialist cataloguers. The approach to cataloguing is based on rules originally developed for the British Museum collections.

A number of catalogue entries are prepared (with the aid of a tape typewriter, at present) for sorting into author and subject sequences, the former on catalogue cards and the latter on slips which are stuck into loose-leaf volumes. The subject index, begun in the 1930s, now includes approximately 1.5 million master entries and cross-references. As two or three entries are prepared for a typical new acquisition, from 20 000–25 000 slips are added to the existing volumes each year. Both the author cards and the subject volumes are on open access, available to all users of the library. (The subject entries are also being microfilmed, and will soon be accessible to a wider audience.) Comparable exhibition and sale catalogue card indexes are also available in the reading room.

The tape typewriter is also used to generate a shelf card for each acquisition, for use during stocktaking, etc. The collections themselves are arranged according to the pressmarking system, being ordered primarily by size and particular storage requirement.

Museum comments

The procedures are felt to be effective in principle at a Departmental level, although there are problems in maintaining indexes and location lists. The greater degree of movement of the collections and staffing difficulties may have resulted in a less effective implementation of the procedures in recent decades.

The museum is currently considering reassessing its procedures.

Update
The Victoria and Albert Museum became a Trustee institution in April 1984, since when it has been reviewing its documentation procedures. A Computer Consultant has been employed to investigate the feasibility of using computers to improve the documentation system. The first pilot automation projects are about to begin. A review of registration procedure, movement control and object security has also been initiated.

Dii2.12 The National Museum of Wales

Introduction

Report based on a discussion with Mr James Holloway (Assistant Keeper, Art), 1 March 1982. Its scope is restricted to the Art Department.

Museum framework

Management/resources
The National Museum of Wales is a Trustee museum with a number of centres:

National Museum of Wales, Cardiff
Legionary Museum, Caerleon
Museum of the Woollen Industry, Drefach Felindre
Turner House, Penarth
Welsh Folk Museum, Cardiff
Welsh Industrial and Maritime Museum, Cardiff
Yr Hen Gapel, Tre'r-ddol

The museum is organised on a departmental basis with associated services and central administration:

Archaeology
Art
Botany
Geology
Industry
Zoology

The Director is assisted by departmental Keepers, Assistant Keepers, etc.

Collections
The object collections of the Art Department are of international significance. They include approximately:

prints and drawings	17 000
paintings	2 000
sculpture	500

Documentation framework

Documentation management
Documentation is a general responsibility within the Art Department being undertaken by all curatorial staff. The procedures are outlined in a memorandum.

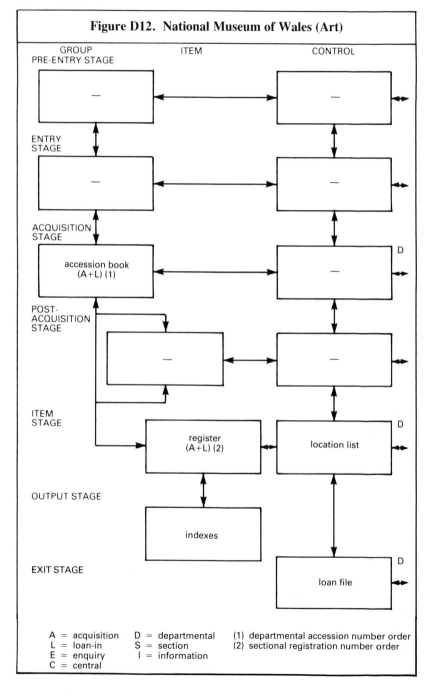

Figure D12. National Museum of Wales (Art)

A = acquisition D = departmental (1) departmental accession number order
L = loan-in S = section (2) sectional registration number order
E = enquiry I = information
C = central

Documentation system
All acquisitions and loans are detailed in an accession book and assigned a group number (Figure D12). Items in acquired groups are subsequently assigned individual registration numbers and described on item record cards with associated indexes.

Documentation and collections audit
The collection of oil paintings was checked by an Assistant Keeper in 1978, with comments noted in the catalogue. The complete paintings, prints and drawings collection has also been checked recently by temporary staff. Both exercises identified misplaced items. A Welsh Office report issued in 1981 included positive guidelines for the department which encouraged it to initiate changes to its procedures.

Object collections documentation

Acquisition stage
Acquisitions and long-term loans are noted in numerical order in a bound departmental accession book. An accession card and donor index entry are prepared at the same time. A file is opened for each acquisition.

Item stage
Each item within the collection is assigned a unique identity (registration) number. Separate sectional registers are maintained, corresponding to the ten divisions of the collection.

A location list for paintings and sculpture was prepared in 1977, including the store code and registration number of each item. It is intended to prepare a complete location file for the oil paintings, noting each on a separate sheet, to which can be added location details and changes. A copy of the location list is maintained in the paintings and sculpture store.

Output stage
In addition to the donor index, artist, medium and subject lists are maintained.

Exit stage
Loans to temporary exhibitions are detailed in a file for that exhibition and their acquisition file is annotated. Long-term loans are listed in a card index maintained by the Department's secretary.

Dii2.13 The Welsh Folk Museum, Cardiff

Introduction
Report based on a discussion with Dr William Linnard (then Head, Department of Documentation) and Mr Robert Child (Senior Conservation Officer), 2 March 1982, incorporating significant changes in departmental organisation introduced after that date.

Museum framework

Management/resources

The museum is part of the National Museum of Wales, organised in three departments:

Building and Domestic Life
Cultural Life
Farming and Crafts

Collections

Its major collections include over 100 000 acquisitions (from 500 000 to 700 000 individual items), with a growth rate of 500 acquisitions (2000 items) per annum; 100 000 photographs, with a very high growth rate; and 3000 archival items, with a low growth rate. There are also locality records of buildings in Wales and conservation records.

Reference is made to the existing collection (through curatorial knowledge and its comprehensive documentation) before acquiring a new item. The collection has been acquired largely by donation. Museum policy is not to acquire material that might be more appropriate in its local environment.

Documentation framework

Documentation management

A documentation research assistant is responsible for the central coordination and development of object documentation, assisting individual collecting departments with the accumulation and processing of information. The first concern is to continue to develop comprehensive documentation of all new acquisitions.

Documentation resources

The museum has a brief guide to its basic procedures, complemented by the MDA guidelines for item documentation and a formal description of its comprehensive internal classification system (National Museum of Wales, 1980). New curatorial staff are instructed in the use of the system by the documentation research assistant.

In addition to extensive card files, the museum has an optical coincidence system for indexing and retrieving information from tape-recorded material.

Documentation system

The first step in the documentation process for acquisitions and loans is initiated by the collecting department, by the completion of an accession form (Figure D13). Details are incorporated in an accession register, an accession number assigned, and individual item records and index entries prepared. The approach is prompt and comprehensive and, after being applied over a long period, has resulted in an almost unparalleled standard and comprehensiveness of documentation. The collections are ordered

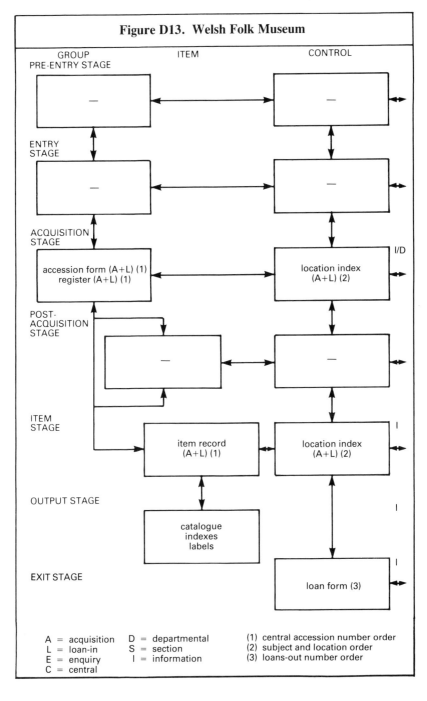

Figure D13. Welsh Folk Museum

GROUP ITEM CONTROL

PRE-ENTRY STAGE

ENTRY STAGE

ACQUISITION STAGE
- accession form (A+L) (1)
- register (A+L) (1)
- location index (A+L) (2) I/D

POST-ACQUISITION STAGE

ITEM STAGE
- item record (A+L) (1)
- location index (A+L) (2) I

OUTPUT STAGE I
- catalogue indexes labels

EXIT STAGE I
- loan form (3)

A = acquisition D = departmental (1) central accession number order
L = loan-in S = section (2) subject and location order
E = enquiry I = information (3) loans-out number order
C = central

according to an internal classification scheme, with two copies of a supporting classified or subject index acting as a location aid. Independent informal steps are taken to process those enquiries that are left in the museum, this being relatively infrequent.

Major uses include aiding the arangement of storage, internal auditing, research on the collections and the publication of catalogues.

The security of the documentation varies. The loose-leaf register is held in a safe, with the current sheet in the Documentation Office. Item records are also in this office, which is considered unsuitable for long-term storage. Supplementary accession files are, however, in parts of the air-conditioned archive. Photographs are available of important items; all objects sent on loan should also be photographed.

Documentation and collections audit
The last comprehensive stocktake was in the early 1960s. The current emphasis is on checks while formulating collection catalogues, selective stockchecks and random dip checks through use. Thought has also been given to non-departmental checks by the Curator.

The checks are part of a general programme of restoration. During this work, the documentation and conservation subject indexes are checked against each other and the collection itself.

The auditors have not yet submitted their views on the documentation.

Deacquisition and indemnification
Relevant records are annotated if a loss is discovered. The collection is covered by indemnity.

Object collections documentation

Pre-entry stage
Informal notes of potential acquisitions are retained within the department, with no central coordination.

Entry stage
Acquisitions and loans are accessioned promptly after their receipt while enquiries are dealt with informally. There are, therefore, few entry procedures.

Curatorial staff complete an accession form for acquisitions and loans, and attach a temporary label to the group (with donor and object description details). No temporary number is assigned. The group is passed to a holding area within conservation pending accessioning. An accession file is opened.

Relatively few enquiries are retained by the museum. They are dealt with informally, within the relevant department.

Acquisition stage
Similar procedures are adopted for acquisitions and loans (of which there

are very few). The departmental Keeper or Assistant Keeper assesses whether to accept the item, and checks its suitability with the Curator. Donations and loans are acknowledged by a formal letter of thanks; purchases have supporting evidence of the financial transaction. No other transfer of ownership document is completed. In the case of photograph negatives (but not art) steps are also taken to acquire the copyright of the work.

The accession form is completed by the department, an accession card and donor card are typed, an accession number assigned and details of the group entered in a loose-leaf hardback register. The register entry omits any reference to storage location. It is annotated if there are any significant changes to the information it does include. The accession number has the form 'museum prefix + year + running number'. The group is held in conservation until its component items are marked with their specific number.

Any correspondence, copy of the letter of thanks, etc., is retained in a central accession file. The register is held in a safe.

Item stage

Individual item records are prepared at the same time as the accessioning, using standard MDA cards. This work is coordinated by the documentation research assistant in consultation with the holding department. (Before 1977, the museum used similar internally designed cards.) The record prepared at this stage is considered to be the full details about the item, subject to later minor additions. It is produced promptly. There is also some upgrading of old records.

The items are retained in conservation until the record is prepared and their number marked on them. This is a straight-forward subdivision of the group accession number. The object is then stored according to the museums's internal classification system (National Museum of Wales, 1980). The single copy of the primary record is held in numerical order. Correspondence is added to the existing accession file, held in accession order in an air-conditioned store.

The record is compiled by referring to the classification scheme and following the general MDA guidelines.

The conservation staff plays an active part in the processing of the group. Any basic conservation is noted on the item record. More substantial work is detailed in a separate conservation report, a copy of which is held in the accession file. Conservation and documentation staff cooperate in checking the effectiveness of the recording procedure. It is also the conservation staff who are responsible for the stores and the primary care and maintenance of items after accessioning.

As noted above, the primary collection is in classified order. Both documentation and conservation hold indexes in this order, the latter of which is annotated to show whether an item is on display, etc. Separate lists

are also maintained for individual galleries and buildings within the museum, and for loans-out. Conservation is responsible for the movement of items, with a movement log being maintained for internal changes. The subject index in conservation is also annotated in the event of a long-term move.

Output stage
Published or unpublished catalogues are being produced for all items within certain parts of the collection (such as ploughs, cooking utensils, basket-work and dolls).

Four indexes are developed (on 5″ × 3″ index cards), entries being produced at the same time as the other documentation. The first, a donor index, is prepared from the accession record. The others are derived from the individual item records on a classification, geographical locality and storage location basis. The donor, classification and geographical sequences are maintained. The store index is held and maintained centrally as an up-to-date record of location in store or on exhibition. No other indexes are felt to be justified.

Both staff and outside visitors have access to the indexes and also to a selection of the correspondence concerning the acquisition. (Details such as valuation are held only on the accession and item cards and in the primary file). The sequences are very heavily used.

A permanent label is prepared by conservation, with basic details of the item.

Exit stage
Loans from the museum are considered by the Curator, on the advice of the Keepers. The borrower is first sent a form with appropriate insurance details, etc. A three-part loan form is then completed, the first part of which is retained by the museum, the second goes to the recipient at the beginning of the loan period and the third to the recipient after the return of the group. The museum copies are held centrally and periodically checked. A complete list of all loans is also prepared.

The register and records are annotated after any disposal.

Other documentation

Conservation records are prepared for major work, and filed in accession number order, with a copy being added to the accession file itself.

Both black and white and colour transparency record photographs are held for the collection, with a cross-reference from the photograph record to the object. Historical photographs are arranged in classified sequence mounted on card with any documentation. A separate register and geographical index are available.

Archives are processed according to standard archival practice, with a schedule being produced, and held in numerical order. They have associ-

ated donor, author, subject and geographical indexes. The oral history
sound archive is also well documented, with a brief summary of each tape
(and a full transcript of some), a speaker index and a post-coordinate
(optical coincidence) index to subjects and geographical locations.

The library is arranged according to the Dewey classification together
with some special collections.

Building records are held in the relevant department.

Museum comments

The museum feels that its procedures are effective and have resulted in
accessible sources of information. There is, however, some lack of coor-
dination between records and a certain dispersal of information. There can
be a lack of feedback from curatorial staff and delay in updating files. The
classification system would benefit from greater use of multiple entries in
addition to the cross-referencing methods already employed.

The system is relatively stable. A future emphasis will therefore be on the
development of additional printed catalogues so that there is more aware-
ness of the collection outside the museum. Similarly, the museum would
welcome more effective access to relevant collections elsewhere in Wales.

Dii2.14 The National Galleries of Scotland

Introduction

Report based on a discussion with Mr Hugh Macandrew (Keeper, National
Gallery of Scotland), 6 April 1982. It concentrates on procedures in the
National Gallery itself.

Museum framework

Management/resources
The National Galleries of Scotland is a Trustee museum, including four
separate galleries:

National Gallery of Scotland
Department of Prints and Drawings
Scottish National Gallery of Modern Art
Scottish National Portrait Gallery

The galleries are arranged on a departmental basis, corresponding to the
individual sections noted above, with central administration and education
functions.

Keepers and Research grade staff within individual sections work in
collaboration with the Directors.

Collections

The National Gallery collection includes a representative selection of European art and Scottish painting. Its size is approximately 1000 paintings and a small number of miniatures and sculpture (including 50 high quality long-term loans). Its current acquisition rate is typically five items a year, with an emphasis on highly selective acquisition to enhance the existing collection.

Documentation framework

Documentation management

Primary responsibility for the maintenance of existing procedures lies with the gallery Keepers. In addition, a Working Group, including representatives of the Trustees and senior staff, is investigating the use of computing techniques. It is particularly concerned to introduce system for the production of published checklists and catalogues and to draw together details of the individual collections.

Documentation resources

The curatorial staff of the National Gallery is a Keeper and two Assistant Keepers, each of whom is involved with documentation, responding to the pressure of enquiries, etc. The permanent staff are aided by volunteers, who – although not concerned with primary documentation – assist with organising material, such as photographs and files.

The galleries have been investigating the use of computers during the last year and are now engaged in a pilot project to process the existing records using the MDA computing bureau (National Galleries of Scotland, 1984).

Documentation system

The gallery procedures are inevitably influenced by its small high-value collection (Figure D14). There is considerable emphasis on detailed assessment of potential acquisitions before their possible acceptance into the collection. If approved, acquisitions are noted in a central accession register and on an A4 record sheet. Confidential details, including acquisition information, are included in one supplementary folder, and non-confidential art historical details in another.

The collection is fully supported by acquisition and item records, although some of the coverage for early material is very limited.

Although there is only one copy of the register and files, full details are available in the published reports and catalogues.

Documentation and collections audit

The gallery is currently undertaking a comprehensive stocktake, as the last stage of a major check and labelling operation. This is being done by the Head Warder by reference to the location lists and then checking in the store itself. It is hoped to repeat the process on a regular basis in the future.

The gallery documentation has not been reviewed by E & AD. However,

the Scottish Education Department has drawn the gallery's attention to recent PAC reports, the comments within which have been noted.

Object collections documentation

Pre-entry stage

The gallery opens a file concerning any item that is of interest as a potential acquisition, whether considered at a sale or noted by a Trustee or member of staff. These files are maintained on a long-term basis in case a rejected or unobtainable item should be reconsidered at a later date. Any potential acquisition that has been considered by an internal gallery committee is referred to the Trustees, before which detailed technical and curatorial examinations will be undertaken in the gallery.

Entry stage

Items brought to the gallery for identification, etc., are dealt with promptly and not retained in the museum (in which case no documentation is completed). If the material is retained, the depositer signs a covering note, but is not given a receipt. These items are logged in a movements book which is checked and countersigned each week by an Assistant Keeper, as an authority for the movements. After the object's return, the note is held by the museum in depositor order.

Acquisition stage

After approval by the Trustees, an acquisition is detailed in the gallery accession register and noted on a record sheet. The register is held in the library. Details of the acquisition and confidential correspondence are included in a confidential file about the item.

The infrequent long-term loans-in are detailed in loan files, and specific indemnity cover arranged. They are not noted in a register or numbered.

Item stage

The initial item record is prepared at the same time as the acquisition entry. It is included within a folder, with non-confidential correspondence and other information, held in artist order, for public use. The item is numbered, using a straightforward running number sequence. Approximately half the collection is on display, including all items of high quality. The remaining material is readily accessible in the reserve collections.

A strip index is maintained in the gallery attendant's office, with details of item number, artist, title and location. Moves are noted in the strip index. If the item is passed to another part of the Galleries it is also logged in the movements book.

Output stage

A detailed entry about each new acquisition and loan is included in the annual report. The gallery has a concise catalogue in which is noted a brief description of each object on display and a checklist of the rest of the

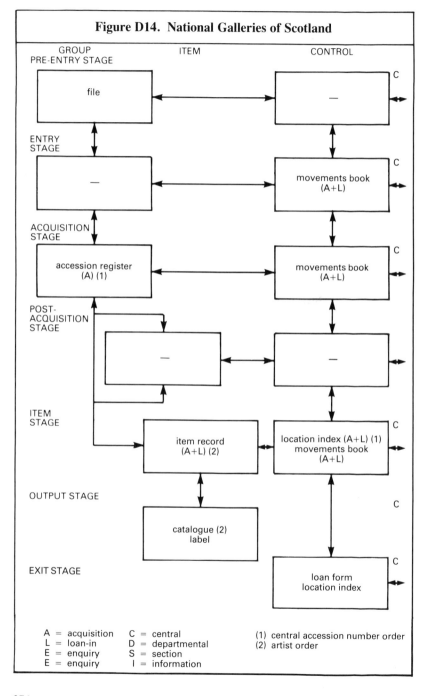

Figure D14. National Galleries of Scotland

GROUP PRE-ENTRY STAGE — ITEM — CONTROL

file — — C

ENTRY STAGE: — | movements book (A+L) C

ACQUISITION STAGE: accession register (A) (1) | movements book (A+L) C

POST-ACQUISITION STAGE: — | — C

ITEM STAGE: item record (A+L) (2) | location index (A+L) (1) movements book (A+L) C

OUTPUT STAGE: catalogue (2) label C

EXIT STAGE: loan form location index C

A = acquisition C = central (1) central accession number order
L = loan-in D = departmental (2) artist order
E = enquiry S = section
E = enquiry I = information

collection. There are also full entry catalogues for specific parts of the collection.

The primary means of access to the collection are by number – via the register – and artist – via the files and catalogues. Other permutations of information are being considered. The gallery is most interested in donor and subject indexes, and cumulative lists prepared in association with the other collections.

An adhesive label is stuck on the back of the stretcher, with details of artist, title and accession number.

Exit stage

The gallery distinguishes short-term and long-term loans-out, both of which are referred to the Trustees for consideration, and are detailed on a series of forms. Short-term loans are logged out of the gallery to the central administration for processing and packing. A loans officer coordinates their management. Long-term loans (of which there are about 50, to government departments, etc.) are restricted to objects that are in good condition and not in public demand. The gallery keeps close control over the items, reassessing their condition every eighteen months.

Museum comments

The gallery is conscious of the need for additional information about its older acquisitions and is concerned to provide more access to its collections through new publications.

Dii2.15 The National Museum of Antiquities of Scotland

Introduction

Report based on a discussion with Dr David Clarke (Deputy Keeper), 7 April 1982.

Museum framework

Management/resources

The National Museum of Antiquities of Scotland is a Trustee museum, organised on a departmental basis, with four collecting departments and a supporting conservation laboratory:

Prehistoric/Viking (to 1100)
Medieval (1100–1607)
Modern (from 1607)
Country Life

The Director is supported by Keeper and Research grade staff.

Collections

The collections accumulated during the last 200 years include 500 000 items in Prehistoric/Viking, 500 000 in Medieval and Modern, and 60 000 in Country Life. Thre is a significant influx of new acquisitions, due to excavation work (with about 50% of excavated material from Scottish sites being accepted into the collections). The museum's primary concern is with objects made and used in Scotland.

Documentation framework

Documentation management

Curatorial staff in each department are responsible for documentation, with no overall formal coordination, although the resulting records are unified. The first concern is the initial documentation of material at the earliest possible stage, followed by accessioning and then the accumulation of specific item details. The museum is conscious of a future emphasis on indexing techniques.

Documentation resources

The seven staff in the archaeology and social history departments each devote from 40–50% of their time to documentation. Country Life's two staff are also concerned with documentation, but to a smaller proportion of their time. The museum has also been assisted by some temporary staff. There are no formal procedural manuals. Training is in-service.

The museum uses a small microcomputer as a data entry mechanism at excavations, passing the accumulated information to the University of Edinburgh, for mapping and documentation purposes. The Research Laboratory also uses a minicomputer, for analytical purposes.

The investigator estimates the recurrent staff cost at £40 000 per annum.

Documentation system

All material deposited in the museum is logged on an entry form (Figure D15). Confirmed acquisitions are subsequently simultaneously accessioned and detailed in individual item records. The acquisition information is included in a loose-leaf accession register (the Scroll Catalogue). The item information is part of a sectional Continuation Catalogue, which complements the entries in the original 1892 published catalogue. A separate location list is held in numerical order.

An estimated 90% of the collection is included in the accession register.

Although multiple copies of the accession register are prepared, they are held together. The copies of the catalogue are, however, dispersed. Approximately 10% of the collection has been photographed.

Documentation and collection audit

There is no internal stocktaking. E & AD do undertake occasional random checks, during which they ask for the production of a small sample of items.

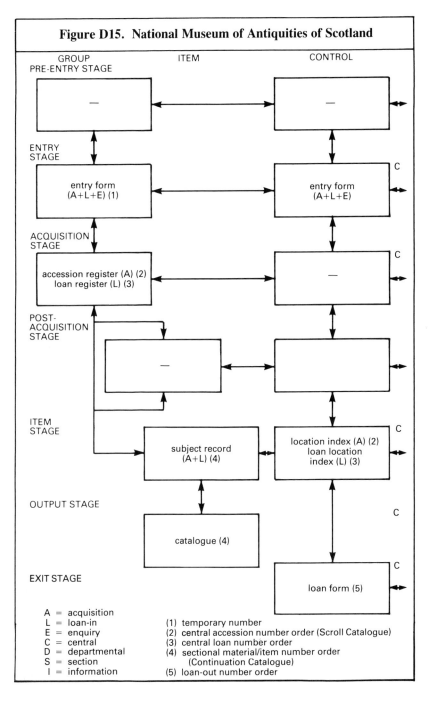

Figure D15. National Museum of Antiquities of Scotland

GROUP — ITEM — CONTROL

PRE-ENTRY STAGE

— —

ENTRY STAGE

entry form (A+L+E) (1) — entry form (A+L+E) — C

ACQUISITION STAGE

accession register (A) (2)
loan register (L) (3) — — — C

POST-ACQUISITION STAGE

—

ITEM STAGE

subject record (A+L) (4) — location index (A) (2)
loan location index (L) (3) — C

OUTPUT STAGE

catalogue (4) — C

EXIT STAGE

loan form (5) — C

A = acquisition
L = loan-in
E = enquiry
C = central
D = departmental
S = section
I = information

(1) temporary number
(2) central accession number order (Scroll Catalogue)
(3) central loan number order
(4) sectional material/item number order
 (Continuation Catalogue)
(5) loan-out number order

Deacquisition and indemnification
The collection is indemnified. There is no separate list of high value items.

Object collections documentation

Pre-entry stage
Individual curators keep informal details of any potential acquisitions.

Entry stage
The museum deals with a large number of enquiries for identification, etc., most of which are processed immediately and not documented. All material deposited in the museum (other than that brought in by staff) is logged on an entry form, completed by either an attendant or curator. The form is numbered by the attendant, and the bottom part given to the depositor as a receipt. The remaining part is then kept with the object and both passed to the relevant member of the curatorial staff. They are then held in a separate storage area, prior to processing.

In the case of an enquiry, a letter is sent to the depositor, who is asked to collect the item. Any items not claimed are eventually disposed of, after further correspondence with the depositor.

Acquisition stage
Any acquisitions are referred to the Director, if necessary. The Trustees will also be consulted in the case of significant purchases. A letter of thanks is sent in response to a donation, but no other formal transfer documentation is completed.

In the past, the processing of acquisitions was done on an annual basis. This has now been revised to a policy of dealing with material as soon as possible after acceptance: the resulting delay varies from one month to fifteen years. The numbered entry form stays with the group during this period. When the material is processed, both its accession and item records are prepared.

The accession register (Scroll Catalogue) is loose-leaf sheets in a spring-back binder, arranged on a 'year + running number' basis for the whole museum. It refers to the separate item number which is assigned at the same time. Entries are prepared in two copies, by the relevant curator. Neither copy includes a reference to the location of the group. Both are held in a cupboard in the museum office.

Approximately 5% of new material in the collection is in the form of long-term loans. These are supported by the exchange of a letter detailing the item concerned. The Scottish Education Department should be advised of relevant indemnity requirements for the item. The loans are processed promptly after receipt, being noted in a loans register analogous to that for acquisitions. This includes a brief description of the item and a loan number, which is itself physically marked on the object. A 5″ × 3″ index card is prepared, on which the loan's storage location is noted.

Item stage
As noted above, individual item records are prepared at the same time as the acquisition entry. These are included within sectional catalogue sequences, forming part of a Continuation Catalogue. (This continues the main museum catalogue, published in 1892, which is still the primary source of information about the early collections.) It has a loose-leaf form, similar to the Scroll Catalogue. Three copies are prepared, for central, department and conservation laboratory use. It is on a material basis, with some site groupings. Each item is assigned an identity number, within a material sequence. The collection itself is also arranged on a material basis.

The entries include a note of the year of processing and a reference back to the earlier acquisition entry. They might also cross-refer to other material from the same acquisition. Store location is not included. The record prepared at this stage is presumed to include the full details about the item. If additional information is found it is added to the departmental copy.

A location index is derived from the item records, maintained by the Museum Assistants. It is produced by underlining key elements in the item record, typing this information onto an index card, and adding the store location. The cards are held in item number order. A tag is left in the store during any temporary movements. The location index is amended in the event of a permanent change.

Output stage
The museum considers its 1892 catalogue and subsequent additions as the primary document about the collection. The original catalogue was produced as a result of the move to a new building. Apart from the prototype donor index, no other lists are maintained. Labels are not prepared.

Exit stage
Loans-out of the collection are considered by the Trustees and processed centrally, by the Administration Officer. A three-part form is completed in advance of the loan.

Museum comments

The museum is conscious of the inefficiencies of the system and aware of its heavy dependency upon staff memory. There is a need for improved indexing facilities, and more formal systems and procedures. The possibility of computerising aspects of the work is being considered.

The museum proposed to the Williams Committee that a national inventory of moveable objects (archaeology, social history, etc.) should be established. This would include references to material in the museum itself, and other relevant collections. All new material might be processed and registered by the museum, then either retained in the national collection or passed to a more appropriate local museum for storage and display.

Dii3 Local Authority Museums

Dii3.1 Bath Museums Service

Introduction

Report based on a discussion with Mr Simon Hunt (Curator), 3 March 1982. Brief details of subsequent progress are given at the end of the report.

Museum framework

Management/resources

The Museum is a local authority (District Council) service, arranged on a departmental basis, in four buildings:

> Costume and Fashion Research Centre
> Museum of Costume
> Roman Baths Museum
> Victoria Art Gallery.

Documentation is seen as an essential tool to achieve the primary aims of education and interpretation, preservation and acquisition of new material and the provision of information.

The Curator is supported by four Keepers and one Assistant Keeper.

Collections

The collections are predominantly object based, apart from the significant fashion archive: 7000 costume items, excluding accessories; 5000 prints, drawings, paintings, etc.; 22 000 coins; at least 10 000 archaeological items; and 2000 archival items. The collection has a very low growth rate, with the exception of the archaeology section.

The Service has an informal acquisition policy agreed by staff and coordinated by the Curator. There is active cooperation with other institutions in Avon concerning the placement of archaeological material.

Documentation framework

Documentation management

The Keeper of each museum has individual responsibility to develop documentation procedures under the general guidance of the Curator. Each museum acts independently in these developments. The emphasis at the Roman Baths Museum and Victoria Art Gallery is on basic acquisition documentation and at Museum of Costume on more extensive item documentation, reflecting the state of resources.

Documentation resources

All five curatorial staff are involved in documentation, to 50% of time in two cases due to a backlog but a negligible proportion in the others. These

documentation duties are referred to in staff job descriptions. The museum has been assisted by some volunteer staff and currently has an MSC Community Enterprise Programme project with two cataloguing assistants.

The overall system has a brief introductory memorandum but no detailed guidelines. Training is informal while in-service.

No use has been made of computers for documentation purposes. The only significant cost is that of staff, estimated by the investigator at around £5000 per annum.

Documentation system
As implied above, each museum has adopted an independent approach around a general framework (Figure D16). Initital documentation consists of an enquiry form for all material coming into the museums. Acquired groups are documented on an accession form, copies of which are held centrally and in the local museum. Individual item records are then prepared locally. Indexes and control procedures are both very limited.

Formal documentation is available for all items in the Museum of Costume and most at the Fashion Research Centre. In contrast, the Roman Baths Museum and Victoria Art Gallery have a 5–10 year acquisitions backlog to accession, due to the inadequate resources prior to the formation of the Service in 1978.

The extensive use of the Museum of Costume records for display and research was noted.

The security of documentation is poor, with records not being kept in a safe and few backup procedures. A microfilm copy of the old art gallery record is available.

Documentation and collections audit
There is no formal museum stocktaking programme, although extensive use of the costume collection acts as one check. The auditors have made no significant checks of the collection itself. In the past, District Audit has expressed criticism of the state of documentation. However, it has accepted the present approach and recognised the problem of the backlog.

Deacquisition and insurance
The relevant documentation would be annotated if a loss were identified. The permanent collection is insured.

Object collections documentation

Pre-entry stage
An informal note may be made of potential acquisitions.

Entry stage
An unnumbered two-part entry form (enquiry form) is used to log material coming into the museum, one part being kept with the group and the other being passed to the depositor as a receipt. The work is undertaken by the assistant staff, with no distinction of procedure for different types of entry,

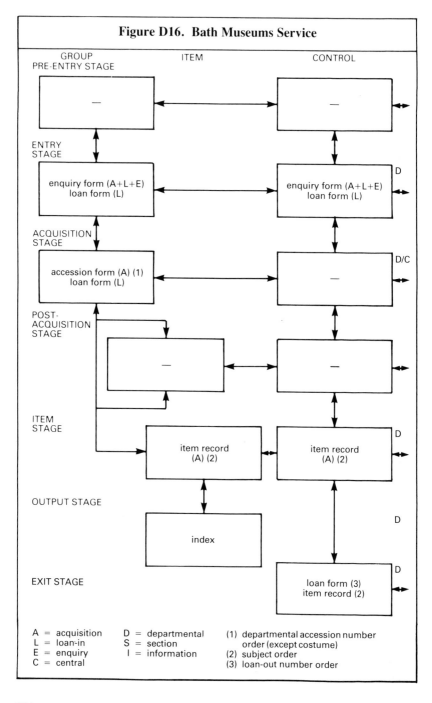

Figure D16. Bath Museums Service

GROUP
PRE-ENTRY STAGE — ITEM — CONTROL

ENTRY STAGE

enquiry form (A+L+E) loan form (L) — enquiry form (A+L+E) loan form (L) — D

ACQUISITION STAGE

accession form (A) (1) loan form (L) — — D/C

POST-ACQUISITION STAGE

—

ITEM STAGE

item record (A) (2) — item record (A) (2) — D

OUTPUT STAGE

index — D

EXIT STAGE

loan form (3) item record (2) — D

A = acquisition D = departmental (1) departmental accession number
L = loan-in S = section order (except costume)
E = enquiry I = information (2) subject order
C = central (3) loan-out number order

384

except in those cases where a Keeper intervenes. The group is then kept at the desk until it can be attended to by a Keeper. In the case of an enquiry, the response is written on one copy of the form to be given to the depositor, and a duplicate then prepared for the museum files.

Only acquired groups are covered by the museum insurance policy.

Details of any correspndence, etc., are initially kept in a general enquiries file held in each museum.

Acquisition stage
The service acquires less that 100 groups in a year, excluding archaeological material. The decision to acquire an item and its subsequent processing is undertaken by the relevant Keeper. Care is taken, particularly with archaeological material, to ensure that the depositor has legal entitlement to give the item to the museum. A letter of acknowledgement is sent by the Keeper to confirm the acquisition. All acquisitions are covered by the insurance policy.

None of the museums use a bound register. However, a standard numbered accession form is used by the Keepers of the four departments to note basic details of the group. One copy is retained by the museum and another passed to the Curator for central filing. These copies are kept in separate unbound sequences for each museum. (The procedures are currently under review.)

Neither the departmental nor central copy is subsequently amended if new information comes to light. There is no formal procedure for attaching a number to the group or for keeping track of the group, due to the low volume of acquisitions being dealt with at any one time.

A similar procedure is adopted for the handful of loans-in received each year (about 5 per annum). An unnumbered loan form is completed and copies held both centrally and in the museum.

Item stage
Some time after the acquisition the Keepers prepare individual item records for each object in the group. The Victoria Art Gallery and Roman Baths Museum now use MDA cards for this work while the Museum of Costume uses a locally-designed but comparable card. In the former cases, the storage location is noted on the card. In the latter case, a note is made indicating whether the object is on display or in store, and the subject classification then acts as a guide to the exact location.

The Victoria Art Gallery and Roman Baths Museum use a standard procedure when numbering objects, adopting a subdivision of the accession number. The Museum of Costume does not number the costume collection, due to the nature of the material and the use of a detailed storage/classification system. In all circumstances, the cards are arranged in the same order as the collection itself and effectively act as a catalogue of the collection. Only one copy of the record is prepared, for use in the museum concerned.

There is no separate location control documentation. Movement of objects is the responsibility of the relevant Keeper.

Output stage

As noted above, the item records act as informal catalogues. With the exception of the archaeological collections, there are no published catalogues of the collections as yet, although selected lists are available of certain parts. The Museum of Costume has a donor index of the collection. No labels are prepared.

Exit stage

A loans-out form is used to control the loans procedure, being completed by the Keeper concerned. The condition of the object is noted before its departure. A note about the loan is added to the item record and the storage location amended in the case of long-term loans.

Any disposals are approved by the museum committee, after which the records are annotated.

Other documentation

Other documentation includes the important fashion archive and a local sites and monuments records.

Museum comments

The Service is conscious of the problems introduced by trying to document a number of very diverse collections, one of which has been well recorded and another very badly recorded. Where deficiencies exist, steps are being taken to rectify them. The service is gradually revising its internal procedures.

Update

The acquisitions backlog of the Roman Baths Museum and the Victoria Art Gallery has now been reduced to one or two years. A programme to microfilm primary records has been introduced and a regular programme of checking has been instigated by Internal Audit.

Dii3.2 Brighton: Royal Pavilion, Art Gallery and Museum

Introduction

Report based on a discussion with Mr John Cooper (Museum Documentation Supervisor and Keeper, Geology), with written comments from Mr J. Morley (Director) and Mr R. Budd (Principal Assistant), 22 June 1982.

A brief reference to recent developments is given at the end of the report.

Museum framework

Management/resources
The museum is a local authority (Borough Council) service, including:

> Royal Pavilion
> Central Museum and Art Gallery
> Booth Museum of Natural History
> Preston Manor
> Rottingdean Grange.

The museums are arranged on a dual departmental and subject basis. The various buildings (departments) are under the control of local Keepers but the collections are arranged by subject and it is the subject curators who are responsible for them, irrespective of the building in which they are housed.

The Director is assisted by an administrative staff, museum Principal Keepers and subject Keepers.

Collections
Its collections include material in the Pavilion itself and:

archaeology	20 000
fine art	20 000
applied art	10 000
geology	30 000
natural history	over 1 000 000
ethnography	10 000

The museum has a formal acquisition policy, based on curatorial knowledge of the collections supplemented by the use of the documentation. There are informal cooperative arrangements with other museums.

Documentation framework

Documentation management
The Museum Documentation Supervisor is responsible for coordinating documentation, in consultation with other curatorial staff and the Director. The primary concern is with the computerised aspects of documentation procedures, accounting for 20% of the person's time. Item documentation and catalogue production is the first priority.

Documentation resources
The nine curatorial staff are all involved in documentation. The time to be spent on these duties was agreed to be 20% during the 1970s, but is now at individual discretion. These duties are referred to in job descriptions. Temporary staff occasionally help with documentation, at the discretion of individual Keepers.

There is a basic overall procedural manual. Detailed manuals and data standards for item documentation are now being developed. Inhouse

documentation meetings and training programmes are also being introduced.

The museum uses a computer package developed on its behalf during the mid-1970s by the local council computer department, using a mainframe computer (Kirk, 1979; Orna and Pettitt, 1980). All data entry and batch processing is carried out by the computer staff, following instructions from the museum coordinator through whom work is routed. Following the purchase of a new computer, consideration is being given to how best to rewrite the package for use on the new systems. The package is used to produce printed checking documents, catalogues and indexes based on the museum's item records. Selective retrieval is also possible.

Documentation system
Acquisitions and loans are processed within the computer-based system, placing emphasis on item documentation (with no entry or acquisition documentation) (Figure D17). The item records are used to produce printed and fiche catalogues and indexes on a sectional basis for local use. Enquiries are managed outside the computer system, being logged on an enquiry form if left in the museum.

There are no formal entry or accessioning procedures for acquisitions. The degree of item documentation is variable, but its continued development is considered important. Individual curators assess the most important collections to document.

The security of the documentation is the responsibility of individual sections. Appropriate back-up computer files are maintained.

Documentation and collections audit
There is no internal stocktaking programme. Internal Audit undertakes occasional spot checks.

Deacquisition and insurance
Any major losses are reported to the Director and the record annotated. The overall collection is covered for fire risk and certain itemised valuable objects are covered for all risks.

Object collections documentation

Pre-entry stage
Major potential acquisitions are referred to the Director and correspondence added to a general subject file held in the departments.

Entry stage
There are no formal entry procedures for acquisitions and loans, both of which pass to the relevant curators. Enquiries are either dealt with immediately or logged on an enquiry form at the museum desk. A one-part form with no number is used. They are then passed to the relevant curator. Subsequent procedures are informal.

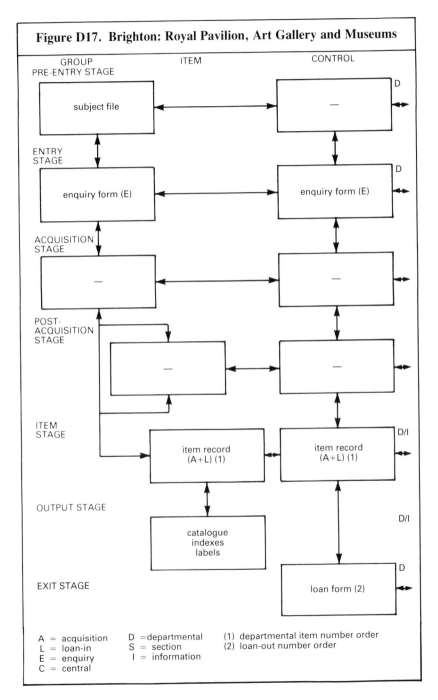

Figure D17. Brighton: Royal Pavilion, Art Gallery and Museums

Acquisition stage

The curators are responsible for assessing acquisitions and loans (with reference to the Director, where necessary) and their subsequent processing, including ensuring that their acceptance will cause no problems. No formal transfer or loan documentation is prepared, although a letter may be sent to acknowledge a donation and confirm the museum's title to the material.

The collections are covered by appropriate fire insurance, with notification of their receipt being managed by the administration.

The museum does not have a group accessioning or numbering procedure. Instead, individual item recording and numbering steps are implemented. Prior to this, there is no documentation control.

Item stage

Individual curators prepare item records for computer input and processing. The work is based on a list of data categories which can be used as necessary to produce a record. The documentation coordinator is now producing procedural manuals and guidelines defining the use of these categories and noting which are appropriate (or manditory) for a given discipline. During the recording procedure, the curators do not use pre-formatted record cards but record appropriate information on plain computer input coding sheets. The storage location should be included in this information. The records are assigned a computer record number which is used as the item's identity number and for ordering the primary files.

Completed records are passed to the documentation supervisor for data entry and processing by the computer centre. The resulting file is considered to be the departmental catalogue.

A considerable amount of recataloguing has been carried out in recent years, with the resulting records being input into the computer system. The current rate is around 20 000 items a year, 80% of which is within natural history.

No separate location lists are available, although they could be produced from the computer files. The record is amended in the event of a long-term movement.

Output stage

Computer-produced printout and microfiche is used as a catalogue of each collection. Copies are held centrally, by the documentation supervisor and by the department itself. Both the master files and the resulting outputs are retained in separate sectional sequences, with no merging to produce unified documents.

A range of computer-produced printed and microfiche indexes are also prepared, and updated annually. These are also produced on a sectional basis with no combination of files. The sections are able to request indexes to satisfy their internal requirements, typically asking for about six to be produced on a regular basis. It is also possible to produce selective retrieval

listings from the computer files. Labels are prepared according to curatorial practice.

Exit stage

In the case of loans from Natural History, a four-part loan form is completed by the responsible curator, one copy of which is retained in a register.

There is no formal disposal procedure, but the relevant computer record would be annotated and retained.

Museum comments

The overall procedures are recognised to have certain deficiencies. Its computing aspects are potentially flexible and effective, although there is a need for the further development of standards.

Update

Further details of procedures are given in a recent paper (Steel, 1985). In the case of the Booth Museum, the main computer-based cataloguing system has been complemented by an inhouse microcomputer used for label production and the maintenance of a basic inventory (Legg, 1984).

Dii3.3 Bristol: City of Bristol Museums and Art Gallery

Introduction

Report based on a discussion with Mr Charles Copp (Assistant Curator, Natural History), 3 March 1982.

Information about recent progress is included at the end of the report.

Museum framework

Management/resources

The museum is a local authority (City and District Council) service, with a number of sites:

City Museum and Art Gallery
Blaise Castle House Museum
Bristol Industrial Museum
The Georgian House
The Red Lodge
St. Nicholas Church Museum
Kings Westan Roman Villa
Sea Mills Roman Site
Bristol Maritime Heritage Centre.

The museum is arranged on a departmental basis, under the overall management of a Director and two Executive Directors for the Art Gallery and the Museum. There are full supporting services including conservation and education. Art gallery and museum departments are:

Fine Art
Applied Art
Oriental Art
Technology
Agricultural and Social History
Geology
Natural History
Archaeology and History.

The first priority is to improve the standard of documenataion, due to concern with the magniture of inadequately documented material in the museum.

Each department includes a Curator and (in most cases) one Assistant Curator.

Collections

The important collections total over two and a half million objects. Approximate figures are:

Fine Art	11 000	(including major watercolour, drawings and prints collections)
Applied Art	15 000	
Oriental Art	6 000	
Technology	40 000	(including a large photograph collection)
Agricultural and Social History	20 000	
Geology	500 000	
Natural History	550 000	(predominantly zoology)
Archaeology and History	1 500 000	(of which 80% is British Archaeology)

Significant growth is continuing in the archaeology and social history collections. The other areas have a low growth rate.

In addition to the object collections, there is a central museum archive and photograph collection. Geology, Natural History and Archaeology each hold extensive locality records. The various departments are supported by library collections with a central catalogue. Geology and Natural History have important biographic records of collectors while Social History keeps details of significant local events. Finally, the conservation staff maintain parallel conservation records of work undertaken.

The museum is currently reformulating its acquisition policy. Items are sometimes acquired with associated conditions.

Documentation framework

Documentation management
The Management Team (Director and two Executive Directors) are responsible for the overall coordination and development of documentation procedures, with technical advice from one member of the curatorial staff. Departmental curators are concerned with the local implementation of the system. A Computer User Group has been established to consider the application of microcomputers in the museum. The most important aspect of documentation is felt to be that of accessioning and control.

Documentation resources
The staff of each department spend a significant proportion of their time concerned with documentation: an overall average of 50% of the time of the 30 staff. These documentation duties are referred to in staff job descriptions. In addition, the museum has had assistance from MSC projects (with 8 temporary staff currently engaged on documentation work). Although some departments have developed internal instructions there is no overall guide to the system. Staff training is on an informal in-service basis.

The museum is now involved in using computers in four distinct ways: an inhouse Sirius 1 microcomputer for local data entry, management and data interchange; the nearby University mainframe computer for experimental analysis; the MDA computing bureau for processing item records; and the University of Manchester for collection research projects in the natural sciences.

Capital investment (primarily in computer equipment) has risen from £750 in 1980–81 to £2500 in 1981–82, paralleled by a recurrent annual investment of £1000 in consumables and external computing. These investments have been supported by the local AMC. The major cost is that of staff resources, estimated at around £100 000 per annum, due to the high priority currently being given to retrospective documentation.

Documentation system
Material entering the museum should be logged in a day book and then either processed as an acquisition/long-term loan or an enquiry (Figure D18). Acquired groups are noted on an accession form at a departmental level and then entered in a central accession register. At a later date, their constituent items are individually documented, using department item registers and (optionally) MDA-style record cards. Independent numbering sequences are used for the acquired groups and individual items. Although there is little control documentation, the museum is undertaking a major stocktaking programme.

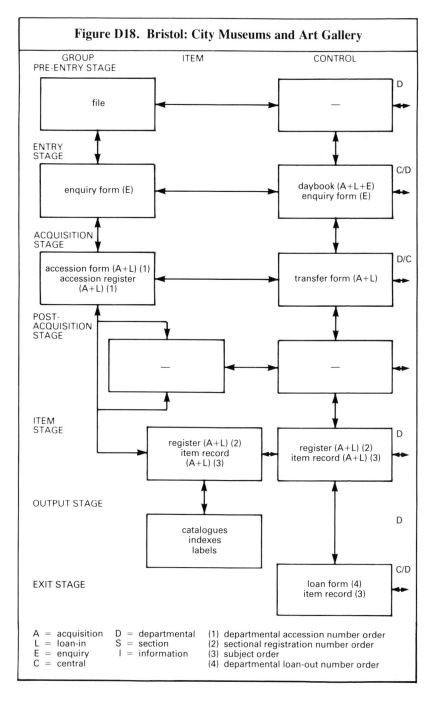

Figure D18. Bristol: City Museums and Art Gallery

GROUP ITEM CONTROL

PRE-ENTRY STAGE

file — D

ENTRY STAGE

enquiry form (E) daybook (A+L+E) enquiry form (E) C/D

ACQUISITION STAGE

accession form (A+L) (1) accession register (A+L) (1) transfer form (A+L) D/C

POST-ACQUISITION STAGE

— —

ITEM STAGE

register (A+L) (2) item record (A+L) (3) register (A+L) (2) item record (A+L) (3) D

OUTPUT STAGE

catalogues indexes labels D

EXIT STAGE

loan form (4) item record (3) C/D

A = acquisition D = departmental (1) departmental accession number order
L = loan-in S = section (2) sectional registration number order
E = enquiry I = information (3) subject order
C = central (4) departmental loan-out number order

All groups acquired since 1895 have been accessioned. A proportion of items in Natural Sciences do not have item documentation since individual collections tend to contain many thousands of objects.

Care has been taken to protect the existing documentation. Registers are kept in locked cabinets or a safe with a duplicate copy held in the record office. There are also back up files to computerised records. Extensive parts of the archaeology, ethnography and art collections have been photographed.

Documentation and collections audit
Following pressure in the mid-1970s, both staff and auditors are now involved in active stocktaking programmes.

Departmental staff (except in Natural History and Geology where the nature of the collections has precluded such activity) have been engaged in a comprehensive stocktaking programme for the last five years. This has involved taking the accession register or item register to the store and physically checking the presence of each object, on a store by store basis. In addition, a list of high-value items has been drawn up which is to be checked on a five-year cycle in the future.

The Directors also undertake independent spot checks in each department every six months. This involves a random dip check of up to 10 items. Internal Audit undertakes similar checks on an annual basis and District Audit has also examined the procedures.

Deacquisition and insurance
The Director annotates the records if a loss is identified. The collection is covered by standard local authority insurance.

Object collections documentation

Pre-entry stage
In the case of minor acquisitions, the curator concerned keeps an informal note of the group. For more significant items, senior staff are consulted and a file opened.

Entry stage
Distinct procedures are adopted for acquisitions and loans-in (noted in movement or day books at each entrance to the museum) and enquiries. The work is coordinated by the duty officer or receptionist.

Acquisitions and loans are passed to the relevant curator, working on a departmental basis. The groups are not numbered, other than by the line number in the day book. Photographs are taken of important objects. The museum insurance covers these groups, with details of their receipt being reported to the central administrative assistant. A file is opened for the group and initially kept in the department.

If a curator is available, informal enquiries are dealt with immediately, in which case they are not documented. If the enquiry is deposited at the information desk, a note is added to the day book and an enquiry form completed in duplicate, with the bottom copy being taken by the depositor as a receipt. The response to the enquiry is noted on the museum copy, which is retrieved together with the object by the depositor. The museum keeps no record of the enquiry other than a general monthly report on progress.

Acquisition stage
Responsibility for processing an acquisition or long-term loan resides with an individual curator, with reference to a director for the final decision concerning its acceptability. No distinction is made between the two types of material.

When the group is accepted, the curator completes a formal transfer document which is countersigned by the depositor and then retained by the museum. A letter of acknowledgement is also sent to the depositor. All such acquisitions are covered by the museum insurance.

The curator then prepares a basic accession form, which is passed to the administrative officer for the central allocation of an accession number. Information from the form is copied into a bound accession register and onto two record cards which are arranged in object name and donor order. The basic details in the register do not include location (although they do specify the department within which the group is held) and are not subject to later amendment, except for significant reasons. The accession form itself is then returned to the curator where it can be filed in accession number order. Complex groups tend to be accessioned as a whole, then subsequently dispersed to relevant departments.

Correspondence, etc., is kept in a historical file, initially maintained by the department but subsequently passed to the museum archive. At this point it is assigned an independent historical file number.

Short-term loans are treated more informally, with different departments adopting distinct practice. In most sections, the depositor is asked to complete a loan form. In the art gallery a separate loans register is maintained.

Item stage
Sometime after the acquisition (occasionally up to 50 years later) each item in the group is documented in a departmental item register. Each department has its own set of bound item registers for this purpose, quite independent of the central accession registers (see Figure 14).

The item register entry can vary from one line to a full record, usually including the storage location. The entry may be updated as new information is accumulated, and will be annotated and signed by the director if the item is disposed of by the museum. There are no written procedures for completing the entries and little control over the style of recording.

At this stage, each item is also assigned a unique item number (registration number) on a 'letter + running number' basis, independent of the earlier accession number. Although the item number is often specific to a single object, it can refer to a group of objects (such as a set of specimens with common data). The accession and item numbers are used to control the order of the respective registers. There is no straightforward link between an accession register entry (which does not include the later item numbers) and an item entry. Similarly there is no direct link between one item entry and the others of the same acquisition. The item number should, in theory, be noted on the earlier departmental accession form which can then act as a key document to bridge these gaps.

Major parts of the collection have been re-registered or newly registered in recent years. This process is continuing.

A duplicate copy of the existing registers is held (as a photocopy or on microfilm) in the separate city record office.

In addition to the item registers, some departments also use A4 MDA-style record sheets for more detailed primary documentation. Given the availability of the numerical register, these sheets tend to be held in a classified sequence. The form and content of the information on these new sheets is controlled. In some cases, the information is being computerised by the MDA.

A separate departmental file may be opened for an object, should this be necessary. These are then ordered by subject.

No location documentation is available in the museum. A separate list is maintained for the art collection. With the exception of the art collection and entomological specimens, no record is kept of movements within a department.

Output stage
The new record cards may be used as a catalogue to the collection. For those that have been computerised, the compuer file and corresponding printouts are treated as the primary documents.

Although considered to be of dubious value, two indexes are held centrally, being generated as part of the accessioning procedure (object name and donor index). A subject index to the historical files is also available, as is a list of library holdings. At a departmental level, indexes are prepared as resources allow. Relatively few are comprehensive, although the Art Section's indexes are approaching this in terms of the percentage of the collection covered by some type of index card.

Labels are prepared by a number of departments. In the case of Natural History they include the store code for the specimen. A number of information sheets and catalogues are available. Selective retrieval requests can be used on those computer files that exist.

Exit stage
Loans-out of the museum are coordinated at a departmental level, with a

monthly report being submitted to the director. A new system has been introduced, based on the departmental use of three-part loan forms. One set is completed for each loan, noting details of the item number, value, condition, etc. The top copy is held in numerical order by the administrative office (although under the control of the department), the second copy passed to the recipient and the third copy retained by the department until the return of the object. In the case of important objects, details of the loan are also noted on the master item record.

The department is responsible for assessing the security and transport arrangements and for ensuring the timely return of the loan. The condition of long-term loans is physically checked by the curator each year.

Disposal of items is administered by the Director who then annotates the relevant records.

Other documentation

Other types of documentation include locality, archive and bibliographic records, for which new record sheets have been devised. The Conservation Department is using MDA conservation cards.

Museum comments

While there have been significant improvements in the last five years, the system is still unable to ensure effective collections management to the extent required by the museum. The museum continues to be concerned to make its collections more accessible. The staff are very conscious of the complex problems encountered when attempting to revise the documentation system in a large and established museum. The museum is particularly interested in developing a network of microcomputers linked to a large computer.

Update

Further details of the museum and its documentation system are given in a recent paper (Copp, 1985).

A member of the curatorial staff has now been designated Information Technology Officer, in addition to existing duties. The computer equipment within the museum has been extended to include three Sirius 1 and one IBM PC microcomputers.

The museum has a team of approximately 80 temporary MSC-funded staff, of whom around 12 are concerned with object and archive documentation and over 10 with site documentation.

The capital investment in systems has been maintained at around £2500 per year, assisted at present by a further £3500 from the MSC projects.

Dii3.4 Derbyshire Museum Service

Introduction

Report based on a discussion with Mr Michael Stanley (Deputy County

Museum Officer) at the then Service headquarters, Matlock, 29 March 1982, incorporating major organisational changes introducted after that date.

The Service has also developed its use of computers and made major changes to its practical procedures, full information about which is given at the end of the report.

Museum framework

Management/resources
The museum is a local authority (County Council) service, forming part of the Education Department. It includes:

Buxton Museum and Art Gallery
Elvaston Castle Working Estate Museum
Sudbury Hall Museum of Childhood
Derbyshire Museum and Arts Centre (John Turner House).

The service is organised on a dual museum and subject basis, with three collections and a central administration and specimen holding centre. Buxton Museum is responsible for all aspects of the Peak District and the main collections of archaeology, fine art and geology; Elvaston Castle for agricultural and social history; Sudbury Hall for its childhood collection; and John Turner House for other aspects of Derbyshire's heritage.

The museum considers the development and documentation of its collections to be its first priority.

The County Museums Officer is supported by a Deputy, Museum Education Advisor, three Curators and four Assistant Curators.

Collections
The object collections total around 50 000 items dispersed among the four museums. They are complemented by a large photograph collection. Both are being actively extended to be more representative of the county heritage. The Service also has archive collections at Buxton Museum and Art Gallery (45 500 items concerning Sir William Boyd Dawkins and J. Wilfred Jackson), a reference library of 10 000 items divided between the museums and a photographic collection of around 10 000 items. The county locality records are maintained in the independent Derby City Museum.

The present informal acquisition policy is to be developed into a formal statement of intent by the county service, delimiting its primary concern to the county. There are informal cooperative agreements with the independent City Museum.

Documentation framework

Documentation management
The Deputy Museums Officer is responsible for coordinating the active

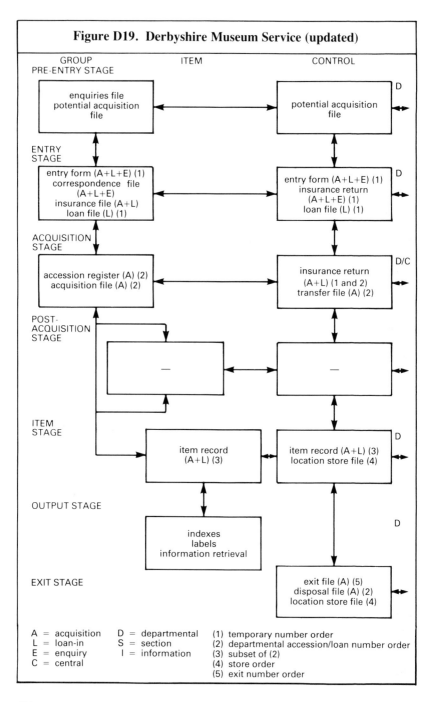

Figure D19. Derbyshire Museum Service (updated)

GROUP · ITEM · CONTROL

PRE-ENTRY STAGE

enquiries file
potential acquisition
file

potential acquisition
file

D

ENTRY STAGE

entry form (A+L+E) (1)
correspondence file
(A+L+E)
insurance file (A+L)
loan file (L) (1)

entry form (A+L+E) (1)
insurance return
(A+L+E) (1)
loan file (L) (1)

D

ACQUISITION STAGE

accession register (A) (2)
acquisition file (A) (2)

insurance return
(A+L) (1 and 2)
transfer file (A) (2)

D/C

POST-ACQUISITION STAGE

—

—

ITEM STAGE

item record
(A+L) (3)

item record (A+L) (3)
location store file (4)

D

OUTPUT STAGE

indexes
labels
information retrieval

D

EXIT STAGE

exit file (A) (5)
disposal file (A) (2)
location store file (4)

A = acquisition D = departmental (1) temporary number order
L = loan-in S = section (2) departmental accession/loan number order
E = enquiry I = information (3) subset of (2)
C = central (4) store order
 (5) exit number order

development of new documentation procedures and coordinates work in the branch museums. The introduction of revised procedures, including computerisation, is a high priority, together with the development of comprehensive item documentation.

Documentation resources
At present, four curatorial and four assistant staff are involved to varying degrees in the documentation procedures. These permanent staff have been assisted by a number of job creation schemes in recent years, with a further project (involving ten temporary assistants) now being contemplated.

There is no documentation manual or formal internal training programme, although both are being considered for the future. A number of permanent and temporary staff have attended MDA seminars and courses.

Work has recently started on the development of computer files of museum records on the county mainframe computer. The service has implemented the MDA programs and applications packages to help it with this plan.

Although it was not possible to quantify the costs of documentation, the service is incurring recurrent expenditure on computer use (commencing in 1982–83).

Documentation system
Although a few new procedures have been introduced in recent years, the system is still felt to be in need of considerable revision (Figure D19). The following discussion will, however, concentrate on the present approach. All material coming into the museum is logged in a daybook. Acquired items and loans are then noted in registers, one copy of which is held in the museum and the other filed on a unified basis at the Administrative Centre. Item records are prepared for the components of the acquired groups, one set of which is again held centrally and will be computerised in the future.

Only a small proportion of the collection has been included in the newly introduced accession book. The degree of item documentation varies considerably, reaching 100% at Sudbury Hall.

The service is very dependent on personal curatorial knowledge in the absence of comprehensive records.

The service has taken care to ensure that duplicate copies of registers and item records are prepared and held centrally. Both sets of documents are normally kept in a safe or secure cabinet.

Documentation and collections audit
There is no specific stocktaking programme by either staff or auditors, although staff do undertake informal checks while gaining familiarity with the collections.

Deacquisition and insurance
There is no formal procedure for documenting a loss.

All groups are covered by the insurance policy, which is currently restricted to fire risk, except in the case of loans where it is comprehensive. (The service is to change to a totally comprehensive policy.)

Object collections documentation

Pre-entry stage
Any information about potential acquisitions is maintained in a general enquiries file.

Entry stage
The service intends to introduce an entry form system. At present, however, groups of items entering the museum are first noted informally then passed to the curator who enters basic details in a two-part daybook. Each entry in the book is assigned a temporary number, a note of which should be left with the object itself. Any correspondence is added to the general enquiries file.

Acquisition stage
Each curator is responsible for decisions concerning acquisitions, with purchases being referred to a senior officer. The curator is then able to process the group.

The formal transfer of ownership of an acquisition is supported by a letter sent to the depositor stating the method of acquisition, etc. Details of the acquisition are noted in a soft bound A3 accession book which consists of pairs of pre-printed pages, one of which can be detached. Blocks of permanent accession numbers are assigned to each museum. One number is allocated to the group and entered in the book. The entry also includes brief details and the storage location of each constituent item. In theory, the location should be amended if it changes at a later date.

When complete, one of the pairs of pages is removed to establish a duplicate copy of the register. This is forwarded to the central administration as part of a unified register for all the collections.

Any changes of information should be added to the register, which has been considered to be the primary source of documentation in the service. Following these principles, the duplicate central copy gradually becomes superceded.

Any correspondence, etc., concerning the group is added to a general correspondence file: each museum has a series of such files for the disciplines represented by its collections.

Similar procedures are adopted for loans into the museums. All of these loans are long-term. A separate loans register is maintained, together with parallel files in individual museums. The museum acknowledges receipt of the loan by means of a letter to the depositor.

Item stage
Parts of the collection have individual item records, prepared by the

curators or temporary assistants, using both local designs and standard MDA cards. Once available, these records are treated as the primary source of information about the object. They include an individual object number, based on a subdivision of the group accession number, by which they are arranged in the files. They are prepared according to MDA guidelines and internal conventions also adopted by the Derby City Museum. A duplicate copy is produced for central use. It is this copy that will form the input document for the computing system.

There is no separate location control procedure. With relatively small collections it is possible to rely upon the accession register and item records for location purposes. Local movements result in a revision to the storage location noted on the acquisition or item record.

Output stage
Informal lists are available for certain parts of the collections. There are no central indexes and only limited local indexes. This is one of the key areas to benefit from the computerisation programme.

Basic labels are prepared.

Exit stage
Movements between the component museums are logged on a memorandum, in addition to the revision of the storage location on the item record.

Any proposed loans-out of the collections is referred to the Museums Officer. The only formal documentation prepared is correspondence with the recipient. This is preserved in a separate loans file.

There is no formal procedure for documenting a disposal.

Museum comments

The service emphasised its intention to introduce revised procedures and to begin a major computerisation project.

Update

The collections have been extended since 1982 to include oral history and film archives. A formal acquisition policy should be published in 1985.

A Community Programme scheme was introduced in 1983, with ten people involved in documentation at the four museums. A formal training programme for both permanent and temporary staff was also implemented in 1983, based on the application of the MDA system and internal museum conventions. A Documentation Officer post is now being established.

The GOS system was implemented on the County Council mainframe in 1982. Since then, the MDA and the Service have cooperated to develop a locality application package (Stanley, 1984) to complement the established object facilities. Computer processing costs from 1982 to 1985 were approximately £20 000. The MSC investment from 1983 to 1985 amounts to £68 000. Permanent staff costs for the eight staff involved are around £10 000 per annum.

There have been significant changes and improvements to the documentation procedures since 1982. A comprehensive entry, exit and transfer of title system was introduced in February 1983, three months prior to the major documentation scheme. Each building is allocated a unique set of sequential numbers and each maintains the relevant forms, but on completion of a form the yellow copy is retained centrally; the blue copy is retained by the originating museum. All transactions, including transfers between buildings, loans-in, loans-out, purchases, gifts, bequests and enquiries are noted by the system. This provides good control of collections and provides 'all risk' insurance for all transactions. A yearly return to the insurance company also provides an 'audit' on the system. The system has completely replaced the daybook and now objects arrive on a curator's desk with a temporary number and details prior to the completion of a flimsy MDA format and accessioning.

A staff object dip check will be implemented during 1985 but Internal Audit still do not check objects. They do, however, regularly check the control documentation referred to above.

There is now a formal procedure for documenting a theft, disposal or transfer. All groups are covered by all risks insurance.

Specific procedural changes include:

Entry stage. Entry form system introduced February 1983 which replaces daybook register. Gifts, purchases, transfers, exchanges, bequests, loans in and enquiries are covered by this system. Major collections have a specific correspondence file and single gifts, etc., have correspondence in the main general file.

Acquisition stage. Transfer of title forms are now used (see Figure 12); together with a letter of thanks to donors of gifts; vendors receive a transfer of title form only. The accession register is still in use but location details other than losses, disposals or transfers (exchanges) are noted on the item records held on computer or on cards. Loans are recorded on the entry forms and that number becomes the loan temporary number. A loan agreement form is completed at the time of the loan for loans of more than one year, which is the norm. Short term loans only appear on entry forms but these are noted separately. Acknowledgement of the loan is therefore by receipt of top copy of entry form and loan agreement form. The entry form provides insurance cover.

Item stage. The procedure is basically unchanged except that a flimsy record of the item is produced. In the branch museums this is typed into two hard copy cards, mainly for security. One hard copy is sent for computer input after being checked by the originator of the flimsy. The other is held locally in whatever filing arrangement desired. The hard copy after input is returned and filed, usually in numerical sequence. In theory, location changes are noted on the cards and computer but this will be more rigorously administered when computer recording is more complete.

Output stage. Computer generated checking displays and indexes are now available for parts of the archaeology, geology, fine art, doll and toy collections, but only one collection of 833 records of birds eggs is complete. Item labels will shortly be prepared from the computer output.

Exit stage. Entry and exit forms now record all movements within and outside the Service. Loans-out are referred to the Museums Officer and exit and loan agreement forms completed. Details of correspondence are kept with duplicate copies of the forms in branch and central files. Disposals and losses are logged on exit forms and countersigned on item documentation and accession registers.

Dii3.5 Glasgow Museums and Art Galleries

Introduction

Report based on a meeting with Miss Helen Adamson (Keeper, Archaeology, Ethnography and History), 7 April 1982.
 A reference to one procedural change is given at the end of the report.

Museum framework

Management/resources
The museum is a local authority (District Council) service, with a series of buildings:

 Art Gallery and Museum
 Burrell Collection
 Hagg's Castle
 Museum of Transport
 People's Palace
 Pollok House
 Costume Museum (Camphill)
 Provend's Lordship
 Rutherglen Museum of Local History.

The museums are organised on a departmental basis with supporting conservation and technical services and a central administration:

 Archaeology, Ethnography and History (including the People's Palace
 and Rutherglen Museum of Local History)
 Natural History
 Decorative Art (including Pollok House and Hagg's Castle)
 Fine Art
 Technology
 Burrell Collection.

The museum has general priorities such as education, display, etc., with no special emphasis on documentation.

The Director is supported by a Depute Director, Administrative Officer and departmental Keepers, Depute Keepers and Assistant Keepers.

Collections

The museum has major object collections of both national and local significance totalling over one million items. It has an extensive historical photograph collection, based at the People's Palace. Record photographs of the collection are held within the departments, as are conservation details. Bibliographic material is dispersed in both departmental collections and a central library. The museum is also responsible for archaeology locality records for the region.

There is no formal overall acquisition policy, although each department has internal understanding based on personal knowledge of the collections. In the past, a number of acquisitions were accepted with restrictive conditions, but this is now discouraged.

Documentation framework

Documentation management

Documentation is organised on a departmental basis, coordinated by individual Keepers, with central duplicate files retained in the Administration. The key importance of acquisition documentation is recognised as the first priority.

Documentation resources

The curatorial staff increased in number during the 1970s to the present complement of around 30, all of whom are involved in documentation to varying degrees. The museum has been aided by a number of relatively small temporary employment schemes. There are brief general and departmental notes outlining procedures. Training is undertaken in-service at a departmental level. No use has yet been made of computers for object documentation.

Documentation system

From 1870 to 1955, documentation was arranged on a unified basis with bound registers being held first in Administration and later (after the 1930s) in the departments. Since then, work has been done in the departments with copies of records being passed to Administration (Figure D20). Acquisitions and long-term loans are processed within departments in a registration system (combining accessioning and item documentation procedures). A group record is prepared to which are added supplementary item details. Copies of this record are held in the department and in the museum's general office. Enquiries are accepted on a central basis, then passed to the relevant department for a response.

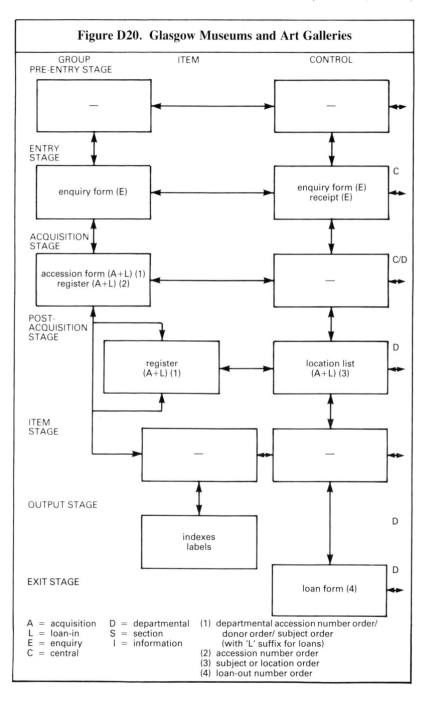

Figure D20. Glasgow Museums and Art Galleries

	GROUP	ITEM	CONTROL	
PRE-ENTRY STAGE	—		—	
ENTRY STAGE	enquiry form (E)		enquiry form (E) receipt (E)	C
ACQUISITION STAGE	accession form (A+L) (1) register (A+L) (2)		—	C/D
POST-ACQUISITION STAGE		register (A+L) (1)	location list (A+L) (3)	D
ITEM STAGE		—	—	
OUTPUT STAGE		indexes labels		D
EXIT STAGE			loan form (4)	D

A = acquisition D = departmental (1) departmental accession number order/
L = loan-in S = section donor order/ subject order
E = enquiry I = information (with 'L' suffix for loans)
C = central (2) accession number order
 (3) subject or location order
 (4) loan-out number order

Basic details are available of most acquisitions, but some departments have major gaps in item documentation.

Multiple copies of the accession forms are held in the departments and the central office, with the latter being kept in a secure cabinet. Photographs are held of valuable items.

Documentation and collections audit

There is no general stocktaking programme although certain collections are under regular control. Internal Audit undertakes sample dip checks of a small random selection of objects and has assessed the loans procedures.

Deacquisition and insurance

Insurance is limited to fire cover, except for loans and the Burrell Collection.

Object collections documentation

Pre-entry stage

Any potential acquisitions are referred to the departmental Keeper for consideration.

Entry stage

There is no formal entry documentation for acquisitions and loans, both of which are referred to the relevant curator. Enquiries are accepted at a central desk, where a receipt and a single part enquiry form are completed. The latter is brought with the object to the relevant department, where a written report is prepared. The depositor is asked to retrieve the object, which is returned to the enquiry desk with a copy of the report. Another copy of the report, any correspondence and the original enquiry form are retained by the department in a file.

Acquisition/post-acquisition stages

Acquisitions are considered by the Keeper, with reference to the Director in the case of purchases, with subsequent processing by departmental staff. A letter of thanks is sent to the depositor of a donation, but it is neither countersigned by the depositor not copied within the accession file. Acquisitions are insured for fire risk.

For both acquisitions and long-term loans, the Keeper assigns a group number (registration number) which (since 1956) has had the form 'loan prefix + department prefix + year + running number'. The relevant Assistant Keeper then completes a four-part form with basic details of the group itself and each item in the group, excluding storage location. The form and any supplementary sheets are typed by the central office, and its parts are then filed in loose-leaf spring binders. Of the different coloured copies of the form, two are passed by the Keeper to the general office for inclusion in the central register and a donor index, one is retained in a departmental register and one is passed to the specific subdepartment for local use. The supplementary sheets usually give details of any individual

component items. Any subsequent changes of information are noted on all copies of the form.

If necessary, a history file is prepared for the acquisition, and held in the department in subject order.

A separate list of long-term loans-in is maintained by each department. All such loans are insured, with Administration responsible for coordinating this work. Short-term loans (for exhibitions, etc.) are documented on a loan form, one copy of which is passed to the depositor and the other retained by the museum.

Item stage
Details of individual objects are noted at the acquisition stage (referred to as 'registration' within the museum).

Individual sections have index cards arranged on a subject basis with details of locations or hold store lists with details of the contents of each store. The primary record does not include location details. The museum storeman is responsible for documenting movements of archaeological items both within the central stores and to other parts of the museum.

Output stage
A few subject catalogues have been prepared. As noted above, one copy of the accession form is passed to the central general office for inclusion in a donor index (dating back to 1950). Another copy is held in subject order in the departments. Labels are prepared according to standard practice.

Exit stage
Two styles of loans form are used (by the museum and art departments) after committee approval for a loan-out. The two-part forms are used by the departments, with one copy being retained for control purposes.

Any disposal questions are referred to the museum committee, after which the register is annotated.

Museum comments

The system is effective although it is very dependent on the internal procedures of individual departments. The central register is of key importance.

Update
A revised acquisition procedure has been introduced since 1982. Donors are now sent a certificate of thanks and a receipt, the latter to be signed and returned to the museum for filing.

Dii3.6 Leeds City Museums

Introduction
Report based on a discussion with Mr Jim Nunney (Senior Curator), 31 March, 1982. It concentrates on the City Museum itself.

Details of important subsequent administrative and procedural changes are given at the end of the report.

Museum framework

Management/resources
The museum is a local authority (City Council) service, with three centres:

City Museum
Abbey House Museum
Armley Mills.

The museum is organised on a departmental basis, corresponding to the three separate buildings, with further sectional divisions within the museums themselves.

The priorities within the City Museum include documentation, improvement of storage, research into the collections, display, education and conservation. The Director is supported by Curators responsible for the three museums and Keepers or Assistant Keepers.

Collections
The collections total around 750 000 objects (archaeology, ethnology, botany, zoology, numismatics, social history and industrial/technology history). The growth rate is variable.

The museum does not have a formal acquisition policy. Any problems will be referred to the Director for consideration.

Documentation framework

Documentation management
The sections have individual responsibility for documentation, with overall policy being decided by the Director. Entry and acquisition documentation are considered most important.

Documentation resources
The four curatorial staff of the City Museum are actively involved in documentaion, to an estimated 60% of their time, due to the problems presented by poorly documented collections. These duties are referred to in their job descriptions. The museum has been assisted by a series of temporary employment schemes, the current one of which is concerned with documenting the photograph collection. The museum refers to the MDA guidelines for item documentation, and undertakes training both inhouse and at MDA seminars. No use has, as yet, been made of computers.

The most significant cost is that of staff time, estimated by the investigator at £15 000 per annum for permanent staff.

Documentation system
Items coming into each museum are seen by the relevant curator wherever

possible (Figure D21). Acquisitions are subsequently detailed in a series of departmental registers, prior to the preparation of individual item records on MDA cards. Enquiries retained in the museum are logged in an enquiry book before being examined by the relevant curator.

The museum was administered by an independent society from 1820 to 1921, when the local authority assumed responsibility. During this period the society maintained internal records but no adequate acquisition details. The position was further complicated by the destruction of records during the war, so that there are serious gaps in the post-1921 accession registers. In terms of individual item records, it is thought that 40% of zoology, 60% of geology, 75% of botany and 100% of ethnography have basic details in an accessible form.

The registers are kept in a safe, to which only senior staff have access. There is however, only one copy of each register.

Documentation and collections audit
The staff are engaged in a long-term programme to check all the collections as part of an overall policy to improve the standard of documentation. In addition, each section has an occasional internal dip check of its collections. Similar procedures are applied by Internal Audit, who have made no further comment on the documentation procedures.

Deacquisition and insurance
The Director considers any losses. The collection is comprehensively insured.

Object collections documentation

Pre-entry stage
Individual staff would open a file to preserve details of important potential acquisitions.

Entry stage
There is no universal documentation procedure when a group enters the museum.

Acquisitions are passed to the curator concerned, who notes any significant details. A receipt is given to the depositor and no temporary documentation or number is assigned to the group.

In the case of an enquiry, if a curator is not available to give an immediate response, it is logged in the enquiry book held at the museum desk. The book is made up of pre-numbered sheets, one of which is passed to the depositor and another to the curator for the completion of a report. The group itself is tagged with a number corresponding to the temporary number on the sheet. The report is posted to the depositor, who is asked to retrieve the group, which is meanwhile held at the desk. A copy of the enquiry and response is kept in the book for future reference.

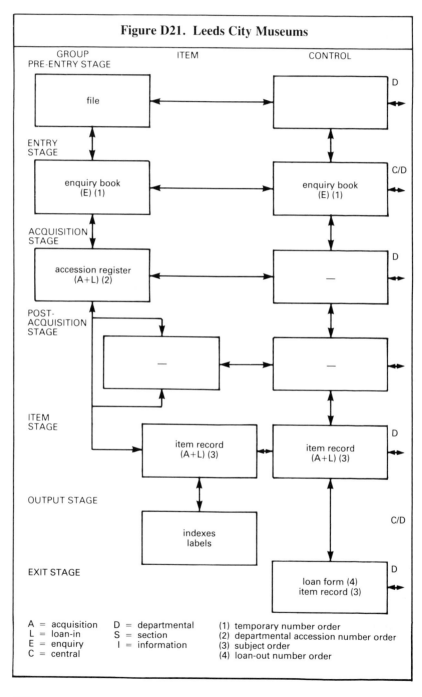

Figure D21. Leeds City Museums

GROUP ITEM CONTROL

PRE-ENTRY STAGE

file D

ENTRY STAGE

enquiry book (E) (1) enquiry book (E) (1) C/D

ACQUISITION STAGE

accession register (A+L) (2) — D

POST-ACQUISITION STAGE

— —

ITEM STAGE

item record (A+L) (3) item record (A+L) (3) D

OUTPUT STAGE

indexes labels C/D

EXIT STAGE

loan form (4) item record (3) D

A = acquisition D = departmental (1) temporary number order
L = loan-in S = section (2) departmental accession number order
E = enquiry I = information (3) subject order
C = central (4) loan-out number order

Acquisition stage
The individual curators decide whether to acquire an item (with reference to the Director, if necessary) and are responsible for the subsequent processing, during which it is kept apart from the main collection. A letter of thanks is sent to the depositor in response to a donation, and an order in the case of a purchase. No other formal transfer documentation is compiled.

The person responsible for the group prepares an entry in an accession register, in which are noted basic details about the material. The acquisition may either be a group or an individual item, as decided by the person concerned. Separate registers are maintained for the different disciplines. They are, however, stored together in a central fireproof safe. Independent numbering sequences are used for the different collections, with each number being made up from a 'letter prefix + running number + year'. Any subsequent significant changes of information are noted in the register.

A separate file is prepared to hold correspondence, etc., should this be necessary.

Loans are also processed within the individual sections. Short-term loans are processed as enquiries; long-term loans (over five years) are treated in the same way as acquisitions, being noted in the register and assigned a permanent number, etc.

Item stage
Some time after receipt, an individual item record is prepared, either by the permanent staff or by temporary assistants. The details are noted on MDA cards or similar internally designed media. They include the storage location. Parts of the old collections have been reprocessed to the new standard in recent years. The unique number assigned to each item is either the accession number or a direct subdivision of that earlier number.

The museum follows the basic recording procedures described in the relevant MDA card guidelines. One copy of the record is prepared and then filed in a convenient local order (usually non-numeric). The record is amended if significant new information comes to light.

Both the records and any supplementary files are kept in the departments. There is no separate control documentation, although locations are noted on the item records. Temporary movements are indicated by means of a tag left in the store. More permanent moves are noted on the item record card.

Output stage
No separate catalogue is maintained. A new central donor index is being prepared. Other indexes depend on individual requirements, such as a collector index for the natural sciences. Labels are prepared according to the normal standards of the various disciplines.

Exit stage
The Director considers proposals for loans, after which the departmental

staff prepare a loans form. The item record for that object is annotated, and the card itself moved to a loans file sequence until the object is returned. A tag is left in the vacant storage location.

Other documentation

The museum has a range of other types of record, including geology locality details.

Museum comments

The system is felt to work, with certain shortcomings that the museum is concerned to overcome. The museum is planning to revise its procedures to make them more comprehensive. It is planning to computerise its documentation in the future.

Update

An eighth department (Photographic Collections) has been added since 1982.

The management of documentation is now the responsibility of a Curator of Collection Services, reporting to the Director.

The temporary employment scheme dealing with the photograph collections has been superceded by a volunteer programme coordinated by the Curator, Collection Services.

Revised documentation procedures were introduced in January 1984. In summary, it includes:

an offers book, offers file and offers rejected file;
the use of MDA entry forms for incoming material (with a separate series for loans-in);
accession registers and accession files for permanent acquisitions and loans;
item records on MDA cards (for all departments except Numismatics);
the use of MDA exit forms for loans-out;
a loans-out register.

Dii3.7 Leicestershire Museums, Art Galleries and Records Service

Introduction

This report has had to be omitted since an approved copy had not been received. Details of procedures are given in a recent paper (Fletcher, 1985).

Dii 3.8 Liverpool: Merseyside County Museum

Introduction

Report based on a discussion with Mr Eric Greenwood (Assistant Director, Academic), 18 March 1982.

Subsequent procedural developments are referred to at the end of the report.

Museum framework

Management/resources
The museum is a local authority (Metropolitan County Council) service, with four sites (excluding stores):

County Museum
Merseyside Maritime Museum
Speke Hall
Croxteth Country Park.

The museum is arranged on a divisional and departmental basis:

Academic Division
 Antiquities
 Botany
 Decorative Art
 Ethnology
 Geology
 Invertebrate Zoology
 Physical Sciences
 Vertebrate Zoology
 Speke Hall
 Survey Archaeology
Maritime and Social History Division
 Maritime History
 Maritime Museum
 Social and Industrial History
 Archives
Museum Services Division
Environmental Conservation Division
Administration Division.

The Director and Deputy Director are supported by divisional Assistant Directors, departmental Keepers and Assistant Keepers and a number of unattached assistants.

Collections
The internationally important object collections include over 1 300 000 items (with 600 000 invertebrate zoology specimens alone) with an average

growth rate of 26 000 (2%) per annum. Detailed historical and projected growth figures have been prepared for management purposes. These show the overall growth figure to be a reflection of wide local variations, with the annual rate ranging from 0.1% in Ethnography to 33% in Archives. The overall rate itself has remained virtually unchanged for many years.

The object collections are complemented by a central archive, conservation records and photographs and departmental archaeology and natural science locality records, photograph collections and biographic and event information.

The museum has a general internal acquisition policy which provides a framework for action by senior staff. This policy is subject to revision in response to changing situations, enabling the management team to deal with new circumstances. It concentrates the interest of the museum on improving the standard of life and the quality of the environment within the county, by a better understanding and appreciation of man and his environment, through the use of the collections and information available to the museum. The policy is based on curatorial knowledge, supported by documentation of the collections. Staff are also concerned to identify research policies and priorities in cooperation with other museums, universities and research agencies. Both the acquisition and research policies are part of a broader awareness of the need for general guidelines for the management of the museum and its collections.

Documentation framework

Documentation management
The investigation of new developments is coordinated by an Assistant Director. The implementation of procedures is, however, the responsibility of individual departments through their Keepers. The museum considers acquisition documentation to be the first priority, followed by location and valuation control of the most important items and the production of published catalogues of some of the collections.

Documentation resources
Of approximately 28 curatorial staff, all are involved in documentation to some degree, estimated to average 7.5% of their time (this figure disguising wide variations between departments). There is also a clerical assistant in Administration who is concerned for part of the time with initial documentation. Documentation duties are referred to in the job description of curatorial staff. There have also been a significant number of job creation schemes. New staff attend a general induction course and receive a basic portfolio describing the museum, but there is no specific documentation training or manual. Guidance is given in-service.

Initial experiments have been undertaken with a microcomputer. More extensive use of computers is being considered.

The dominant cost is recurrent expenditure on staff, estimated by the investigator at £20 000 per annum for the permanent establishment (appro-

ximately 7.5% of salary costs). A major contribution has also been made by the MSC in support of temporary staff. In 1981–82, for example, over £100 000 was contributed toward object documentation and over £130 000 towards field survey work.

Documentation system
The museum places an emphasis on departmental procedures, with a certain amount of assistance from a central Information Desk and Administration (Figure D23). Acquisitions are passed to the department, where they are logged in a daybook or its equivalent before the Keeper prepares an accession form, which is passed to Administration where basic details are incorporated in an accession register and a group number assigned. The form, with an annotation showing the accession number, is returned to the department as a source for the preparation of individual item records. Steps are taken to ensure that the museum has adequate evidence of ownership. Enquiries are managed by the Information Desk, using an entry form. There is limited valuation and location control and stocktaking.

It is estimated that 80% of the collection has been accessioned (the outstanding proportion being old material.) The production of basic item records and indexes varies widely in different departments. Although numerically small, a significant range of detailed catalogues have also been produced in recent years.

Duplicate copies of post-1950 registers have been prepared and stored elsewhere. The museum files are in lockable cabinets within departments, with access controlled by Keepers.

Documentation and collections audit
Individual departments have an informal stocktaking procedure as part of their overall collections management programme. In the case of Ethnology, for example, stocktaking is being undertaken in parallel with a check of the available documentation.

The only other stocktaking is that by District Audit, who undertake an annual dip check of new acquisitions (typically six items a year). Prior to the check, the audit team will have examined the duplicate records in the Treasurer's Department. Their concern within the museum is with the retrieval of the object, which will usually be undertaken without reference to its documentation. They have also been involved in the development of a high value inventory.

Deacquisition and insurance
Losses are reported to the museum committee and the record annotated. The collection is insured.

Object collections documentation

Pre-entry stage
Most departments take informal steps to preserve details of potential acquisitions.

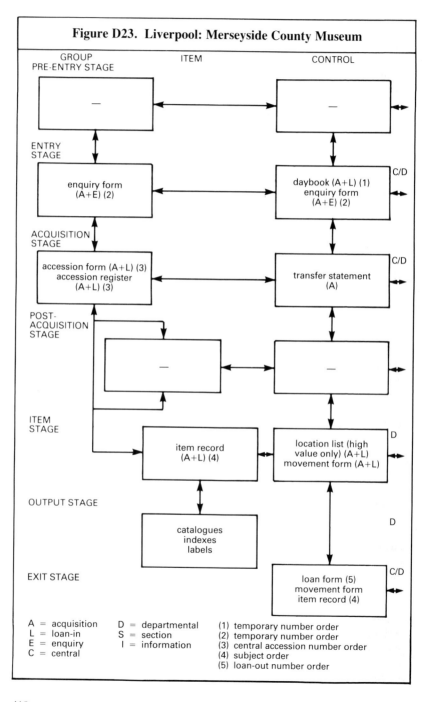

Figure D23. Liverpool: Merseyside County Museum

Entry stage

Distinct procedures are adopted for incoming acquisitions/loans and enquiries, with known examples of the former being processed by the department concerned and all other material being handled by the central Information Desk. In most acquisition cases, a decision is taken before the group enters the museum concerning whether it is to be accepted into collections. Other, unanticipated, groups will first go through the enquiry procedure.

The anticipated acquisitions and loans are logged in departmental day books, with sequentially numbered entries corresponding to all movements into the department. Subsequent work is coordinated by the departmental Keeper.

Enquiries are logged on an entry form at the Information Desk. The pre-numbered form is completed in triplicate, and one copy passed to the depositor as a receipt. A separate note is also made in a daybook. The group and two copies of the form are taken to the appropriate curator, who signs for the objects and form in the daybook. The book is then retained by the Information Desk. The curator completes the report section of the form, one copy of which is retained in the department and the other returned with the group to the Information Desk. The Desk is responsible for asking the depositor to retrieve the group, at which point they will be asked to show the receipt copy as evidence of ownership. Items that are not retrieved are eventually disposed of, following time limits given in the conditions printed on the form. The number of enquiries is monitored by the Information Desk. Details are, however, only kept in the departments.

Certain duplicate material may be held in the natural science departments for exchange purposes. Although documented, this will not be accessioned.

All material entering the museum is covered by its insurance policy.

Acquisition stage

No distinction is made between acquisitions and long-term loans. The decision to acquire a group will be taken by the Keeper, with reference to the Assistant Director (Academic) and, if necessary, the Director. The Keeper will then be responsible for subsequent processing and ensuring the museum is able to acquire the material.

The museum is currently examining its transfer of ownership procedure to ensure that all necessary steps are being undertaken. The present procedure in the case of the depositor of a gift is for the person to be asked to sign a statement specifying the details of the transfer. In the case of a bequest, the museum files a copy of the relevant extract from the will. In the case of a purchase it depends upon the payment invoice. It also considers the copyright position of acquired material, and may take steps to acquire the copyright of certain photographs.

The Keeper concerned notes basic details of the group on a standard accession form, based on information supplied by the depositor, and from

the Keeper's own knowledge of the objects. (This information is also recorded in the departmental daybook or equivalent and on the enquiry form if appropriate.) The details include an indication of the department concerned and a valuation, but not a specific location. The completed form is passed to Administration where a clerical assistant enters details in an accession register and assigns an accession number. The register is currently in the style of looseleaf sheets, although this is being changed to accession sheets which are subsequently bound. The numbers are in a single sequence for the whole museum. There is no separate register of loans. The annotated accession form is returned to the department where it serves to advise the Keeper of the group's accession number and becomes part of the departmental documentation.

It is intended to prepare three copies of the bound register, one of which will be kept in the museum safe and another in an external building for reference and security.

The acquisition may concern a group of items or a single object, depending on departmental practice and convenience. The accession record refers to a 'transaction', and will indicate the department most concerned. The acquired group may be subdivided, with this action being noted in the departmental records (usually daybooks) as an internal transfer.

At present, correspondence is kept in departmental files.

Short-term loans, which are infrequent, are treated by informal *ad hoc* procedures, frequently depending on correspondence files. No loan form is used, although the depositor will be sent a letter giving details of the group. There is also no established arrangement for ensuring the return of the loan. Formal procedures are in preparation.

Item stage
Item documentation is undertaken at departmental level by the full time curatorial staff, sometimes with the assistance of temporary staff. Master records are now usually prepared fairly promptly after the acquisition. The form of the recording medium varies from internal designs to standard MDA record cards. They tend not to include the storage location of the objects. The records and the collections themselves are, however, often arranged in a classified sequence.

The record is considered to be a first stage document, subject to later extension. A single copy is produced, with no back-up. Significant parts of the collection have been reprocessed to new standards in recent years, often with the help of temporary staff. The individual number assigned to each object is based on a subdivision (if necessary) of the group accession number.

Supplementary files for individual objects are prepared if necessary.

A new control index of high value items (those over £5000) has been assembled and will be revised annually. One copy is kept centrally and a second coppy is held by the County Treasurer's Department. Within a department, objects are moved at the discretion of curatorial staff, often

with no record being maintained of their movements. However, departments are now developing systems to record internal movements, sometimes with the help of a microcomputer.

Output stage
A number of major catalogues and handlists have been prepared in recent years with a selection of information about key parts of the collections. These are distributed as widely as possible. There are no central indexes. Those in the department will depend on local convenience, but will often include donor lists. A label is usually prepared about a new object.

Exit stage
Semi-permanent moves between departments are to be logged by means of a new transfer of custodianship procedure. This will involve the use of a movement form to be completed and maintained by the Keepers concerned.

All loans-out are sanctioned by the Director, then managed by the department concerned. Although requests from institutions are normally approved, there is reluctance to agree to a loan to an individual. A three-part loan form is completed before the object leaves the museum, one copy of which accompanies the object, another is passed to Administration as part of a passive central record, and the third retained by the department. It is a curatorial responsibility to ensure that the loan is returned. The loan will also be logged on the movement form, and may be noted on the permanent item record. New procedures for loans are being developed.

The decision to dispose of an acquired object is referred to the Director, after which the register is annotated.

Other documentation

Reference was made earlier to the importance of locality records. Separate archive records and procedures are also being introduced.

Museum comments

The museum is conscious that the system is not statisfactory. It is examining in detail the procedures relating to all aspects of museum documentation and moving towards the implementation of revised methods of collections management. In the case of the Maritime Museum, the post of Assistant Keeper (Collections Management) has been created to develop and coordinate these control procedures. The role of computers has been examined and areas where they may be useful have been identified. The museum has been impressed by the potential of microcomputers.

Update

Additional sites opened since 1982 include the Prescot Museum of Clock and Watchmaking (jointly administered with Knowsley Borough Council) and the Large Object Store in Liverpool.

A number of new museum-wide procedures have been introduced for controlling incoming material (including loans-in), loans-out, insurance arrangments, internal transfers, etc. These are supported by various A4 forms and procedural guidelines.

Dii3.9 Newport, Gwent: Museum and Art Gallery

Introduction

Report based on a discussion with Mr Chris Newbery (Curator), 1 March 1982.

Details of subsequent developments are noted later.

Museum framework

Management/resources

The museum is a local authority (Borough Council) service, with two centres:

Museum and Art Gallery
Tredegar House

The museum is arranged as a single unit, with subordinate departments and a Curator and Keepers. Tredegar House has separate estimates but its Keeper is responsible to the Curator concerning curatorial matters.

The priorities of the museum include collections management and condition control, documentation to improve the knowledge of the existing collections and interpretation.

Collections

The collections total over 100 000 objects, including significant archaeological material, social and industrial history, fine and decorative arts, costume and textiles, numismatics, photographs and natural science specimens. The current growth rate is small, except for archaeology where it is more variable due to excavation work.

There is an important emphasis on environmental documentation, including an archaeological sites and monuments record and a natural sciences record centre. Other types of collections are less significant, with archival items, for example, normally being transferred to the the county archive. The museum undertakes limited conservation, with the assistance of contract conservators.

A policy statement published in 1981 includes a formal acquisition policy for each area of interest to the museum, based on a knowledge of the collection which was partly derived from the available documentation. The acquisition of items with conditions attached is at the discretion of the curator. The museum is interested in the establishment of a county museum committee, one of whose aims would be to develop more formal collecting

agreements than those already in operation. This would be in line with the recommendations in the Morris report on museums in Wales.

Documentation framework

Documentation management
The Curator is responsible for overall documentation policy and the coordination of the existing procedures. Concern for the unsatisfactory state of these procedures was expressed in a recent policy statement which included the recommendation that the old system be revised. Basic accessioning and indexing of the backlog and new acquisitions is considered most important.

Documentation resources
The five sectional Keepers and two Clerical Assistants are all involved in documenting the collections and the Curator in the overall management of the system. However, the time that it is possible to spend on documentation is relatively small. There has been no help from temporary staff. The job description of the Curator includes reference to maintaining and developing an adequate documentation system.

A basic documentation guideline produced in 1971 has recently been updated. Changes to the procedures are notified to staff by a memorandum. New staff become familiar with the system through these notes and by practical experience of its use. The museum is considering using the MDA system and its associated procedural manuals, training seminars, etc., for specific parts of the collections.

No computerisation scheme has been implemented.

Documentation system
The procedures established during the 1960s and early 1970s have recently been reassessed and new record cards, etc., have been introduced. The basic framework, however, has remained relatively unchanged (Figure D24). Material entering the museum is noted on an enquiries and gifts form, with acquired items then being further recorded on an A4 accession form which is used as the entry in a loose-leaf register. Basic item records are prepared from these forms for arrangement in numerical order. These are also duplicated and arranged as index entries in donor and subject order. There has been little emphasis on collections control documentation.

It is estimated that at least 30% of the collection is either completely undocumented or has inadequate acquisition and item documentation. The current policy statement refers to the need for additional staff to rectify this position.

Attention has been given to the security of the documentation, with the accession forms being stored in a safe.

Documentation and collections audit
There is no formal stocktaking programme, although the Keepers are

Planning the Documentation of Museum Collections

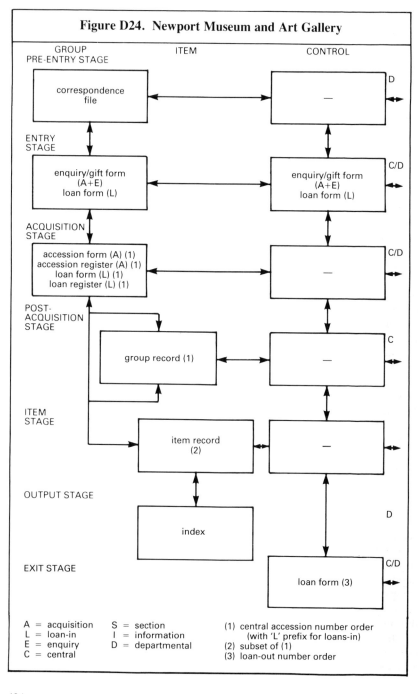

Figure D24. Newport Museum and Art Gallery

| GROUP | ITEM | CONTROL |

PRE-ENTRY STAGE

correspondence file — D

ENTRY STAGE

enquiry/gift form (A+E) loan form (L) — enquiry/gift form (A+E) loan form (L) — C/D

ACQUISITION STAGE

accession form (A) (1) accession register (A) (1) loan form (L) (1) loan register (L) (1) — C/D

POST-ACQUISITION STAGE

group record (1) — C

ITEM STAGE

item record (2) —

OUTPUT STAGE

index — D

EXIT STAGE

loan form (3) — C/D

A = acquisition S = section (1) central accession number order
L = loan-in I = information (with 'L' prefix for loans-in)
E = enquiry D = departmental (2) subset of (1)
C = central (3) loan-out number order

424

checking the collection by their use of its material. The auditors have not considered the integrity of the collection itself or its documentation.

Deacquisition and insurance
Any losses would be reported and the documentation annotated. The collection is insured.

Object collections documentation

Pre-entry stage
Individual keepers respond to potential acquisitions. They open a correspondence file, if necessary.

Entry stage
Objects entering the museum are initially noted on an enquiries and gifts sheet or on a (new) loans-in form. It is estimated that the museum receives around 200 verbal enquiries, 400–500 written identifications, 200 acquisitions and 50 loans-in each year.

All items are processed immediately, either by a Keeper (who will be called to the museum desk) or by a warder. If available, the relevant Keeper will complete the entry form and decide whether to accept the item as an enquiry or gift. Warders who accept an item in the absence of a Keeper also complete the form but only have authority to enter the item as an enquiry. In either case, the numbered three-part form is separated, one part to accompany the item, one to be filed and one to be passed to the depositor as a receipt. The item is held in a storage area near the entrance desk until it can be processed by the Keeper. The opinion given in response to the enquiry is noted on the copy with the item and duplicated onto the file copy. The depositor is asked to retrieve the item and its form, with the museum reserving the option of disposal if it is not collected within 8 weeks.

All material is covered by the museum insurance policy.

Details of deposits are kept in a general correspondence file or, if relevant, a gifts file, both of which are maintained centrally.

Acquisition stage
Keepers are authorised to accept and process gifts; the Curator considers all purchases. The Keeper is also responsible for ensuring that the item can be acquired, particularly in the case of archaeological material.

A museum representative signs the enquiry/gift form as a receipt. In the case of a donation, a formal letter of acknowledgement is then sent to the depositor. Copyright is obtained, where relevant. An accession form is completed for each new acquisition (which may be a group of items). Although kept in a loose-leaf folder, this form is considered to be a part of the museum accession register. Forms are completed by the various curatorial staff, as relevant. They are preserved in numerical sequence in the central safe. A complex group of items from one source might be treated as a single acquisition, being noted on one or more accession sheets, each

representing the interests of different subjects. The accession number assigned to new acquisitions is in the form of 'year + running number', with a single sequence being applied to the whole museum. These numbers are written on the accession forms prior to use.

Details of correspondence, etc., are kept in a gifts file, in date order, which is preserved centrally.

Loans-in are now documented on a specific loans-in form. The form is incorporated in a special loans register. They receive a running number sequence, including an 'L' prefix. Details of correspondence are kept with other museum papers in the general correspondence files.

Item stage

The accession form is now used as the basis of individual item records. These are prepared by a clerical assistant on basic record cards using the information about the group and its constituent items given on the overall form. The period between accessioning and item documentation is variable.

As noted earlier, significant parts of the collection have not yet been documented to this level. In other cases, the item records are limited to a description of complete groups of objects analogous to the acquisitions themselves. There has been no major reprocessing of old acquisitions during the last decade.

New information about the object is added to the accession form (which remains the primary document) and the item record. Four copies of the record are prepared, one of which is held in numerical order. This item number is based directly on the accession number assigned earlier.

The storage location is added to the cards, in pencil. No other inventory control is exercised. There is no formal documentation of movements, but this is being reviewed.

Output stage

There is no separate catalogue of the collection. This is considered a low priority, in view of other requirements. The four copies of the item record are arranged in numerical, donor and subject order (held centrally), and as a duplicate subject sequence (held in the department). The cards are produced by the Clerical Assistant who files the numerical and donor sets in the central indexes. The subject cards are passed to the Keepers for departmental use. Labels are not prepared.

Exit stage

As with loans-in, a new form has been prepared to aid the control of loans out of the museum. This form is in duplicate, one part being passed to the recipient and the other retained in a numerical file. No details of the loan are noted on the item record. However, a condition report is prepared and checked before and after the loan. Steps are taken to ensure adequate insurance, etc., is available.

The curator is responsible for administering any disposals, in which case the accession form would be annotated.

Other documentation

As noted earlier, locality records are maintained. Archival and photographic items are treated as objects for documentation purposes.

Museum comments

If implemented fully, the system would be effective in helping the museum to document its collections. The recent changes should result in a more satisfactory situation.

Update

An MSC-funded Community Programme to photograph and catalogue the collection was introduced in 1984 as a result of which much of the early collection is now being reprocessed. A plan to computerise the local biological records is also being considered, also with MSC support.

Dii3.10 North Hertfordshire Museum Service

Introduction

Report based on a meeting with Mr John Marjoram (Senior Curator), Mr Peter Field (Curator, Letchworth Museum) and Mr Alan Fleck (Curator, Hitchin Museum), 16 February 1982, revised to take account of subsequent administrative changes.

Other documentation developments in the intervening years are noted at the end of the report.

Museum framework

Management/resources
The museum is a local authority (District Council) service incorporating two museums:

> Letchworth Museum and Art Gallery
> Hitchin Museum and Art Gallery.

The museums are treated as a single unit. There has been some movement of collections since local government reorganisation, with, for example, archaeology now concentrated in Letchworth.

Documentation is considered to have a high priority in both museums, but particularly in Letchworth where its standard is considered to be poor.

The service has a Senior Curator, Curators and Keepers.

Collections
The museums include a broad range of collections of local interest, totalling about 500 000 items (archaeology, social history, coins, costume and textiles, natural history). The current growth rate is low, with the exception

of archaeology excavation material from Baldock. A press cuttings collection is also being developed. Building and natural science locality records are available.

The museum has a formal acquisition policy, based on curatorial knowledge of the collections. Only items of exceptional interest would be acquired with conditions attached.

Documentation framework

Documentation management

The museums are developing documentation on an independent basis, with no formal coordination of approach or central responsibility. Any coordination that does take place tends to be at a subject level. Staff have, however, been actively involved in the plans of the Hertfordshire and Bedfordshire Curators Group to develop agreed conventions for documentation throughout the two counties. Given the size of the collection and limited staff time, basic documentation is felt to be most important.

Documentation resources

On average, 30% of staff time (10 curatorial staff) is concerned with documentation. Documentation duties are specified in job descriptions of relevant staff. The museums have not had significant outside help with documentation. The staff have been involved with the development and use of the Hertfordshire/Bedfordshire conventions noted above. Otherwise the need for staff training is felt to be negligible due to lack of new staff.

Work has begun on the computerisation of the costume records through the MDA. The museum is also considering the use of the local council mainframe for data entry and initial processing.

Total staff costs for documentation are estimated at from £20 000 to £30 000 per annum. Computing costs have been negligible in the past.

Documentation system

The presence of large existing collections with relatively few entries is reflected in the documentation procedures and systems (Figure D25). New entries are logged in a day book and then treated as either acquisitions (with a register entry and item record being prepared simultaneously) or enquiries (with an enquiry form being completed). Selected parts of the collection have been indexed. There is limited control documentation.

It is a stated policy of the museum to complete the basic documentation of the collections. At present, the initial stages have been accomplished for 80% of the Hitchin collection and 50–60% of the Letchworth collection. An emphasis has been placed on natural history material, which is also 80% complete.

The register is kept in a fire proof safe and had been copied. Records are not kept in locked cabinets, although the room itself is locked. Photographs are available if an illustration had been needed for a publication.

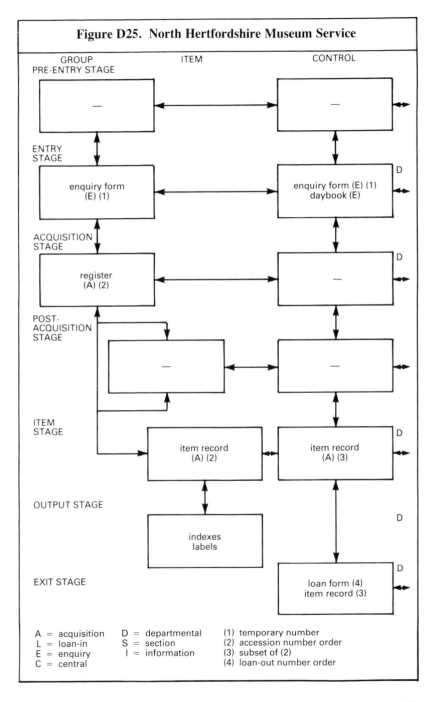

Figure D25. North Hertfordshire Museum Service

GROUP ITEM CONTROL

PRE-ENTRY STAGE

—

—

ENTRY STAGE

enquiry form (E) (1)

enquiry form (E) (1) daybook (E)

ACQUISITION STAGE

register (A) (2)

—

POST-ACQUISITION STAGE

—

—

ITEM STAGE

item record (A) (2)

item record (A) (3)

OUTPUT STAGE

indexes labels

EXIT STAGE

loan form (4) item record (3)

A = acquisition D = departmental (1) temporary number
L = loan-in S = section (2) accession number order
E = enquiry I = information (3) subset of (2)
C = central (4) loan-out number order

Documentation and collections audit

The museum itself does not undertake any stocktaking, apart from one exercise in the 1960s. However, staff are systematically checking and documenting the collection for more general management purposes.

Internal Audit has implemented a basic dipchecking procedure. For example, in 1977 they examined a random sample of objects and in 1979 asked to see all purchases made during that year. These examination resulted in a recommendation to catalogue the collections, which the curators found a positive assistance. They did not, however, result in additional resources.

Deacquisition and insurance

Documentation procedure following a loss would be controlled by the Director. The collection is insured. The insurance company has commented on the need for a catalogue of the collection.

Object collections documentation

Pre-entry stage

Individual curators deal informally with a potential acquisition, checking the acquisition policy and the existing collection where necessary. A note of the offer may be made in the daybook.

Entry stage

The number of items entering the museum is relatively low (about 800 per year). Different procedures are adopted for acquisitions, enquiries and informal identifications. In the case of acquisitions, no initial procedures are undertaken prior to simultaneous accessioning and item documentation, which may be some time after their initial entry. Enquiries are noted on an enquiry form, completed by the relevant curator, with a sequential temporary number. A copy of the enquiry form is left with relevant items prior to their collection by the depositor. Details of the enquiry are added to a general enquiry file. More informal identifications, etc., are logged in a daybook which acts as a record of events. Loans-in are discouraged and infrequent.

All items coming into the museum are covered by the insurance arrangements, with those valued at over £100 being reported to the insurance officer.

Acquisition stage

The decision whether to acquire an item is taken by the individual officer, after relevant checks, such as ensuring that a landowner's permission has been given in the case of archaeological finds. No formal transfer document is completed, although a letter of thanks is sent by the curator concerned.

The general policy is to treat an individual object, rather than a group, as the acquired item. Both an entry in a bound register and an item record are then prepared about this acquisition. The registers are simple accounts books in which are written basic details including accession numbers, fairly

full description (including a sketch), acquisition method, source and date and any remarks. The object is assigned an accession number with the form of a straightforward running number (Hitchin) or 'year + running number'.

Details such as correspondence, etc., are kept in a general donation file.

Item stage
New acquisitions are processed as soon as possible after receipt (usually within a few weeks) by the relevant curator, sometimes with temporary assistance. All available details are noted on a record card. These include storage location, which is altered if the object is moved for a significant period.

Procedures also differ when completing the cards. At Letchworth, a manuscript version is produced first from which a typed equivalent is prepared and used as the master copy, arranged in numerical order. (It is intended to arrange the manuscript copy in classified order in the future.) At Hitchin, the original card itself is typed and filed in numerical order.

Additional details are kept in supplementary files, in numerical order.

The only current control documentation is a listing of the items in the costume store. Individual curators are responsible for keeping track of movements.

Output stage
No separate catalogue is maintained, except in the case of the computer files now being produced. At this early stage in the documentation programme, relatively few indexes are available. It is presumed that a wide range will be produced as part of the computerisation programme. At Hitchin, the item records are complemented by a basic 8" × 6" index card system in classified name sequence. In the case of the archaeological collection, material, chronological, provenance and name indexes are available. A label is prepared for the Hitchin collection and the archaeological material.

Exit stage
Details of loans-out are noted on a special form and a reference to the loan made on the item record.

Any disposals would be referred to the museum committee, and the register and item record annotated.

Museum comments

In general the museum was satisfied with current procedures, but concerned that the degree of documentation was far from complete.

Update

Documentation is now being developed on a coordinated basis. An analysis has been made of computing options, with the intended strategy being to adopt the Council's mainframe facilities. Terminals have been installed at Hitchin Museum and Art Gallery.

The accession registers are being microfilmed.

A number of improvements have also been made to practical control procedures.

Dii3.11 St Albans Museums Services

Introduction

Report based on a discussion with Ms Sheila Stone (Keeper of Archaeology) and Mr Gareth Davies (Director), 16 February 1982.

Information about procedural changes and subsequent progress is noted at the end of the report.

Museum framework

Management/resources

The museum is a local authority (City and District Council) service, with two centres:

 Verulamium Museum
 City Museum.

The service is a single unit, with a Director, Keepers and Assistant Keepers.

Collections

The collections are predominantly object based, with major archaeological collections relating to the Roman city (up to 50 000 discrete objects and another 600 000 sherds, etc.), social history material (around 40 000 objects) and natural science specimens (quantity unknown, but probably around 30 000). The active excavation programme of the integral field unit is resulting in an average of another 250 boxes of material being deposited in the museum each year. Other new acquisitions are infrequent.

Other types of collection are far less significant. For example, there are no bibliographic, biographic or photograph records. However, there are a small number of locality records and about 1000 conservation records of work on museum material.

The museum has a general published acquisition policy which places an emphasis on the history of the area, developed from curatorial knowledge. It will occasionally acquire an object with conditions attached, such as agreeing to pass it to a more local museum.

Documentation framework

Documentation management

Coordination of documentation resides with the Keeper of Archaeology who has the function of Documentation Officer. She initiates policy and procedural changes in consultation with the Director. Item documentation

is felt to be most important, due to the massive backlog of material to process. However, initial documentation of new acquisitions is adequate.

Documentation resources
Of the seven curatorial staff, two spend 50% and another two spend up to 10% of their time on documentation. These functions are specified in the job descriptions of the staff. A part-time assistant is employed for 250 hours per year to help with archaeological cataloguing. A basic procedural manual is available, and is revised as necessary. The Documentation Officer introduces staff to the procedures. New entrants attend MDA seminars. Two members of staff have also attended an Aslib course on indexing methods.

The museum uses the MDA computing bureau to provide a wide range of indexes to respond to enquiries, to assist with collections management and (ultimately) to aid the production of published catalogues and particularly to provide effective documentation of the excavation archive (Orna and Pettitt, 1980).

Record production costs are felt to be too variable to quantify, although total staff costs are estimated at around £7500 per annum. The museum uses the MDA computing bureau for computing work, with an annual expenditure of £2000 for data entry, processing and management. Capital investment in 1981–82 was £580.

Documentation system
There is a reasonably well established (if not always implemented) sequence of activities, including both acquisition and item documentation and limited control documentation (Figure D26) (Stone, 1978; 1979). The approach is characterised by its simplicity, which is partly made possible by the small number of movements of items in and out of the museum. Acquisitions are immediately documented, with no initial entry stages or completion of a register entry. Standard MDA record cards are adopted for this work. The MDA computing service is then used to produce catalogues and indexes. There is a growing stress on control documentation as one product of the computing procedures.

While it is felt that a complete coverage is desirable, only a small proportion of the formal collection has been fully documented (10% – 5000 – of the discrete archaeological objects, although this includes perhaps 25% of the most significant material; 5% – 2000 – of the social history objects; and less than 5% – 1400 – of the natural science specimens). The remaining archaeological items are under control, being supported by basic 5″ × 3″ index cards and a classified storage arrangement. Although it is not possible to estimate when the coverage will be complete, the present cover has been achieved in the last four years.

Attention has been given to the security of the documentation, with records being kept in lockable cabinets. Photographs are available of

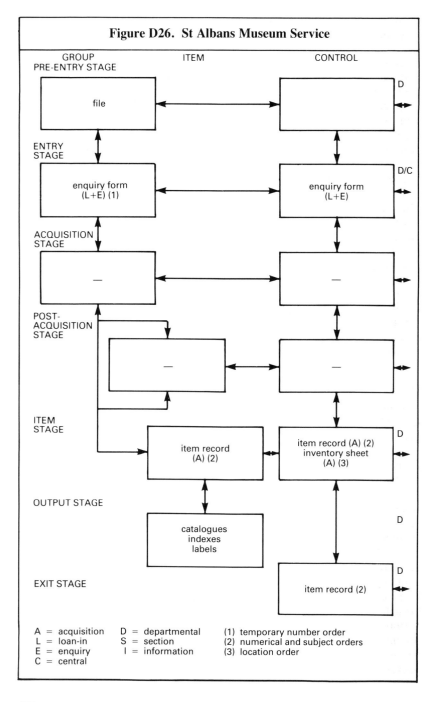

Figure D26. St Albans Museum Service

GROUP	ITEM	CONTROL

PRE-ENTRY STAGE

file — D

ENTRY STAGE

enquiry form (L+E) (1) — enquiry form (L+E) — D/C

ACQUISITION STAGE

— — —

POST-ACQUISITION STAGE

— —

ITEM STAGE

item record (A) (2) — item record (A) (2) inventory sheet (A) (3) — D

OUTPUT STAGE

catalogues indexes labels — D

EXIT STAGE

item record (2) — D

A = acquisition D = departmental (1) temporary number order
L = loan-in S = section (2) numerical and subject orders
E = enquiry I = information (3) location order
C = central

valuable or significant items and of those that have been conserved by the museum laboratory.

Documentation and collections audit
Although there is no formal stocktaking programme, the collections are being checked during the current documentation scheme and are subject to frequent use by staff. In addition, Internal Audit undertakes an irregular sample spot check. The available documentation is referred to during the checks, providing both store lists and master records against which the objects can be compared. It is not felt that additional documentation (as compared with comprehensive coverage) would help.

The current emphasis on documentation within the museum was partly prompted by critical comments from auditors following a theft in the 1970s. Their attitude and support was felt to be most constructive. Following the most recent audit, they have expressed satisfaction with the current procedures.

In the event of a loss from the collection, the Director would report to the insurers and auditors, and the documentation would be annotated.

Deacquisition and insurance
In the rare cases of disposal, the decision is taken by the Director in consultation with the museum management committee. The relevant records are annotated and retained within the documentation system. The collection is insured.

Object collections documentation

Pre-entry stage
Staff discuss potential acquisitions with the Director, when necessary. A file may be opened for the item concerned.

Entry stage
With the exception of the field department, the number of items entering the museum is low (about 100 a year). The two museums act independently when receiving items, with the initial action being undertaken at the entrance desk, either by the receptionist or by the curator. Although different procedures are adopted for acquisitions, enquiries and field material, all items are processed immediately. Those items that are known to be for acquisition will be given an accession number (typically just 10 per annum for archaeology); other more random entries for enquiry, etc., will be given a temporary enquiry number (about 70 per annum); and those brought in by the field staff, a field department code.

Both acquisitions and enquiries are normally documented by a curator, noting basic details about the depositor and the item. The permanent accession number or the temporary enquiry number is written on the package holding the objects. Details of correspondence, etc., are kept in

ring binders and envelopes. The appropriate procedures are summarised on an information sheet.

In the case of the small number of enquiries, a verbal identification is given if possible. If not, a temporary number is assigned and an enquiry form completed when the object enters the museum. A report on the item is added to this form. The enquiry is normally managed by the relevant curator until it has been considered, after which it is stored in a specific cabinet. If the object is not collected within three months, a letter is sent to the enquirer asking them to retrieve the item. Brief notes of verbal enquiries are kept in the curator's diary for statistical purposes. For other enquiries, a copy of the enquiry form is filed in numerical order.

Acquisition stage
The decision to acquire a group is taken by the Director and relevant Keeper, after which responsibility for action rests with the Keeper, who will check the museum's entitlement to acquire the group. A letter of acknowledgement is sent to the depositor giving basic details of the group and its method of acquisition.

The museum does not record acquisitions in a bound register. It considers the item record cards fulfill this function adequately. These are prepared in permanent ink and amended as necessary. Two copies are produced, one of which is filed centrally to form the 'register' sequence. Most acquisitions are single items, with a grouping procedure being adopted only in exceptional circumstances (such as identical material with common documentation). The number first assigned to the group when it enters the museum is treated as its accession number. It has the form 'year + running number', and is assigned centrally. A single sequence is used for the whole museum. The number is marked on the object itself, and lacquer applied as a protective layer.

A file is opened for the acquisition, to include any correspondence, photographs, receipts, etc.

Objects are initially kept in a safe or the Keeper's office until they have been accessioned, after which they are passed for inhouse conservation.

The museum receives a negligible number of items on loan. In general, they are treated as if they were enquiries, receiving a temporary number and being documented on an enquiry form. In addition, an informal loan document is signed by both parties and steps taken to provide specific insurance cover. They are not included in the long-term item documentation.

Item stage
As already noted, new acquisitions are processed to the item documentation stage soon after receipt (within a month). Two copies of the item record are prepared, one of which is held centrally (in numerical order) and the other within the department (in classified order). The majority of the early collection is not yet documented to this extent (particularly in the case of the

field collections). Work is done by relevant curatorial staff with no help from MSC teams.

The Museum uses MDA record cards on which standard information, including storage location, is noted. The location details are amended if the object is moved for a significant period. The record will often be non-intensive, and more information may be addded at a later date. The records are being computerised by the MDA computing bureau. After the initial computerisation, both manual and automated records are maintained. The accession number continues to be used to uniquely identify the object. When an old acquisition is being reprocessed it is assigned a new accession number (the numbering system having been introduced in 1978).

A basic procedural manual is used to guide completion of the record, with some control over terminology.

Supplementary details, if available, are kept in a file arranged in numerical order.

Permanent locations are noted on the item record, when available, and in the corresponding computer file. A computer index in location order is maintained, which gives details of specific location and object number. (As implied earlier, this is only available for a small proportion of items at present). In addition, for those parts of the collection that have been accessioned, an inventory sheet is kept at each store location, on which movements of objects are logged. In theory, an effective track is maintained of all accessioned items.

Output stage

Completed item records are being computerised by the MDA computing bureau. The resulting file (in numerical order) is considered to be the catalogue of the collection. Copies are available on printout and microfiche. These copies include all available information from the item record. They are accessible to all staff and to the public at the discretion of staff. The processing is coordinated by the Documentation Officer.

Similar procedures apply to the computer aided preparation of indexes, which are also available on printout and microfiche. In addition, a manual classified index is available for archaeology. As noted above, one copy of the item record is also held in classified order. A label is also usually prepared with basic details about the item. If the item is on display, its label is preserved in a supplementary information file. Information sheets are produced occasionally.

Exit stage

The Director authorises the few loans-out that take place. Each year a condition report is noted on the item record, and checked on the return of the loan. The details of the loan itself are noted on the item record, and copies of correspondence, etc., added to the supplementary file. A loan form is not used. The relevant curator is responsible for ensuring that the

loan is returned by the agreed date. This date is subsequently noted on the item record.

Prior to the loan, the insurance and audit advisors in the local authority are consulted and insurance cover extended to include the loan.

Other documentation

Records are available for conservation (laboratory treatment sheets). Limited site records are also held, using MDA locality cards. The field archaeology department maintains context, item and group records of recently excavated material.

Museum comments

While noting the need for comprehensive coverage, the system does seem to satisfy all the current and future needs of the museum. The current procedures are felt to be effective.

It is recognised that procedures for entry of items and loans-out are not sufficiently formalised, but the small number of objects requiring this type of documentation allows adequate control by informal methods. The small proportion of the social history and natural science collections with adequate documentation is disconcerting, but should improve in the future.

Documentation of the 'bulk' archaeological excavation material represents a serious problem, which should be eased by initial processing and basic records. Locality recording is also weak, but should be improved in the future.

Update

Further details of the museum and its documentation procedures are given in a recent paper (Stone, 1985).

The museum now has three centres. Kyngston House Resources Centre was opened in 1984, and provides additional storage space for the collection, offices for the field archaeology section, and accommodation for archaeological diggers.

The staff resources available for documentation have increased. The part-time cataloguing post is now a full-time museum assistant post: this person spends approximately 80% of his time on documentation, making an input into both archaeology and social history cataloguing.

The museum now has an Epson portable microcomputer for inhouse data entry for the social history collection. Only very basic information is recorded.

Major advances have been made in the area of control documentation (as a direct result of the visit in 1982) and both museums now use MDA entry, exit and transfer of title forms. Objects brought in for identification are still recorded on enquiry forms. Major developments have also taken place on the computerisation of the archaeological collection records. The produc-

tion of cumulative indexes has led to more efficient searches for information, and has greatly improved terminology control for simple name, full name and site name terms. The large size of the archaeological collection catalogues has caused problems of updating, and a new separate store file and index has been created to make store location updates easier and cheaper (see Figure 16). Over 25 000 items have now been accessioned into the new system since 1978.

Dii3.12 Saffron Walden Museum

Introduction

Report based on a discussion with Mr Len Pole (Curator), 8 March 1982.
A brief reference to revised procedures is given at the end of the report.

Museum framework

Management/resources

The museum is a local authority (District Council) service and private trust museum, with the collections owned by the society, on loan to the local authority. While noting the dominant financial input in recent years by the local authority, new acquisitions are the property of the society. The administration of the museum is governed by the constitution of the society.

The museum is arranged as a single unit, with a Curator, Assistant Curator and Conservation Officer.

Conservation and display are considered to be of primary importance, with documentation serving as an adjunct to both.

Collections

The museum has large and important object collections dating back over the 150 years since its foundation and totalling around 130 000 objects, photographs and archival items (including 80 000 natural history specimens). The annual growth rate is low, averaging some 300 acquisitions (including groups).

The museum has an internal acquisition agreement which is now being formalised, based on curatorial knowledge of the collections, and strongly influenced by storage limitations. The museum is concerned to cooperate in providing county-wide collecting agreements through the Essex Curators Group.

Documentation framework

Documentation management

The Curator coordinates documentation procedures, with all three full-time staff being involved in their implementation. The first documentation priority is the full documentation of new material and the location control of

the rest of the collections. Full cataloguing of all material remains the long-term aim when staff and resources are available.

Documentation resources
The three full-time staff each spend 20% of their time on documentation duties. They are assisted by part-time volunteers. Basic internal procedural notes and a flow chart are available as a complement to the MDA guidelines. Training is in-service and at MDA seminars. No use has been made of computers.

The only quantifiable costs are that of staff (estimated by the investigator to be over £5000 per annum) and MDA cards, cabinets, etc. (estimated at £700 over the past three years).

Documentation system
The museum is having to concentrate on both the documentation of new material and the reprocessing of old collections (Figure D27) (Pole, 1983). New acquisitions are logged in a day book and then individually registered in a bound volume. In parallel with registration, an MDA item record, a donor index card and an internal location record are prepared. The latter is also used when any uncatalogued object is moved within the museum. It is then maintained as a location log for that object. If the object needs immediate treatment, a conservation card is also made out. An entry form is completed for enquiries and loans coming into the museum. Significant proportions of the old collections are being reprocessed, with this involving their being re-registered and then having an item record prepared.

Certain parts of the collection (ethnography, some ceramics and recent acquisitions) are fully documented. In other cases, work is being concentrated on basic item documentation for location control purposes. 75% of the archaeology collections, 50% of the social history and less than 50% of the natural history material has been processed in this way.

The documentation is heavily used by researchers and when developing new displays.

Consideration has been given to the security of the documentation. Records are kept in a secure, but not fire-proof, room, and access is limited to staff. The registers have been microfilmed. Photographs are taken of important objects and during any conservation work.

Documentation and collections audit
Although there is no specific stocktaking programme, the more important parts of the collection are regularly checked through use and recataloguing. Both Internal and District Audit have undertaken limited dip checks from the register. They have not recommended any changes to the procedure.

Deacquisition and insurance
Losses are reported to the committee, and the records annotated. The collection is insured.

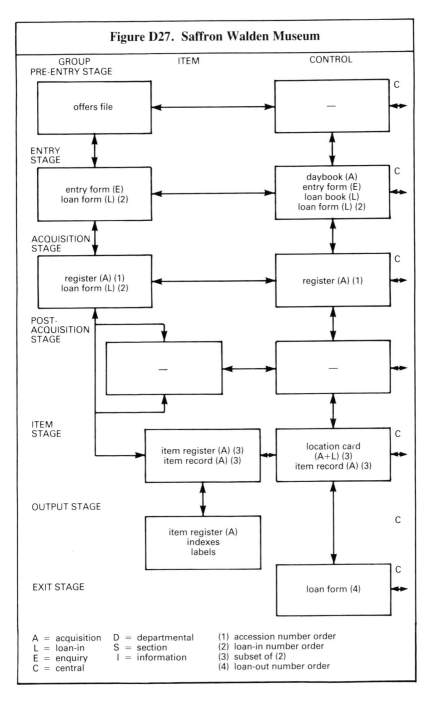

Figure D27. Saffron Walden Museum

GROUP ITEM CONTROL

PRE-ENTRY STAGE

offers file — C

ENTRY STAGE

entry form (E)
loan form (L) (2)
daybook (A)
entry form (E)
loan book (L)
loan form (L) (2) C

ACQUISITION STAGE

register (A) (1)
loan form (L) (2)
register (A) (1) C

POST-ACQUISITION STAGE

— — C

ITEM STAGE

item register (A) (3)
item record (A) (3)
location card
(A+L) (3)
item record (A) (3) C

OUTPUT STAGE

item register (A)
indexes
labels C

EXIT STAGE

loan form (4) C

A = acquisition D = departmental (1) accession number order
L = loan-in S = section (2) loan-in number order
E = enquiry I = information (3) subset of (2)
C = central (4) loan-out number order

441

Object collections documentation

Pre-entry stage
Details of potential acquisitions are noted in an offers file or in a Daily Event Book if made verbally or by phone.

Entry stage
Different procedures are used for acquisitions, long-term loans and enquiries and short-term loans, with the distinction being made at the time of receipt whenever possible.

Acquisitions are passed to the curator's office, where they are logged in a day book. They are assigned a permanent accession number which is added to the group or individual object it represents. The new items are included in the museum insurance cover. Correspondence etc., is added to an accession file, in date order.

Long-term loans are noted in a loans book and on a numbered two-part form which acts as a receipt for the depositor. They are also tagged with the loan number, and steps taken to include them in the insurance cover. The form is kept apart from the loan. Correspondence, etc., is ordered in a loans file.

Requests for identification, etc., are dealt with informally, and only documented in the recently opened Daily Events Book. More significant enquiries and short-term loans are noted on the entry form (around 50 per annum). The depositor is expected to collect the object after a reasonable period, when a verbal answer will be given in response to the enquiry. The museum retains a copy of the enquiry form.

Material also comes in for conservation, in which case independent documentation is prepared.

Acquisition stage
After a decision concerning an acquisition, the group is logged in the day book and in a bound register. A letter of acknowledgement is usually sent to the depositor. Its constituent objects are assigned individual item numbers.

Correspondence, etc., is retained in the general acquisition file. The resulting documents are kept in the museum office.

Long-term loans are noted in a loans book and on a loans-in/deposit form. A letter of acknowledgement is forwarded to the depositor. The loan is assigned a unique number which is tagged or marked on the object. Details are included in the loans file.

Item stage
As noted above, details of acquisitions are noted in a hard-bound register, with ruled columns but no printed headings. Each object is described and illustrated in some detail in the register, including initial storage location. Individual item numbers are marked on each object. The register is annotated if significant changes become apparent, but not for minor actions such as change of location. It is kept in the Curator's office. In addition, an

MDA record card is completed and filed in numerical order, usually immediately after registration. The location is also noted on the card, but not subsequently amended. Terminology is controlled by following the MDA guidelines and referring to an object name thesaurus developed by the museum.

Large parts of the collection have inadequate item records and a recataloguing process has been underway for some years. If an item cannot be found in the old registers it will either be re-registered (and renumbered) or given a temporary number to enable it to be referred to in the documentation procedures.

No specific object files are prepared, correspondence, etc., being added to the general acquisition files. A microfilm copy of the files is kept at the County Record Office.

A location card is prepared for each object when it is catalogued, or if not yet catalogued, when it is moved. This card includes a summary of the information for that object, including name, number, description, condition and a series of detailed store entries. Each time the object is moved, a new location entry is added to the card, together with the mover's name and date. The purpose of the system is to provide a means of location control for use when finding objects and when undertaking stock checks. The cards are kept in the store, arranged in object name order not location order. They therefore act as both an index and a stock list for a subject rather than for a location.

Output stage

A separate catalogue is not maintained. Indexes have been prepared for parts of the collection, notably name, donor and location lists for the social history material. Basic labels (including object number) have also been prepared for some parts of the collection. An information sheet describing some parts of the ceramics collection is available.

Exit stage

The museum uses a numbered loans form for a group of objects borrowed by an institution, with the loan being managed by the curatorial staff. A note of the loan and its return are included on the location card.

Disposals are referred to the society committee, and the records for that object then annotated.

Other documentation

The museum maintains conservation files, photograph records, a bibliographic catalogue and records of localities with a local history interest.

Museum comments

Although the system has developed empirically and is subject to improvements, it is felt to be effective and satisfactory. The museum is conscious of

the need to revise the enquiries procedure, with a more detailed form giving the museum the option of disposing of uncollected items, and of needing additional copies of documents and fire-proof storage conditions for the master set of documentation. It is also concerned to complete its long-term cataloguing programme. It is interested in the potential use of a word processor or microcomputer, particularly for the new conservation records.

Update

Two separate forms are now used to log enquiries and incoming short-term loans. The enquiry procedure itself has been revised to allow the disposal of uncollected items.

Dii3.13 Sheffield City Museums

Introduction

Report based on a discussion with Mr John Bartlett (Director) and Miss Anneke Bambery (Assistant Keeper, Applied Arts), 31 March 1982.

Some changes have been made to practical procedures in the intervening period, details of which are given at the end of the report.

Museum framework

Management/resources

The museum is a local authority (Metropolitan District Council) service, with five centres:

City Museum
Abbeydale Industrial Hamlet
Bishops' House
Sheffield Industrial Museum
Shepherd Wheel.

The museum is arranged on a sectional basis:

Antiquities
Applied Arts
Natural Sciences
Extension Services
Industrial Sites (Abbeydale and Shepherd Wheel)
Industrial Collections
Industrial Conservation.

These sections are assisted by a central Administration. The Director and Deputy Director are supported by departmental Keepers and Assistant Keepers.

Collections
The collections include some 120 000 objects with an even spread across the museum's sections. The growth rate is less than 1% per annum, with the exception of natural history field work. Other important material includes about 10 000 record photographs, a growing archive collection (including a large collection of archaeological archives relating to field work and objects) and central library stock in the central museum (around 10 000 items) and Kelham Island (about 1000 items). There are also sectional conservation and locality records (within archaeology, natural sciences and industry).

Individual sections have agreed acquisition policies which, in the case of Natural Sciences, have been published. The emphasis in on local material and the further development of existing holdings, based on a curatorial knowledge of the present collections. In the case of Antiquities, the policy incorporates cooperative arrangements with other museums.

Documentation framework

Documentation management
Documentation procedures are implemented by the curatorial staff within individual sections. The Director is responsible for any policy proposals and changes, the implementation of which would then be discussed at group meetings of section staff. Equal emphasis is placed on accessioning and cataloguing of new material, documentation of previously uncatalogued material and recataloguing of inadequately recorded material.

Documentation resources
The museum has approximately 20 curatorial staff, whose involvement with documentation varies considerably. (The investigator estimates the average as 5% of their time, excluding the current exceptional stocktaking programme.) With the exception of one site recording scheme, temporary staff have not been involved in documentation duties. Staff use the MDA guidelines for item documentation, supplemented by internal conventions detailed in a folder. Training is both in-service and by attending MDA seminars.

No use has yet been made of computers, apart from cooperative collection research projects. The museum is, however, interested in inhouse use of microcomputers.

Costs include recurrent expenditure on consumables, attendance at training seminars and staff time (estimated by the investigator at around £10 000 per annum).

Documentation system
Material coming into the museum is first logged on a receipt form and then passed to individual sections for examination and processing (Figure D28). Acquisitions and long-term loans are detailed as individual objects in sectional registers and items records are prepared on MDA record cards. The museum is currently involved in a comprehensive stocktaking programme to assess the current state of documentation.

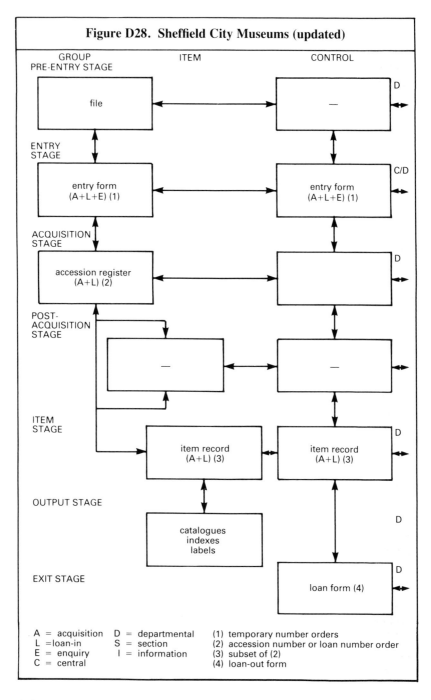

Figure D28. Sheffield City Museums (updated)

A = acquisition D = departmental (1) temporary number orders
L = loan-in S = section (2) accession number or loan number order
E = enquiry I = information (3) subset of (2)
C = central (4) loan-out form

It is estimated that all important material has been accessioned. The degree and quality of item documentation varies between sections, being estimated by 50% in Natural History, 60% in Antiquities and 85% in Applied Art. A stocktake is in progress, one of the functions of which is to identify the proportion of uncatalogued material. It is appreciated that comprehensive cataloguing, while desirable, would require years of work.

Primary uses include internal collections management, responding to outside enquiries and undertaking research. The archaeology and natural science locality records are in particularly frequent use.

Central files are kept in a locked catalogue room accessible only to staff. Sectional records are to be stored in lockable cabinets in the future. The museum has a programme to microfilm old records, which has now reached back to 1920. The microfilming is done in the museum itself, by an outside firm. Photographs are taken of important items.

Documentation and collections audit
All sections are involved in a comprehensive stocktake of the collections, the first such exercise to have been attempted since 1967. The primary function of the programme is to assess the proportion of the collection that has been catalogued to ensure the existence of acquired items and to confirm their location. It is expected to take a major proportion of staff time over a twelve month period. The work has been initiated following internal discussions, without any active involvement of outside parties, such as auditors. The programme involves working through the collection itself, and checking the objects against whatever records are available. A proportion of anomalies are anticipated. As part of the exercise, photographs are being taken of valuable objects.

More generally, the Director coordinates a regular annual dip check by non-departmental staff. Typically, thirty items are selected from the records of each section which the local staff then have to trace. Staff from other sections supervise and report on the results. This programme was prompted by Internal Audit. The auditors themselves carry out sample checks of the collection in cooperation with sectional staff.

Deacquisition and insurance
The Director considers any losses, after which the records are annotated. Comprehensive insurance is provided for specified valuable items; fire insurance for the rest of the collections.

Object collections documentation

Pre-entry stage
Any potential acquisition is referred to the relevant Keeper. A file is opened in exceptional circumstances.

Entry stage
The museum deals with a large number of enquiries (roughly 1000 each

month), the majority of which are answered immediately and not documented. Nearly all other groups left in the museum are first logged on a receipt. (The exceptions are known purchases and material collected in the field by staff.) Two styles of receipt are used: for loans and for enquiries/ acquisitions. The two-part loan form is completed by curatorial staff. The numbered three-part enquiries/acquisitions form is either completed at the enquiry desk or by a member of the curatorial staff. One copy of the form is given to the depositor, another attached to the group itself and the third retained in the receipt book. The material is then processed within the relevant section, where it is held in a designated area.

The scale and type of enquiries are monitored. After the object has been identified, the depositor is contacted and it is returned to the central cataloguing room to await collection. If not retrieved after six months, the depositor is advised that the museum will dispose of it. In practice, however, all such material is retained in the museum basement.

Degradable natural science material which comes into the museum for initial examination is logged in a freezer day book prior to a decision concerning acquisitions.

All groups coming into the museum are covered by the basic insurance policy (fire risk). Valuable material is covered for all risks.

The section will open a supplementary file should this be necessary. General correspondence files are retained in the museum office while those relating to specific collections are held in the sectional offices.

Acquisition stage
The decision to acquire a group is taken by the Keeper, with reference to the Director if necessary. The section staff are then responsible for processing the group. A letter of acknowledgement is sent to the depositor. The group is then entered in the sectional accession book (day book) – a hardbound book that is kept in the local offices – and assigned a permanent accession number on a 'year + running number' basis. The museum has a unified numbering system, with blocks of numbers from within this system being assigned to individual sections. Most items coming into the collection are processed individually, even if they originate as a group from one depositor. Details entered in the book refer to the depositor and the item, but do not include storage location. The item itself is, however, held in the office until item documentation has been completed and a specific storage location can be assigned to each object. The daybook system has been used since the last century, except for a decade prior to 1975 for which no such records exist. The details in the register are only amended if significant changes are identified, in which case the corrections are signed and dated.

Loans into the museum are now infrequent except for temporary exhibitions. They are considered and processed by the curatorial staff with reference to the Director if necessary. A numbered loan form is completed for each item. If a long term loan, the item is then processed following the

standard accessioning procedure, with details being entered in the register. The loan retains the number allocated to it on its form.

Item stage
Individual item records are prepared fairly promptly after accessioning, depending on local circumstances. The work is done by the permanent staff using MDA record cards (Bambery, 1982) (see Figure 15). There is usually a one-to-one relationship between the accession and item records. Standard details are recorded at this time, including storage location, which is subsequently amended if there is a permanent move. The individual item numbers are based on the earlier accession number, with the addition of a suffix should this be necessary. The procedures and recording conventions are based on those given in the MDA guidelines, supplemented by internal notes.

Small parts of the old collections have been reworked in recent years, but the bulk of the material needs recataloguing to the new standards. Records prior to 1978 are noted on basic cards.

The original manuscript copy of the record is stored in subject order in the section, with a typed equivalent in numerical order in the central files. Microfilm copies of the old records (pre-1978) are also available in the museum library and a separate building. The records are only accessible to staff. They are checked occasionally by the Director and auditors.

In addition to these cards, the Antiquities section also uses a data sheet and logs items in its locality files.

Supplementary files are held in the section offices. Natural Sciences, for example, hold files of object and collector information.

The museum does not maintain a separate location list. It does, however, note the current location of each catalogued object on its item record. This is currently being checked. Sectional staff are responsible for movements, noting long-term changes on the relevant item records. Material can usually be found with little difficulty.

Output stage
The item records, in subject order, are considered to form a catalogue of the collections. Although there are no central indexes, each department prepares a donor index on basic cards. Other indexes are also produced according to individual requirements. Detailed labels are prepared for the Natural Science collection. Information sheets and booklets are available for parts of the collections.

Exit stage
Loans from the museum are administered by the curatorial staff who complete a loans-out form and arranged insurance cover, etc., in consultation with the Director. The form used is common to the whole museum,

although held on a sectional basis. Once copy is passed to the recipient and another retained in a loans file. Long-term loans are also noted on the item record.

Any disposals are considered by the Director, after which the records are annotated.

Other documentation

From a documentation viewpoint, the museum frequently treats material such as archives and photographs as if they were objects, using standard item record cards. Record photographs of the collection are stored on a sectional basis, in accession number order, with a note on the item record. Conservation details are also noted on the item record and in conservation daybooks. Library items are noted in a daybook, numbered, and then included in an author index. Separate locality records are held in Natural Sciences and Antiquities with associated maps, etc.

Museum comments

The system is felt to be reasonably effective although there are obvious areas for improvement. The museum is most concerned about the backlog of uncatalogued and inadequately catalogued material. The sectional emphasis within the museum does lead to problems when trying to develop new procedures and control standards.

The museum is concerned to develop its procedures as allowed by available resources. It is interested in the use of inhouse microcomputers to help with the documentation of the backlog.

Update

Various improvements and alterations of procedures have been introduced since 1982. Two new forms have been adopted in place of the acquisitions, loans-in and loans-out forms. The entry form is based on the MDA design, with variations to cater for specific needs. This is used as an initial record for gifts, purchases, loans and enquiries. Similarly, the MDA exit form has been adopted for loans-out.

The entry form is completed either at the reception desk or by a member of the curatorial staff. In the case of a long-term loan-in, the item is then recorded in the daybook before being allocated a number from a central museum register. The loan numbering sequence is distinct from that for permanent acquisitions. The item is then recorded on an MDA card in the same way as a permanent acquisition.

The exit form is completed by the curatorial staff in support of any loans from the museum. As before, these loans are also noted on the item record.

Dii3.14 Stevenage Museum

Introduction

Report based on a discussion with Mr Colin Dawes (Curator), 8 March 1982.

Information about subsequent progress is given at the end of the report.

Museum framework

Management/resources

The museum is a local authority (Borough Council) service, arranged as a single unit, with two curatorial staff. The primary areas of concern are to develop the collections of objects and photographs (particularly where this can illustrate the past history of a rapidly changing urban environment) and to ensure their adequate storage, conservation and documentation, to prepare displays and to record local oral history.

Collections

The main collections are of objects (12 000, with an annual growth of about 400), photographs (20 000, increasing by 500 per annum), archival items (1000) and oral history tape recordings. The collections reflect the history of the area and the development of the new town.

The museum acquisition policy defines its geographical area of interest to be within the borough and its immediately surrounding villages. It hopes that the policy can be extended to include agreements with other museums in the county.

Documentation framework

Documentation management

The Curator coordinates procedures. The documentation priorities are to transfer details of all objects and photographs onto MDA record cards and to index the photograph collections.

Documentation resources

The two curatorial staff each spend 20% of their time on documentation duties, with these being defined in their job descriptions. They are assisted by one volunteer for a day each week, and by a new MSC scheme, which involves two staff in a twelve month project to document the photograph collection. It is hoped to extend this scheme for a further twelve months.

The museum follows the MDA instructions for item documentation, supplemented by the common conventions agreed by the Bedfordshire and Hertfordshire Curators Group. Training is given in-service and at MDA seminars. No use has been made of computers.

The only significant cost is that of staff, estimated by the investigator to be £3000 per annum for the permanent establishment.

Documentation system

The primary concern has been the documentation of the object and photograph collections, concentrating on immediate recording of new material and the gradual processing of the backlog (Figure D29) (Dawes, 1982). All items coming into the museum are logged on an entry form and assigned a temporary number. Acquisitions and long-term loans are accessioned and have an item record prepared as soon as possible after receipt. Neither a catalogue nor indexes have been produced, although they are planned (particularly in the case of the photograph collection).

Although all items have been accessioned, only 20% have been fully recorded as individual item records. This includes all items on display.

Extensive use is made of the photograph collection, hence the need for effective catalogues and indexes to enable the museum to retrieve relevant images to answer an enquiry.

Care has been taken to ensure that the register and item records are kept in separate rooms, each of which is secure and accessible only to staff. Photographs are taken of valuable acquisitions and long-term loans.

Documentation and collections audit

No stocktaking is carried out. Although the museum has both internal and external auditors, they have not considered the integrity of the collection or its documentation.

Deacquisition and insurance

Losses are reported to the controlling body and the record annotated. Parts of the collection are insured.

Object collections documentation

Pre-entry stage

Most potential acquisitions are treated informally, but details may be included in a donation file, if necessary.

Entry stage

Approximately 400 acquisitions and 50 enquiries are retained in the museum each year. Each is documented on a pre-numbered three-part entry form, one copy of which is given to the depositor, one kept with the object and one filed in numerical order. The number is in a straightforward sequence, prefixed by 'E', indicating an entry.

The group and its associated form are passed to designated shelves in a store room and subsequently processed by staff (during which they pass from one shelf to another, indicating their progress). The form includes details of the depositor and a brief description of the group. After processing, the depositor is asked to retrieve the item and countersign the museum copy of the form. Details of the response to the enquiry are given separately. The form is retained by the museum, in numerical order.

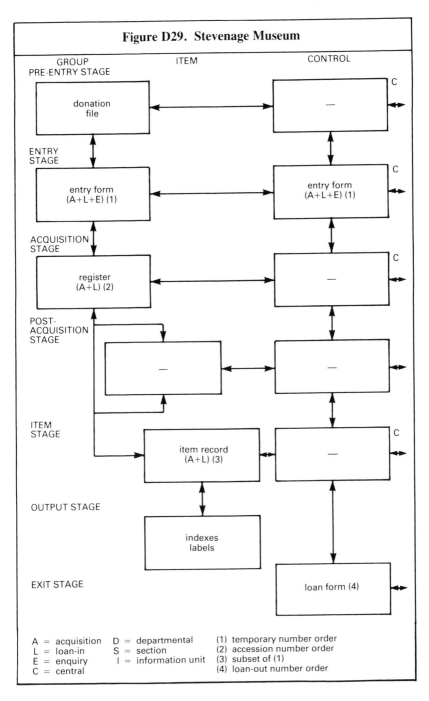

Figure D29. Stevenage Museum

A = acquisition D = departmental (1) temporary number order
L = loan-in S = section (2) accession number order
E = enquiry I = information unit (3) subset of (1)
C = central (4) loan-out number order

The museum also borrows photographs for copying, in which case the originals go through the entry procedure.

These groups are not covered by the museum's insurance, other than in exceptional circumstances.

Correspondence, etc., will be kept with the file copy of the form in the museum's general office.

Acquisition stage

The Curator assesses whether to acquire an offered item and is then responsible for subsequent action, including checking the museum's entitlement to take the group. Similar procedures are adopted for long-term loans.

The entry form is annotated and a receipt and letter of thanks sent to the depositor. Steps are taken to ensure that major acquisitions are included in the insurance cover. An item record card is prepared for each object, after which an entry is made in the museum register. This is a simple bound cash book, without printed headings, in which are noted details of the depositor and a brief description of the group. Details of storage location are not included. The entries are ususally restricted to one line. They may refer to a group, in which case a specific reference will be made to each object in the group. The register is then amended only if significant information comes to light.

The object numbering system consists of a 'running number (for the group) + year + S suffix (for Stevenage)'. The photographs are assigned a 'P + running number'.

The group is retained in the office until the register entry and item record have been prepared, after which it will be incorporated into the collection.

Material is borrowed on short-term loan only if it is needed for specific display within the museum, with the decision being taken by the Curator. Details of the loan are noted on the entry form. It is not accessioned. Steps are taken to ensure that the loan is insured.

Item stage

As noted above, item records are prepared for each new acquisition or long-term loan. This is done as soon as possible after receipt of the object, prior to the parallel accessioning process, by either the Curator, volunteer or (in the case of the photographs) temporary staff. Standard details are noted on MDA record cards, but the storage location is not included. The MDA guidelines and county conventions are followed when recording information. The items are assigned unique numbers, based on a subdivisions of the accession number (by incorporating a third element between the running number and the year suffix).

Significant parts of the old collection have been recatalogued to this standard in recent years (including all objects on display).

A single copy of the record is prepared and filed in numerical order. (The collection itself is in an informal subject order which is to be changed to a SHIC sequence.)

No detailed files are kept for the individual objects themselves.

No control documentation is available, except for lists of those objects that are on display. Any internal movements are carried out by the Curator and have no effect on the documentation.

Output stage
No catalogue is prepared although subject sequences may be produced in the future. Similarly, no indexes have yet been prepared for the object collections. The current scheme to process the photographs will, however, include three indexes, arranged by date and then by personal name, subject and place name. Labels are prepared during the accessioning procedure, with basic information (number, name and provenance) about the object.

Exit stage
The museum has an active loan programme to local schools, etc. Following approval by the Curator, a pre-numbered three-part loans-out form is completed with details of the object and the recipient, who is then asked to sign the document. Copies of the form are passed to the recipient, the education office and a loan file. The file copy is retained in numerical order, being transferred to a parallel 'returned' sequence at the end of the loan. The work is coordinated by a clerical assistant.

After a decision to dispose of an item by the Curator, the records are annotated.

Museum comments

Within the limitations of restricted staff time, the museum is generally satisfied with its system, although concerned to introduce indexes and history files and have more effective control procedures. It is working towards the completion of its item records and the subsequent preparation of indexes, paralleled by a reorganisation of the store to accord with the SHIC classification.

Update

A new external store is now being added to the museum, as a result of which storage locations will gradually be added to the item records.

The new MSC scheme has since been extended and enlarged to cover more aspects of the photograph collection. 90% of the black and white photographs have been catalogued and indexed. A further MSC scheme has been introduced to help with oral recording, with the work including the transcription and indexing of the recordings.

The SHIC system has been adopted for use with the object and oral history collections in addition to the photograph collection. In addition, the Hertfordshire simple name list is used to standardise object names for local history material.

It is planned to revise the existing entry form and to begin the computerisation of documentation.

Dii3.15 Stoke-on-Trent: City Museum and Art Gallery

Introduction
Report based on a discussion with Mr Geoff Halfpenny (Keeper, Natural History), 16 March 1982.
 A brief reference to subsequent developments is given later.

Museum framework

Management/resources
The museum is a local authority (District Council) service, with three site:

 City Museum and Art Gallery
 Ford Green Hall
 Spitfire Museum.

It is arranged on a departmental basis, with six collecting departments:

 Ceramics
 Decorative Art
 Fine Art
 Archaeology
 Natural History
 Social History.

It has a separate Administration and a Design/Display section, with responsibility for a photograph collection, but no internal conservation service.
 The Director is supported by departmental Keepers and Assistant Keepers, with a total of 12 curatorial staff.

Collections
One of the great historical strengths of the museum has been its important ceramics material, now complemented by collections of fine and decorative arts, natural history (including geology), archaeology and social history. There is also a separate photograph collection. The size of the collections has not been quantified, although that in Natural History is around 100 000 specimens, with a growth of over 1000 per annum.
 Both Archaeology and Natural History have a locality recording programme (the latter including both natural history and geology sites, undertaking a broad county function). A survey of historic buildings in the city is also underway.
 There is no overall acquisition policy, decisions being delegated to individual departments, based on their knowledge of the collections. The museum cooperates with the Staffordshire County Museum where relevant.

Documentation framework

Documentation management
Although general policy is discussed at regular meetings of senior staff, the individual departments have considerable independence in the development and implementation of procedures. Changes involving more than one department depend upon personal initiatives by the staff concerned. The first priority is that of acquisition documentation.

Documentation resources
All the curatorial staff are involved in documentation to varying degrees, with these duties specified in job descriptions. A temporary employment project is also planned, to upgrade the standard of departmental records. There are no formal procedural manuals, with training being undertaken in-service within the individual departments.

No use has yet been made of computers, although the museum is interested in the future application of microcomputers.

Documentation system
The emphasis within the system is on departmental action and responsibility, supported by central assistance (Figure D30). Most objects entering the museum (the exceptions being those brought in by staff for immediate acquisition) are noted on an enquiry or loan entry form. In the case of acquired material, the Keeper completes a transfer of ownership form and details the group in a departmental accession register. Individual item records are prepared at a later date. Loans-in and loans-out go through comparable procedures, being noted in central loans registers. Duplicate copies of key documents are passed to the local authority for security and audit purposes.

The majority of the collections have been accessioned but the degree of item documentation is variable.

Significant uses of the documentation include answering enquiries and responding to audit investigations.

Care has been taken over the security of the documentation, with duplicate copies of registers and item records being held by the local authority, and departmental documents being kept in locked cabinets. Staff have to sign-out the old registers from the central office. The environment of the building and the physical quality of the records themselves is of high quality. Photographs are taken of all ceramics and other significant objects.

Documentation and collections audit
No staff stocktaking is carried out, other than by use of the collections. Internal Audit does undertake an occasional dip check of about 10 objects from each department. The objects are selected from the duplicate records held at the Town Hall. The curators are required to trace the objects through the accession register or item records. The internal auditors have

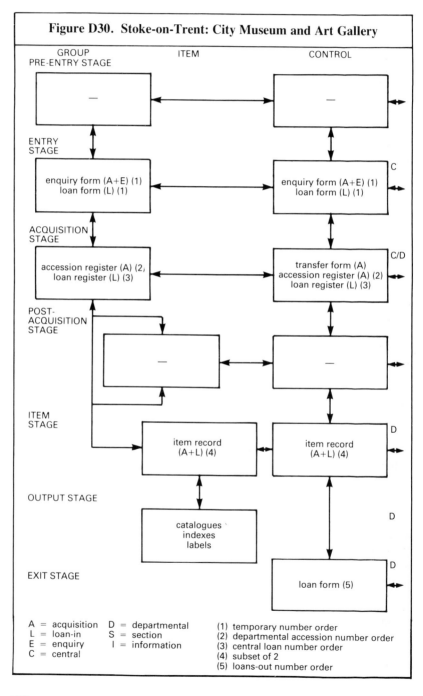

Figure D30. Stoke-on-Trent: City Museum and Art Gallery

GROUP	ITEM	CONTROL

PRE-ENTRY STAGE
— ↔ — ↔

ENTRY STAGE
enquiry form (A+E) (1) / loan form (L) (1) ↔ enquiry form (A+E) (1) / loan form (L) (1) C

ACQUISITION STAGE
accession register (A) (2) / loan register (L) (3) ↔ transfer form (A) / accession register (A) (2) / loan register (L) (3) C/D

POST-ACQUISITION STAGE
— ↔ —

ITEM STAGE
item record (A+L) (4) ↔ item record (A+L) (4) D

OUTPUT STAGE
catalogues / indexes / labels D

EXIT STAGE
loan form (5) D

A = acquisition D = departmental
L = loan-in S = section
E = enquiry I = information
C = central

(1) temporary number order
(2) departmental accession number order
(3) central loan number order
(4) subset of 2
(5) loans-out number order

also made specific recommendations concerning loans procedures, which are reflected in the current systems for loans in and out.

Deacquisition and insurance
Losses are reported to the museum committee and the record annotated. The collection is insured.

Object collections documentation

Pre-entry stage
No formal file is prepared prior to an acquisition.

Entry stage
All groups coming into the museum are documented at the information desk, except for material brought in by staff and intended for acquisition. The assistant at the desk uses an entry form, noting basic details about the group and the department. Separate sets of pre-numbered three-part forms are kept for each department. One copy is passed to the depositor as a receipt, the second to the relevant curator and the third kept with the group. The group itself is bagged and tagged, and passed to an identification room to await attention.

The response to the enquiry is noted on the entry form, one copy of which is returned to the information desk with the object itself. The depositor is asked to retrieve the object a week after it was left. The form notes that such material may be disposed of after fourteen days.

A copy of the completed form is kept in the department and a third may be retained at the desk. In addition, details of the enquiry are noted in a bound enquiries book. Both this and the form are used as one basis for the preparation of the annual report.

A further complication in Natural History relates to incoming corpses and other specimens which may not be suitable for preservation. The department uses a separate fridge book (miscellaneous natural history register) for this material until it can be decided whether it should be formally acquired.

The incoming items are covered by the museum insurance policy. No separate correspondence file is prepared.

Acquisition stage
The acquisition procedure is coordinated within departments, with the Keeper referring proposed purchases to the Director and museum committee. A new pre-numbered three-part transfer of title form (similar to the MDA equivalent) is completed for gifts and an official order for purchases.

At one time the museum had only two register sequences: for ceramics and all other non-ceramic (or 'miscellaneous') material. Departmental accesssion registers (hard bound books with preprinted headings) are now maintained by the Keepers. Basic details are recorded about each group, including its initial location within the museum.

The group is assigned a permanent accession number, using departmental sequences that have no relation to the earlier temporary numbers. The new number is noted on the entry form, as a link between the two records. This number is then attached to the group.

A copy of the register entry is prepared on a form and sent to the Town Hall as part of a secure archive. (This copy is not amended if there are later changes of information and consequently gradually becomes out-of-date.) The current master register is kept in the department in metal storage cabinets. Earlier registers are housed in the central museum administration office.

A deparmental file is opened for significant material.

A separate form is used for loans-in to the museum (either after, or instead of, the initial enquiry form). The details on the form are completed by the relevant Keeper and a copy then passed to administration, to be copied into a single central loans register with its own numbering sequences. The form includes the location of the object. In the case of material sent for a display, a separate exhibition agreement form is also completed. The loan is supervised by the Keeper who is responsible for ensuring its eventual return.

Item stage

In Natural History, Social History and Archaeology, parts of the collection have yet to be catalogued, due to the pressure of other work such as extensive new displays. There can, therefore, be a long gap between accessioning and item documentation. In contrast, Ceramics, Decorative Art and Fine Art number and catalogue each incoming item soon after its acceptance.

Item records are prepared by the curatorial staff on a variety of record cards, including MDA cards and internal designs. These records include details of location which will be revised if there is a significant move. An individual item number is assigned to the object based on the accession number, except in Natural History where independent registration sequences are used.

Some parts of the collection have been recatalogued in recent years.

These records are kept in numerical sequence within the departments. A copy is also held in the Town Hall, except for the natural history records. (In the case of Natural History, copies of acquisition records are held at the Town Hall.) The master record, but not the copy, is annotated if there is any significant change to the object.

A supplementary file is prepared for significant objects.

The only location control is the information noted on the acquisition and item records. No storage lists are maintained. Movements are controlled by curatorial staff, who note significant changes on the item record. A tag is left in the store if an item is moved for a short period, such as a loan-out.

Output stage

Practice varies between the departments, some of which have prepared

selective catalogues. No central indexes are held, but each department has a donor and vendor index. Individual departments may have other indexes, such as a species list in Natural History and a potters index in Ceramics. A label is prepared while cataloguing the objects.

Exit stage
Persons or schools wishing to borrow objects are asked to submit a written request to the relevant department, after which a curator will be responsible for subsequent action. A loans form is completed, one copy of which is held in the department and another passed to the administrative office where an entry is made in a loans register. On the object's return, the departmental copy is annotated and the administration advised of its receipt. The master item record is not annotated to indicate that the object is on loan, but a tag is left at its storage location.

The record is annotated if an object is disposed of after the approval of the Director, Committee and the local audit office.

Other documentation
Important locality files are maintained in Archaeology, Natural History and Social History.

Museum comments
The procedures are thought to be effective, although the museum would wish to have a more comprehensive level of item documentation. The museum is concerned to develop a central records room and keen to explore computertisation options.

Update
Formal acquisition policies have now been introduced by the museum.

A major MSC scheme was introduced in 1983–84 and continued in 1984–85 (21 and 13 staff respectively).

Dii3.16 Tyne and Wear County Museum Service

Introduction
Report based on a discussion with Mr Neil Sinclair (Group Museum Officer East) and Mr John Bainbridge (Senior Museum Officer, Natural Sciences), Sunderland Museum, 2 April 1982.

Subsequent progress is described at the end of the report.

Museum framework

Management/resources
The museum is a local authority (Metropolitan County Council) service,

with certain pre-1974 collections leased from District Councils. It includes a number of sites:

John George Joicey Museum, Newcastle
Laing Art Gallery, Newcastle
Museum of Science and Engineering, Newcastle
Shipley Art Gallery, Gateshead
Museum and Art Gallery, South Shields
Roman Fort, South Shields
Museum and Art Gallery, Sunderland
Grindon Closs Museum, Sunderland
Monkwearmouth Station Museum, Sunderland.

The service is organised on a geographic and subject basis, although the divisions are not totally exclusive:

East (Sunderland and South Shields), with an emphasis on human history and natural sciences;
West (Newcastle and Gateshead), with an emphasis on art;
Sciences (Blandford House, Newcastle).

Each major museum is further organised on a discipline basis. Certain staff also deal with subject material, irrespective of its location.

The Director is aided by an administrative staff, and a range of curatorial staff.

Collections management is considered to be the primary concern of the service.

Collections
The collections total around 250 000 items:

fine art	12 000
applied art	10 000
costume	4 000
social history	57 000
ethnography	5 000
archaeology	5 000
science and technology	30 000
maritime history	9 500
land transport	7 500
natural history	90 000
geology	20 000

The service has a general acquisition policy, based on curatorial knowledge, with increasing reference to the documentation.

Documentation framework

Documentation management
The overall coordination and development of documentation procedures is

the responsibility of a Senior Museums Officer, who devotes 20% of his time to this work. Policy consideration are referred to the central directorate for consideration. The preparation of records is a departmental activity. Initial entry and acquisition documentation is the first concern.

Documentation resources
Of the permanent establishment, five senior staff are involved in varying degrees of supervision and a further twenty one officers are directly involved in documentation duties, to an estimated 25% of their time (including both original documentation and the supervision of temporary staff). They are assisted by administrative staff, including a full-time Clerical Assistant. The service has also been aided by major contributions from the MSC with a serious of large projects in operation since 1977. The current team includes eighteen graduate and five typing assistants. The service is seriously concerned by the threatened withdrawal of this assistance, the impact of which would be severe.

Procedural manuals have been prepared for both the overall system and specific aspects of item documentation (incorporating the general MDA guidelines) (such as Pettigrew and Holden, 1978). Permanent staff are responsible for training new temporary assistants. They attend MDA seminars and courses.

The service has undertaken a series of computerisation projects in association with the MDA computing bureau. The early experiments involved both data entry and processing by the Association, but more recent schemes have incorporated inhouse data entry by the service's clerical cataloguer/typist.

The service has assessed the total investment by the MSC as £460 000 from 1977 to 1982, over 95% of which was staff costs. The figures for 1982–83 are £134 000 for temporary assistants, £3000 for consumables and £3000 in capital expenditure. The service's own investment, although smaller, is still significant, with the investigator estimating expenditure on permanent staff to be around £60 000 per annum.

Documentation system
The service inherited a number of badly documented collections when it was established in 1974. Its emphasis since then has been on the development of effective procedures for current acquisitions and the documentation of the backlog, the latter with temporary assistance (Figure D31). Separate entry forms are used for acquisitions, loans and enquiries. Material other than enquiries is logged in departmental registers. A manuscript copy and two typed versions of individual item records are then prepared for local and central use. Work has begun on the computerisation of these item records.

It is estimated that 65% of the collection has been catalogued (often for the first time) during recent years. The completion of this exercise and the subsequent data entry and processing of the information remain to be accomplished, a task that will be very slow without further temporary help.

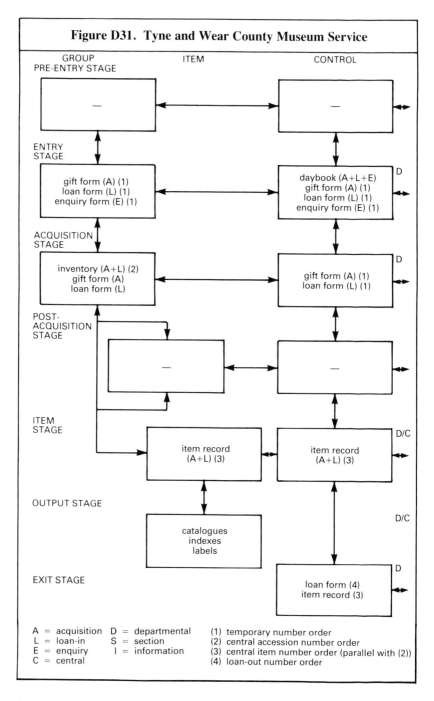

Figure D31. Tyne and Wear County Museum Service

GROUP — ITEM — CONTROL

PRE-ENTRY STAGE

ENTRY STAGE

gift form (A) (1)
loan form (L) (1)
enquiry form (E) (1)

daybook (A+L+E)
gift form (A) (1)
loan form (L) (1)
enquiry form (E) (1) D

ACQUISITION STAGE

inventory (A+L) (2)
gift form (A)
loan form (L)

gift form (A) (1)
loan form (L) (1) D

POST-ACQUISITION STAGE

ITEM STAGE

item record (A+L) (3)

item record (A+L) (3) D/C

OUTPUT STAGE

catalogues
indexes
labels

D/C

EXIT STAGE

loan form (4)
item record (3) D

A = acquisition D = departmental (1) temporary number order
L = loan-in S = section (2) central accession number order
E = enquiry I = information (3) central item number order (parallel with (2))
C = central (4) loan-out number order

No duplicate copy is kept of the accession registers nor are they kept in a safe or cabinet. Duplicate copies (one filed centrally) of item records are, however, maintained. Photographs are taken of valuable items.

Documentation and collections audit
Although there is no specific internal stocktaking programme, the current documentation exercise does involve a thorough check of the collections.

Internal Audit makes occasional dip checks based on the register entries. Concern which the auditors expressed some years ago was one of the spurs to the new procedures. District Audit has not been involved with the collection itself.

Deacquisition and insurance
Records are annotated after any loss. Comprehensive insurance cover is maintained for all acquisitions.

Object collections documentation

Pre-entry stage
Relevant curatorial staff assess and monitor potential acquisitions.

Entry stage
Distinct procedures are adopted for acquisitions, loans and enquiries, for each of which entry forms have been designed for local use, within the individual museums. All material left in the museums is immediately documented according to one or other of these procedures, and assigned a temporary number which is tagged on the group itself.

The museums use numbered four-part enquiry forms for material left for identification, etc. Pads of forms are available in each museum for use by the relevant curator: one copy of the form is passed to the depositor, one left with the object in an enquiry area, and two retained on the pad. The response to the enquiry is noted on these latter two copies, one of which is passed back to the depositor when the object is retrieved.

A day book is used to advise other offices in the Service that objects brought in as enquiries or potential gifts might be of interest.

Acquisitions and loans (but not enquiries) are included in the insurance policy.

Acquisition stage
Acquisitions are considered and then processed by curatorial staff, who are responsible for the preparation of a numbered one-part memorandum of gift form, detailing the group, and signed by the depositor. (After accessioning, an insurance form is sent to the Treasurer's Department as an advice of the receipt of the group, for inclusion in the insurance manifest.) Details of the group are then entered in bound accession registers (inventory) held by the local museums. This is usually done fairly promptly after the accept-

ance of the group. Details in the register are not changed if new information is found, nor do they include the storage location of the group.

The register is used to check the correct numbering of the group, with numbers being allocated from a central sequence (on a 'year + running number' basis). A group may be assigned one number which is subsequently superceded by individual item numbers taken from the same sequence. Entries in the register are in date, not number, order. Complex groups received from one depositor are treated as separate acquisitions, with appropriate cross-references being included in the individual records.

A single copy of the register is prepared and stored in the department, as is any associated file. The latter are arranged on a subject basis.

Loans are processed by curatorial staff using a numbered two-part loan form, one copy of which is passed to the depositor and the other retained by the museum. Separate pads of forms are held in each museum. Long-term loans are subsequently processed through the standard acquisition procedure. Individual members of staff are responsible for the loan's management and subsequent return.

Item stage
The temporary assistants have been responsible for the bulk of the item documentation of both current acquisitions and the large backlogs. As noted earlier, they have made a significant impact on this backlog. New acquisitions are processed as soon as possible after their receipt.

The records are based on standard MDA cards (Pettigrew and Holden, 1978). An initial manuscript record is prepared on a flimsy A4 sheet, including details of the storage location of the object. The information from this sheet is then typed onto two A5 cards, one of which is held in a central numerical file while the other is used within the department, normally in subject order. The flimsy copy is discarded after the typescripts have been checked. The local card is the primary record, maintained by curatorial staff and used as the basis of any computer records. Any revisions of the details on this card are noted on a memorandum, and sent with the card itself to the central typing team for implementation.

There is no independent location list although store is noted on the item records. No tag is left in store if an item is moved. An object placed on display may have its label clipped to the record.

Output stage
Selective catalogues have been prepared, based on work for exhibitions and the computer projects. The local item records are retained by the departments in convenient subject order. Additional indexes may also be prepared at local discretion. Labels are prepared if this is in accordance with curatorial practice in the discipline.

Exit stage
A three-part form is used for loans from the museum, one copy being sent with the object, one copy used as a receipt to acknowledge the object and

the third retained in the loan pad. Although the change of location is noted on the item record, no permanent reference is made to the loan itself. The return of the loan is acknowledged on the third copy. The Officer who initiated the loan is responsible for checking its return.

Records are annotated after any disposal.

Other documentation

Separate records are held for conservation work by the Service. Details of photographs of collection objects are noted on the item record. Historical photographs are treated as objects for documentation purposes. Both natural history and archaeology locality records are also held.

Museum comments

Given the work required to overcome the appalling state of the old records, the Service feels the current procedures are reasonably effective. Their future value depends very much on the long-term commitment of the permanent staff.

The Service is also conscious of problems such as lack of consistency in the new records developed by temporary staff. It is anxious to undertake further computerisation work so that indexes may be produced as a guide to current terminology and the use of conventions. The Service is keen to explore the application of the county mainframe computer.

Update

Further details of the Service and its documentation procedures are given in a recent paper (Baker, 1985).

The Service still has an MSC scheme, although it is reduced in number from the earlier scale. By the end of 1985–86, several important parts of the collections will have been fully catalogued within the new system. Over 50 000 records have now been computerised, with a wide range of auto-mated catalogues and indexes having been produced (see, for example, Figures 18, 20 and 21). The indexes have been extremely useful in dealing with enquiries, although their production has underlined the importance of careful control of terminology, particularly when work is being done by temporary staff. In some cases, data entry is now carried out from the manuscript flimsy records, without a card being prepared. At present, data entry is undertaken by the Service and the records then transferred to the MDA for processing. The possible future development of computer-based procedures is being considered in consultation with the County Computer Service Department.

Dii3.17 Wiltshire County Museum Service

Introduction

Report based on a discussion with Mr Martin Norgate (Museums Officer), 4 March 1982.

of both the conservation and archaeological sections, documentation is seen as a key priority.

Collections
As implied above, the object collections of the service itself are minor, although it does have extensive photograph collections. The independent museums do include a wide range of collections. The Service also holds sites and monuments records for archaeological localities in the county and conservation records of objects that it has processed. The overall position is summarised below:

pictorial collections of the library and museum service, at headquarers and in branch libraries (30 000 images, with a 5% per annum growth rate);
object and other collections in the nine pastoral care museums being documented by the Service (12 000 items with a growth rate of around 15% per annum);
collections in other museums which are being documented by the Service (about 2700 items with minimal growth rate);
museums to whom advice may be given and encouragement to adopt standard conventions, etc.;
conservation records of the service;
museum records of the service;
building records concerning buildings of interest in the county (1000 records with very high growth rate, reflecting the infancy of the project);
archaeological section Sites and Monuments Record (9500 records) and associated photographs (3000), maps (2000), etc.;
local studies collection in the Service headquarters and local libraries.

The various client museums have individual acquisition policies in different stages of development, based on personal knowledge of the existing collection, geographical subject interests and a rational assessment of the aims of the museum. There is concern to develop cooperative agreements to delimit geographical and discipline collecting areas within the county, initially for local social history material.

Documentation framework

Documentation management
The museum officer coordinates the work of colleagues in the Service and acts as advisor and superviser of work in the other museums. The documentation process is seen as a coherent whole with no significant aspects taking priority.

Documentation resources
In the Service itself, all six staff are actively involved in documentation with two of the senior officers spending 60% and 70% of their time in this

activity. Extensive use is also made of part-time fee-paid assistants and volunteers. This investment includes the documentation work done for the various associated museums.

An extensive set of documentation conventions has been built up in recent years, including general rules for all museums and specific guidelines for the particular features of individual institutions. The pictorial and object documentation is based on MDA systems and procedures, for which detailed internal conventions have been devised by the Museums Officer. The part-time and volunteer assistants are trained in the procedures by the Officer. Similar procedures are adopted for conservation and have also been detailed in internal conventions. For the sites and monuments record, procedural notes have been developed and revised as it has been constructed.

The Service uses the MDA computing bureau for the date entry and processing of the pictorial, object and conservation records. It has developed its own system for the processing of the sites and monuments files, using a local mainframe computer. The Service is exploring the possibility of inhouse data entry using a small portable microcomputer that could be taken to local museums.

The only significant capital cost has been the development of a computing system for the sites and monuments record, estimated at £3000 over four financial years. The major recurrent cost is the computerisation of the records, which has totalled approximately £3000 per annum in recent years. The third significant cost is that of staff, estimated by the investigator at around £15 000 per annum.

Documentation system
The service is in a unique position of offering advice and practical assistance to over ten small independent museums. In such a situation it has chosen to adopt a straightforward, yet effective approach to the documentation of a previously uncatalogued set of collections (Figure D32). All items coming in to the museum are logged on an entry form (Deposit Record). Acquisitions and long-term loans are then documented on standard MDA record cards which are subsequently passed to the Association's computing bureau for data entry and processing. The resulting catalogues and indexes will be widely available and used by both the individual museums and on a cooperative union basis.

The service is concentrating on the item documentation of the pictorial and object collections in the county, with 25% of the photographs and 75% of the objects now having been documented. The remaining 25% of the object collection should be completed during the next year. Effective records are also available for all the work of the conservation laboratory. The Sites and Monuments Record is also approaching completion. Effort is now being concentrated on the computerisation of the records and the production of catalogues and indexes. In the case of the archaeology field records this has now been achieved.

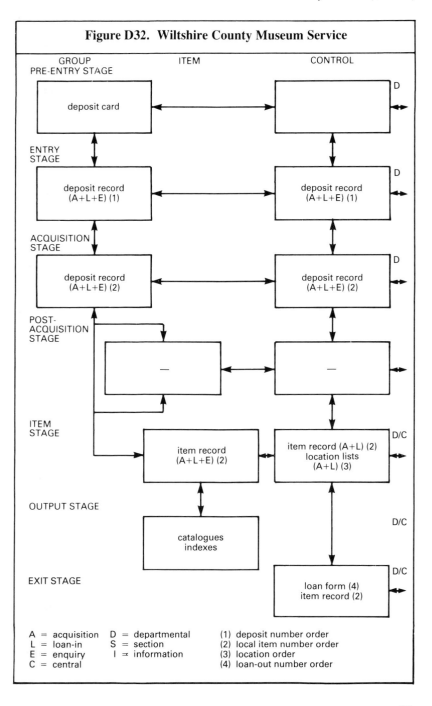

Figure D32. Wiltshire County Museum Service

GROUP ITEM CONTROL

PRE-ENTRY STAGE

deposit card

ENTRY STAGE

deposit record (A+L+E) (1) deposit record (A+L+E) (1)

ACQUISITION STAGE

deposit record (A+L+E) (2) deposit record (A+L+E) (2)

POST-ACQUISITION STAGE

— —

ITEM STAGE

item record (A+L+E) (2) item record (A+L) (2) location lists (A+L) (3)

OUTPUT STAGE

catalogues indexes

EXIT STAGE

loan form (4) item record (2)

D D D D/C D/C D/C

A = acquisition	D = departmental	(1) deposit number order
L = loan-in	S = section	(2) local item number order
E = enquiry	I = information	(3) location order
C = central		(4) loan-out number order

471

With the rapid development of computer files most uses of the records lie in the near future, when effective indexes should be widely available. In the case of the sites and monuments record, the use is expected to increase significantly when complete coverage is achieved in 1982. The incomplete files are already extensively used in the preparation of structure plans, etc.

The security of the documentation has been considered, particularly in view of the straightforward procedures that are in operation. Care is taken to ensure that the single item record is computerised as soon as possible, and then available in a number of machine-readable copies. Control over access to documentation is informal, reflecting the unique situation and the low value of the collections.

Documentation and collections audit
The use of the location lists in each museum is noted below. It is intended that honorary curators implement a regular stockchecking programme for security and control purposes. This is likely to be a rolling programme. No external checking is anticipated. Auditing provisions are at the discretion of the local museum committees.

Deacquisition and insurance
There are no formal procedures for reporting losses, although the record would be annotated and the committee informed. Insurance arrangements are at local discretion.

Object collections documentation

Pre-entry stage
If necessary (for example, in the case of a future bequest) an entry form will be completed for a potential acquisition.

Entry stage
Comparable documentation procedures have now been introduced for pictorial and object material coming in to both the Service and its client pastoral care museums. For convenience, the term 'local museum' will be used below for both these groups.

The local museums are encouraged to use an entry form (Deposit Record) for all material coming into their care. This is completed by either the Museums Officer when next at the museum or by the honorary curator. The form includes details of the depositor and the group. Both the form and group are then assigned a deposit number which is attached to the group with a tag. The group is then passed to a temporary storage area in the museum and examined for obvious conservation problems. Its location is noted on the form.

Enquiries are examined by the Museums Officer when next in the museum. If necessary, the item will be passed to an expert for consideration, with its movements being logged on the deposit form. The depositor is asked to retrieve the item, after which the form is retained by the museum.

If of interest, the information might be incorporated within the permanent museum records. One corner of the entry form is removed when the item is returned, as a visual guide.

The Museums Officer is also accumulating information about other non-acquired objects for incorporation in the museum records.

The insurance arrangements in the museums are defined on the Deposit Record. The form and any associated correspondence is kept in a ring binder at the local museums, which is considered to act as a Deposit Register.

Acquisition stage

The procedure for deciding whether to acquire a group differs among the local museums. Subsequent processing is, however, undertaken by the Museums Officer.

As the Deposit Record is considered to fulfill the function of an accession register, the minimum of additional steps are required prior to item documentation. No separate register is maintained. As the Record includes a transfer of ownership statement, it is also considered to be an adequate indication of the transfer of title of the group and no separate transfer document is maintained. This approach helps one person to manage procedures in a broad range of museums spread across a large county.

At this stage the group retains its temporary numbered label. Its location is noted on the form.

A similar approach is adopted with short-term loans-in to the museum, which go through the standard deposit procedure (long-term loans are not accepted). No separate manual list of loans is maintained although this will be a feature of the computerised system. The decision to return a loan is implemented by the honorary curator and is logged on the form, which is then retained in the museum.

Item stage

A formal item record is prepared about each acquired object within a few weeks of its incorporation into the collection. This is done by the Museums Officer using standard MDA record cards. Storage location is noted on these records, and amended if an object is moved for a significant period.

During the processing, an individual item identity number is assigned, using a straightforward alpha-numeric sequence distinct from that on the entry form (Norgate, 1984). Both the earlier initial number and any superceded item number are noted on the new record or are implicit in the new number.

Detailed conventions for the completion of the records have been prepared and are rigorously followed.

A single master copy of the manual record is produced and passed for computerisation, after which the computer equivalent is considered to be the master document. No attempt is then made to update the manual cards.

Both the manual and computer masters are arranged in numerical order while the collection itself is in a classified sequence.

Details of correspondence, etc., are either attached to the earlier deposit form (which is itself annotated with the item number) or treated as archival items. No separate object files are maintained, although there are history files in some museums for holding miscellaneous notes.

One of the newly designed indexes is for location control and stock checking of acquisitions and long term loans (see Figure 17). It is arranged in store order, with a separate page for each location giving details of the item number and name of each object at that location. The pages are to be checked on a regular basis. Control over internal movements is at the discretion of the local museum. Any significant move is noted and the record subsequently amended by the Museums Officer.

Output stage
It is intended to produce a computerised short entry union catalogue in classified order, on printout or microfiche. This will include a selection of the information available for each item. Multiple copies will be available for use by visitors to any of the museums. A range of computerised union indexes has also been designed for use by the museums. As with the catalogue, these are available on printout and microfiche. Similarly, it is hoped that computer produced labels will be prepared for each item.

Exit stage
Honorary curators are also responsible for deciding on loans out of the local museum. A Loan form is completed with details of the recipient, the condition of the object, etc. The forms are filed in loan order, and annotated when the object is returned. The primary object record is not altered when the loan is a long-term arrangement.

The decision to dispose of an object resides with the local committee, with the advice of the Museums Officer. In the event of a disposal, the record would be annotated by the Museums Officer and then retained in the file.

Other documentation

The Service has also been actively upgrading its conservation documentation procedures (Corfield, 1983). Its conservation department based in Salisbury undertakes work for both the Service and its pastoral care museums and on an agency basis for other institutions in the area. Primary recording of the results of conservation (including management information such as the time taken and cost of the work) is noted on MDA-style conservation record cards, the full details from which have been computerised by the MDA bureau. The conservation department is planning to complement this full computerisation with an inhouse microcomputer-based system suitable for the active control of its work.

Reference has already been made to the importance of archaeological and building locality records. Most other types of material (archives, photographs, etc., and bibliographic items) in the museum collections are treated as objects for documentation purposes, and recorded on an appropriate MDA record card.

Museum comments

The full aspects of the system are yet to be tested, but the indications are that it is working well. There is a feeling that its scope should be even more comprehensive, dealing in a unified way with all information of relevance to the collection and museums. The first concern is the completion of computerisation, after which there may be minor revisions to procedures. Once the backlog has been documented it may be necessary to amend some aspects of the work.

Update

The collections now considered by the Service are estimated to include over 20 000 items in pastoral care, over 8000 items in associated museums and over 42 000 photographs.

Although the practical procedures described above are essentially the same some three years later, there have been specific detailed revisions and a considerable consolidation. Over 15 000 records have now been computerised, with the MDA continuing to undertake the data entry and processing. The cumulative file from eight museums has been used as the basis for a series of printed and mirofiche indexes, including a unified classified inventory and complex general index.

Dii3.18 York: Castle Museum

Introduction

Report based on a discussion with Dr Graham Nicholson (Curator), 1 April 1982.

Important changes since 1982 are noted at the end of the report.

Museum framework

Management/resources

The museum is a local authority (District Council) service, arranged on a departmental basis:

Folk Life
Military History
Costume
Decorative Arts.

The nucleus of the museum (now 20% of the total) is the Kirk Collection, passed to the City in 1941, with a Deed of Trust prohibiting its disposal. The broad function of the museum is defined as educational in the Deed of Trust. The current priority is, however, documentation, reflecting the lack of information about the collections, which is severely limiting their use, study, publication and security.

The Curator is supported by a Deputy and departmental Keepers and Assistant Keepers.

Collections
The collections now total about 100 000 objects, built up during the last forty years, with a considerable emphasis on social history material. The current acquisition rate has declined to a few hundred items each year. There has been some rationalisation and exchange of collections in cooperation with the nearby Yorkshire Museum, which concentrates on the natural sciences and archaeology.

The museum does not have a formal acquisition policy, although it is concentrating on highly selective additions to fill gaps in the collections.

Documentation framework

Documentation management
The Curator has an active overall responsibility for the development of documentation procedures, coordinating the work of the curatorial staff in each department. Initial documentation of both new and old acquisitions is seen as the first priority.

Documentation resources
The five permanent curatorial staff spend an average of 20% of their time concerned with documentation, with these duties being specified in their job descriptions. They are assisted by a part-time Records Clerk. The museum also benefits from help from graduate volunteers, particularly during the current stockcheck programme. Draft guidelines have been established for the new system and discussed at regular meetings of staff. New staff are trained in-service.

As well as normal equipment and consumables, staff use cassette recorders for dictation while in the stores during the checking programme. The museum is also installing a terminal to the City's mainframe computer. Basic catalogue records will then be entered into a new computerised system.

The museum is anticipating a capital investment of £3000 in computer equipment and £4500 in computer applications costs. It has also invested £500 in dictaphone equipment. Total staff costs are estimated at around £14 000 per annum.

Documentation system
The museum has been involved in a complete reassessment of its proce-

dures, in parallel with a comprehensive stocktaking to establish the standard of documentation and the integrity of the collections. Acquisitions and long-term loans are currently simultaneously entered in departmental registers and have an item record prepared (Figure D33). This procedure is being applied to both new acquisitions and old material that are being reprocessed. Enquiries, if left in the museum, are noted on a form for the attention of the relevant Keeper.

Material acquired before 1974 was inadequately documented in accession registers, the details within which are now suspect and in need of reassessment. They are being used as the basis for provisional new records being prepared by the Records Clerk. These records will then be used as the nucleus for a recataloguing procedure. The old records are thought to cover 80% of the collections; the new records scheme has recently been initiated and currently covers 5% of the material.

Records are only accessible to staff and are maintained in lockable cabinets or a safe. A comprehensive programme of photographing the collections is underway.

Documentation and collections audit
The current reprocessing includes a complete stocktake and assessment of the old documentation. At the beginning of the programme, the Curator undertook a dipcheck of over 300 items, which confirmed the inadequacies of the existing records.

Internal and District Audit has been actively involved in assessing the problems over the last five years, following a paper from the Curator that drew the museum committee's attention to the seriousness of the position. The auditors have responded by advising the Curator, suggesting exploratory dipchecks, examining the museum's new proposals and offering comments on their implementation. They have approved the initial stage of producing an interim subject index based on the old records and the need for complete recataloguing. They have also aided the appointment of the Records Clerk.

Deacquisition and insurance
The museum will be able to assess and respond to losses when its recataloguing programme is complete. Valuable items and loans are insured.

Object collections documentation

Pre-entry stage
Individual Keepers open a file for details of potential acquisitions, if necessary.

Entry stage
Separate procedures are adopted for acquisitions, loans and enquiries, with no formal initial steps except in the case of enquiries.

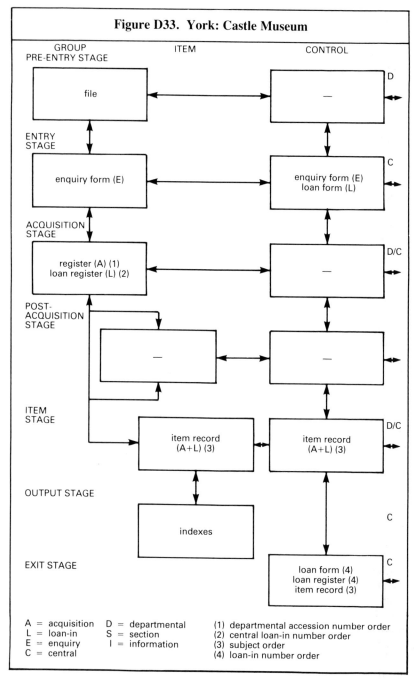

Figure D33. York: Castle Museum

GROUP	ITEM	CONTROL	
PRE-ENTRY STAGE			
file	↔	—	D ↔
ENTRY STAGE			
enquiry form (E)	↔	enquiry form (E) loan form (L)	C ↔
ACQUISITION STAGE			
register (A) (1) loan register (L) (2)	↔	—	D/C ↔
POST-ACQUISITION STAGE			
—	↔	—	↔
ITEM STAGE			
item record (A+L) (3)	↔	item record (A+L) (3)	D/C ↔
OUTPUT STAGE			
indexes			C
EXIT STAGE		loan form (4) loan register (4) item record (3)	C ↔

A = acquisition D = departmental (1) departmental accession number order
L = loan-in S = section (2) central loan-in number order
E = enquiry I = information (3) subject order
C = central (4) loan-in number order

Most enquiries are dealt with immediately by a Keeper. Those that are left in the museum are logged on an enquiry form and passed to the relevant Keeper. One copy of the form is given to the depositor and the other kept with the object itself. Neither form nor object are numbered. The Keeper replies to the enquiry by letter, which also asks that the item be retrieved. Any items not collected are referred to the Curator for eventual disposal.

Acquisition stage
Acquisitions are considered by a Keeper (with reference to the Curator, if necessary) who is then responsible for their processing into the collection. Donations are acknowledged by means of a letter; purchases by the transfer of payment details. No other formal transfer of ownership document is completed.

The first stage of documenting the acquisition is to note it simultaneously in a register (bound ledger) and to prepare an MDA item record card. The group is assigned an accession number on a 'department + running number' basis (formerly 'year + running number'). Separate registers are maintained for each department, the use of which is to be abandoned in the future, in favour of direct data entry of item records into a computer system. The register is annotated if subsequent changes become apparent. It does not, however, include the storage location.

New acquisitions are not included in the museum's insurance policy (although the original Kirk Collection is covered for all risks).

Details of correspondence, etc., are kept in central files, arranged by donor. The records, however, are kept in the individual departments.

Loans are assessed by the Keeper and Curator, after which a three-part loan form is prepared for the depositor, the department and for inclusion within the loans register (with the form being glued into the register). Long-term loans, which are now discouraged, are treated by a procedure similar to that for acquisitions, receiving a permanent number and being detailed on an item record card. Handling and processing of the loan is a departmental responsibility, although the primary records and correspondence files are kept centrally. The Curator periodically checks the status of loans.

Item stage
All acquisitions and long-term loans have individual item records prepared at the time of their group documentation. There is usually a one-to-one relationship between the acquisition and the individual item. This work is done by curatorial staff and the Records Clerk, assisted by volunteers. They either note information direct onto the record card or use a cassette recorder, the contents of which are later typed onto a card. In either case, standard details are noted on MDA cards. These details now include the storage location, although this is only a recent development.

All old acquisitions are to be reprocessed, with new records being produced and new numbers assigned, on a different basis from the old sequence.

The work is guided by the MDA instructions and draft internal manuals.

The records are ordered in various departmental sequences. Folk Life, for example, is using the SHIC system which the museum was involved in developing. The collections themselves are arranged by type of object.

No location control documentation is available. The museum is in the process of moving and rearranging its stores, after which it will depend upon the collections being self-indexing. Long-term movements are noted on the new item records.

Output stage

A primary aim of the current reprocessing is to enable the museum to produce new catalogues. A number of old sectional lists are currently available. The Records Clerk has prepared an index in subject order based on the old accession registers. This is being used as a primary source when checking the collection. A central donor index is also available, based on the old registers. These lists are recognised to be incomplete. Future indexes will be based on the new records, using computing procedures, if possible.

Exit stage

After approval by the Curator, loans-out are detailed on a form and entered in a loans register. The change of location is noted on the item record. Any loan for which there is no item record is first documented within the new system.

Disposals are referred to the museum committee by the Curator, after which the records are annotated. The museum follows the Museums Association guidelines for disposal.

Other documentation

Separate conservation records are held in object number order, supplementing the object records themselves.

Photographs of historical interest are treated as objects for documentation purposes. In contrast, details of any photographs of objects in the collection itself are noted on the object item record.

Museum comments

While emphasising the inadequacies of the old procedures, the museum feels that the new system will be effective, while recognising that it will involve twenty man-years work. Although certain details have still to be decided, the overall form of the new system has now been agreed by staff.

Update

The museum now has a central warehouse with curatorial offices and a conservation laboratory in the same building. A new acquisition policy has been adopted, focussing attention on gaps in the collection.

Item records are gradually being prepared on MDA cards and then transferred onto the City's mainframe computer via a terminal in the museum. All loan records have already been included within the automated system.

In line with the policy of preparing new catalogues, a sword catalogue was issued in August 1985.

Dii4 University Museums

Dii4.1 Glasgow: Hunterian Museum and Art Gallery

Introduction

Report of a discussion with a number of curatorial staff held on 7 April 1982.

Museum framework

Management/resources

The Hunterian Museum and Art Gallery is part of the University of Glasgow. The museum is organised on a mixed central and departmental basis:

Art Gallery
Archaeology and Anthropology, Numismatics, Geology
Zoology, Anatomy, Pathology, Natural Philosophy (within teaching departments).

Its priorities are conservation, documentation, teaching and display and research. The Director is assisted by ten departmental curatorial staff.

Collections

Its major object collections include material of international importance:

fine art (15 000 prints, 1000 paintings)
archaeology and ethnography (35 000 acquisitions, with an annual growth of up to 200 items)
geology (750 000 specimens, with a typical increase of 10 000 per annum)
zoology
numismatics (70 000 coins and medals with an annual acquisition rate of 250)
anatomy.

The Numismatics Department also holds records of Scottish coin finds. Major archival material is held in a separate University Archive. Conserva-

tion work (other than works of art on paper) is undertaken outside the museum.

Each department has an agreed acquisition policy based on curatorial knowledge of its collection. There are informal arrangements with other museums concerning cooperative collecting.

Documentation framework

Documentation management

Each department has an independent responsibility for its procedures, although there is frequent informal discussion and overall coordination by the Director. The first priority is acquisition documentation, followed by the preparation of item records. In practice, the work pattern is influenced by the availability and expertise of temporary staff.

Documentation resources

Of the museum's ten curatorial staff (three of whom are in the art gallery and one in zoology), nine are involved in documentation to up to 10% of their time. The museum has also received major assistance from a series of job creation schemes during the last five years. These have typically included a team of 10–15 temporary assistants working with documentation.

Individual departments follow the MDA procedural guidelines and internal manuals for item documentation. Notable internal proposals have been drawn up for geology (McInnes, 1978) and human histroy (MacKie, 1978; 1980; Orna and Pettitt, 1980). Training of temporary staff is carried out in-service, with some background assistance from the MDA.

The museum is actively involved in an automation programme, concentrating on the computerisation of its item records using the MDA computing bureau and (for the coin collections) the local University service. After an initial concentration on using the MDA for both data entry and processing, it has now developed its own data entry and editing facilities (Fraser, 1982). When the data is sufficiently complete, it will be sent on floppy discs to the MDA for the production of printed catalogues and indexes. The museum intends to add to this equipment nucleus in future years.

The investigator has estimated the permanent staff costs of documentation at around £15 000 per annum.

Documentation system

Most documentation procedures are initiated and maintained at a department level, with certain distinctive aspects in each department (Figure D34) (MacKie, 1980). The overall approach for acquisitions is to note details of the group in a basic accession book and to subsequently prepare individual item records on standard MDA cards or comparable internal designs. A proportion of these records is being computerised. Enquiries are accepted centrally before being passed to the department for examination.

The degree of documentation varies between departments. Overall, most material received in the last 20 years has been fully accessioned and

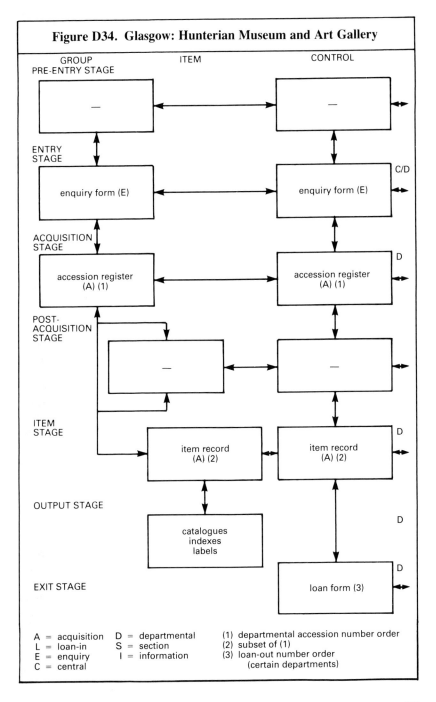

Figure D34. Glasgow: Hunterian Museum and Art Gallery

GROUP ITEM CONTROL

PRE-ENTRY STAGE

ENTRY STAGE

enquiry form (E) ⟷ enquiry form (E) C/D

ACQUISITION STAGE

accession register (A) (1) ⟷ accession register (A) (1) D

POST-ACQUISITION STAGE

ITEM STAGE

item record (A) (2) ⟷ item record (A) (2) D

OUTPUT STAGE

catalogues indexes labels D

EXIT STAGE

loan form (3) D

A = acquisition D = departmental (1) departmental accession number order
L = loan-in S = section (2) subset of (1)
E = enquiry I = information (3) loan-out number order
C = central (certain departments)

significant proportions have item records. Smaller subsets of the item records have been computerised and published. The museum considers duplicate computer files to be an important security provision. Backup files are held both on floppy disc in the museum and on the University mainframe's File Archive System.

Documentation and collections audit
The only stocktaking programme is that undertaken every 5–10 years within archaeology. Staff do, of course, work through their collections for more general purposes. The auditors have not checked the collection.

Deacquisition and insurance
No formal procedures have been adopted for losses, other than to maintain the item record of the missing object. Basic insurance cover is held for the collection.

Object collections documentation

Pre-entry stage
Individual staff note details of potential acquisitions.

Entry stage
Acquisitions are processed by the individual departments, where they are accessioned promptly, with no interim procedures. Long-term loans into the museum are very rare and are processed on an individual basis.

Enquiries are dealt with informally, if possible. In other cases, the attendant completes a receipt and a three-part enquiry form. One part is passed to the depositor, another kept at the desk and the third taken with the object itself to the relevant curator. The curator either responds on the form or sends a separate letter, after which the object can be retrieved. A copy of the response is kept at the desk.

General material is included in the fire risk cover provided by the University's insurance policy. Valuable items and loans have comprehensive cover.

Acquisition stage
Acquisitions are considered and processed by staff of each department. If accepted, a certificate or letter of thanks is sent to the depositor. Details of the group are entered in departmental bound accession registers as soon as possible after receipt. This is often done by the temporary staff. These registers hold basic information about the group (including location in the case of archaeology and ethnography). They are amended if significant new information come to light.

The registers are kept on open access in the departmental offices. Any correspondence, etc., is entered into a file, most of which are in collector rather than object sequence.

The museum accepts very few loans, responsibility for which is then vested in the accepting curator. The loans are documented informally.

Item stage

Individual item records are prepared by permanent or temporary staff on standard MDA-style record cards, with the information including the current storage location. An A4 flimsy sheet is prepared first, in manuscript. From this, information is either typed onto a card or entered directly into a microcomputer, which prints an A5 record card and a specimen label, if required. The flimsy is filled in numerical order and the typed or printed equivalent is filed in a convenient subject sequence. The individual item numbers are either identical to, or subdivisions of, the earlier accession numbers.

Significant parts of the old acquisitions have been reprocessed in recent years, according to these procedures.

As noted above, a proportion of the new item records have been computerised, with the computer file then acting as the primary document.

No separate location control documentation is available, although the item record does note the relevant current information. Procedures for controlling internal movements differ in the various departmental stores. A tag is left in the place of an object during a temporary move in Archaeology and Numismatics.

Output stage

Important published catalogues are available for numismatic, anatomical and pathological collections, geology material (Rolfe *et al*, 1981) and certain excavations. Others are in preparation.

No central indexes are held, but a number are available within departments, particularly where the records are being computerised. Labels are prepared according to curatorial practice.

Exit stage

Loans-out are also processed on a departmental basis. Archaeology has very few loans and depends upon the storage control tag, amending the item records and having general correspondence. In contrast, Geology has an active loan policy. Use is made of a three-part loan form, two parts of which are sent to the recipient (one to be returned after counter-signature). A tag and the label is left in the store to indicate the removal of the specimen, while a photocopy of the label is sent to the recipient. Other departments have fewer loans: the loan form or more informal procedures will be used, according to individual circumstances.

Museum comments

The museum is conscious of the scope for improvement, such as the need for a procedural manual, but is also aware of the gradual progress that is being made. It is concerned about the standard of work done by temporary staff and most aware of the need for such staff to be supervised and their tasks to be carefully selected. A decline of temporary help would, however, present serious problems. The gradual development of computer based files will accelerate in the future.

Update

Further details of the msueum and its documentation procedures are given in a recent paper (Willett, 1985).

Dii4.2 Manchester Museum

Introduction

Report based on a written response by Mr Alan Warhurst (Director) and Mr Charles Pettitt (Controller, Computer Cataloguing Unit), submitted 30 March 1982, following a visit on 19 March 1982.

Brief reference to subsequent developments is made at the end of the report.

Museum framework

Management/resources

Manchester Museum is a major university museum, with assistance from the Greater Manchester Council (around 40% of income), governed by a museum committee reporting to the University Council.

The museum is arranged on a departmental basis, with conservation, display and education services and eight collecting departments:

Archaeology (including Egyptology)
Archery
Botany
Entomology
Ethnology
Geology
Numismatics
Zoology

Its priorities are considered to be the collections themselves (acquisitions, conservation, storage and documentation), research (both original research by staff and assisting other researchers) and education of undergraduates and school children and interpretation for staff and students on the University campus as well as the general public.

Its staff consists of a Director, six Keepers and six Assistant Keepers of collecting departments; Keeper of display; Keeper of conservation; and a head and four teachers in the education service. There are also seven Honorary Keepers.

Collections

The early stress on university teaching and research collections is reflected in the catholic nature and scale of the current collections, the total of which may be as many as nine million objects. The dominant collections in numerical terms are those in Entomology and Botany (each about three

million specimens, the former being the third largest of its kind in the country). The current growth rate ranges from high in Entomology and Geology to low in Numismatics.

While the museum does not at the moment have an acquisition policy, there is a clear understanding by curators of the area to be developed. Any problems are discussed with the Director.

Documentation framework

Documentation management
The museum has a Steering Committee on Museum Documentation (with members including the Director, computing controller and representative senior staff) which is reassessing all documentation procedures. However, responsibility for the procedures resides with the individual departments, between which there are considerable variations in approach. Documentation priorities are the maintenance of basic acquisition and item records about the collections, catalogue production, systematic research and the dissemination of information.

Documentation resources
All 13 full-time curatorial staff are involved in documentation, the overall proportion probably being 10–20% of their time (considerably higher than that in one case). This is complemented by the work of Honorary Keepers and a significant input of temporary staff (Orna and Pettitt, 1980; Pettitt, 1981). The MSC has cooperated with the museum in a number of major job creation schemes since the late 1970s, which have had a dramatic effect on the documentation programme. As an example, the 1981–82 Community Enterprise Project scheme involved 21 temporary staff (5 supervisors and 16 assistants) working in the self-contained Computer Cataloguing Unit.

Individual departments have procedural notes, from which staff gain general guidance, complemented by in-service training. Aspects of the parallel computer system are fully documented.

The museum has been a major user of computer systems for some years, with the work being coordinated by an Assistant Keeper heading the Computer Cataloguing Unit, using a team funded by the museum and the MSC (Orna and Pettitt, 1980; Pettitt, 1981). The overall objective of the scheme is to increase the availability of collection information to all users of the museum and to relieve curatorial staff of routine collections management work. In the early stages, the dominant staff contribution came from the temporary assistants responsible for building up the computer files. There is now a growing involvement by permanent staff who are gradually taking over responsibility for the maintenance and updating of the records. The scheme has made considerable use of the computer resources provided by the University, applying systems (including the FAMULUS package) supported on the nearby mainframe computers. It is now concentrating on the use of inhouse microcomputers for data entry prior to processing on the

mainframe machine. It intends to place a series of terminals linked to the main computer in individual departments, for independent use by curators.

As an illustration of documentation costs, in 1981–82 the gross cost of the salaries of permanent staff for time spent on computer cataloguing (including the work of the controller of the computer unit) was £17 100. In the same period, the MSC contributed £110 150 for salaries of temporary staff and £8800 towards running costs.

Documentation system
Most procedures are departmental, with pronounced differences between the natural sciences and other sections (Figure D35). In the case of the natural science departments, simple but effective procedures have had to be evolved to help the limited staff cope with vast collections. In these sections primary documentation tends to be kept with the systematically arranged object itself (on a label or herbarium sheet) and there are few formal files. Elsewhere, more usual procedures are adopted, with initial details being noted in an accession register, to be followed later by item documentation and indexing. A significant effort has been invested in developing new computing procedures, using temporary assistants on job creation projects.

All material in Ethnology, Archaeology and Numismatics has been accessioned and is supported by item records. Significant parts of these collections also have card indexes. The special conditions in the natural science collections, where material is not accessioned, have already been noted.

Attention has been paid to the security of the documentation with registers, etc., being maintained in locked cabinets, or in the strong room. Multiple copies are held of all computer files. Photographs are taken of items of significant value.

Documentation and collections audit
There is no internal or external stocktaking. The auditors have not examined the integrity of the collection or its documentation.

Deacquisition and insurance
In the event of loss or damage, the documentation is annotated accordingly. The collection is insured for fire risk.

Object collections documenation

Pre-entry stage
Informal steps are taken to preserve details of potential acquisitions.

Entry stage
Distinct procedures are adopted for acquisitions/loans and enquiries. The former are passed to the relevant curator (or the secure store in the absence of the Keeper) with no initial documentation prior to their acquisition. Any suspect material is first passed to the conservation laboratory for examina-

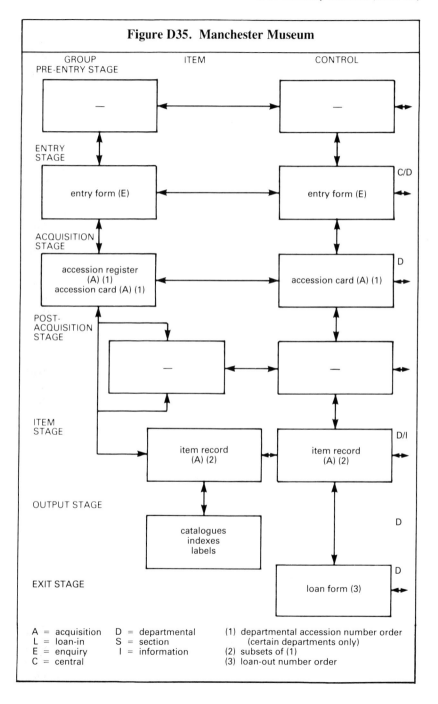

Figure D35. Manchester Museum

A = acquisition D = departmental (1) departmental accession number order
L = loan-in S = section (certain departments only)
E = enquiry I = information (2) subsets of (1)
C = central (3) loan-out number order

tion. Valuable items (such as objects sent for an exhibition) will be stored in the central security store and will often be photographed.

Enquiries are received by the duty porter at the entrance Enquiry Desk, who completes a three-part entry form and passes the object and one copy of the form to the relevant curator. A second copy is retained at the desk and a third given to the depositor as a receipt. The response to the enquiry is noted on the form and the object then stored in the secure room to await collection. On the return of the depositor the porter collects the object from the secure room and passes it to the person, accompanied by the form with its response. Low value items that are not collected by the depositor are retained for six months prior to disposal. Anything valuable is retained indefinitely. A copy of the completed form is filed in the relevant department.

The museum also accepts material from other museums for conservation, from the local public health services for identification and from regional archaeology excavations for long-term processing and storage.

All items coming into the museum are included within its standard insurance cover, which is, however, limited to fire risk. All-risk cover is taken for loans-in.

Acquisition stage
The decision to acquire a group is taken by the relevant curator, after consultation with the Director where appropriate. The curator will then be responsible for judging whether the museum is able to acquire the group and for undertaking subsequent action. The museum does not prepare any formal transfer of ownership documentation, unless it is required for legal or other reasons.

In Ethnology, Archaeology and Numismatics, the group is detailed in formal bound departmental accession registers, in which is noted a basic description, the accession number, etc. The storage location is not recorded in the register, although it is included on a parallel accession card, filed in numerical order. The accession register is only subsequently amended if a significant change (such as disposal) comes to light, in which case the entry is altered and initialled by the curator. Relatively minor changes such as re-identification are noted on the accession card. A photocopy of the accession register is held as a security duplicate. An accession file will be prepared, if necessary, and kept in the department.

The decision to borrow an object for an exhibition or research is taken by the curator in consultation with the Director. The loan does not pass through the accessioning procedure. In the case of a loan from an institution, it is assumed that institution will provide appropriate documentation. If the loan were from a private individual, it would be acknowledged by a receipt and appropriate letter of thanks. As noted above, all loans are insured against all-risks by the museum, using the owner's valuation.

Item stage
Although material tends to be accessioned soon after receipt, there can be a

significant delay before further processing is possible. When done, it is undertaken by the curator (with assistance from the temporary teams in the case of the computerisation process). Details are noted on a record card (usually of internal design) or flimsy sheet. The latter is a computer printout document, which, after completion, is intended for computer input. The information is considered to form a basic record, subject to later extension. The details include storage location (which is revised if the object is moved for a significant period), and a unique identity number (which is either the same as, or a subdivision of, the group accession number). The record is kept in numerical order.

In the case of the computing operation, local data standards, conventions and terminology control procedures have been adopted and enforced. Over 200 000 records were included within the computer files from 1979–82, using these procedures. A significant change, such as the disposal of the objects, is noted on the records. The record itself is informally checked through use for internal and external purposes. Both these files, and any associated supplementary files, are kept in the department. Computer file equivalents are kept in the museum and the nearby computer centre.

No separate inventory system is maintained. Internal moves are coordinated by the departmental staff, with the note of storage location being amended on all relevant records.

Output stage
Selective catalogues have been prepared for certain parts of the collections, either in published form or as computer outputs. The increasing availability of computerised records will have a significant effect on the catalogue production procedure.

Both manual and computer indexes are available for parts of the collection (donor, geographic, taxonomic, chronological index, etc.). They are used by staff, students and researchers, and other indexes are clearly needed.

Labels are prepared in various forms, according to the requirements of the collection. They are of key importance in the natural science departments. Their information includes the permanent location of the object.

The museum offers a selective retrieval service based on the information in its computer files. It is keen to exploit this area of interest, both for internal use and in response to enquiries from researchers.

Exit stage
Responsibility for loans from the museum is vested in the curators, with references to the Director where necessary. A three-part pre-numbered departmental loan form is completed, with details of the object. In the case of long-term loans, the object's location would also be revised on its primary records.

The Director is responsible for any disposals, after which the documentation is annotated.

Other documentation

The museum has a wide range of other types of record, each of a relatively limited extent.

Museum comments
While recognising that the procedures might be less than comprehensive, the museum feels that they are effective. None of the deficiences, of which the most serious is the absence of comprehensive initial records, could be overcome without the introduction of considerable extra resources. As with so many other university museums, the institution is grossly understaffed considering the size and importance of its collections. The simple but effective documentation system reflects this position.

The Documentation Steering Committee is currently re-examining procedures and gradually developing a comprehensive system integrating manual and computer procedures and retaining departmental flexibility.

Update

From April 1986, it is expected that the museum will be completely funded by the University of Manchester.

The plan to install computer termianls in individual departments for curatorial use has now been implemented.

Dii4.3 Newcastle: Hancock Museum

Introduction

Report based on a discussion with Mr Tony Tynan (Curator), 2 April 1982.
Details of progress since 1982 are given at the end of the report.

Museum framework

Management/resources
The Hancock Museum is a university museum (University of Newcastle), reporting to the University Council and Senate via a management committee. Both the early collections and the building remain the property of the Natural History Society of Northumbria. Following an agreement between the University and the Society finalised in 1974, the majority of funding is received from the University, which owns post-1974 acquisitions.

The museum is organised as a single unit.

The primary functions of the museum are curation of the collections (including documentation), research and education.

The staff includes the Curator, Deputy Curator and a Technical Assistant.

Collections
Its important collections are primarily of natural science material, totalling

over 350 000 specimens, with a highly variable growth rate of over 1000 items per year:

Geology	37 500
Vertebrate Zoology	30 000
Invertebrate Zoology	40 000
Insecta	160 000
Herbarium	60 000
Ethnography	6 500
Archaeology	3 000
Archives	5 000
Others (microscope slides, etc.)	8 000

The museum has an informal acquisition policy.

Documentation framework

Documentation management
The Curator coordinates documentation practice. The first concern is acquisition documentation.

Documenatation resources
Two permanent staff are concerned with documentation: one for 10–15% and the other for 80% of their time. The latter Technical Assistant post has recently been regraded to reflect the emphasis on documentation (including computing) duties. The museum has also received major assistance from a series of MSC schemes: the 1981–82 project including an eight person cataloguing team and a six person curatorial team. It is particularly concerned that changes of policies by the MSC might result in the decline of such schemes.

Although there are no manuals describing the overall systems, its computing aspects are fully described. New staff are trained in-service by the permanent staff. Computing expertise has been acquired with help from the University Computing Laboratory.

Since the late 1970s the museum has become a major user of the University computing facilities, including the SPIRES database management system (Davis and Hebron, 1982; Orna and Pettitt, 1980; Turner and Robson, 1979). This work involves the data entry and processing of item records, with over 130 000 records having been incorporated within the system by 1982. The project has been undertaken by the temporary employment staff, under the general supervision of the museum curators. The data is available for online searching from terminals in the museum or can be used as the basis for printed catalogues and indexes.

The museum has received significant help with equipment from the University, so that its only capital outlay has been £1500 for computer terminals. Consumable and maintenance cost of the order of £400 per year and permanent staff around £5000 per year. Computing resources are

available free of charge. The total MSC investment to 1982 exceeds £160 000.

Documentation system
With its small staff and large collections the museum has adopted simple but effective procedures, the core of which are now computer-based (Figure D36). It is very dependent on help from temporary staff, including regular volunteers. Material entering the museum for accessioning or on loan is logged in a temporary fridge book if subject to decay. Details of acquired groups are noted in an accession register. Individual items are registered in a series of subject sequences, the details from which have now been computerised.

Most collections received by the museum have been fully accessioned but the degree of item documentation (registration) varies depending on the material. It is the latter area that has benefited most from the temporary employment schemes and computerisation process, and is most likely to suffer should the schemes decline. Certain areas (geology, herbarium, etc.) have been fully documented; some (notably the large insect collection) are considered to be self-cataloguing once curated, and not to justify independent documentation.

The museum is developing record rooms, accessible to staff only, in which files are maintained. Duplicate copies of the computer records are available. Important items are photographed.

Documentation and collections audit
While there is no stocktaking programme, the museum is confident of the security of the collection. The auditors do not consider the integrity of the collection or its documentation.

Deacquisition and insurance
Losses are reported to the committee and records annotated. The collection is insured for fire risks.

Object collections documentation

Pre-entry stage
Staff try to be aware of all major potential acquisitions (such as the collections of important local naturalists) and anticipate their receipt. Any proposals are referred to the Curator for acceptance or rejection. A file may be opened, if required, for significant new material.

Entry stage
Different procedures are adopted for acquisitions/loans and enquiries, with additional steps in the case of specimens requiring preservation. Stable material offered as an acquisition is noted on a Receipt of Object form, and enquiries on an enquiry form. Any 'corruptable material' such as corpses requiring preservation is passed to the taxidermist after receipt, and entered

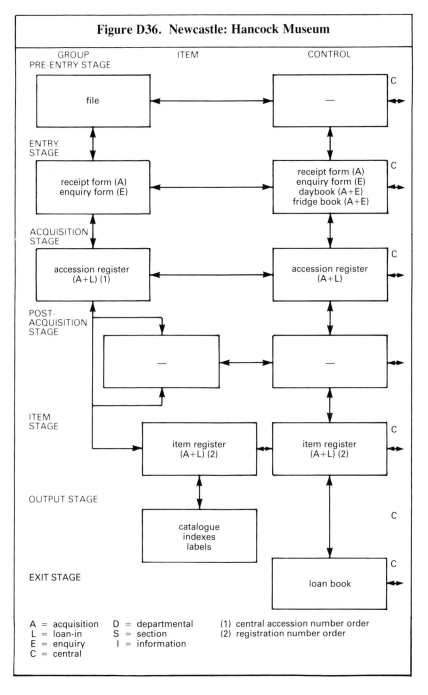

Figure D36. Newcastle: Hancock Museum

GROUP ITEM CONTROL

PRE-ENTRY STAGE

file — C

ENTRY STAGE

receipt form (A)
enquiry form (E)

receipt form (A)
enquiry form (E)
daybook (A+E)
fridge book (A+E)
C

ACQUISITION STAGE

accession register (A+L) (1)

accession register (A+L)
C

POST-ACQUISITION STAGE

— — C

ITEM STAGE

item register (A+L) (2)

item register (A+L) (2)
C

OUTPUT STAGE

catalogue
indexes
labels
C

EXIT STAGE

loan book
C

A = acquisition D = departmental (1) central accession number order
L = loan-in S = section (2) registration number order
E = enquiry I = information
C = central

495

in a taxidermy day book (or fridge book), with a temporary numbering sequence. It is then preserved while awaiting attention. Material noted in the temporary fridge book is eventually added to the permanent collection, the school loan collection, disposed of or passed to the Ministry of Agriculture for additional analysis.

Enquiries are accepted by the museum receptionist, where they are noted on a numbered enquiry form, part of which is given to the depositor as a receipt. The form is passed with the object to the relevant member of staff. After examination, a typed copy of the form is posted to the depositor and they are asked to retrieve the object from the reception.

Material entering the museum is included in its insurance cover.

The work is done on a central basis, with any files, etc., being kept in the Curator's office.

Acquisition stage

The Curator ultimately decides whether to acquire material and is responsible for subsequent processing. All staff, including the taxidermist, are aware of the laws concerning wildlife protection, and take note of these when considering material. No formal transfer documentation is completed except in the case of major bequests.

One of the curatorial staff notes details of acquired groups in a central bound accession register, as a historical record of the collection, including its initial location. Similar material is accessioned as a group, but in other cases individual items are accessioned independently. Accessioning takes place as soon as possible after receipt of a collection (except for material held in the fridge book). The items are then passed for immediate item documentation and curation.

The museum receives very few loans, each of which is considered and processed by the Curator. Documentation procedures are identical to those for permanent acquisitions.

Correspondence relating to acquisitions is kept in a general file (referred to as an 'historical file'), if relevant. Both the file and the accession book are held in the Curator's office, in secure wooden cabinets.

Item stage

Collections are registered in a subject basis using loose-leaf registers, containing basic details of each item, including its location. Individual item numbers are assigned at this stage, using subject sequences independent of the earlier accession number. The record is kept in item number order while the collection itself is in taxonomic order. Any necessary supplementary files are in date order.

In addition to current acquisitions, large parts of the old material have been reprocessed to the new standards in recent years. Perhaps 25% of the relevant section of the collections (excluding insects) still require processing.

The loose-leaf registers are subsequently copied and bound. A copy is kept with the collection itself. They are also used as input documents for the computerisation process.

No separate locations lists are maintained, although location details are noted on the item records (which can be searched online). The item record for a specimen is amended in the event of a long term move. A tag is left in the store during a temporary change.

Output stage
Selective card and printed catalogues already exist for small parts of the collection. The new computer files will be used as the basis of additional sequences in the future. Similarly, computer-generated indexes are now being produced, for use by staff and outside researchers. Standard labels are prepared by the curatorial and temporary staff. The museum is able to undertake selective online searches of the computer files.

Exit stage
Loans-out are processed by the curators, with details being entered in a loan book. This is checked on a monthly basis.

Any major disposal questions are referred to the committee, and the register entry amended.

Other documentation

The museum has important archive, bibliographic, biographic and ephemera files, each of which is retained in alphabetical order. They refer to both the collections and local collectors and naturalists.

The County Biological Records Centre is supported by the museum, holding comprehensive species files, many of which have been computerised (some 19 000 records). The museum works closely with the Northumberland Wildlife Trust regarding the documentation of biological and geological sites in Northumberland. SPIRES files have been created to store and retrieve site information (some 1700 records).

Museum comments

The museum feels its procedures are effective, although there is still a great deal of work to be done to complete the item documentation process. The feared decline of temporary help would severely handicap this programme.

Update

The staff complement now also includes an Assistant Curator (Geology). The three permanent staff are concerned with documentation for 10–15% (two) and 80% (one) of their time.

The museum has been without temporary assistance from an MSC project during 1984–85. The opportunity has been taken to review the situation, refine the existing files and begin to capitalise on the earlier achievements.

Help from regular volunteers has been particularly important during this period.

The number of records of the SPIRES system has grown to 172 000, including 13 500 biographic and bibliographic records. The first published catalogue to be derived from the database (*Catalogue of the George Brown Ethnographical Collection*) was issued in 1985. Others are in preparation, including *A catalogue of natural history collection in N. E. England* and a list of type specimens in an important slide collection. The publication of catalogues of specific finite collections of major significance is seen as an important product of the system.

Appendix Diii:
Surveys of automation, collections control and procedural developments (North American museums)

Diii3.7 International Museum of Photography,
Rochester, N.Y.
Diii3.8 Margaret Woodbury Strong Museum,
Rochester, N.Y.
Diii3.9 Detroit Institute of Arts, Detroit, Michigan

Diii1 Introduction

Appendix Diii is a review of documentation developments by a number of museums and related organisations in Canada and the United States, based on visits made by the investigator in late 1982. It concentrates on aspects of the development of automated systems, collections control systems and overall documentation procedures.

Diii2 Canadian institutions

Diii2.1 Canadian Heritage Information Network, National Museums of Canada, Ottawa

Peter Homulos, Director
Jane Sledge, Chief of Museum Services
Barbara Rottenberg, Chief Museum Consultant
Ted Poulos, Documentation Research Group

The Canadian Heritage Information Network (CHIN) is a branch of the National Museums of Canada, responsible for supporting computer systems and documentation advisory services on behalf of Canadian museums (Anon, 1982a; Sledge and Comstock, 1985). It is a development of the National Inventory Programme (NIP), established in 1972 (Homulos, 1978). Its computing facilities include the new Pictorial and Artefact Retrieval Information System (PARIS) database management system running on an inhouse mainframe CDC computer.

The National Museums incorporate four museums (National Gallery, National Museum of Man, National Museum of Natural Sciences and National Museum of Science and Technology) together with a National Programmes office. The responsibilities of the latter include the Museum Assistance Programmes (which supports documentation schemes in museums, etc.) and CHIN. The responsibility of a group such as CHIN is both internal, to help the constituent bodies of the National Museums itself, and external, to help other associated museums across Canada. A recent report has recommended that both the Museum Assistance Programmes and CHIN be transferred to a new Canadian Heritage Council, within which they would have a broader remit (Canada. Department of Com-

munication, 1982). The report considers that the National Museums should continue as a unifying organisation but concentrating more on the collection-holding institutions. It endorses the role of CHIN in developing a national inventory of collections, and urges that that work be completed.

When established, the primary role of NIP was to develop a complete inventory of works of art and cultural objects in all Canadian museums, for use by the museums themselves, outside researchers and the general public. Although this aim has been pursued during the last 10 years, there has been a growing emphasis on the use of the systems for day-to-day collections management by individual museums. The need for independent databases for each museum to pursue their own collections management objectives (rather than a single general file) and the need of dynamic control over records were two of the factors influencing the decision to use the PARIS system. In 1981, a report on the National Museums by the Auditor General noted some of the problems created by this gradual change of approach (Canada. Auditor General, 1981). It quotes the cost of the programme to 1980–81 as $7.5 million. The recent Federal Cultural Policy report adds that another $2.7 million will be required to complete the initial inventory. It describes the scale of the project as being to document 34 million objects in various institutions, of which 9 million are in 150 collaborating museums (including 1.5 million in the National Museums). In February 1982, it was estimated that approximately 42% of the items which had been given high priority had been processed, and that the rest of the 9 million museum objects would have been entered in five years time.

The collections control responsibility of museums emphasised in the Auditor General's report is the key factor influencing the management of the National Museums towards the computerisation of their records. (This attitude is not necessarily shared by the more junior curatorial staff in the national museums or by other non-national museums across the country.) Until recently there has been no positive stocktaking or auditing procedure in the national museums (Canada. National Museums of Canada, 1981). The Auditor General is now to take a more active role in an annual dipchecking procedure. As examples of the new attitude, the Museum of Man has been working to build up basic inventory files and the National Gallery has expressed interest in receiving monthly stock lists as part of its proposed checking procedure.

From 1982, therefore, CHIN has a dual role of continuing to develop a national inventory based on the records of individual museums, while providing these museums with facilities to use these records for collections management purposes. To fulfil this role, it provides access via telecommunication links to a central computer in Ottawa on which the information of the museums is stored.

A number of options were considered during 1980 when deciding how best to develop the systems supported by CHIN. At this time, Control Data Canada (CDC) put forward a cooperative research and development

proposal which was accepted by the National Museums. The nucleus of PARIS is a standard database management system called BASIS. CDC has used this as a starting point when developing extensive museum-orientated applications. In addition, it has indicated a willingness to provide a long-term service and to cooperate with CHIN in the mutual extension of facilities. The two organisations have embarked on an eight-year programme of development.

Features of the system include its ability to deal with variable length fields, good end-user online capabilities, data entry procedures, thesaurus control, report generation mechanisms and an SPSS (Statistical Package for the Social Sciences) interface. CDC offer a wide range of machines on which the procedures might be implemented. At one extreme, it may be possible to develop micro- or mini-based versions for use by individual museums, while at the other extreme the use of large and combined processors would enable the national centre to cope with a far greater demand than at present. The package itself is written in Fortran, running on 6- or 8-bit architecture machines. CHIN has a CDC Cyber 170 Model 720 mainframe, with 3000 mb of online store. Current system costs are $32 000 per month for hardware and software. (CHIN also has a number of other computer systems, including its earlier Univac mainframe which is still used for a number of projects, various minicomputers and a Cromemco microcomputer based in a museum at Yellowknife.) The network expects to have 110 terminals connected to the system by the end of 1983 and a further 170 thereafter. It is moving towards the use of the X25 packet switching service for communication from remote users, including Canadian scholars overseas.

Each project in a museum now has its own database, made up of a common set of data categories. (The earlier approach of separate lists of data categories for each discipline has been revised in favour of two basic sets for the humanities and natural sciences, to which can be added additional categories for particular local requirements.) Despite this emphasis on independent files, the idea of a combined national inventory continues to be a key factor in users' minds. The probable approach is to extract a selection of around 20 key categories from each museum file for incorporation within a parallel overall database. This continuing emphasis on pooling information was another of the factors which encouraged CHIN to still have a central system with major processing and storage capacity. It is recognised, however, that much of the work for individual museums prior to the pooling of information might be carried out on smaller local machines. (In practice, one or two museums have already developed local approaches to computing, such as the University of Waterloo and University of Victoria. CHIN maintains close contacts with such cases and examines how to incorporate details from their records into the overall inventory.)

These central systems and the parallel advisory functions are undertaken

by a total of 38 staff, at a direct operating cost of $1.5 million per annum. (This excludes staff salaries and the basic office/administrative infrastructure, which are the responsibility of the overall National Museums. The staff figure excludes data entry staff, this being done outside on a contract basis.) Of these staff, 15 are on the systems-orientated team (including operations and systems development) and 10 are on the museum-orientated team. The latter group includes 5 museum consultants who act as liaison officers and 4 members of a Documentation Research Group who are responsible for training and documentation development. This represents a significant shift of emphasis in recent years towards non-technical support and advice to individual museums. The role of these staff is gradually changing towards a general consultancy function, advising the museums on documentation problems, educating new users and encouraging a positive attitude towards information management.

Each user museum has a designated contact within CHIN, and itself agrees to form a user group and nominate a link person. The museum consultants are now frequently called upon for help as part of this procedure. One of the most active stages in this consultancy is during the transfer of files from the existing ISIS system to PARIS, during which the opportunity is taken to reassess the standard of the museum's records. A number of the major users (such as the Museum of Man, Royal Ontario Museum and Montreal Museum of Fine Art) have been through this process in the last year.

At the time of the transfer, a three-day meeting is held at the museum to discuss conversion problems and the use of the new system. In a case like the Montreal Museum of Fine Art, a number of members of the museum staff took part in this meeting (including some not immediately concerned with the project). This is followed up by a five-day training course held in Ottawa, for which CHIN absorbs the cost of training. The data is then transferred into the two types of file, for humanities and natural science records. (The natural science records are felt to require additional support, such as plotting and analytical procedures.) The museum is then responsible for the future management and use of its records, referring to the liaison officer when necessary.

The museum uses the central system through one or more local terminals. In the past, CHIN has provided all equipment, but it is now expected that museums will be responsible for local facilities while CHIN will concentrate on the communication links.

A number of museums have benefited from various external funding schemes. The Museum Assistance Programmes, for example, provides financial assistance to non-national museums. One of its schemes is the Registration Assistance Programme which can fund both cataloguing and data entry for a museum project. This has a budget of $800 000 per annum. It concentrates on non-national associate museums, excluding natural science collections (with the exception of ornithology!). CHIN itself is also

able to provide help through a manpower funding scheme. In 1982, this involved the placement of 76 students in local museums where they prepared basic manual records. Part of the exercise includes the production of a procedural documentation manual for the future use of the museum. A number of provincial and municipal schemes can also be used for general museum purposes. In Ontario, for example, job creation assistance can be given for students to work in museums during the summer.

These external funding programmes have had a major impact on the development of documentation in Canadian museums. They sometimes act as a spur in encouraging the museum to appoint a registrar or collections manager, both of which are fairly recent developments in most museums. At the Royal Ontario Museum, for example, the collections manager acts as the link with CHIN. At the Museum of Man, a user group has been established by the five curatorial divisions, each of which has independent registrars or cataloguers, and a representative has been nominated to act as the CHIN contact.

Both CHIN and its users are generally satisfied with the new developments and systems. Many areas still have to be developed, such as thesaurus control and basic familiarity with the use of the system. However, the transfer of responsibility for managing records from a remote central organisation to the individual museums has had a significant effect on user satisfaction and involvement. The only major aspect of record management now carried out by the CHIN system staff is that of file updates. The approach adopted within PARIS is to have a stable database, with full inverted direct access files, a queue file and workspace. New records are prepared using a data entry processor and then held in the queue file. The current data entry facility is OLIVE (a module of BASIS), but in the future an additional module will be implemented to provide a rapid data entry facility. This additional MCS system has the capability to set up screens of chosen data. When this change has been implemented, OLIVE will resume its proper function as a module for editing existing records. This involves extracting a copy from the database to the workspace, making relevant changes, then adding the revised record to the queue file. This queue file is then used to update the main database on a regular basis (typically, every week at present).

There are various controls over who can access and amend data, most of which have yet to be fully exploited by the museums. The onus again falls upon the museum to decide on its own requirements and priorities.

As noted above, CHIN is concentrating on its primary area of responsibility of supporting those applications necessary for a museum to demonstrate accountability for its collections and for information sharing. It is, however, also able to respond to pressure from museums to examine other areas. Museum libraries, administrative and financial systems, conservation, public activities and word processing are being examined. It is very interested in the use of viewdata systems for the provision of both

graphical and textual information, and in the longer-term potential of video-text as a public information resource.

Diii2.2 National Museum of Man, National Museums of Canada, Ottawa

James Donnolley, History Division
Kathleen Bishop-Glover, Canadian Ethnology Service
Judith Marsh, Curator of Site Information

The National Museum of Man is one of the four constituent museums of the National Museums of Canada. At present, museum staff and collections are dispersed to a number of buildings in the Ottawa area. A new museum is, however, now being planned.

The *History Division* was established in 1966, since when it has accumulated 55 000 items, represented by 46 000 records. Its first exhibition opened in 1977, before which there was a very high acquisition rate, resulting in a large backlog of material to process. It now has 14 staff, of whom 2 have registrar functions and 3 are curatorial.

After the state of documentation was criticised in a report from the Auditor General, the museum designated funds to be used for a minimum registration exercise. As a result of this, 20 000 skeletal records were prepared (initially with 8 categories of information and subsequently with 15 categories) and input into the NIP/CHIN computer systems. It was also agreed to reduce the acquisition rate so that the existing collections could be processed more effectively.

The current system is a mixture of manual and computer-based procedures, including the maintenance of manual accession and donor indexes, the completion of basic item record cards and general record sheets (for costume, textiles, silver, etc.) and the use of history files. Incoming material is logged on an acquisition approval form or in a gift agreement book. Most acquisitions are by purchase, using a network of local contacts across Canada. The manually prepared index cards are stored in order of material type. The computer records, in contrast, have a function emphasis. The Division has been guided to some extent by *Nomenclature* (Chenhall, 1978a) when assessing its terminology. It is very aware of the problems of standardisation.

Data entry into the computer system is done by the curatorial staff. The original skeletal records have now been complemented by full details for post-1980 acquisitions. It is intended to gradually work back through the earlier material. The resulting computer file is considered to be the primary source about the collection.

The most significant use of the system at present is for the management of location details. This will be particularly important during the movement of material to the new museum. When using the PARIS system, the staff have been most impressed by its retrieval capabilities and speed, but have

experienced some problems with file maintenance and updating. Moving a large number of records to and from the queue file can cause problems.

The division is very interested in the provision of comprehensive printed indexes from the computer files, as a complement to selective online retrieval.

A parallel feature of the concern for the standard of documentation was a comprehensive physical inventory of the collection. Random dip checks of a sample of items are also undertaken for auditing purposes, starting with a purchase order and then working to the record cards and the collection itself. Inventory control will continue during the forthcoming move to the new museum. A movement committee is concerned with planning the registrarial aspects of the move. It may be decided to employ a collections manager for overall control of the collections and a movements officer for the control of the passage of material to and from a local storage area. The use of microcomputers as aids is being considered. Thought is also being given to the provision of a single Documentation Centre, to which the public would have access.

The museum's *Canadian Ethnology Service* is responsible for an ethnographic collection of 52 000 items, the great majority of which are from North America. The main sequence of material is complemented by collections of Eskimo sculpture and prints, with independent documentation.

Prior to 1967, the documentation resources devoted to the collection were unable to support the full processing of incoming material, as a result of which a 10-year backlog of cataloguing accumulated. Since then, work has been underway to reduce this backlog. The current procedure is to note incoming groups on accession register sheets and then assign a temporary number. When the item is subsequently catalogued, a basic item record card is completed and the details typed into the computer system. (In the future, a worksheet is to be completed, data typed into the computer, and the card then produced as one of the automated outputs.) The permanent number assigned during cataloguing is based on Murdock's *Ethnographic bibliography of North America*.

A typical basic record tends to include about 15 categories, although there may be more details (including extensive descriptions) for specific areas of the collection. A museum committee is currently evaluating its requirements concerning field definitions and terminology control. Terminology and linguistic differences are a particular problem within such a varied collection.

The *Site Information Unit* of the *Archaeological Survey of Canada* is developing computer-based records of archaeological sites in Canada, in cooperation with various provincial organisations. The Survey presently holds a computer-based file of records from the Northwest Territories, Yukon and sites on federal land; provincial site information is managed by the responsible provincial organisations.

The unit is concerned to interrelate information about acquisitions, sites and individual items. The federal site file of 6000 site records is to be complemented by 3500 acquisition records to relate the site collections to these site records. These site records have been transferred and updated from the earlier National Inventory of Sites.

The separate National Inventory of Prehistoric Sites includes 32 000 records. This is to be transferred into the PARIS system, when the records will be edited and updated.

The unit uses the Borden system for identifying Canadian sites by means of a grid referencing procedure.

Diii2.3 Royal Ontario Museum, Toronto

Gillian Pearson, Acquisitions and Records Coordinator, Registration Department

The Royal Ontario Museum includes one of the largest and most varied collections in North America, ranging across the natural sciences to social history, represented by 19 curatorial departments (Tanner-Kaplash, 1985). During the last five years, the museum has been involved in a major inventory scheme as part of an expansion and renovation project which has affected the entire collection. It is a major user of the Canadian Heritage Information Network computer systems.

Four service departments (Registration, Preparators, Conservation and Library) provide support to the curatorial staff. The preparators are responsible for the movement of the collection and transport arrangements. Registration is currently concerned with the coordination of the documentation of the nine art and archaeology departments; the ten science departments maintain independent records. In the latter case, the records for the Mammalogy, Ichthyology and Herpetology and Invertebrate Palaeontology collections have largely been automated and prepared for inclusion in the CHIN operated PARIS system and the total record holdings for the Ornithology collection are in the process of being converted. At some time in the future, it is hoped that all artefact and specimen records will reside in an institutional database.

One person based in the science departments coordinates aspects of the documentation and automation work. This Coordinator of Collections Management reports to the Associate Director-Curatorial and has the following responsibilities:

develops, implements and coordinates collections management related plans, schedules and activities in concert with the demands on personnel, time and space resources imposed by Museum-wide programmes;
chairs the Collections Management Task Force ensuring that collections management information is distributed and discussed; problems are identified and solved; priorities are set and action is initiated where appropriate;

generally supervises the implementation of collections management related plans and activities, acting in a trouble-shooting capacity as required;
evaluates collections management plans and activities so that methods and procedures are systematically improved.

The main use of the CHIN computer systems has been to support the inventory work. In the case of the Art and Archaeology departments, around 370 000 basic records have been prepared by the registration department, including accession number, department, object name, location and date, error code. (These may be upgraded to include donor, acquisition method and disposal method.) Comparable details are held for the science material.

The records for 32 000 textiles have already been further upgraded to include additional curatorial information. The West Asian Department has also been examining the implications of an upgrade, in this case by using a separate computer system at the University of Toronto. These records will be converted to the PARIS system in the future.

The movement of collections as part of the building programme began in 1978 and is now largely completed (Tanner-Kaplash, 1985). Early in this period temporary staff were used to prepare the initial basic inventory records. These were then updated as the collections were relocated, a procedure which often involved a number of steps. Most material has now been seen and checked during this process.

The scale and speed of the move has meant that some departments have made parts of their collections out of sequence with the records (usually due to staff and computer access limitations). There may therefore be a need for some reinventorying of collections to ensure that their records are a correct basis for the future. In the long-term, it is hoped that the departments will take responsibility for the maintenance of the files.

These location records are now used as the basis for audit dipchecks. This has been initiated by the museum, with the encouragement of its auditors. Ten items are selected at random each month from each of 10 departments, with the results of the check being noted on the printout. In the last year, this internal check has taken the place of a comparable exercise by the external auditors.

In parallel with the emphasis on the inventory project, the registration and curatorial departments have continued with the long-term management of the collections. In the case of incoming material left by an enquirer, a temporary receipt is issued, one part of which is retained with the item and another passed to the registrar. Each department has a holding area within which the material is stored. The department is responsible for advising the registrar before subsequent action. In the case of an acquisition, the registrar then coordinates the overall procedures. Unconditional low value gifts can be recommended to the director by a curator. Other cases may be referred to the monthly meeting of the collections committee of the Board of

Trustees and, if necessary, the full Board. Detailed action is influenced by the legal position. In the case of items on which tax relief is being claimed, the museum is responsible for obtaining appraisals. Both this and the related agenda for the collections committee are coordinated by the registrar's office.

A typical annual donation rate is around 350 groups. After their acceptance, a copy of the gift form is countersigned by the depositor as the final formal stage in the procedure. The procedures for purchases are less formalised and less frequently applied. They are not as strongly influenced by external tax requirements. A department may approve a purchase up to $2000; the director may approve one of up to $10 000.

After the acquisition, the registrar assigns a group accession number and prepares a series of temporary catalogue cards, one of which is retained and the other passed to the department to advise it of the accession number. The department is responsible for marking the items in its care. Location information is returned to the registrar. Basic item details are then included in the computer file.

Each department is responsible for cataloguing acquisitions, including the production of a master card about each item, a copy of which is sent to the registrar for incorporation within the central catalogue, where it replaces the temporary card. This central catalogue in numerical order is held in the registration area, although it is the responsibility of the curatorial staff. This is the primary reference to the collection for numbering purposes, etc.

Although all primary paperwork is held in the registrar's department, the curatorial departments keep accession files (with copies of relevant information) in donor order. Access to all these files is available to staff and federal authorities. The latter have full right of access for auditing and tax purposes. Requests for information from these files by the public are passed to the relevant curator for approval, after which the file is vetted for confidential details.

A security copy of the gift and appraisal forms is kept in an outside store, together with insurance lists and photographs of important collections.

Long-term loans-in, of which there are around 3500, are detailed in the central records, using a separate numbering sequence. Both these and short-term loans-in are coordinated by a member of the registration team, supported by an exhibitions assistant.

The loans coordinator is also responsible for loans-out. A Loans Sub-committee (a standing committee of the Collections Management Task Force) chaired by the loans coordinator assesses the suitability of the requesting museum while the curatorial and conservation staff assess the suitability of the object itself. Depending on the value of the material, loans may require the approval of the Collections Committee or the full Board of Trustees. A word processor is used to help with the correspondence, etc., concerning loans and exhibitions.

The use of the CHIN computing systems was noted earlier. The

Coordinator of Collections Management acts as the liaison with CHIN, contacting a specified museum adviser within the Ottawa office. However, as the registrar's department is a major user it also has close informal links. It noted its favourable impression of the new system. Seven terminals within the museum are linked to PARIS.

The current emphasis within the registrar's department is on using the system to maintain precise location details and during the monthly audit checks. One person has become most familiar with its capabilities, drawing up standard profiles and procedures to aid the use of the new system.

The system allows multiple entries within linked fields. One use of this is in preserving details of previous locations and dates, thereby building up an audit trail. It was noted, however, that there is no procedure to check that a date is always added to complement a location change, and that the sequence of entries could become broken.

Diii2.4 Public Archives of Canada, Ottawa

Georges Delisle, Director, Picture Division
Jean-Pierre Luckowycz, Chief, Reference and Information Processing, Archives Branch
Raymond Vézina, Chief, Art Inventory Section, Picture Division
Denis Castonguay, Picture Division
Hugo L. P. Stibbe, Chief, Document Control Section, Maps Division

The Public Archives is responsible for acquiring all significant archival material relating to aspects of Canadian life and the development of the country and for the promotion of efficiency and economy in the management of government records. Its Archives Branch consists of eight divisions:

Manuscript
Federal Archives
Public Archives Library
Machine Readable Archives Division
National Map Collection
Picture Division
National Photography Collection
National Film, Television and Sound Archives

Its documentation approach and collecting remit are closely analogous to those of a number of United Kingdom museums.

The Archive has been actively investigating the use of computer systems and videodiscs for some years. It has recently appointed a coordinator as head of a new section to advise on documentation aspects. Each division is assessing its current procedures to see how they should evolve in the future, as part of an overall approach to documentation. The conversion to a computer-based system is expected to take at least ten years. An early priority is for every division to have basic control over its collections by

1987. Ideally this would be achieved by using a single computer system as the support.

The *Federal Archive Division* is one of the first to have operational facilities. It is developing collections management procedures as the primary step in an automation programme for the 80 000 ft of records in its care. Basic acquisition details are included within the system as an initial control over incoming material. The records have categories for acquisition details and management information. 130 000 records have now been included within the system in the last year. Reports generated from this information are used as a means of monitoring the progress of material.

The division uses a bureau service for its processing, applying the MINISIS software package. It is moving from a standard processing charge to a facilities management procedure, whereby it pays a regular monthly sum ($14 000) for guaranteed resources.

The *National Map Collection* is to begin using the UTLAS bibliographic utility for the computer-based cataloguing of its cartographic collection of around 1 million items. The Toronto-based UTLAS centre allows individual users to prepare independent computer files on the single system, each of which can have its own database definitions, etc. In the case of the cartographic collection, the Archive is to use a MARC based system, applying a PRECIS approach to subject indexing.

It is particularly concerned to have an effective geographic area access method. Topographic subject and geographic names are to be included in the PRECIS string. An area classification scheme and geographical coordinates are also to be noted.

The first concern will be to develop a file of the most recent acquisitions in the collection. These records tend to be fairly extensive when compared with those of other divisions. Two terminals are to be used for online data entry.

The *Picture Division* has been developing the idea of a computer-based documentation centre, concentrating on pictorial and textual description of works of art, biographical details of artists and file organisation. Much importance has been given to procedures for precise image descriptions. It has been involved in the use of MINISIS and experiments with videodiscs, first with Thompson and now with Sony. Specialists from Tsukuba University (Japan) were also consulted.

The Division is concerned to develop detailed description standards for each category in a record before beginning major cataloguing and data entry (Computerized Inventory Standards, 1981). As part of this work, an iconographic approach has been developed. Beside titles, proper names, places and dates of representation, a thesaurus of subject terms is being produced. It includes eight terms at the first level (architecture and engineering, transportation, people, animals and plants, activities and events, physical geography, artefacts), subordinate defined terms at the second level and an open terminology at the third level. Other terms dealing with non-figurative realities and human behaviour in general are being considered.

This thesaurus has been influenced by an assessment of the information requests received by the Division. Some 30 000 inquiries were analysed, as a result of which 3000 terms were added to the third level of the thesaurus. This is now being evaluated, by analysing the images in 15 000 posters forming a test file.

The test is to be used as the basis for a further videodisc experiment. An overall view and two detailed sections from each item are to be incorporated on the videodisc. Index information is to be stored on a linked microcomputer which can then be used as an aid when selecting images.

Parallel work is being done to build a file of records about Canadian artists, based on images in the collection, supported by bibliographic details.

The Division is very keen to cooperate with other archives, libraries and museums in the promotion of this work for the benefit of the public.

Diii3 United States institutions

Diii3.1 Smithsonian Institution, Washington, D.C.

Office of the Registrar
 Philip Leslie, Registrar
Office of Information Resource Management
 Richard H. Lytle, Director
 Reginald Creighton, Special Projects
National Air and Space Museum
 K. P. Suthard, Chief, Records Management Division
Hirshhorn Museum
 Douglas Robinson, Registrar
National Museum of American History
 Frank D. Roche, Manager, Inventory Project
 Darroll M. Sharer, Coordinator, Inventory Survey Office
 Virginia Beets, Registrar
 Diana Ansley, Registrar's Office
 Raelene Leanitt, Computer Services Center
National Museum of Natural History
 Gary Gautier, Chief, ADP Program
 Alice Thomson, Inventory Coordinator (Anthropology)
 Bruce Daniels, ADP Program

During the last decade, the Smithsonian Institution has been involved in a major inventory programme, become a significant user of automated systems (building on facilities introduced in the late 1960s) and developed new collections management policies. This report looks at aspects of the work of six separate parts of the Institution: the Offices of the Registrar and Information Resource Management, the National Air and Space Museum,

Hirshhorn Museum, National Museum of American History and National Museum of Natural History.

Central advice to the ten constituent museums is provided by the Smithsonian Office of the Registrar and the recently established Office of Information Resource Management. The second office includes responsibility for the former Office of Computer Services, which supports a mainframe Honeywell computer as a service to the individual museums. A number of the museums also have local computing facilities, either as data entry systems or as independent processing centres, interfacing in various ways with the distant mainframe.

The *Office of the Registrar* is a small unit concerned with coordinating the development of collections management policies, monitoring the preparation of collection inventories, advising at workshops on computerisation aspects of documentation, etc. These residual functions exclude the active preparation of primary object documentation, a role which has gradually devolved to the individual museums. The museums have their own registrars and – in the case of the National Museum of Natural History – collections managers.

Museums in the United States faced growing pressure during the 1970s to respond to the developing attitude that they were holding collections in trust for the nation. The Smithsonian Institution was itself under examination during this period, due to its having requested funds from Congress for a major support centre (Duckworth, 1984). An internal task force which was established in 1977 to examine collecting practice and management control, recommended that each museum be asked to establish collections management policies. At the same time, external enquiries from Congress focused attention on the immediate problem of inventory control.

Prior to this, there had been no formal stocktaking policy or procedure and no dipchecking. The Registrar then drew up an outline collection inventory programme, the detailed implementation of which was to be delegated to the individual museums. The primary aim of this programme was that each museum conduct a comprehensive physical inventory of its holdings. A five-year project was initiated, to be completed by 30th June 1983. Congress noted these proposals and provided additional funding of $500 000 in the first year to help the work. The Institution itself directed major additional funds and staff resources to the scheme. The contributions and investments have since been continued on an annual basis, with the result that the original scheme is now nearing completion. As an indication of its long-term commitment, the Institution has established an internal audit team, one duty of which is to monitor the maintenance of the inventories. It is hoped that further additional funds will be provided by Congress so that the work can be continued in the future on a permanent basis.

The emphasis during the five-year project has been on the creation of a base line inventory for each museum. This comprehensive physical inventory will have been completed by June 1983, and work will have

begun to match the resulting findings details against the existing object documentation. Subsequent action will concentrate on the reconciliation of these two sources of information, leading to long-term inventory maintenance.

A dominant factor influencing the work within the individual museums was the status of their existing records. If these were good, the museum's basic objective was to see whether everything in the records could be accounted for. If they were not good, the first objective would have to be the creation of records showing what was present in the museum at the time of the inventory. In six of the museums, it was possible to adopt the first approach. At the Freer Gallery, for example, the existing high-quality manual system was used as the basis. At the Hirshhorn Museum, the existing computer files were used to produce location lists which were then checked against the collection itself. Four musuems fell into the second category. In the case of the Cooper-Hewitt Museum in New York, the collection had not been inventoried when it was transferred to the Smithsonian Institution in the 1970s. As the existing records were unreliable, it was decided to first prepare a new computer-based inventory and then to match this with the existing records. The Air and Space, American History and Natural History collections are developments of the nineteenth century National Museum. As there were serious doubts concerning the comprehensiveness and accuracy of the old records from this earlier museum, it was decided that each of the present institutions would concentrate initially on a physical inventory. As it was felt that any universal attempt to match this to the existing records would be futile, this new inventory would form the base from which future records would be developed. It should be noted that these three museums together account for by far the greater part of the items within the Institution's care.

In a number of the museums, it was possible for existing staff, such as their registrar, to take responsibility for the inventory work. However, in both American History and Natural History, major temporary teams were employed to pursue the basic inventory development (in the former, within an Inventory Project unit; in the latter, within the existing Automated Data Processing Program). In these cases, basic details such as object name, number, location, material and conservation requirements were being noted. In Air and Space, additional catalogue information was being added, with a significant input from the curatorial staff being necessary to ensure that the 1983 deadline was achieved.

Many of these projects rely upon computer-based procedures for their effective implementation. The Institution has been involved in using computers for object documentation since 1968. During the 1970s its central Office of Computer Services (OCS) acted as a service agency, responding to the individual computing requirements of users by applying standard program packages (such as SELGEM) to their particular needs. In recent years, there has been a growing concern at the lack of standardisation and

gradual divergence of approach which has resulted from this service agency/customer relationship. The OCS has now been subsumed within a new *Office of Information Resource Management* (OIRM), responsible for the future coordination of the management of documentation procedures (see, for example, Smithsonian Institution, 1984).

In addition to the OCS staff, the Office has a nucleus of four advisers with information science and systems experience. One of its primary functions will be to assist users with information needs assessment. The Office will respond to a requirement proposal by investigating the true needs of the user. As a result of this assessment it would be possible to make a decision on the appropriate hardware/software configuration and whether the required facilities should be internal or external.

In the long-term, it was intended to concentrate on overall processes and methodology, rather than specific system problems. However, in the short-term the Office was undertaking an evaluation of the immediate computer requirements of the Institution. It was tending towards a centrally conceived and managed distributed system. Software requirements might be satisfied by a generalised database management system, suitable for use on different hardware.

The Office was concerned to advise on data standards, terminology control and data interchange problems. It would work to establish a directory of information resources within the Institution.

The role of microcomputers was also being assessed, for both archive and museum applications. Existing guidelines concentrating on the use of Z80-based machines were being extended to cover the new generation of microcomputers.

One museum that was already actively involved in local computer use was the *National Air and Space Museum.* A recently donated Prime computer was to be used to develop computer-aided exhibits design. The Office of Information Resource Management would cooperate in this project, monitoring its progress on behalf of the other museums. There was a similar level of involvement in the museum's use of videodisc equipment, which would be interfaced to the local Prime computer for automated retrieval of images.

The museum has been actively investigating the use of videodiscs to store copies of images from its historical files. These currently include about 1 million photographs of aircraft, space craft, biographical images, etc., of which 100 000 have been copied onto a double sided videodisc. The exercise was seen as a means of preserving the original images, providing means of access to the images, giving prompt retrieval of a specific image and improving methods of publication and distribution.

The procedure involves preparing a 35mm film containing the relevant images, transferring this film onto a videotape, preparing a master disc of the videotape and then producing working copies from this master. The museum was involved in the production of the original film, using inhouse

facilities, the assignment and checking of numbers to the images on the videotape and the overall management of the project. Outside firms were responsible for subsequent stages, with 3M being used to produce the master disc. Although there had been a number of technical problems at various stages in the transfer process, the museum was very satisfied with the results. It thought that it would now take about one year to produce a new disc.

The videodisc equipment currently used by the museum is a laser-based optical videodisc system of the type manufactured by Discovision, Pioneer and Sony. The optical system had distinct advantages in that the images were not liable to wear and tear, and it was amenable to single image viewing. The Air and Space exercise concentrated on single images rather than motion picture images, in contrast to most exercises elsewhere.

Individual images are viewed by keying their number using a simple keypad. The images on the disc are arranged in classified order. A basic printed index is available, containing concept keywords, photograph negative numbers and image numbers. By referring to this list it is possible to gain access to relevant images. Although the list is a computer-produced index, there is no need for a computer to be linked to the videodisc equipment. Such a link will be more useful in the future, when additional index terms have been added to the file. At this point, the records will be transferred to the local computer which will itself be linked to the videodisc. The software to manage these procedures is currently being developed.

The system has already proved successful, with satisfactory image quality and a good response from outside users. The museum is, however, conscious of the key need for a significant staff commitment to the work. It had the advantage of working with a collection that had already been classified and which was large enough to justify the investment.

The overall costs are difficult to quantify, in view of the extent of the work done by the museum itself. Its external costs were around $1800 for the videotape master and $3600 for the videodisc master, copies of which were $22 each (for a double sided disc, in all cases). Capital investment costs include the disc player and a television.

The discussion at the *Hirshhorn Museum* concentrated on the role of the registrar. The current procedures in this museum had been based upon those at the Museum of Modern Art. The registrar had moved from the Museum of Modern Art to the new museum, with a smaller collection but similar problems. The function of the seven staff in the department concentrated on three areas: documentation of the permanent collection (including details of new acquisitions and computer-based cataloguing), loans-out and loans-in for temporary exhibitions. Its responsibility included aspects of the physical safety of objects such as packing and shipping, although there was a separate department for exhibits.

New acquisitions are considered by the curatorial staff, the director and trustees. The registrar is involved at an early stage, prior to the initial

meeting of the trustees, when the object is received for evaluation. After its acceptance the registrar is responsible for preparing a basic catalogue entry. If it is conserved, a separate conservation record is also produced.

The registrar is responsible for monitoring all material coming into the museum, assigning a temporary receipt number on its initial entry, and an accession number after its formal acquisition. The basic catalogue record prepared by the registrar includes physical descriptive details. A copy is passed to the relevant curator for verification. After approval, the key information is entered into the computer system. These steps are guided by a procedural manual. The computer file is used to produce a master list held in the registrar's office, and multiple copies of indexes which are passed to the curators. These are updated every six months.

Separate curatorial files are kept for each object in the collection, including information such as correspondence with the artist. When the museum was formed (in the early 1970s) it acquired a major collection from its benefactor. Basic records were prepared for each item in the collection, about half of which have since been extended to include fuller details.

The museum has few long-term loans. Those that are held are treated in a similar way to acquisitions, but receive a distinctive loan number. Loans-out are coordinated by the registrar's office and approved by the director. They are noted in exhibition history files (one sequence for internal exhibitions and one for external loans).

The museum has a well established inventory procedure, introduced some time before the current Institution-wide emphasis on inventory control. The collection is divided into three subject areas (painting, sculpture and paper), each of which is checked every three years. The computer file is used to produce an artist printout as the basis for the check. The exercise was felt to be well worth-while for a collection of manageable size. It served to identify items needing conservation and helped with the management of the stores. The inventory work is done by the registrar staff. Recent checks had taken 300 hours for 2139 sculptures, 500 hours for 3398 paintings and 200 hours for 1800 paper items.

More generally, the registrar noted the growing realisation of the importance of record keeping and a long-term commitment to collection management, accountability and security during the last decade. In many museums this had led to a recognition of the need for a registrar. One problem in introducing a new attitude and functions was that of established precedents, particularly in larger museums. Another was where the status of the registrar was subordinate to that of the curatorial staff, leading to potential conflicts of interest. At the Hirshhorn Museum the registrar reported to the director.

The acquisitions in the *National Museum of American History* date back to the original National Museum, formed in the nineteenth century. The existing catalogue books cover this period. From the late 1880s, basic acquisition details were recorded by the central Institution registrar's office.

This approach continued to the 1960s, when the registrar was responsible for maintaining acquisition details, loans and movement control, with the help of a separate shipping office. By this time, a number of small museums had begun to develop away from the main Smithsonian buildings, and there was growing pressure for local registrars. In the case of what is now the American History Museum, this resulted in a registrar's office being established in 1972. The newly appointed registrar had previously been an administrative officer within the National Museum.

In the last decade, the office has gradually introduced new procedures for basic documentation. The move to central coordination has been particularly difficult in view of the long-established practice of individual curators. The dispersal of the registrar's staff in a number of separate rooms within the building has done little to help the position.

The initial pressure within the museum was to develop new exhibitions in preparation for the 1976 centennial celebrations. (The resulting 1876 exhibition in the separate Arts and Industries Building is now the responsibility of a special exhibits officer within the registrar's team.) One of the first priorities was therefore to develop effective insurance procedures for material entering the museum.

It was only in 1976 that the primary accession files for the collection were brought into the museum from the original Institution registrar's office. The museum registrar is now responsible for coordinating four aspects of work:

accessioning;
object processing facility;
loans, insurance and special exhibits;
computer services centre.

The existing social history collections total around 16 million items, the greater proportion of which are philatelic or numismatic. The current accession rate is approximately 1200 groups (around 50 000 individual items) per annum, the majority of which are donations. A collections committee monitors the development of the collections, examining all purchases and all significant donations.

Individual curators are responsible for preparing the initial paperwork prior to an acquisition proposal. This is then passed to the registrar, who coordinates the formal accession records, checking the accuracy of any legal details. The curator remains responsible for information other than that concerning the acquisition.

Following pressure from the auditors, most material entering the museum now passes through the Object Processing Facility. In the past, it was common for items to be taken direct to the relevant department, with no entry documentation. (There are still occasional cases when undocumented material is left within a department.) The Object Processing Facility handles about 10 000 incoming groups (for both acquisition and loan) and 8000 outgoing objects in a year. It coordinates security, handling and transport

arrangements. A basic condition report is prepared for all incoming material.

Acquisitions are documented by the adjacent accessioning office, which includes the primary central legal and historical files for the collection. It holds the original catalogue books back to the early 1880s. Records prior to the 1958 have been microfilmed as a security measure. Basic details of each acquisition are noted in a bound accession register and a file prepared. The files are stored in carousels and held in numerical order, within permalife envelopes. Each page in the file includes a note of the accession number and is itself numbered sequentially. The details include a formal accession memorandum.

A separate set of checklists is maintained, showing the state of progress of each file. This sheet is annotated when a new paper is added to a file. It is the basis of a computer record about the acquisition.

The files do not include detailed location information about the items in the collection, this being the responsibility of the individual departments and a separate inventory project. In the future, however, current location details may be included.

The museum does not accept long-term loans. It does, however, have a very active exhibition programme, the documentation of which is coordinated by the registrar's office. Loan details are held separate from the main acquisition sequences. They have not yet been automated.

The museum has been interested in the adoption of computing systems since the late 1960s. The subsequent impetus has come from the registrar's office and the Mathematics Division, the Curator of which has coordinated the development of a data standard for social history objects (MIRDS – Museum Information Retrieval and Documentation System). Most progress has been made in the last three years. The Computer Services Center within the museum is part of the registrar's office.

The Center now uses the Institution computer facilities and has internal systems, including a Wang minicomputer (Wang VS 80 system with 150 mb disc pack, magnetic tape unit and 14 terminals). A present, its main function is to support the inventory project with basic data entry facilities. In the future the inventory work may become the responsibility of the individual departments, each of which will then have terminals. The Center may also offer financial, accounting and personnel systems.

The Wang is to be used to accumulate data in a form suitable for regular transfer to the central OIRM mainframe. In the case of philatelic material and numismatics, the staff concerned undertake direct data entry onto the new system. The Wang will gradually replace a number of existing approaches to data entry. One of these is three microcomputers which act as stand-alone work stations. These are wheeled into a storage area for use during the inventory work. The data from them is transferred to the mainframe. The museum also has six Nixdorf terminals linked direct to the mainframe. Much of the inventory typing has been done by an outside

bureau which also uses a Nixdorf data entry system. The predominant documentation use of the computer system has therefore been for the basic accession records and the inventory data. Only one curator has been involved in the use of the system for catalogue records.

The Inventory Project was established in the late 1970s in response to the Institution's priority on the inventory work (Evelyn, 1981). The team is independent of the registrar's office, although a major user of the computer facilities. An Inventory Review Board is responsible for the overall policy of the work.

The project is supported by a manager, 2 coordinators and over 10 assistants. There are also additional temporary staff in the Center. The coordinators are responsible for work in the museum itself and at the distant Silver Hill store, where the exercise includes an extensive cleaning and reorganisation programme. Although the manager is on the permanent staff, the other members of the team are either on temporary or term contracts. Staff are usually well qualified and experienced in museum practice. The primary purpose of the project is to gain control over the collection by undertaking a comprehensive stockcheck, ensuring that items are numbered and that records match the collection. The computerisation of the information is seen as a means to allow the future manipulation and use of the data for research, etc.

The approach adopted has been influenced by the background of the museum, with its history of curatorial independence, and lack of rigid control over internal and external movements. Although the introduction of the registrar's office has had a marked effect on the problems, it was still possible for individuals to move material without reporting the change. Location details were noted locally, at the department level. Many of the existing manual departmental recording systems were of an arbitary nature, with little categorisation of information or control over terminology, etc.

Since 1977, the museum has used a year-based accession numbering system, with individual items having a number formed from the overall group number. Prior to that, separate independent catalogue numbers had been assigned to individual items on a departmental basis. Only those catalogue numbers were noted on the objects themselves. There were major problems of reconciling the various numbering systems and of managing objects with no numbers at all.

In the circumstances, it was decided to establish an independent inventory team, and to concentrate initially on a shelf stockcheck. Reconciliation of these store details with the existing records would come later. The physical inventory should be complete by April 1983. The data entry and processing of these records will then be pursued, in parallel with moves to improve the standard of information and the first step towards reconciliation with the existing records.

The main project will end in 1983, after which it was hoped to continue the work on a more limited scale by retaining some of the term positions.

These staff may be placed in individual departments to help them maintain their own section of the inventory, deal with local problems and begin the reconciliation. How the central inventory file would be maintained and how it would interrelate with the accession and catalogue records had yet to be decided.

The long-term usefulness of the present exercise was very dependent upon its further funding. The current work was funded by various sources, totalling around $750 000 per annum. This included special inventory appropriations of around $250 000 and a major investment from the museum's own budget, topped up with supplementary requests drawing upon the overall Institution budget. (These sums included curatorial staff time allocations.)

The collection of some 16 million items is concentrated in three areas: philatelics (13 million), numismatics and social and cultural history. The latter is further divided into a number of divisions. In the case of the main stamp collections the inventory work depends upon the use of standard published catalogues. The classified numbers from these catalogues are noted in a stock book, together with a count of the number of items held by the museum. For some of the less significant stamps, a more limited approximate count is being prepared, using the MIRDS categorisation approach. Some batching of related items was allowed. Items or batches without identity numbers are assigned a new record serial number.

The work is being done at a divisional level. Before moving into the stores, the inventory coordinators draw up a written statement of agreement with the division, noting the mthods to be used and the information to be recorded. Using the MIRDS categories as a basis, one or more record sheets are prepared for each division. The amount of information to be included on the sheets depends on local circumstances, but is often some way between the minimum needed for inventory requirements and more comprehensive catalogue requirements. (In a few cases, direct data entry has been used, circumventing the manual recording stage.)

Certain categories of information are considered mandatory for all divisions, including location, object name or function, number of parts and identity number (or the newly assigned serial number). Some divisions restrict the full inventory record to from 5 to 8 categories (adding details such as association or basic physical description); others range up to 15 categories (such as in ceramics and glass). The location information may be specific, or as general as a room (in which case subsequent movements of material within that room may not be recorded). Little reference is made to any existing documentation.

New inventory staff are given three days basic training before beginning their work. The recording procedure requires a complex use of links between categories, the application of which is highly subjective. When using the sheets, it is possible to establish header information which is then merged into subsequent records.

The normal procedure is for a member of the inventory staff to work

through the material in a particular store. Ideally, a member of the curatorial staff is actively involved in the recording, providing information to the inventory person, who then acts as a clerk. In practice, the involvement of the curator is usually limited to their being on hand to offer advice if there are any problems of interpretation. Once the record is complete a series of sheets are passed for data entry at the service bureau or within the Computer Center. A listing of the resulting file is later returned to the division for proofreading. The list is in category order, but with the minimum of analysis and interpretation of the initial input. In many cases, the records for a division are only now reaching this stage. The number of records completed in a day is very variable, ranging up to 3000. The aim is to exceed an average of 150 for a 6-hour shift.

The nearby *National Museum of Natural History* has also been involved in a major inventory project. Unlike American History, the Institution-wide pressure for inventory control came at a time when Natural History already had a positive attitude towards inventory work and a well established and experienced computer team. This Automatic Data Processing (ADP) office has been used to coordinate the subsequent inventory work, as a result of which from 7 to 8 million records will have been produced by mid-1983.

ADP is responsible for managing aspects of the museum's computerised documentation projects, supporting an inhouse word processing system, liaising with the central OIRM and advising on future computing developments (Gautier, 1978b; 1985). It is one of the major customers of the mainframe facilities.

The availability of an experienced team before undertaking the inventory project is seen as a major factor behind the subsequent success of the exercise. The positive attitude of staff in the museum was another key factor. Previous experience also meant that the museum was able to make informed estimates of the scale of the project which it was contemplating.

It is felt that the concentration on the inventory project has been of overall benefit to the museum, although it may have deflected effort from other aspects of documentation which might otherwise have been developed, and may have biased the emphasis of some of the computing systems. Ironically, it may have delayed the development of certain aspects of the computing systems (such as the change to new software), due to the pressure of day-to-day practical problems. However, it has led to a considerable willingness on the part of staff to use automated systems: a willingness which might not have developed in more normal circumstances.

The approach to documentation within the museum is one of decentralisation. Material coming into the museum is logged by a registrar who maintains basic acquisition and loan records. Subsequent action is the responsibility of the departments, a number of which have a collections manager or the curatorial staff develop inventory and catalogue records as part of an overall procedure. All the inventory records and selective catalogue records are then automated, with the support of the central ADP

program which provides advice and facilities and overall coordination of the temporary inventory teams. Responsibility for both inventory and catalogue records remains at a departmental level.

The collections total around 60 million specimens. As any attempt at a comprehensive item-by-item inventory was clearly unrealistic, the approach of a collection-based inventory has been developed. This will be used as a guide when deciding on the physical arrangement of the collections and when monitoring the future development of the collection for management purposes. The overall collection has been split up into around 1000 units, on the basis of criteria such as material type, mode of preservation, current arrangement and scientific importance. Once demarcated, the collections are inventoried by means of group records, which note basic information such as where they are stored and the scale of the collection.

Comprehensive item inventories have been undertaken within some departments and for certain material such as type specimens. Three approaches have been adopted. In the first, the items themselves have been checked *in situ,* the details have been processed and the resulting file compared with the existing catalogue. In the second, the catalogue is used as the source for a physical check. In the third, both the store check and the catalogue details are processed and then automatically matched. As in American History, the second stage of matching and verification has still to be done for most material. The shelf check will, however, have been completed by June 1983.

The core of the inventory work has been undertaken by staff coordinated through the ADP program, within two different budgets. The regular programme of ADP now has 34 staff, most of whom are permanent, dealing with both inventory and cataloguing work. The special inventory programme has 38 temporary staff (with a target figure of 52). In addition, various departmental staff are involved with the project. The total investment is currently around 100 man-years per annum, at a cost of around $750 000. (The total staffing in the museum is around 500 curators and assistants.) The cumulative figure for the five-year project will have been over 300 man-years.

The museum hopes that the Institution will receive further permanent funds to continue the inventory work after mid-1983. If this happens, a proportion of the temporary inventory staff may become a permanent addition to the existing long-term ADP team. It would then be possible to maintain the inventory files, to reconcile these files with other records, to enhance the existing information, to expand into new areas and to upgrade the computing systems. The inventory itself would be used as the basis for both comprehensive and spot checks. It is intended to identify various categories for checking purposes: frequent checks (for high-value items), random cyclic checks, regular cyclic checks, spot checks and a group that is never checked.

Although coordinated by ADP, many of the temporary staff have been

seconded to individual departments. (In some cases, such as Anthropology, this approach has been formalised, and the position is now permanently assigned to the department.) These staff and the departmental staff have cooperated to design record sheets which are used to note the inventory details while in the stores. This information is then input into the computer system, using data entry terminals within the departments. The computer system itself is supported by the central ADP staff and the Institution's OIRM. Requests for indexes, etc., are channelled through ADP.

The information being recorded is a subset of the full catalogue record that might be developed for that material. A record typically includes around 14 categories including the components of the taxonomic name, number of specimens, catalogue number, geographic and cultural details and storage location. (The latter may be omitted if it is apparent from other aspects of the record.) Departments have been able to request the addition of other, non-inventory, details as long as this has not significantly affected the schedule.

One of the most active departments has been Anthropology (including archaeology and ethnology), whose collection is now fully inventoried. This department has a collections manager and an inventory coordinator (Willcox, 1980). It was already actively developing inventory procedures before the Institution-wide approach, primarily due to its impending move to a new Museum Support Center (MSC). The collections include 40 000 physical anthropology specimens, 120 000 ethnology specimens and millions of archaeological items, of which all material in the latter two categories is to be moved to the new Center, outside the main Mall complex. Departmental staff are to retain offices in the museum but also have workspace at the MSC.

The inventory project was consequently seen as both a long-term collections management exercise and a short-term aid in the move to the new facility. In the event it proved an indispensible aspect of the move, helping the department assess details such as conservation and storage requirements. (For example, by logging the storage requirements of individual items, it was possible to build up a picture of the optimal shelf arrangement within the MSC.) The worksheets used during the project were designed to take both the long-term and short-term priorities into account.

The project has now been underway for 4 years, with 8 staff involved in its implementation. The department undertook careful planning to eliminate unnecessary effort. For example, two staff were involved in the early stages in a detailed assessment and evaluation of the practicality of the proposals. Two years were then spent in the comprehensive physical check of the stores, during which the existing catalogue information was ignored. This has been followed by one year resolving inconsistencies in the ethnology records and another year working through the archaeology data.

Inventory worksheets were used in the stores, the latest version of which was used within a mark-sensing system. No non-descriptive information

was recorded. Each record included an inventory serial number, the item catalogue number (if available) or an arbitary temporary number, exact location, number of specimens, reference to any associated information such as a label, basic material description, conservation assessment and storage assessment.

Most of the collection already had an assigned catalogue number which could be incorporated in the record. For those items that did not, the temporary number was added and any other basic details which might help to resolve the anomaly were noted (such as earlier field numbers). 12 000 temporary numbers were eventually assigned. Most of these problems have since been resolved by means of clues such as an alternate number.

The location details were highly specific. A location numbering system was developed at an early stage in the project and used as a basis during the inventory. The storage assessment included an indication of future storage requirements and a note of dimensions, as part of the preparation for the move to the external MSC. The parallel conservation assessment has also proved valuable when planning future conservation programmes.

The physical inventory work has been done by individual members of staff with no direct involvement from the curatorial staff. In exceptional circumstances, a second inventory assistant might help (e.g. when dealing with large items). The recording rate was very variable, ranging from less than 100 items per day in ethnology to 100s per day in archaeology.

Once the physical inventory had been completed, the catalogue card records were used as the second source of information. After these had been processed, the two sources were used to produce a single printout in numerical order, with the inventory details to the left of a number and the catalogue details to the right. Staff are now working through these lists to reconcile the details, judging whether the two sets of information for each number match up and querying any omissions. Once validated, the two records for an item can be combined into a single file.

The department intends to maintain the inventory on a long-term basis as a key part of its overall collections management procedure. Any long-term movement of material is noted on a specimen transfer form which is submitted to the inventory controller who arranges for the file to be updated.

The problems in the Entomology Department are rather different. Only a small proportion of the collection is moving to the Support Center, the collection itself is far larger and a significant proportion of specimens (from 30% to 50%) are not numbered. In the circumstances, the inventory team are concentrating on the type specimens, some of which are held in specific locations while others are dispersed.

The physical inventory of these key specimens has been mainly completed and the nine inventory staff are now working on the data entry stage. As in Anthropology, the curatorial staff have not been actively involved in this work. The fragility of the specimens has been a particular problem during their physical handling. The fact that most of the staff concerned

have a relevant biological background has been an important factor in reducing the danger to the collection. Work is now under way to resolve problems identified during the physical inventory by turning to the existing catalogue records.

Reference was made above to the new MSC, the manager of which is to be the former collections manager of the Department of Anthropology. All material entering the MSC will be rigorously controlled, passing through a single entry point and being immediately logged into the computerised inventory system.

A DEC VAX 750 minicomputer is to be used to control the records, using standard DEC database management software, and to provide facilities such as word processing. This will be linked to the other systems in both Natural History and American History and the OIRM itself.

In the longer term, the museum is monitoring with interest the developments and planning within the Office of Information Resource Management concerning the availability of portable database management systems. The ADP section would like to be able to rely upon such a system for many of the aspects of its work which are currently controlled manually, such as file management and system monitoring. It would also actively explore the use of such a system for control documentation purposes, such as location and loan management.

Diii3.2 University Museum, Philadelphia, Pa.
Philadelphia Museum of Art, Philadelphia, Pa.
Pennsylvania Academy of Fine Art, Philadelphia, Pa.
Winterthur Museum, Winterthur, Delaware

Caroline Stuckert, Registrar, University Museum
Irene Taurins, Registrar, Philadelphia Museum of Art
Janice Stanland, Registrar, Pennsylvania Academy of Fine Art
Karol Schmiegel, Associate Registrar, Winterthur Museum

These four museums in the Philadelphia area each have an active registrar's department. The University Museum, founded in 1887, has a major collection of around one million items of international importance, concentrating on archaeology and anthropology. The Winterthur Museum is based upon the 70 000 items in the Americana collections of H. F. du Pont, opened to the public in 1951 in a large country estate. The Academy of Fine Arts has a strong collection of European and American works, while the Museum of Art's collections range over both the fine and decorative arts from around the world.

The first registrar of the University Museum was appointed in 1929. The present registrar was appointed three years ago as the first full-time officer in that post since around 1970. The office has now been upgraded to include the Registrar, Assistant Registrar, Secretary, Computer Facilities Manager

and two Interns. In addition, 15 University students and approximately 50 volunteers are taking part in a retrospective inventorying project.

This major project is part of a broader scheme to improve the standard of collections management within the museum, covering aspects such as documentation and storage facilities. In the case of the documentation work, the museum has received financial assistance from outside organisations to help it implement its plans. These have included the use of an inhouse microcomputer system (Stuckert, 1982). The inventorying project began in 1978, since when approximately half the collection has been checked and basic details incorporated within the automated system. Before a part of the collection is moved from one store to another, it is inventoried as an initial step in the procedure. Location details are then updated after the move.

The existing manual catalogue records cover approximately 80% of the collections. Three sets of catalogue cards are maintained for use by the registrar, curators and in the stores. In the case of new acquisitions, a temporary catalogue card is prepared by the registrar prior to the formal entry being drawn up by the relevant curator.

The museum is hoping to automate the overall location procedures within the next five years. The registrar is responsible for controlling outside access to the collections after approval has been given by a curator.

The registrar's staff at Winterthur consists of two Registrars and three Assistants, in a museum with five curators. The Registrars are involved in lecturing and research work, in addition to administrative and registrarial duties. The Catalogue Assistant is responsible for inventory records and the production of catalogue cards. The Registration Assistant coordinates loans from the collection, aspects of the specialised catalogue files and the production of gift acknowledgement and appraisal correspondence for new acquisitions. The part-time Assistant to the Registrar is concerned with aspects such as a photographic reproduction programme. The registrar's office and the curators form part of a single Department of Collections.

The Registrar is responsible for all collection documentation, including catalogue details. 90% of the collection is from one source. Cataloguing this material began when the museum opened in 1951, and developed during the 1960s as part of the registrar's function. The initial retrospective cataloguing was done by going to the displays themselves (most of the collection being laid out within the rooms in the estate mansion). The manual system uses a catalogue worksheet from which a master record card is typed. Eleven sets of cards are printed from these masters, one of which is stored in a separate building for security purposes. Object files are also held, with full details of each item, including confidential information. Either the registrar or the curatorial staff refer to these records when dealing with enquiries. Being actively involved in using the records, both groups of staff are conscious of the inadequacy of some of the existing details, such as object descriptions.

Location details are kept in a separate file for inventory control purposes. Any move is logged on a movement control form. A metal tag is added to

the object's index card during any temporary movement for loan, conservation, marketing and special exhibitions. Movements are a major problem due to the seasonal redisplaying of the museum as part of a visitor tour programme. The museum is now examining the use of its inhouse minicomputer to assist this inventory work. This minicomputer has been acquired for general museum use, after a two year investigation by a study committee during which departmental needs were identified. In the case of the location control work, basic details (such as number, name, location, material and tour details) will be recorded and processed using either standard commercial software or a specially prepared program.

By comparison, the Philadelphia Museum of Art has a Registrar's Office with a Registrar, one Associate Registrar, three Assistant Registrars and a Secretary. The Philadelphia Academy of Fine Art has a staff of one Registrar and one Associate Registrar, with part-time help from students.

Diii3.3 Carnegie Institute, Pittsburgh, Pa.

Mij Zidian, Coordinator of Data Services
Claudia N. Medoff, Collections Manager, Section of Man,
 Museum of Natural History
Suzanne McLaren, Section of Mammals,
 Museum of Natural History

The Carnegie Institute has been actively involved in the use of computing systems since the mid-1970s. The early stages in the development are detailed in an article by the then Collections Data Manager (Sutton, 1979). Much of the early work was done at an external bureau using the MARKIV commercial software package. Since 1980, however, the Institute has had an inhouse system using a Wang VS 80 minicomputer. A software package has been written for the Institute by a local consultancy firm.

The system configuration includes 512 kb of machine memory (using a 16-bit architecture), a series of hard discs (88 mb for documentation use; 88 mb for non-documentation; 75 mb for operating system, etc., and a backup 75 mb), a 1600 bpi magnetic tape drive, a floppy disc drive, upper/lower case line-printers and daisy wheel printer. Overall costs have been $200 000 for hardware and $60 000 for software.

The *Data Services* section acts as a central unit, supporting these facilities on behalf of the museum departments. The software includes facilities for both documentation and administrative work (financial control, etc.). The primary use from 1980–82 was for documentation; administrative use has been developed since 1982. There is an interest in using the system for word processing, but this would require alternative terminals.

Six museum departments are now using the documentation facilities, including a wide range of item records:

subject	records	average size (including structure)
art	6500	1950
bird bands	246 000	174
birds	45 000	680
ethnography	47 000	810
herpetology	101 000	630
mammals	77 000	750
minerals	20 000	650
palaeontology	39 000	900

The system uses fixed length fields (of which there may be up to 200 in a record, each of up to 256 characters), which may include multiple subfields. Records are usually stored by accession number in indexed sequential files, allowing direct access to a record by number. Retrieval or access by any other criteria is done as a sequential search through the disc file, which may take an hour or so. Records can be updated interactively. Data is stored in upper case only

Up to 14 terminals can be logged on at any one time, more than one of which can be using the same file. Most departments tend to note information on data sheets and then type a series of entries into the system, direct onto the master disc. All procedures after logging on are guided by elaborate menus, displayed across the VDU screen. Each department has access to a series of such menus for facilities such as file maintenance, inquiry, global changes, loans and labels. The typical approach is for a department to produce a number of record cards as standard output from system and then undertake specific selective searches should these be necessary. Two to three searches tend to be initiated each day. When undertaking a search, the user can specify the fields to be examined and the fields to be included in the resulting report.

The data services section is able to offer advice to departments when they are developing a project. It maintains a central file of procedural manuals, etc. There is, however, little overall standardisation between users.

The Institute includes a major *Museum of Natural History*, comprising various curatorial sections, a number of which are housed at a distant external storage facility. Neither the Museum nor its sections has a registrar.

One of the major users of the computing services is the *Section of Man*, responsible for approximately 100 000 anthropology, archaeology and social history artefacts, resulting from 30 000 accessions. The section has a curator, an assistant and a collections manager. The collections manager is responsible for controlling the collection, and preparing documentation details.

When a new group is received, an accession sheet is completed with basic information. This is held in an accession folder, together with a processing control form which shows details of the subsequent progress of the group. The material is stored in a holding area while a catalogue description is pre-

pared. Details of the group are then passed to the director for formal acquisition and the assignment of an accession number as part of a single sequence for the whole museum. A copy of the authorised form is returned to the section, where the items are numbered, the folder added to a sequence of donor files and an acknowledgement card prepared. The ethnographic items are assigned a catalogue number based on the group accession number; archaeological items receive an independent field-based catalogue number. Three copies of the catalogue sheets are held in the section, two in accession number and donor sequences in locked cabinets, and one in number order in the work area. Individual item cards are produced and filed by continent/culture/tribe, conforming to the store arrangement. A donor card is also produced at this time. Much of the catalogue information is also noted on an inventory sheet which is then used as the basis for the computer record. The computer files are used to produce shelf lists, object name lists and culture lists. The main function of the file itself is to provide details of the location of an individual object, specified by its number. In the case of location details, the computer record is amended if the object is moved out of the building, but not for short term internal moves. Only the current location details are preserved.

One of the main pressures behind starting the computer work, some five years ago, was an impending move to the new store. As part of the planning for that move, a physical inventory was undertaken. Location, box number and item number details were recorded as a basic skeletal record. This has been used to control the subsequent moves of boxes of material into the new store.

The separate *Section of Mammals* has had a similar experience. It began to use the computer system in 1976. Work is now underway to standardise the terminology used within records and to incorporate new loan control fields. It was noted that only the current taxonomic name of a specimen can be preserved in the record as there are no multiple occurrences of fields.

Diii3.4 American Numismatic Society, New York, N.Y.

William E. Metcalf, Chief Curator

The Society has a museum collection of around 700 000 numismatic items, acquired since its foundation in 1858, in a building adjacent to the Museum of the American Indian. The adverse experience in the latter museum was a strong factor in encouraging the Society to reassess its documentation priorities. It is now introducing a computer-based system for both inventory and catalogue details.

Material entering the museum is dealt with on a departmental basis by staff of the six divisions. There is no registrar. Acquisitions are noted in a central ledger, and a formal transfer of title document exchanged. The Society encourages unrestricted gifts to the collection. It sometimes disposes

of duplicate material, using the resulting funds to aid new purchases, with the support of the auditors.

The basic initial documentation unit is the acquisition, which may include thousands of individual items. (The largest single acquisition is of 88 000 items.) The collection now includes 18 000 separate acquisitions with a significant growth rate. Prior to 1976 the individual items were not numbered. As they are dispersed into systematically arranged stores, there were serious problems in linking the objects and documentation.

A new computer system was introduced in August 1981, based on an inhouse Prime minicomputer with 300 mb of hard disc. The computer, its consultant-designed software and the associated staff costs have been contributed by a benefactor, at a total cost of $300 000. The software has been developed for the Society using a standard database management system as its core. Although the initial use of the system has been for documentation purposes, this may be extended to financial control and word processing activities in the future. The availability of funds to develop the system was a powerful incentive to encourage the curators to adopt the facilities.

The first stage in the computing project was to transfer the existing acquisition ledger details into the system. These 18 000 records have formed the nucleus for subsequent stages. Each can include 11 basic fields about the acquisition. A parallel system is used for the individual coin records. Input is by means of prompts on a VDU screen, taking data direct from the coin itself and its basic descriptive label. Standard transliteration schemes and texts are used as a basis when developing the item record. Uniform information is automatically transferred from one record to the next at the time of input. A unique identity number is also assigned, based on the group accession number (with the system retaining a count of the last individual number assigned within each accession): when provided by the system, this number is added to the coin label for future reference purposes. Loan details are also added to the records. Each field in the record is held as an inverted file, suitable for direct access. A field may be either alpha or numeric, thus allowing effective sorting of the varied information.

The first stage in the project is to process the primary research collection over a five-year period. One full-time data entry clerk is concerned with the schemes, visiting individual departments on a regular basis to help them with input. A number of volunteers are also helping.

The records and system are already proving of considerable value in the management of the collection and for research purposes.

Diii3.5 Museum of the American Indian, New York, N.Y

Dr R. Force, Director
Ruth Slivka, Registrar's Assistant

The experiences of the Museum of the American Indian are often referred to by curators as the example of malpractice which did most to create a new

attitude of responsibility towards collections and their documentation. Abuse of their position by the director and trustees led to an investigation by New York State authorities and the growth of awareness that museums hold collections in public trust (Malaro, 1979; Weil, 1983).

The Museum now has a new Director and Board of Trustees who have been working to overcome the problems introduced by their predecessors. A formal collections management policy was published in 1978 (Museum of the American Indian, 1978), and a major inventory programme is underway. The collections are the largest example of American Indian material in existence, including over one million items.

All requests for an accession, loan or deaccession are now referred to a monthly curatorial meeting of all senior staff. All proposals are considered and recommendations then forwarded to a subcommittee of the Trustees, which itself reports to the main Board. The museum now has few long-term loans. Deaccessioning is rarely carried out.

The inventorying project began in 1976 when a five-year programme to undertake a physical stockcheck and reconciliation with the existing records was initiated. Although the first stages of the computerised scheme were undertaken on a mainframe computer, the data is now being transferred to an inhouse microcomputer system. This will be a multi-user 8-bit machine with a standard software system written in Basic, using an 80 mb hard disc and a 16 mb removable disc.

The inventory work is being coordinated by the four staff within the museum's registrar's office. The computerisation scheme is not intended to replace the use of the existing manual catalogue records but to provide alternative means of access to these records. The manual catalogue will therefore be maintained in the future. The current catalogue record is prepared by the registrar and curator in consultation. Basic A5 record sheets are used for the catalogue details. A manual catalogue card, condition report and supplementary information sheet are also produced.

The inventory was developed from two sources: a physical check of the collections themselves, and the existing catalogue records. Input sheets were produced for the information from both sources. The resulting files were then merged into a single sequence, by catalogue number, showing up discrepancies, etc. Many of the resulting problems were due to mistyping of the catalogue numbers, rather than losses from the collection, demonstrating the vital importance of high standard of typing. There are also major outstanding problems resulting from a lack of terminology control and syntactical analysis of the information within the records. However, the project has already been a major factor in helping the museum assess the state of the collection and improving the standard of its future management.

Diii3.6 Museum of Modern Art, New York, N.Y.

Eloise Ricciardelli, Registrar

Suzanne Gyorgy, Department of Registration
Jon Gartenberg, Assistant Curator, Department of Film

The Museum of Modern Art, formed in 1929, has a major collection of around 100 000 items arranged in six curatorial departments: Painting and Sculpture; Drawings; Prints and Illustrated Books; Architecture and Design; Photography; and Film. Documentation is undertaken by the curatorial departments and a separate Department of Registration, with varying interrelationships between the two (Ricciardelli, 1985).

Both the registrar's records and those from the departments have been computerised for some years, using the GRIPHOS package supported by the Museum Computer Network. The data entry and editing aspects are now being brought inhouse onto an IBM 38 system acquired for general purposes within the museum.

The *Department of Registration* is primarily concerned with transportation, handling and packing of loans to and from the museum, with dealing with pending acquisitions, and with the documentation of acquisitions and exhibitions.

The location system is one area that has not yet been automated. A Traffic Coordinator is responsible for all movements of material both within and without the museum. Movements can be authorised by a curator or registrar: the coordinator must be forewarned by means of an alerting form. Details of movements are then passed to the registrar on a daily basis. Permanent changes are noted on the history file for the object. The coordinator also keeps a series of location cards (in artist order) with the current details of each item in the collection. If necessary, separate lists are also maintained in the stores themselves (although most material is arranged by artist).

The museum itself has been undergoing a major reconstruction and extension in recent years. In addition to the main building, collections are also held in six outside stores. Consequently the role of the Traffic Coordinator is a key function in ensuring the security of the collections.

The acquisition procedure adopted depends on the type of material. In the case of paintings, sculpture and drawing, a registration assistant prepares a collection worksheet which is then sent to the relevant curator for approval. Other departments do their own cataloguing. In most cases, the registrar's department is then responsible for the data entry and processing of the records. The computing system is used to promptly produce a series of cards for each record, for filing within the registrar's department (in artist, donor and number order) and the curatorial departments. Indexes are also prepared at a later date.

Before the recent building upheavals, it was practice for the registrar's staff to undertake an inventory of the paintings and sculpture collections every two years. (These collections are the direct responsibility of the registrar, while others are in the care of curatorial departments.) The museum's external auditors undertake random dipchecks of the collection

each year. They select a master record and then request the relevant proof of acquisition, location details and authority for any transfers.

The main exception to these overall procedures is the *Department of Film*, where all aspects of collecting, inventory, loans and documentation are undertaken independently by the archives staff. The department has been computerising details of the 8000 films in its collection. The last decade's work has been undertaken using GRIPHOS. A major survey of new systems has recently been completed with the aim of converting existing data into a new hardware and software system by 1985, funded by external sources (Gartenberg, 1982). The department is actively consulting other film collections to identify any common base to these developments.

Recent practical work has concentrated on the cataloguing of the collection, most of which has now been documented. 60% has been incorporated within the existing computer system which has been used to produce indexes by title and artist. Extensive inventories of the physical collection have recently been undertaken. The new system will incorporate cataloguing, inventory control, loan and conservation features.

All the collections management activities have been documented as fully as possible, including a published book on cataloguing rules (Gartenberg, 1979), and expected acquisition, accession and technical inspection forms.

Diii3.7 International Museum of Photography, Rochester, N.Y.

Andrew Eskind, Director, Interdepartmental Services

The Museum has a major collection of around half a million visual images of considerable historical and technical importance. It has been developing computer-based documentation procedures and actively investigating the use of videodiscs. It is conscious of its accountability under New York State law. As a public trust and educational institution with no-profit tax status it has an obligation to take proper care of its collections.

Within this framework, basic details of each acquired group are noted in an accession register, and the group itself assigned a number. The collections are broken down by types of material, medium and size, conforming to museum storage areas. Items within a single store are arranged by maker and then individual item number (formed from a subdivision of the group number). In the absence of a catalogue to the collection, the archivists and registrar responsible for its arrangement utilise COM indexes, providing access to artist, number, provenance or object type. These indexes presently list nearly 40 000 groups and are reissued bi-monthly.

The predominant curatorial interest in the museum has been art-orientated. There has, as yet, been less emphasis on the content of the images themselves, although this may be a strong development in the future. This attitude contrasts with that of organisations like historical societies and the Library of Congress which have often had a greater subject-based

approach. Staff in a number of these organisations are now concerned to reconcile the two extremes.

The museum has been exploring the role of computer-based systems for some time. Around 25 000 records were processed using GRIPHOS during the 1970s. These records are now being transferred to a new system based on the Adabas database management package available on the local university IBM 3032 computer. The use of the new system is still in its early stages, with future application work being necessary. A programmer has been involved in preparing applications during the last year. For the future, the museum is very interested in exploring the use of an inhouse computer system. It is concerned that a non-commercial cooperative approach should be adopted if at all possible.

It has also been experimenting with videodisc systems. A demonstration disc has been prepared, with both still and movie images, the former sample being of 208 items from the collection. The originals were copied onto 35mm colour negative film, transferred to tape and then made into a master disc by 3M. The film itself can be preserved for future reuse when higher quality mastering procedures are available. The disc is backed up by printed indexes which can be used to guide access to relevant images.

In the future, the museum would like to expand the use of videodiscs and to link the videodisc system to a local micro- or minicomputer. It feels that the use of videodisc has strong merits when considering conservation of the original images, access to the images and interpretation of the collections.

Reference was made to advanced work with videodiscs undertaken by the Library of Congress, under contract with Sony. Thirteen thousand images from the Prints and Photographs Division will be processed, and the resulting discs tested for archival quality, etc. Another experiment was being undertaken with images from the National Geographic Society. There was also interest in applications of the approach for the dissemination of images from commercial picture agencies.

Diii3.8 Margaret Woodbury Strong Museum, Rochester, N.Y.

Mary E. Case, Registrar

The Strong Museum was founded ten years ago as a bequest of a collector of nineteenth century Americana. Since its foundation, staff have been working to develop and document the collections and to prepare displays for the opening of a substantial new building in October 1982. They were in the unusual position of being able to design a museum and its systems, with major collections but no previous history of inherited procedures.

The first director (H. J. Swinney) was very aware of the problems and opportunities created by this circumstance. He was responsible for a large collection (around 300 000 items) with no documentation, in need of rationalisation and exploitation, with a plan for considerable growth of new acquisitions. R. Chenhall was appointed to investigate the options, con-

centrating on the classification of the collection rather than particular hardware problems. With assistance from experts in museums around the country, Chenhall developed a classification scheme suitable for use as a starting point within the Strong Museum but also with wider utility (published as *Nomenclature*) (Chenhall, 1978a).

Nomenclature is now used within the museum as one of the key aspects of its documentation system. Procedures are coordinated by a registrar's office with five permanent staff. The status of the Registrar is comparable with that of the Chief Curator. Basic collections control procedures are managed by the registrar's team on a manual basis. The primary catalogue records, however, have been computerised.

The collection includes a range of nineteenth and twentieth century manufactured materials (miniatures, dolls, toys, etc.) reflecting the social history of the Eastern United States during the last 150 years. Apart from the main public display areas, much of the material is held in high-density stores, accessible to the public.

Unanticipated material brought to the museum is dealt with in the public area. Anticipated material is usually handled at a loading bay and then passed to a holding room within the registrar's area. This typically includes about 600 to 1000 items a year. A loan agreement form is then completed for each group, irrespective of its eventual purpose in the museum. Potential acquisitions are assessed by a collections committee and then, if accepted, are photographed. An accession number is assigned and transfer agreement prepared. An overall accession record, individual item records and location details are kept within the computer system, in three separate files. The basic development of the computer aspects of the system was undertaken by the previous registrar who had a computing background. It now uses a bureau service for bulk data entry and the Inquire system on the nearby university computer for batch processing of records. The museum has felt no marked need for online facilities, finding printed listings and catalogue cards adequate for its purposes.

The location file is prepared by the registrar's office and amended in the event of any change of location, with the superseded details being maintained in the records. Movements staff within the registrar's office are responsible for major changes. Curators are authorised to make changes but must report the effect to the registrar. The collection itself is stored by material. While the registrar is responsible for the allocation of space at a general level, the curators are concerned with its detailed utilisation.

The item records are prepared by the curatorial staff, using a copy of the group accession record as a basis. The cataloguing procedure follows detailed guidelines which are described in a formal manual prepared and maintained by the registrar. Information about the item is noted on a worksheet which is then passed to the registrar for editing and validation against a number of authority lists. After bureau data entry, the records are checked by a preprocessing programme. Record cards are produced by the system,

passed to the curators for proofreading and then corrections are made by the registrar's staff.

Three sets of record cards are produced for use by the individual curator, the curatorial department and in the visible storage area. The file is also available for selective searching, with four to five searches being carried out weekly. A charge is made for a significant search for a member of the public.

Typical computing costs for the 47 000 records are 75 cents per record for data entry and 25 cents per record for additional costs.

Diii3.9 *Detroit Institute of Arts, Detroit, Michigan*

Judith L. Schulman, Registrar – DARIS
Karen Serota, Registrar – Loans and Exhibitions

The Detroit Institute of Arts has been one of the museums in the United States that has taken a lead in reassessing its documentation procedures and introducing a computer-based system (Schulman, 1985). The key impetus for this change was the need for an effective inventory control mechanism, highlighted by a theft from the collection. The original inventory system has been extended into an overall documentation system called DARIS (Detroit Arts Registration Information System) which is now complemented by DAMIS (Detroit Arts Management Information Systems). These systems are now used by a network of nine art museums in Michigan, centred in Detroit. They may also be acquired by other museums in the future. There are interim plans to transfer the systems onto IBM machines, in addition to their current Burroughs host. The present DARIS package is being marketed through Burroughs at $30 000.

The inhouse use of DARIS is coordinated by a special team, parallel with a registrar's office, both of which are the responsibility of the Assistant Administrator. The DARIS team currently uses a Burroughs 1955 computer with 1 mb of memory (a recent upgrade from a Burroughs 1860, at a cost of $100 000 for the new processor). The current system has 260 mb of disc store, of which the catalogue data uses some 60 mb. There is no magnetic tape backup, copies of the disc files being taken on a regular basis. The documentation application is seen as a fundamental use of the system. Fifteen terminals are in the building for various purposes, three of which are in the DARIS area and one with an inventory clerk.

The DARIS unit includes three full-time staff, supported by part-time assistants. The system was designed by an outside consultancy, who completed the basic package three years ago. Work since then has concentrated on the development and processing of each item in the collection, a programme which should have been completed in another year. The DARIS staff will then concentrate on current accessions, exhibitions, etc.

Full catalogue records are held on the disc units, and interrogated by either an inquiry or an inventory system. The former allows direct access by

various data categories; the latter by accession number. The system makes extensive use of screen prompting mechanisms during data entry, which takes place into a temporary file. New records are added and amendments to existing records undertaken as a batch process, running overnight. There is initial validation of data during its entry and as part of the updating cycle.

The files are maintained and used by a combination of the DARIS and registration staff. The registrar is in charge of management of loans, rights and reproductions, and internal and external exhibitions. The museum has a very active touring exhibition programme with international users. Its permanent collection is of around 50 000 fine and decorative art items.

All material coming into the museum is assigned a loan number. The numbers are then arranged according to the reason for the entry, such as exhibition, examination, loan or potential purchase. Curatorial staff are encouraged to complete an incoming shipment form in advance of the receipt of anticipated material. The item is then handled by the museum packers, who come under the control of the superintendent, not the registrar. The packers complete an entry form while the item is in a holding area. The registrar's office then coordinates basic action and movements of the incoming item. If it is a loan, details are added to an exhibition file. If an acquisition, basic records are prepared and details entered into the computer system.

Until 1980, two card indexes were maintained of the permanent collection, in numerical order. These are not now supported. Full catalogue records are now held in the computer system, but cards are not produced as standard output for all new entries. Printouts are sent to each department. The manual catalogue files are the responsibility of the curatorial staff.

Some 200 to 300 items are sent on loan from the collection each year, many of which go to nearby museums. Other items pass out of the museum, after a short period in its hands during which a touring exhibition has been built up. Outgoing material is accompanied by a control form, shipping instructions and security pass.

Details of any move, whether external or internal, are noted and then logged in the computer system. The inventory details are held in an online index as a subset of the main catalogue records. As noted above, the need to develop an inventory was the primary factor behind the introduction of the computer system.

The first stage in the development of the system was a physical inventory of the collection, noting number, location and date for the items. Of the 33 000 records in the computer system, 18 000 include location. In a number of cases, only the inventory record is available as the initial step in the accumulation of full details. The various movement procedures are now used as a means of maintaining the inventory details. An inventory control clerk is responsible for monitoring all movements and updating the computer file to reflect the changes. The inventory part of the system allows the clerk to change the location details after having accessed a record by its

object number. Although the location information is held as part of the main object record it can only be amended by the special inventory system. The inventory system displays basic information about an item on a terminal, including object number, general location, specific location, date, time of move, artist, title, department, date moved and date updated. The file includes the current and immediately preceding location information: earlier details are discarded.

The computer system is used during a monthly random check of the collection. Twenty catalogue entries for each of ten departments are selected automatically by the system. The inventory clerk draws together copies of the manual and computer records for each item and passes these to the department for validation. While the curator is expected to check all aspects of the record, particular attention is paid to location and insurance value. Any errors or omissions are reported to the clerk who arranges for the computer file to be updated and returns the various records to their permanent positions. This approach contrasts sharply with the attitude just five years ago, when no inventory control procedures were in operation.

The various DARIS and registration procedures are supported by extensive manuals, defining the data standards and terminology to be used by the museum. The computer system is used to produce master authority lists of the terms that have been used within the existing records. These are then validated and used to edit the existing data and as a source for subsequent records. Separate detailed lexicons are maintained for functions, subject and medium/technique. A description glossary has also been developed, with definitions of documentation, computing terms and art historical language.

Sources of further information

The following organisations may be able to provide further information and advice.

American Association of Museums
1055 Thomas Jefferson Street
Northwest
Washington DC 20007
(202) 338-5300

> Responsibilities include the development of statements of ethics and an accreditation scheme (see Section 2.5). It also has an active Registrars Committee which arranges workshops, etc., and issues an informal newsletter.

The Art Museum Association
270 Sutter Street
San Francisco
CA 94108
(415) 392-9222

> One of the functions of the AMA is to provide member museums with information about computers and their use, release low-cost software for art museums (covering accounting, collections management, etc.), and provide education and technical assistance.

Aslib
26/27 Boswell Street
London WC1N 3JZ
(01) 430 2671

> Offers a variety of training courses on aspects of bibliographic cataloguing and computer use. Publishes several journals, including *Journal of Documentation* and *Program*.

Canadian Museums Association
280 Metcalfe Street
Suite 202
Ottawa, Ontario K2P 1R7
(613) 233-5653

> Subsections include an active Registrar's Special Interest Group which publishes an informal newsletter.

Central Computer and Telecommunications Agency
Riverwalk House
157-161 Millbank
London SW1P 4RT
(01) 211 3000

Provides support for major, complex or novel computerisation projects undertaken by government departments. Disseminates information on micros and maintains a workshop where potential users can try out the current range of CCTA-approved systems and obtain initial advice on proposed applications. Publications include *CCTA News*.

Cimtech, the National Centre for Information Media and Technology
Hatfield Polytechnic
PO Box 109
College Lane, Hatfield
Herts AL10 9AB
(07072) 68100

Offers advice and training on aspects of information technology. Publications include *Information Media and Technology*.

Library Association
7 Ridgmount Street
London WC1E 7AE
(01) 636 7543

Organises training courses in the use of all aspects of information technology, with a library emphasis.

Library Technology Centre
309 Regent Street
London W1R 8AL
(01) 636 2383

Based at the Polytechnic of Central London, the Centre is supported by grants from the British Library. Its aim is to increase awareness of information technology among librarians, information scientists, etc. Functions include encouraging visits to the Centre, which houses a range of microcomputer-based hardware and software. Publications include *Library Micromation News* and *Vine*.

Local Authorities Management Services and Computer Committee
3 Buckingham Gate
London SW1E 6JH
(01) 828 2333

Provides advisory and consultancy services to help local authorities to make the best use of their resources. Has registers and indexes of computer applications, and a series of reports giving guidance.

Museum Computer Network
Department of Computer Science
State University of New York at Stony Brook
Long Island

NY 11794
(516) 246-6077

Acts as a clearing-house for information on computerised cataloguing of museum collections (see Section 2.3). Publications include *Spectra.*

The Museum Documentation Association
Duxford Airfield
Duxford
Cambs CB2 4QR
(0223) 833288

The MDA undertakes research and development in all aspects of documentation, provides advice to museums on documentation practice, issues publications and software, and supports a computing bureau able to process museum records (see Section 2). Publications include *MDA Information.*

The National Computing Centre
Oxford Road
Manchester M1 7ED
(061) 228 6333

Provides advice and publications on all aspects of computers. Coordinates a number of Microsystems Centres where a range of popular microcomputers and program packages can be tried out.

National Museums of Canada
Canadian Heritage Information Network
Ottawa, Ontario K1A 0M8

Responsible for supporting computer systems and documentation advisory services on behalf of Canadian museums (see Section 2.3, 2.20–2.21 and Appendix Diii).

References

Abell Seddon, B., 1982. A natural history computer-based catalogue. *Museums Journal*, *82*(2), 93–97.

American Association of Museums, 1978. *Museum ethics*. Washington, D.C.: AAM. 31p.

American Association of Museums, 1984. *Museums for a New Century. Report of the Commission on Museums for a new century*. Washington, D.C.: AAM. 144p. ISBN 0-931201-08-X.

Anon., 1978. Museums and computers. *Museum*, *30* (3/4), whole issue.

Anon., 1981. Introducing viewdata. *CCTA News*, *2*, [4–5].

Anon., 1982a. Canadian Heritage Information Network. *Echo* (National Museums of Canada), *2* (8), 1–3.

Anon., 1982b. NMC grants for registration. *Museogramme*, *10* (5), 7.

Anon., 1982c. CCTA procurement procedures. *CCTA NEWS*, *16*, 11–13 and *17*, 7–12.

Anon., 1983. Standard range of microcomputers for government departments. *CCTA News*, *24*, 2–3.

Anon., 1984. Code of ethics for registrars. *Registrar*, *1*(2), 1–13

Armstrong, C., 1981. *Software for printed indexes: a guide*. (British Library. Research and Development Department Report, 5622.) London: Aslib. 98p. ISBN 0-85142-142-3.

Armstrong, C. J., Guy, R. F. and Painter, J. D., 1981. Microcomputers or word processors in the library. *Reprographics Quarterly*, *14* (3), 98–103.

Art Museum Association, 1982. *Technology in museum environments*. A national survey of current and anticipated computer use in art museums. San Francisco, Ca.: The Association. 59p.

Ashford, J. H., 1980. Information management packages on minicomputers. *Journal of Information Science*, *2*, 23–28.

Ashford, J. H. and Matkin, D., 1982. *Studies in the application of free text package systems for information storage and retrieval in libraries and related information centres*. London: Library Association. 50p. ISBN 0-85365-539-9.

Association of County Archaeological Officers, 1978. *A guide to the establishment of sites and monuments records.*: ACAO. 36p

Auditing Practices Committee, 1983. *Auditing guideline. 405. Attendance at stocktaking*. London: APC. 9p.

Baker, J. C., 1985. Tyne and Wear County Museum Service. *In* Light *et al*, 1985.

Bamberry, A., 1982. The use of MDS decorative arts cards at Sheffield City Museums. *MDA Information*, *6* (2), 26–28.

Barrett, R., 1981a. *Developments in optical disc technology and the implication for information storage and retrieval*. (British Library Research and Development Department Report, 5623.) London: British Library. ISBN 0-905984-71-4.

Barrett, R., 1981b. Prospects for the optical disc in the office of the future. *Reprographics Quarterly*, *14* (4), 140–143.

Bartle, R. and Cook, M., 1983. *Computer applications in archives: a survey*. (British Library Research and Development Department Report, 5749.) Liverpool: University of Liverpool. Archives Unit. iii, 58p. ISBN 0-907156-01-0.

Beelitz, P.F., 1979. Assigning new identities to old exhibit cases. *Curator*, *22* (1), 21–30.

Bennett, W. E., 1981. *Choosing a small computer*. A checklist guide. London: British Institute of Management. 36p. ISBN 0-85946-120-3.

Boss, R. W., 1983 *The library manager's guide to automation*. 2nd edition. White Plains, NY: Knowledge Industry Publications. 169p. ISBN 0-86729-051-X.

Boss, R. W. and McQueen, J., 1982. Automated circulation control systems. *Library Technology Reports*, *18* (2), 125–266.

Boylan, P. J., 1976a. The ethics of acquisition: the Leicestershire code. *Museums Journal*, *75* (4), 169–170.

Boylan, P. J., 1976b. An East Midlands regional agreement on industrial and technology museums. *Museums Journal, 76* (2), 67–68.

Boylan, P. J., 1977. Museum ethics: Museums Association policies. *Museums Journal, 77* (3), 106–111.

Boylan, P. J., 1982. New law may solve problem of uncollected enquiries. *Museums Bulletin, 22* (8), 151.

Bradbeer, R., de Bono, P. and Laurie, P., 1982. *The computer book. An introduction to computers and computing.* London: BBC. 208p. ISBN 0-563-16484-0.

Bradley, S., 1983. Conservation recording in the British Museum. *The Conservator, 7,* 9–12.

British Library. Bibliographic Services Division, 1980. *UK MARC manual.* Second edition. ISBN 0-900220-84-8. London: British Library.

Brunton, C. H. C., 1979. The development of a computer-based curatorial system for palaeontology at the British Museum (Natural History). *In* Bassett, M. G. (ed.). Curation of palaeontological collections. (Special Papers in Palaeontology, 22.) London: The Palaeontological Association. Pages 159–173.

Brunton, C. H. C., 1980. The use of a computer based curatorial system in the Dept. of Palaeontology B.M. (N.H.). *Geological Curator, 2* (9/10), 624–628.

Bryant, J. M., 1983. Biological collections: legacy or liability? *Curator, 26* (3), 203–218.

Bryant, P., 1980. Progress in documentation. The catalogue. *Journal of Documentation, 36* (2), 133–163.

Bryant, P., 1982. The library catalogue: key or combination lock? *Catalogue and Index, 67,* 1–7.

Burnett, J. and Wright, D.,1982. Practical problems in cataloguing the Wellcome Collection. *Museums Journal, 82* (2), 86–88.

Burrett, F. G., 1982. *Rayner scrutiny of the departmental museums: Science Museum and Victoria and Albert Museum.* [London: DES.] 87p, appendices.

Canada. Auditor General of Canada, 1981. *Report of the Auditor General of Canada to the House of Commons. Fiscal year ended 31 March 1981.* Ottawa: Ministry of Supply and Services. vi, 525p. ISBN 0-660-11055-5.

Canada. Department of Communication, 1982. *Report of the Federal Cultural Policy Review Committee.* Ottawa, Ont.: Ministry of Supply and Services. 406p. ISBN 0-660-11228-0.

Canada. National Museums of Canada, 1981. *Collections policy and procedures.* (Codex musealis, 1.) Ottawa: National Museums. 93p.

Chaldecott, J. A., 1967. The automatic typewriter for computer input. *Museums Journal, 67* (2), 97–105.

Chen, C.-C. and Bressler, S. E. (eds.), 1982. *Microcomputers in libraries.* (Applications in information management and technology.) London: Mansell and New York, NY: Neal-Schuman. v, 259p. ISBN 0-918212-61-8.

Chenhall, R. G., 1975. *Museum cataloguing in the computer age.* Nashville, Tenn.: American Association for State and Local History. viii, 261p. ISBN 0-910050-12-0.

Chenhall, R. G., 1978a. *Nomenclature for museum cataloguing: a system for classifying man-made objects.* Nashville, Tenn,: American Association for State and Local History. viii, 512p. ISBN 0-910050-30-9.

Chenhall, R. G., 1978b. Computer use in museums today. *Museum, 30* (3/4), 139–145.

Chenhall, R. G. and Homulos, P., 1978. Museum data standards. *Museum News, 56* (6), 43–48. (Also *Museum, 30* (3/4), 205–121 and *Gazette, 11* (3), 12–18.)

Clarke, D. L., 1978. *Analytical archaeology.* Second edition. London: Methuen. ISBN 0-416-85460-5.

Computerized Inventory Standards for Works of Art, 1981. *Conference proceedings Nov 1–3 1979.* Collection of papers prepared under the direction of Raymond Vézina. Montreal: Editions Fides. 287p. ISBN 2-7621-1110-2.

Consultative Committee of Accountancy Bodies, 1969. *Stock-in-trade and work in progress.* (Statement U11.) London: CCAB. 5p.

Consultative Committee of Accounting Bodies, 1975. *Stocks and work in progress.* (Statements of Standard Accounting Practice, 9.) London: CCAB. 15p.

Cook, M., 1980. *Archives and the computer.* London: Butterworth. 152p. ISBN 0-408-10734-0.

Cook, M., 1983. Applying automated techniques to archives administration: a commentary on the present situation and areas of likely progress. *Journal of Documentation, 39* (2), 73–84.

Cooper, J. D., Phillips, P. W., Sedman, K. W. and Stanley, M. F., 1980. *Geological record centre handbook.* Duxford, Cambridgeshire: MDA. vii, 65p. ISBN 0-905963-28-8.

Copp, C. J. T., 1985. The development of documentation procedures in the City of Bristol Museum and Art Gallery. *In* Light *et al*, 1985.

Corfield, M., 1983. Conservation records in the Wiltshire Library and Museum Service. *The Conservator, 7,* 5–8.

Cutbill, J. L. (ed.), 1971. *Data processing in biology and geology.* (Systematics Association Special Volume, 3.) London: Academic Press. xv, 346p. SBN 12-199750-2.

Cutbill, J. L., 1985. Documentation services at the National Maritime Museum: Project Petrel. *In* Light *et al*, 1985.

Davis, P. and Hebron, J., 1982. Computer cataloguing at the Hancock Museum, Newcastle upon Tyne: a review of progress to date. *Museums Journal, 82* (2), 89–91.

Dawes, C. C., 1982. Pictorial representation cataloguing in Stevenage Museum. *MDA Information, 6* (2), 20–23.

Dierieckx, H. and Hopkinson, A., 1981. *Reference manual for machine-readable bibliographic descriptions.* Second edition. (PGI/81/WS/22.) Paris: Unesco.

Doran, J. E. and Hodson, F. R., 1975. *Mathematics and computers in archaeology.* Edinburgh: University Press. ISBN 0-85224-350-6.

Doughty, P. S., 1982. *The state and status of geology in U.K. museums.* Report on a survey conducted on behalf of the Geological Curators' Group. (Geological Society, Miscellaneous Paper, 13.) London: Geological Society. 118p.

Duckworth, W. D., 1984. The Smithsonian's new Museum Support Center. *Museum News, 62* (4), 32–35.

Dudley, D. H. and Wilkinson, I. B. (eds.), 1979. *Museum registration methods.* 3rd ed. Washington, D.C.: American Association of Museums. ix, 437p.

Elbra, T., 1982 *Database for the small computer user.* Oxford: John Wiley for National Computing Centre. 177p. ISBN 0-85012-328-3.

Englander, N., 1983. Museum computer systems and the J. Paul Getty Trust. *International Journal of Museum Management and Curatorship, 2* (3), 229–234.

Etchells–Butler, S. H., 1982. From matchbox to computer or the computerisation of the Philip Cambridge Collection at the Sedgwick Museum. *Geological Curator, 3* (5), 300–310.

Evans, C., 1981. *The making of the micro. A history of the computer.* London: Victor Gollancz Ltd. 118p. ISBN 0-575-02913-7.

Evelyn, D. E., 1981. Taking stock in the nation's attic. *Museum News, 59* (7), 39–42.

Fédération Internationale des Archives du Film. Cataloguing Commission, 1979a. *Film cataloguing.* New York: Burt Franklin and Co. 198p. ISBN 0-89102-076-4.

Fédération Internationale des Archives du Film. Cataloguing Commission, 1979b. *Study on the usage of computers for film cataloguing.* Brussels: FIAF. 60p.

Fletcher, A., 1985. Computerizing records from Leicestershire's museums. *In* Light *et al*, 1985.

Flewitt, P., 1980. *Word processing: an introduction.* London: Macmillan. ISBN 0-333-29435-1.

Flood, S. and Perring, F., 1978. *A handbook for local biological record centres,*: Biology Curators Group and Biological Records Centre. Unpaginated.

Force, R. W., 1983. An orderly house. *The Museologist,* Spring, 12–14.

Fraser, S., 1982. Recent experience at the Hunterian Museum. *MDA Information*, 6 (3), 39–41.

Ganning, M. K. D., 1976. The catalog: its nature and prospects. *Journal of Library Automation*, 9 (1), 48–66.

Gartenburg, J., 1979. *Film cataloguing manual: a computer system.* New York, NY: Museum of Modern Art. 206p.

Gartenburg, J., 1982. *Research leading to the design of a new computer system for the Museum of Modern Art, Department of Film.* New York, NY: Museum of Modern Art, Department of Film. New York, NY: Museum of Modern Art. 32p.

Gautier, T. G., 1978a. The changing nature of entomological collections. 4. Electronic data processing in systematic collections. *Entomologia Scandinavia*, 9, 161–168.

Gautier, T. G., 1978b. Automated collection documentation system at the National Museum of Natural History, Smithsonian Institution, Washington, D.C. *Museum*, 30 (3/4), 160–168.

Gautier, T. G., 1985. National Museum of Natural History, Smithsonian Institution. *In* Light *et al*, 1985.

GB. CCTA *see* Great Britain. Central Computer and Telecommunications Agency.

GB. DES *see* Great Britain. Department of Education and Science.

GB. E & AD *see* Great Britain. Exchequer and Audit Department.

GB. HC. CPA *see* Great Britain. Parliament. House of Commons. Committee of Public Accounts.

GB. Health and Safety Executive *see* Great Britain. Health and Safety Executive.

GB. SED *see* Great Britain. Scottish Education Department.

GB. Treasury. *see* Great Britain. Treasury.

Gorman, M. and Winkler, P. W. (eds.), 1978. *Anglo-American cataloguing rules.* Second edition. London: Library Association. xvii, 620p. ISBN 0-85365-681-9.

Graddon, P. H. B. and Cannon, T. H., 1982. Advances in technology II. *British Library. Research Reviews*, 3, whole issue.

Great Britain. Central Computer and Telecommunications Agency, 1980. *Stand-alone word processors.* Report on trials in UK government typing pools 1979/80. London: CCTA. 34p, appendices. ISBN 0-7115-0028-2.

Great Britain. Central Computer and Telecommunications Agency, 1982a. *CCTA procedures review for the development and procurement of computer based systems.* A review and comments on the recommendations. London: CCTA. ISBN 0-7115-0043-6.

Great Britain. Central Computer and Telecommunications Agency, 1982b. *Report of the CCTA/PSA Working Party examining the requirements for accommodating visual display systems in government offices.* Revised edition. London: CCTA. 44p. ISBN 0-7115-0035-5.

Great Britain. Department of Education and Science, 1971. *Inventory control and independent stocktaking in the national museums and galleries.* Report by the Establishment and Organisation Branch. Management Services. London: DES. [Confidential.]

Great Britain. Department of Education and Science, 1973a. *Provincial museums and galleries. A report of a committee appointed by the Paymaster General.* [Chairman, C. W. Wright.] London: HMSO. vii, 92p. SBN 11-270344-5.

Great Britain. Department of Education and Science, 1973b. *Local Government Act, 1972. Reorganisation of local government: museums and galleries and the arts.* (Circular 9/73). London: DES. 5p.

Great Britain. Exchequer and Audit Department, 1912. *Civil report (Classes I–VIII).* [London: HMSO.] Paras 10–13.

Great Britain. Exchequer and Audit Department, 1953. *Appropriation accounts.* [London: HMSO.]

Great Britain. Exchequer and Audit Department, 1974. *Appropriation accounts, 1972–73. Report. Volume 3.* London: HMSO. xxxv–xxxviii (paras 117–123). ISBN 0-10-206874-7.

Great Britain. Exchequer and Audit Department, 1981. *Appropriation accounts, 1979–80.*

Report. Volume 3. London: HMSO. xiv–xviii (paras 38–55). ISBN 0-10-209781-6.

Great Britain. Health and Safety Executive, 1983. *Visual display units.* London: HMSO. 29p. ISBN 0-11-883685-4.

Great Britain. Parliament. House of Commons. Committee of Public Accounts, 1912. *Second report, 1912.* [London: HMSO.] Pages 539–540.

Great Britain. Parliament. House of Commons. Committee of Public Accounts, 1914. *Second report, 1913. Report, 1914.* HC 249. [London: HMSO.] Page 551.

Great Britain. Parliament. House of Commons. Committee of Public Accounts, 1915. *Report, 1914. Second report, 1915.* HC 270. [London: HMSO.] Page 555.

Great Britain. Parliament. House of Commons. Committee of Public Accounts, 1954. *Third report. Session 1953–54.* [London: HMSO.] xxxvii–xxxviii (paras 8–10) and pages 64–71 (paras 801–887).

Great Britain. Parliament. House of Commons. Committee of Public Accounts, 1974. *Third report, 1974.* HC 303. London: HMSO. Pages 155–160 (questions 890–906). ISBN 0-10-230375-4.

Great Britain. Parliament. House of Commons. Committee of Public Accounts, 1981. *Tenth report from the Committee of Public Accounts . . . Session 1980–81.* London: HMSO. pages x–xii (paras 23–35) and 20–36. ISBN 0-10-223381-0.

Great Britain. Scottish Education Department, 1981. *A heritage for Scotland. Scotland's national museums and galleries, the next 25 years.* (Report of a Committee . . . under the Chairmanship of Dr Alwyn Williams.) London: HMSO. xi, 106p. ISBN 0-11-491746-9.

Great Britain. Treasury, 1980. *The role of the Comptroller and Auditor General.* (Cmnd 7845.) London: HMSO. 44p. ISBN 0-10-178450-3.

Great Britain. Treasury, 1981a. *Government accounting. A guide on accounting and financial procedures for the use of government departments.* Second edition. London: HMSO. ISBN 0-11-630668-8.

Great Britain. Treasury, 1981b. *Treasury minute in the First, Third to Sixth and Eighth to Seventeenth Reports from the Committee of Public Accounts, Session 1980–81 . . .* (Cmnd 8413. Session 1981–82.) London: HMSO. Pages 12–13 (paras 71–74). ISBN 0-10-184130-2.

Greenhalgh, M., 1982. New technologies for data and image storage and their applications to the history of art. *Art Libraries Journal, 7* (2), 67–81.

Grosch, A. M., 1982. *Minicomputers in libraries, 1981–82: the era of distributed systems.* White Plains, NY: Knowledge Industry Publications. ii, 263p. ISBN 0-914236-96-2.

Group for Regional Studies in Museums. SHIC Working Party, 1983. *Social History and Industrial Classification (SHIC). A subject classification for museum collections.* Vol. 1: classification; vol 2: index. Sheffield: University of Sheffield for SHIC Working Party. xiv, 96p and v, 74p.

Hagler, R. and Simmons, P., 1982. *The bibliographic record and information technology.* Chicago, Ill.: American Library Association. xv, 346p. ISBN 0-8389-0370-3.

Hamilton, C. D., Kimberley, R. and Smith, C. H., 1985. *Text retrieval: a directory of software.* Aldershot, Hants.: Gower. xxxiv, 239p. ISBN 0-566-03527-8.

Hancock, E. G. and Pettitt, C. W. (eds.), 1981. *Register of natural science collections in North West England.* Manchester: Manchester Museum for North West Collections Research Unit. 188p. ISBN 0-904630-04-8.

Hector, E. J., 1981. Art galleries in the UK. *In* Harrison, H. P. (ed.), 1981. Picture librarianship. London: Library Association. Pages 287–296. ISBN 0-85365-912-5.

Henry, W. M., Leigh, J. A., Tedd, L. A. and Williams, P. W., 1980. *Online searching. An introduction.* Sevenoaks: Butterworth. 209p. ISBN 0-408106-96-4.

Hickerson, H. T., 1981. Archives and manuscripts: an introduction to automated access. Chicago: Society of American Archivists. 60p. ISBN 0-931828-29-5.

Hoachlander, M., 1979. *Profile of a museum registrar.* New York, NY: Academy for Educational Development. vi, 120p. ISBN 0-89492-038-3.

Homulos, P., 1978. The Canadian National Inventory Programme. *Museum, 30* (3/4),

153–159.

Horder, A., 1980. Developments in systems providing remote access to graphic information stores. *Reprographics Quarterly, 13* (2), 51–54.

Horder, A., 1981a. *Video discs – their application to information storage and retrieval.* Second edition., (NRCd publication, 17.) (British Library Research and Development Report, 5671.) Bayfordbury, Herts.: NRCd. 50p. ISBN 0-85267-199-7.

Horder, A., 1981b. Automated retrieval of microforms. *Reprographics Quarterly, 14* (2), 57–60.

Horder, A., 1981c. *Remote access to microform stores: a guide and directory.* (NRCd publication, 16). Bayfordbury, Herts.: NRCd. 38p. ISBN 0-85267-197-0.

Humphrey, P. S. and Clausen, A. C., 1977. *Automated cataloguing for museum collections: a model for decision making and a guide to implementation.* Lawrence, Kan.: Association of Systematics Collections. 79p.

Imperial War Museum. Department of Sound Records, 1984. *The British Army in Africa 1919–1939.* London: IWM. 70p.

Institute of Purchasing and Supply, 1979. *Model form of conditions of contract for the supply and installation (purchase) of computer equipment. Shortened form of model form of conditions of contract. Notes for guidance.* Stamford, Lincs.: IPS. 20p, 4p, 4p. ISBN 0-900607-08-4.

International Organization for Standardisation, 1973a. *7-bit coded character set for information processing interchange.* (ISO 646.) Geneva: ISO.

International Organization for Standardisation, 1973b. *Coded extension techniques for use with the ISO 7-bit coded character set. (ISO 2022.)* Geneva: ISO.

International Organization for Standardisation, 1976. *Information processing – 9-track, 12,7mm (0.5in) wide magnetic tape for information interchange recorded at 63 rpmm (1600 rpi), phase encoded.* (ISO 3788). Geneva: ISO.

International Organization for Standardisation, 1979. *Information processing – magnetic tape labelling and file structure for information interchange.* (ISO 1001.) Geneva: ISO.

International Organization for Standardisation, 1981. *Documentation – format for bibliographic information interchange on magnetic tape.* Second edition. (ISO 2709.) Geneva: ISO.

Irwin, H. S., Payne, W. W., Bates, D. M. and Humphrey, P. S., 1973. *America's systematics collections: a national plan.* Lawrence, Kansas: Association of Systematics Collections. xiii, 63p.

ISO *see* International Organization for Standardisation.

Kesner, R. M. 1982. Microcomputer archives and record management systems: guidelines for future development. *American Archivist, 45* (3), 299–311.

Kirk, J. J., 1979. Using a computer in Brighton's museums. *Museums Journal, 79* (1), 17–20.

Knight, B. (ed.), 1982. *Guide to small business computers and word processing systems, 1983.* London: Computer Guides.

Lee, B. (ed.), 1978. *Introducing systems analysis and design.* Volume 1. Manchester: National Computing Centre. 166p. ISBN 0-85012-206-6.

Lee, B. (ed.), 1979. *Introducing systems analysis and design.* Volume 2. Manchester: National Computing Centre. Pages 167–556. ISBN 0-85012-207-4.

Legg, G., 1984. The Booth bird labels: a case for relabelling and cataloguing using a mini-computer. *BCG Newsletter, 3* (10), 571–575.

Levitan, K. B., 1982. Information resource(s) management – IRM. *Annual Review of Information Science and Technology, 17,* 227–266.

Leviton, A. E., Gibbs, R. H., Johnson, R. K. and McDiarmid, R., 1982. *Computer applications to collection management in herpetology and ichthyology.* A survey and report . . . Washington, D.C.: [National Museum of Natural History. Division of Fishes.] 109p.

Lewis, R. H., 1976. *Manual for museums.* Washington, D.C.: US Department of the Interior. National Park Service. xiii, 412p.

Library Association, 1982. *The impact of new technology on libraries and information centres.* (Library Association pamphlet, 38.) London: Library Association. ix, 54p. ISBN 0-85365-925-7.

Library Association, 1983. *Information technology on screen.* Proceedings of the Aslib/ IIS/LA conference . . . November 1982. (LA Conference Proceedings in Library Automation: 2.) London: Library Association. v, 63p. ISBN 0-85365-736-X.

Light, R. B., 1979. Computer-based cataloguing in British museums. *In* Bassett, M. G. (ed.), 1979. Curation of palaeontological collections. (Special Papers in Palaeontology, 22). London: The Palaeontological Association. Pages 149–157.

Light, R. B., 1982. Today's microcomputers for museum documentation? *Museums Journal, 82* (2), 77–78.

Light, R. B., 1983. Proceedings of the MDA microcomputer workshop, Leicester University, 12–13 April, 1983. *MDA Information, 7* (1), 1–14.

Light, R. B. and Roberts, D. A., 1981. *International museum data standards and experiments in data transfer.* (MDA Occasional Paper, 5.) Duxford, Cambridgeshire: MDA. iv, 100p. ISBN 0-905963-36-9.

Light, R. B. and Roberts, D. A. (eds.), 1984. *Microcomputers in museums.* (MDA Occasional Paper, 7.) Duxford, Cambridgeshire: MDA. v, 78p. ISBN 0-905963-50-4.

Light, R. B., Roberts, D. A. and Stewart, J. D. (eds.), 1985. *Museum documentation systems.* Sevenoaks, Kent: Butterworth. ISBN 0-408-10815-0.

Loughbrough, B., 1982. Professional standards and accreditation. *Museums Association. Conference Proceedings,* 5–7.

Lundeen, G. W. and Davis, C. H., 1982. Library automation. *Annual Review of Information Science and Technology, 17,* 161–186.

McInnes, G., 1978. The Hunterian IRGMA geology vocabulary and grammar. *MDA Information, 2* (2), 11–17.

MacKie, E. W., 1978. A hierarchy of artifact names for the MDA cards. *MDA Information, 2* (6), 55–79 and *2* (7), 66–69.

MacKie, E. W., 1980. Using the MDA cards in the Hunterian Museum. *Museums Journal, 80* (2), 86–88.

Malaro, M.C., 1979. Collections management policies. *Museum News,* Nov/Dec, 57–61.

Martyn, J. and Lancaster, F. W., 1981. *Investigative methods in library and information science: an introduction.* Arlington, Va.: Information Resources Press. v, 206p. ISBN 0-87815-035-8.

Matthews, J. R., 1980. *Choosing an automated library system. A planning guide.* Chicago: American Library Association. vii, 119p. ISBN 0-8389-0310-X.

McCutcheon, D., 1985. The British Museum. *In* Light *et al,* 1985.

MDA *see* Museum Documentation Association.

Meadows, A. J., 1980. *New technology and developments in the communication of research during the 1980s.* (British Library Research and Development Report, 5562.) Leicester: Primary Communications Research Centre. ii, 40p. ISBN 0-906083-12-5.

Megna, R. J., 1983. Solving big problems with small computers. *Museum News, 62* (1), 61–66.

Mollo, B., 1982. Use of ADP cataloguing at the National Army Museum. *MDA Information, 6* (3), 42–43.

Morris, B., 1982. Professional standards and accreditation. *Museums Association. Conference Proceedings,* 7–8.

Museum Documentation Association, 1980. *Data definition language and data standard.* Duxford, Cambridgeshire: MDA. v, 144p. ISBN 0-905963-26-1.

Museum Documentation Association, 1981a. *Guide to the Museum Documentation System.* 2nd edition. Duxford, Cambridgeshire: MDA. iv, 42p forms. ISBN 0-905963-22-9.

Museum Documentation Association, 1981b. *Practical museum documentation.* 2nd edition. Duxford, Cambridgeshire: MDA. viii, 188p. ISBN 0-905963-41-5.

Museum Documentation Association. Development Committee, 1982. The future de-

velopment of the Museum Documentation Association. *Museums Journal, 82* (2), 72–76.

Museum of the American Indian, 1978. Collections policies. *Indian Notes* (Museum of the American Indian), *12* (1), 1–16.

Museums Association, 1981. *Museum security.* (Museums Association Information Sheet, 25.) London: Museums Asssociation. 16p.

Museums Association, 1982. *Museums yearbook 1982.* London: Museums Association. 176p. ISBN 0-902102-57-5.

Museums Association. Information Retrieval Group. Standards Subcommittee, 1977. Ten years of IRGMA, 1967–1977. *Museums Journal, 77* (1), 11–14.

Museums Association. Working Party on Ethics, 1983. *Code of conduct for museum curators: final draft.* [London: Museums Association.] 8p.

National Assembly of State Arts Agencies, 1981. *All in order: information systems for the arts.*, Washington, D.C.: NASAA. 192p. ISBN 0-89062-132-2.

National Association of Local Government Officers, [1980]. *New technology. A guide for NALGO negotiators.*: NALGO. 46p.

National Computing Centre. 1981. *Guidelines for computer managers.* Manchester: NCC. 265p. ISBN 0-85012-248-1.

National Galleries of Scotland, 1984. *Checklist of paintings, sculpture and drawings. Gallery of Modern Art. Edinburgh.* Edinburgh: National Galleries. ISBN 0-903148-56-0.

National Museum of Wales, 1980. *Classification of objects in the Welsh Folk Museum collections.* St Fagans, Cardiff: National Museum of Wales. iii, 42p. ISBN 0-85485-047-3.

Neufeld, S. D., 1981. *The MDA systems and services: a user's view.* (MDA Occasional Paper, 6.) Duxford, Cambridgeshire: MDA. v, 115p. ISBN 0-905963-42-3.

Neufeld, S. D., 1982. Using the MDS pictorial representation card for the historic photograph collection, Museum of London. *MDA Information, 6* (2), 16–20.

Neufeld, S. D., 1983. Using portable microcomputers to create an inventory of collections in storage. *MDA Information, 7* (4), 51–55.

Norgate, M., 1982. Museum record. *Museums Journal, 82* (2), 83–85.

Norgate, M., 1984. Documentation in pastoral care museums – two considerations. *MDA Information, 8* (1), 21–26.

North American Planning Conference, 1980. *Spectra, 7* (2/3), 1–4.

Nyerges, A. L., 1982. Museums and the videodisc revolution: cautious involvement. *Videodisc/Videotex, 2* (4), 267–274.

Oakeshott, P. and Meadows, A. J., 1981. *The current use of word processors by British publishers.* British Library Research and Development Report, 5598.) Leicester: Primary Communications Research Centre. ii, 31p. ISBN 0-906083-15-X.

Olney, R. (ed.), 1982. *The microcomputer handbook. A buyer's guide.* London: Century Publishing. 224p. ISBN 0-7126-0048-5.

Orna, E., 1982. Information management in museums: there's more to it than documentation and computers. *Museums Journal, 82* (2), 79–82.

Orna, E., 1983. *Build yourself a thesaurus.* Norwich: Running Angel. 32p. ISBN 0-946600-00-7.

Orna, E. and Pettitt, C. W., 1980. *Information handling in museums.* London: Clive Bingley. 190p. ISBN 0-85157-300-2.

Orton, C., 1980. *Mathematics in archaeology.* London: Collins.

Painter, J. D., 1982. NRCd, word processors and the information industry. *Aslib Proceedings, 34* (9), 406-414.

Painter, J. D., 1983. List processing/records management software available on dedicated word processors. *Reprographics Quarterly, 16* (3), 105–108.

Perry, K. D., (ed.), 1980. *The museum forms book.* Austin, Tx.: Texas Association of Museums. xii, 380p.

Perry, R., 1983. Tate Gallery Conservation Department records. *The Conservator, 7,*

13–16.

Pettigrew, T. H. and Holden, J., 1978. Internal conventions used with the IRGMA geology and mineral specimen cards in the documentation of the geology collections of Tyne and Wear County Council Museums. *Geological Curators Group Newsletter, 2* (3), supplement. 26p.

Pettit, C. W., 1979. A comparison of the Famulus and Gos packages for handling museum data. *Geological Curators Group Newsletter, 2* (6), 369–371 and *BCG Newsletter, 2* (3), 105–108.

Pettitt, C. W., 1981. The Manchester Museum Computer Cataloguing Unit: a STEP in the right direction? *Museums Journal, 80* (4), 187–191.

Pettitt, C. W., 1985. Collections research in the United Kingdom. *In Light et al,* 1985.

Pettitt, C. W. and Hancock, E. G., 1981. Natural science collection research units, their origin, aims and current status. *Museums Journal, 81* (2), 73–74.

Platnauer, H. M. and Howarth, E. (eds.), 1890. *Report of proceedings.* Museums Association. First Annual Report. London: Museums Association. Pages 1–10.

Pole, L. M., 1983. Saffron Walden Museum. *MDA Information, 6* (4), 67–69.

Porta, E., Montserrat, R. M. and Morral, E., 1982. *Sistema de documentacio an para museos.* Barcelona: Department de Cultura de la Generalitat de Catalunya. 84p. ISBN 84-500-8019-3.

Porter, M. F., 1983. Information retrieval at the Sedgwick Museum. *Information Technology: Research and Development, 2,* 169–186.

Porter, M. F., Light, R. B. and Roberts, D. A., 1976. *A unified approach to the computerization of museum catalogues.* (British Library Research and Development Report, 5338 HC.) London: British Library. v, 75p. ISBN 0-905984-01-3.

Porter, R., 1984. The future of museum registration. *Museums News, 62* (6), 5–9.

Prowse, S., 1983. *Software for producing library keyword catalogues: a description of selected packages.* Oxford: Elsevier International Bulletins. viii, 48p. ISBN 0-946395-01-2.

Reger, L. L., 1982. Professional standards: keynote address. *Museums Association. Conference Proceedings,* 2–5.

Reynolds, L., 1979. Progress in documentation. Legibility studies: their relevance to present-day documentation methods. *Journal of Documentation, 35,* 307–340.

Ricciardelli, E., 1985. The Museum of Modern Art. *In Light et al,* 1985.

Ritchie Calder, P., 1981. The Imperial War Museum, London. *In* Harrison, H.P. (ed.), 1981. Picture librarianship. London. Library Association. Pages 259–267. ISBN 0-85365-912-5.

Roads, C. H., 1968. Data recording, retrieval and presentation in the Imperial War Museum. *Museum Journal, 67* (4), 277–283.

Roberts, D. A., 1975. Proposals for a survey of cataloguing practice in British museums. *Museums Journal, 75* (2), 78–80.

Roberts, D. A., 1982. Computerized inventories, catalogues and indexes of museum collections. *Art Libraries Journal, 7* (2), 33–40.

Roberts, D. A., 1984. The development of computer-based documentation. *In* Thompson, J. M. A. (ed.), 1984. Manual of curatorship. London: Butterworth. Pages 136–141. ISBN 0-408-01411-3.

Roberts, D. A. and Light, R. B., 1980. Progress in documentation. Museum documentation. *Journal of Documentation, 36* (1), 42–84.

Roberts, D. A., Light, R. B. and Stewart, J. D., 1980. The Museum Documentation Association. *Museums Journal, 80* (2), 81–85.

Rolfe, W. D. I., Ingham, J. K., Currie, E. D., Neville, S., Brannan, J. and Campbell, E., 1981. *Type specimens of fossils from the Hunterian Museum and Glasgow Art Gallery and Museum.* Glasgow: Hunterian Museum. 12p and 5 microfiche.

Rowat, M. J., 1982. Microcomputers in libraries and information departments. *Aslib Proceedings, 34* (1), 26–37.

Royal Ontario Museum. Committee on Ethics and Conduct, 1982. *The Royal Ontario*

Museum. Statement of principles and policies on ethics and conduct. Toronto, Ont.: ROM. xi, 103p. ISBN 0-88854-291-7.

Rush, C. and Chenhall, R., 1979. Computers and registration: principles of information management. *In* Dudley and Wilkinson, 1979. Pages 319–334.

Sambridge, E. R., 1979. *Purchasing computers.* Farnborough, Hants.: Gower Press. xvi, 156p. ISBN 0-566-02193-5.

Samet, P. (ed.), 1981. *Query languages: a unified approach.* A report of the British Computer Society Query Languages Group. London: Heydon. xi, 105p. ISBN 0-85501-494-6.

Sarasan, L., 1979. An economical approach to computerization. *Museum News, 57* (4) 61–64.

Sarasan, L., 1981. Why museum computer projects fail. *Museum News, 59* (4), 40–49.

Sarasan, L., 1985. A system for analysing museum documentation. *In* Light *et al*, 1985.

Sarasan, L. and Neuner, A. M., 1983. *Museum collections and computers.* Report of an ASC survey. Lawrence, Kansas: Association of Systematic Collections. viii, 292p. ISBN 0-942924-03-7.

Schulman, J. L., 1985. The Detroit Art Registration Information System (DARIS). *In* Light *et al*, 1985.

Seabourne, M. J., 1984. SHIC and the Museum of London Historic Photograph Collection. *MDA Information, 8* (2), 35–37.

Seaborne, M. J. and Neufeld, S., 1982. Historic photograph collection management at the Museum of London. *Museums Journal, 82* (2), 99–103.

Seal, A., Bryant, P. and Hall, C., 1982. *Full and short entry catalogues: library needs and uses.* (British Library Research and Development Report, 5669.) Bath: University Library. vi, 146p. ISBN 0-86197-032-5.

Sheridan, W., 1981a. The Science Museum, London. *In* Harrison, H.P. (ed.), 1981. Picture librarianship. London: Library Association. Pages 297–308. ISBN 0-85365-912-5.

Sheridan, W., 1981b. AACR2 and 'graphic materials': use for a descriptive catalogue for the Science Museum. *Art Libraries Journal, 6 (4)* 13–33.

Shimmin. P., 1984. MSC cataloguing project at the Sussex Archaeological Society. *MDA Information, 8* (1), 13–14.

Sledge, J. and Comstock, B., 1985. The Canadian Heritage Information Network. *In* Light *et al*, 1985.

Smith, J. F., 1983. Stamford Museum. *MDA Information, 6* (4), 61–65.

Smither, R. B. N., 1979. Using APPARAT: cataloguing film and sound recordings at the Imperial War Museum. *Aslib Proceedings, 31* (4), 170–179.

Smither, R. B. N., 1980. The film archive of the Imperial War Museum: a case history. *Computer Bulletin, 2* (26), 24–26.

Smither, R. B. N., 1985. The Imperial War Museum. *In* Light *et al*, 1985.

Smither, R. B. N. with Penn, D. J., 1976. *Film cataloguing handbook.* London: Imperial War Museum. 58p

Smithsonian Institution, 1977. *A report on the management of collections in the museums of the Smithsonian Institution.* Washington, D.C.: Smithsonian Institution.

Smithsonian Institution, 1984. *A plan for the acquisition of an integrated, generalized collections management information system.* Washington, D.C.: Smithsonian Institution.

Sorkow, J., 1983. Videodiscs and art documentation. *Art Libraries Journal, 8* (3), 27–41.

Spirer, L., 1981. Small computers for the small museum. *The Museologist, 157,* 24–26.

Stanley, M., 1984. The National Scheme for Geological Site Documentation and the Locality Applications Package. *MDA Information, 8* (4), 94–99.

Stansfield, G., 1984. The development of environmental recording by museums. *MDA Information, 8* (4), 88–93.

Steel, C. A. B., 1985. Royal Pavilion, Art Gallery and Museum, Brighton. *In* Light *et al*, 1985.

Stewart, J. D., 1980a. *Environmental record centres: a decade of progress?* (MDA Occasional Paper, 3.) Duxford, Cambridgeshire: MDA. vi, 44p. ISBN 0-905963-32-6.

Stewart, J. D., 1980b. A summary of local environmental record centres in Britain. *Museums Journal, 80* (3), 161–164.

Stewart, J. D. (ed.), 1980c. *Microcomputers in archaeology.* (MDA Occasional Paper, 4). Duxford, Cambridgeshire: MDA. vii, 136p. ISBN 0-905963-34-2.

Stewart, J. D., 1983. Museum documentation in Britain – a review of some recent developments. *Museums Journal, 83* (1), 61–63.

Stone, S. M., 1978. St Albans Museums documentation project. *Museums Journal, 78* (3), 117–119.

Stone, S. M., 1979. MDA user experience – St Albans Museums. *MDA Information, 3* (7), 49–54.

Stone, S. M., 1985. Collection recording at St Albans Museums. *In* Light *et al,* 1985.

Stuckert, C. M., 1982. Adventures in inventory. *The Museologist, 159,* 10–13.

Sunderland, J., 1983. The Witt Library Getty project. *Art Libraries Journal, 8* (2), 27–31.

Sunderland, J. and Geyer, G., 1982. A traditional art museum – modern inventory control. *Perspectives in Computing* (IBM), *2* (3), 32–41.

Sustik, J. M., 1981. *Art history interactive videodisc project at the University of Iowa.* Iowa City, Iowa: University of Iowa. Weeg Computing Center. 12p.

Sutton, J. F., 1979. Data services. *Carnegie Magazine, 53* (10), 8–14.

Swinney, H. J. (ed.), 1978. *Professional standards for museum accreditation. A handbook of the accreditation program of the American Association of Museums.* Washington, D.C.: AAM. 79p.

Tanner-Kaplash, S., 1985. The Royal Ontario Museum, Toronto. *In* Light *et al,* 1985.

Tate Gallery, 1980. *The Tate Gallery collections.* Seventh edition. London: Tate Gallery. 373p. ISBN 0-905005-02-3.

Tedd, L.A., 1983. Software for microcomputers in libraries and information units. *Electronic Library, 1 (1), 31–48.*

Tedd, L.A., 1984. *An introduction to computer-based library systems.* Second edition. Chichester: Wiley. xiv, 262p. ISBN 0-471-26285-4.

Tenorio, J. M., Nishida, G. M., Yee, S. J. and Shin, D., 1983. Applications for microcomputers in museum science. *ASC Newsletter, 11* (3), 25–29.

Thompson, J., 1982. The accreditation scheme of the Museums Association 1974–82: a review. *Museums Journal, 82* (2), 67–69.

Thompson, K. M., 1984. Leicestershire Museums, Art Galleries and Records Service – MSC photographic project. *MDA Information, 8* (1), 20–21.

Thornton, C. E., 1983. Williamson Art Gallery and Museum. *MDA Information, 6* (4), 58–61.

Turner, S. and Robson, P., 1979. Computer controlled data bank system at the Hancock Museum. *GCG Newsletter, 2* (7), 443–447.

Vanns, M., 1984. Use of MSC teams to document collections at Ironbridge Gorge Museum. *MDA Information, 8* (1), 11–13.

Vaughan, V., 1981. The National Portrait Gallery archive and library, London. *Art Libraries Journal, 6* (1), 34–37.

Warren, L., 1983. Computer assisted retrieval from microfiche: a microcomputer based system. *CCTA News, 23,* 5–6.

Watson, J. S., 1983. Is there a computer in your future? An expert examines the applications of microcomputers. *History News, 38* (8), 13–15.

Weil, S. E., 1983. Breaches of trust: remedies and standards in the American private art museums. *International Journal of Museum Management and Curatorship, 2* (1), 53–70.

Whitehead, J. B., 1980a. Progress in documentation. Word processing: an introduction and appraisal. *Journal of Documentation, 36* (4), 313–341.

Whitehead, J. B., 1980b. Developments in word processing systems and their application to information needs. *Aslib Proceedings, 32* (3), 118–133.

Whitehead, J. B., 1981. Word processing and information management. *Aslib Proceedings, 33* (9), 325–342.

Whitehead, J. B., 1983. Developments in word processing systems. *Program, 17* (3), 130–153.

Wilcox, U.V., 1980. Collections management with the computer. *Curator, 23* (1), 43–54.

Will, L., 1982. Computerisation of museum records at the Science Museum. *MDA Information, 6* (3), 36–39.

Willett, F., 1985. The Hunterian Museum and Art Gallery, University of Glasgow. *In* Light *et al*, 1985.

Williams, D. W., 1981. How museums can use information management systems. *History News, 36* (6), 37–40.

Williams, D. W., 1983. How to speak 'computer': a glossary of computer terminology. *History News, 38* (1), 30–33.

Williams, H. L. (ed.), 1983. *Computerised systems in library and Information services.* Proceedings of a conference . . . London: Aslib. 76p. ISBN 0-85142-169-5.

Williams, I., 1982. *Computers and arts management.* London: Gulbenkian Foundation. 54p. ISBN 0-903319-24-1.

Williams, P. W. and Goldsmith, G., 1981. Information retrieval on mini- and microcomputers. *Annual Review of Information Science and Technology, 16*, 85–111.

Woods, R. G., 1982. Library automation. *British Library. Research Reviews, 2*, whole issue.

Woods, L. A. and Pope, N. F., 1983. *The librarian's guide to microcomputer technology and applications.* White Plains, NY: Knowledge Industry Publications (for the American Society for Information Science). vi, 209p. ISBN 0-86729-044-7.

Yung, K. K., 1981. *National Portrait Gallery. Complete illustrated catalogue 1856–1979.* London: National Portrait Gallery. x, 749p. ISBN 0-904017-38-9.

Index

examining Ai
excavation documentation 5.2, B.5.3
exchange collections 6.9
Exchequer and Audit Department *see* E & AD
exhibiting Ai
exit file 3.4, 5.8, 6.17, Aii
exit number 5.8
exit recording 3.4, 5.8, 6.17, Ai, B.4.1–B.4.4
exit register 3.4, 5.8
exit stage 3.2, 3.4, 5.8, 6.17, B.4.1–B.4.4, Di4.1–Di4.4
external audit programme 8.1–8.2, B.3.4, Di3.4, Dii
external automated system 9.6–9.11, Dii, Diii2.2–Diii2.4, Diii3.6–Diii3.8
Famulus package C.2.9, Dii4.2
Federation for Natural Sciences Collection Research 5.11, 10.12
field notes 5.2
field record file Aii
field recording 5.2, Ai
file, documentation 3.4
file, index 3.4, 4.9–4.10
file, main 3.4, 4.9–4.10
file, index 3.4, 4.9–4.10
file maintenance 3.5, 4.10, 6.21
file organisation 4.11–4.12
file organisation methods C.2.4
financial planning package C.2.10
financial resources 2.17, 9.11, 10.1–10.9, B.2.2, Di2.2, Dii, Diii2.1, Diii3.1
finding records *see* location records
Firs package C.2.9
floppy discs C.2.2–C.2.3
flow charts 9.3
Focus package C.2.9
forms 9.3
forms design 4.9
forms design, input 4.6–4.8
framework, documentation 3.2, B.4.1–B.4.4, Di4.1–Di4.4, Dii
free-text system C.2.9
funding for documentation 2.17, 10.7–10.9
Getty Trust 2.16
Glasgow: Hunterian Museum and Art Gallery Di, Dii4.1
Glasgow Museums and Art Galleries Di, Dii3.5
Gos package C.2.9, Dii2.1, Dii2.7, Diii3.4
Griphos package Diii3.6–Diii3.7
group records 5.4–5.5, 6.8, 6.12, 7.7
growth rate 2.11, 8.5, B.2.3, Di2.3, Dii
Hancock Museum, Newcastle Di, Dii4.3
hard discs C.2.2–C.2.3
hardware 9.6–9.10, 9.12, C.2.1–C.2.7
Hirshhorn Museum, Smithsonian Institution Diii3.1
Homer package C.2.9
Hunterian Museum and Art Gallery, Glasgow Di, Dii4.1
ICOM Documentation Committee *see* CIDOC
identifying Ai
identity number *see* item number
Imperial War Museum Di, Dii2.3
implementation 10.6

negotiation procedure 10.5
new technology agreement 10.4
New York: American Numismatics Society Diii3.4
New York: Museum of Modern Art Diii3.6
New York: Museum of the American Indian Diii3.5
Newcasatle: Hancock Museum Di, Dii4.3
Newport Museum and Art Gallery Di, Dii3.9
non-acquired items 6.9–6.10
non-national museums 2.1–2.3, 2.8, 10.9, Di, Diii3–Dii4
non-object collections 2.11, 2.14, 3.3, B.2.3, B.4.1–B.4.4, Di2.3, Di4.1–Di4.4
North Herfordshire Museum Service Di, Dii3.10
numbering 7.8, Ai, Diii3.1
numbers, museum 2.1
OAL 2.7, 10.9, 10.11
object collections 2.11, 2.14, 3.3, 8.5, B.2.3, B.4.1–B.4.4, Di2.3, Di4.1–Di4.4, Dii, Diii2–Diii3
object file Aii
objectives, development 10.3
observation 9.3
Office of Arts and Libraries *see* OAL
Office of Information Resource Management, Smithsonian Institution Diii3.1
Office of the Registrar, Smithsonian Institution Diii3.1
online system 4.9, C.2.4
operating speed C.2.1
operating system C.2.8
operation, documentation system 3.6
operations, input 4.6–4.8
operations, processing 3.5, 4.1–4.12
operations, scale of 3.7, 10.4, B.3.3, C.2.2–C.2.3, Di3.3
optical character recognition C.2.5
optical videodiscs C.2.2–C.2.3, Diii3.1, Diii3.7
organisation, file 4.11–4.12
organisation, museum 2.1, B.2.1, Di2.1
organisation, record 4.11–4.12
Ottawa: National Museum of Man Diii2.2
Ottawa: Public Archives of Canada Diii2.4
output, data 3.5, 4.9, C.2.7
output stage 3.2, 3.4, 5.7, 6.22, B.4.1–B.4.4, Di4.1–Di4.4
PAC 2.6–2.7, 8.1–8.2
parent organisation 2.2, 3.6, 9.1–9.2, 9.5–9.10, 10.1–10.2, B.2.1–B.2.2, Di2.1–Di2.2, Dii
Paris package C.2.9, Diii2.1–Diii2.3
Pennsylvania Academy of Fine Art, Philadelphia Diii3.2
peripherals C.2.5–C.2.6
permanent acquisition 5.3–5.5, 6.9–6.12, 7.8
permanent staff 10.7–10.8, B.3.2, Di3.2, Dii
Philadelphia: Museum of Art Diii3.2
Philadelphia: Pennsylvania Academy of Fine Art Diii3.2
Philadelphia: University Museum Diii3.2
photograph documentation 3.3, 5.10, 9.15, B.2.3, B.5.2, Di2.3, Di5
photograph file Aii
photograph number 5.10
photographing Ai
pilot project 7.2–7.4, 10.6
Pittsburgh: Carnegie Institute Diii3.3
policy, acquisition 2.5, 7.8, Dii

supplementary information file 3.4, 5.2, 5.3, Aii, B.4.1–B.4.4
support groups *see* advisory organisation
support package C.2.8, C.2.10
syntax 4.4
system *see* documentation system
system change *see* documentation system change
system communications C.2.7
system dialogue 4.9
tailoring C.2.8–C.2.9
tape deck C.2.2–C.2.3
Tate Gallery 2.7, Di, Dii2.10
telecommunications C.2.7
teletext C.2.11
temporary staff 10.7–10.8, B.3.2, Di3.2, Dii, Diii3.1
terminology control *see* terminology standards
terminology standards 3.4, 4.4, 5.1–5.14, 6.18–6.20, Diii2.2, Diii3.8–Diii3.9
timesharing 9.6–9.11
Toronto: Royal Ontario Museum Diii2.3
trade unions 10.4
training 3.6, 10.6, B.3.2, Di3.2
transfer 5.8, 6.17, B.3.5, Di3.5
transfer, data 3.5, 4.9, C.2.5, C.2.7
transfer of title documentation 5.4–5.5
transfer of title file 3.4, 5.4–5.5, Aii, B.4.1–B.4.4
transferring of title 3.4, 5.4–5.5, Ai, B.4.1–B.4.4
transitional period 10.6
turnkey system C.2.8–C.2.9
Tyne and Wear County Museum Service Di, Dii3.16
types, data 4.3
types, documentation 3.3
union catalogues *see* cooperative catalogues
unions, trade 10.4
United Kingdom museums 2.1–2.17, Di, Dii
United States museums 2.1, 2.3–2.6, 2.10–2.11, 2.16–2.17, Diii3
University Museum, Philadelphia Diii3.2
university museums *see* non-national museums
UNIX C.2.8
usability 6.22
user education 6.22
users, documentation 3.1
uses, automated system 2.14
uses, documentation 3.1, 9.3, B.3.3, Di3.3, Dii
validation data 3.5, 4.6–4.8
valuation 8.5, Ai, B.3.5, Di3.5
valuation control Ai
VDU C.2.5–C.2.6
vendors 10.5
Victoria and Albert Museum 2.7, Di, Dii2.11
videodiscs, optical C.2.2–C.2.3, Diii3.1, Diii3.7
videotex systems C.2.11
viewdata C.2.11
Visicalc package C.2.10
visual display unit C.2.5–C.2.6
vocabulary 4.4
Washington, D.C.: Smithsonian Institution Diii3.1